COLOR INDEX XL

COLOR INDEX XL

MORE THAN 1,100 NEW PALETTES WITH CMYK AND RGB FORMULAS
FOR DESIGNERS AND ARTISTS

JIM KRAUSE

WATSON · GUPTILL
CALIFORNIA | NEW YORK

This one's for James and Doran

CONTENTS

INTRODUCTION

Color Index XL is the latest volume in my *Color Index* series. The first came out in 2002 and the second was released in 2007. It's been fun to watch the popularity of the first two indexes grow over the years. Both are heavily used around the globe by designers and artists who are searching for good-looking, attention-grabbing, and thematically on-target color schemes for their design and art projects.

Why a new edition of *Color Index*? And why now? For one thing—whether you're talking about cars, computers, vacuum cleaners, or books—there's always room for improvement with newer models. Also, as I'm sure you've noticed, tastes and fads constantly evolve when it comes to color. The palettes in this volume reflect changes in trends in the last decade or so.

Here, I'd like to showcase four key features in *Color Index XL*. I think these upgrades are especially noteworthy.

First of all, *Color Index XL* is a lot bigger than its pocket-size predecessors (and this is where the "*XL*" in the title comes from). The main advantage of this extra-large format is that it'll give you a much better look at the book's palettes. As a result, you'll have an easier time imagining how a palette's colors will look when added to a project of your own.

The second feature applies to the print edition of this book. As you can see, its colors go right to the edges of the book's pages (in printer terminology, this is known as allowing colors to "bleed"). The nice thing about having this book's palettes bleed is that you can now lay a page's colors directly against another work of design or art for easy and direct comparison. Not only that, but the bleeding palettes in *Color Index XL* also make it possible to conveniently fan along the edges of its pages when you're either brainstorming for palette ideas or looking for a specific range of colors. I think you'll really like this feature. I know I do, and I also really like the way these multicolored pages look when the book lies closed. It's a neat visual effect.

The third feature is that each of the palettes in *Color Index XL* contains five colors (the earlier

incarnations of *Color Index* featured palettes with as few as two colors). Why the expanded palettes? Well, why not? After all, advances in printing and digital technology have largely done away with cost barriers that once severely limited the number of colors that designers and artists could use on a project.

Now, given that this book's palettes each contain five colors, you might wonder if you have to incorporate all five hues when selecting a particular palette. The answer is no. Not at all. Choose anywhere from just one to all five colors, depending on the needs of your project and the look you're aiming for.

And, finally, the fourth key feature of *Color Index XL* is that each of its palettes is shown in four versions: brighter, darker, lighter, and more muted. This is an especially practical upgrade, since it allows you to find a palette with just the right visual personality and properties. For example, you might choose brighter palettes for projects that call for feelings of extroversion and energy. Meanwhile, darker palettes could be the answer when you're

preparing backdrops for lighter headlines, text, or graphics. You might apply lighter palettes to backdrops that are meant to sit beneath darker visual elements, or use muted palettes to generate feelings of sophistication or restraint.

All in all, these features should make *Color Index XL* an even more timely, practical, and idea-expanding creative tool than any of my previous *Color Index* books.

How to Use *Color Index XL*

Use this book however you like. Look through it from beginning to end, from end to beginning, from the middle outward, or by opening random pages and seeing where your selection leads you. Consult this book toward the start of a project; right in the middle of things; or just before finalizing your layout, illustration, or work of art. Use it alone or with other designers or artists. Use it right-side up, upside down, and either before or after your morning coffee. Anything goes. And heck, why not leaf through the pages of *Color Index XL* just for fun every once in a while?

It's a great way to sharpen your awareness of practical and eye-catching color schemes while also loading your brain with potentially useful ideas.

As far as this book's organization goes, there is a thread of method behind the apparent color madness in the pages ahead. The palettes in *Color Index XL* have been organized into three sections: Warmer Palettes, Mixed Palettes, and Cooler Palettes. In general, the first section features color schemes that tend toward the warmer slices of the color wheel—red, orange, and yellow; the final section presents palettes that are biased toward the cooler hues of green, blue, and violet; and the middle section contains a huge range of palettes made from a wide variety of hues (this section, by the way, starts with warmer-leaning mixed palettes and gradually moves toward cooler-leaning mixed palettes).

You'll notice that each color within this book's palettes is presented with its corresponding CMYK and RGB formula. CMYK colors are generally used for print jobs and RGB colors are for on-screen use. These formulas can be entered into documents created in Illustrator, Photoshop, and InDesign—as well as most other illustration and design programs—to create ready-to-use color swatches. Check out your software's documentation if you're unsure about how colors can be added to the files you create for your illustrations, layouts, logos, and more.

Before concluding this introduction, I'd also like to mention that there's a short section on color theory up next. It's useful material, and, if nothing else, it should break things down in a way that'll show that color really isn't all that complicated as long as you look at it in the right way.

Thank you for picking up a copy of *Color Index XL*. I really enjoyed designing and assembling this book, and I hope you'll find its assortment of palettes extremely useful and idea expanding.

Jim K.

Jim Krause

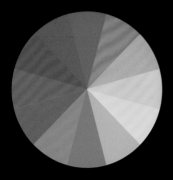

COLOR THEORY

Know a Little and You'll Know a Lot

A basic grasp of color will give you a sense for the thinking behind this book's palettes. It'll also make it easier for you to evaluate the palettes you're considering and to make adjustments to any of the colors you want to use.

Begin your knowledge of color theory with a clear understanding that the look of any color is determined by just three qualities: hue, saturation, and value.

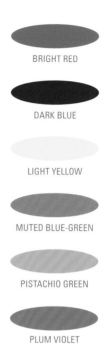

BRIGHT RED

DARK BLUE

LIGHT YELLOW

MUTED BLUE-GREEN

PISTACHIO GREEN

PLUM VIOLET

Hue

Hue is another word for color. Simple as that. Hues can be described using color wheel–based names like bright red, dark blue, light yellow, or muted blue-green. Colors can also be tagged with more evocative names like pistachio green or plum violet. (Keep in mind, however, that names like these should be used with care since they may be more open to interpretation than the color wheel–based labels mentioned above.)

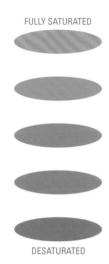

FULLY SATURATED

DESATURATED

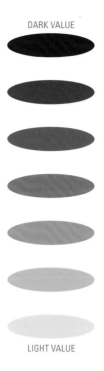

DARK VALUE

LIGHT VALUE

Saturation

A color's saturation is its degree of intensity. A fully saturated orange, for example, is an orange in its purest and most vibrant form. When the same orange is desaturated slightly, it takes on a muted appearance. As the orange is increasingly desaturated, it becomes either a brown or a warm gray. (Other warm hues like red and yellow also become browns and warm grays when desaturated; cool hues like blue, green, and violet become cool grays.)

Value

In terms of color, value refers to the lightness or darkness of a hue. Of the three components of color (hue, saturation, and value), value must be your top priority when building a palette. Why? Technically speaking, it's because neither hue nor saturation can even exist without a value to latch onto. On a more practical level, color values are an essential consideration because the human eye strongly prioritizes differences in value when making sense of what it sees.

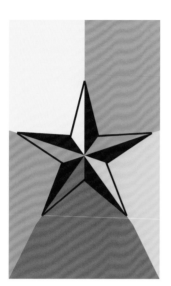

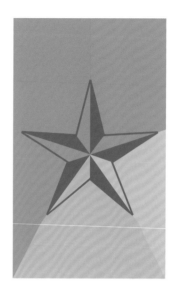

How Important Is Value?

When it comes to color, value is *very* important. In fact, painters have a saying that goes like this: "A color *can't* be right if its value is wrong." Heed this saying whenever you apply color to your visual creations. Clear differences in value help ensure that the various elements of your layouts and illustrations stand out neatly and attractively against each other; weak value differences, on the other hand, often lead to unattractive and incoherent works of design and art.

Strong or Subtle Value Differences

The strong value differences in the first illustration on this page (far left) empahsize the energetic impression of its vibrant hues. The subtle (but still distinct) value differences in the sample directly above help this illustration's colors communicate a feeling of subdued refinement.

Clear differences in value—whether strong, moderate, or subtle—are acceptable to the eye. It's up to you to decide what's best for the project at hand.

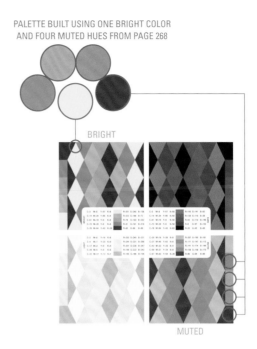

BRIGHT

MUTED

Weak Value Differences

Squint your eyes at the illustration above and you'll see that the value differences among its colors are far too close for comfort. (Squinting, by the way, helps your eyes and brain bypass color cues and focus exclusively on values.) The nearly alike values of this illustration's colors make its content difficult to perceive, and viewers with less-than-perfect vision might not be able to make it out at all.

Color Substitutions

Value, more than anything, determines whether or not a color looks good next to others. Keep this in mind when making color substitutions among this book's palettes. If, for instance, you like the colors from a page's muted palette, but want to add a bright hue from its bright palette, go right ahead: just make sure the bright hue's value allows it to stand out clearly within the muted color scheme.

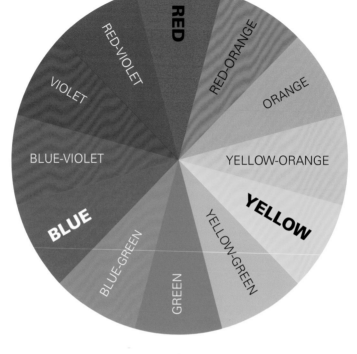

The traditional color wheel with segments labeled: RED, RED-ORANGE, ORANGE, YELLOW-ORANGE, YELLOW, YELLOW-GREEN, GREEN, BLUE-GREEN, BLUE, BLUE-VIOLET, VIOLET, RED-VIOLET.

Color Wheels

Color wheels are useful diagrams that help artists understand what happens when colors are blended. They can also be used to find associations between hues when building palettes (as illustrated on this spread).

There are several kinds of color wheels. The three commonly used versions shown on this spread are the traditional wheel, the painters' wheel, and the RGB wheel. The first two deal with physical pigments; the last relates to colors of light.

The Traditional Wheel

Shown above is the traditional color wheel— a schematic that's been embraced by artists for centuries as a model of how color works. It would be a good idea to commit this color wheel to memory if you haven't done so already. Not only will it help you predict and understand what happens when colors are blended, but it'll also help you come up with palettes like those featured on the next spread.

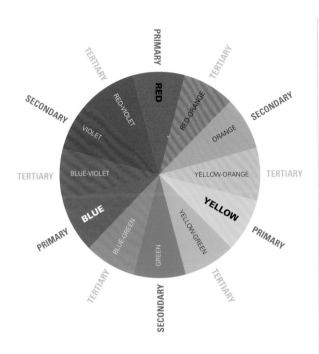

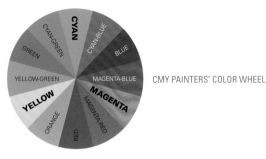

CMY PAINTERS' COLOR WHEEL

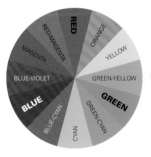

RGB COLOR WHEEL OF LIGHT

Kinds of Colors: Primary, Secondary, and Tertiary

Red, yellow, and blue occupy the primary spokes of the traditional color wheel. These three hues are the foundational colors of the wheel and mixes between them create the secondary hues of orange, green, and violet. The rest of this wheel's spokes contain tertiary hues—colors that are made by blending primary and secondary hues.

Other Wheels

If you like to paint, then consider looking into the CMY painters' color wheel. With cyan, magenta, and yellow as its primary hues, this wheel provides a slightly more accurate picture of the behavior of paints and pigments than does the traditional color wheel.

Light behaves differently than pigments, so, if you regularly work with colored light, get to know the RGB color wheel of light. This graphic positions red, green, and blue as its primary hues.

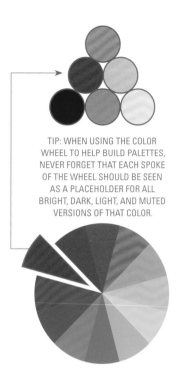

TIP: WHEN USING THE COLOR WHEEL TO HELP BUILD PALETTES, NEVER FORGET THAT EACH SPOKE OF THE WHEEL SHOULD BE SEEN AS A PLACEHOLDER FOR ALL BRIGHT, DARK, LIGHT, AND MUTED VERSIONS OF THAT COLOR.

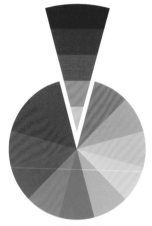

MONOCHROMATIC

Building Color Schemes

The palettes described on this spread were used to build many of this book's color schemes. Infinite possibilities exist when you begin with simple color wheel associations like these and then allow yourself to use bright, dark, light, or muted versions of each of your palette's colors. Get to know these palettes: the whole topic of color becomes a lot easier to grasp once you realize that most color schemes can be built according to simple color wheel associations like these.

Monochromatic

Take any spoke from the color wheel, break it down into darker shades and/or lighter tints, and you'll have a monochromatic palette. The individual members of monochromatic color schemes can have different levels of saturation, if so desired.

Tip: You can add hues to any of this book's palettes by expanding any or all of its colors into sets of two or more monochromatic relatives.

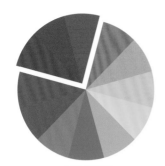

ANALOGOUS

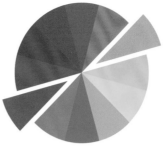

COMPLEMENTARY

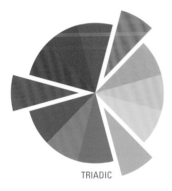

TRIADIC

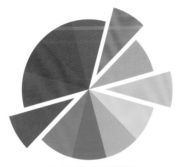

SPLIT-COMPLEMENTARY

Analogous and Triadic

Analogous palettes are made from three, four, or five adjacent hues from the color wheel.

Triadic palettes are made from three equally spaced colors from the wheel.

And remember, when building an analogous, a triadic, or any other kind of color-wheel palette, consider using bright, dark, light, or muted versions of your colors.

Complementary and Split Complementary

Complementary hues sit on opposite sides of the color wheel.

Split-complementary palettes are made by taking a color from one side of the wheel and combining it with the two hues on either side of its complement. Split-complementary palettes are special favorites of many designers and artists since they simultaneously convey feelings of redundant contrast and harmony.

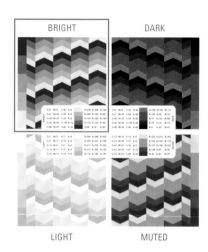

BRIGHT DARK

LIGHT MUTED

THE BRIGHT PALETTE FROM PAGE 174
WAS USED TO COLOR ALL THE ILLUSTRATIONS
ON THIS SPREAD.

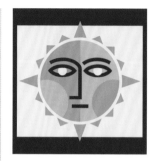
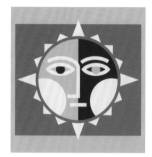
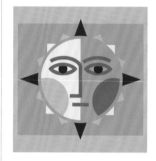

Keep At It

Say you've found a great-looking set of colors, applied them to an illustration, and are happy with what you see. What next? Turn off the computer and head home early? Well, maybe, but a better idea might be to keep your computer running a bit longer, save a copy of your illustration, and then use it to explore two, three, or a dozen coloring options. And why not? Computers make it easier and faster than ever to apply, alter, and substitute colors in illustrations, graphics, and layouts.

One Palette, Many Possible Outcomes

Each of the fourteen illustrations on this spread was colored using only the bright palette from the quad-set of color schemes from page 174.

Time permitting, make an effort to thoroughly explore your options when working with color. You might be surprised to find out how often the better ideas hide themselves until later stages of the color exploration process.

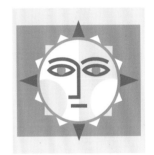

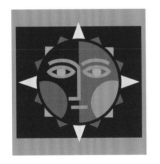
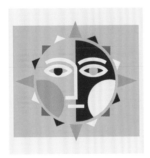

Add Black? Add White?

The four illustrations shown above include black and/or white as part of their palettes. Keep in mind the possibility of adding these "colors" to the palettes you select from this book (as well as to color schemes you create from scratch). Black and/or white might add just the touch needed to give a palette exactly the visual the punch and flavor you're going for.

CHAPTER 1
WARMER PALETTES

336 color schemes made from hues
that lean toward the warm colors
of red, orange, and yellow.

Reminders:

• Each of this book's palettes includes five colors. Feel free to use all five colors for a project, or to go with just one, two, three, or four.

• Any of this book's palettes can be attractively expanded into more colors by including monochromatic relatives of one or more of its hues (see page 10 for more about monochromatic color schemes).

• Substitutions between the colors of each page's quad-set of palettes is permissible. Just be certain of the value differences between the hues you're combining (see page 5–7 for more about values and color substitutions).

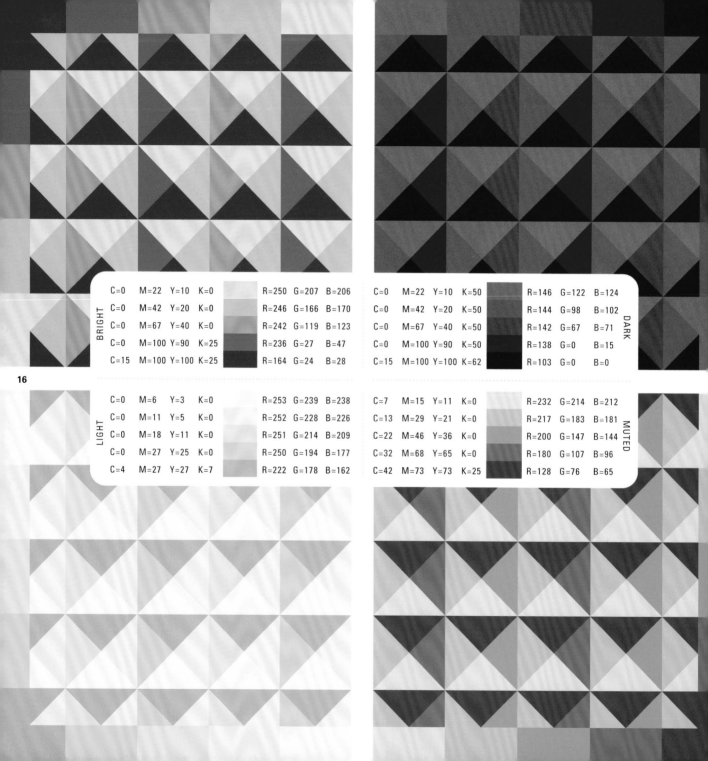

BRIGHT

C=0	M=22	Y=10	K=0		R=250	G=207	B=206
C=0	M=42	Y=20	K=0		R=246	G=166	B=170
C=0	M=67	Y=40	K=0		R=242	G=119	B=123
C=0	M=100	Y=90	K=25		R=236	G=27	B=47
C=15	M=100	Y=100	K=25		R=164	G=24	B=28

DARK

C=0	M=22	Y=10	K=50		R=146	G=122	B=124
C=0	M=42	Y=20	K=50		R=144	G=98	B=102
C=0	M=67	Y=40	K=50		R=142	G=67	B=71
C=0	M=100	Y=90	K=50		R=138	G=0	B=15
C=15	M=100	Y=100	K=62		R=103	G=0	B=0

LIGHT

C=0	M=6	Y=3	K=0		R=253	G=239	B=238
C=0	M=11	Y=5	K=0		R=252	G=228	B=226
C=0	M=18	Y=11	K=0		R=251	G=214	B=209
C=0	M=27	Y=25	K=0		R=250	G=194	B=177
C=4	M=27	Y=27	K=7		R=222	G=178	B=162

MUTED

C=7	M=15	Y=11	K=0		R=232	G=214	B=212
C=13	M=29	Y=21	K=0		R=217	G=183	B=181
C=22	M=46	Y=36	K=0		R=200	G=147	B=144
C=32	M=68	Y=65	K=0		R=180	G=107	B=96
C=42	M=73	Y=73	K=25		R=128	G=76	B=65

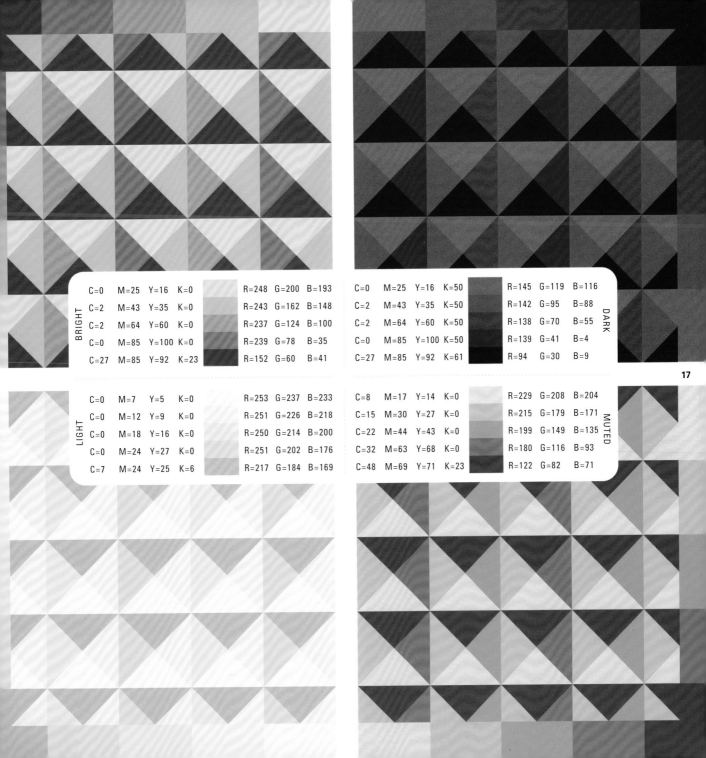

BRIGHT	C=0	M=25	Y=16	K=0		R=248	G=200	B=193
	C=2	M=43	Y=35	K=0		R=243	G=162	B=148
	C=2	M=64	Y=60	K=0		R=237	G=124	B=100
	C=0	M=85	Y=100	K=0		R=239	G=78	B=35
	C=27	M=85	Y=92	K=23		R=152	G=60	B=41

C=0	M=25	Y=16	K=50		R=145	G=119	B=116
C=2	M=43	Y=35	K=50		R=142	G=95	B=88
C=2	M=64	Y=60	K=50		R=138	G=70	B=55
C=0	M=85	Y=100	K=50		R=139	G=41	B=4
C=27	M=85	Y=92	K=61		R=94	G=30	B=9

DARK

LIGHT	C=0	M=7	Y=5	K=0		R=253	G=237	B=233
	C=0	M=12	Y=9	K=0		R=251	G=226	B=218
	C=0	M=18	Y=16	K=0		R=250	G=214	B=200
	C=0	M=24	Y=27	K=0		R=251	G=202	B=176
	C=7	M=24	Y=25	K=6		R=217	G=184	B=169

C=8	M=17	Y=14	K=0		R=229	G=208	B=204
C=15	M=30	Y=27	K=0		R=215	G=179	B=171
C=22	M=44	Y=43	K=0		R=199	G=149	B=135
C=32	M=63	Y=68	K=0		R=180	G=116	B=93
C=48	M=69	Y=71	K=23		R=122	G=82	B=71

MUTED

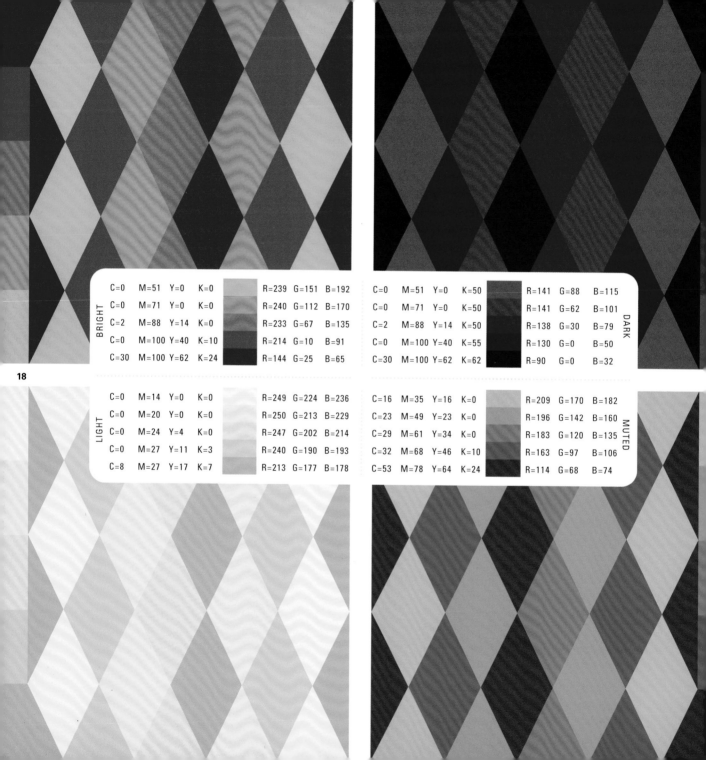

18

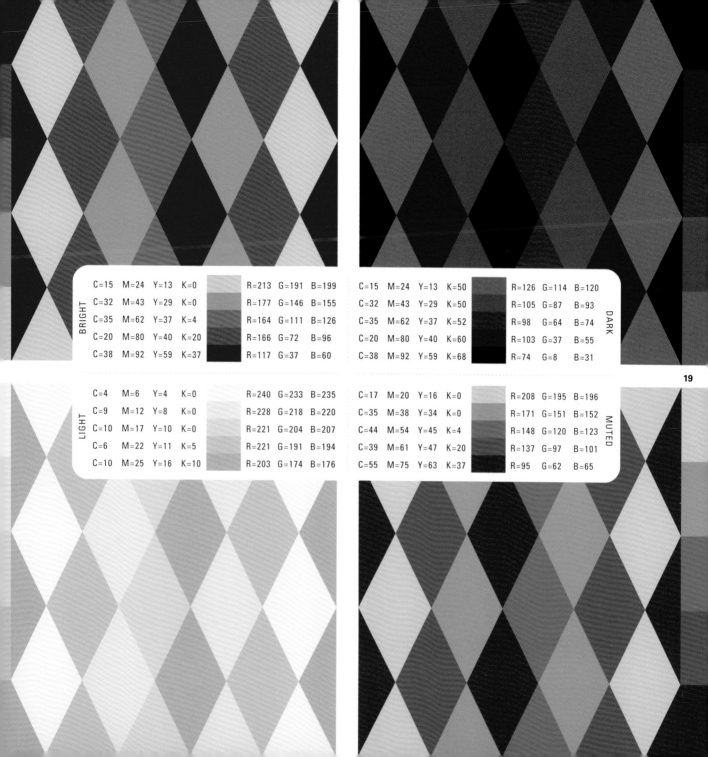

BRIGHT

				R=	G=	B=
C=15	M=24	Y=13	K=0	R=213	G=191	B=199
C=32	M=43	Y=29	K=0	R=177	G=146	B=155
C=35	M=62	Y=37	K=4	R=164	G=111	B=126
C=20	M=80	Y=40	K=20	R=166	G=72	B=96
C=38	M=92	Y=59	K=37	R=117	G=37	B=60

DARK

C=15	M=24	Y=13	K=50	R=126	G=114	B=120
C=32	M=43	Y=29	K=50	R=105	G=87	B=93
C=35	M=62	Y=37	K=52	R=98	G=64	B=74
C=20	M=80	Y=40	K=60	R=103	G=37	B=55
C=38	M=92	Y=59	K=68	R=74	G=8	B=31

LIGHT

C=4	M=6	Y=4	K=0	R=240	G=233	B=235
C=9	M=12	Y=8	K=0	R=228	G=218	B=220
C=10	M=17	Y=10	K=0	R=221	G=204	B=207
C=6	M=22	Y=11	K=5	R=221	G=191	B=194
C=10	M=25	Y=16	K=10	R=203	G=174	B=176

MUTED

C=17	M=20	Y=16	K=0	R=208	G=195	B=196
C=35	M=38	Y=34	K=0	R=171	G=151	B=152
C=44	M=54	Y=45	K=4	R=148	G=120	B=123
C=39	M=61	Y=47	K=20	R=137	G=97	B=101
C=55	M=75	Y=63	K=37	R=95	G=62	B=65

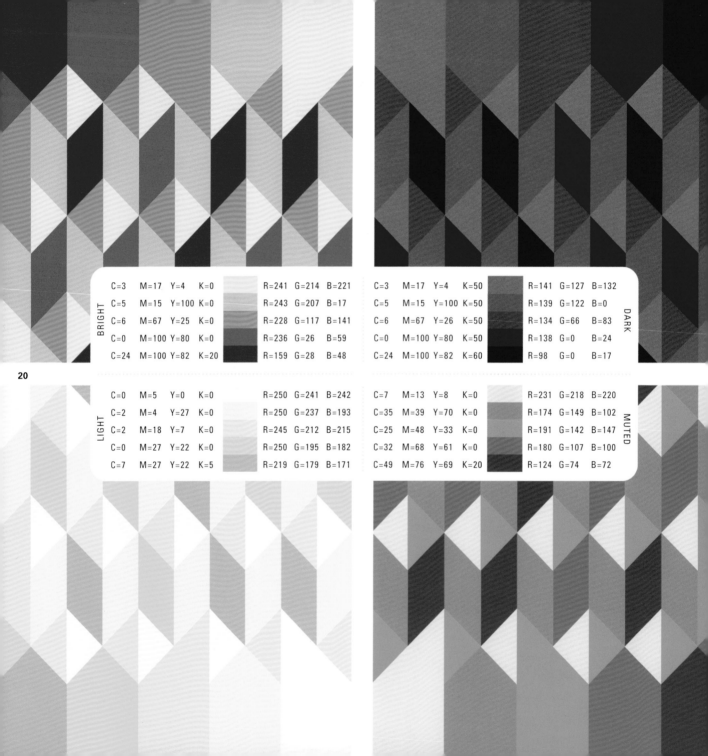

BRIGHT

C=3	M=17	Y=4	K=0		R=241	G=214	B=221
C=5	M=15	Y=100	K=0		R=243	G=207	B=17
C=6	M=67	Y=25	K=0		R=228	G=117	B=141
C=0	M=100	Y=80	K=0		R=236	G=26	B=59
C=24	M=100	Y=82	K=20		R=159	G=28	B=48

DARK

C=3	M=17	Y=4	K=50		R=141	G=127	B=132
C=5	M=15	Y=100	K=50		R=139	G=122	B=0
C=6	M=67	Y=26	K=50		R=134	G=66	B=83
C=0	M=100	Y=80	K=50		R=138	G=0	B=24
C=24	M=100	Y=82	K=60		R=98	G=0	B=17

LIGHT

C=0	M=5	Y=0	K=0		R=250	G=241	B=242
C=2	M=4	Y=27	K=0		R=250	G=237	B=193
C=2	M=18	Y=7	K=0		R=245	G=212	B=215
C=0	M=27	Y=22	K=0		R=250	G=195	B=182
C=7	M=27	Y=22	K=5		R=219	G=179	B=171

MUTED

C=7	M=13	Y=8	K=0		R=231	G=218	B=220
C=35	M=39	Y=70	K=0		R=174	G=149	B=102
C=25	M=48	Y=33	K=0		R=191	G=142	B=147
C=32	M=68	Y=61	K=0		R=180	G=107	B=100
C=49	M=76	Y=69	K=20		R=124	G=74	B=72

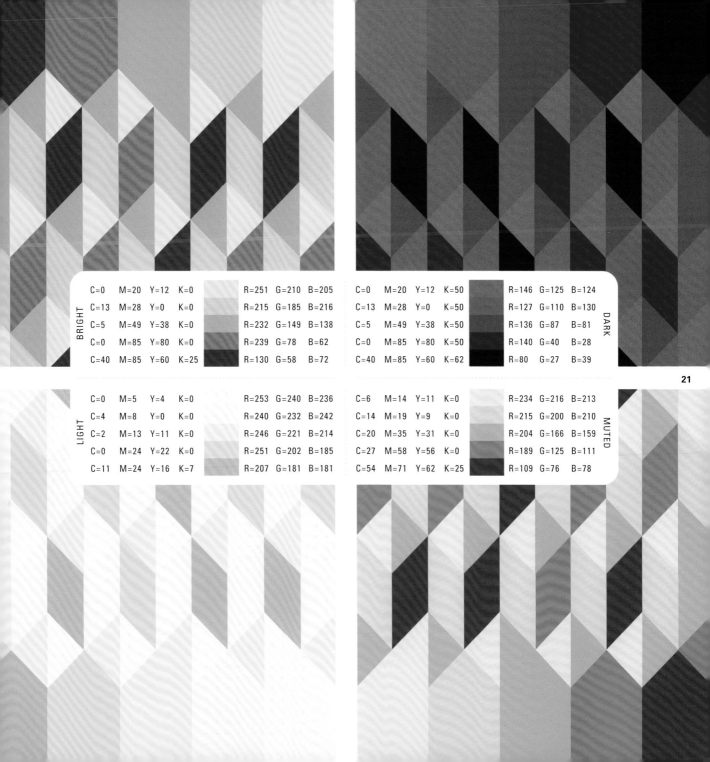

BRIGHT

C=0	M=20	Y=12	K=0		R=251	G=210	B=205
C=13	M=28	Y=0	K=0		R=215	G=185	B=216
C=5	M=49	Y=38	K=0		R=232	G=149	B=138
C=0	M=85	Y=80	K=0		R=239	G=78	B=62
C=40	M=85	Y=60	K=25		R=130	G=58	B=72

DARK

C=0	M=20	Y=12	K=50		R=146	G=125	B=124
C=13	M=28	Y=0	K=50		R=127	G=110	B=130
C=5	M=49	Y=38	K=50		R=136	G=87	B=81
C=0	M=85	Y=80	K=50		R=140	G=40	B=28
C=40	M=85	Y=60	K=62		R=80	G=27	B=39

LIGHT

C=0	M=5	Y=4	K=0		R=253	G=240	B=236
C=4	M=8	Y=0	K=0		R=240	G=232	B=242
C=2	M=13	Y=11	K=0		R=246	G=221	B=214
C=0	M=24	Y=22	K=0		R=251	G=202	B=185
C=11	M=24	Y=16	K=7		R=207	G=181	B=181

MUTED

C=6	M=14	Y=11	K=0		R=234	G=216	B=213
C=14	M=19	Y=9	K=0		R=215	G=200	B=210
C=20	M=35	Y=31	K=0		R=204	G=166	B=159
C=27	M=58	Y=56	K=0		R=189	G=125	B=111
C=54	M=71	Y=62	K=25		R=109	G=76	B=78

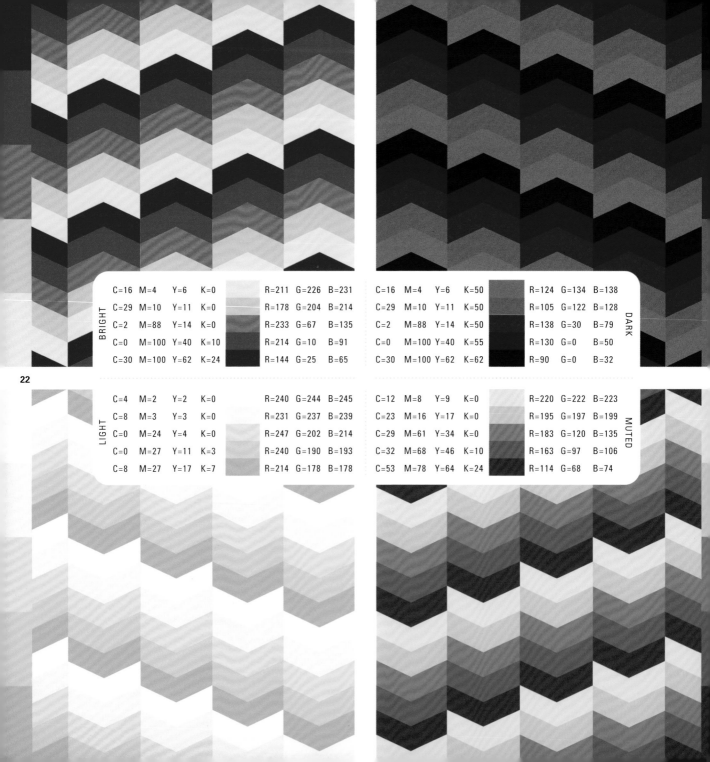

BRIGHT

					R	G	B
C=16	M=4	Y=6	K=0		R=211	G=226	B=231
C=29	M=10	Y=11	K=0		R=178	G=204	B=214
C=2	M=88	Y=14	K=0		R=233	G=67	B=135
C=0	M=100	Y=40	K=10		R=214	G=10	B=91
C=30	M=100	Y=62	K=24		R=144	G=25	B=65

DARK

					R	G	B
C=16	M=4	Y=6	K=50		R=124	G=134	B=138
C=29	M=10	Y=11	K=50		R=105	G=122	B=128
C=2	M=88	Y=14	K=50		R=138	G=30	B=79
C=0	M=100	Y=40	K=55		R=130	G=0	B=50
C=30	M=100	Y=62	K=62		R=90	G=0	B=32

LIGHT

					R	G	B
C=4	M=2	Y=2	K=0		R=240	G=244	B=245
C=8	M=3	Y=3	K=0		R=231	G=237	B=239
C=0	M=24	Y=4	K=0		R=247	G=202	B=214
C=0	M=27	Y=11	K=3		R=240	G=190	B=193
C=8	M=27	Y=17	K=7		R=214	G=178	B=178

MUTED

					R	G	B
C=12	M=8	Y=9	K=0		R=220	G=222	B=223
C=23	M=16	Y=17	K=0		R=195	G=197	B=199
C=29	M=61	Y=34	K=0		R=183	G=120	B=135
C=32	M=68	Y=46	K=10		R=163	G=97	B=106
C=53	M=78	Y=64	K=24		R=114	G=68	B=74

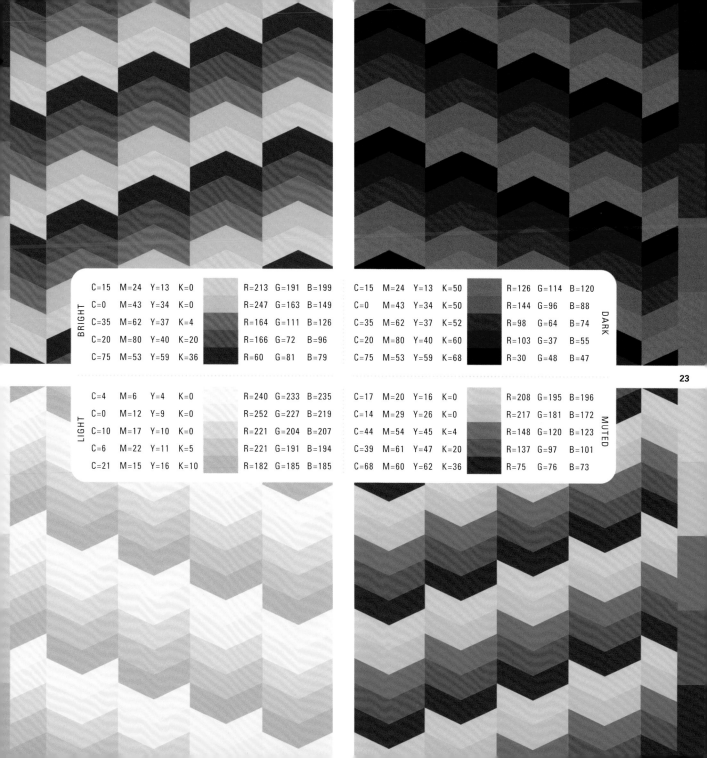

BRIGHT

C=15	M=24	Y=13	K=0		R=213	G=191	B=199
C=0	M=43	Y=34	K=0		R=247	G=163	B=149
C=35	M=62	Y=37	K=4		R=164	G=111	B=126
C=20	M=80	Y=40	K=20		R=166	G=72	B=96
C=75	M=53	Y=59	K=36		R=60	G=81	B=79

DARK

C=15	M=24	Y=13	K=50		R=126	G=114	B=120
C=0	M=43	Y=34	K=50		R=144	G=96	B=88
C=35	M=62	Y=37	K=52		R=98	G=64	B=74
C=20	M=80	Y=40	K=60		R=103	G=37	B=55
C=75	M=53	Y=59	K=68		R=30	G=48	B=47

LIGHT

C=4	M=6	Y=4	K=0		R=240	G=233	B=235
C=0	M=12	Y=9	K=0		R=252	G=227	B=219
C=10	M=17	Y=10	K=0		R=221	G=204	B=207
C=6	M=22	Y=11	K=5		R=221	G=191	B=194
C=21	M=15	Y=16	K=10		R=182	G=185	B=185

MUTED

C=17	M=20	Y=16	K=0		R=208	G=195	B=196
C=14	M=29	Y=26	K=0		R=217	G=181	B=172
C=44	M=54	Y=45	K=4		R=148	G=120	B=123
C=39	M=61	Y=47	K=20		R=137	G=97	B=101
C=68	M=60	Y=62	K=36		R=75	G=76	B=73

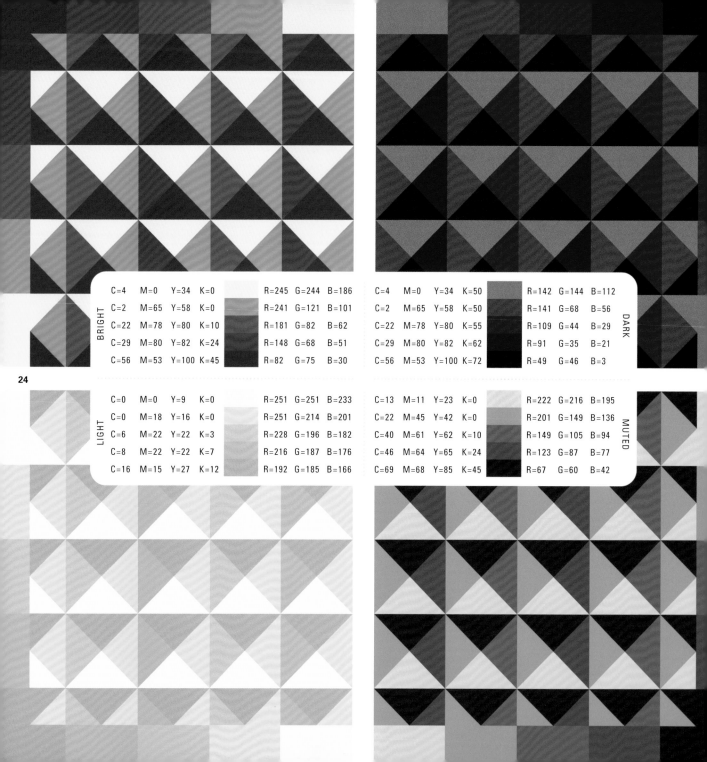

BRIGHT	C=4	M=0	Y=34	K=0		R=245	G=244	B=186
	C=2	M=65	Y=58	K=0		R=241	G=121	B=101
	C=22	M=78	Y=80	K=10		R=181	G=82	B=62
	C=29	M=80	Y=82	K=24		R=148	G=68	B=51
	C=56	M=53	Y=100	K=45		R=82	G=75	B=30

	C=4	M=0	Y=34	K=50		R=142	G=144	B=112	DARK
	C=2	M=65	Y=58	K=50		R=141	G=68	B=56	
	C=22	M=78	Y=80	K=55		R=109	G=44	B=29	
	C=29	M=80	Y=82	K=62		R=91	G=35	B=21	
	C=56	M=53	Y=100	K=72		R=49	G=46	B=3	

LIGHT	C=0	M=0	Y=9	K=0		R=251	G=251	B=233
	C=0	M=18	Y=16	K=0		R=251	G=214	B=201
	C=6	M=22	Y=22	K=3		R=228	G=196	B=182
	C=8	M=22	Y=22	K=7		R=216	G=187	B=176
	C=16	M=15	Y=27	K=12		R=192	G=185	B=166

	C=13	M=11	Y=23	K=0		R=222	G=216	B=195	MUTED
	C=22	M=45	Y=42	K=0		R=201	G=149	B=136	
	C=40	M=61	Y=62	K=10		R=149	G=105	B=94	
	C=46	M=64	Y=65	K=24		R=123	G=87	B=77	
	C=69	M=68	Y=85	K=45		R=67	G=60	B=42	

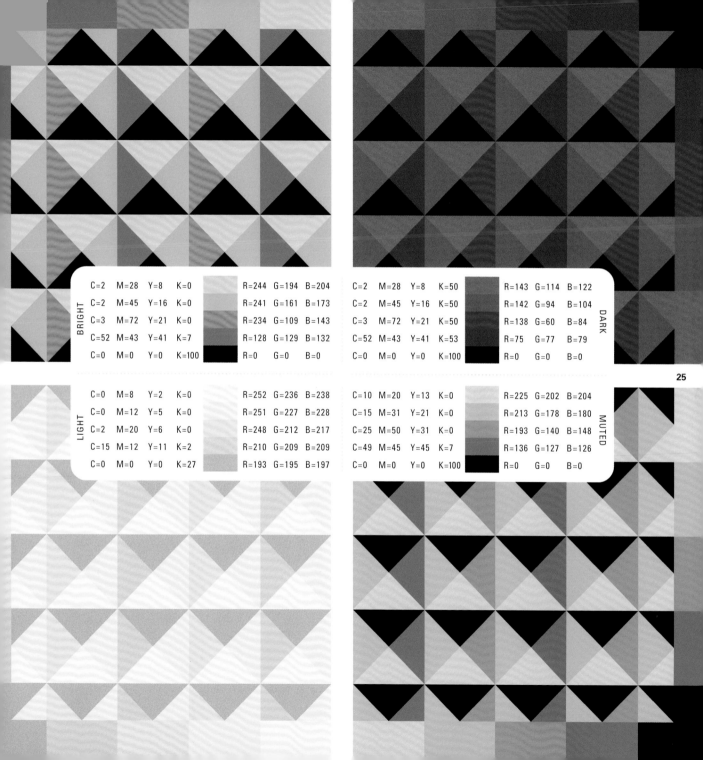

BRIGHT	C=2	M=28	Y=8	K=0		R=244	G=194	B=204	C=2	M=28	Y=8	K=50		R=143	G=114	B=122	DARK
	C=2	M=45	Y=16	K=0		R=241	G=161	B=173	C=2	M=45	Y=16	K=50		R=142	G=94	B=104	
	C=3	M=72	Y=21	K=0		R=234	G=109	B=143	C=3	M=72	Y=21	K=50		R=138	G=60	B=84	
	C=52	M=43	Y=41	K=7		R=128	G=129	B=132	C=52	M=43	Y=41	K=53		R=75	G=77	B=79	
	C=0	M=0	Y=0	K=100		R=0	G=0	B=0	C=0	M=0	Y=0	K=100		R=0	G=0	B=0	

LIGHT	C=0	M=8	Y=2	K=0		R=252	G=236	B=238	C=10	M=20	Y=13	K=0		R=225	G=202	B=204	MUTED
	C=0	M=12	Y=5	K=0		R=251	G=227	B=228	C=15	M=31	Y=21	K=0		R=213	G=178	B=180	
	C=2	M=20	Y=6	K=0		R=248	G=212	B=217	C=25	M=50	Y=31	K=0		R=193	G=140	B=148	
	C=15	M=12	Y=11	K=2		R=210	G=209	B=209	C=49	M=45	Y=45	K=7		R=136	G=127	B=126	
	C=0	M=0	Y=0	K=27		R=193	G=195	B=197	C=0	M=0	Y=0	K=100		R=0	G=0	B=0	

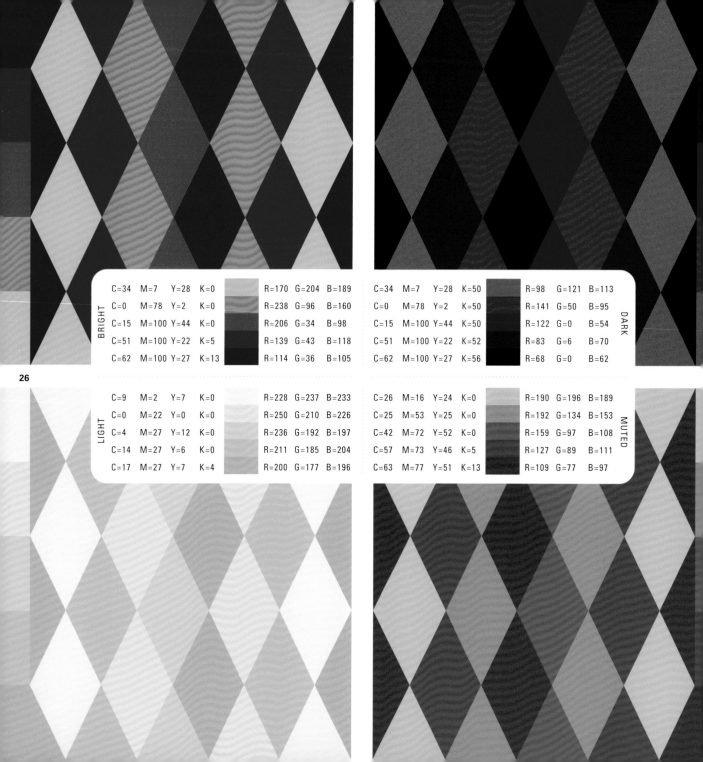

BRIGHT	C=34	M=7	Y=28	K=0		R=170	G=204	B=189
	C=0	M=78	Y=2	K=0		R=238	G=96	B=160
	C=15	M=100	Y=44	K=0		R=206	G=34	B=98
	C=51	M=100	Y=22	K=5		R=139	G=43	B=118
	C=62	M=100	Y=27	K=13		R=114	G=36	B=105

DARK	C=34	M=7	Y=28	K=50		R=98	G=121	B=113
	C=0	M=78	Y=2	K=50		R=141	G=50	B=95
	C=15	M=100	Y=44	K=50		R=122	G=0	B=54
	C=51	M=100	Y=22	K=52		R=83	G=6	B=70
	C=62	M=100	Y=27	K=56		R=68	G=0	B=62

LIGHT	C=9	M=2	Y=7	K=0		R=228	G=237	B=233
	C=0	M=22	Y=0	K=0		R=250	G=210	B=226
	C=4	M=27	Y=12	K=0		R=236	G=192	B=197
	C=14	M=27	Y=6	K=0		R=211	G=185	B=204
	C=17	M=27	Y=7	K=4		R=200	G=177	B=196

MUTED	C=26	M=16	Y=24	K=0		R=190	G=196	B=189
	C=25	M=53	Y=25	K=0		R=192	G=134	B=153
	C=42	M=72	Y=52	K=0		R=159	G=97	B=108
	C=57	M=73	Y=46	K=5		R=127	G=89	B=111
	C=63	M=77	Y=51	K=13		R=109	G=77	B=97

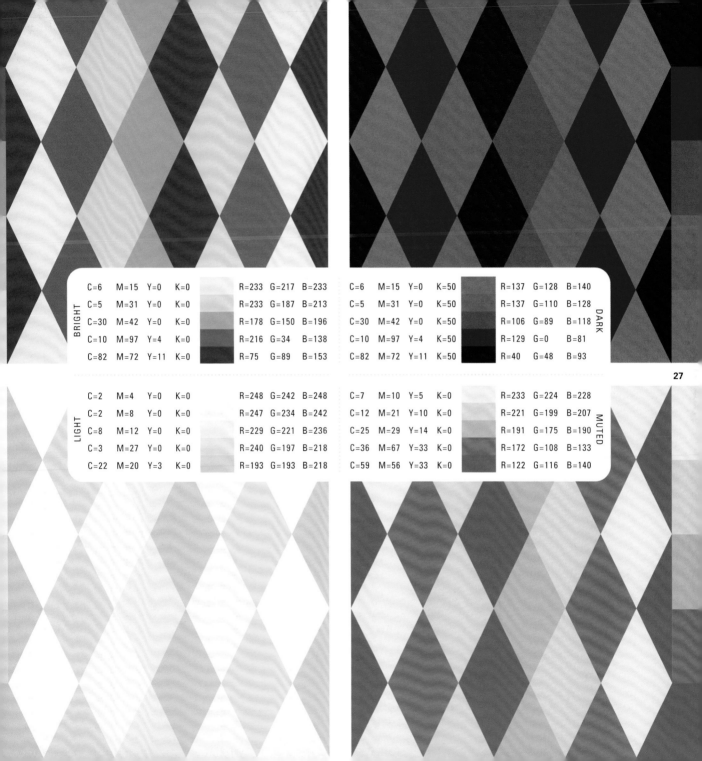

BRIGHT

C=6	M=15	Y=0	K=0		R=233	G=217	B=233
C=5	M=31	Y=0	K=0		R=233	G=187	B=213
C=30	M=42	Y=0	K=0		R=178	G=150	B=196
C=10	M=97	Y=4	K=0		R=216	G=34	B=138
C=82	M=72	Y=11	K=0		R=75	G=89	B=153

DARK

C=6	M=15	Y=0	K=50		R=137	G=128	B=140
C=5	M=31	Y=0	K=50		R=137	G=110	B=128
C=30	M=42	Y=0	K=50		R=106	G=89	B=118
C=10	M=97	Y=4	K=50		R=129	G=0	B=81
C=82	M=72	Y=11	K=50		R=40	G=48	B=93

LIGHT

C=2	M=4	Y=0	K=0		R=248	G=242	B=248
C=2	M=8	Y=0	K=0		R=247	G=234	B=242
C=8	M=12	Y=0	K=0		R=229	G=221	B=236
C=3	M=27	Y=0	K=0		R=240	G=197	B=218
C=22	M=20	Y=3	K=0		R=193	G=193	B=218

MUTED

C=7	M=10	Y=5	K=0		R=233	G=224	B=228
C=12	M=21	Y=10	K=0		R=221	G=199	B=207
C=25	M=29	Y=14	K=0		R=191	G=175	B=190
C=36	M=67	Y=33	K=0		R=172	G=108	B=133
C=59	M=56	Y=33	K=0		R=122	G=116	B=140

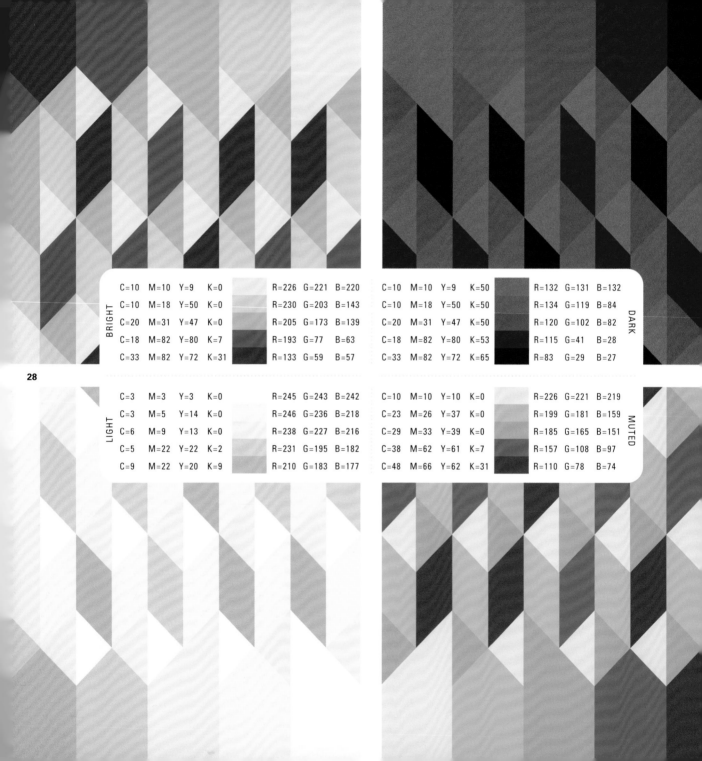

BRIGHT

C=10	M=10	Y=9	K=0		R=226	G=221	B=220
C=10	M=18	Y=50	K=0		R=230	G=203	B=143
C=20	M=31	Y=47	K=0		R=205	G=173	B=139
C=18	M=82	Y=80	K=7		R=193	G=77	B=63
C=33	M=82	Y=72	K=31		R=133	G=59	B=57

DARK

C=10	M=10	Y=9	K=50		R=132	G=131	B=132
C=10	M=18	Y=50	K=50		R=134	G=119	B=84
C=20	M=31	Y=47	K=50		R=120	G=102	B=82
C=18	M=82	Y=80	K=53		R=115	G=41	B=28
C=33	M=82	Y=72	K=65		R=83	G=29	B=27

LIGHT

C=3	M=3	Y=3	K=0		R=245	G=243	B=242
C=3	M=5	Y=14	K=0		R=246	G=236	B=218
C=6	M=9	Y=13	K=0		R=238	G=227	B=216
C=5	M=22	Y=22	K=2		R=231	G=195	B=182
C=9	M=22	Y=20	K=9		R=210	G=183	B=177

MUTED

C=10	M=10	Y=10	K=0		R=226	G=221	B=219
C=23	M=26	Y=37	K=0		R=199	G=181	B=159
C=29	M=33	Y=39	K=0		R=185	G=165	B=151
C=38	M=62	Y=61	K=7		R=157	G=108	B=97
C=48	M=66	Y=62	K=31		R=110	G=78	B=74

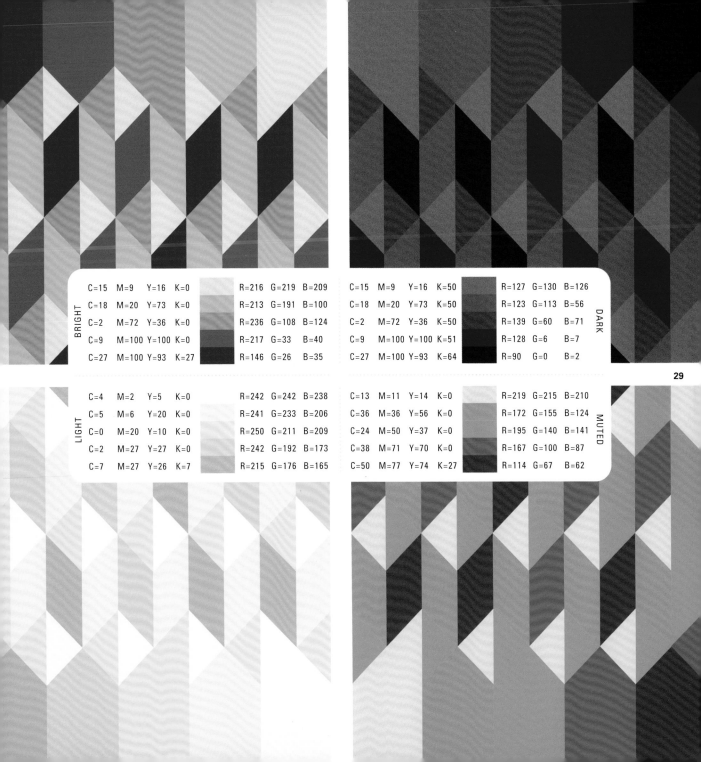

BRIGHT

					R	G	B
C=15	M=9	Y=16	K=0		R=216	G=219	B=209
C=18	M=20	Y=73	K=0		R=213	G=191	B=100
C=2	M=72	Y=36	K=0		R=236	G=108	B=124
C=9	M=100	Y=100	K=0		R=217	G=33	B=40
C=27	M=100	Y=93	K=27		R=146	G=26	B=35

DARK

					R	G	B
C=15	M=9	Y=16	K=50		R=127	G=130	B=126
C=18	M=20	Y=73	K=50		R=123	G=113	B=56
C=2	M=72	Y=36	K=50		R=139	G=60	B=71
C=9	M=100	Y=100	K=51		R=128	G=6	B=7
C=27	M=100	Y=93	K=64		R=90	G=0	B=2

LIGHT

					R	G	B
C=4	M=2	Y=5	K=0		R=242	G=242	B=238
C=5	M=6	Y=20	K=0		R=241	G=233	B=206
C=0	M=20	Y=10	K=0		R=250	G=211	B=209
C=2	M=27	Y=27	K=0		R=242	G=192	B=173
C=7	M=27	Y=26	K=7		R=215	G=176	B=165

MUTED

					R	G	B
C=13	M=11	Y=14	K=0		R=219	G=215	B=210
C=36	M=36	Y=56	K=0		R=172	G=155	B=124
C=24	M=50	Y=37	K=0		R=195	G=140	B=141
C=38	M=71	Y=70	K=0		R=167	G=100	B=87
C=50	M=77	Y=74	K=27		R=114	G=67	B=62

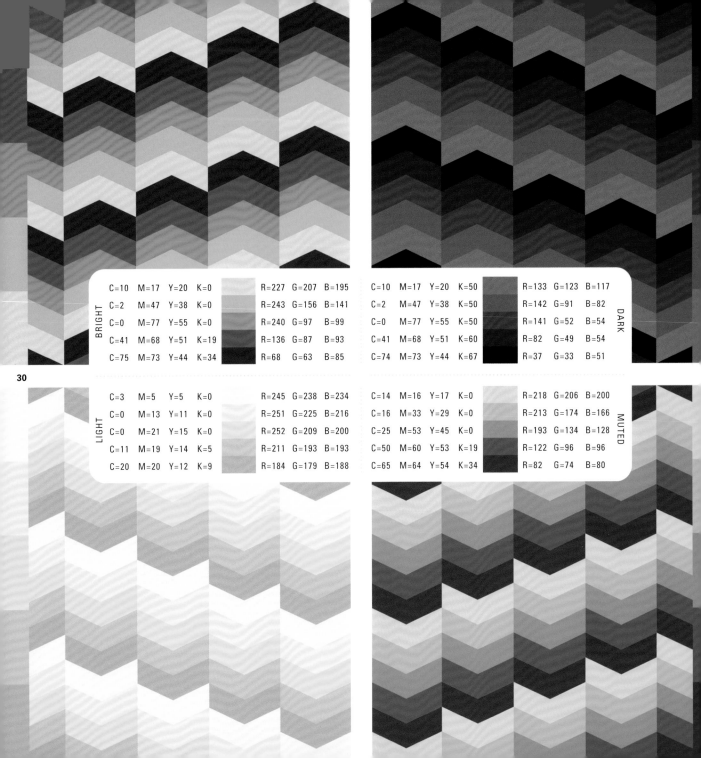

BRIGHT

C=10	M=17	Y=20	K=0		R=227	G=207	B=195
C=2	M=47	Y=38	K=0		R=243	G=156	B=141
C=0	M=77	Y=55	K=0		R=240	G=97	B=99
C=41	M=68	Y=51	K=19		R=136	G=87	B=93
C=75	M=73	Y=44	K=34		R=68	G=63	B=85

DARK

C=10	M=17	Y=20	K=50		R=133	G=123	B=117
C=2	M=47	Y=38	K=50		R=142	G=91	B=82
C=0	M=77	Y=55	K=50		R=141	G=52	B=54
C=41	M=68	Y=51	K=60		R=82	G=49	B=54
C=74	M=73	Y=44	K=67		R=37	G=33	B=51

LIGHT

C=3	M=5	Y=5	K=0		R=245	G=238	B=234
C=0	M=13	Y=11	K=0		R=251	G=225	B=216
C=0	M=21	Y=15	K=0		R=252	G=209	B=200
C=11	M=19	Y=14	K=5		R=211	G=193	B=193
C=20	M=20	Y=12	K=9		R=184	G=179	B=188

MUTED

C=14	M=16	Y=17	K=0		R=218	G=206	B=200
C=16	M=33	Y=29	K=0		R=213	G=174	B=166
C=25	M=53	Y=45	K=0		R=193	G=134	B=128
C=50	M=60	Y=53	K=19		R=122	G=96	B=96
C=65	M=64	Y=54	K=34		R=82	G=74	B=80

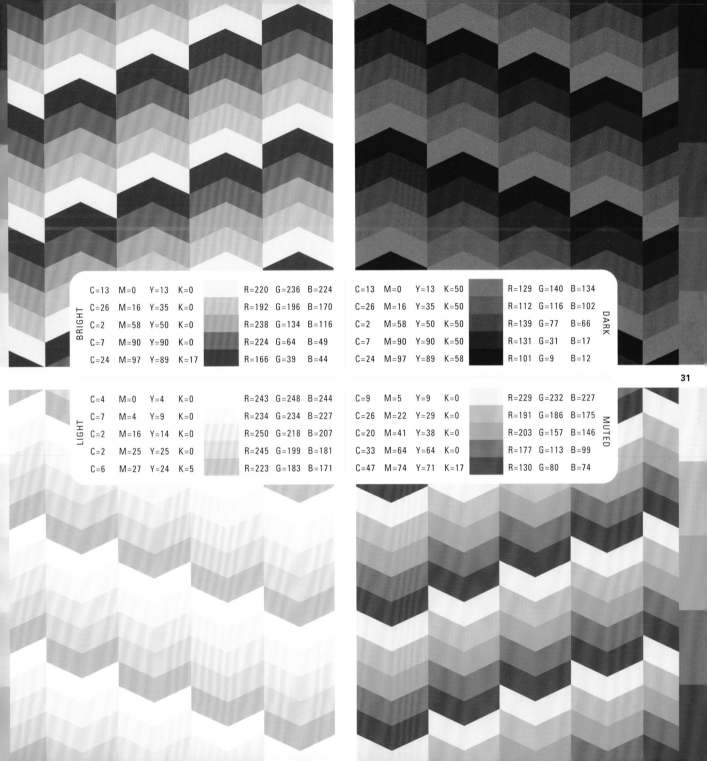

BRIGHT	C=13	M=0	Y=13	K=0		R=220	G=236	B=224
	C=26	M=16	Y=35	K=0		R=192	G=196	B=170
	C=2	M=58	Y=50	K=0		R=238	G=134	B=116
	C=7	M=90	Y=90	K=0		R=224	G=64	B=49
	C=24	M=97	Y=89	K=17		R=166	G=39	B=44

C=13	M=0	Y=13	K=50		R=129	G=140	B=134	**DARK**
C=26	M=16	Y=35	K=50		R=112	G=116	B=102	
C=2	M=58	Y=50	K=50		R=139	G=77	B=66	
C=7	M=90	Y=90	K=50		R=131	G=31	B=17	
C=24	M=97	Y=89	K=58		R=101	G=9	B=12	

LIGHT	C=4	M=0	Y=4	K=0		R=243	G=248	B=244
	C=7	M=4	Y=9	K=0		R=234	G=234	B=227
	C=2	M=16	Y=14	K=0		R=250	G=218	B=207
	C=2	M=25	Y=25	K=0		R=245	G=199	B=181
	C=6	M=27	Y=24	K=5		R=223	G=183	B=171

C=9	M=5	Y=9	K=0		R=229	G=232	B=227	**MUTED**
C=26	M=22	Y=29	K=0		R=191	G=186	B=175	
C=20	M=41	Y=38	K=0		R=203	G=157	B=146	
C=33	M=64	Y=64	K=0		R=177	G=113	B=99	
C=47	M=74	Y=71	K=17		R=130	G=80	B=74	

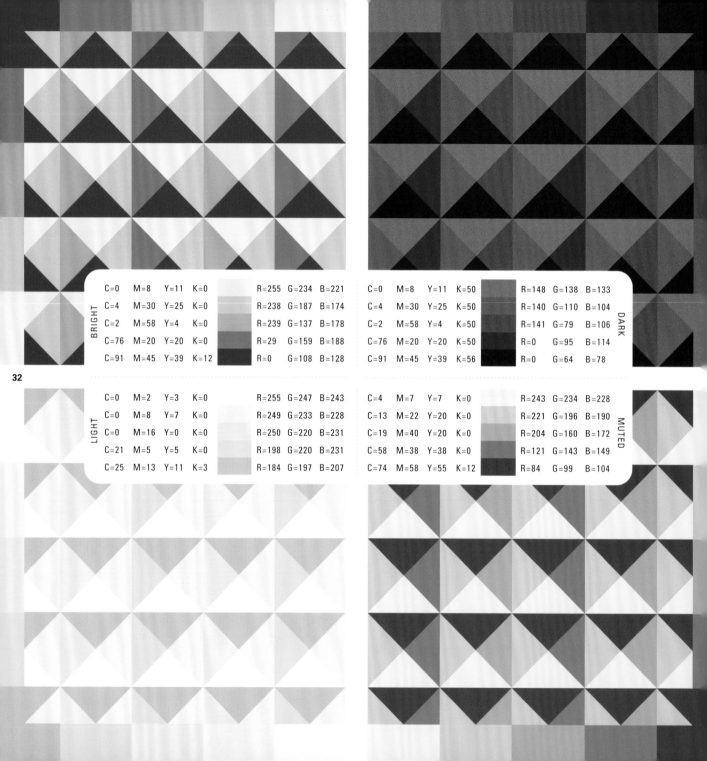

BRIGHT					R=255	G=234	B=221
C=0	M=8	Y=11	K=0		R=255	G=234	B=221
C=4	M=30	Y=25	K=0		R=238	G=187	B=174
C=2	M=58	Y=4	K=0		R=239	G=137	B=178
C=76	M=20	Y=20	K=0		R=29	G=159	B=188
C=91	M=45	Y=39	K=12		R=0	G=108	B=128

DARK							
C=0	M=8	Y=11	K=50		R=148	G=138	B=133
C=4	M=30	Y=25	K=50		R=140	G=110	B=104
C=2	M=58	Y=4	K=50		R=141	G=79	B=106
C=76	M=20	Y=20	K=50		R=0	G=95	B=114
C=91	M=45	Y=39	K=56		R=0	G=64	B=78

LIGHT							
C=0	M=2	Y=3	K=0		R=255	G=247	B=243
C=0	M=8	Y=7	K=0		R=249	G=233	B=228
C=0	M=16	Y=0	K=0		R=250	G=220	B=231
C=21	M=5	Y=5	K=0		R=198	G=220	B=231
C=25	M=13	Y=11	K=3		R=184	G=197	B=207

MUTED							
C=4	M=7	Y=7	K=0		R=243	G=234	B=228
C=13	M=22	Y=20	K=0		R=221	G=196	B=190
C=19	M=40	Y=20	K=0		R=204	G=160	B=172
C=58	M=38	Y=38	K=0		R=121	G=143	B=149
C=74	M=58	Y=55	K=12		R=84	G=99	B=104

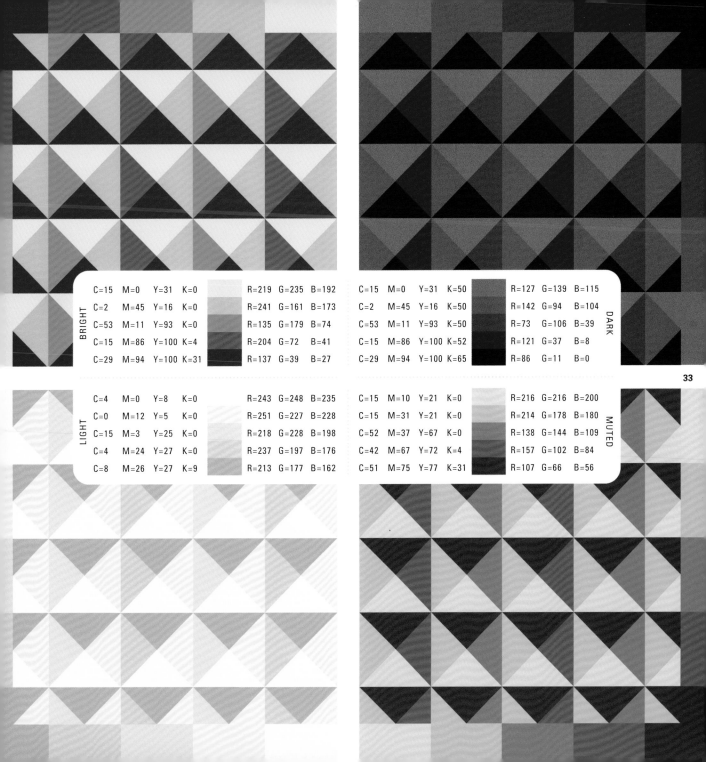

	C=15	M=0	Y=31	K=0		R=219	G=235	B=192
BRIGHT	C=2	M=45	Y=16	K=0		R=241	G=161	B=173
	C=53	M=11	Y=93	K=0		R=135	G=179	B=74
	C=15	M=86	Y=100	K=4		R=204	G=72	B=41
	C=29	M=94	Y=100	K=31		R=137	G=39	B=27

	C=15	M=0	Y=31	K=50		R=127	G=139	B=115	
	C=2	M=45	Y=16	K=50		R=142	G=94	B=104	**DARK**
	C=53	M=11	Y=93	K=50		R=73	G=106	B=39	
	C=15	M=86	Y=100	K=52		R=121	G=37	B=8	
	C=29	M=94	Y=100	K=65		R=86	G=11	B=0	

	C=4	M=0	Y=8	K=0		R=243	G=248	B=235
LIGHT	C=0	M=12	Y=5	K=0		R=251	G=227	B=228
	C=15	M=3	Y=25	K=0		R=218	G=228	B=198
	C=4	M=24	Y=27	K=0		R=237	G=197	B=176
	C=8	M=26	Y=27	K=9		R=213	G=177	B=162

	C=15	M=10	Y=21	K=0		R=216	G=216	B=200	
	C=15	M=31	Y=21	K=0		R=214	G=178	B=180	**MUTED**
	C=52	M=37	Y=67	K=0		R=138	G=144	B=109	
	C=42	M=67	Y=72	K=4		R=157	G=102	B=84	
	C=51	M=75	Y=77	K=31		R=107	G=66	B=56	

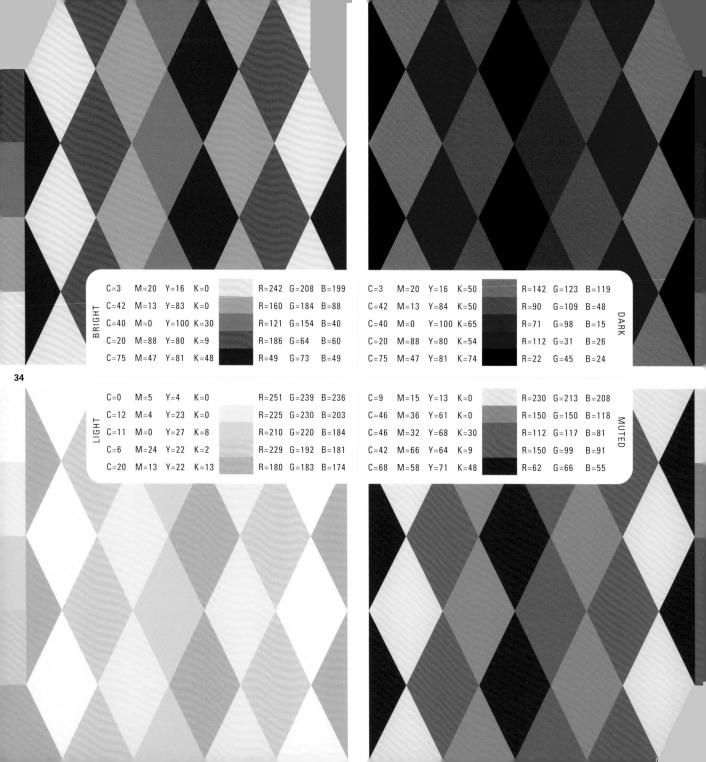

34

BRIGHT

C=3	M=20	Y=16	K=0		R=242	G=208	B=199
C=42	M=13	Y=83	K=0		R=160	G=184	B=88
C=40	M=0	Y=100	K=30		R=121	G=154	B=40
C=20	M=88	Y=80	K=9		R=186	G=64	B=60
C=75	M=47	Y=81	K=48		R=49	G=73	B=49

DARK

C=3	M=20	Y=16	K=50		R=142	G=123	B=119
C=42	M=13	Y=84	K=50		R=90	G=109	B=48
C=40	M=0	Y=100	K=65		R=71	G=98	B=15
C=20	M=88	Y=80	K=54		R=112	G=31	B=26
C=75	M=47	Y=81	K=74		R=22	G=45	B=24

LIGHT

C=0	M=5	Y=4	K=0		R=251	G=239	B=236
C=12	M=4	Y=23	K=0		R=225	G=230	B=203
C=11	M=0	Y=27	K=8		R=210	G=220	B=184
C=6	M=24	Y=22	K=2		R=229	G=192	B=181
C=20	M=13	Y=22	K=13		R=180	G=183	B=174

MUTED

C=9	M=15	Y=13	K=0		R=230	G=213	B=208
C=46	M=36	Y=61	K=0		R=150	G=150	B=118
C=46	M=32	Y=68	K=30		R=112	G=117	B=81
C=42	M=66	Y=64	K=9		R=150	G=99	B=91
C=68	M=58	Y=71	K=48		R=62	G=66	B=55

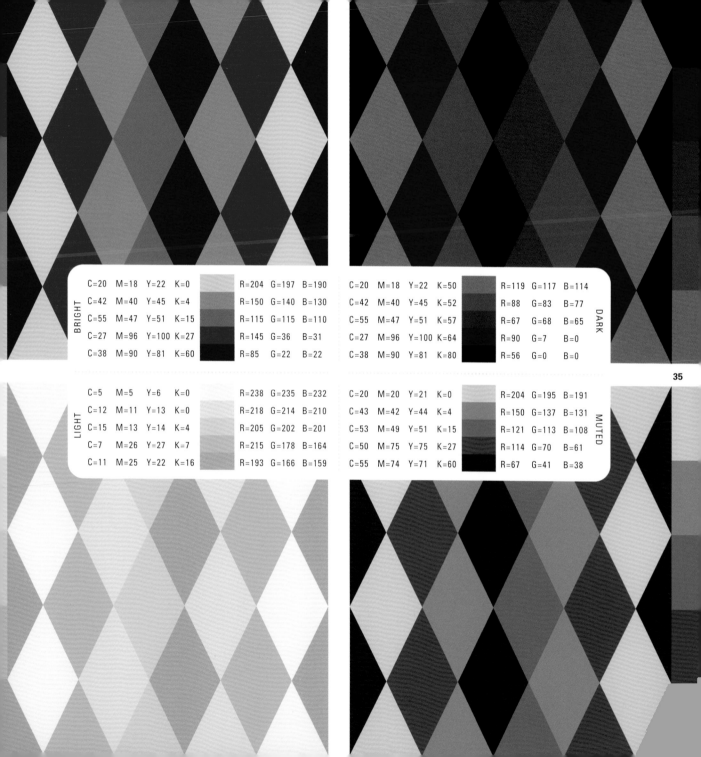

BRIGHT

C=20	M=18	Y=22	K=0		R=204	G=197	B=190
C=42	M=40	Y=45	K=4		R=150	G=140	B=130
C=55	M=47	Y=51	K=15		R=115	G=115	B=110
C=27	M=96	Y=100	K=27		R=145	G=36	B=31
C=38	M=90	Y=81	K=60		R=85	G=22	B=22

DARK

C=20	M=18	Y=22	K=50		R=119	G=117	B=114
C=42	M=40	Y=45	K=52		R=88	G=83	B=77
C=55	M=47	Y=51	K=57		R=67	G=68	B=65
C=27	M=96	Y=100	K=64		R=90	G=7	B=0
C=38	M=90	Y=81	K=80		R=56	G=0	B=0

LIGHT

C=5	M=5	Y=6	K=0		R=238	G=235	B=232
C=12	M=11	Y=13	K=0		R=218	G=214	B=210
C=15	M=13	Y=14	K=4		R=205	G=202	B=201
C=7	M=26	Y=27	K=7		R=215	G=178	B=164
C=11	M=25	Y=22	K=16		R=193	G=166	B=159

MUTED

C=20	M=20	Y=21	K=0		R=204	G=195	B=191
C=43	M=42	Y=44	K=4		R=150	G=137	B=131
C=53	M=49	Y=51	K=15		R=121	G=113	B=108
C=50	M=75	Y=75	K=27		R=114	G=70	B=61
C=55	M=74	Y=71	K=60		R=67	G=41	B=38

BRIGHT

C=4	M=9	Y=49	K=0		R=246	G=224	B=150
C=0	M=15	Y=90	K=0		R=255	G=213	B=49
C=11	M=83	Y=100	K=2		R=214	G=81	B=39
C=18	M=100	Y=100	K=8		R=190	G=36	B=40
C=42	M=79	Y=80	K=61		R=80	G=36	B=26

DARK

C=4	M=9	Y=49	K=50		R=143	G=132	B=89
C=0	M=15	Y=90	K=50		R=149	G=125	B=24
C=11	M=83	Y=100	K=51		R=126	G=43	B=7
C=18	M=100	Y=100	K=54		R=113	G=7	B=7
C=42	M=79	Y=80	K=80		R=52	G=13	B=0

LIGHT

C=0	M=2	Y=13	K=0		R=253	G=244	B=222
C=0	M=4	Y=25	K=0		R=255	G=241	B=200
C=3	M=23	Y=27	K=0		R=241	G=200	B=177
C=5	M=27	Y=27	K=2		R=231	G=187	B=171
C=11	M=22	Y=22	K=17		R=191	G=170	B=162

MUTED

C=18	M=20	Y=35	K=0		R=210	G=195	B=168
C=29	M=34	Y=61	K=0		R=188	G=162	B=117
C=39	M=65	Y=71	K=2		R=164	G=107	B=87
C=44	M=73	Y=73	K=8		R=147	G=89	B=78
C=54	M=68	Y=68	K=61		R=67	G=46	B=41

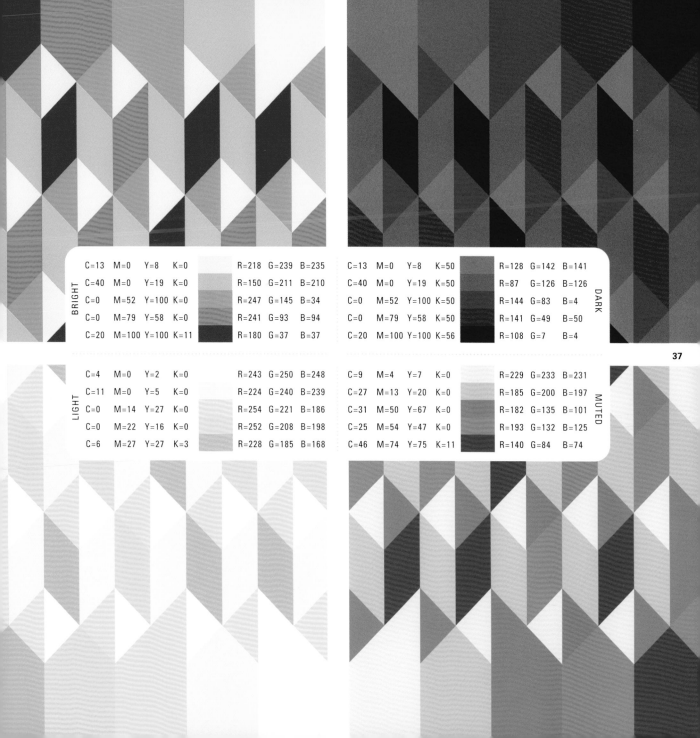

BRIGHT

C=13	M=0	Y=8	K=0		R=218	G=239	B=235
C=40	M=0	Y=19	K=0		R=150	G=211	B=210
C=0	M=52	Y=100	K=0		R=247	G=145	B=34
C=0	M=79	Y=58	K=0		R=241	G=93	B=94
C=20	M=100	Y=100	K=11		R=180	G=37	B=37

DARK

C=13	M=0	Y=8	K=50		R=128	G=142	B=141
C=40	M=0	Y=19	K=50		R=87	G=126	B=126
C=0	M=52	Y=100	K=50		R=144	G=83	B=4
C=0	M=79	Y=58	K=50		R=141	G=49	B=50
C=20	M=100	Y=100	K=56		R=108	G=7	B=4

LIGHT

C=4	M=0	Y=2	K=0		R=243	G=250	B=248
C=11	M=0	Y=5	K=0		R=224	G=240	B=239
C=0	M=14	Y=27	K=0		R=254	G=221	B=186
C=0	M=22	Y=16	K=0		R=252	G=208	B=198
C=6	M=27	Y=27	K=3		R=228	G=185	B=168

MUTED

C=9	M=4	Y=7	K=0		R=229	G=233	B=231
C=27	M=13	Y=20	K=0		R=185	G=200	B=197
C=31	M=50	Y=67	K=0		R=182	G=135	B=101
C=25	M=54	Y=47	K=0		R=193	G=132	B=125
C=46	M=74	Y=75	K=11		R=140	G=84	B=74

BRIGHT

C=9	M=12	Y=42	K=0		R=233	G=215	B=161
C=28	M=29	Y=36	K=0		R=187	G=172	B=157
C=0	M=71	Y=46	K=0		R=242	G=111	B=113
C=2	M=83	Y=60	K=0		R=237	G=82	B=89
C=95	M=97	Y=11	K=2		R=58	G=52	B=133

DARK

C=9	M=12	Y=42	K=50		R=136	G=127	B=96
C=28	M=29	Y=36	K=50		R=109	G=102	B=93
C=0	M=71	Y=46	K=50		R=142	G=62	B=64
C=2	M=84	Y=60	K=50		R=139	G=42	B=47
C=95	M=97	Y=11	K=51		R=29	G=15	B=80

LIGHT

C=2	M=3	Y=11	K=0		R=247	G=241	B=225
C=8	M=8	Y=10	K=0		R=232	G=226	B=221
C=0	M=20	Y=13	K=0		R=252	G=212	B=206
C=0	M=23	Y=16	K=0		R=250	G=205	B=196
C=26	M=27	Y=3	K=0		R=184	G=178	B=208

MUTED

C=19	M=20	Y=31	K=0		R=207	G=193	B=173
C=31	M=31	Y=34	K=0		R=180	G=167	B=159
C=23	M=49	Y=40	K=0		R=198	G=142	B=138
C=27	M=57	Y=49	K=0		R=189	G=126	B=120
C=69	M=70	Y=39	K=2		R=105	G=94	B=123

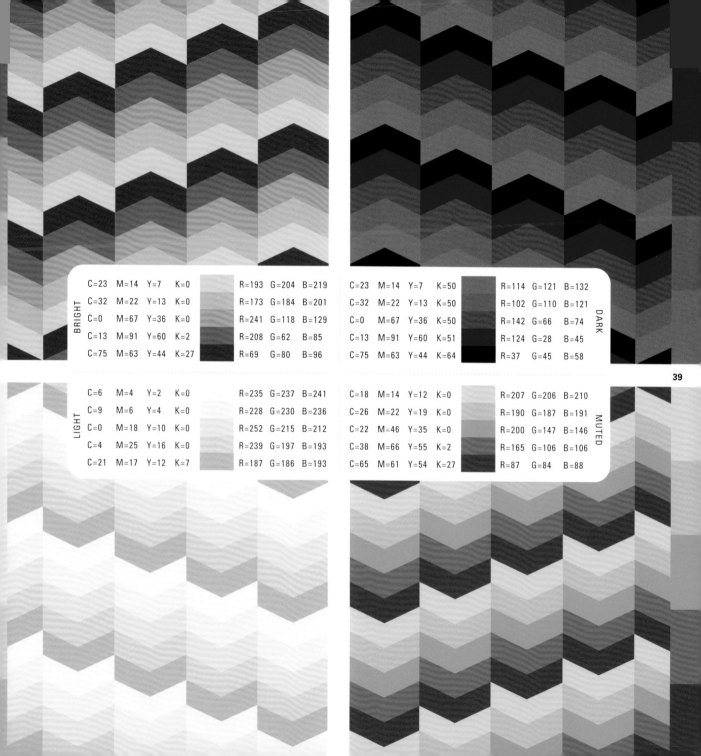

BRIGHT

C=23	M=14	Y=7	K=0		R=193	G=204	B=219
C=32	M=22	Y=13	K=0		R=173	G=184	B=201
C=0	M=67	Y=36	K=0		R=241	G=118	B=129
C=13	M=91	Y=60	K=2		R=208	G=62	B=85
C=75	M=63	Y=44	K=27		R=69	G=80	B=96

DARK

C=23	M=14	Y=7	K=50		R=114	G=121	B=132
C=32	M=22	Y=13	K=50		R=102	G=110	B=121
C=0	M=67	Y=36	K=50		R=142	G=66	B=74
C=13	M=91	Y=60	K=51		R=124	G=28	B=45
C=75	M=63	Y=44	K=64		R=37	G=45	B=58

LIGHT

C=6	M=4	Y=2	K=0		R=235	G=237	B=241
C=9	M=6	Y=4	K=0		R=228	G=230	B=236
C=0	M=18	Y=10	K=0		R=252	G=215	B=212
C=4	M=25	Y=16	K=0		R=239	G=197	B=193
C=21	M=17	Y=12	K=7		R=187	G=186	B=193

MUTED

C=18	M=14	Y=12	K=0		R=207	G=206	B=210
C=26	M=22	Y=19	K=0		R=190	G=187	B=191
C=22	M=46	Y=35	K=0		R=200	G=147	B=146
C=38	M=66	Y=55	K=2		R=165	G=106	B=106
C=65	M=61	Y=54	K=27		R=87	G=84	B=88

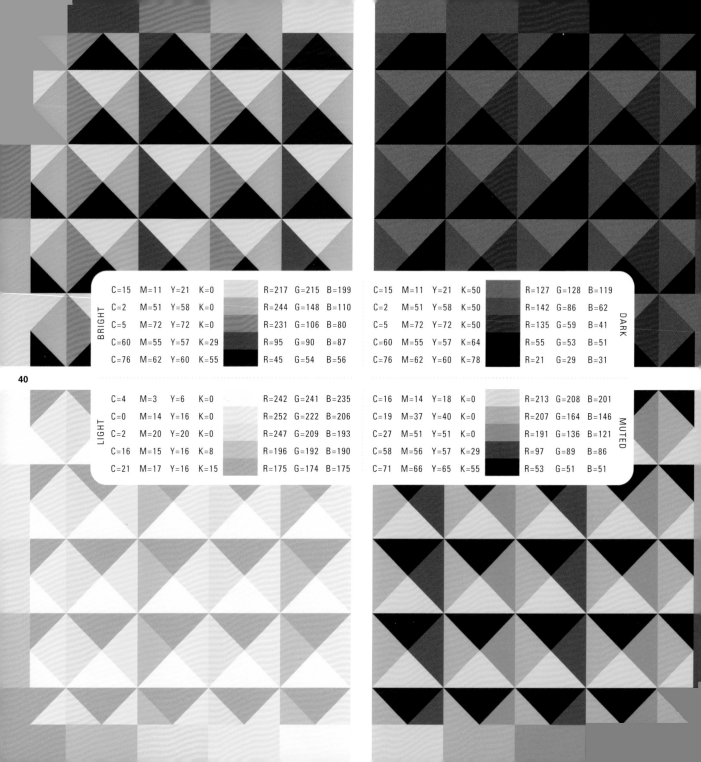

40

BRIGHT

C=15	M=11	Y=21	K=0	R=217	G=215	B=199
C=2	M=51	Y=58	K=0	R=244	G=148	B=110
C=5	M=72	Y=72	K=0	R=231	G=106	B=80
C=60	M=55	Y=57	K=29	R=95	G=90	B=87
C=76	M=62	Y=60	K=55	R=45	G=54	B=56

DARK

C=15	M=11	Y=21	K=50	R=127	G=128	B=119
C=2	M=51	Y=58	K=50	R=142	G=86	B=62
C=5	M=72	Y=72	K=50	R=135	G=59	B=41
C=60	M=55	Y=57	K=64	R=55	G=53	B=51
C=76	M=62	Y=60	K=78	R=21	G=29	B=31

LIGHT

C=4	M=3	Y=6	K=0	R=242	G=241	B=235
C=0	M=14	Y=16	K=0	R=252	G=222	B=206
C=2	M=20	Y=20	K=0	R=247	G=209	B=193
C=16	M=15	Y=16	K=8	R=196	G=192	B=190
C=21	M=17	Y=16	K=15	R=175	G=174	B=175

MUTED

C=16	M=14	Y=18	K=0	R=213	G=208	B=201
C=19	M=37	Y=40	K=0	R=207	G=164	B=146
C=27	M=51	Y=51	K=0	R=191	G=136	B=121
C=58	M=56	Y=57	K=29	R=97	G=89	B=86
C=71	M=66	Y=65	K=55	R=53	G=51	B=51

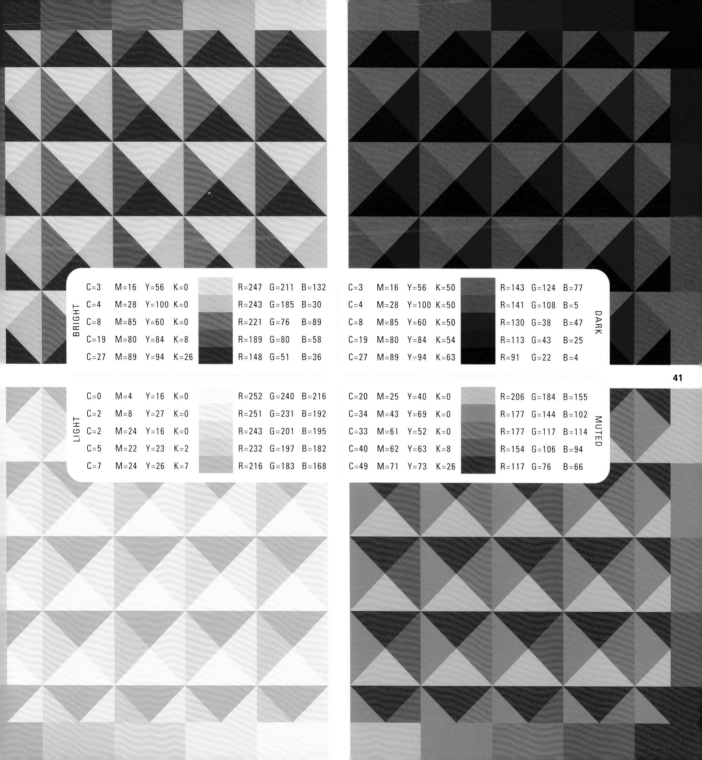

BRIGHT

C=3	M=16	Y=56	K=0		R=247	G=211	B=132
C=4	M=28	Y=100	K=0		R=243	G=185	B=30
C=8	M=85	Y=60	K=0		R=221	G=76	B=89
C=19	M=80	Y=84	K=8		R=189	G=80	B=58
C=27	M=89	Y=94	K=26		R=148	G=51	B=36

DARK

C=3	M=16	Y=56	K=50		R=143	G=124	B=77
C=4	M=28	Y=100	K=50		R=141	G=108	B=5
C=8	M=85	Y=60	K=50		R=130	G=38	B=47
C=19	M=80	Y=84	K=54		R=113	G=43	B=25
C=27	M=89	Y=94	K=63		R=91	G=22	B=4

LIGHT

C=0	M=4	Y=16	K=0		R=252	G=240	B=216
C=2	M=8	Y=27	K=0		R=251	G=231	B=192
C=2	M=24	Y=16	K=0		R=243	G=201	B=195
C=5	M=22	Y=23	K=2		R=232	G=197	B=182
C=7	M=24	Y=26	K=7		R=216	G=183	B=168

MUTED

C=20	M=25	Y=40	K=0		R=206	G=184	B=155
C=34	M=43	Y=69	K=0		R=177	G=144	B=102
C=33	M=61	Y=52	K=0		R=177	G=117	B=114
C=40	M=62	Y=63	K=8		R=154	G=106	B=94
C=49	M=71	Y=73	K=26		R=117	G=76	B=66

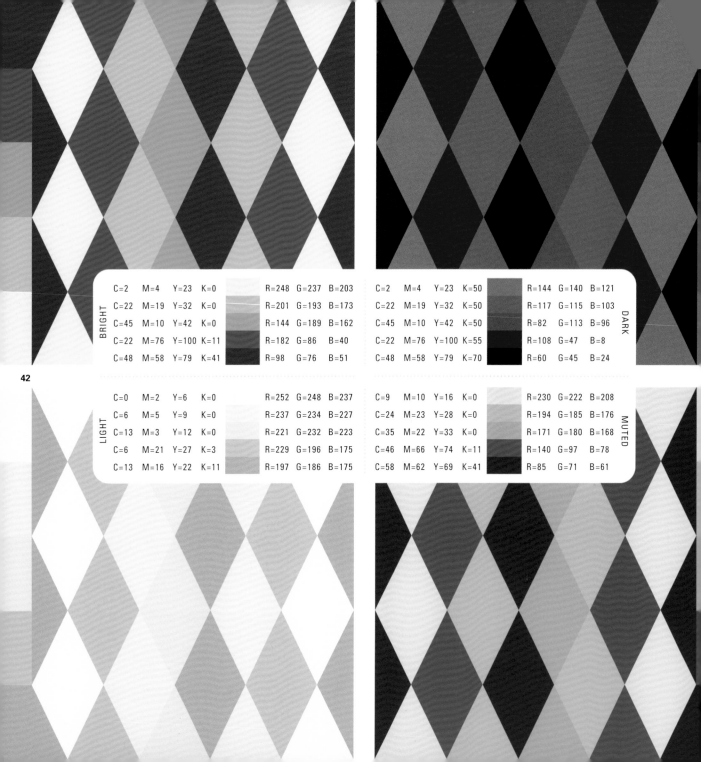

BRIGHT	C=2	M=4	Y=23	K=0		R=248	G=237	B=203
	C=22	M=19	Y=32	K=0		R=201	G=193	B=173
	C=45	M=10	Y=42	K=0		R=144	G=189	B=162
	C=22	M=76	Y=100	K=11		R=182	G=86	B=40
	C=48	M=58	Y=79	K=41		R=98	G=76	B=51

	C=2	M=4	Y=23	K=50		R=144	G=140	B=121	DARK
	C=22	M=19	Y=32	K=50		R=117	G=115	B=103	
	C=45	M=10	Y=42	K=50		R=82	G=113	B=96	
	C=22	M=76	Y=100	K=55		R=108	G=47	B=8	
	C=48	M=58	Y=79	K=70		R=60	G=45	B=24	

LIGHT	C=0	M=2	Y=6	K=0		R=252	G=248	B=237
	C=6	M=5	Y=9	K=0		R=237	G=234	B=227
	C=13	M=3	Y=12	K=0		R=221	G=232	B=223
	C=6	M=21	Y=27	K=3		R=229	G=196	B=175
	C=13	M=16	Y=22	K=11		R=197	G=186	B=175

	C=9	M=10	Y=16	K=0		R=230	G=222	B=208	MUTED
	C=24	M=23	Y=28	K=0		R=194	G=185	B=176	
	C=35	M=22	Y=33	K=0		R=171	G=180	B=168	
	C=46	M=66	Y=74	K=11		R=140	G=97	B=78	
	C=58	M=62	Y=69	K=41		R=85	G=71	B=61	

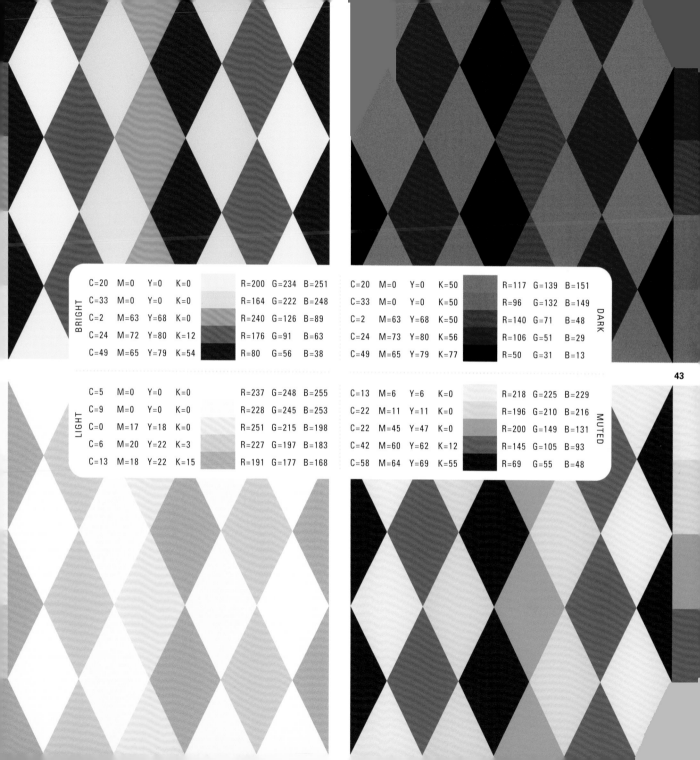

BRIGHT

C=20	M=0	Y=0	K=0		R=200	G=234	B=251
C=33	M=0	Y=0	K=0		R=164	G=222	B=248
C=2	M=63	Y=68	K=0		R=240	G=126	B=89
C=24	M=72	Y=80	K=12		R=176	G=91	B=63
C=49	M=65	Y=79	K=54		R=80	G=56	B=38

DARK

C=20	M=0	Y=0	K=50		R=117	G=139	B=151
C=33	M=0	Y=0	K=50		R=96	G=132	B=149
C=2	M=63	Y=68	K=50		R=140	G=71	B=48
C=24	M=73	Y=80	K=56		R=106	G=51	B=29
C=49	M=65	Y=79	K=77		R=50	G=31	B=13

LIGHT

C=5	M=0	Y=0	K=0		R=237	G=248	B=255
C=9	M=0	Y=0	K=0		R=228	G=245	B=253
C=0	M=17	Y=18	K=0		R=251	G=215	B=198
C=6	M=20	Y=22	K=3		R=227	G=197	B=183
C=13	M=18	Y=22	K=15		R=191	G=177	B=168

MUTED

C=13	M=6	Y=6	K=0		R=218	G=225	B=229
C=22	M=11	Y=11	K=0		R=196	G=210	B=216
C=22	M=45	Y=47	K=0		R=200	G=149	B=131
C=42	M=60	Y=62	K=12		R=145	G=105	B=93
C=58	M=64	Y=69	K=55		R=69	G=55	B=48

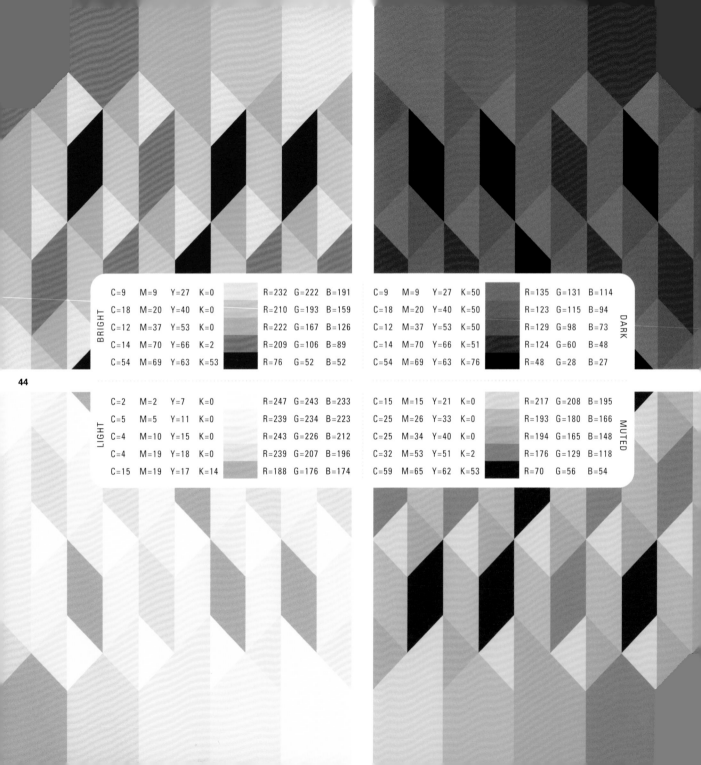

BRIGHT

C=9	M=9	Y=27	K=0	R=232	G=222	B=191
C=18	M=20	Y=40	K=0	R=210	G=193	B=159
C=12	M=37	Y=53	K=0	R=222	G=167	B=126
C=14	M=70	Y=66	K=2	R=209	G=106	B=89
C=54	M=69	Y=63	K=53	R=76	G=52	B=52

DARK

C=9	M=9	Y=27	K=50	R=135	G=131	B=114
C=18	M=20	Y=40	K=50	R=123	G=115	B=94
C=12	M=37	Y=53	K=50	R=129	G=98	B=73
C=14	M=70	Y=66	K=51	R=124	G=60	B=48
C=54	M=69	Y=63	K=76	R=48	G=28	B=27

LIGHT

C=2	M=2	Y=7	K=0	R=247	G=243	B=233
C=5	M=5	Y=11	K=0	R=239	G=234	B=223
C=4	M=10	Y=15	K=0	R=243	G=226	B=212
C=4	M=19	Y=18	K=0	R=239	G=207	B=196
C=15	M=19	Y=17	K=14	R=188	G=176	B=174

MUTED

C=15	M=15	Y=21	K=0	R=217	G=208	B=195
C=25	M=26	Y=33	K=0	R=193	G=180	B=166
C=25	M=34	Y=40	K=0	R=194	G=165	B=148
C=32	M=53	Y=51	K=2	R=176	G=129	B=118
C=59	M=65	Y=62	K=53	R=70	G=56	B=54

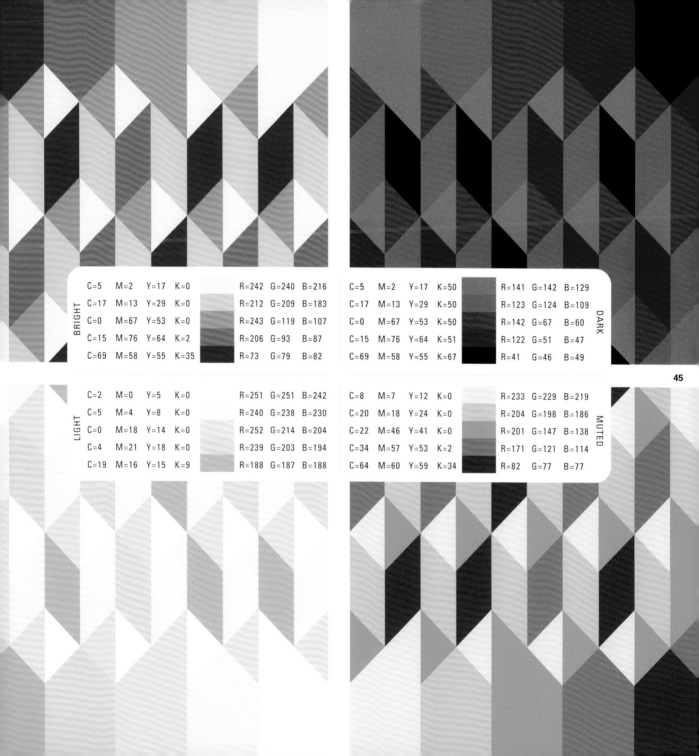

BRIGHT

C=5	M=2	Y=17	K=0		R=242	G=240	B=216
C=17	M=13	Y=29	K=0		R=212	G=209	B=183
C=0	M=67	Y=53	K=0		R=243	G=119	B=107
C=15	M=76	Y=64	K=2		R=206	G=93	B=87
C=69	M=58	Y=55	K=35		R=73	G=79	B=82

DARK

C=5	M=2	Y=17	K=50		R=141	G=142	B=129
C=17	M=13	Y=29	K=50		R=123	G=124	B=109
C=0	M=67	Y=53	K=50		R=142	G=67	B=60
C=15	M=76	Y=64	K=51		R=122	G=51	B=47
C=69	M=58	Y=55	K=67		R=41	G=46	B=49

45

LIGHT

C=2	M=0	Y=5	K=0		R=251	G=251	B=242
C=5	M=4	Y=8	K=0		R=240	G=238	B=230
C=0	M=18	Y=14	K=0		R=252	G=214	B=204
C=4	M=21	Y=18	K=0		R=239	G=203	B=194
C=19	M=16	Y=15	K=9		R=188	G=187	B=188

MUTED

C=8	M=7	Y=12	K=0		R=233	G=229	B=219
C=20	M=18	Y=24	K=0		R=204	G=198	B=186
C=22	M=46	Y=41	K=0		R=201	G=147	B=138
C=34	M=57	Y=53	K=2		R=171	G=121	B=114
C=64	M=60	Y=59	K=34		R=82	G=77	B=77

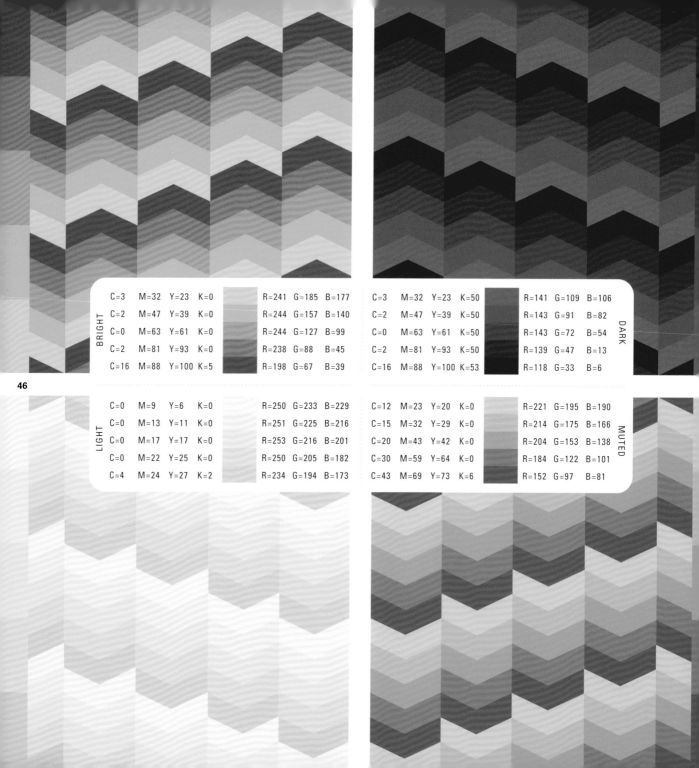

BRIGHT

C=3	M=32	Y=23	K=0		R=241	G=185	B=177
C=2	M=47	Y=39	K=0		R=244	G=157	B=140
C=0	M=63	Y=61	K=0		R=244	G=127	B=99
C=2	M=81	Y=93	K=0		R=238	G=88	B=45
C=16	M=88	Y=100	K=5		R=198	G=67	B=39

DARK

C=3	M=32	Y=23	K=50		R=141	G=109	B=106
C=2	M=47	Y=39	K=50		R=143	G=91	B=82
C=0	M=63	Y=61	K=50		R=143	G=72	B=54
C=2	M=81	Y=93	K=50		R=139	G=47	B=13
C=16	M=88	Y=100	K=53		R=118	G=33	B=6

LIGHT

C=0	M=9	Y=6	K=0		R=250	G=233	B=229
C=0	M=13	Y=11	K=0		R=251	G=225	B=216
C=0	M=17	Y=17	K=0		R=253	G=216	B=201
C=0	M=22	Y=25	K=0		R=250	G=205	B=182
C=4	M=24	Y=27	K=2		R=234	G=194	B=173

MUTED

C=12	M=23	Y=20	K=0		R=221	G=195	B=190
C=15	M=32	Y=29	K=0		R=214	G=175	B=166
C=20	M=43	Y=42	K=0		R=204	G=153	B=138
C=30	M=59	Y=64	K=0		R=184	G=122	B=101
C=43	M=69	Y=73	K=6		R=152	G=97	B=81

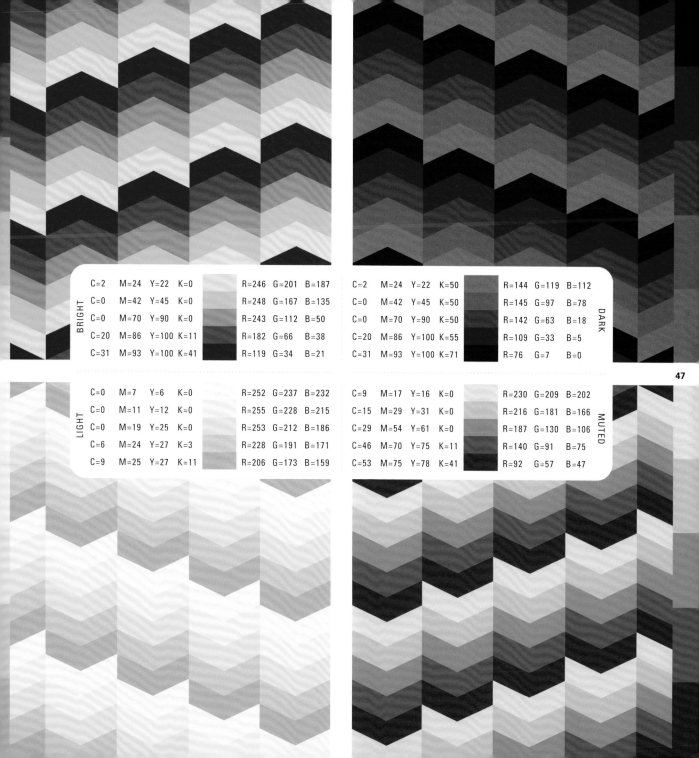

BRIGHT

C=2	M=24	Y=22	K=0		R=246	G=201	B=187
C=0	M=42	Y=45	K=0		R=248	G=167	B=135
C=0	M=70	Y=90	K=0		R=243	G=112	B=50
C=20	M=86	Y=100	K=11		R=182	G=66	B=38
C=31	M=93	Y=100	K=41		R=119	G=34	B=21

DARK

C=2	M=24	Y=22	K=50		R=144	G=119	B=112
C=0	M=42	Y=45	K=50		R=145	G=97	B=78
C=0	M=70	Y=90	K=50		R=142	G=63	B=18
C=20	M=86	Y=100	K=55		R=109	G=33	B=5
C=31	M=93	Y=100	K=71		R=76	G=7	B=0

LIGHT

C=0	M=7	Y=6	K=0		R=252	G=237	B=232
C=0	M=11	Y=12	K=0		R=255	G=228	B=215
C=0	M=19	Y=25	K=0		R=253	G=212	B=186
C=6	M=24	Y=27	K=3		R=228	G=191	B=171
C=9	M=25	Y=27	K=11		R=206	G=173	B=159

MUTED

C=9	M=17	Y=16	K=0		R=230	G=209	B=202
C=15	M=29	Y=31	K=0		R=216	G=181	B=166
C=29	M=54	Y=61	K=0		R=187	G=130	B=106
C=46	M=70	Y=75	K=11		R=140	G=91	B=75
C=53	M=75	Y=78	K=41		R=92	G=57	B=47

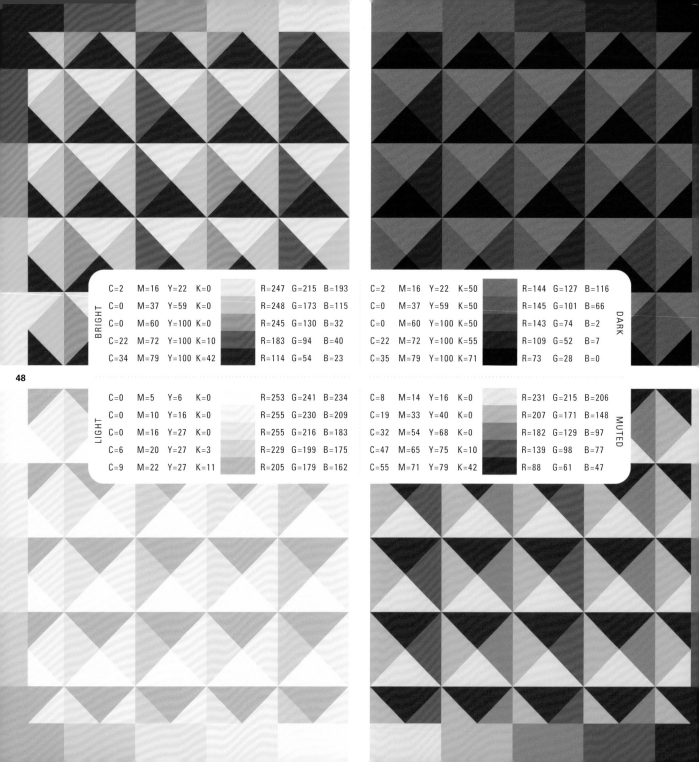

	C=2	M=16	Y=22	K=0		R=247	G=215	B=193
BRIGHT	C=0	M=37	Y=59	K=0		R=248	G=173	B=115
	C=0	M=60	Y=100	K=0		R=245	G=130	B=32
	C=22	M=72	Y=100	K=10		R=183	G=94	B=40
	C=34	M=79	Y=100	K=42		R=114	G=54	B=23

	C=2	M=16	Y=22	K=50		R=144	G=127	B=116
	C=0	M=37	Y=59	K=50		R=145	G=101	B=66
	C=0	M=60	Y=100	K=50		R=143	G=74	B=2
	C=22	M=72	Y=100	K=55		R=109	G=52	B=7
DARK	C=35	M=79	Y=100	K=71		R=73	G=28	B=0

	C=0	M=5	Y=6	K=0		R=253	G=241	B=234
LIGHT	C=0	M=10	Y=16	K=0		R=255	G=230	B=209
	C=0	M=16	Y=27	K=0		R=255	G=216	B=183
	C=6	M=20	Y=27	K=3		R=229	G=199	B=175
	C=9	M=22	Y=27	K=11		R=205	G=179	B=162

	C=8	M=14	Y=16	K=0		R=231	G=215	B=206
	C=19	M=33	Y=40	K=0		R=207	G=171	B=148
	C=32	M=54	Y=68	K=0		R=182	G=129	B=97
	C=47	M=65	Y=75	K=10		R=139	G=98	B=77
MUTED	C=55	M=71	Y=79	K=42		R=88	G=61	B=47

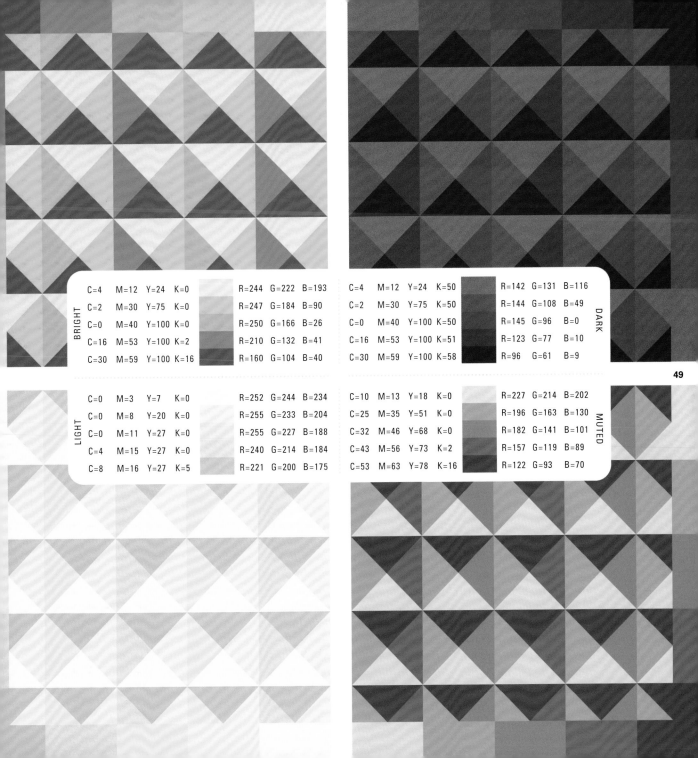

BRIGHT

C=4	M=12	Y=24	K=0		R=244	G=222	B=193
C=2	M=30	Y=75	K=0		R=247	G=184	B=90
C=0	M=40	Y=100	K=0		R=250	G=166	B=26
C=16	M=53	Y=100	K=2		R=210	G=132	B=41
C=30	M=59	Y=100	K=16		R=160	G=104	B=40

DARK

C=4	M=12	Y=24	K=50		R=142	G=131	B=116
C=2	M=30	Y=75	K=50		R=144	G=108	B=49
C=0	M=40	Y=100	K=50		R=145	G=96	B=0
C=16	M=53	Y=100	K=51		R=123	G=77	B=10
C=30	M=59	Y=100	K=58		R=96	G=61	B=9

LIGHT

C=0	M=3	Y=7	K=0		R=252	G=244	B=234
C=0	M=8	Y=20	K=0		R=255	G=233	B=204
C=0	M=11	Y=27	K=0		R=255	G=227	B=188
C=4	M=15	Y=27	K=0		R=240	G=214	B=184
C=8	M=16	Y=27	K=5		R=221	G=200	B=175

MUTED

C=10	M=13	Y=18	K=0		R=227	G=214	B=202
C=25	M=35	Y=51	K=0		R=196	G=163	B=130
C=32	M=46	Y=68	K=0		R=182	G=141	B=101
C=43	M=56	Y=73	K=2		R=157	G=119	B=89
C=53	M=63	Y=78	K=16		R=122	G=93	B=70

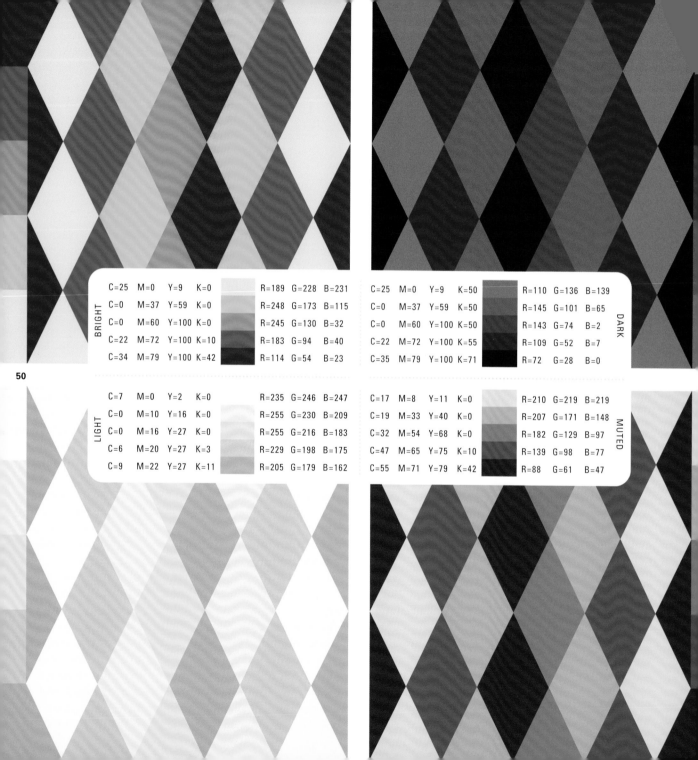

BRIGHT	C=25	M=0	Y=9	K=0		R=189	G=228	B=231
	C=0	M=37	Y=59	K=0		R=248	G=173	B=115
	C=0	M=60	Y=100	K=0		R=245	G=130	B=32
	C=22	M=72	Y=100	K=10		R=183	G=94	B=40
	C=34	M=79	Y=100	K=42		R=114	G=54	B=23

DARK	C=25	M=0	Y=9	K=50		R=110	G=136	B=139
	C=0	M=37	Y=59	K=50		R=145	G=101	B=65
	C=0	M=60	Y=100	K=50		R=143	G=74	B=2
	C=22	M=72	Y=100	K=55		R=109	G=52	B=7
	C=35	M=79	Y=100	K=71		R=72	G=28	B=0

LIGHT	C=7	M=0	Y=2	K=0		R=235	G=246	B=247
	C=0	M=10	Y=16	K=0		R=255	G=230	B=209
	C=0	M=16	Y=27	K=0		R=255	G=216	B=183
	C=6	M=20	Y=27	K=3		R=229	G=198	B=175
	C=9	M=22	Y=27	K=11		R=205	G=179	B=162

MUTED	C=17	M=8	Y=11	K=0		R=210	G=219	B=219
	C=19	M=33	Y=40	K=0		R=207	G=171	B=148
	C=32	M=54	Y=68	K=0		R=182	G=129	B=97
	C=47	M=65	Y=75	K=10		R=139	G=98	B=77
	C=55	M=71	Y=79	K=42		R=88	G=61	B=47

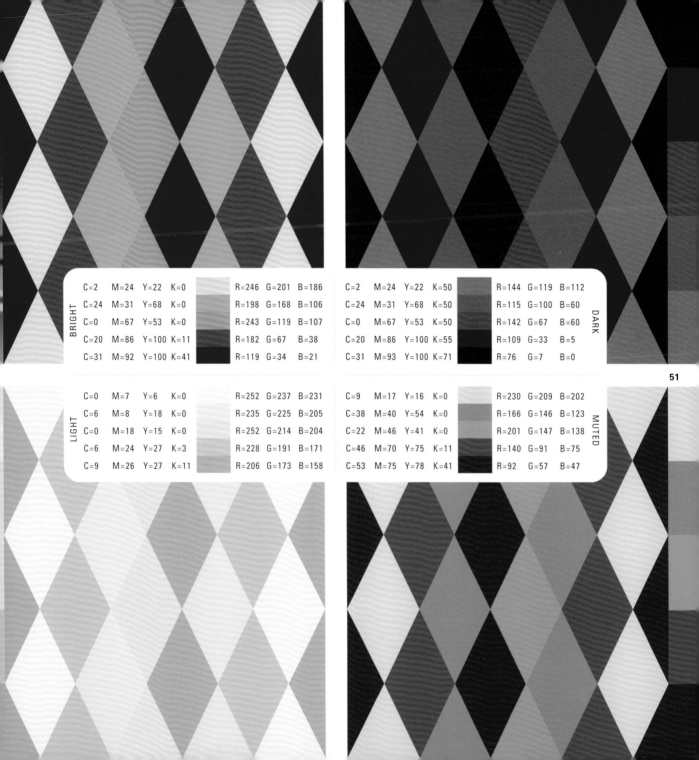

BRIGHT							
C=2	M=24	Y=22	K=0		R=246	G=201	B=186
C=24	M=31	Y=68	K=0		R=198	G=168	B=106
C=0	M=67	Y=53	K=0		R=243	G=119	B=107
C=20	M=86	Y=100	K=11		R=182	G=67	B=38
C=31	M=92	Y=100	K=41		R=119	G=34	B=21

DARK							
C=2	M=24	Y=22	K=50		R=144	G=119	B=112
C=24	M=31	Y=68	K=50		R=115	G=100	B=60
C=0	M=67	Y=53	K=50		R=142	G=67	B=60
C=20	M=86	Y=100	K=55		R=109	G=33	B=5
C=31	M=93	Y=100	K=71		R=76	G=7	B=0

LIGHT							
C=0	M=7	Y=6	K=0		R=252	G=237	B=231
C=6	M=8	Y=18	K=0		R=235	G=225	B=205
C=0	M=18	Y=15	K=0		R=252	G=214	B=204
C=6	M=24	Y=27	K=3		R=228	G=191	B=171
C=9	M=26	Y=27	K=11		R=206	G=173	B=158

MUTED							
C=9	M=17	Y=16	K=0		R=230	G=209	B=202
C=38	M=40	Y=54	K=0		R=166	G=146	B=123
C=22	M=46	Y=41	K=0		R=201	G=147	B=138
C=46	M=70	Y=75	K=11		R=140	G=91	B=75
C=53	M=75	Y=78	K=41		R=92	G=57	B=47

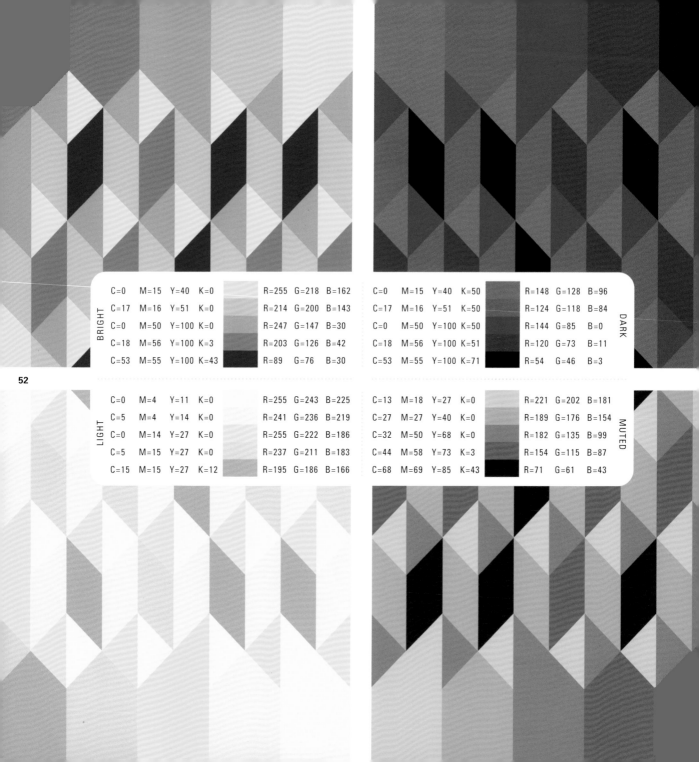

BRIGHT

C=0	M=15	Y=40	K=0		R=255	G=218	B=162
C=17	M=16	Y=51	K=0		R=214	G=200	B=143
C=0	M=50	Y=100	K=0		R=247	G=147	B=30
C=18	M=56	Y=100	K=3		R=203	G=126	B=42
C=53	M=55	Y=100	K=43		R=89	G=76	B=30

DARK

C=0	M=15	Y=40	K=50		R=148	G=128	B=96
C=17	M=16	Y=51	K=50		R=124	G=118	B=84
C=0	M=50	Y=100	K=50		R=144	G=85	B=0
C=18	M=56	Y=100	K=51		R=120	G=73	B=11
C=53	M=55	Y=100	K=71		R=54	G=46	B=3

52

LIGHT

C=0	M=4	Y=11	K=0		R=255	G=243	B=225
C=5	M=4	Y=14	K=0		R=241	G=236	B=219
C=0	M=14	Y=27	K=0		R=255	G=222	B=186
C=5	M=15	Y=27	K=0		R=237	G=211	B=183
C=15	M=15	Y=27	K=12		R=195	G=186	B=166

MUTED

C=13	M=18	Y=27	K=0		R=221	G=202	B=181
C=27	M=27	Y=40	K=0		R=189	G=176	B=154
C=32	M=50	Y=68	K=0		R=182	G=135	B=99
C=44	M=58	Y=73	K=3		R=154	G=115	B=87
C=68	M=69	Y=85	K=43		R=71	G=61	B=43

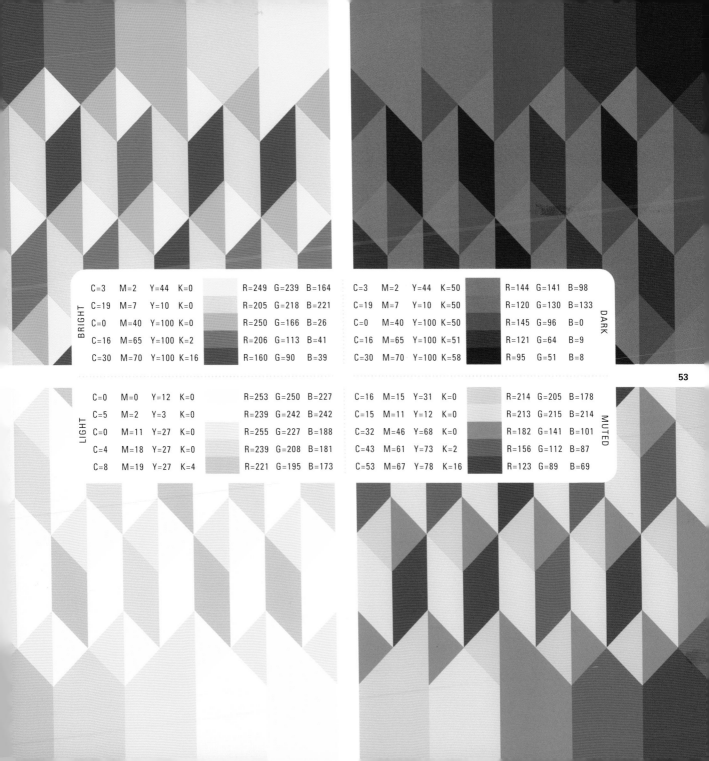

BRIGHT

C=3	M=2	Y=44	K=0
C=19	M=7	Y=10	K=0
C=0	M=40	Y=100	K=0
C=16	M=65	Y=100	K=2
C=30	M=70	Y=100	K=16

R=249	G=239	B=164
R=205	G=218	B=221
R=250	G=166	B=26
R=206	G=113	B=41
R=160	G=90	B=39

DARK

C=3	M=2	Y=44	K=50
C=19	M=7	Y=10	K=50
C=0	M=40	Y=100	K=50
C=16	M=65	Y=100	K=51
C=30	M=70	Y=100	K=58

R=144	G=141	B=98
R=120	G=130	B=133
R=145	G=96	B=0
R=121	G=64	B=9
R=95	G=51	B=8

LIGHT

C=0	M=0	Y=12	K=0
C=5	M=2	Y=3	K=0
C=0	M=11	Y=27	K=0
C=4	M=18	Y=27	K=0
C=8	M=19	Y=27	K=4

R=253	G=250	B=227
R=239	G=242	B=242
R=255	G=227	B=188
R=239	G=208	B=181
R=221	G=195	B=173

MUTED

C=16	M=15	Y=31	K=0
C=15	M=11	Y=12	K=0
C=32	M=46	Y=68	K=0
C=43	M=61	Y=73	K=2
C=53	M=67	Y=78	K=16

R=214	G=205	B=178
R=213	G=215	B=214
R=182	G=141	B=101
R=156	G=112	B=87
R=123	G=89	B=69

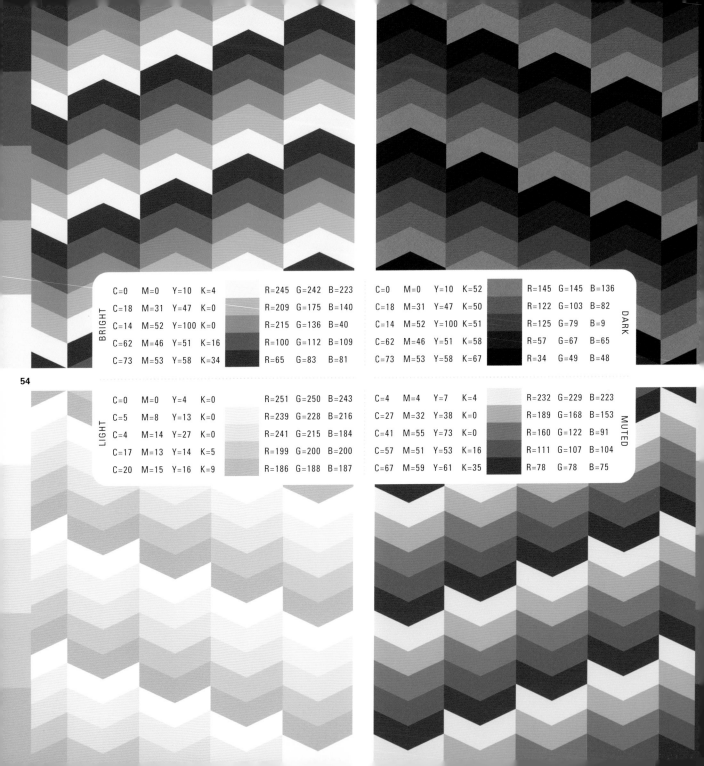

BRIGHT

C=0	M=0	Y=10	K=4		R=245	G=242	B=223
C=18	M=31	Y=47	K=0		R=209	G=175	B=140
C=14	M=52	Y=100	K=0		R=215	G=136	B=40
C=62	M=46	Y=51	K=16		R=100	G=112	B=109
C=73	M=53	Y=58	K=34		R=65	G=83	B=81

DARK

C=0	M=0	Y=10	K=52		R=145	G=145	B=136
C=18	M=31	Y=47	K=50		R=122	G=103	B=82
C=14	M=52	Y=100	K=51		R=125	G=79	B=9
C=62	M=46	Y=51	K=58		R=57	G=67	B=65
C=73	M=53	Y=58	K=67		R=34	G=49	B=48

LIGHT

C=0	M=0	Y=4	K=0		R=251	G=250	B=243
C=5	M=8	Y=13	K=0		R=239	G=228	B=216
C=4	M=14	Y=27	K=0		R=241	G=215	B=184
C=17	M=13	Y=14	K=5		R=199	G=200	B=200
C=20	M=15	Y=16	K=9		R=186	G=188	B=187

MUTED

C=4	M=4	Y=7	K=4		R=232	G=229	B=223
C=27	M=32	Y=38	K=0		R=189	G=168	B=153
C=41	M=55	Y=73	K=0		R=160	G=122	B=91
C=57	M=51	Y=53	K=16		R=111	G=107	B=104
C=67	M=59	Y=61	K=35		R=78	G=78	B=75

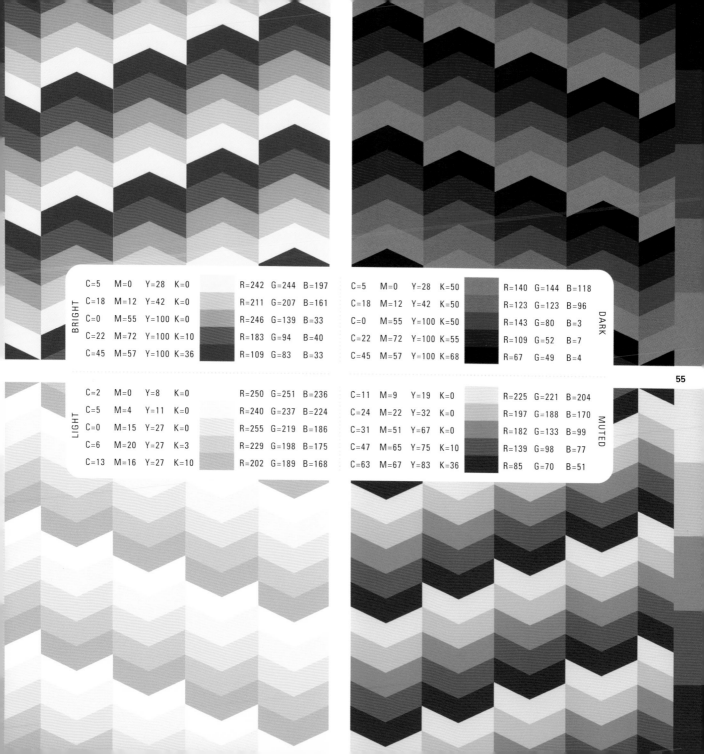

BRIGHT

C=5	M=0	Y=28	K=0		R=242	G=244	B=197
C=18	M=12	Y=42	K=0		R=211	G=207	B=161
C=0	M=55	Y=100	K=0		R=246	G=139	B=33
C=22	M=72	Y=100	K=10		R=183	G=94	B=40
C=45	M=57	Y=100	K=36		R=109	G=83	B=33

DARK

C=5	M=0	Y=28	K=50		R=140	G=144	B=118
C=18	M=12	Y=42	K=50		R=123	G=123	B=96
C=0	M=55	Y=100	K=50		R=143	G=80	B=3
C=22	M=72	Y=100	K=55		R=109	G=52	B=7
C=45	M=57	Y=100	K=68		R=67	G=49	B=4

LIGHT

C=2	M=0	Y=8	K=0		R=250	G=251	B=236
C=5	M=4	Y=11	K=0		R=240	G=237	B=224
C=0	M=15	Y=27	K=0		R=255	G=219	B=186
C=6	M=20	Y=27	K=3		R=229	G=198	B=175
C=13	M=16	Y=27	K=10		R=202	G=189	B=168

MUTED

C=11	M=9	Y=19	K=0		R=225	G=221	B=204
C=24	M=22	Y=32	K=0		R=197	G=188	B=170
C=31	M=51	Y=67	K=0		R=182	G=133	B=99
C=47	M=65	Y=75	K=10		R=139	G=98	B=77
C=63	M=67	Y=83	K=36		R=85	G=70	B=51

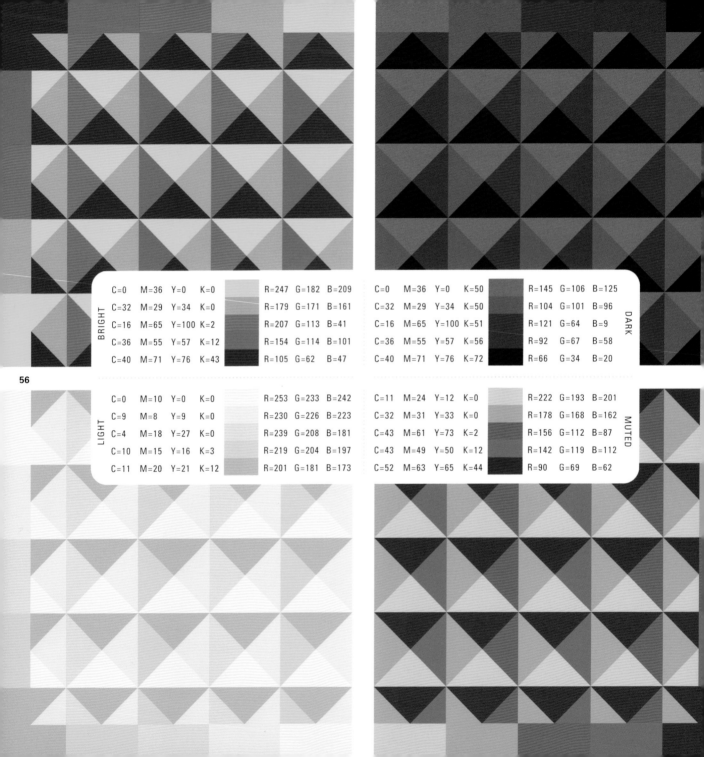

BRIGHT

C=0	M=36	Y=0	K=0		R=247	G=182	B=209
C=32	M=29	Y=34	K=0		R=179	G=171	B=161
C=16	M=65	Y=100	K=2		R=207	G=113	B=41
C=36	M=55	Y=57	K=12		R=154	G=114	B=101
C=40	M=71	Y=76	K=43		R=105	G=62	B=47

DARK

C=0	M=36	Y=0	K=50		R=145	G=106	B=125
C=32	M=29	Y=34	K=50		R=104	G=101	B=96
C=16	M=65	Y=100	K=51		R=121	G=64	B=9
C=36	M=55	Y=57	K=56		R=92	G=67	B=58
C=40	M=71	Y=76	K=72		R=66	G=34	B=20

LIGHT

C=0	M=10	Y=0	K=0		R=253	G=233	B=242
C=9	M=8	Y=9	K=0		R=230	G=226	B=223
C=4	M=18	Y=27	K=0		R=239	G=208	B=181
C=10	M=15	Y=16	K=3		R=219	G=204	B=197
C=11	M=20	Y=21	K=12		R=201	G=181	B=173

MUTED

C=11	M=24	Y=12	K=0		R=222	G=193	B=201
C=32	M=31	Y=33	K=0		R=178	G=168	B=162
C=43	M=61	Y=73	K=2		R=156	G=112	B=87
C=43	M=49	Y=50	K=12		R=142	G=119	B=112
C=52	M=63	Y=65	K=44		R=90	G=69	B=62

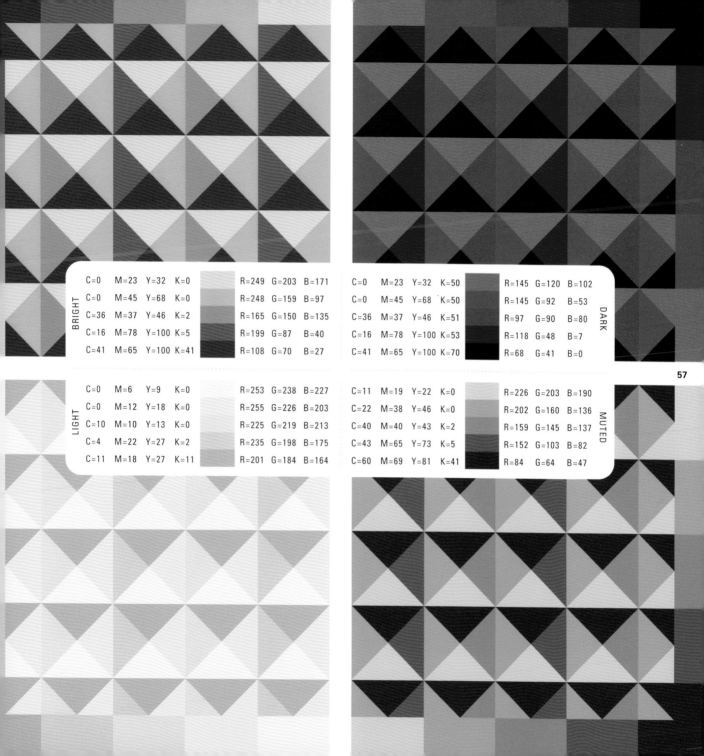

BRIGHT

C=0	M=23	Y=32	K=0		R=249	G=203	B=171
C=0	M=45	Y=68	K=0		R=248	G=159	B=97
C=36	M=37	Y=46	K=2		R=165	G=150	B=135
C=16	M=78	Y=100	K=5		R=199	G=87	B=40
C=41	M=65	Y=100	K=41		R=108	G=70	B=27

DARK

C=0	M=23	Y=32	K=50		R=145	G=120	B=102
C=0	M=45	Y=68	K=50		R=145	G=92	B=53
C=36	M=37	Y=46	K=51		R=97	G=90	B=80
C=16	M=78	Y=100	K=53		R=118	G=48	B=7
C=41	M=65	Y=100	K=70		R=68	G=41	B=0

LIGHT

C=0	M=6	Y=9	K=0		R=253	G=238	B=227
C=0	M=12	Y=18	K=0		R=255	G=226	B=203
C=10	M=10	Y=13	K=0		R=225	G=219	B=213
C=4	M=22	Y=27	K=2		R=235	G=198	B=175
C=11	M=18	Y=27	K=11		R=201	G=184	B=164

MUTED

C=11	M=19	Y=22	K=0		R=226	G=203	B=190
C=22	M=38	Y=46	K=0		R=202	G=160	B=136
C=40	M=40	Y=43	K=2		R=159	G=145	B=137
C=43	M=65	Y=73	K=5		R=152	G=103	B=82
C=60	M=69	Y=81	K=41		R=84	G=64	B=47

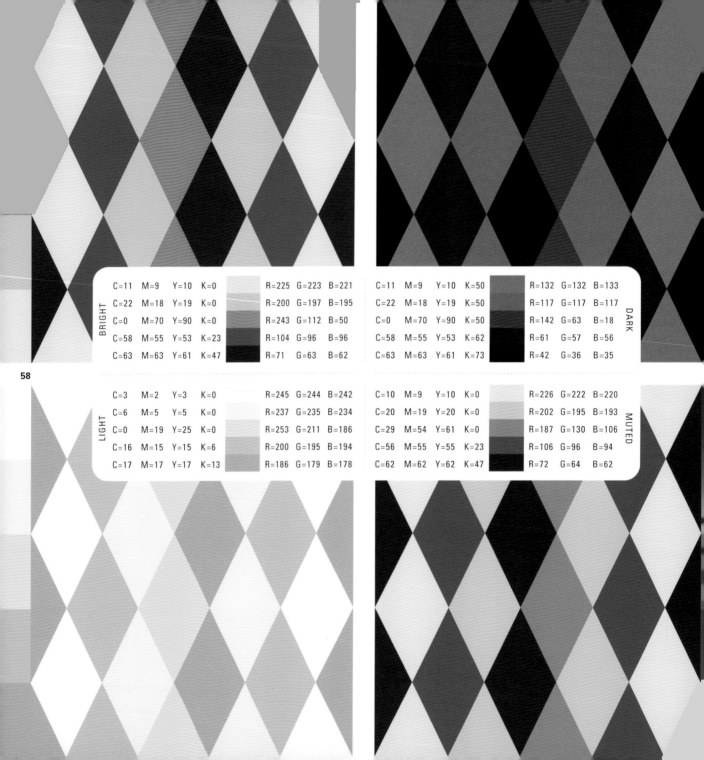

BRIGHT

C=11	M=9	Y=10	K=0		R=225	G=223	B=221
C=22	M=18	Y=19	K=0		R=200	G=197	B=195
C=0	M=70	Y=90	K=0		R=243	G=112	B=50
C=58	M=55	Y=53	K=23		R=104	G=96	B=96
C=63	M=63	Y=61	K=47		R=71	G=63	B=62

DARK

C=11	M=9	Y=10	K=50		R=132	G=132	B=133
C=22	M=18	Y=19	K=50		R=117	G=117	B=117
C=0	M=70	Y=90	K=50		R=142	G=63	B=18
C=58	M=55	Y=53	K=62		R=61	G=57	B=56
C=63	M=63	Y=61	K=73		R=42	G=36	B=35

LIGHT

C=3	M=2	Y=3	K=0		R=245	G=244	B=242
C=6	M=5	Y=5	K=0		R=237	G=235	B=234
C=0	M=19	Y=25	K=0		R=253	G=211	B=186
C=16	M=15	Y=15	K=6		R=200	G=195	B=194
C=17	M=17	Y=17	K=13		R=186	G=179	B=178

MUTED

C=10	M=9	Y=10	K=0		R=226	G=222	B=220
C=20	M=19	Y=20	K=0		R=202	G=195	B=193
C=29	M=54	Y=61	K=0		R=187	G=130	B=106
C=56	M=55	Y=55	K=23		R=106	G=96	B=94
C=62	M=62	Y=62	K=47		R=72	G=64	B=62

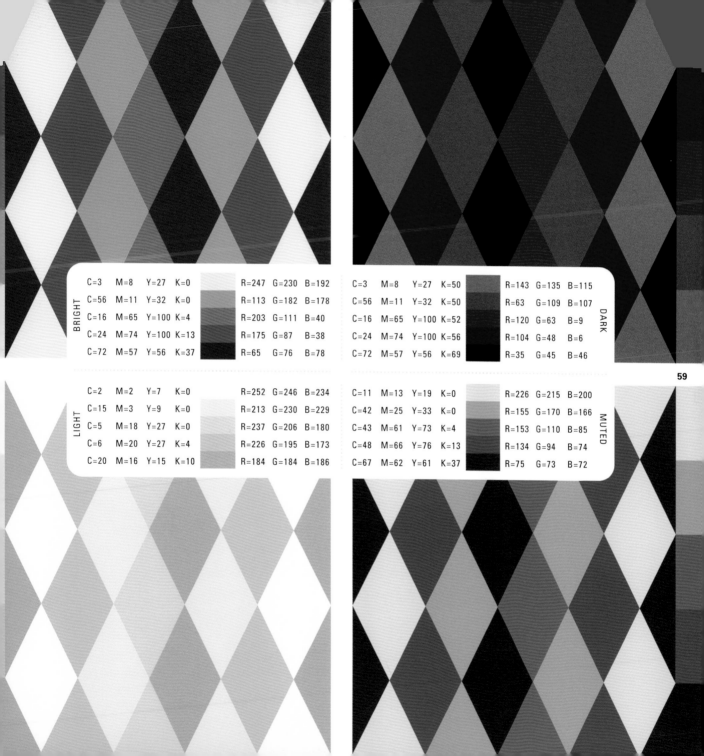

BRIGHT

C=3	M=8	Y=27	K=0		R=247	G=230	B=192
C=56	M=11	Y=32	K=0		R=113	G=182	B=178
C=16	M=65	Y=100	K=4		R=203	G=111	B=40
C=24	M=74	Y=100	K=13		R=175	G=87	B=38
C=72	M=57	Y=56	K=37		R=65	G=76	B=78

DARK

C=3	M=8	Y=27	K=50		R=143	G=135	B=115
C=56	M=11	Y=32	K=50		R=63	G=109	B=107
C=16	M=65	Y=100	K=52		R=120	G=63	B=9
C=24	M=74	Y=100	K=56		R=104	G=48	B=6
C=72	M=57	Y=56	K=69		R=35	G=45	B=46

LIGHT

C=2	M=2	Y=7	K=0		R=252	G=246	B=234
C=15	M=3	Y=9	K=0		R=213	G=230	B=229
C=5	M=18	Y=27	K=0		R=237	G=206	B=180
C=6	M=20	Y=27	K=4		R=226	G=195	B=173
C=20	M=16	Y=15	K=10		R=184	G=184	B=186

MUTED

C=11	M=13	Y=19	K=0		R=226	G=215	B=200
C=42	M=25	Y=33	K=0		R=155	G=170	B=166
C=43	M=61	Y=73	K=4		R=153	G=110	B=85
C=48	M=66	Y=76	K=13		R=134	G=94	B=74
C=67	M=62	Y=61	K=37		R=75	G=73	B=72

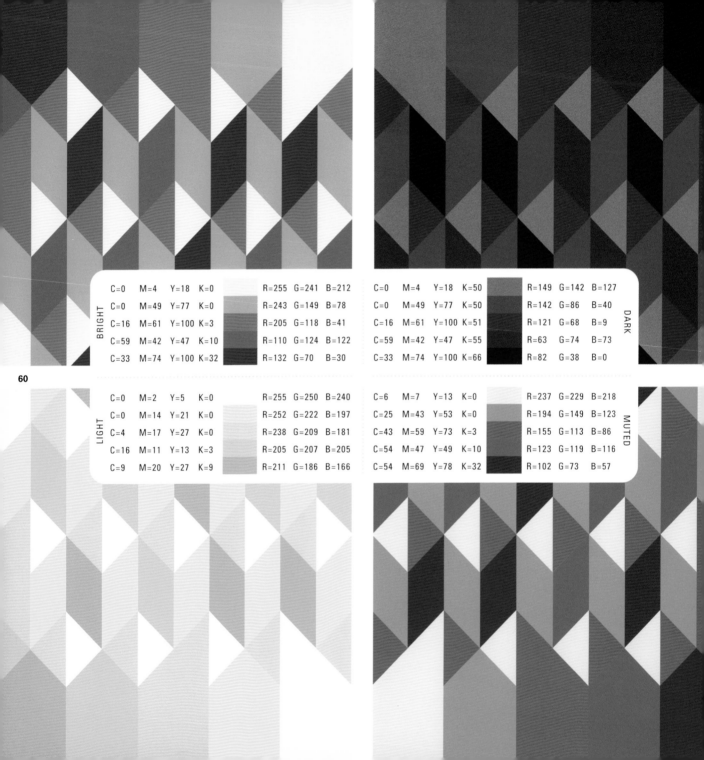

BRIGHT

C=0	M=4	Y=18	K=0		R=255	G=241	B=212
C=0	M=49	Y=77	K=0		R=243	G=149	B=78
C=16	M=61	Y=100	K=3		R=205	G=118	B=41
C=59	M=42	Y=47	K=10		R=110	G=124	B=122
C=33	M=74	Y=100	K=32		R=132	G=70	B=30

DARK

C=0	M=4	Y=18	K=50		R=149	G=142	B=127
C=0	M=49	Y=77	K=50		R=142	G=86	B=40
C=16	M=61	Y=100	K=51		R=121	G=68	B=9
C=59	M=42	Y=47	K=55		R=63	G=74	B=73
C=33	M=74	Y=100	K=66		R=82	G=38	B=0

60

LIGHT

C=0	M=2	Y=5	K=0		R=255	G=250	B=240
C=0	M=14	Y=21	K=0		R=252	G=222	B=197
C=4	M=17	Y=27	K=0		R=238	G=209	B=181
C=16	M=11	Y=13	K=3		R=205	G=207	B=205
C=9	M=20	Y=27	K=9		R=211	G=186	B=166

MUTED

C=6	M=7	Y=13	K=0		R=237	G=229	B=218
C=25	M=43	Y=53	K=0		R=194	G=149	B=123
C=43	M=59	Y=73	K=3		R=155	G=113	B=86
C=54	M=47	Y=49	K=10		R=123	G=119	B=116
C=54	M=69	Y=78	K=32		R=102	G=73	B=57

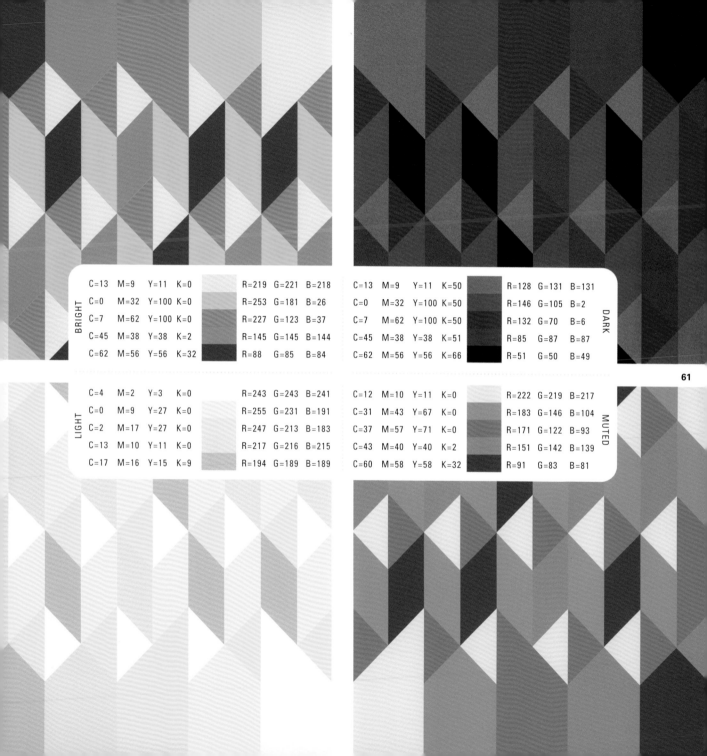

BRIGHT

C=13	M=9	Y=11	K=0
C=0	M=32	Y=100	K=0
C=7	M=62	Y=100	K=0
C=45	M=38	Y=38	K=2
C=62	M=56	Y=56	K=32

R=219	G=221	B=218
R=253	G=181	B=26
R=227	G=123	B=37
R=145	G=145	B=144
R=88	G=85	B=84

DARK

C=13	M=9	Y=11	K=50
C=0	M=32	Y=100	K=50
C=7	M=62	Y=100	K=50
C=45	M=38	Y=38	K=51
C=62	M=56	Y=56	K=66

R=128	G=131	B=131
R=146	G=105	B=2
R=132	G=70	B=6
R=85	G=87	B=87
R=51	G=50	B=49

LIGHT

C=4	M=2	Y=3	K=0
C=0	M=9	Y=27	K=0
C=2	M=17	Y=27	K=0
C=13	M=10	Y=11	K=0
C=17	M=16	Y=15	K=9

R=243	G=243	B=241
R=255	G=231	B=191
R=247	G=213	B=183
R=217	G=216	B=215
R=194	G=189	B=189

MUTED

C=12	M=10	Y=11	K=0
C=31	M=43	Y=67	K=0
C=37	M=57	Y=71	K=0
C=43	M=40	Y=40	K=2
C=60	M=58	Y=58	K=32

R=222	G=219	B=217
R=183	G=146	B=104
R=171	G=122	B=93
R=151	G=142	B=139
R=91	G=83	B=81

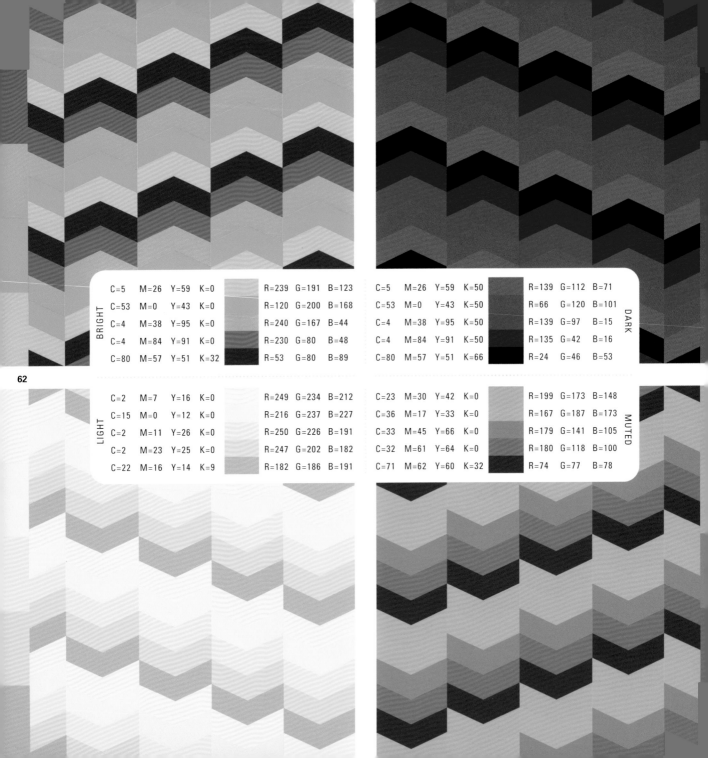

BRIGHT	C=5	M=26	Y=59	K=0	R=239	G=191	B=123
	C=53	M=0	Y=43	K=0	R=120	G=200	B=168
	C=4	M=38	Y=95	K=0	R=240	G=167	B=44
	C=4	M=84	Y=91	K=0	R=230	G=80	B=48
	C=80	M=57	Y=51	K=32	R=53	G=80	B=89

DARK	C=5	M=26	Y=59	K=50	R=139	G=112	B=71
	C=53	M=0	Y=43	K=50	R=66	G=120	B=101
	C=4	M=38	Y=95	K=50	R=139	G=97	B=15
	C=4	M=84	Y=91	K=50	R=135	G=42	B=16
	C=80	M=57	Y=51	K=66	R=24	G=46	B=53

LIGHT	C=2	M=7	Y=16	K=0	R=249	G=234	B=212
	C=15	M=0	Y=12	K=0	R=216	G=237	B=227
	C=2	M=11	Y=26	K=0	R=250	G=226	B=191
	C=2	M=23	Y=25	K=0	R=247	G=202	B=182
	C=22	M=16	Y=14	K=9	R=182	G=186	B=191

MUTED	C=23	M=30	Y=42	K=0	R=199	G=173	B=148
	C=36	M=17	Y=33	K=0	R=167	G=187	B=173
	C=33	M=45	Y=66	K=0	R=179	G=141	B=105
	C=32	M=61	Y=64	K=0	R=180	G=118	B=100
	C=71	M=62	Y=60	K=32	R=74	G=77	B=78

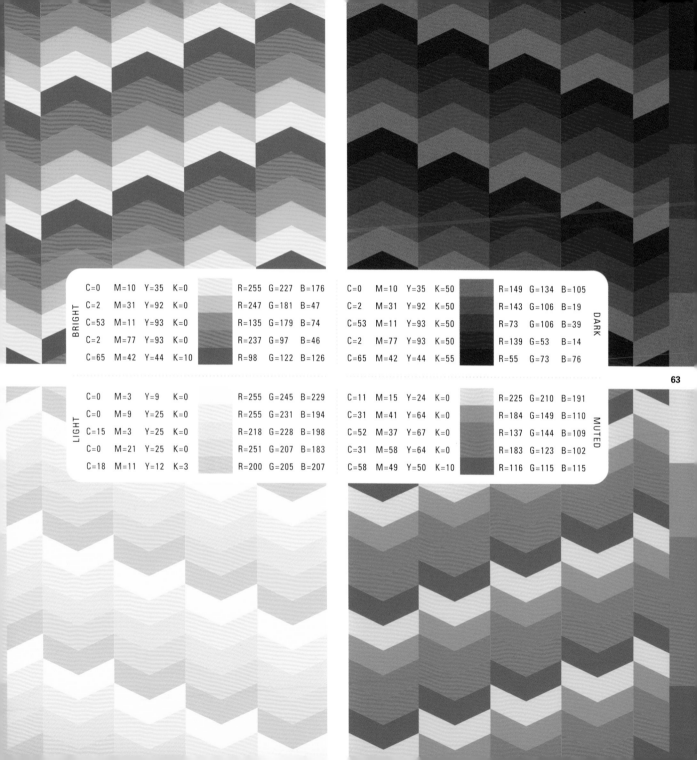

BRIGHT
C=0 M=10 Y=35 K=0 R=255 G=227 B=176
C=2 M=31 Y=92 K=0 R=247 G=181 B=47
C=53 M=11 Y=93 K=0 R=135 G=179 B=74
C=2 M=77 Y=93 K=0 R=237 G=97 B=46
C=65 M=42 Y=44 K=10 R=98 G=122 B=126

DARK
C=0 M=10 Y=35 K=50 R=149 G=134 B=105
C=2 M=31 Y=92 K=50 R=143 G=106 B=19
C=53 M=11 Y=93 K=50 R=73 G=106 B=39
C=2 M=77 Y=93 K=50 R=139 G=53 B=14
C=65 M=42 Y=44 K=55 R=55 G=73 B=76

63

LIGHT
C=0 M=3 Y=9 K=0 R=255 G=245 B=229
C=0 M=9 Y=25 K=0 R=255 G=231 B=194
C=15 M=3 Y=25 K=0 R=218 G=228 B=198
C=0 M=21 Y=25 K=0 R=251 G=207 B=183
C=18 M=11 Y=12 K=3 R=200 G=205 B=207

MUTED
C=11 M=15 Y=24 K=0 R=225 G=210 B=191
C=31 M=41 Y=64 K=0 R=184 G=149 B=110
C=52 M=37 Y=67 K=0 R=137 G=144 B=109
C=31 M=58 Y=64 K=0 R=183 G=123 B=102
C=58 M=49 Y=50 K=10 R=116 G=115 B=115

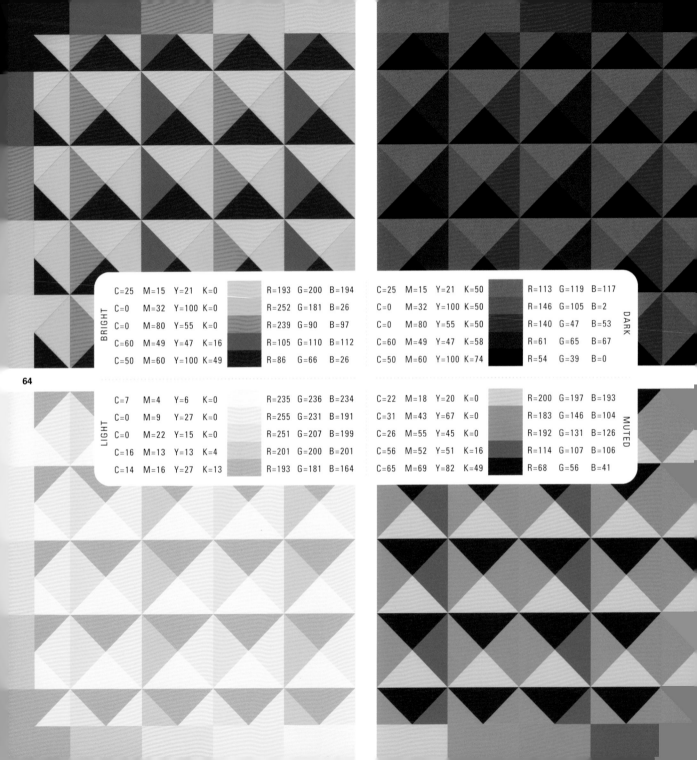

BRIGHT

C=25	M=15	Y=21	K=0		R=193	G=200	B=194
C=0	M=32	Y=100	K=0		R=252	G=181	B=26
C=0	M=80	Y=55	K=0		R=239	G=90	B=97
C=60	M=49	Y=47	K=16		R=105	G=110	B=112
C=50	M=60	Y=100	K=49		R=86	G=66	B=26

DARK

C=25	M=15	Y=21	K=50		R=113	G=119	B=117
C=0	M=32	Y=100	K=50		R=146	G=105	B=2
C=0	M=80	Y=55	K=50		R=140	G=47	B=53
C=60	M=49	Y=47	K=58		R=61	G=65	B=67
C=50	M=60	Y=100	K=74		R=54	G=39	B=0

LIGHT

C=7	M=4	Y=6	K=0		R=235	G=236	B=234
C=0	M=9	Y=27	K=0		R=255	G=231	B=191
C=0	M=22	Y=15	K=0		R=251	G=207	B=199
C=16	M=13	Y=13	K=4		R=201	G=200	B=201
C=14	M=16	Y=27	K=13		R=193	G=181	B=164

MUTED

C=22	M=18	Y=20	K=0		R=200	G=197	B=193
C=31	M=43	Y=67	K=0		R=183	G=146	B=104
C=26	M=55	Y=45	K=0		R=192	G=131	B=126
C=56	M=52	Y=51	K=16		R=114	G=107	B=106
C=65	M=69	Y=82	K=49		R=68	G=56	B=41

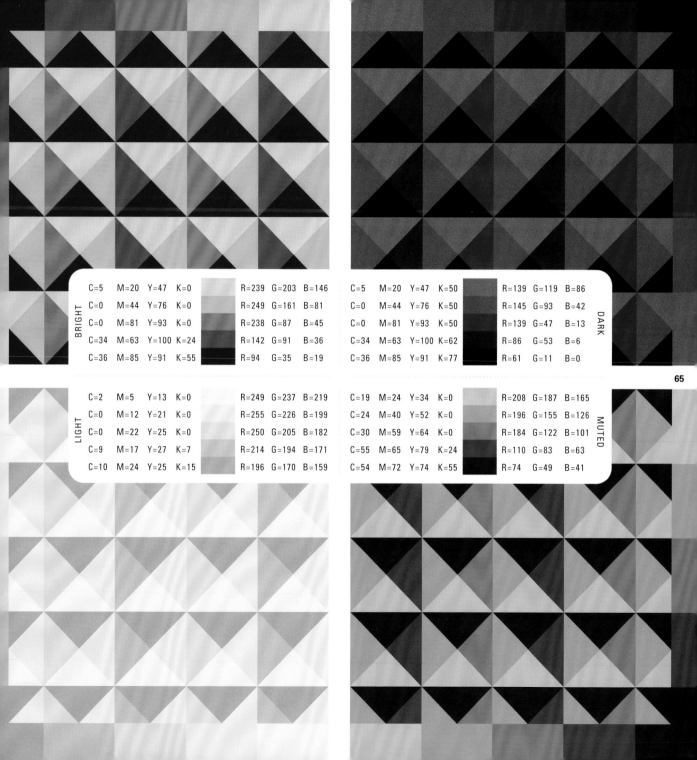

BRIGHT	C=5	M=20	Y=47	K=0		R=239	G=203	B=146	
	C=0	M=44	Y=76	K=0		R=249	G=161	B=81	
	C=0	M=81	Y=93	K=0		R=238	G=87	B=45	
	C=34	M=63	Y=100	K=24		R=142	G=91	B=36	
	C=36	M=85	Y=91	K=55		R=94	G=35	B=19	

C=5	M=20	Y=47	K=50		R=139	G=119	B=86		**DARK**
C=0	M=44	Y=76	K=50		R=145	G=93	B=42		
C=0	M=81	Y=93	K=50		R=139	G=47	B=13		
C=34	M=63	Y=100	K=62		R=86	G=53	B=6		
C=36	M=85	Y=91	K=77		R=61	G=11	B=0		

LIGHT	C=2	M=5	Y=13	K=0		R=249	G=237	B=219	
	C=0	M=12	Y=21	K=0		R=255	G=226	B=199	
	C=0	M=22	Y=25	K=0		R=250	G=205	B=182	
	C=9	M=17	Y=27	K=7		R=214	G=194	B=171	
	C=10	M=24	Y=25	K=15		R=196	G=170	B=159	

C=19	M=24	Y=34	K=0		R=208	G=187	B=165		**MUTED**
C=24	M=40	Y=52	K=0		R=196	G=155	B=126		
C=30	M=59	Y=64	K=0		R=184	G=122	B=101		
C=55	M=65	Y=79	K=24		R=110	G=83	B=63		
C=54	M=72	Y=74	K=55		R=74	G=49	B=41		

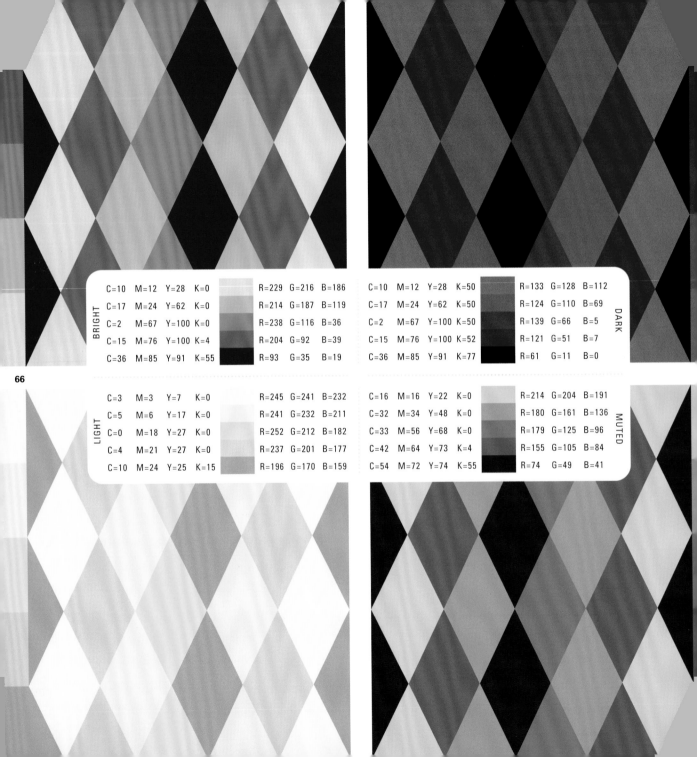

66

BRIGHT

C=10	M=12	Y=28	K=0	R=229	G=216	B=186
C=17	M=24	Y=62	K=0	R=214	G=187	B=119
C=2	M=67	Y=100	K=0	R=238	G=116	B=36
C=15	M=76	Y=100	K=4	R=204	G=92	B=39
C=36	M=85	Y=91	K=55	R=93	G=35	B=19

DARK

C=10	M=12	Y=28	K=50	R=133	G=128	B=112
C=17	M=24	Y=62	K=50	R=124	G=110	B=69
C=2	M=67	Y=100	K=50	R=139	G=66	B=5
C=15	M=76	Y=100	K=52	R=121	G=51	B=7
C=36	M=85	Y=91	K=77	R=61	G=11	B=0

LIGHT

C=3	M=3	Y=7	K=0	R=245	G=241	B=232
C=5	M=6	Y=17	K=0	R=241	G=232	B=211
C=0	M=18	Y=27	K=0	R=252	G=212	B=182
C=4	M=21	Y=27	K=0	R=237	G=201	B=177
C=10	M=24	Y=25	K=15	R=196	G=170	B=159

MUTED

C=16	M=16	Y=22	K=0	R=214	G=204	B=191
C=32	M=34	Y=48	K=0	R=180	G=161	B=136
C=33	M=56	Y=68	K=0	R=179	G=125	B=96
C=42	M=64	Y=73	K=4	R=155	G=105	B=84
C=54	M=72	Y=74	K=55	R=74	G=49	B=41

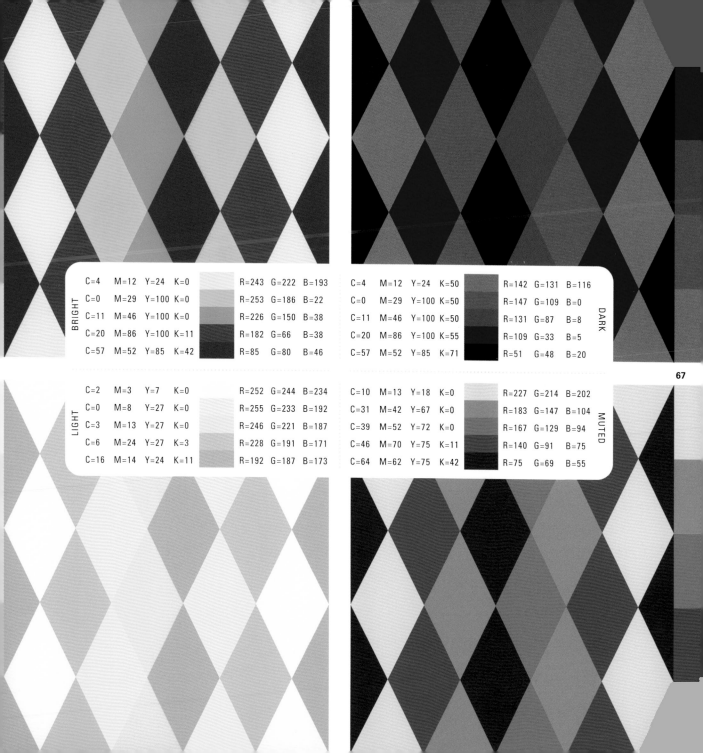

BRIGHT

C=4	M=12	Y=24	K=0		R=243	G=222	B=193
C=0	M=29	Y=100	K=0		R=253	G=186	B=22
C=11	M=46	Y=100	K=0		R=226	G=150	B=38
C=20	M=86	Y=100	K=11		R=182	G=66	B=38
C=57	M=52	Y=85	K=42		R=85	G=80	B=46

DARK

C=4	M=12	Y=24	K=50		R=142	G=131	B=116
C=0	M=29	Y=100	K=50		R=147	G=109	B=0
C=11	M=46	Y=100	K=50		R=131	G=87	B=8
C=20	M=86	Y=100	K=55		R=109	G=33	B=5
C=57	M=52	Y=85	K=71		R=51	G=48	B=20

LIGHT

C=2	M=3	Y=7	K=0		R=252	G=244	B=234
C=0	M=8	Y=27	K=0		R=255	G=233	B=192
C=3	M=13	Y=27	K=0		R=246	G=221	B=187
C=6	M=24	Y=27	K=3		R=228	G=191	B=171
C=16	M=14	Y=24	K=11		R=192	G=187	B=173

MUTED

C=10	M=13	Y=18	K=0		R=227	G=214	B=202
C=31	M=42	Y=67	K=0		R=183	G=147	B=104
C=39	M=52	Y=72	K=0		R=167	G=129	B=94
C=46	M=70	Y=75	K=11		R=140	G=91	B=75
C=64	M=62	Y=75	K=42		R=75	G=69	B=55

	C=10	M=0	Y=2	K=0		R=227	G=243	B=246	
BRIGHT	C=25	M=5	Y=7	K=0		R=188	G=217	B=228	
	C=2	M=30	Y=74	K=0		R=247	G=184	B=90	
	C=0	M=70	Y=90	K=0		R=243	G=112	B=50	
	C=68	M=60	Y=66	K=58		R=53	G=53	B=49	

	C=10	M=0	Y=2	K=50		R=132	G=144	B=147	
	C=25	M=5	Y=7	K=50		R=110	G=129	B=137	**DARK**
	C=2	M=30	Y=74	K=50		R=143	G=108	B=49	
	C=0	M=70	Y=90	K=50		R=142	G=63	B=18	
	C=68	M=60	Y=66	K=79		R=28	G=29	B=25	

	C=4	M=0	Y=0	K=0		R=245	G=251	B=251	
LIGHT	C=7	M=2	Y=2	K=0		R=234	G=241	B=244	
	C=0	M=8	Y=20	K=0		R=255	G=233	B=203	
	C=0	M=19	Y=25	K=0		R=253	G=212	B=186	
	C=18	M=16	Y=18	K=16		R=178	G=175	B=172	

	C=7	M=3	Y=4	K=0		R=235	G=238	B=238	
	C=19	M=11	Y=12	K=0		R=205	G=211	B=213	**MUTED**
	C=25	M=35	Y=51	K=0		R=196	G=163	B=130	
	C=29	M=54	Y=61	K=0		R=187	G=130	B=106	
	C=65	M=63	Y=65	K=58		R=56	G=52	B=49	

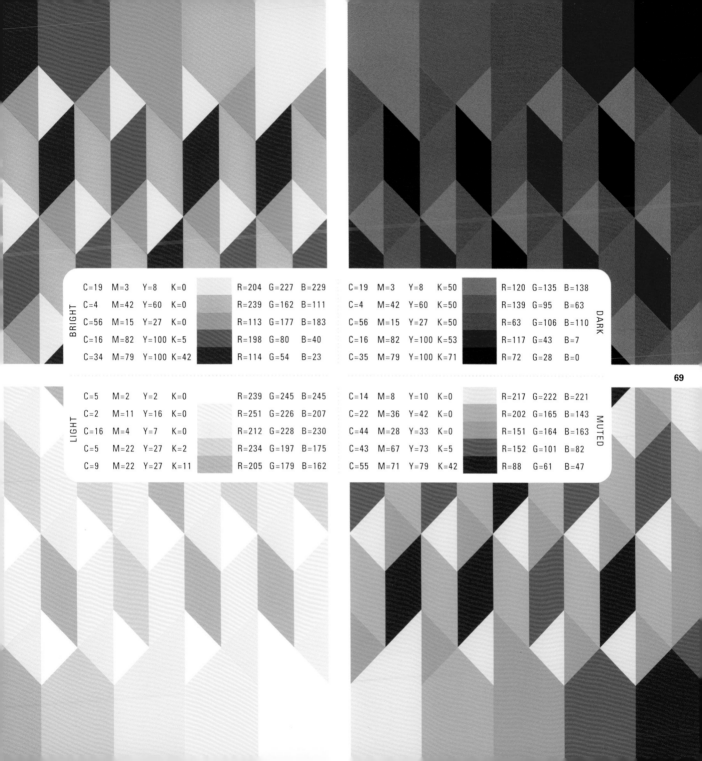

BRIGHT

C	M	Y	K		R	G	B
C=19	M=3	Y=8	K=0		R=204	G=227	B=229
C=4	M=42	Y=60	K=0		R=239	G=162	B=111
C=56	M=15	Y=27	K=0		R=113	G=177	B=183
C=16	M=82	Y=100	K=5		R=198	G=80	B=40
C=34	M=79	Y=100	K=42		R=114	G=54	B=23

DARK

C	M	Y	K		R	G	B
C=19	M=3	Y=8	K=50		R=120	G=135	B=138
C=4	M=42	Y=60	K=50		R=139	G=95	B=63
C=56	M=15	Y=27	K=50		R=63	G=106	B=110
C=16	M=82	Y=100	K=53		R=117	G=43	B=7
C=35	M=79	Y=100	K=71		R=72	G=28	B=0

LIGHT

C	M	Y	K		R	G	B
C=5	M=2	Y=2	K=0		R=239	G=245	B=245
C=2	M=11	Y=16	K=0		R=251	G=226	B=207
C=16	M=4	Y=7	K=0		R=212	G=228	B=230
C=5	M=22	Y=27	K=2		R=234	G=197	B=175
C=9	M=22	Y=27	K=11		R=205	G=179	B=162

MUTED

C	M	Y	K		R	G	B
C=14	M=8	Y=10	K=0		R=217	G=222	B=221
C=22	M=36	Y=42	K=0		R=202	G=165	B=143
C=44	M=28	Y=33	K=0		R=151	G=164	B=163
C=43	M=67	Y=73	K=5		R=152	G=101	B=82
C=55	M=71	Y=79	K=42		R=88	G=61	B=47

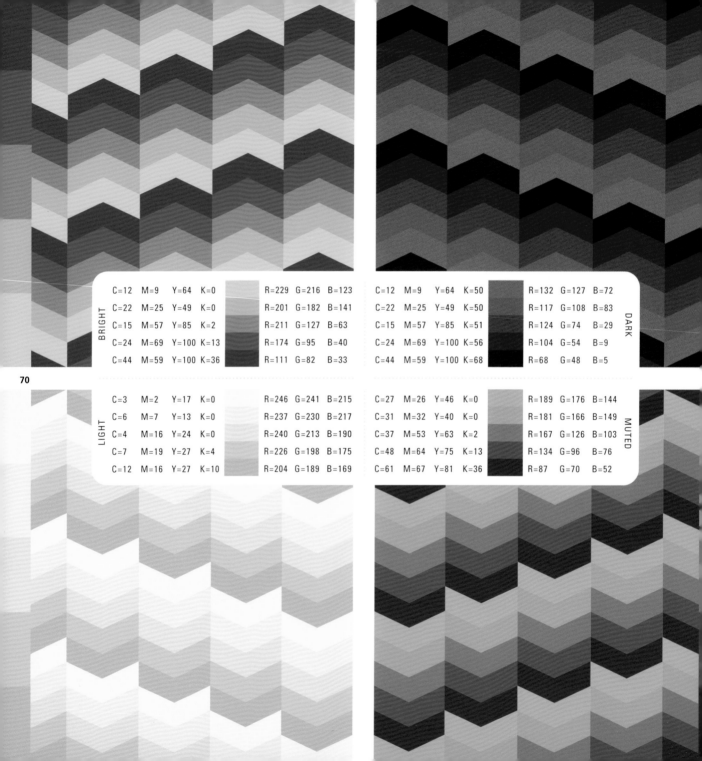

	C	M	Y	K		R	G	B
BRIGHT	C=12	M=9	Y=64	K=0		R=229	G=216	B=123
	C=22	M=25	Y=49	K=0		R=201	G=182	B=141
	C=15	M=57	Y=85	K=2		R=211	G=127	B=63
	C=24	M=69	Y=100	K=13		R=174	G=95	B=40
	C=44	M=59	Y=100	K=36		R=111	G=82	B=33

	C	M	Y	K		R	G	B	
	C=12	M=9	Y=64	K=50		R=132	G=127	B=72	**DARK**
	C=22	M=25	Y=49	K=50		R=117	G=108	B=83	
	C=15	M=57	Y=85	K=51		R=124	G=74	B=29	
	C=24	M=69	Y=100	K=56		R=104	G=54	B=9	
	C=44	M=59	Y=100	K=68		R=68	G=48	B=5	

	C	M	Y	K		R	G	B
LIGHT	C=3	M=2	Y=17	K=0		R=246	G=241	B=215
	C=6	M=7	Y=13	K=0		R=237	G=230	B=217
	C=4	M=16	Y=24	K=0		R=240	G=213	B=190
	C=7	M=19	Y=27	K=4		R=226	G=198	B=175
	C=12	M=16	Y=27	K=10		R=204	G=189	B=169

	C	M	Y	K		R	G	B	
	C=27	M=26	Y=46	K=0		R=189	G=176	B=144	**MUTED**
	C=31	M=32	Y=40	K=0		R=181	G=166	B=149	
	C=37	M=53	Y=63	K=2		R=167	G=126	B=103	
	C=48	M=64	Y=75	K=13		R=134	G=96	B=76	
	C=61	M=67	Y=81	K=36		R=87	G=70	B=52	

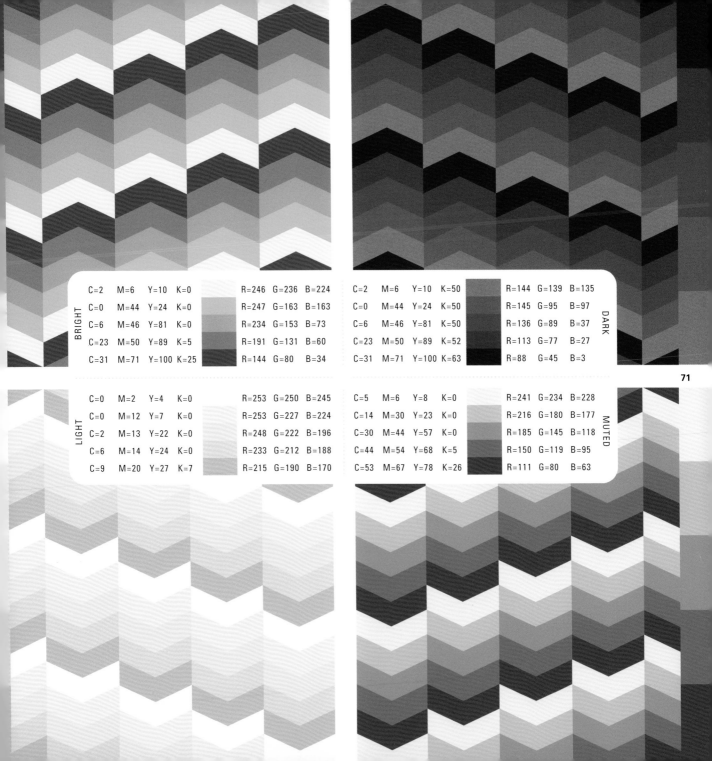

BRIGHT

C=2	M=6	Y=10	K=0		R=246	G=236	B=224
C=0	M=44	Y=24	K=0		R=247	G=163	B=163
C=6	M=46	Y=81	K=0		R=234	G=153	B=73
C=23	M=50	Y=89	K=5		R=191	G=131	B=60
C=31	M=71	Y=100	K=25		R=144	G=80	B=34

DARK

C=2	M=6	Y=10	K=50		R=144	G=139	B=135
C=0	M=44	Y=24	K=50		R=145	G=95	B=97
C=6	M=46	Y=81	K=50		R=136	G=89	B=37
C=23	M=50	Y=89	K=52		R=113	G=77	B=27
C=31	M=71	Y=100	K=63		R=88	G=45	B=3

71

LIGHT

C=0	M=2	Y=4	K=0		R=253	G=250	B=245
C=0	M=12	Y=7	K=0		R=253	G=227	B=224
C=2	M=13	Y=22	K=0		R=248	G=222	B=196
C=6	M=14	Y=24	K=0		R=233	G=212	B=188
C=9	M=20	Y=27	K=7		R=215	G=190	B=170

MUTED

C=5	M=6	Y=8	K=0		R=241	G=234	B=228
C=14	M=30	Y=23	K=0		R=216	G=180	B=177
C=30	M=44	Y=57	K=0		R=185	G=145	B=118
C=44	M=54	Y=68	K=5		R=150	G=119	B=95
C=53	M=67	Y=78	K=26		R=111	G=80	B=63

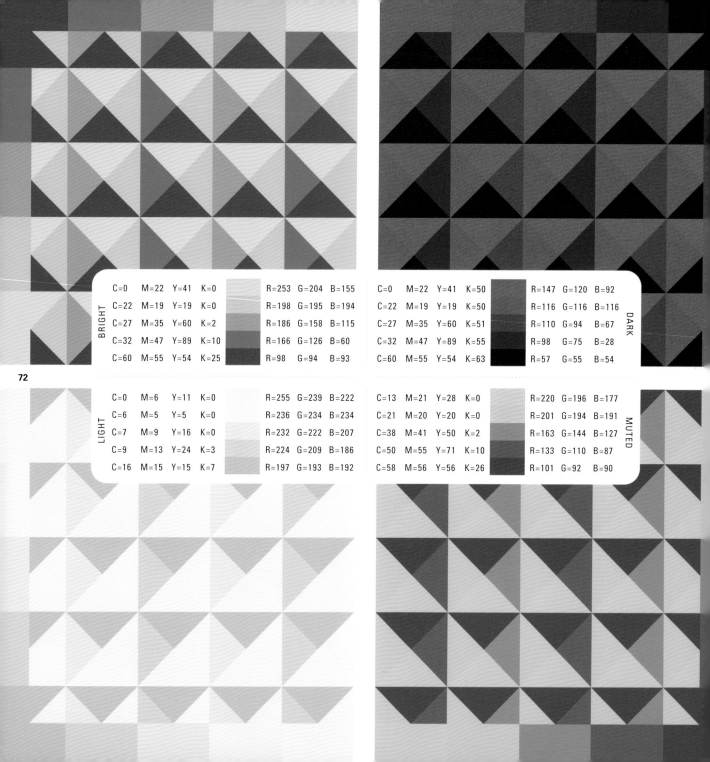

BRIGHT

C=0	M=22	Y=41	K=0		R=253 G=204 B=155
C=22	M=19	Y=19	K=0		R=198 G=195 B=194
C=27	M=35	Y=60	K=2		R=186 G=158 B=115
C=32	M=47	Y=89	K=10		R=166 G=126 B=60
C=60	M=55	Y=54	K=25		R=98 G=94 B=93

DARK

C=0	M=22	Y=41	K=50		R=147 G=120 B=92
C=22	M=19	Y=19	K=50		R=116 G=116 B=116
C=27	M=35	Y=60	K=51		R=110 G=94 B=67
C=32	M=47	Y=89	K=55		R=98 G=75 B=28
C=60	M=55	Y=54	K=63		R=57 G=55 B=54

LIGHT

C=0	M=6	Y=11	K=0		R=255 G=239 B=222
C=6	M=5	Y=5	K=0		R=236 G=234 B=234
C=7	M=9	Y=16	K=0		R=232 G=222 B=207
C=9	M=13	Y=24	K=3		R=224 G=209 B=186
C=16	M=15	Y=15	K=7		R=197 G=193 B=192

MUTED

C=13	M=21	Y=28	K=0		R=220 G=196 B=177
C=21	M=20	Y=20	K=0		R=201 G=194 B=191
C=38	M=41	Y=50	K=2		R=163 G=144 B=127
C=50	M=55	Y=71	K=10		R=133 G=110 B=87
C=58	M=56	Y=56	K=26		R=101 G=92 B=90

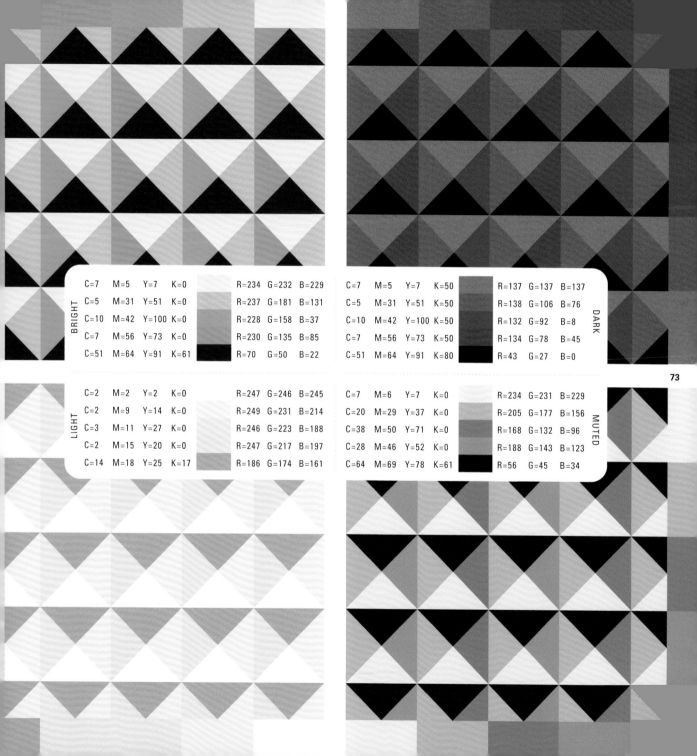

BRIGHT

C=7	M=5	Y=7	K=0		R=234	G=232	B=229
C=5	M=31	Y=51	K=0		R=237	G=181	B=131
C=10	M=42	Y=100	K=0		R=228	G=158	B=37
C=7	M=56	Y=73	K=0		R=230	G=135	B=85
C=51	M=64	Y=91	K=61		R=70	G=50	B=22

DARK

C=7	M=5	Y=7	K=50		R=137	G=137	B=137
C=5	M=31	Y=51	K=50		R=138	G=106	B=76
C=10	M=42	Y=100	K=50		R=132	G=92	B=8
C=7	M=56	Y=73	K=50		R=134	G=78	B=45
C=51	M=64	Y=91	K=80		R=43	G=27	B=0

73

LIGHT

C=2	M=2	Y=2	K=0		R=247	G=246	B=245
C=2	M=9	Y=14	K=0		R=249	G=231	B=214
C=3	M=11	Y=27	K=0		R=246	G=223	B=188
C=2	M=15	Y=20	K=0		R=247	G=217	B=197
C=14	M=18	Y=25	K=17		R=186	G=174	B=161

MUTED

C=7	M=6	Y=7	K=0		R=234	G=231	B=229
C=20	M=29	Y=37	K=0		R=205	G=177	B=156
C=38	M=50	Y=71	K=0		R=168	G=132	B=96
C=28	M=46	Y=52	K=0		R=188	G=143	B=123
C=64	M=69	Y=78	K=61		R=56	G=45	B=34

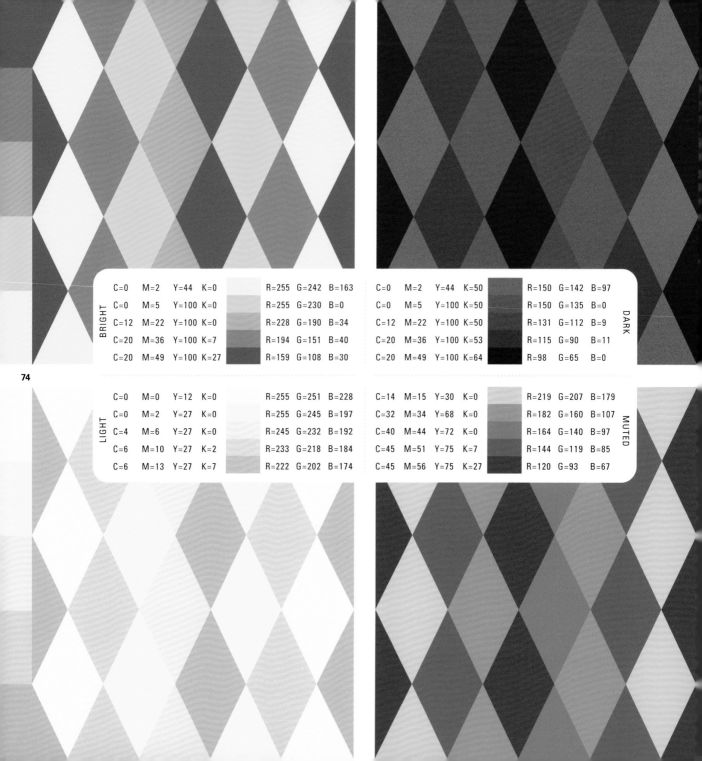

BRIGHT

C=0	M=2	Y=44	K=0		R=255	G=242	B=163
C=0	M=5	Y=100	K=0		R=255	G=230	B=0
C=12	M=22	Y=100	K=0		R=228	G=190	B=34
C=20	M=36	Y=100	K=7		R=194	G=151	B=40
C=20	M=49	Y=100	K=27		R=159	G=108	B=30

DARK

C=0	M=2	Y=44	K=50		R=150	G=142	B=97
C=0	M=5	Y=100	K=50		R=150	G=135	B=0
C=12	M=22	Y=100	K=50		R=131	G=112	B=9
C=20	M=36	Y=100	K=53		R=115	G=90	B=11
C=20	M=49	Y=100	K=64		R=98	G=65	B=0

LIGHT

C=0	M=0	Y=12	K=0		R=255	G=251	B=228
C=0	M=2	Y=27	K=0		R=255	G=245	B=197
C=4	M=6	Y=27	K=0		R=245	G=232	B=192
C=6	M=10	Y=27	K=2		R=233	G=218	B=184
C=6	M=13	Y=27	K=7		R=222	G=202	B=174

MUTED

C=14	M=15	Y=30	K=0		R=219	G=207	B=179
C=32	M=34	Y=68	K=0		R=182	G=160	B=107
C=40	M=44	Y=72	K=0		R=164	G=140	B=97
C=45	M=51	Y=75	K=7		R=144	G=119	B=85
C=45	M=56	Y=75	K=27		R=120	G=93	B=67

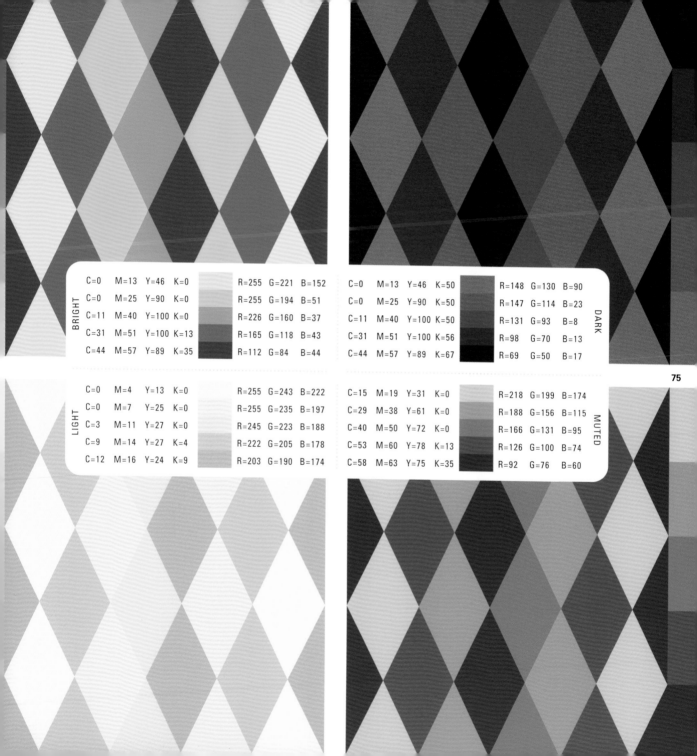

BRIGHT

C=0	M=13	Y=46	K=0		R=255	G=221	B=152
C=0	M=25	Y=90	K=0		R=255	G=194	B=51
C=11	M=40	Y=100	K=0		R=226	G=160	B=37
C=31	M=51	Y=100	K=13		R=165	G=118	B=43
C=44	M=57	Y=89	K=35		R=112	G=84	B=44

DARK

C=0	M=13	Y=46	K=50		R=148	G=130	B=90
C=0	M=25	Y=90	K=50		R=147	G=114	B=23
C=11	M=40	Y=100	K=50		R=131	G=93	B=8
C=31	M=51	Y=100	K=56		R=98	G=70	B=13
C=44	M=57	Y=89	K=67		R=69	G=50	B=17

LIGHT

C=0	M=4	Y=13	K=0		R=255	G=243	B=222
C=0	M=7	Y=25	K=0		R=255	G=235	B=197
C=3	M=11	Y=27	K=0		R=245	G=223	B=188
C=9	M=14	Y=27	K=4		R=222	G=205	B=178
C=12	M=16	Y=24	K=9		R=203	G=190	B=174

MUTED

C=15	M=19	Y=31	K=0		R=218	G=199	B=174
C=29	M=38	Y=61	K=0		R=188	G=156	B=115
C=40	M=50	Y=72	K=0		R=166	G=131	B=95
C=53	M=60	Y=78	K=13		R=126	G=100	B=74
C=58	M=63	Y=75	K=35		R=92	G=76	B=60

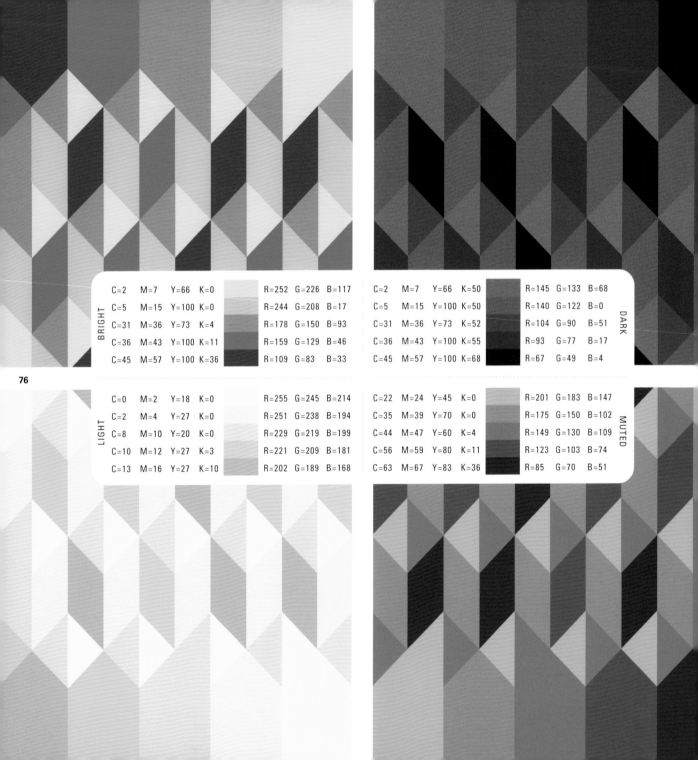

	C	M	Y	K		R	G	B
BRIGHT	C=2	M=7	Y=66	K=0		R=252	G=226	B=117
	C=5	M=15	Y=100	K=0		R=244	G=208	B=17
	C=31	M=36	Y=73	K=4		R=178	G=150	B=93
	C=36	M=43	Y=100	K=11		R=159	G=129	B=46
	C=45	M=57	Y=100	K=36		R=109	G=83	B=33

	C	M	Y	K		R	G	B
DARK	C=2	M=7	Y=66	K=50		R=145	G=133	B=68
	C=5	M=15	Y=100	K=50		R=140	G=122	B=0
	C=31	M=36	Y=73	K=52		R=104	G=90	B=51
	C=36	M=43	Y=100	K=55		R=93	G=77	B=17
	C=45	M=57	Y=100	K=68		R=67	G=49	B=4

	C	M	Y	K		R	G	B
LIGHT	C=0	M=2	Y=18	K=0		R=255	G=245	B=214
	C=2	M=4	Y=27	K=0		R=251	G=238	B=194
	C=8	M=10	Y=20	K=0		R=229	G=219	B=199
	C=10	M=12	Y=27	K=3		R=221	G=209	B=181
	C=13	M=16	Y=27	K=10		R=202	G=189	B=168

	C	M	Y	K		R	G	B
MUTED	C=22	M=24	Y=45	K=0		R=201	G=183	B=147
	C=35	M=39	Y=70	K=0		R=175	G=150	B=102
	C=44	M=47	Y=60	K=4		R=149	G=130	B=109
	C=56	M=59	Y=80	K=11		R=123	G=103	B=74
	C=63	M=67	Y=83	K=36		R=85	G=70	B=51

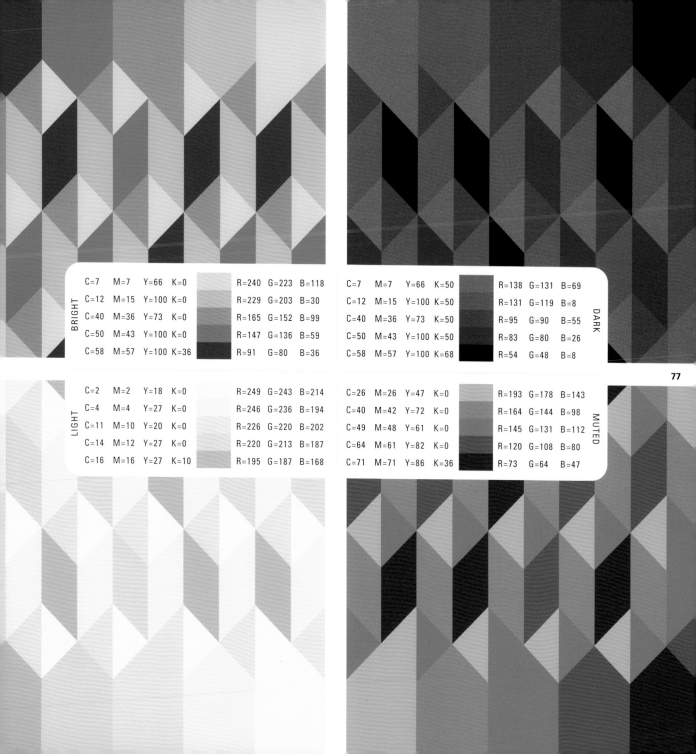

BRIGHT

C=7	M=7	Y=66	K=0		R=240	G=223	B=118
C=12	M=15	Y=100	K=0		R=229	G=203	B=30
C=40	M=36	Y=73	K=0		R=165	G=152	B=99
C=50	M=43	Y=100	K=0		R=147	G=136	B=59
C=58	M=57	Y=100	K=36		R=91	G=80	B=36

DARK

C=7	M=7	Y=66	K=50		R=138	G=131	B=69
C=12	M=15	Y=100	K=50		R=131	G=119	B=8
C=40	M=36	Y=73	K=50		R=95	G=90	B=55
C=50	M=43	Y=100	K=50		R=83	G=80	B=26
C=58	M=57	Y=100	K=68		R=54	G=48	B=8

LIGHT

C=2	M=2	Y=18	K=0		R=249	G=243	B=214
C=4	M=4	Y=27	K=0		R=246	G=236	B=194
C=11	M=10	Y=20	K=0		R=226	G=220	B=202
C=14	M=12	Y=27	K=0		R=220	G=213	B=187
C=16	M=16	Y=27	K=10		R=195	G=187	B=168

MUTED

C=26	M=26	Y=47	K=0		R=193	G=178	B=143
C=40	M=42	Y=72	K=0		R=164	G=144	B=98
C=49	M=48	Y=61	K=0		R=145	G=131	B=112
C=64	M=61	Y=82	K=0		R=120	G=108	B=80
C=71	M=71	Y=86	K=36		R=73	G=64	B=47

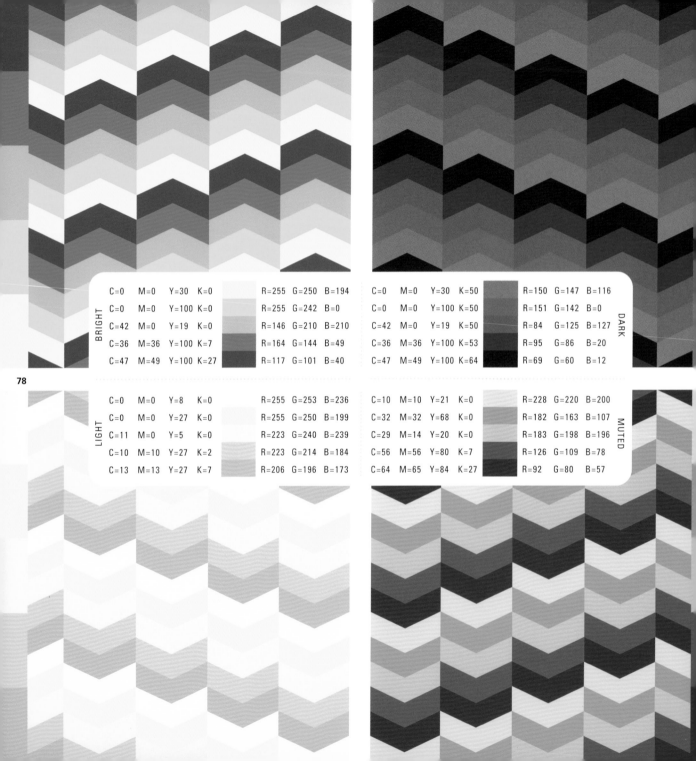

78

BRIGHT

					R	G	B
C=0	M=0	Y=30	K=0		R=255	G=250	B=194
C=0	M=0	Y=100	K=0		R=255	G=242	B=0
C=42	M=0	Y=19	K=0		R=146	G=210	B=210
C=36	M=36	Y=100	K=7		R=164	G=144	B=49
C=47	M=49	Y=100	K=27		R=117	G=101	B=40

DARK

					R	G	B
C=0	M=0	Y=30	K=50		R=150	G=147	B=116
C=0	M=0	Y=100	K=50		R=151	G=142	B=0
C=42	M=0	Y=19	K=50		R=84	G=125	B=127
C=36	M=36	Y=100	K=53		R=95	G=86	B=20
C=47	M=49	Y=100	K=64		R=69	G=60	B=12

LIGHT

					R	G	B
C=0	M=0	Y=8	K=0		R=255	G=253	B=236
C=0	M=0	Y=27	K=0		R=255	G=250	B=199
C=11	M=0	Y=5	K=0		R=223	G=240	B=239
C=10	M=10	Y=27	K=2		R=223	G=214	B=184
C=13	M=13	Y=27	K=7		R=206	G=196	B=173

MUTED

					R	G	B
C=10	M=10	Y=21	K=0		R=228	G=220	B=200
C=32	M=32	Y=68	K=0		R=182	G=163	B=107
C=29	M=14	Y=20	K=0		R=183	G=198	B=196
C=56	M=56	Y=80	K=7		R=126	G=109	B=78
C=64	M=65	Y=84	K=27		R=92	G=80	B=57

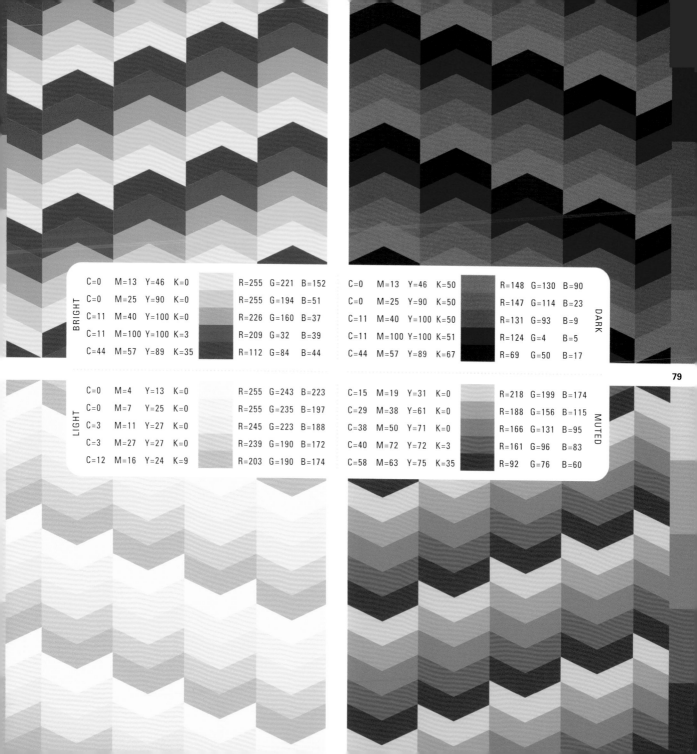

BRIGHT

C=0	M=13	Y=46	K=0		R=255	G=221	B=152
C=0	M=25	Y=90	K=0		R=255	G=194	B=51
C=11	M=40	Y=100	K=0		R=226	G=160	B=37
C=11	M=100	Y=100	K=3		R=209	G=32	B=39
C=44	M=57	Y=89	K=35		R=112	G=84	B=44

DARK

C=0	M=13	Y=46	K=50		R=148	G=130	B=90
C=0	M=25	Y=90	K=50		R=147	G=114	B=23
C=11	M=40	Y=100	K=50		R=131	G=93	B=9
C=11	M=100	Y=100	K=51		R=124	G=4	B=5
C=44	M=57	Y=89	K=67		R=69	G=50	B=17

LIGHT

C=0	M=4	Y=13	K=0		R=255	G=243	B=223
C=0	M=7	Y=25	K=0		R=255	G=235	B=197
C=3	M=11	Y=27	K=0		R=245	G=223	B=188
C=3	M=27	Y=27	K=0		R=239	G=190	B=172
C=12	M=16	Y=24	K=9		R=203	G=190	B=174

MUTED

C=15	M=19	Y=31	K=0		R=218	G=199	B=174
C=29	M=38	Y=61	K=0		R=188	G=156	B=115
C=38	M=50	Y=71	K=0		R=166	G=131	B=95
C=40	M=72	Y=72	K=3		R=161	G=96	B=83
C=58	M=63	Y=75	K=35		R=92	G=76	B=60

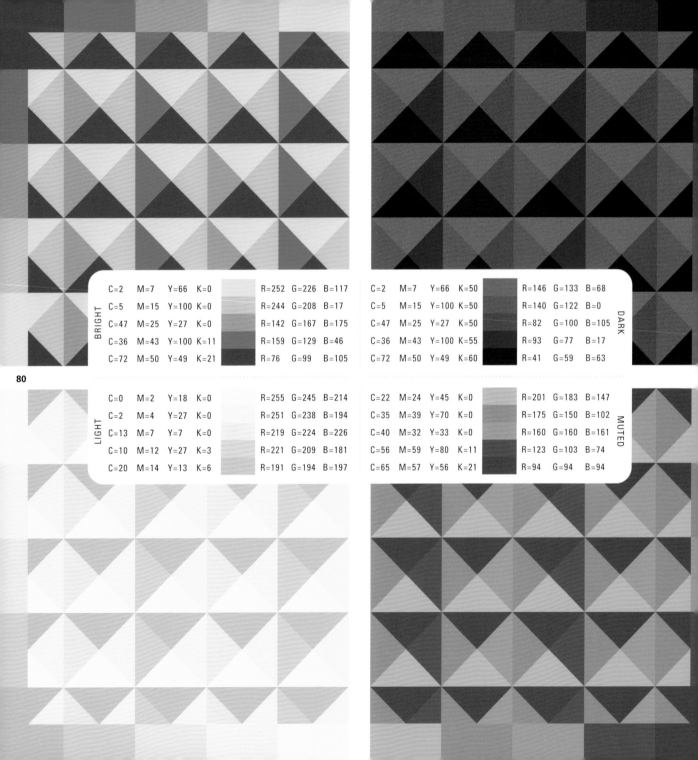

BRIGHT

C=2	M=7	Y=66	K=0		R=252	G=226	B=117
C=5	M=15	Y=100	K=0		R=244	G=208	B=17
C=47	M=25	Y=27	K=0		R=142	G=167	B=175
C=36	M=43	Y=100	K=11		R=159	G=129	B=46
C=72	M=50	Y=49	K=21		R=76	G=99	B=105

DARK

C=2	M=7	Y=66	K=50		R=146	G=133	B=68
C=5	M=15	Y=100	K=50		R=140	G=122	B=0
C=47	M=25	Y=27	K=50		R=82	G=100	B=105
C=36	M=43	Y=100	K=55		R=93	G=77	B=17
C=72	M=50	Y=49	K=60		R=41	G=59	B=63

LIGHT

C=0	M=2	Y=18	K=0		R=255	G=245	B=214
C=2	M=4	Y=27	K=0		R=251	G=238	B=194
C=13	M=7	Y=7	K=0		R=219	G=224	B=226
C=10	M=12	Y=27	K=3		R=221	G=209	B=181
C=20	M=14	Y=13	K=6		R=191	G=194	B=197

MUTED

C=22	M=24	Y=45	K=0		R=201	G=183	B=147
C=35	M=39	Y=70	K=0		R=175	G=150	B=102
C=40	M=32	Y=33	K=0		R=160	G=160	B=161
C=56	M=59	Y=80	K=11		R=123	G=103	B=74
C=65	M=57	Y=56	K=21		R=94	G=94	B=94

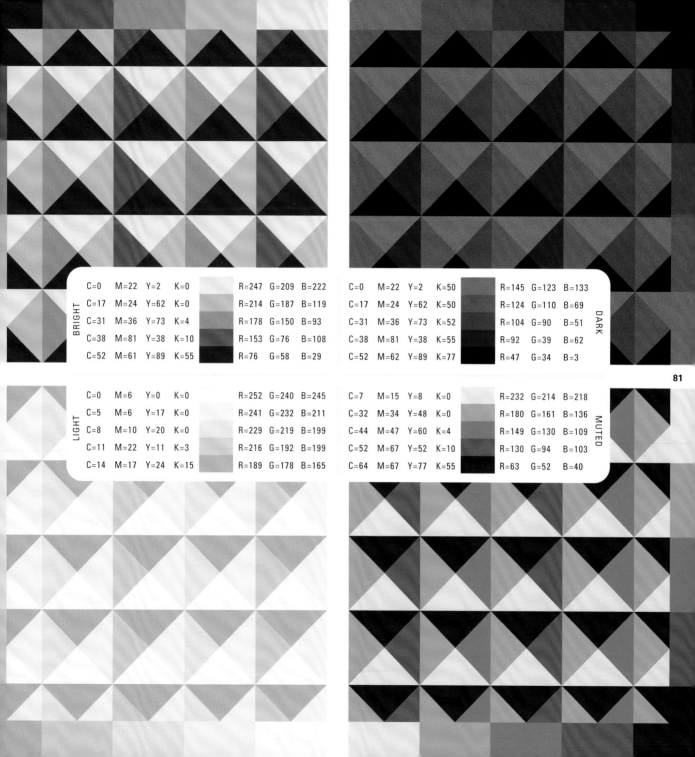

	C=0	M=22	Y=2	K=0		R=247	G=209	B=222
BRIGHT	C=17	M=24	Y=62	K=0		R=214	G=187	B=119
	C=31	M=36	Y=73	K=4		R=178	G=150	B=93
	C=38	M=81	Y=38	K=10		R=153	G=76	B=108
	C=52	M=61	Y=89	K=55		R=76	G=58	B=29

	C=0	M=22	Y=2	K=50		R=145	G=123	B=133
	C=17	M=24	Y=62	K=50		R=124	G=110	B=69
	C=31	M=36	Y=73	K=52		R=104	G=90	B=51
	C=38	M=81	Y=38	K=55		R=92	G=39	B=62
DARK	C=52	M=62	Y=89	K=77		R=47	G=34	B=3

	C=0	M=6	Y=0	K=0		R=252	G=240	B=245
LIGHT	C=5	M=6	Y=17	K=0		R=241	G=232	B=211
	C=8	M=10	Y=20	K=0		R=229	G=219	B=199
	C=11	M=22	Y=11	K=3		R=216	G=192	B=199
	C=14	M=17	Y=24	K=15		R=189	G=178	B=165

	C=7	M=15	Y=8	K=0		R=232	G=214	B=218
	C=32	M=34	Y=48	K=0		R=180	G=161	B=136
	C=44	M=47	Y=60	K=4		R=149	G=130	B=109
	C=52	M=67	Y=52	K=10		R=130	G=94	B=103
MUTED	C=64	M=67	Y=77	K=55		R=63	G=52	B=40

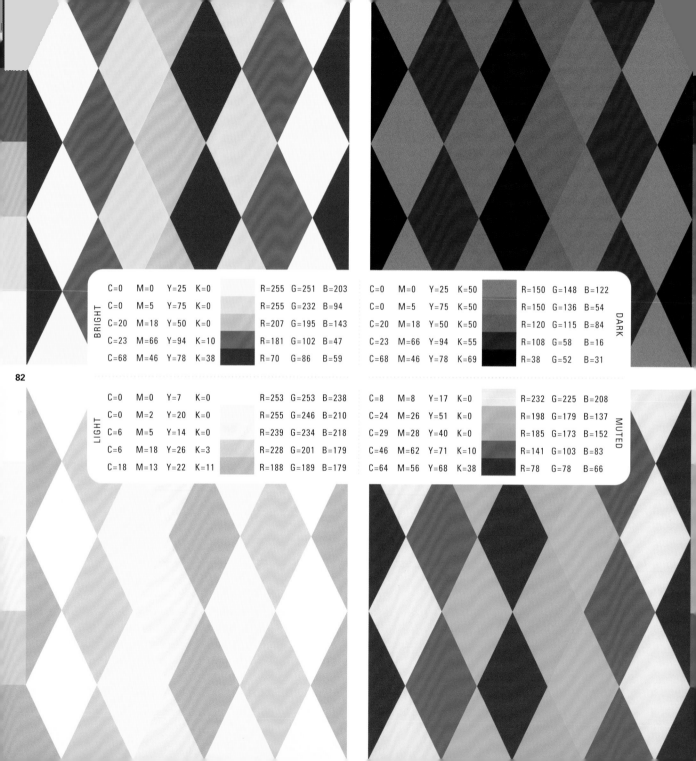

BRIGHT

C=0	M=0	Y=25	K=0		R=255	G=251	B=203
C=0	M=5	Y=75	K=0		R=255	G=232	B=94
C=20	M=18	Y=50	K=0		R=207	G=195	B=143
C=23	M=66	Y=94	K=10		R=181	G=102	B=47
C=68	M=46	Y=78	K=38		R=70	G=86	B=59

DARK

C=0	M=0	Y=25	K=50		R=150	G=148	B=122
C=0	M=5	Y=75	K=50		R=150	G=136	B=54
C=20	M=18	Y=50	K=50		R=120	G=115	B=84
C=23	M=66	Y=94	K=55		R=108	G=58	B=16
C=68	M=46	Y=78	K=69		R=38	G=52	B=31

LIGHT

C=0	M=0	Y=7	K=0		R=253	G=253	B=238
C=0	M=2	Y=20	K=0		R=255	G=246	B=210
C=6	M=5	Y=14	K=0		R=239	G=234	B=218
C=6	M=18	Y=26	K=3		R=228	G=201	B=179
C=18	M=13	Y=22	K=11		R=188	G=189	B=179

MUTED

C=8	M=8	Y=17	K=0		R=232	G=225	B=208
C=24	M=26	Y=51	K=0		R=198	G=179	B=137
C=29	M=28	Y=40	K=0		R=185	G=173	B=152
C=46	M=62	Y=71	K=10		R=141	G=103	B=83
C=64	M=56	Y=68	K=38		R=78	G=78	B=66

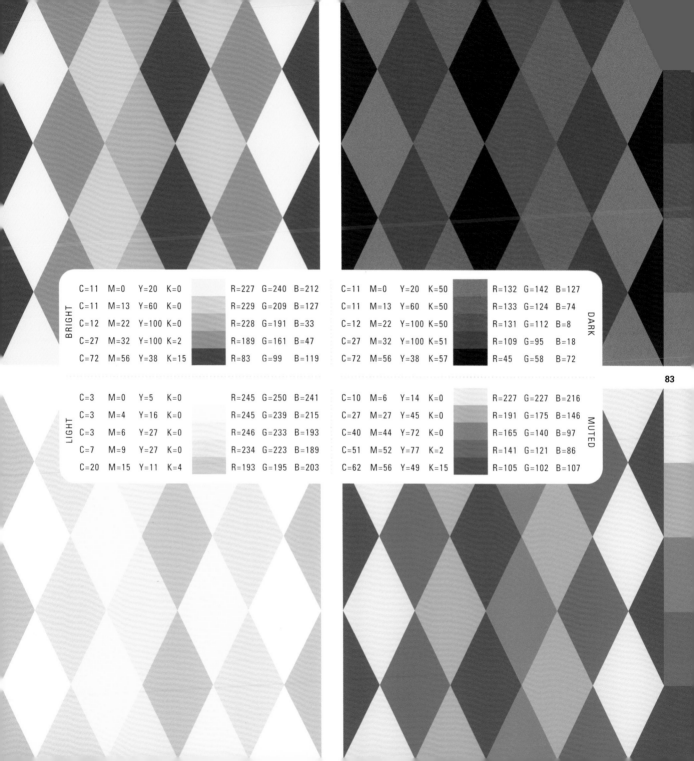

BRIGHT

C=11	M=0	Y=20	K=0	R=227	G=240	B=212
C=11	M=13	Y=60	K=0	R=229	G=209	B=127
C=12	M=22	Y=100	K=0	R=228	G=191	B=33
C=27	M=32	Y=100	K=2	R=189	G=161	B=47
C=72	M=56	Y=38	K=15	R=83	G=99	B=119

DARK

C=11	M=0	Y=20	K=50	R=132	G=142	B=127
C=11	M=13	Y=60	K=50	R=133	G=124	B=74
C=12	M=22	Y=100	K=50	R=131	G=112	B=8
C=27	M=32	Y=100	K=51	R=109	G=95	B=18
C=72	M=56	Y=38	K=57	R=45	G=58	B=72

LIGHT

C=3	M=0	Y=5	K=0	R=245	G=250	B=241
C=3	M=4	Y=16	K=0	R=245	G=239	B=215
C=3	M=6	Y=27	K=0	R=246	G=233	B=193
C=7	M=9	Y=27	K=0	R=234	G=223	B=189
C=20	M=15	Y=11	K=4	R=193	G=195	B=203

MUTED

C=10	M=6	Y=14	K=0	R=227	G=227	B=216
C=27	M=27	Y=45	K=0	R=191	G=175	B=146
C=40	M=44	Y=72	K=0	R=165	G=140	B=97
C=51	M=52	Y=77	K=2	R=141	G=121	B=86
C=62	M=56	Y=49	K=15	R=105	G=102	B=107

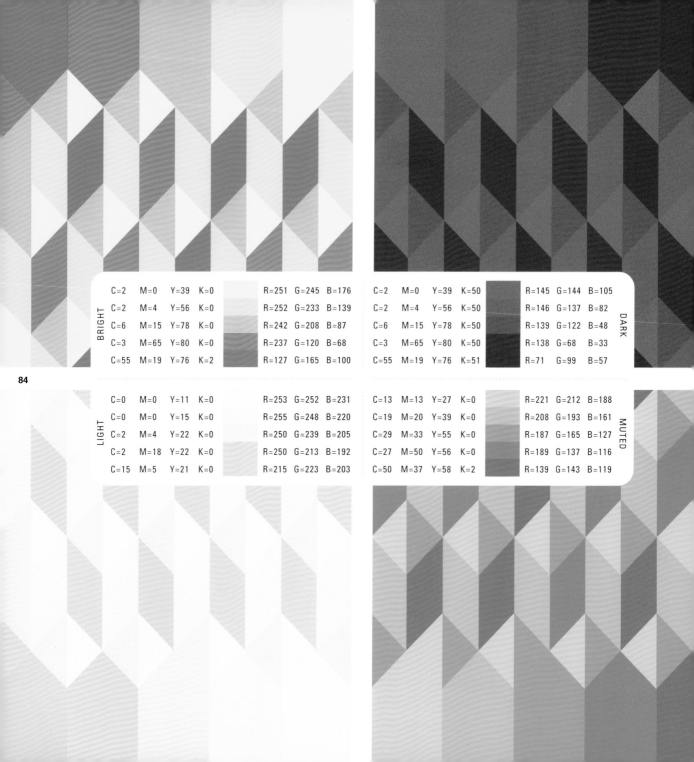

BRIGHT

C=2	M=0	Y=39	K=0		R=251	G=245	B=176
C=2	M=4	Y=56	K=0		R=252	G=233	B=139
C=6	M=15	Y=78	K=0		R=242	G=208	B=87
C=3	M=65	Y=80	K=0		R=237	G=120	B=68
C=55	M=19	Y=76	K=2		R=127	G=165	B=100

DARK

C=2	M=0	Y=39	K=50		R=145	G=144	B=105
C=2	M=4	Y=56	K=50		R=146	G=137	B=82
C=6	M=15	Y=78	K=50		R=139	G=122	B=48
C=3	M=65	Y=80	K=50		R=138	G=68	B=33
C=55	M=19	Y=76	K=51		R=71	G=99	B=57

LIGHT

C=0	M=0	Y=11	K=0		R=253	G=252	B=231
C=0	M=0	Y=15	K=0		R=255	G=248	B=220
C=2	M=4	Y=22	K=0		R=250	G=239	B=205
C=2	M=18	Y=22	K=0		R=250	G=213	B=192
C=15	M=5	Y=21	K=0		R=215	G=223	B=203

MUTED

C=13	M=13	Y=27	K=0		R=221	G=212	B=188
C=19	M=20	Y=39	K=0		R=208	G=193	B=161
C=29	M=33	Y=55	K=0		R=187	G=165	B=127
C=27	M=50	Y=56	K=0		R=189	G=137	B=116
C=50	M=37	Y=58	K=2		R=139	G=143	B=119

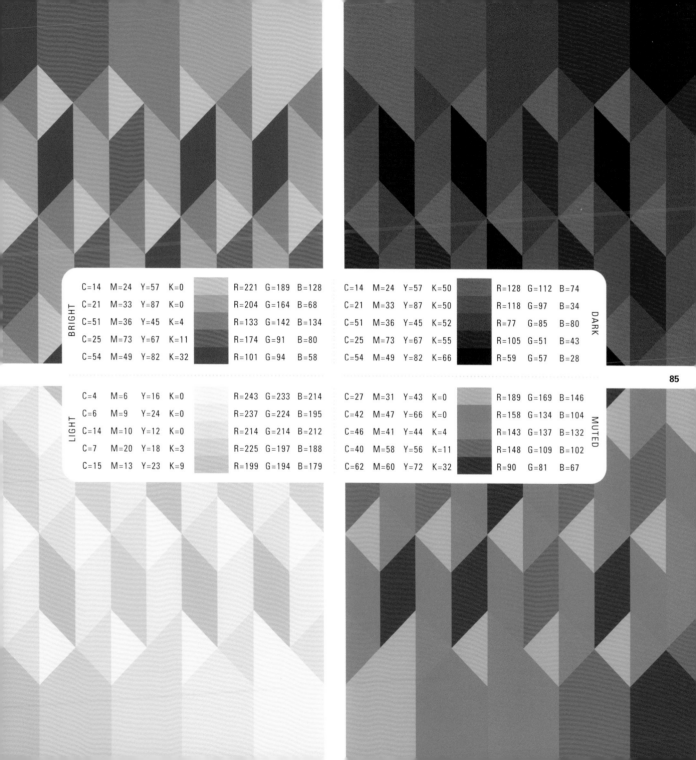

BRIGHT

C=14	M=24	Y=57	K=0	R=221	G=189	B=128
C=21	M=33	Y=87	K=0	R=204	G=164	B=68
C=51	M=36	Y=45	K=4	R=133	G=142	B=134
C=25	M=73	Y=67	K=11	R=174	G=91	B=80
C=54	M=49	Y=82	K=32	R=101	G=94	B=58

DARK

C=14	M=24	Y=57	K=50	R=128	G=112	B=74
C=21	M=33	Y=87	K=50	R=118	G=97	B=34
C=51	M=36	Y=45	K=52	R=77	G=85	B=80
C=25	M=73	Y=67	K=55	R=105	G=51	B=43
C=54	M=49	Y=82	K=66	R=59	G=57	B=28

LIGHT

C=4	M=6	Y=16	K=0	R=243	G=233	B=214
C=6	M=9	Y=24	K=0	R=237	G=224	B=195
C=14	M=10	Y=12	K=0	R=214	G=214	B=212
C=7	M=20	Y=18	K=3	R=225	G=197	B=188
C=15	M=13	Y=23	K=9	R=199	G=194	B=179

MUTED

C=27	M=31	Y=43	K=0	R=189	G=169	B=146
C=42	M=47	Y=66	K=0	R=158	G=134	B=104
C=46	M=41	Y=44	K=4	R=143	G=137	B=132
C=40	M=58	Y=56	K=11	R=148	G=109	B=102
C=62	M=60	Y=72	K=32	R=90	G=81	B=67

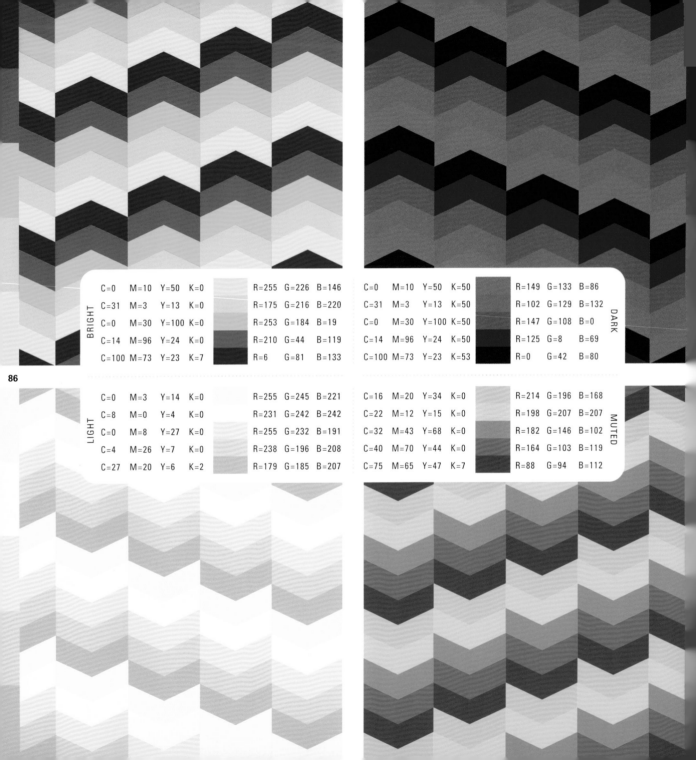

					R	G	B
BRIGHT	C=0	M=10	Y=50	K=0	R=255	G=226	B=146
	C=31	M=3	Y=13	K=0	R=175	G=216	B=220
	C=0	M=30	Y=100	K=0	R=253	G=184	B=19
	C=14	M=96	Y=24	K=0	R=210	G=44	B=119
	C=100	M=73	Y=23	K=7	R=6	G=81	B=133

					R	G	B
DARK	C=0	M=10	Y=50	K=50	R=149	G=133	B=86
	C=31	M=3	Y=13	K=50	R=102	G=129	B=132
	C=0	M=30	Y=100	K=50	R=147	G=108	B=0
	C=14	M=96	Y=24	K=50	R=125	G=8	B=69
	C=100	M=73	Y=23	K=53	R=0	G=42	B=80

					R	G	B
LIGHT	C=0	M=3	Y=14	K=0	R=255	G=245	B=221
	C=8	M=0	Y=4	K=0	R=231	G=242	B=242
	C=0	M=8	Y=27	K=0	R=255	G=232	B=191
	C=4	M=26	Y=7	K=0	R=238	G=196	B=208
	C=27	M=20	Y=6	K=2	R=179	G=185	B=207

					R	G	B
MUTED	C=16	M=20	Y=34	K=0	R=214	G=196	B=168
	C=22	M=12	Y=15	K=0	R=198	G=207	B=207
	C=32	M=43	Y=68	K=0	R=182	G=146	B=102
	C=40	M=70	Y=44	K=0	R=164	G=103	B=119
	C=75	M=65	Y=47	K=7	R=88	G=94	B=112

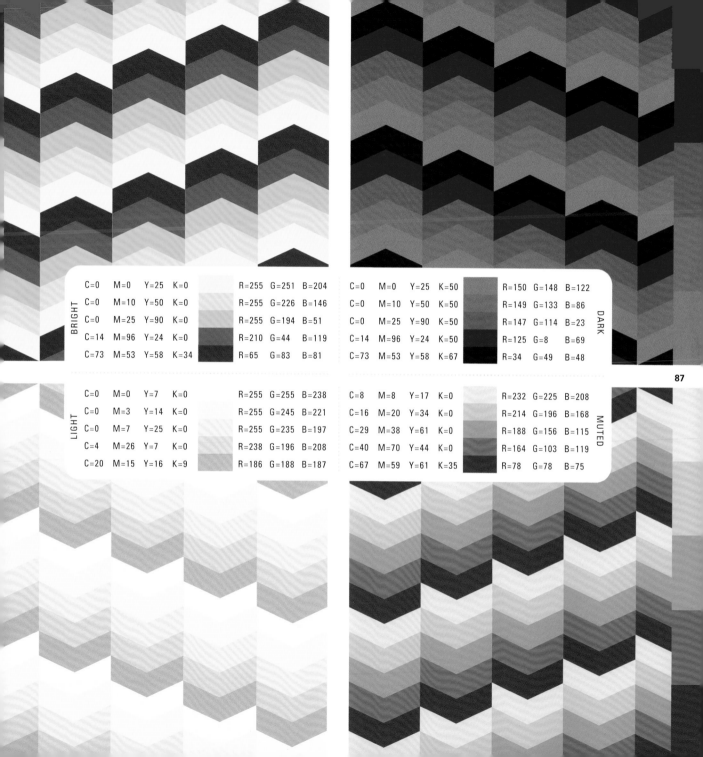

BRIGHT

C=0	M=0	Y=25	K=0		R=255	G=251	B=204
C=0	M=10	Y=50	K=0		R=255	G=226	B=146
C=0	M=25	Y=90	K=0		R=255	G=194	B=51
C=14	M=96	Y=24	K=0		R=210	G=44	B=119
C=73	M=53	Y=58	K=34		R=65	G=83	B=81

DARK

C=0	M=0	Y=25	K=50		R=150	G=148	B=122
C=0	M=10	Y=50	K=50		R=149	G=133	B=86
C=0	M=25	Y=90	K=50		R=147	G=114	B=23
C=14	M=96	Y=24	K=50		R=125	G=8	B=69
C=73	M=53	Y=58	K=67		R=34	G=49	B=48

LIGHT

C=0	M=0	Y=7	K=0		R=255	G=255	B=238
C=0	M=3	Y=14	K=0		R=255	G=245	B=221
C=0	M=7	Y=25	K=0		R=255	G=235	B=197
C=4	M=26	Y=7	K=0		R=238	G=196	B=208
C=20	M=15	Y=16	K=9		R=186	G=188	B=187

MUTED

C=8	M=8	Y=17	K=0		R=232	G=225	B=208
C=16	M=20	Y=34	K=0		R=214	G=196	B=168
C=29	M=38	Y=61	K=0		R=188	G=156	B=115
C=40	M=70	Y=44	K=0		R=164	G=103	B=119
C=67	M=59	Y=61	K=35		R=78	G=78	B=75

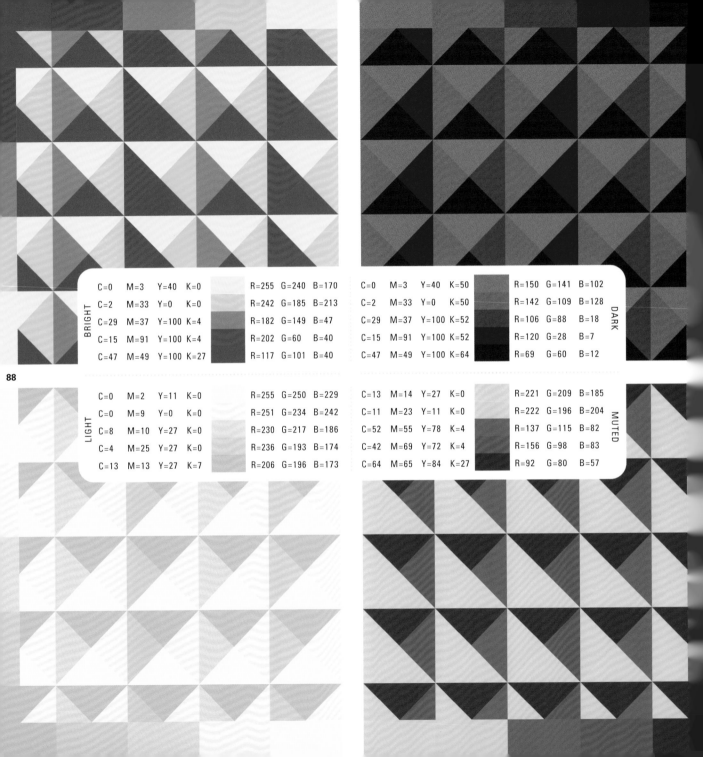

88

	C	M	Y	K		R	G	B
BRIGHT	C=0	M=3	Y=40	K=0		R=255	G=240	B=170
	C=2	M=33	Y=0	K=0		R=242	G=185	B=213
	C=29	M=37	Y=100	K=4		R=182	G=149	B=47
	C=15	M=91	Y=100	K=4		R=202	G=60	B=40
	C=47	M=49	Y=100	K=27		R=117	G=101	B=40

	C	M	Y	K		R	G	B
DARK	C=0	M=3	Y=40	K=50		R=150	G=141	B=102
	C=2	M=33	Y=0	K=50		R=142	G=109	B=128
	C=29	M=37	Y=100	K=52		R=106	G=88	B=18
	C=15	M=91	Y=100	K=52		R=120	G=28	B=7
	C=47	M=49	Y=100	K=64		R=69	G=60	B=12

	C	M	Y	K		R	G	B
LIGHT	C=0	M=2	Y=11	K=0		R=255	G=250	B=229
	C=0	M=9	Y=0	K=0		R=251	G=234	B=242
	C=8	M=10	Y=27	K=0		R=230	G=217	B=186
	C=4	M=25	Y=27	K=0		R=236	G=193	B=174
	C=13	M=13	Y=27	K=7		R=206	G=196	B=173

	C	M	Y	K		R	G	B
MUTED	C=13	M=14	Y=27	K=0		R=221	G=209	B=185
	C=11	M=23	Y=11	K=0		R=222	G=196	B=204
	C=52	M=55	Y=78	K=4		R=137	G=115	B=82
	C=42	M=69	Y=72	K=4		R=156	G=98	B=83
	C=64	M=65	Y=84	K=27		R=92	G=80	B=57

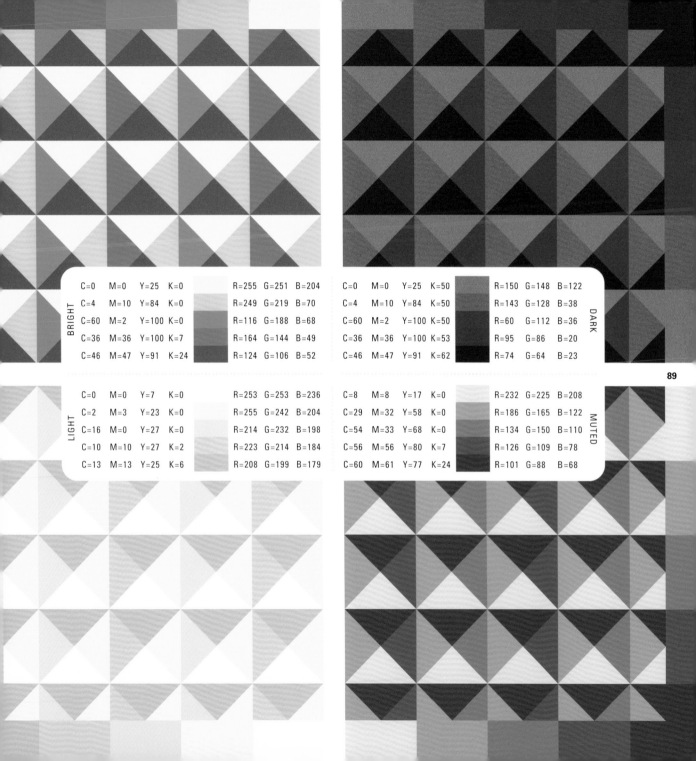

BRIGHT

C=0	M=0	Y=25	K=0		R=255	G=251	B=204
C=4	M=10	Y=84	K=0		R=249	G=219	B=70
C=60	M=2	Y=100	K=0		R=116	G=188	B=68
C=36	M=36	Y=100	K=7		R=164	G=144	B=49
C=46	M=47	Y=91	K=24		R=124	G=106	B=52

DARK

C=0	M=0	Y=25	K=50		R=150	G=148	B=122
C=4	M=10	Y=84	K=50		R=143	G=128	B=38
C=60	M=2	Y=100	K=50		R=60	G=112	B=36
C=36	M=36	Y=100	K=53		R=95	G=86	B=20
C=46	M=47	Y=91	K=62		R=74	G=64	B=23

LIGHT

C=0	M=0	Y=7	K=0		R=253	G=253	B=236
C=2	M=3	Y=23	K=0		R=255	G=242	B=204
C=16	M=0	Y=27	K=0		R=214	G=232	B=198
C=10	M=10	Y=27	K=2		R=223	G=214	B=184
C=13	M=13	Y=25	K=6		R=208	G=199	B=179

MUTED

C=8	M=8	Y=17	K=0		R=232	G=225	B=208
C=29	M=32	Y=58	K=0		R=186	G=165	B=122
C=54	M=33	Y=68	K=0		R=134	G=150	B=110
C=56	M=56	Y=80	K=7		R=126	G=109	B=78
C=60	M=61	Y=77	K=24		R=101	G=88	B=68

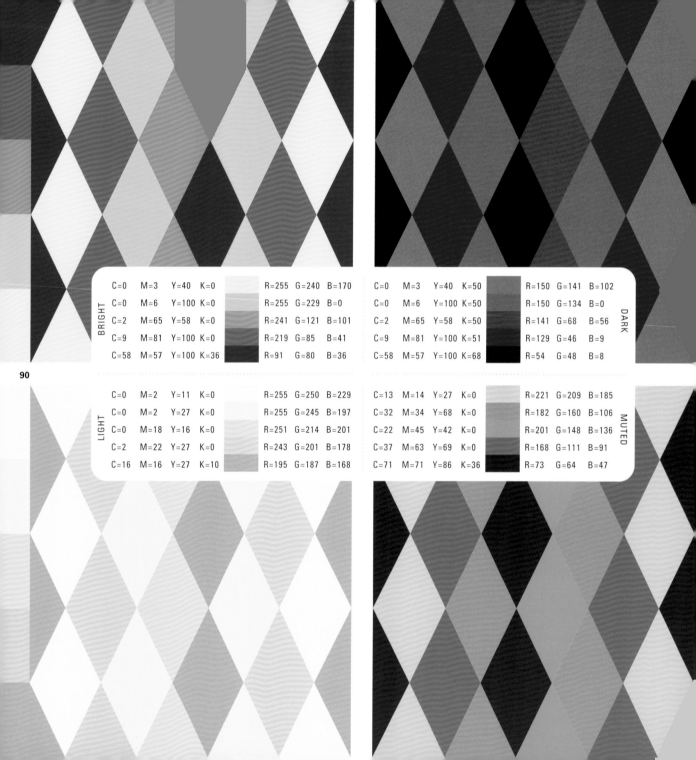

BRIGHT				
C=0	M=3	Y=40	K=0	R=255 G=240 B=170
C=0	M=6	Y=100	K=0	R=255 G=229 B=0
C=2	M=65	Y=58	K=0	R=241 G=121 B=101
C=9	M=81	Y=100	K=0	R=219 G=85 B=41
C=58	M=57	Y=100	K=36	R=91 G=80 B=36

DARK				
C=0	M=3	Y=40	K=50	R=150 G=141 B=102
C=0	M=6	Y=100	K=50	R=150 G=134 B=0
C=2	M=65	Y=58	K=50	R=141 G=68 B=56
C=9	M=81	Y=100	K=51	R=129 G=46 B=9
C=58	M=57	Y=100	K=68	R=54 G=48 B=8

LIGHT				
C=0	M=2	Y=11	K=0	R=255 G=250 B=229
C=0	M=2	Y=27	K=0	R=255 G=245 B=197
C=0	M=18	Y=16	K=0	R=251 G=214 B=201
C=2	M=22	Y=27	K=0	R=243 G=201 B=178
C=16	M=16	Y=27	K=10	R=195 G=187 B=168

MUTED				
C=13	M=14	Y=27	K=0	R=221 G=209 B=185
C=32	M=34	Y=68	K=0	R=182 G=160 B=106
C=22	M=45	Y=42	K=0	R=201 G=148 B=136
C=37	M=63	Y=69	K=0	R=168 G=111 B=91
C=71	M=71	Y=86	K=36	R=73 G=64 B=47

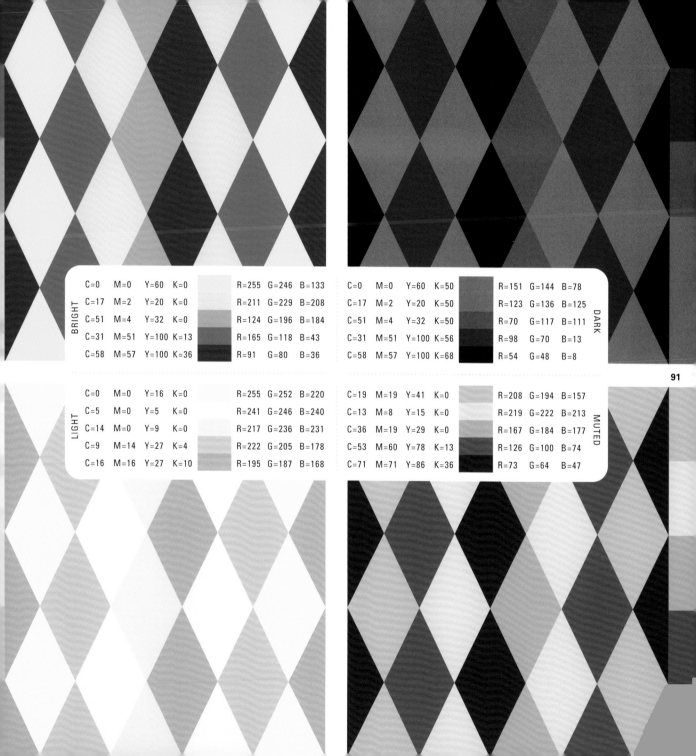

BRIGHT

C=0	M=0	Y=60	K=0		R=255	G=246	B=133
C=17	M=2	Y=20	K=0		R=211	G=229	B=208
C=51	M=4	Y=32	K=0		R=124	G=196	B=184
C=31	M=51	Y=100	K=13		R=165	G=118	B=43
C=58	M=57	Y=100	K=36		R=91	G=80	B=36

DARK

C=0	M=0	Y=60	K=50		R=151	G=144	B=78
C=17	M=2	Y=20	K=50		R=123	G=136	B=125
C=51	M=4	Y=32	K=50		R=70	G=117	B=111
C=31	M=51	Y=100	K=56		R=98	G=70	B=13
C=58	M=57	Y=100	K=68		R=54	G=48	B=8

LIGHT

C=0	M=0	Y=16	K=0		R=255	G=252	B=220
C=5	M=0	Y=5	K=0		R=241	G=246	B=240
C=14	M=0	Y=9	K=0		R=217	G=236	B=231
C=9	M=14	Y=27	K=4		R=222	G=205	B=178
C=16	M=16	Y=27	K=10		R=195	G=187	B=168

MUTED

C=19	M=19	Y=41	K=0		R=208	G=194	B=157
C=13	M=8	Y=15	K=0		R=219	G=222	B=213
C=36	M=19	Y=29	K=0		R=167	G=184	B=177
C=53	M=60	Y=78	K=13		R=126	G=100	B=74
C=71	M=71	Y=86	K=36		R=73	G=64	B=47

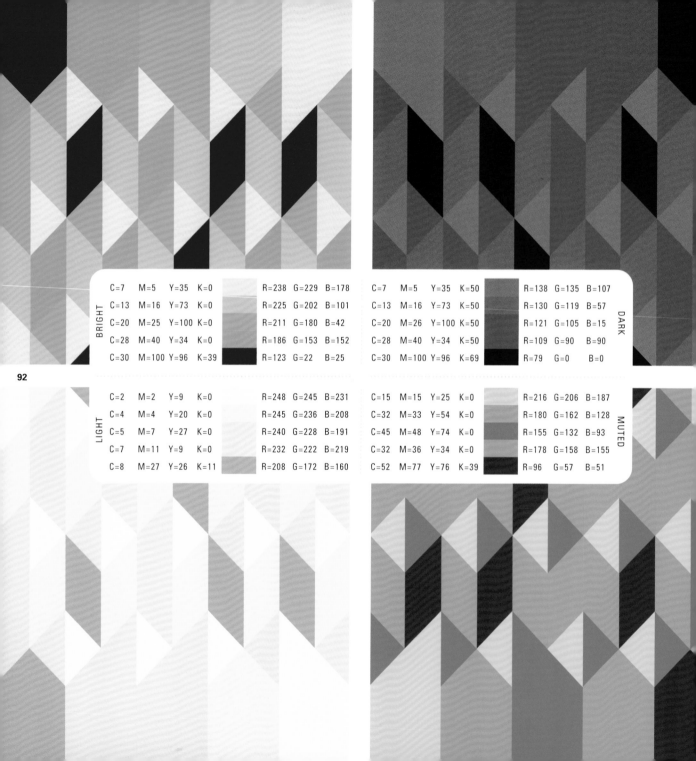

BRIGHT	C=7	M=5	Y=35	K=0		R=238	G=229	B=178
	C=13	M=16	Y=73	K=0		R=225	G=202	B=101
	C=20	M=25	Y=100	K=0		R=211	G=180	B=42
	C=28	M=40	Y=34	K=0		R=186	G=153	B=152
	C=30	M=100	Y=96	K=39		R=123	G=22	B=25

DARK	C=7	M=5	Y=35	K=50		R=138	G=135	B=107
	C=13	M=16	Y=73	K=50		R=130	G=119	B=57
	C=20	M=26	Y=100	K=50		R=121	G=105	B=15
	C=28	M=40	Y=34	K=50		R=109	G=90	B=90
	C=30	M=100	Y=96	K=69		R=79	G=0	B=0

LIGHT	C=2	M=2	Y=9	K=0		R=248	G=245	B=231
	C=4	M=4	Y=20	K=0		R=245	G=236	B=208
	C=5	M=7	Y=27	K=0		R=240	G=228	B=191
	C=7	M=11	Y=9	K=0		R=232	G=222	B=219
	C=8	M=27	Y=26	K=11		R=208	G=172	B=160

MUTED	C=15	M=15	Y=25	K=0		R=216	G=206	B=187
	C=32	M=33	Y=54	K=0		R=180	G=162	B=128
	C=45	M=48	Y=74	K=0		R=155	G=132	B=93
	C=32	M=36	Y=34	K=0		R=178	G=158	B=155
	C=52	M=77	Y=76	K=39		R=96	G=57	B=51

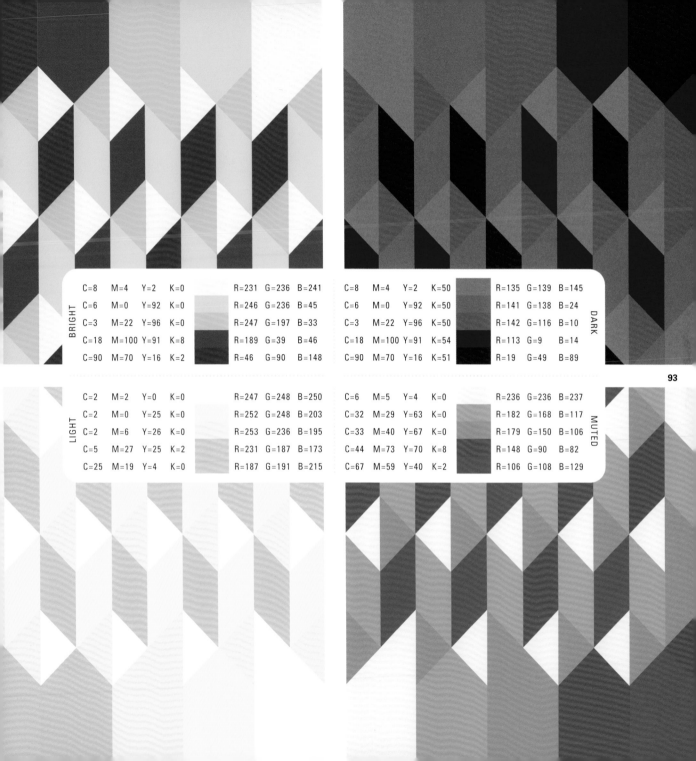

BRIGHT							
C=8	M=4	Y=2	K=0		R=231	G=236	B=241
C=6	M=0	Y=92	K=0		R=246	G=236	B=45
C=3	M=22	Y=96	K=0		R=247	G=197	B=33
C=18	M=100	Y=91	K=8		R=189	G=39	B=46
C=90	M=70	Y=16	K=2		R=46	G=90	B=148

DARK							
C=8	M=4	Y=2	K=50		R=135	G=139	B=145
C=6	M=0	Y=92	K=50		R=141	G=138	B=24
C=3	M=22	Y=96	K=50		R=142	G=116	B=10
C=18	M=100	Y=91	K=54		R=113	G=9	B=14
C=90	M=70	Y=16	K=51		R=19	G=49	B=89

LIGHT							
C=2	M=2	Y=0	K=0		R=247	G=248	B=250
C=2	M=0	Y=25	K=0		R=252	G=248	B=203
C=2	M=6	Y=26	K=0		R=253	G=236	B=195
C=5	M=27	Y=25	K=2		R=231	G=187	B=173
C=25	M=19	Y=4	K=0		R=187	G=191	B=215

MUTED							
C=6	M=5	Y=4	K=0		R=236	G=236	B=237
C=32	M=29	Y=63	K=0		R=182	G=168	B=117
C=33	M=40	Y=67	K=0		R=179	G=150	B=106
C=44	M=73	Y=70	K=8		R=148	G=90	B=82
C=67	M=59	Y=40	K=2		R=106	G=108	B=129

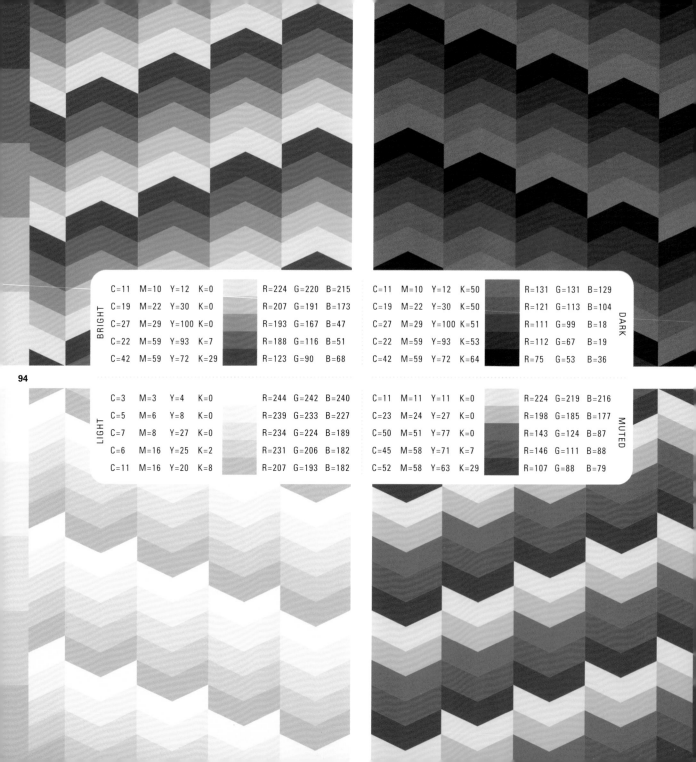

BRIGHT

C=11	M=10	Y=12	K=0		R=224	G=220	B=215
C=19	M=22	Y=30	K=0		R=207	G=191	B=173
C=27	M=29	Y=100	K=0		R=193	G=167	B=47
C=22	M=59	Y=93	K=7		R=188	G=116	B=51
C=42	M=59	Y=72	K=29		R=123	G=90	B=68

DARK

C=11	M=10	Y=12	K=50		R=131	G=131	B=129
C=19	M=22	Y=30	K=50		R=121	G=113	B=104
C=27	M=29	Y=100	K=51		R=111	G=99	B=18
C=22	M=59	Y=93	K=53		R=112	G=67	B=19
C=42	M=59	Y=72	K=64		R=75	G=53	B=36

LIGHT

C=3	M=3	Y=4	K=0		R=244	G=242	B=240
C=5	M=6	Y=8	K=0		R=239	G=233	B=227
C=7	M=8	Y=27	K=0		R=234	G=224	B=189
C=6	M=16	Y=25	K=2		R=231	G=206	B=182
C=11	M=16	Y=20	K=8		R=207	G=193	B=182

MUTED

C=11	M=11	Y=11	K=0		R=224	G=219	B=216
C=23	M=24	Y=27	K=0		R=198	G=185	B=177
C=50	M=51	Y=77	K=0		R=143	G=124	B=87
C=45	M=58	Y=71	K=7		R=146	G=111	B=88
C=52	M=58	Y=63	K=29		R=107	G=88	B=79

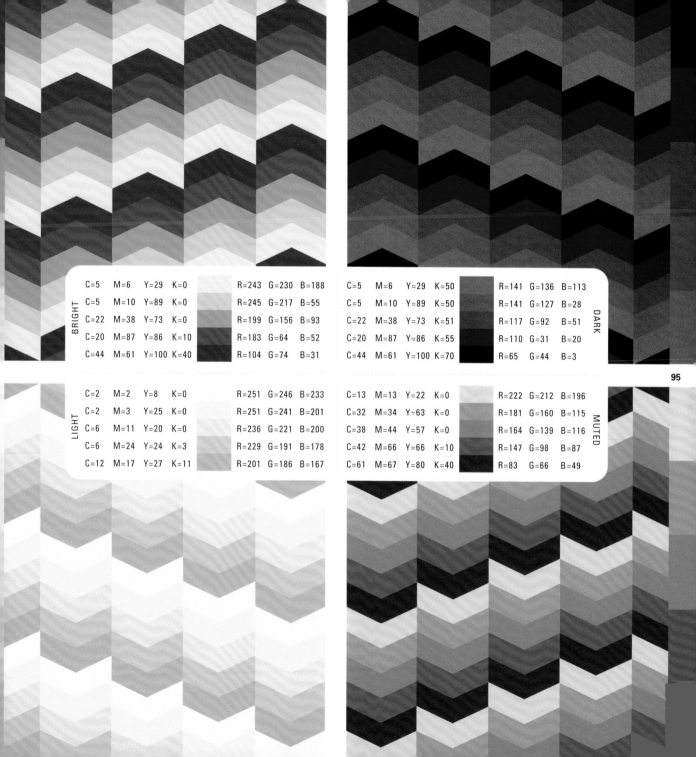

BRIGHT					R=243	G=230	B=188
C=5	M=6	Y=29	K=0		R=245	G=217	B=55
C=5	M=10	Y=89	K=0		R=199	G=156	B=93
C=22	M=38	Y=73	K=0		R=183	G=64	B=52
C=20	M=87	Y=86	K=10		R=104	G=74	B=31
C=44	M=61	Y=100	K=40				

DARK					R=141	G=136	B=113
C=5	M=6	Y=29	K=50		R=141	G=127	B=28
C=5	M=10	Y=89	K=50		R=117	G=92	B=51
C=22	M=38	Y=73	K=51		R=110	G=31	B=20
C=20	M=87	Y=86	K=55		R=65	G=44	B=3
C=44	M=61	Y=100	K=70				

LIGHT					R=251	G=246	B=233
C=2	M=2	Y=8	K=0		R=251	G=241	B=201
C=2	M=3	Y=25	K=0		R=236	G=221	B=200
C=6	M=11	Y=20	K=0		R=229	G=191	B=178
C=6	M=24	Y=24	K=3		R=201	G=186	B=167
C=12	M=17	Y=27	K=11				

MUTED					R=222	G=212	B=196
C=13	M=13	Y=22	K=0		R=181	G=160	B=115
C=32	M=34	Y=63	K=0		R=164	G=139	B=116
C=38	M=44	Y=57	K=0		R=147	G=98	B=87
C=42	M=66	Y=66	K=10		R=83	G=66	B=49
C=61	M=67	Y=80	K=40				

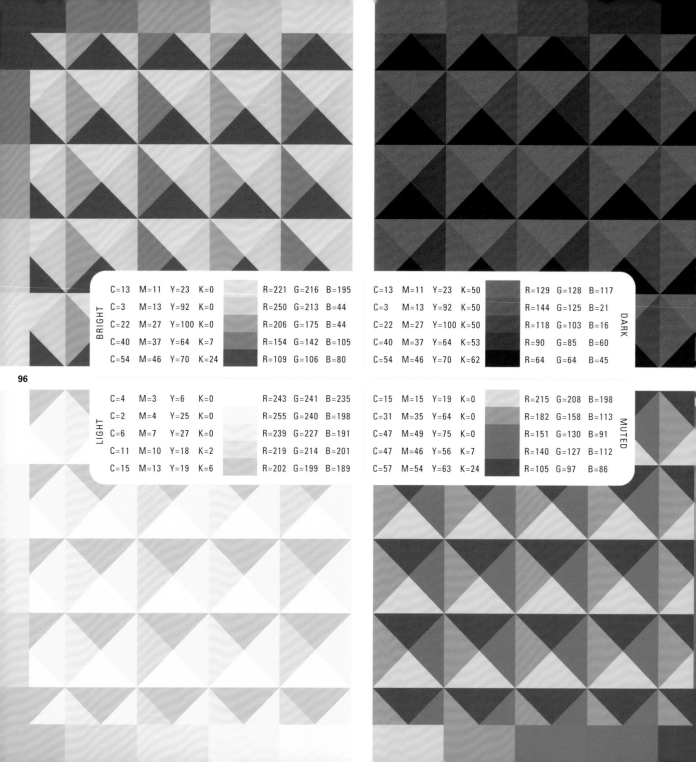

	C=13	M=11	Y=23	K=0		R=221	G=216	B=195
BRIGHT	C=3	M=13	Y=92	K=0		R=250	G=213	B=44
	C=22	M=27	Y=100	K=0		R=206	G=175	B=44
	C=40	M=37	Y=64	K=7		R=154	G=142	B=105
	C=54	M=46	Y=70	K=24		R=109	G=106	B=80

	C=13	M=11	Y=23	K=50		R=129	G=128	B=117
	C=3	M=13	Y=92	K=50		R=144	G=125	B=21
	C=22	M=27	Y=100	K=50		R=118	G=103	B=16
	C=40	M=37	Y=64	K=53		R=90	G=85	B=60
DARK	C=54	M=46	Y=70	K=62		R=64	G=64	B=45

	C=4	M=3	Y=6	K=0		R=243	G=241	B=235
LIGHT	C=2	M=4	Y=25	K=0		R=255	G=240	B=198
	C=6	M=7	Y=27	K=0		R=239	G=227	B=191
	C=11	M=10	Y=18	K=2		R=219	G=214	B=201
	C=15	M=13	Y=19	K=6		R=202	G=199	B=189

	C=15	M=15	Y=19	K=0		R=215	G=208	B=198
	C=31	M=35	Y=64	K=0		R=182	G=158	B=113
	C=47	M=49	Y=75	K=0		R=151	G=130	B=91
	C=47	M=46	Y=56	K=7		R=140	G=127	B=112
MUTED	C=57	M=54	Y=63	K=24		R=105	G=97	B=86

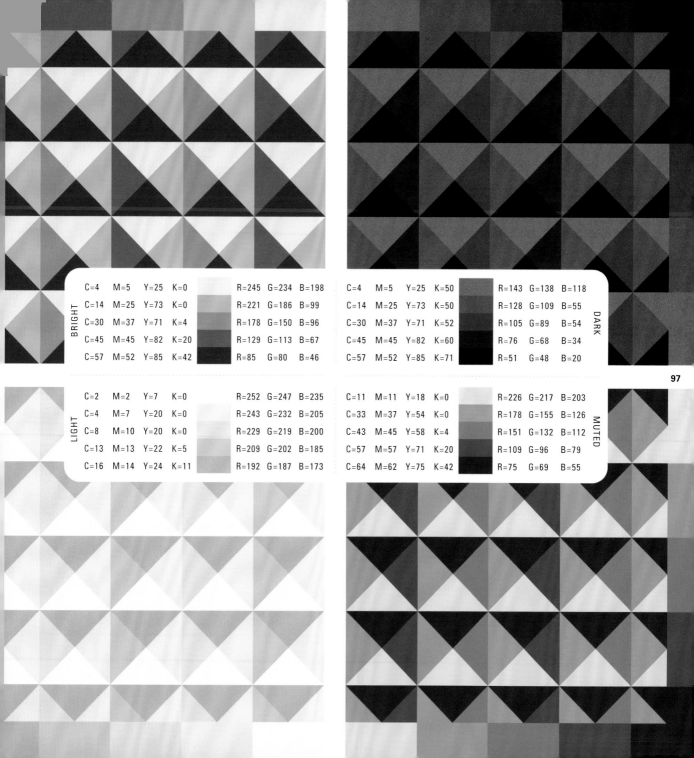

BRIGHT						
C=4	M=5	Y=25	K=0	R=245	G=234	B=198
C=14	M=25	Y=73	K=0	R=221	G=186	B=99
C=30	M=37	Y=71	K=4	R=178	G=150	B=96
C=45	M=45	Y=82	K=20	R=129	G=113	B=67
C=57	M=52	Y=85	K=42	R=85	G=80	B=46

DARK

C=4	M=5	Y=25	K=50	R=143	G=138	B=118
C=14	M=25	Y=73	K=50	R=128	G=109	B=55
C=30	M=37	Y=71	K=52	R=105	G=89	B=54
C=45	M=45	Y=82	K=60	R=76	G=68	B=34
C=57	M=52	Y=85	K=71	R=51	G=48	B=20

LIGHT

C=2	M=2	Y=7	K=0	R=252	G=247	B=235
C=4	M=7	Y=20	K=0	R=243	G=232	B=205
C=8	M=10	Y=20	K=0	R=229	G=219	B=200
C=13	M=13	Y=22	K=5	R=209	G=202	B=185
C=16	M=14	Y=24	K=11	R=192	G=187	B=173

MUTED

C=11	M=11	Y=18	K=0	R=226	G=217	B=203
C=33	M=37	Y=54	K=0	R=178	G=155	B=126
C=43	M=45	Y=58	K=4	R=151	G=132	B=112
C=57	M=57	Y=71	K=20	R=109	G=96	B=79
C=64	M=62	Y=75	K=42	R=75	G=69	B=55

BRIGHT

C=3	M=2	Y=9	K=0		R=246	G=243	B=230
C=28	M=22	Y=35	K=0		R=187	G=185	B=165
C=31	M=33	Y=69	K=2		R=180	G=159	B=104
C=62	M=46	Y=51	K=17		R=100	G=112	B=109
C=73	M=53	Y=58	K=35		R=65	G=83	B=81

DARK

C=3	M=2	Y=9	K=50		R=143	G=143	B=138
C=28	M=22	Y=35	K=50		R=109	G=110	B=98
C=31	M=33	Y=69	K=51		R=105	G=95	B=59
C=62	M=46	Y=51	K=58		R=57	G=67	B=65
C=73	M=53	Y=58	K=67		R=34	G=49	B=48

LIGHT

C=2	M=2	Y=4	K=0		R=252	G=251	B=246
C=7	M=6	Y=10	K=0		R=233	G=231	B=224
C=8	M=9	Y=19	K=0		R=231	G=222	B=204
C=17	M=13	Y=14	K=5		R=199	G=200	B=200
C=20	M=15	Y=16	K=9		R=186	G=188	B=187

MUTED

C=5	M=4	Y=7	K=0		R=240	G=237	B=231
C=28	M=26	Y=31	K=0		R=186	G=178	B=169
C=43	M=44	Y=56	K=2		R=154	G=137	B=117
C=57	M=51	Y=53	K=16		R=111	G=107	B=104
C=67	M=59	Y=61	K=34		R=78	G=78	B=75

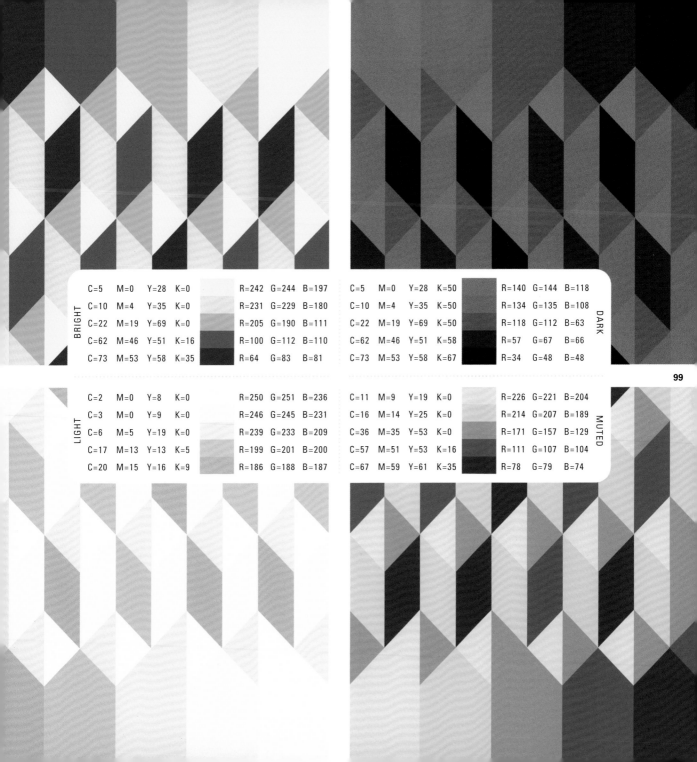

BRIGHT

C=5	M=0	Y=28	K=0		R=242	G=244	B=197
C=10	M=4	Y=35	K=0		R=231	G=229	B=180
C=22	M=19	Y=69	K=0		R=205	G=190	B=111
C=62	M=46	Y=51	K=16		R=100	G=112	B=110
C=73	M=53	Y=58	K=35		R=64	G=83	B=81

DARK

C=5	M=0	Y=28	K=50		R=140	G=144	B=118
C=10	M=4	Y=35	K=50		R=134	G=135	B=108
C=22	M=19	Y=69	K=50		R=118	G=112	B=63
C=62	M=46	Y=51	K=58		R=57	G=67	B=66
C=73	M=53	Y=58	K=67		R=34	G=48	B=48

LIGHT

C=2	M=0	Y=8	K=0		R=250	G=251	B=236
C=3	M=0	Y=9	K=0		R=246	G=245	B=231
C=6	M=5	Y=19	K=0		R=239	G=233	B=209
C=17	M=13	Y=13	K=5		R=199	G=201	B=200
C=20	M=15	Y=16	K=9		R=186	G=188	B=187

MUTED

C=11	M=9	Y=19	K=0		R=226	G=221	B=204
C=16	M=14	Y=25	K=0		R=214	G=207	B=189
C=36	M=35	Y=53	K=0		R=171	G=157	B=129
C=57	M=51	Y=53	K=16		R=111	G=107	B=104
C=67	M=59	Y=61	K=35		R=78	G=79	B=74

CHAPTER 2
MIXED PALETTES

440 color schemes made from
a wide variety of hues.

Reminders:

• Each of this book's palettes includes five colors. Feel free to use all five colors for a project, or to go with just one, two, three, or four.

• Any of this book's palettes can be attractively expanded into more colors by including monochromatic relatives of one or more of its hues (see page 10 for more about monochromatic color schemes).

• Substitutions between the colors of each page's quad-set of palettes is permissible. Just be certain of the value differences between the hues you're combining (see page 5–7 for more about values and color substitutions).

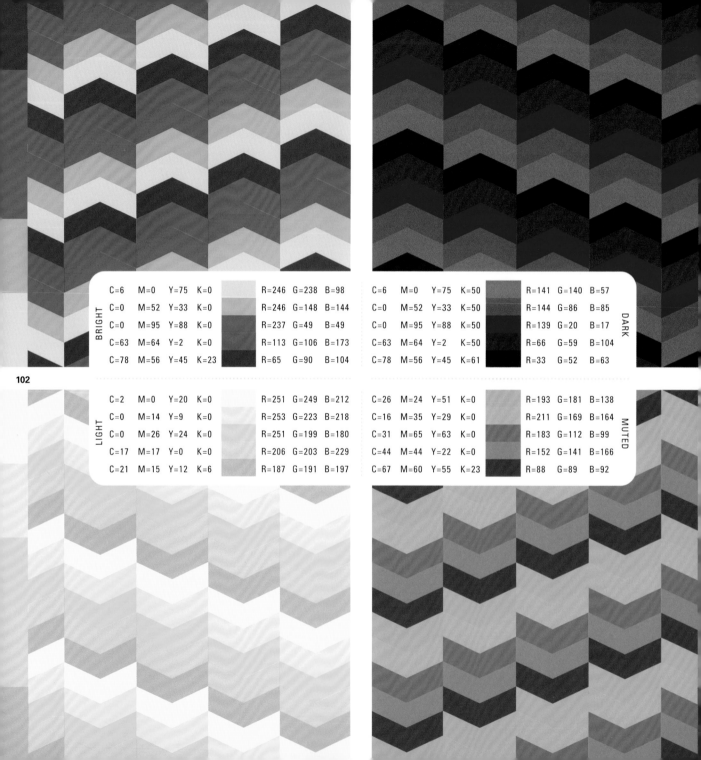

BRIGHT							
C=6	M=0	Y=75	K=0		R=246	G=238	B=98
C=0	M=52	Y=33	K=0		R=246	G=148	B=144
C=0	M=95	Y=88	K=0		R=237	G=49	B=49
C=63	M=64	Y=2	K=0		R=113	G=106	B=173
C=78	M=56	Y=45	K=23		R=65	G=90	B=104

							DARK
C=6	M=0	Y=75	K=50		R=141	G=140	B=57
C=0	M=52	Y=33	K=50		R=144	G=86	B=85
C=0	M=95	Y=88	K=50		R=139	G=20	B=17
C=63	M=64	Y=2	K=50		R=66	G=59	B=104
C=78	M=56	Y=45	K=61		R=33	G=52	B=63

LIGHT							
C=2	M=0	Y=20	K=0		R=251	G=249	B=212
C=0	M=14	Y=9	K=0		R=253	G=223	B=218
C=0	M=26	Y=24	K=0		R=251	G=199	B=180
C=17	M=17	Y=0	K=0		R=206	G=203	B=229
C=21	M=15	Y=12	K=6		R=187	G=191	B=197

							MUTED
C=26	M=24	Y=51	K=0		R=193	G=181	B=138
C=16	M=35	Y=29	K=0		R=211	G=169	B=164
C=31	M=65	Y=63	K=0		R=183	G=112	B=99
C=44	M=44	Y=22	K=0		R=152	G=141	B=166
C=67	M=60	Y=55	K=23		R=88	G=89	B=92

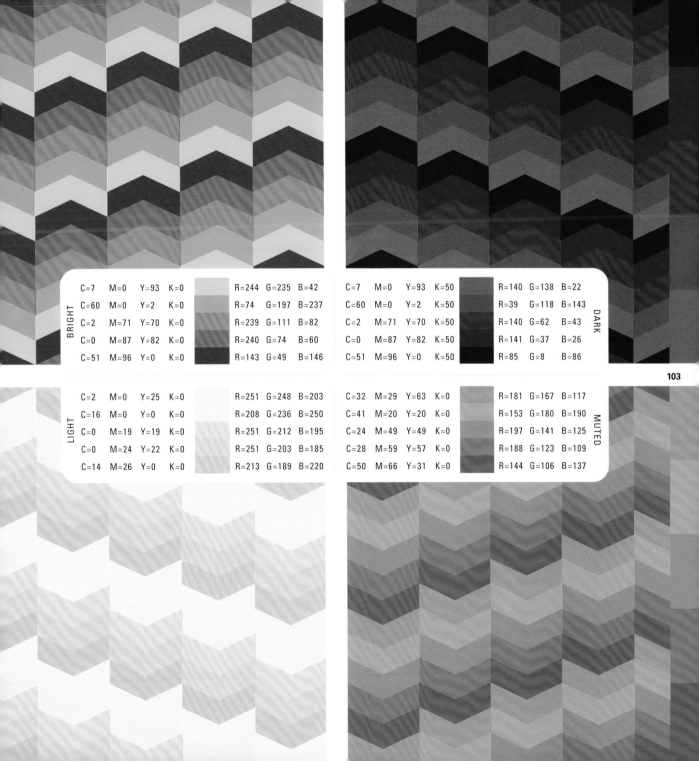

BRIGHT

C=7	M=0	Y=93	K=0
C=60	M=0	Y=2	K=0
C=2	M=71	Y=70	K=0
C=0	M=87	Y=82	K=0
C=51	M=96	Y=0	K=0

R=244	G=235	B=42
R=74	G=197	B=237
R=239	G=111	B=82
R=240	G=74	B=60
R=143	G=49	B=146

DARK

C=7	M=0	Y=93	K=50
C=60	M=0	Y=2	K=50
C=2	M=71	Y=70	K=50
C=0	M=87	Y=82	K=50
C=51	M=96	Y=0	K=50

R=140	G=138	B=22
R=39	G=118	B=143
R=140	G=62	B=43
R=141	G=37	B=26
R=85	G=8	B=86

LIGHT

C=2	M=0	Y=25	K=0
C=16	M=0	Y=0	K=0
C=0	M=19	Y=19	K=0
C=0	M=24	Y=22	K=0
C=14	M=26	Y=0	K=0

R=251	G=248	B=203
R=208	G=236	B=250
R=251	G=212	B=195
R=251	G=203	B=185
R=213	G=189	B=220

MUTED

C=32	M=29	Y=63	K=0
C=41	M=20	Y=20	K=0
C=24	M=49	Y=49	K=0
C=28	M=59	Y=57	K=0
C=50	M=66	Y=31	K=0

R=181	G=167	B=117
R=153	G=180	B=190
R=197	G=141	B=125
R=188	G=123	B=109
R=144	G=106	B=137

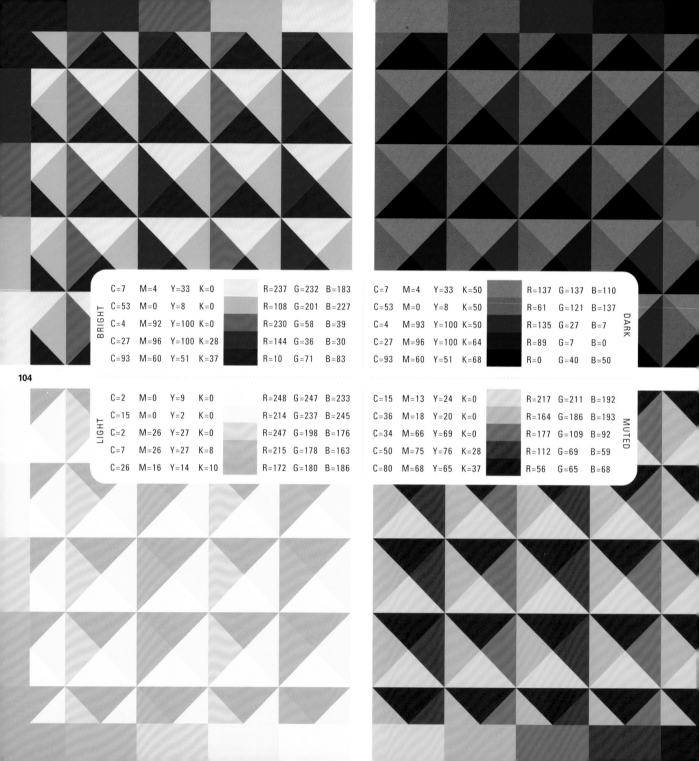

	C	M	Y	K		R	G	B
BRIGHT	C=7	M=4	Y=33	K=0		R=237	G=232	B=183
	C=53	M=0	Y=8	K=0		R=108	G=201	B=227
	C=4	M=92	Y=100	K=0		R=230	G=58	B=39
	C=27	M=96	Y=100	K=28		R=144	G=36	B=30
	C=93	M=60	Y=51	K=37		R=10	G=71	B=83

	C	M	Y	K		R	G	B	
	C=7	M=4	Y=33	K=50		R=137	G=137	B=110	**DARK**
	C=53	M=0	Y=8	K=50		R=61	G=121	B=137	
	C=4	M=93	Y=100	K=50		R=135	G=27	B=7	
	C=27	M=96	Y=100	K=64		R=89	G=7	B=0	
	C=93	M=60	Y=51	K=68		R=0	G=40	B=50	

	C	M	Y	K		R	G	B
LIGHT	C=2	M=0	Y=9	K=0		R=248	G=247	B=233
	C=15	M=0	Y=2	K=0		R=214	G=237	B=245
	C=2	M=26	Y=27	K=0		R=247	G=198	B=176
	C=7	M=26	Y=27	K=8		R=215	G=178	B=163
	C=26	M=16	Y=14	K=10		R=172	G=180	B=186

	C	M	Y	K		R	G	B	
	C=15	M=13	Y=24	K=0		R=217	G=211	B=192	**MUTED**
	C=36	M=18	Y=20	K=0		R=164	G=186	B=193	
	C=34	M=66	Y=69	K=0		R=177	G=109	B=92	
	C=50	M=75	Y=76	K=28		R=112	G=69	B=59	
	C=80	M=68	Y=65	K=37		R=56	G=65	B=68	

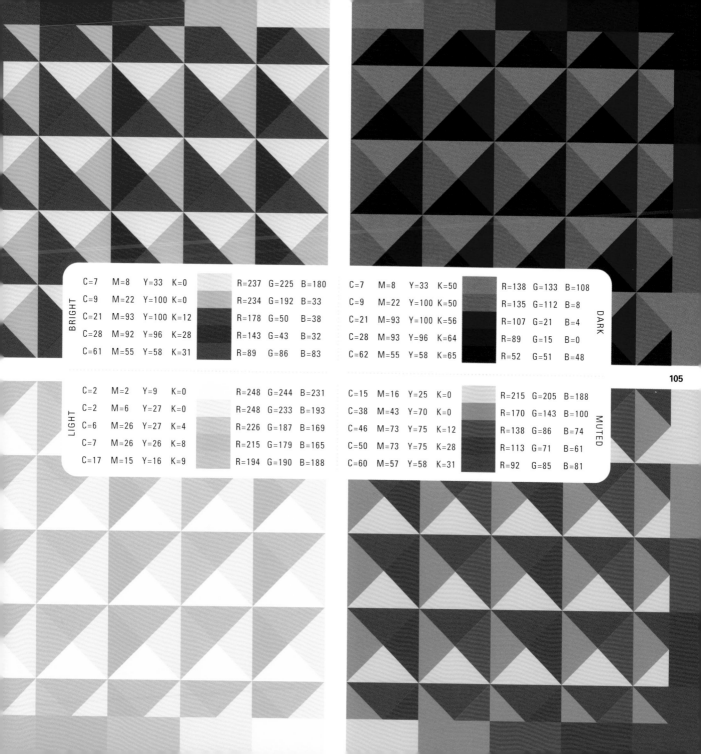

BRIGHT

C=7	M=8	Y=33	K=0		R=237	G=225	B=180
C=9	M=22	Y=100	K=0		R=234	G=192	B=33
C=21	M=93	Y=100	K=12		R=178	G=50	B=38
C=28	M=92	Y=96	K=28		R=143	G=43	B=32
C=61	M=55	Y=58	K=31		R=89	G=86	B=83

DARK

C=7	M=8	Y=33	K=50		R=138	G=133	B=108
C=9	M=22	Y=100	K=50		R=135	G=112	B=8
C=21	M=93	Y=100	K=56		R=107	G=21	B=4
C=28	M=93	Y=96	K=64		R=89	G=15	B=0
C=62	M=55	Y=58	K=65		R=52	G=51	B=48

LIGHT

C=2	M=2	Y=9	K=0		R=248	G=244	B=231
C=2	M=6	Y=27	K=0		R=248	G=233	B=193
C=6	M=26	Y=27	K=4		R=226	G=187	B=169
C=7	M=26	Y=26	K=8		R=215	G=179	B=165
C=17	M=15	Y=16	K=9		R=194	G=190	B=188

MUTED

C=15	M=16	Y=25	K=0		R=215	G=205	B=188
C=38	M=43	Y=70	K=0		R=170	G=143	B=100
C=46	M=73	Y=75	K=12		R=138	G=86	B=74
C=50	M=73	Y=75	K=28		R=113	G=71	B=61
C=60	M=57	Y=58	K=31		R=92	G=85	B=81

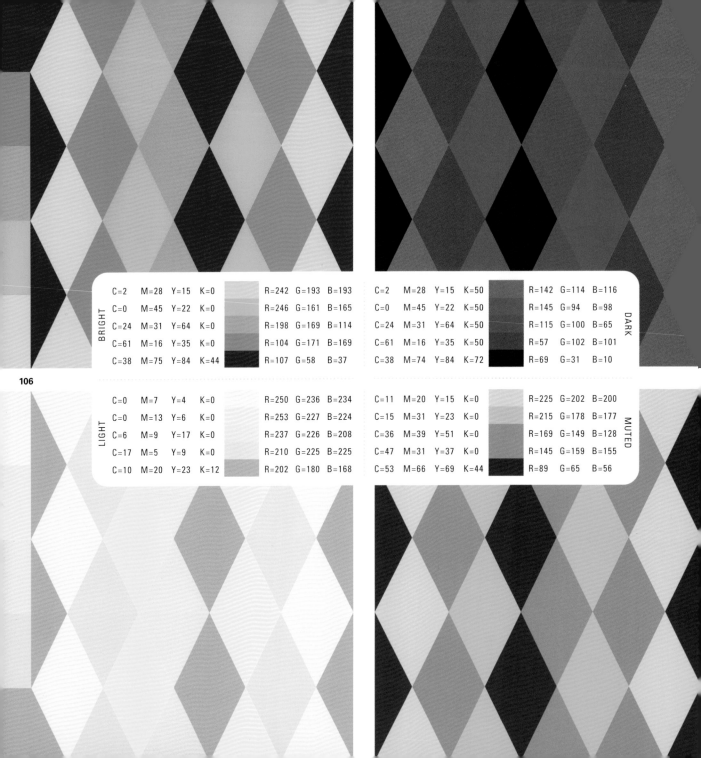

BRIGHT

C=2	M=28	Y=15	K=0		R=242	G=193	B=193
C=0	M=45	Y=22	K=0		R=246	G=161	B=165
C=24	M=31	Y=64	K=0		R=198	G=169	B=114
C=61	M=16	Y=35	K=0		R=104	G=171	B=169
C=38	M=75	Y=84	K=44		R=107	G=58	B=37

DARK

C=2	M=28	Y=15	K=50		R=142	G=114	B=116
C=0	M=45	Y=22	K=50		R=145	G=94	B=98
C=24	M=31	Y=64	K=50		R=115	G=100	B=65
C=61	M=16	Y=35	K=50		R=57	G=102	B=101
C=38	M=74	Y=84	K=72		R=69	G=31	B=10

LIGHT

C=0	M=7	Y=4	K=0		R=250	G=236	B=234
C=0	M=13	Y=6	K=0		R=253	G=227	B=224
C=6	M=9	Y=17	K=0		R=237	G=226	B=208
C=17	M=5	Y=9	K=0		R=210	G=225	B=225
C=10	M=20	Y=23	K=12		R=202	G=180	B=168

MUTED

C=11	M=20	Y=15	K=0		R=225	G=202	B=200
C=15	M=31	Y=23	K=0		R=215	G=178	B=177
C=36	M=39	Y=51	K=0		R=169	G=149	B=128
C=47	M=31	Y=37	K=0		R=145	G=159	B=155
C=53	M=66	Y=69	K=44		R=89	G=65	B=56

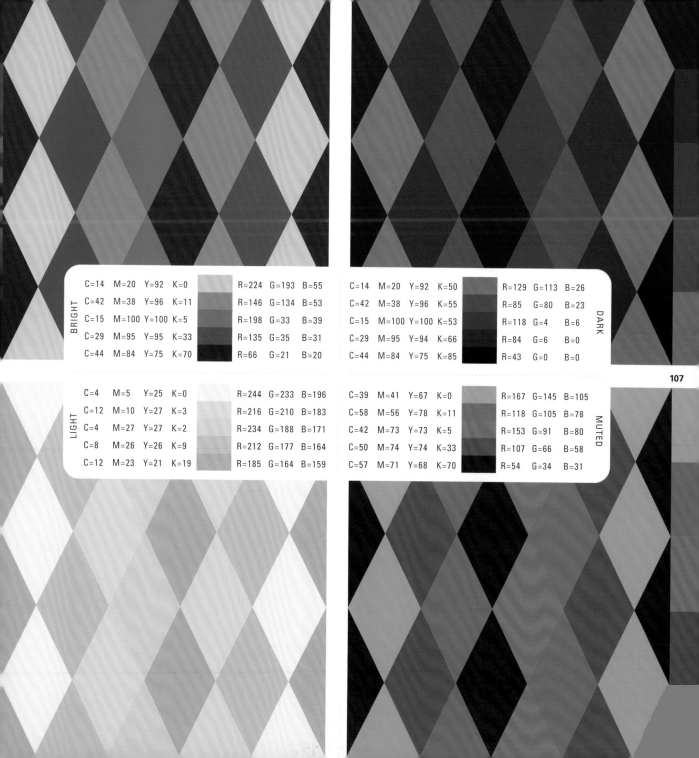

BRIGHT	C=14	M=20	Y=92	K=0		R=224	G=193	B=55

BRIGHT

C=14 M=20 Y=92 K=0 R=224 G=193 B=55
C=42 M=38 Y=96 K=11 R=146 G=134 B=53
C=15 M=100 Y=100 K=5 R=198 G=33 B=39
C=29 M=95 Y=95 K=33 R=135 G=35 B=31
C=44 M=84 Y=75 K=70 R=66 G=21 B=20

DARK

C=14 M=20 Y=92 K=50 R=129 G=113 B=26
C=42 M=38 Y=96 K=55 R=85 G=80 B=23
C=15 M=100 Y=100 K=53 R=118 G=4 B=6
C=29 M=95 Y=94 K=66 R=84 G=6 B=0
C=44 M=84 Y=75 K=85 R=43 G=0 B=0

107

LIGHT

C=4 M=5 Y=25 K=0 R=244 G=233 B=196
C=12 M=10 Y=27 K=3 R=216 G=210 B=183
C=4 M=27 Y=27 K=2 R=234 G=188 B=171
C=8 M=26 Y=26 K=9 R=212 G=177 B=164
C=12 M=23 Y=21 K=19 R=185 G=164 B=159

MUTED

C=39 M=41 Y=67 K=0 R=167 G=145 B=105
C=58 M=56 Y=78 K=11 R=118 G=105 B=78
C=42 M=73 Y=73 K=5 R=153 G=91 B=80
C=50 M=74 Y=74 K=33 R=107 G=66 B=58
C=57 M=71 Y=68 K=70 R=54 G=34 B=31

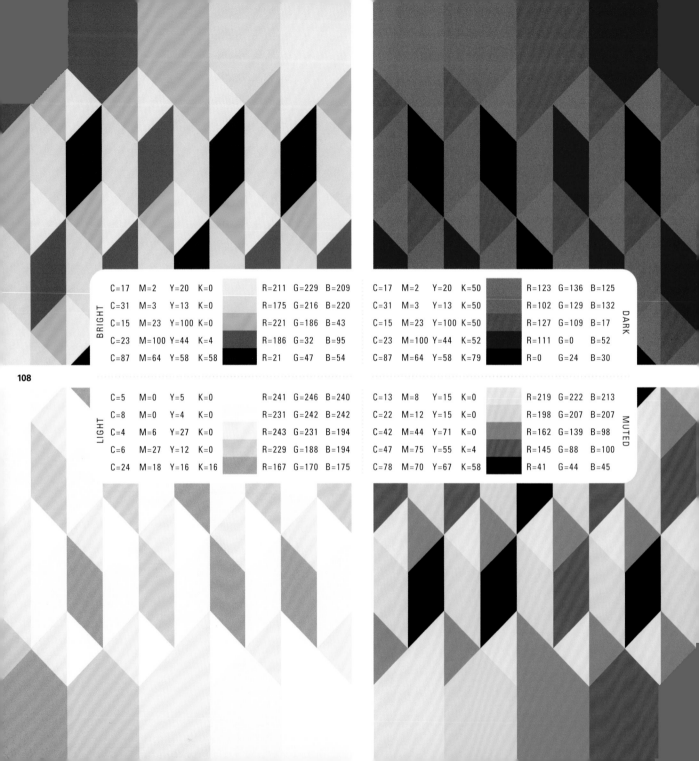

BRIGHT

C=17	M=2	Y=20	K=0		R=211	G=229	B=209
C=31	M=3	Y=13	K=0		R=175	G=216	B=220
C=15	M=23	Y=100	K=0		R=221	G=186	B=43
C=23	M=100	Y=44	K=4		R=186	G=32	B=95
C=87	M=64	Y=58	K=58		R=21	G=47	B=54

DARK

C=17	M=2	Y=20	K=50		R=123	G=136	B=125
C=31	M=3	Y=13	K=50		R=102	G=129	B=132
C=15	M=23	Y=100	K=50		R=127	G=109	B=17
C=23	M=100	Y=44	K=52		R=111	G=0	B=52
C=87	M=64	Y=58	K=79		R=0	G=24	B=30

LIGHT

C=5	M=0	Y=5	K=0		R=241	G=246	B=240
C=8	M=0	Y=4	K=0		R=231	G=242	B=242
C=4	M=6	Y=27	K=0		R=243	G=231	B=194
C=6	M=27	Y=12	K=0		R=229	G=188	B=194
C=24	M=18	Y=16	K=16		R=167	G=170	B=175

MUTED

C=13	M=8	Y=15	K=0		R=219	G=222	B=213
C=22	M=12	Y=15	K=0		R=198	G=207	B=207
C=42	M=44	Y=71	K=0		R=162	G=139	B=98
C=47	M=75	Y=55	K=4		R=145	G=88	B=100
C=78	M=70	Y=67	K=58		R=41	G=44	B=45

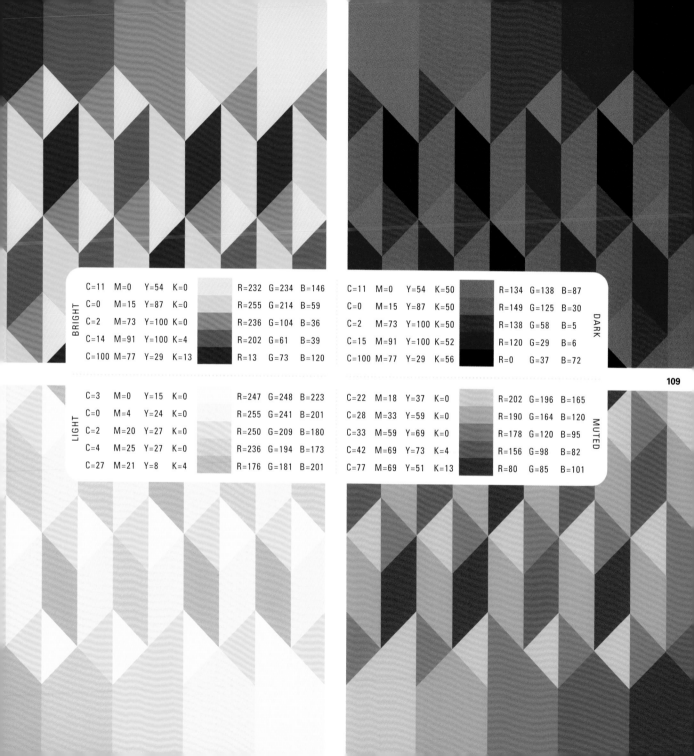

BRIGHT

C=11	M=0	Y=54	K=0		R=232	G=234	B=146
C=0	M=15	Y=87	K=0		R=255	G=214	B=59
C=2	M=73	Y=100	K=0		R=236	G=104	B=36
C=14	M=91	Y=100	K=4		R=202	G=61	B=39
C=100	M=77	Y=29	K=13		R=13	G=73	B=120

DARK

C=11	M=0	Y=54	K=50		R=134	G=138	B=87
C=0	M=15	Y=87	K=50		R=149	G=125	B=30
C=2	M=73	Y=100	K=50		R=138	G=58	B=5
C=15	M=91	Y=100	K=52		R=120	G=29	B=6
C=100	M=77	Y=29	K=56		R=0	G=37	B=72

LIGHT

C=3	M=0	Y=15	K=0		R=247	G=248	B=223
C=0	M=4	Y=24	K=0		R=255	G=241	B=201
C=2	M=20	Y=27	K=0		R=250	G=209	B=180
C=4	M=25	Y=27	K=0		R=236	G=194	B=173
C=27	M=21	Y=8	K=4		R=176	G=181	B=201

MUTED

C=22	M=18	Y=37	K=0		R=202	G=196	B=165
C=28	M=33	Y=59	K=0		R=190	G=164	B=120
C=33	M=59	Y=69	K=0		R=178	G=120	B=95
C=42	M=69	Y=73	K=4		R=156	G=98	B=82
C=77	M=69	Y=51	K=13		R=80	G=85	B=101

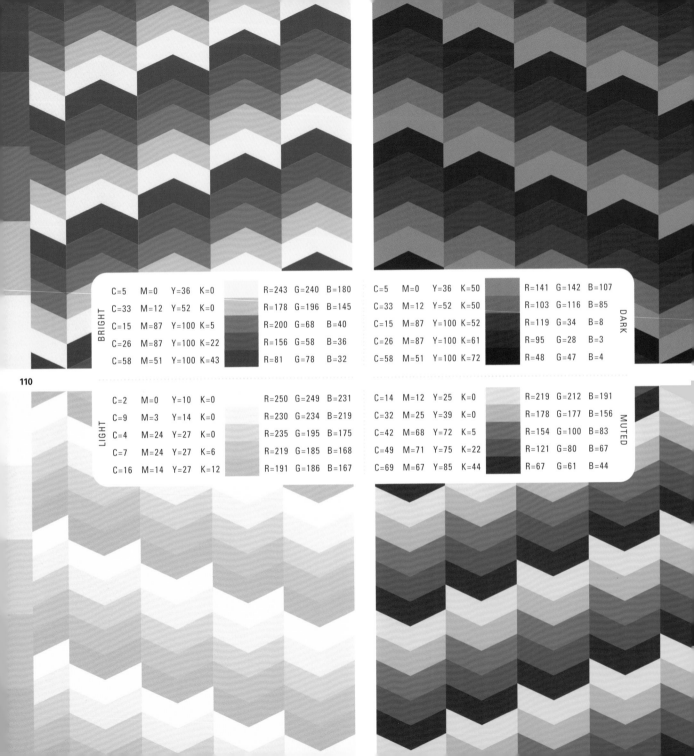

BRIGHT

C=5	M=0	Y=36	K=0		R=243	G=240	B=180
C=33	M=12	Y=52	K=0		R=178	G=196	B=145
C=15	M=87	Y=100	K=5		R=200	G=68	B=40
C=26	M=87	Y=100	K=22		R=156	G=58	B=36
C=58	M=51	Y=100	K=43		R=81	G=78	B=32

DARK

C=5	M=0	Y=36	K=50		R=141	G=142	B=107
C=33	M=12	Y=52	K=50		R=103	G=116	B=85
C=15	M=87	Y=100	K=52		R=119	G=34	B=8
C=26	M=87	Y=100	K=61		R=95	G=28	B=3
C=58	M=51	Y=100	K=72		R=48	G=47	B=4

LIGHT

C=2	M=0	Y=10	K=0		R=250	G=249	B=231
C=9	M=3	Y=14	K=0		R=230	G=234	B=219
C=4	M=24	Y=27	K=0		R=235	G=195	B=175
C=7	M=24	Y=27	K=6		R=219	G=185	B=168
C=16	M=14	Y=27	K=12		R=191	G=186	B=167

MUTED

C=14	M=12	Y=25	K=0		R=219	G=212	B=191
C=32	M=25	Y=39	K=0		R=178	G=177	B=156
C=42	M=68	Y=72	K=5		R=154	G=100	B=83
C=49	M=71	Y=75	K=22		R=121	G=80	B=67
C=69	M=67	Y=85	K=44		R=67	G=61	B=44

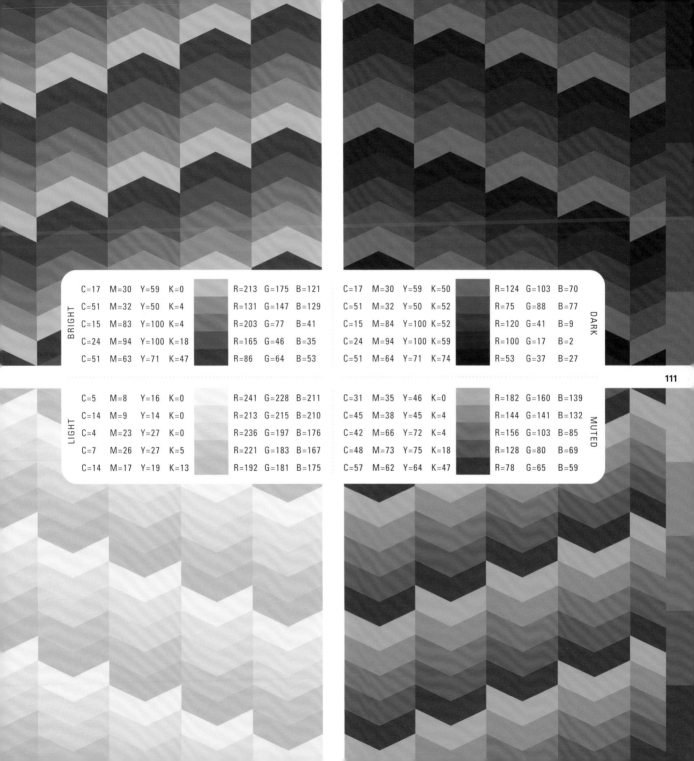

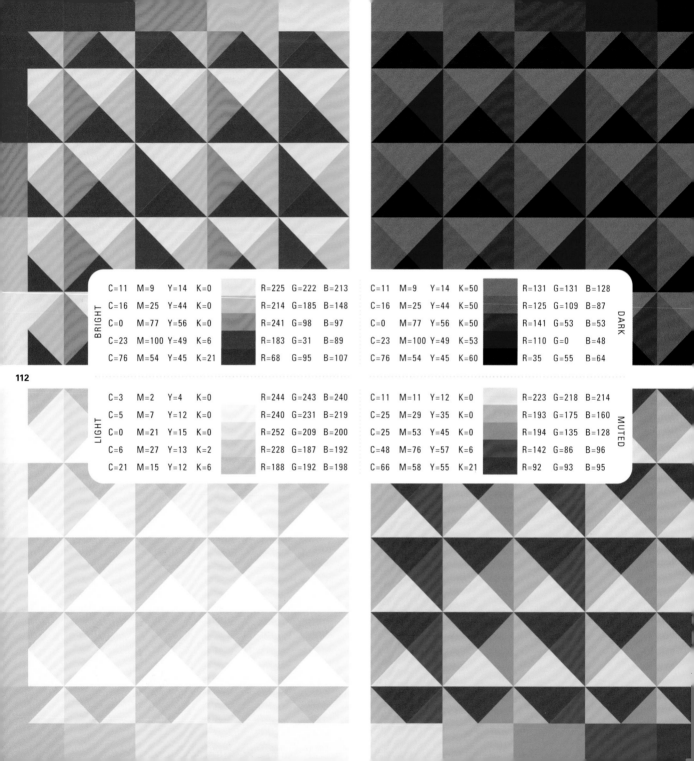

BRIGHT

C=11	M=9	Y=14	K=0
C=16	M=25	Y=44	K=0
C=0	M=77	Y=56	K=0
C=23	M=100	Y=49	K=6
C=76	M=54	Y=45	K=21

R=225	G=222	B=213
R=214	G=185	B=148
R=241	G=98	B=97
R=183	G=31	B=89
R=68	G=95	B=107

DARK

C=11	M=9	Y=14	K=50
C=16	M=25	Y=44	K=50
C=0	M=77	Y=56	K=50
C=23	M=100	Y=49	K=53
C=76	M=54	Y=45	K=60

R=131	G=131	B=128
R=125	G=109	B=87
R=141	G=53	B=53
R=110	G=0	B=48
R=35	G=55	B=64

LIGHT

C=3	M=2	Y=4	K=0
C=5	M=7	Y=12	K=0
C=0	M=21	Y=15	K=0
C=6	M=27	Y=13	K=2
C=21	M=15	Y=12	K=6

R=244	G=243	B=240
R=240	G=231	B=219
R=252	G=209	B=200
R=228	G=187	B=192
R=188	G=192	B=198

MUTED

C=11	M=11	Y=12	K=0
C=25	M=29	Y=35	K=0
C=25	M=53	Y=45	K=0
C=48	M=76	Y=57	K=6
C=66	M=58	Y=55	K=21

R=223	G=218	B=214
R=193	G=175	B=160
R=194	G=135	B=128
R=142	G=86	B=96
R=92	G=93	B=95

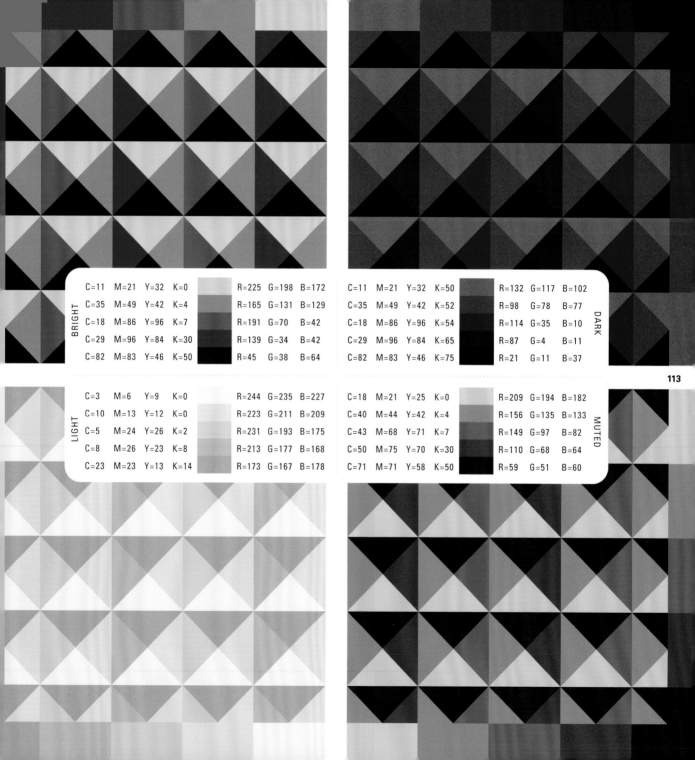

BRIGHT

C=11	M=21	Y=32	K=0		R=225	G=198	B=172
C=35	M=49	Y=42	K=4		R=165	G=131	B=129
C=18	M=86	Y=96	K=7		R=191	G=70	B=42
C=29	M=96	Y=84	K=30		R=139	G=34	B=42
C=82	M=83	Y=46	K=50		R=45	G=38	B=64

DARK

C=11	M=21	Y=32	K=50		R=132	G=117	B=102
C=35	M=49	Y=42	K=52		R=98	G=78	B=77
C=18	M=86	Y=96	K=54		R=114	G=35	B=10
C=29	M=96	Y=84	K=65		R=87	G=4	B=11
C=82	M=83	Y=46	K=75		R=21	G=11	B=37

LIGHT

C=3	M=6	Y=9	K=0		R=244	G=235	B=227
C=10	M=13	Y=12	K=0		R=223	G=211	B=209
C=5	M=24	Y=26	K=2		R=231	G=193	B=175
C=8	M=26	Y=23	K=8		R=213	G=177	B=168
C=23	M=23	Y=13	K=14		R=173	G=167	B=178

MUTED

C=18	M=21	Y=25	K=0		R=209	G=194	B=182
C=40	M=44	Y=42	K=4		R=156	G=135	B=133
C=43	M=68	Y=71	K=7		R=149	G=97	B=82
C=50	M=75	Y=70	K=30		R=110	G=68	B=64
C=71	M=71	Y=58	K=50		R=59	G=51	B=60

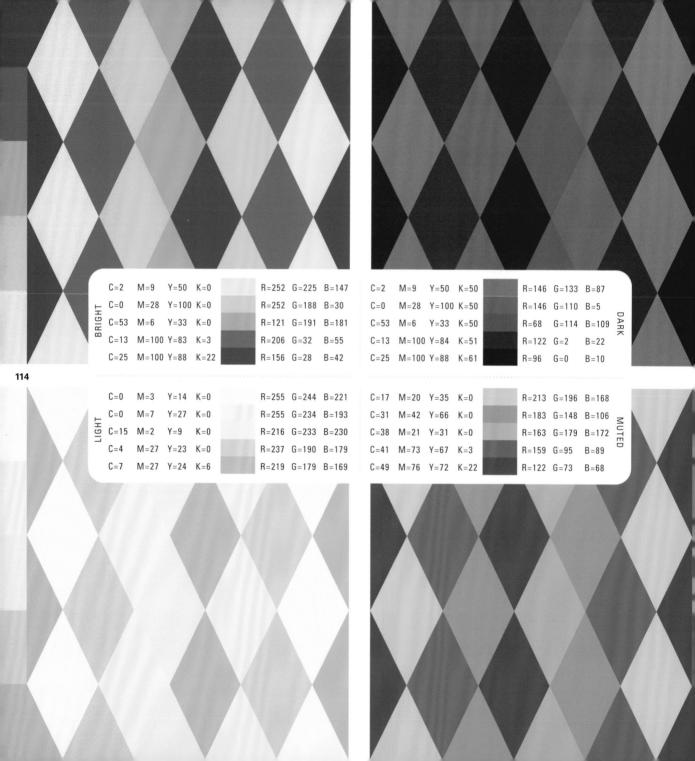

114

BRIGHT

C=2	M=9	Y=50	K=0		R=252	G=225	B=147
C=0	M=28	Y=100	K=0		R=252	G=188	B=30
C=53	M=6	Y=33	K=0		R=121	G=191	B=181
C=13	M=100	Y=83	K=3		R=206	G=32	B=55
C=25	M=100	Y=88	K=22		R=156	G=28	B=42

DARK

C=2	M=9	Y=50	K=50		R=146	G=133	B=87
C=0	M=28	Y=100	K=50		R=146	G=110	B=5
C=53	M=6	Y=33	K=50		R=68	G=114	B=109
C=13	M=100	Y=84	K=51		R=122	G=2	B=22
C=25	M=100	Y=88	K=61		R=96	G=0	B=10

LIGHT

C=0	M=3	Y=14	K=0		R=255	G=244	B=221
C=0	M=7	Y=27	K=0		R=255	G=234	B=193
C=15	M=2	Y=9	K=0		R=216	G=233	B=230
C=4	M=27	Y=23	K=0		R=237	G=190	B=179
C=7	M=27	Y=24	K=6		R=219	G=179	B=169

MUTED

C=17	M=20	Y=35	K=0		R=213	G=196	B=168
C=31	M=42	Y=66	K=0		R=183	G=148	B=106
C=38	M=21	Y=31	K=0		R=163	G=179	B=172
C=41	M=73	Y=67	K=3		R=159	G=95	B=89
C=49	M=76	Y=72	K=22		R=122	G=73	B=68

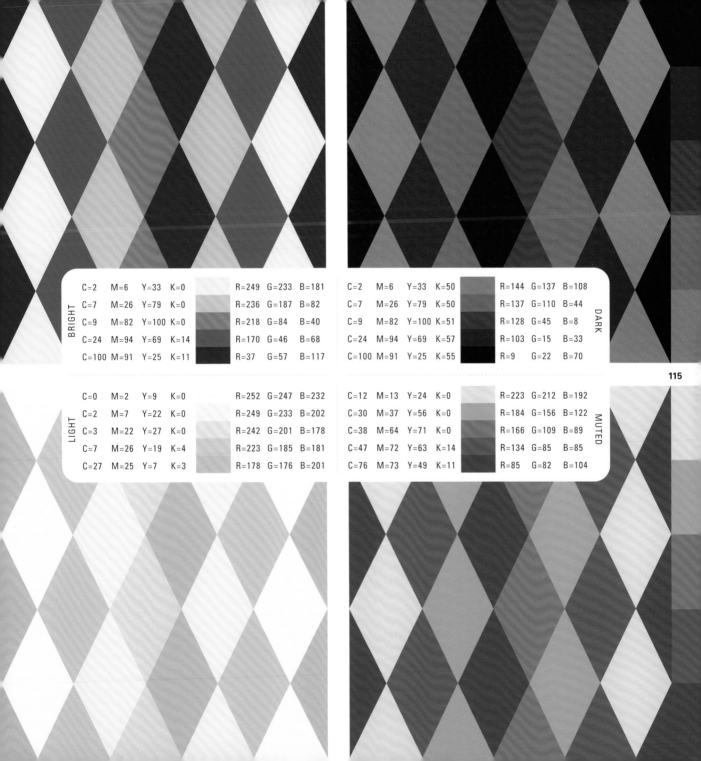

BRIGHT					R=249	G=233	B=181
C=2	M=6	Y=33	K=0		R=249	G=233	B=181
C=7	M=26	Y=79	K=0		R=236	G=187	B=82
C=9	M=82	Y=100	K=0		R=218	G=84	B=40
C=24	M=94	Y=69	K=14		R=170	G=46	B=68
C=100	M=91	Y=25	K=11		R=37	G=57	B=117

DARK							
C=2	M=6	Y=33	K=50		R=144	G=137	B=108
C=7	M=26	Y=79	K=50		R=137	G=110	B=44
C=9	M=82	Y=100	K=51		R=128	G=45	B=8
C=24	M=94	Y=69	K=57		R=103	G=15	B=33
C=100	M=91	Y=25	K=55		R=9	G=22	B=70

LIGHT							
C=0	M=2	Y=9	K=0		R=252	G=247	B=232
C=2	M=7	Y=22	K=0		R=249	G=233	B=202
C=3	M=22	Y=27	K=0		R=242	G=201	B=178
C=7	M=26	Y=19	K=4		R=223	G=185	B=181
C=27	M=25	Y=7	K=3		R=178	G=176	B=201

MUTED							
C=12	M=13	Y=24	K=0		R=223	G=212	B=192
C=30	M=37	Y=56	K=0		R=184	G=156	B=122
C=38	M=64	Y=71	K=0		R=166	G=109	B=89
C=47	M=72	Y=63	K=14		R=134	G=85	B=85
C=76	M=73	Y=49	K=11		R=85	G=82	B=104

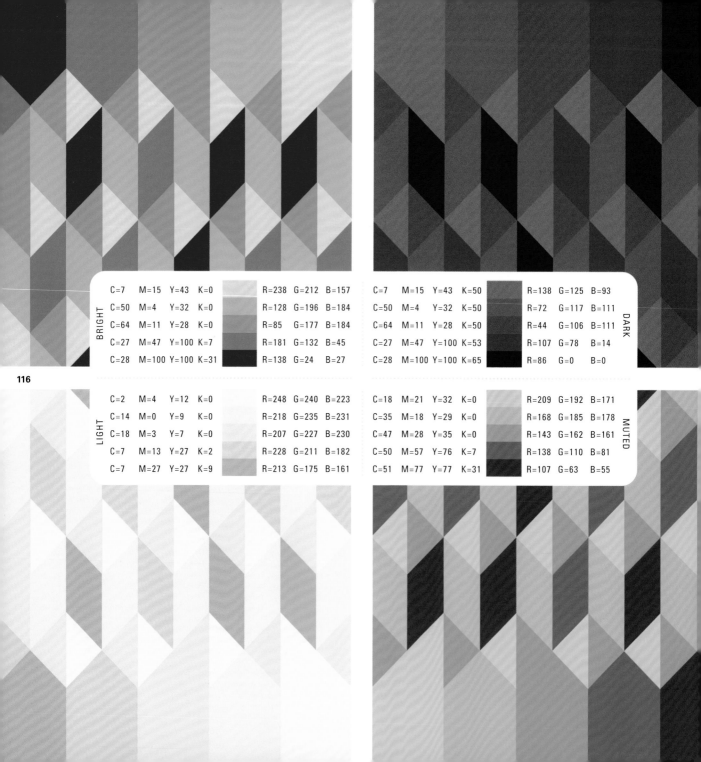

BRIGHT

C=7	M=15	Y=43	K=0		R=238	G=212	B=157
C=50	M=4	Y=32	K=0		R=128	G=196	B=184
C=64	M=11	Y=28	K=0		R=85	G=177	B=184
C=27	M=47	Y=100	K=7		R=181	G=132	B=45
C=28	M=100	Y=100	K=31		R=138	G=24	B=27

DARK

C=7	M=15	Y=43	K=50		R=138	G=125	B=93
C=50	M=4	Y=32	K=50		R=72	G=117	B=111
C=64	M=11	Y=28	K=50		R=44	G=106	B=111
C=27	M=47	Y=100	K=53		R=107	G=78	B=14
C=28	M=100	Y=100	K=65		R=86	G=0	B=0

LIGHT

C=2	M=4	Y=12	K=0		R=248	G=240	B=223
C=14	M=0	Y=9	K=0		R=218	G=235	B=231
C=18	M=3	Y=7	K=0		R=207	G=227	B=230
C=7	M=13	Y=27	K=2		R=228	G=211	B=182
C=7	M=27	Y=27	K=9		R=213	G=175	B=161

MUTED

C=18	M=21	Y=32	K=0		R=209	G=192	B=171
C=35	M=18	Y=29	K=0		R=168	G=185	B=178
C=47	M=28	Y=35	K=0		R=143	G=162	B=161
C=50	M=57	Y=76	K=7		R=138	G=110	B=81
C=51	M=77	Y=77	K=31		R=107	G=63	B=55

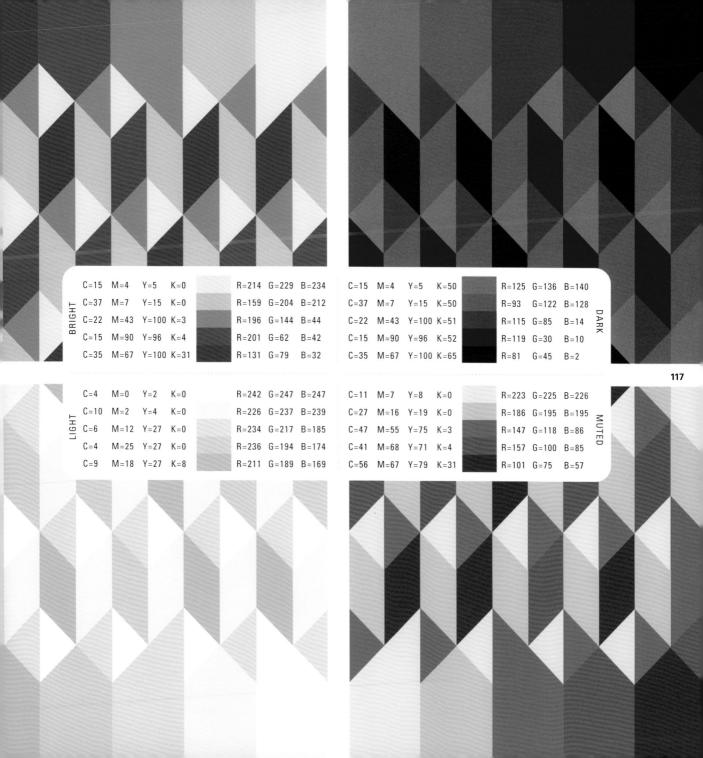

BRIGHT

C=15	M=4	Y=5	K=0		R=214	G=229	B=234
C=37	M=7	Y=15	K=0		R=159	G=204	B=212
C=22	M=43	Y=100	K=3		R=196	G=144	B=44
C=15	M=90	Y=96	K=4		R=201	G=62	B=42
C=35	M=67	Y=100	K=31		R=131	G=79	B=32

DARK

C=15	M=4	Y=5	K=50		R=125	G=136	B=140
C=37	M=7	Y=15	K=50		R=93	G=122	B=128
C=22	M=43	Y=100	K=51		R=115	G=85	B=14
C=15	M=90	Y=96	K=52		R=119	G=30	B=10
C=35	M=67	Y=100	K=65		R=81	G=45	B=2

117

LIGHT

C=4	M=0	Y=2	K=0		R=242	G=247	B=247
C=10	M=2	Y=4	K=0		R=226	G=237	B=239
C=6	M=12	Y=27	K=0		R=234	G=217	B=185
C=4	M=25	Y=27	K=0		R=236	G=194	B=174
C=9	M=18	Y=27	K=8		R=211	G=189	B=169

MUTED

C=11	M=7	Y=8	K=0		R=223	G=225	B=226
C=27	M=16	Y=19	K=0		R=186	G=195	B=195
C=47	M=55	Y=75	K=3		R=147	G=118	B=86
C=41	M=68	Y=71	K=4		R=157	G=100	B=85
C=56	M=67	Y=79	K=31		R=101	G=75	B=57

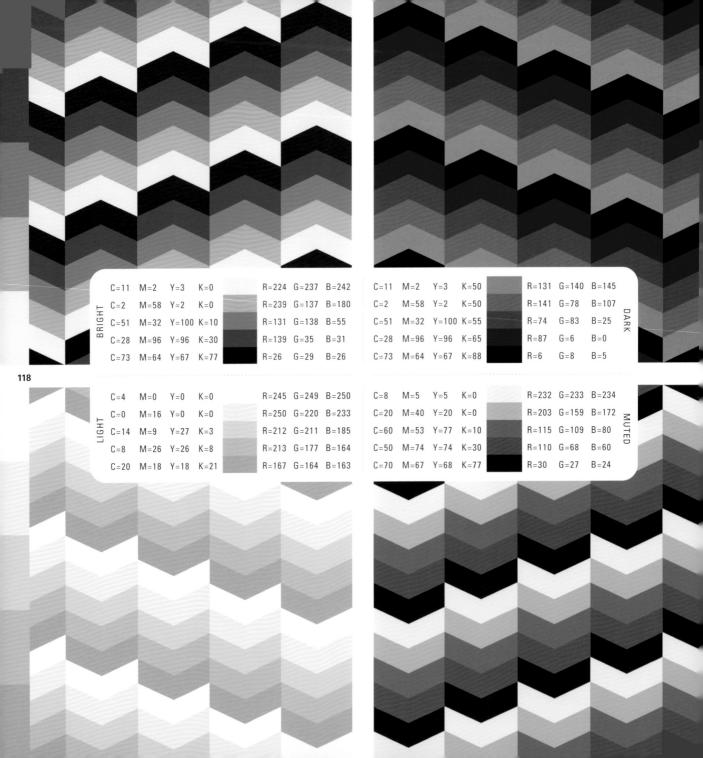

BRIGHT

C=11	M=2	Y=3	K=0		R=224	G=237	B=242
C=2	M=58	Y=2	K=0		R=239	G=137	B=180
C=51	M=32	Y=100	K=10		R=131	G=138	B=55
C=28	M=96	Y=96	K=30		R=139	G=35	B=31
C=73	M=64	Y=67	K=77		R=26	G=29	B=26

DARK

C=11	M=2	Y=3	K=50		R=131	G=140	B=145
C=2	M=58	Y=2	K=50		R=141	G=78	B=107
C=51	M=32	Y=100	K=55		R=74	G=83	B=25
C=28	M=96	Y=96	K=65		R=87	G=6	B=0
C=73	M=64	Y=67	K=88		R=6	G=8	B=5

LIGHT

C=4	M=0	Y=0	K=0		R=245	G=249	B=250
C=0	M=16	Y=0	K=0		R=250	G=220	B=233
C=14	M=9	Y=27	K=3		R=212	G=211	B=185
C=8	M=26	Y=26	K=8		R=213	G=177	B=164
C=20	M=18	Y=18	K=21		R=167	G=164	B=163

MUTED

C=8	M=5	Y=5	K=0		R=232	G=233	B=234
C=20	M=40	Y=20	K=0		R=203	G=159	B=172
C=60	M=53	Y=77	K=10		R=115	G=109	B=80
C=50	M=74	Y=74	K=30		R=110	G=68	B=60
C=70	M=67	Y=68	K=77		R=30	G=27	B=24

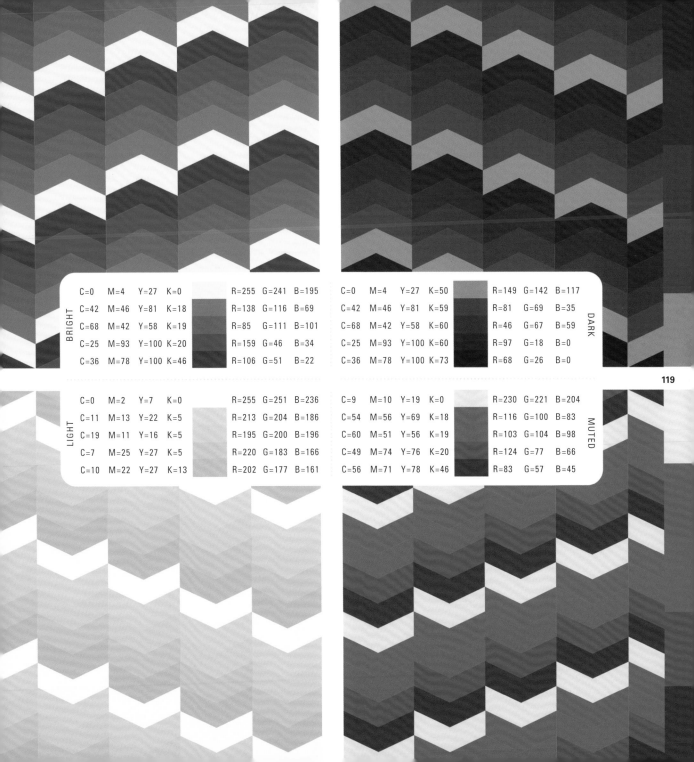

BRIGHT

C=0	M=4	Y=27	K=0
C=42	M=46	Y=81	K=18
C=68	M=42	Y=58	K=19
C=25	M=93	Y=100	K=20
C=36	M=78	Y=100	K=46

R=255	G=241	B=195
R=138	G=116	B=69
R=85	G=111	B=101
R=159	G=46	B=34
R=106	G=51	B=22

DARK

C=0	M=4	Y=27	K=50
C=42	M=46	Y=81	K=59
C=68	M=42	Y=58	K=60
C=25	M=93	Y=100	K=60
C=36	M=78	Y=100	K=73

R=149	G=142	B=117
R=81	G=69	B=35
R=46	G=67	B=59
R=97	G=18	B=0
R=68	G=26	B=0

LIGHT

C=0	M=2	Y=7	K=0
C=11	M=13	Y=22	K=5
C=19	M=11	Y=16	K=5
C=7	M=25	Y=27	K=5
C=10	M=22	Y=27	K=13

R=255	G=251	B=236
R=213	G=204	B=186
R=195	G=200	B=196
R=220	G=183	B=166
R=202	G=177	B=161

MUTED

C=9	M=10	Y=19	K=0
C=54	M=56	Y=69	K=18
C=60	M=51	Y=56	K=19
C=49	M=74	Y=76	K=20
C=56	M=71	Y=78	K=46

R=230	G=221	B=204
R=116	G=100	B=83
R=103	G=104	B=98
R=124	G=77	B=66
R=83	G=57	B=45

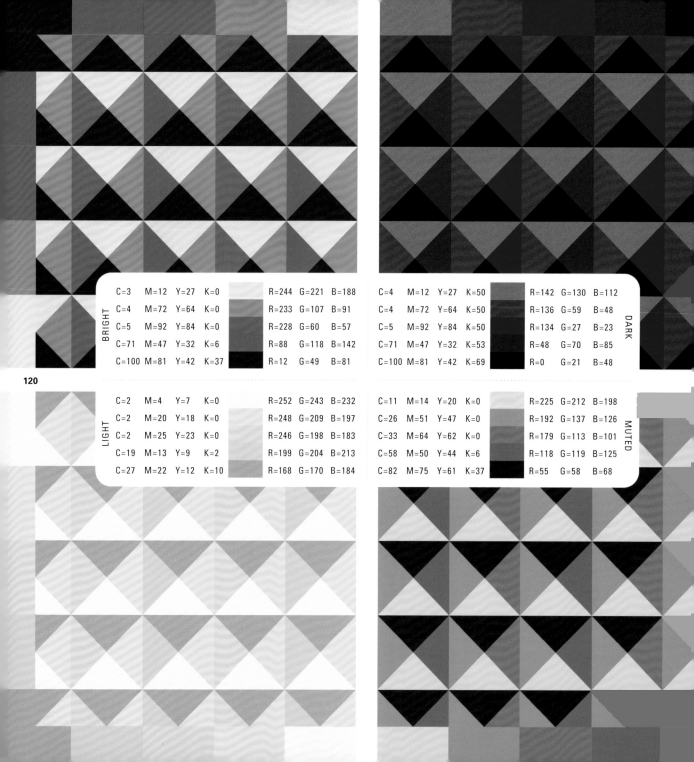

BRIGHT

C=3	M=12	Y=27	K=0
C=4	M=72	Y=64	K=0
C=5	M=92	Y=84	K=0
C=71	M=47	Y=32	K=6
C=100	M=81	Y=42	K=37

R=244	G=221	B=188
R=233	G=107	B=91
R=228	G=60	B=57
R=88	G=118	B=142
R=12	G=49	B=81

DARK

C=4	M=12	Y=27	K=50
C=4	M=72	Y=64	K=50
C=5	M=92	Y=84	K=50
C=71	M=47	Y=32	K=53
C=100	M=81	Y=42	K=69

R=142	G=130	B=112
R=136	G=59	B=48
R=134	G=27	B=23
R=48	G=70	B=85
R=0	G=21	B=48

LIGHT

C=2	M=4	Y=7	K=0
C=2	M=20	Y=18	K=0
C=2	M=25	Y=23	K=0
C=19	M=13	Y=9	K=2
C=27	M=22	Y=12	K=10

R=252	G=243	B=232
R=248	G=209	B=197
R=246	G=198	B=183
R=199	G=204	B=213
R=168	G=170	B=184

MUTED

C=11	M=14	Y=20	K=0
C=26	M=51	Y=47	K=0
C=33	M=64	Y=62	K=0
C=58	M=50	Y=44	K=6
C=82	M=75	Y=61	K=37

R=225	G=212	B=198
R=192	G=137	B=126
R=179	G=113	B=101
R=118	G=119	B=125
R=55	G=58	B=68

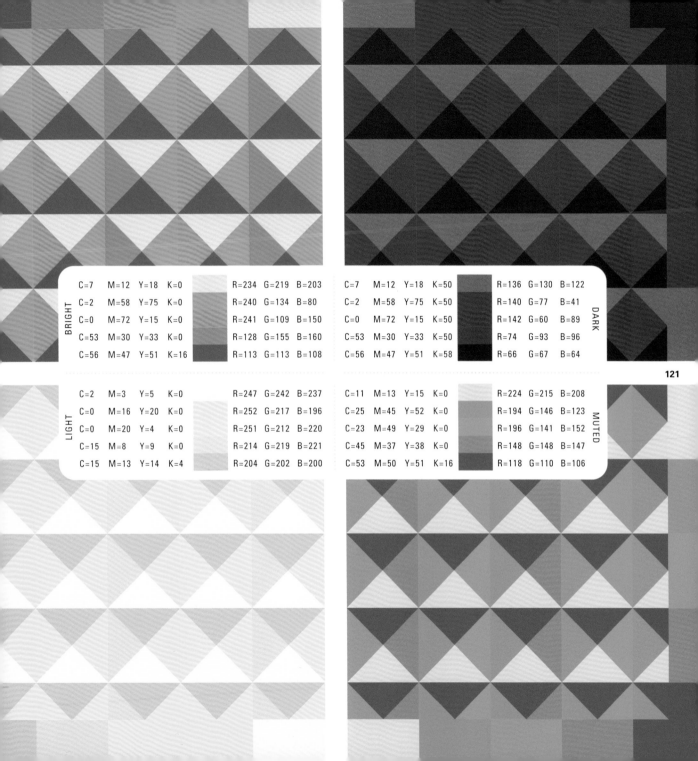

BRIGHT	C=7	M=12	Y=18	K=0		R=234	G=219	B=203
	C=2	M=58	Y=75	K=0		R=240	G=134	B=80
	C=0	M=72	Y=15	K=0		R=241	G=109	B=150
	C=53	M=30	Y=33	K=0		R=128	G=155	B=160
	C=56	M=47	Y=51	K=16		R=113	G=113	B=108

	C=7	M=12	Y=18	K=50		R=136	G=130	B=122	DARK
	C=2	M=58	Y=75	K=50		R=140	G=77	B=41	
	C=0	M=72	Y=15	K=50		R=142	G=60	B=89	
	C=53	M=30	Y=33	K=50		R=74	G=93	B=96	
	C=56	M=47	Y=51	K=58		R=66	G=67	B=64	

LIGHT	C=2	M=3	Y=5	K=0		R=247	G=242	B=237
	C=0	M=16	Y=20	K=0		R=252	G=217	B=196
	C=0	M=20	Y=4	K=0		R=251	G=212	B=220
	C=15	M=8	Y=9	K=0		R=214	G=219	B=221
	C=15	M=13	Y=14	K=4		R=204	G=202	B=200

	C=11	M=13	Y=15	K=0		R=224	G=215	B=208	MUTED
	C=25	M=45	Y=52	K=0		R=194	G=146	B=123	
	C=23	M=49	Y=29	K=0		R=196	G=141	B=152	
	C=45	M=37	Y=38	K=0		R=148	G=148	B=147	
	C=53	M=50	Y=51	K=16		R=118	G=110	B=106	

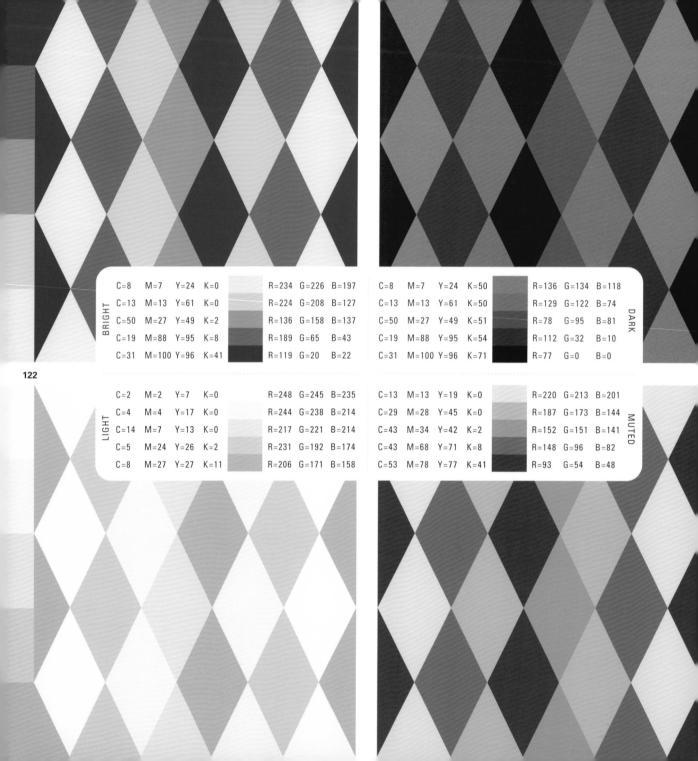

BRIGHT

C=8	M=7	Y=24	K=0		R=234	G=226	B=197
C=13	M=13	Y=61	K=0		R=224	G=208	B=127
C=50	M=27	Y=49	K=2		R=136	G=158	B=137
C=19	M=88	Y=95	K=8		R=189	G=65	B=43
C=31	M=100	Y=96	K=41		R=119	G=20	B=22

DARK

C=8	M=7	Y=24	K=50		R=136	G=134	B=118
C=13	M=13	Y=61	K=50		R=129	G=122	B=74
C=50	M=27	Y=49	K=51		R=78	G=95	B=81
C=19	M=88	Y=95	K=54		R=112	G=32	B=10
C=31	M=100	Y=96	K=71		R=77	G=0	B=0

LIGHT

C=2	M=2	Y=7	K=0		R=248	G=245	B=235
C=4	M=4	Y=17	K=0		R=244	G=238	B=214
C=14	M=7	Y=13	K=0		R=217	G=221	B=214
C=5	M=24	Y=26	K=2		R=231	G=192	B=174
C=8	M=27	Y=27	K=11		R=206	G=171	B=158

MUTED

C=13	M=13	Y=19	K=0		R=220	G=213	B=201
C=29	M=28	Y=45	K=0		R=187	G=173	B=144
C=43	M=34	Y=42	K=2		R=152	G=151	B=141
C=43	M=68	Y=71	K=8		R=148	G=96	B=82
C=53	M=78	Y=77	K=41		R=93	G=54	B=48

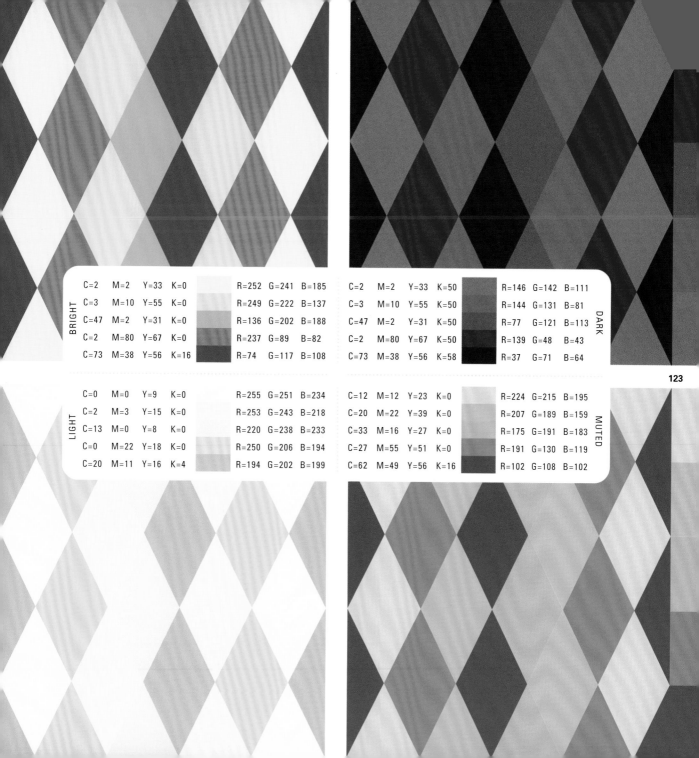

123

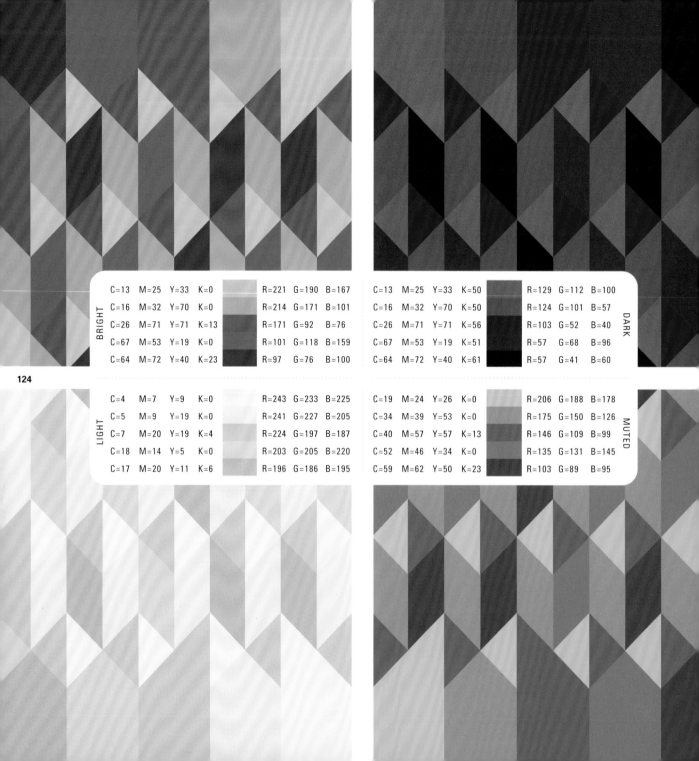

BRIGHT

C=13	M=25	Y=33	K=0		R=221	G=190	B=167
C=16	M=32	Y=70	K=0		R=214	G=171	B=101
C=26	M=71	Y=71	K=13		R=171	G=92	B=76
C=67	M=53	Y=19	K=0		R=101	G=118	B=159
C=64	M=72	Y=40	K=23		R=97	G=76	B=100

DARK

C=13	M=25	Y=33	K=50		R=129	G=112	B=100
C=16	M=32	Y=70	K=50		R=124	G=101	B=57
C=26	M=71	Y=71	K=56		R=103	G=52	B=40
C=67	M=53	Y=19	K=51		R=57	G=68	B=96
C=64	M=72	Y=40	K=61		R=57	G=41	B=60

LIGHT

C=4	M=7	Y=9	K=0		R=243	G=233	B=225
C=5	M=9	Y=19	K=0		R=241	G=227	B=205
C=7	M=20	Y=19	K=4		R=224	G=197	B=187
C=18	M=14	Y=5	K=0		R=203	G=205	B=220
C=17	M=20	Y=11	K=6		R=196	G=186	B=195

MUTED

C=19	M=24	Y=26	K=0		R=206	G=188	B=178
C=34	M=39	Y=53	K=0		R=175	G=150	B=126
C=40	M=57	Y=57	K=13		R=146	G=109	B=99
C=52	M=46	Y=34	K=0		R=135	G=131	B=145
C=59	M=62	Y=50	K=23		R=103	G=89	B=95

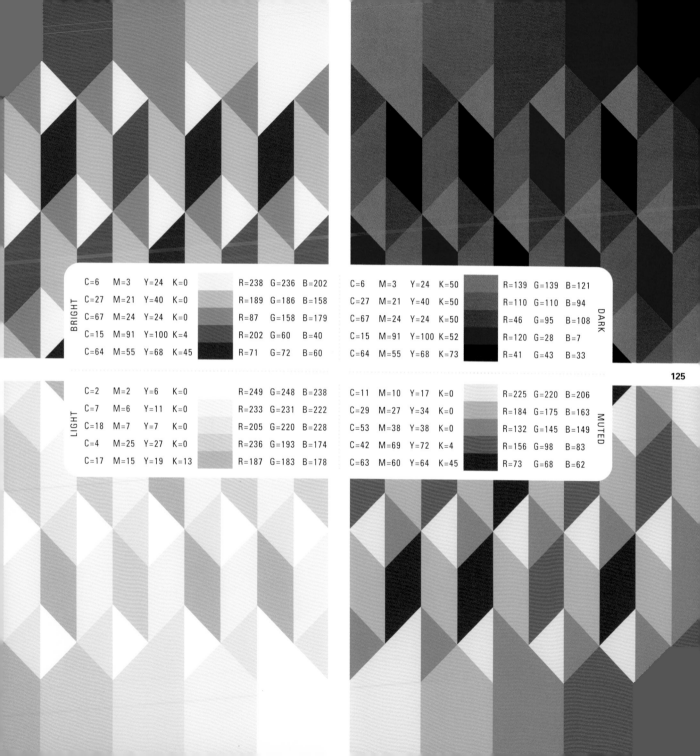

				R	G	B
C=6	M=3	Y=24	K=0	R=238	G=236	B=202
C=27	M=21	Y=40	K=0	R=189	G=186	B=158
C=67	M=24	Y=24	K=0	R=87	G=158	B=179
C=15	M=91	Y=100	K=4	R=202	G=60	B=40
C=64	M=55	Y=68	K=45	R=71	G=72	B=60

DARK

				R	G	B
C=6	M=3	Y=24	K=50	R=139	G=139	B=121
C=27	M=21	Y=40	K=50	R=110	G=110	B=94
C=67	M=24	Y=24	K=50	R=46	G=95	B=108
C=15	M=91	Y=100	K=52	R=120	G=28	B=7
C=64	M=55	Y=68	K=73	R=41	G=43	B=33

125

LIGHT

				R	G	B
C=2	M=2	Y=6	K=0	R=249	G=248	B=238
C=7	M=6	Y=11	K=0	R=233	G=231	B=222
C=18	M=7	Y=7	K=0	R=205	G=220	B=228
C=4	M=25	Y=27	K=0	R=236	G=193	B=174
C=17	M=15	Y=19	K=13	R=187	G=183	B=178

MUTED

				R	G	B
C=11	M=10	Y=17	K=0	R=225	G=220	B=206
C=29	M=27	Y=34	K=0	R=184	G=175	B=163
C=53	M=38	Y=38	K=0	R=132	G=145	B=149
C=42	M=69	Y=72	K=4	R=156	G=98	B=83
C=63	M=60	Y=64	K=45	R=73	G=68	B=62

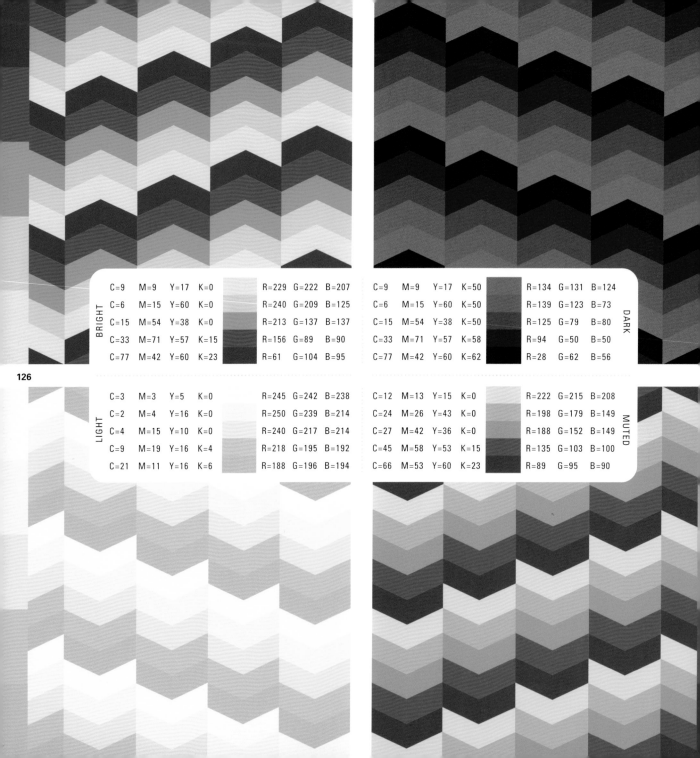

BRIGHT

C=9	M=9	Y=17	K=0		R=229	G=222	B=207
C=6	M=15	Y=60	K=0		R=240	G=209	B=125
C=15	M=54	Y=38	K=0		R=213	G=137	B=137
C=33	M=71	Y=57	K=15		R=156	G=89	B=90
C=77	M=42	Y=60	K=23		R=61	G=104	B=95

DARK

C=9	M=9	Y=17	K=50		R=134	G=131	B=124
C=6	M=15	Y=60	K=50		R=139	G=123	B=73
C=15	M=54	Y=38	K=50		R=125	G=79	B=80
C=33	M=71	Y=57	K=58		R=94	G=50	B=50
C=77	M=42	Y=60	K=62		R=28	G=62	B=56

LIGHT

C=3	M=3	Y=5	K=0		R=245	G=242	B=238
C=2	M=4	Y=16	K=0		R=250	G=239	B=214
C=4	M=15	Y=10	K=0		R=240	G=217	B=214
C=9	M=19	Y=16	K=4		R=218	G=195	B=192
C=21	M=11	Y=16	K=6		R=188	G=196	B=194

MUTED

C=12	M=13	Y=15	K=0		R=222	G=215	B=208
C=24	M=26	Y=43	K=0		R=198	G=179	B=149
C=27	M=42	Y=36	K=0		R=188	G=152	B=149
C=45	M=58	Y=53	K=15		R=135	G=103	B=100
C=66	M=53	Y=60	K=23		R=89	G=95	B=90

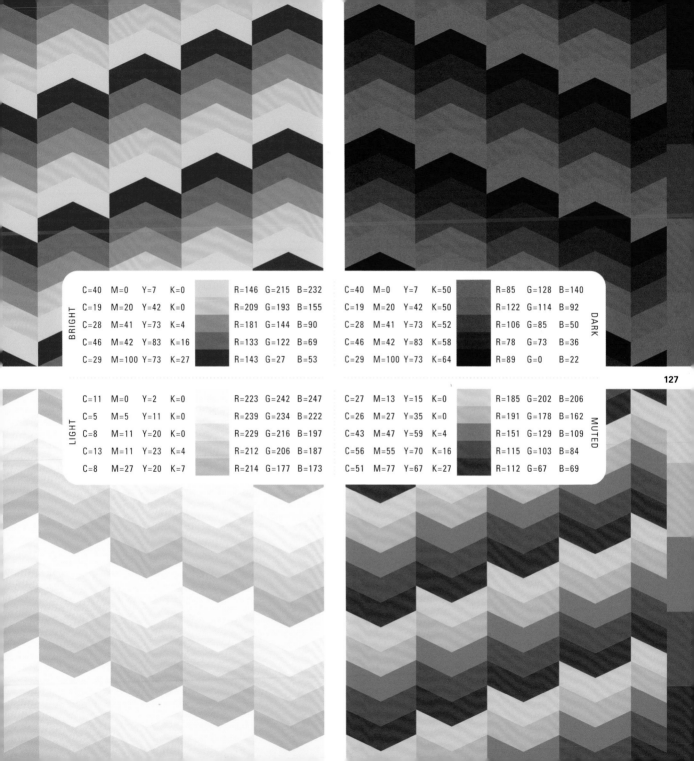

	C=40	M=0	Y=7	K=0		R=146	G=215	B=232
BRIGHT	C=19	M=20	Y=42	K=0		R=209	G=193	B=155
	C=28	M=41	Y=73	K=4		R=181	G=144	B=90
	C=46	M=42	Y=83	K=16		R=133	G=122	B=69
	C=29	M=100	Y=73	K=27		R=143	G=27	B=53

	C=40	M=0	Y=7	K=50		R=85	G=128	B=140
	C=19	M=20	Y=42	K=50		R=122	G=114	B=92
	C=28	M=41	Y=73	K=52		R=106	G=85	B=50
	C=46	M=42	Y=83	K=58		R=78	G=73	B=36
	C=29	M=100	Y=73	K=64		R=89	G=0	B=22
DARK

	C=11	M=0	Y=2	K=0		R=223	G=242	B=247
LIGHT	C=5	M=5	Y=11	K=0		R=239	G=234	B=222
	C=8	M=11	Y=20	K=0		R=229	G=216	B=197
	C=13	M=11	Y=23	K=4		R=212	G=206	B=187
	C=8	M=27	Y=20	K=7		R=214	G=177	B=173

	C=27	M=13	Y=15	K=0		R=185	G=202	B=206
	C=26	M=27	Y=35	K=0		R=191	G=178	B=162
	C=43	M=47	Y=59	K=4		R=151	G=129	B=109
	C=56	M=55	Y=70	K=16		R=115	G=103	B=84
	C=51	M=77	Y=67	K=27		R=112	G=67	B=69
MUTED

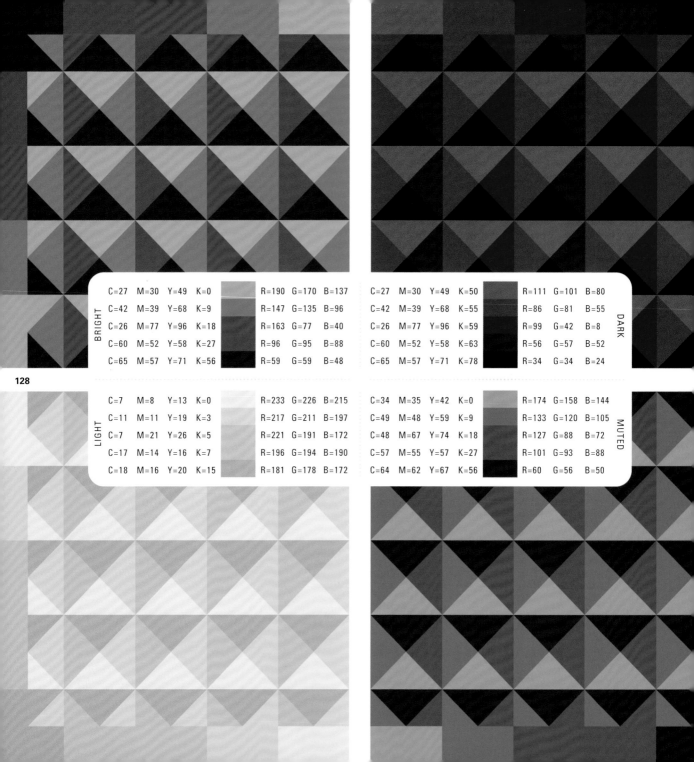

	BRIGHT							
	C=27	M=30	Y=49	K=0		R=190	G=170	B=137
	C=42	M=39	Y=68	K=9		R=147	G=135	B=96
	C=26	M=77	Y=96	K=18		R=163	G=77	B=40
	C=60	M=52	Y=58	K=27		R=96	G=95	B=88
	C=65	M=57	Y=71	K=56		R=59	G=59	B=48

DARK							
C=27	M=30	Y=49	K=50		R=111	G=101	B=80
C=42	M=39	Y=68	K=55		R=86	G=81	B=55
C=26	M=77	Y=96	K=59		R=99	G=42	B=8
C=60	M=52	Y=58	K=63		R=56	G=57	B=52
C=65	M=57	Y=71	K=78		R=34	G=34	B=24

LIGHT							
C=7	M=8	Y=13	K=0		R=233	G=226	B=215
C=11	M=11	Y=19	K=3		R=217	G=211	B=197
C=7	M=21	Y=26	K=5		R=221	G=191	B=172
C=17	M=14	Y=16	K=7		R=196	G=194	B=190
C=18	M=16	Y=20	K=15		R=181	G=178	B=172

MUTED							
C=34	M=35	Y=42	K=0		R=174	G=158	B=144
C=49	M=48	Y=59	K=9		R=133	G=120	B=105
C=48	M=67	Y=74	K=18		R=127	G=88	B=72
C=57	M=55	Y=57	K=27		R=101	G=93	B=88
C=64	M=62	Y=67	K=56		R=60	G=56	B=50

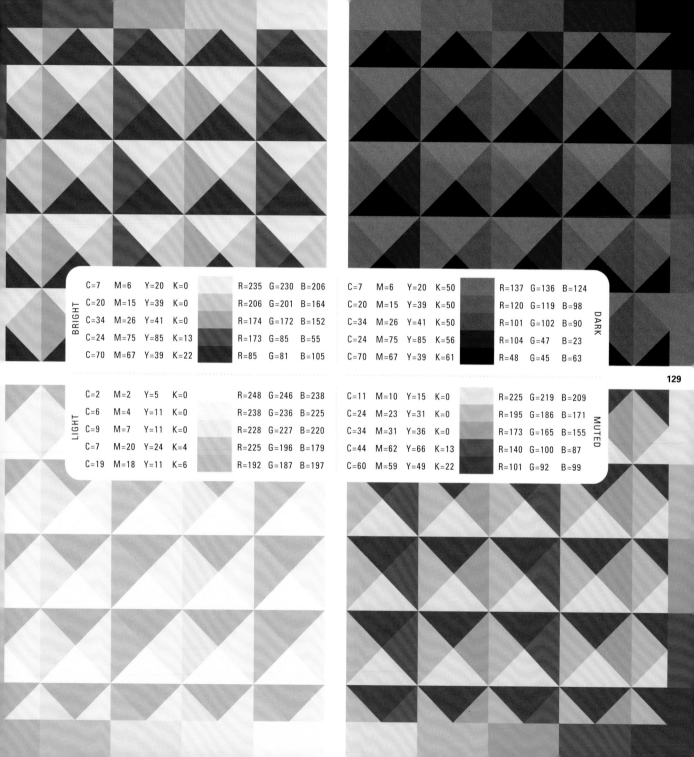

BRIGHT

C=7	M=6	Y=20	K=0		R=235	G=230	B=206
C=20	M=15	Y=39	K=0		R=206	G=201	B=164
C=34	M=26	Y=41	K=0		R=174	G=172	B=152
C=24	M=75	Y=85	K=13		R=173	G=85	B=55
C=70	M=67	Y=39	K=22		R=85	G=81	B=105

DARK

C=7	M=6	Y=20	K=50		R=137	G=136	B=124
C=20	M=15	Y=39	K=50		R=120	G=119	B=98
C=34	M=26	Y=41	K=50		R=101	G=102	B=90
C=24	M=75	Y=85	K=56		R=104	G=47	B=23
C=70	M=67	Y=39	K=61		R=48	G=45	B=63

LIGHT

C=2	M=2	Y=5	K=0		R=248	G=246	B=238
C=6	M=4	Y=11	K=0		R=238	G=236	B=225
C=9	M=7	Y=11	K=0		R=228	G=227	B=220
C=7	M=20	Y=24	K=4		R=225	G=196	B=179
C=19	M=18	Y=11	K=6		R=192	G=187	B=197

MUTED

C=11	M=10	Y=15	K=0		R=225	G=219	B=209
C=24	M=23	Y=31	K=0		R=195	G=186	B=171
C=34	M=31	Y=36	K=0		R=173	G=165	B=155
C=44	M=62	Y=66	K=13		R=140	G=100	B=87
C=60	M=59	Y=49	K=22		R=101	G=92	B=99

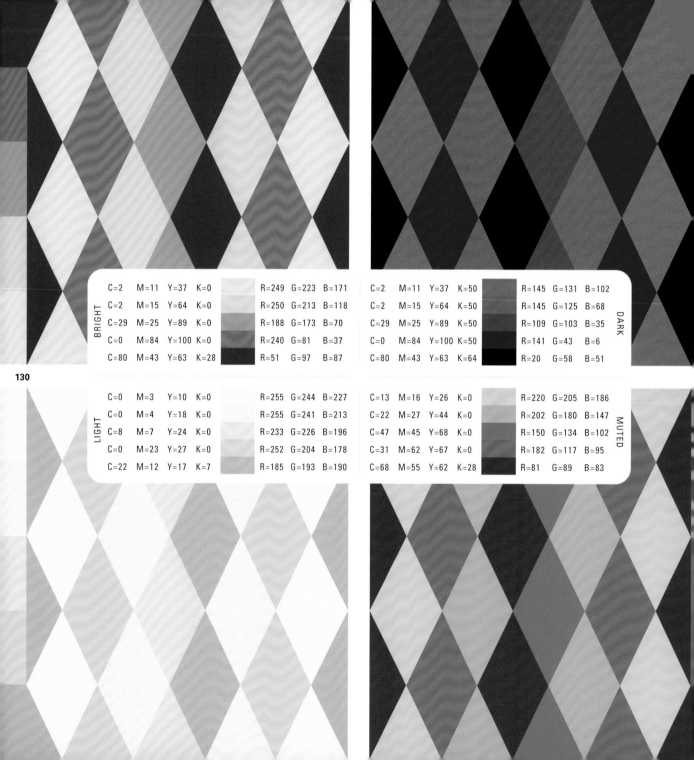

	C	M	Y	K		R	G	B
BRIGHT	C=2	M=11	Y=37	K=0		R=249	G=223	B=171
	C=2	M=15	Y=64	K=0		R=250	G=213	B=118
	C=29	M=25	Y=89	K=0		R=188	G=173	B=70
	C=0	M=84	Y=100	K=0		R=240	G=81	B=37
	C=80	M=43	Y=63	K=28		R=51	G=97	B=87

	C	M	Y	K		R	G	B
	C=2	M=11	Y=37	K=50		R=145	G=131	B=102
	C=2	M=15	Y=64	K=50		R=145	G=125	B=68
	C=29	M=25	Y=89	K=50		R=109	G=103	B=35
	C=0	M=84	Y=100	K=50		R=141	G=43	B=6
DARK	C=80	M=43	Y=63	K=64		R=20	G=58	B=51

	C	M	Y	K		R	G	B
LIGHT	C=0	M=3	Y=10	K=0		R=255	G=244	B=227
	C=0	M=4	Y=18	K=0		R=255	G=241	B=213
	C=8	M=7	Y=24	K=0		R=233	G=226	B=196
	C=0	M=23	Y=27	K=0		R=252	G=204	B=178
	C=22	M=12	Y=17	K=7		R=185	G=193	B=190

	C	M	Y	K		R	G	B
	C=13	M=16	Y=26	K=0		R=220	G=205	B=186
	C=22	M=27	Y=44	K=0		R=202	G=180	B=147
	C=47	M=45	Y=68	K=0		R=150	G=134	B=102
	C=31	M=62	Y=67	K=0		R=182	G=117	B=95
MUTED	C=68	M=55	Y=62	K=28		R=81	G=89	B=83

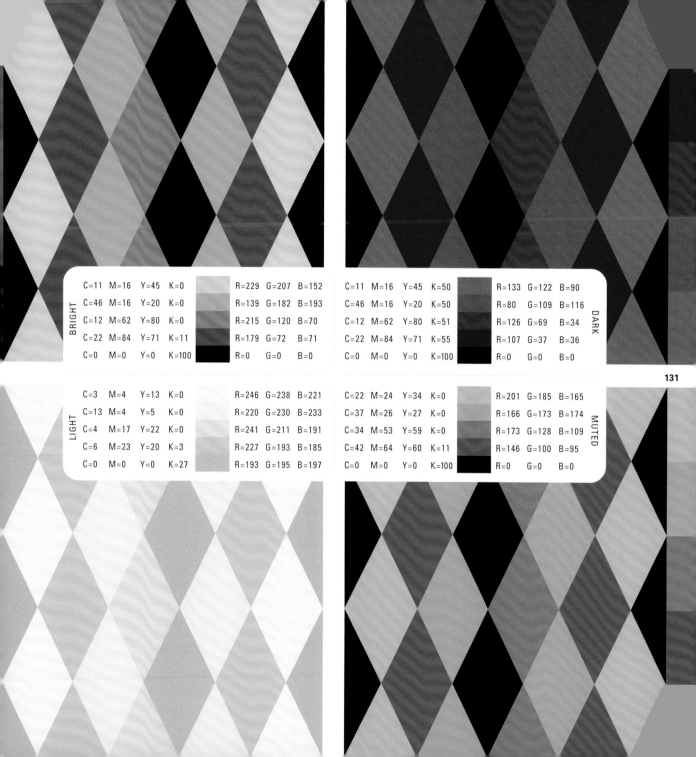

BRIGHT

C=11	M=16	Y=45	K=0		R=229	G=207	B=152
C=46	M=16	Y=20	K=0		R=139	G=182	B=193
C=12	M=62	Y=80	K=0		R=215	G=120	B=70
C=22	M=84	Y=71	K=11		R=179	G=72	B=71
C=0	M=0	Y=0	K=100		R=0	G=0	B=0

DARK

C=11	M=16	Y=45	K=50		R=133	G=122	B=90
C=46	M=16	Y=20	K=50		R=80	G=109	B=116
C=12	M=62	Y=80	K=51		R=126	G=69	B=34
C=22	M=84	Y=71	K=55		R=107	G=37	B=36
C=0	M=0	Y=0	K=100		R=0	G=0	B=0

LIGHT

C=3	M=4	Y=13	K=0		R=246	G=238	B=221
C=13	M=4	Y=5	K=0		R=220	G=230	B=233
C=4	M=17	Y=22	K=0		R=241	G=211	B=191
C=6	M=23	Y=20	K=3		R=227	G=193	B=185
C=0	M=0	Y=0	K=27		R=193	G=195	B=197

MUTED

C=22	M=24	Y=34	K=0		R=201	G=185	B=165
C=37	M=26	Y=27	K=0		R=166	G=173	B=174
C=34	M=53	Y=59	K=0		R=173	G=128	B=109
C=42	M=64	Y=60	K=11		R=146	G=100	B=95
C=0	M=0	Y=0	K=100		R=0	G=0	B=0

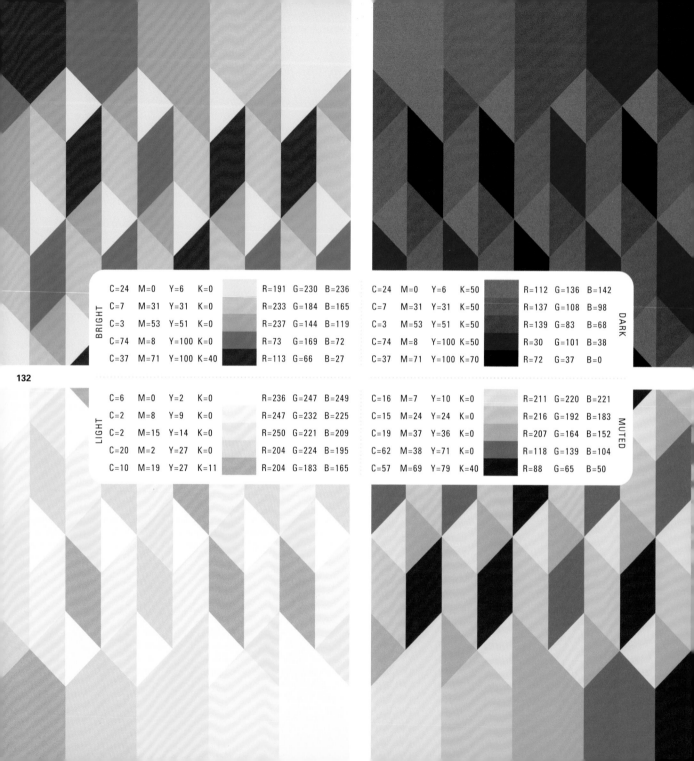

BRIGHT

C=24	M=0	Y=6	K=0		R=191	G=230	B=236
C=7	M=31	Y=31	K=0		R=233	G=184	B=165
C=3	M=53	Y=51	K=0		R=237	G=144	B=119
C=74	M=8	Y=100	K=0		R=73	G=169	B=72
C=37	M=71	Y=100	K=40		R=113	G=66	B=27

DARK

C=24	M=0	Y=6	K=50		R=112	G=136	B=142
C=7	M=31	Y=31	K=50		R=137	G=108	B=98
C=3	M=53	Y=51	K=50		R=139	G=83	B=68
C=74	M=8	Y=100	K=50		R=30	G=101	B=38
C=37	M=71	Y=100	K=70		R=72	G=37	B=0

LIGHT

C=6	M=0	Y=2	K=0		R=236	G=247	B=249
C=2	M=8	Y=9	K=0		R=247	G=232	B=225
C=2	M=15	Y=14	K=0		R=250	G=221	B=209
C=20	M=2	Y=27	K=0		R=204	G=224	B=195
C=10	M=19	Y=27	K=11		R=204	G=183	B=165

MUTED

C=16	M=7	Y=10	K=0		R=211	G=220	B=221
C=15	M=24	Y=24	K=0		R=216	G=192	B=183
C=19	M=37	Y=36	K=0		R=207	G=164	B=152
C=62	M=38	Y=71	K=0		R=118	G=139	B=104
C=57	M=69	Y=79	K=40		R=88	G=65	B=50

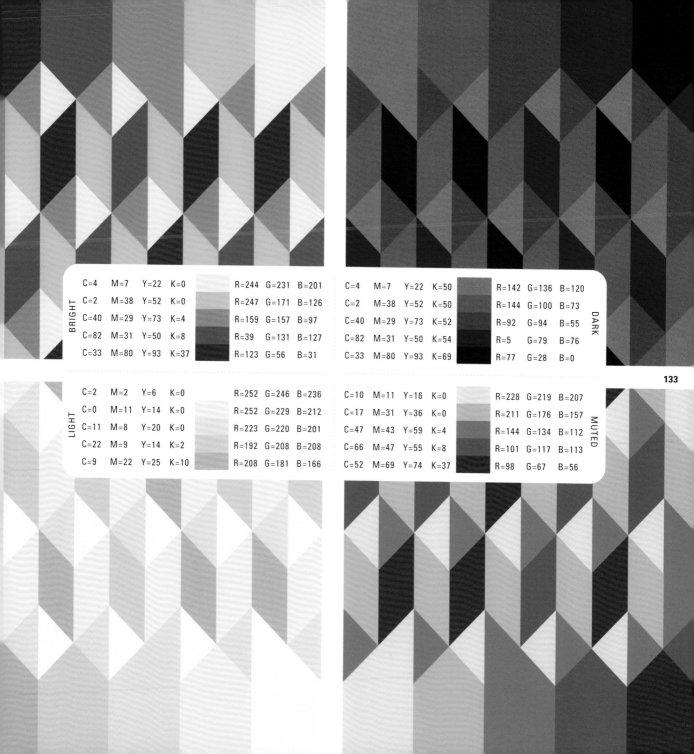

BRIGHT

C=4	M=7	Y=22	K=0		R=244	G=231	B=201
C=2	M=38	Y=52	K=0		R=247	G=171	B=126
C=40	M=29	Y=73	K=4		R=159	G=157	B=97
C=82	M=31	Y=50	K=8		R=39	G=131	B=127
C=33	M=80	Y=93	K=37		R=123	G=56	B=31

DARK

C=4	M=7	Y=22	K=50		R=142	G=136	B=120
C=2	M=38	Y=52	K=50		R=144	G=100	B=73
C=40	M=29	Y=73	K=52		R=92	G=94	B=55
C=82	M=31	Y=50	K=54		R=5	G=79	B=76
C=33	M=80	Y=93	K=69		R=77	G=28	B=0

LIGHT

C=2	M=2	Y=6	K=0		R=252	G=246	B=236
C=0	M=11	Y=14	K=0		R=252	G=229	B=212
C=11	M=8	Y=20	K=0		R=223	G=220	B=201
C=22	M=9	Y=14	K=2		R=192	G=208	B=208
C=9	M=22	Y=25	K=10		R=208	G=181	B=166

MUTED

C=10	M=11	Y=16	K=0		R=228	G=219	B=207
C=17	M=31	Y=36	K=0		R=211	G=176	B=157
C=47	M=43	Y=59	K=4		R=144	G=134	B=112
C=66	M=47	Y=55	K=8		R=101	G=117	B=113
C=52	M=69	Y=74	K=37		R=98	G=67	B=56

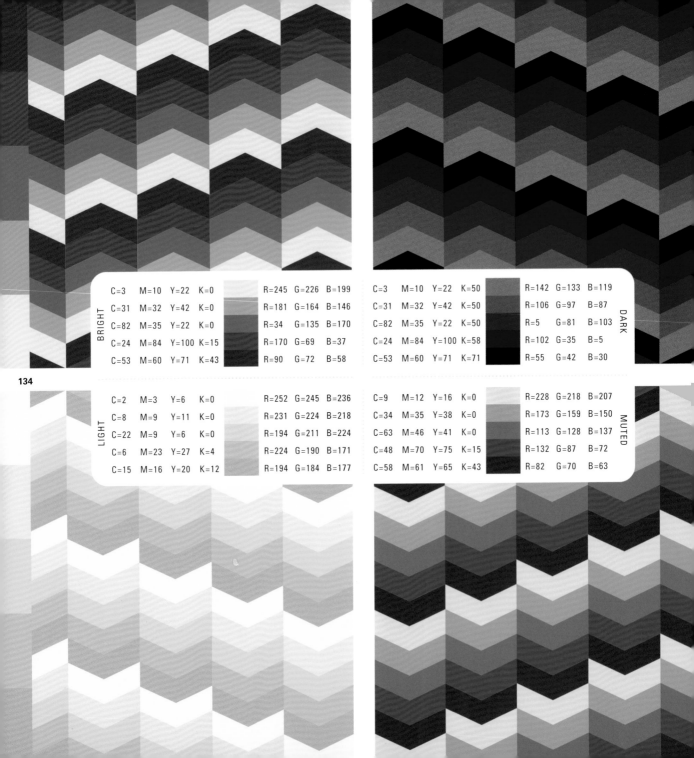

BRIGHT

C=3	M=10	Y=22	K=0		R=245	G=226	B=199
C=31	M=32	Y=42	K=0		R=181	G=164	B=146
C=82	M=35	Y=22	K=0		R=34	G=135	B=170
C=24	M=84	Y=100	K=15		R=170	G=69	B=37
C=53	M=60	Y=71	K=43		R=90	G=72	B=58

DARK

C=3	M=10	Y=22	K=50		R=142	G=133	B=119
C=31	M=32	Y=42	K=50		R=106	G=97	B=87
C=82	M=35	Y=22	K=50		R=5	G=81	B=103
C=24	M=84	Y=100	K=58		R=102	G=35	B=5
C=53	M=60	Y=71	K=71		R=55	G=42	B=30

134

LIGHT

C=2	M=3	Y=6	K=0		R=252	G=245	B=236
C=8	M=9	Y=11	K=0		R=231	G=224	B=218
C=22	M=9	Y=6	K=0		R=194	G=211	B=224
C=6	M=23	Y=27	K=4		R=224	G=190	B=171
C=15	M=16	Y=20	K=12		R=194	G=184	B=177

MUTED

C=9	M=12	Y=16	K=0		R=228	G=218	B=207
C=34	M=35	Y=38	K=0		R=173	G=159	B=150
C=63	M=46	Y=41	K=0		R=113	G=128	B=137
C=48	M=70	Y=75	K=15		R=132	G=87	B=72
C=58	M=61	Y=65	K=43		R=82	G=70	B=63

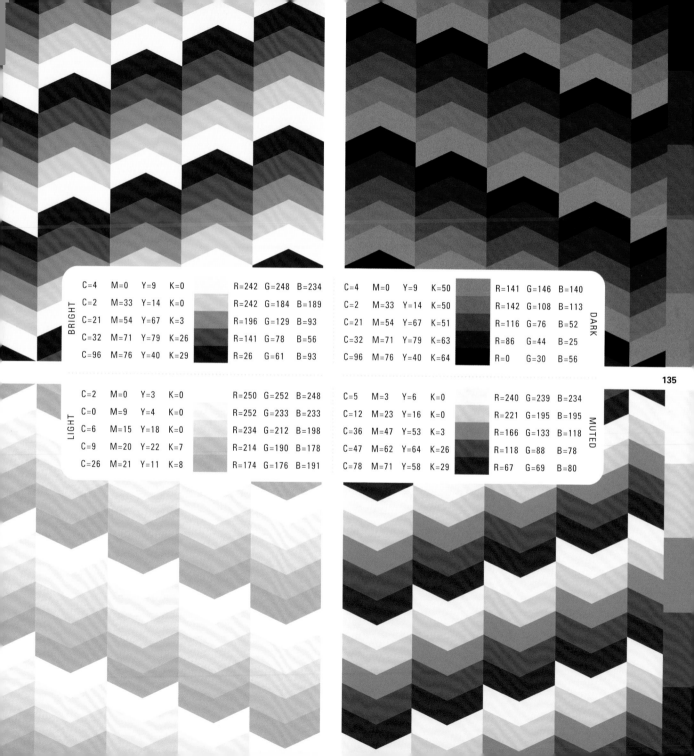

BRIGHT					R=242	G=248	B=234
C=4	M=0	Y=9	K=0		R=242	G=248	B=234
C=2	M=33	Y=14	K=0		R=242	G=184	B=189
C=21	M=54	Y=67	K=3		R=196	G=129	B=93
C=32	M=71	Y=79	K=26		R=141	G=78	B=56
C=96	M=76	Y=40	K=29		R=26	G=61	B=93

DARK							
C=4	M=0	Y=9	K=50		R=141	G=146	B=140
C=2	M=33	Y=14	K=50		R=142	G=108	B=113
C=21	M=54	Y=67	K=51		R=116	G=76	B=52
C=32	M=71	Y=79	K=63		R=86	G=44	B=25
C=96	M=76	Y=40	K=64		R=0	G=30	B=56

135

LIGHT							
C=2	M=0	Y=3	K=0		R=250	G=252	B=248
C=0	M=9	Y=4	K=0		R=252	G=233	B=233
C=6	M=15	Y=18	K=0		R=234	G=212	B=198
C=9	M=20	Y=22	K=7		R=214	G=190	B=178
C=26	M=21	Y=11	K=8		R=174	G=176	B=191

MUTED							
C=5	M=3	Y=6	K=0		R=240	G=239	B=234
C=12	M=23	Y=16	K=0		R=221	G=195	B=195
C=36	M=47	Y=53	K=3		R=166	G=133	B=118
C=47	M=62	Y=64	K=26		R=118	G=88	B=78
C=78	M=71	Y=58	K=29		R=67	G=69	B=80

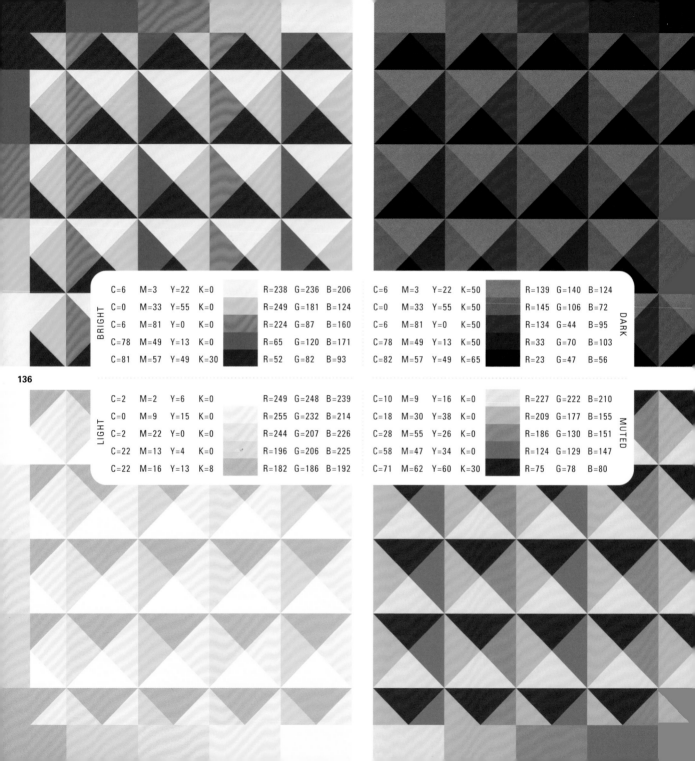

BRIGHT							
C=6	M=3	Y=22	K=0		R=238	G=236	B=206
C=0	M=33	Y=55	K=0		R=249	G=181	B=124
C=6	M=81	Y=0	K=0		R=224	G=87	B=160
C=78	M=49	Y=13	K=0		R=65	G=120	B=171
C=81	M=57	Y=49	K=30		R=52	G=82	B=93

DARK							
C=6	M=3	Y=22	K=50		R=139	G=140	B=124
C=0	M=33	Y=55	K=50		R=145	G=106	B=72
C=6	M=81	Y=0	K=50		R=134	G=44	B=95
C=78	M=49	Y=13	K=50		R=33	G=70	B=103
C=82	M=57	Y=49	K=65		R=23	G=47	B=56

LIGHT							
C=2	M=2	Y=6	K=0		R=249	G=248	B=239
C=0	M=9	Y=15	K=0		R=255	G=232	B=214
C=2	M=22	Y=0	K=0		R=244	G=207	B=226
C=22	M=13	Y=4	K=0		R=196	G=206	B=225
C=22	M=16	Y=13	K=8		R=182	G=186	B=192

MUTED							
C=10	M=9	Y=16	K=0		R=227	G=222	B=210
C=18	M=30	Y=38	K=0		R=209	G=177	B=155
C=28	M=55	Y=26	K=0		R=186	G=130	B=151
C=58	M=47	Y=34	K=0		R=124	G=129	B=147
C=71	M=62	Y=60	K=30		R=75	G=78	B=80

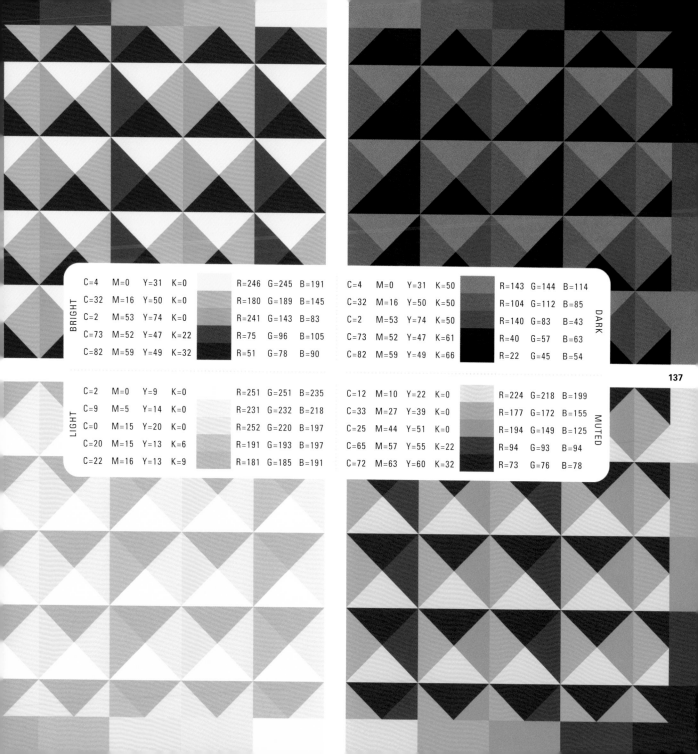

BRIGHT								
C=4	M=0	Y=31	K=0		R=246	G=245	B=191	
C=32	M=16	Y=50	K=0		R=180	G=189	B=145	
C=2	M=53	Y=74	K=0		R=241	G=143	B=83	
C=73	M=52	Y=47	K=22		R=75	G=96	B=105	
C=82	M=59	Y=49	K=32		R=51	G=78	B=90	

DARK								
C=4	M=0	Y=31	K=50		R=143	G=144	B=114	
C=32	M=16	Y=50	K=50		R=104	G=112	B=85	
C=2	M=53	Y=74	K=50		R=140	G=83	B=43	
C=73	M=52	Y=47	K=61		R=40	G=57	B=63	
C=82	M=59	Y=49	K=66		R=22	G=45	B=54	

LIGHT								
C=2	M=0	Y=9	K=0		R=251	G=251	B=235	
C=9	M=5	Y=14	K=0		R=231	G=232	B=218	
C=0	M=15	Y=20	K=0		R=252	G=220	B=197	
C=20	M=15	Y=13	K=6		R=191	G=193	B=197	
C=22	M=16	Y=13	K=9		R=181	G=185	B=191	

MUTED								
C=12	M=10	Y=22	K=0		R=224	G=218	B=199	
C=33	M=27	Y=39	K=0		R=177	G=172	B=155	
C=25	M=44	Y=51	K=0		R=194	G=149	B=125	
C=65	M=57	Y=55	K=22		R=94	G=93	B=94	
C=72	M=63	Y=60	K=32		R=73	G=76	B=78	

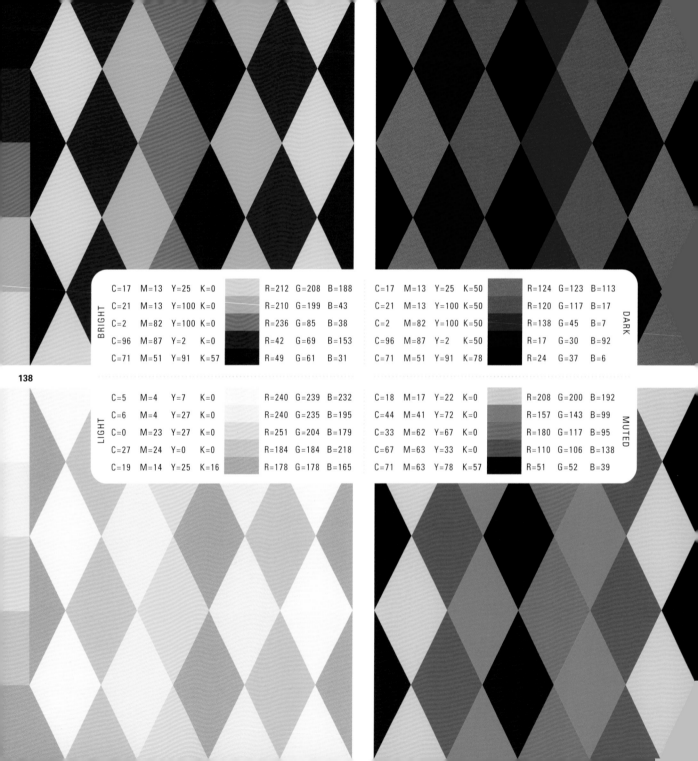

BRIGHT

C=17	M=13	Y=25	K=0
C=21	M=13	Y=100	K=0
C=2	M=82	Y=100	K=0
C=96	M=87	Y=2	K=0
C=71	M=51	Y=91	K=57

R=212	G=208	B=188
R=210	G=199	B=43
R=236	G=85	B=38
R=42	G=69	B=153
R=49	G=61	B=31

DARK

C=17	M=13	Y=25	K=50
C=21	M=13	Y=100	K=50
C=2	M=82	Y=100	K=50
C=96	M=87	Y=2	K=50
C=71	M=51	Y=91	K=78

R=124	G=123	B=113
R=120	G=117	B=17
R=138	G=45	B=7
R=17	G=30	B=92
R=24	G=37	B=6

LIGHT

C=5	M=4	Y=7	K=0
C=6	M=4	Y=27	K=0
C=0	M=23	Y=27	K=0
C=27	M=24	Y=0	K=0
C=19	M=14	Y=25	K=16

R=240	G=239	B=232
R=240	G=235	B=195
R=251	G=204	B=179
R=184	G=184	B=218
R=178	G=178	B=165

MUTED

C=18	M=17	Y=22	K=0
C=44	M=41	Y=72	K=0
C=33	M=62	Y=67	K=0
C=67	M=63	Y=33	K=0
C=71	M=63	Y=78	K=57

R=208	G=200	B=192
R=157	G=143	B=99
R=180	G=117	B=95
R=110	G=106	B=138
R=51	G=52	B=39

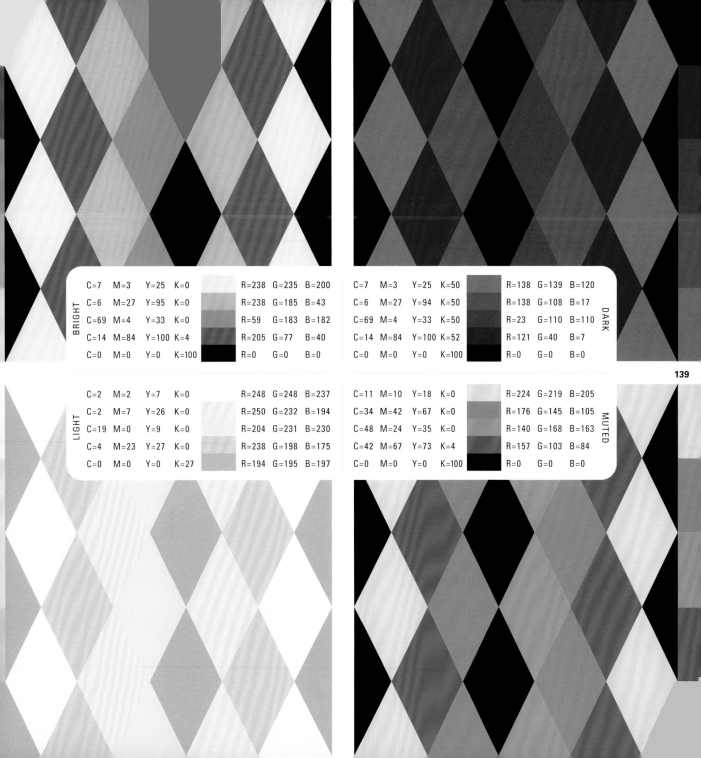

BRIGHT

C=7	M=3	Y=25	K=0		R=238	G=235	B=200
C=6	M=27	Y=95	K=0		R=238	G=185	B=43
C=69	M=4	Y=33	K=0		R=59	G=183	B=182
C=14	M=84	Y=100	K=4		R=205	G=77	B=40
C=0	M=0	Y=0	K=100		R=0	G=0	B=0

DARK

C=7	M=3	Y=25	K=50		R=138	G=139	B=120
C=6	M=27	Y=94	K=50		R=138	G=108	B=17
C=69	M=4	Y=33	K=50		R=23	G=110	B=110
C=14	M=84	Y=100	K=52		R=121	G=40	B=7
C=0	M=0	Y=0	K=100		R=0	G=0	B=0

LIGHT

C=2	M=2	Y=7	K=0		R=248	G=248	B=237
C=2	M=7	Y=26	K=0		R=250	G=232	B=194
C=19	M=0	Y=9	K=0		R=204	G=231	B=230
C=4	M=23	Y=27	K=0		R=238	G=198	B=175
C=0	M=0	Y=0	K=27		R=194	G=195	B=197

MUTED

C=11	M=10	Y=18	K=0		R=224	G=219	B=205
C=34	M=42	Y=67	K=0		R=176	G=145	B=105
C=48	M=24	Y=35	K=0		R=140	G=168	B=163
C=42	M=67	Y=73	K=4		R=157	G=103	B=84
C=0	M=0	Y=0	K=100		R=0	G=0	B=0

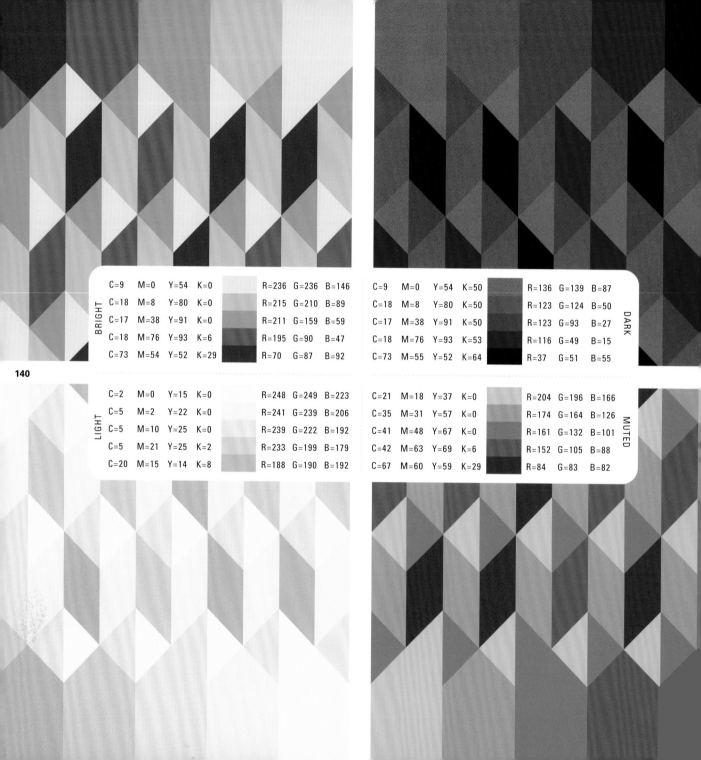

140

BRIGHT

C=9	M=0	Y=54	K=0		R=236	G=236	B=146
C=18	M=8	Y=80	K=0		R=215	G=210	B=89
C=17	M=38	Y=91	K=0		R=211	G=159	B=59
C=18	M=76	Y=93	K=6		R=195	G=90	B=47
C=73	M=54	Y=52	K=29		R=70	G=87	B=92

DARK

C=9	M=0	Y=54	K=50		R=136	G=139	B=87
C=18	M=8	Y=80	K=50		R=123	G=124	B=50
C=17	M=38	Y=91	K=50		R=123	G=93	B=27
C=18	M=76	Y=93	K=53		R=116	G=49	B=15
C=73	M=55	Y=52	K=64		R=37	G=51	B=55

LIGHT

C=2	M=0	Y=15	K=0		R=248	G=249	B=223
C=5	M=2	Y=22	K=0		R=241	G=239	B=206
C=5	M=10	Y=25	K=0		R=239	G=222	B=192
C=5	M=21	Y=25	K=2		R=233	G=199	B=179
C=20	M=15	Y=14	K=8		R=188	G=190	B=192

MUTED

C=21	M=18	Y=37	K=0		R=204	G=196	B=166
C=35	M=31	Y=57	K=0		R=174	G=164	B=126
C=41	M=48	Y=67	K=0		R=161	G=132	B=101
C=42	M=63	Y=69	K=6		R=152	G=105	B=88
C=67	M=60	Y=59	K=29		R=84	G=83	B=82

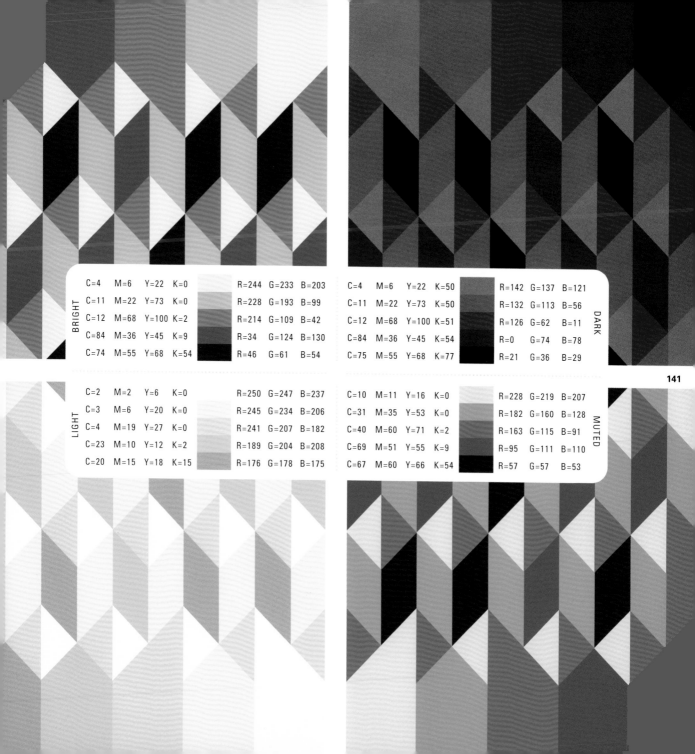

BRIGHT

C=4	M=6	Y=22	K=0		R=244	G=233	B=203
C=11	M=22	Y=73	K=0		R=228	G=193	B=99
C=12	M=68	Y=100	K=2		R=214	G=109	B=42
C=84	M=36	Y=45	K=9		R=34	G=124	B=130
C=74	M=55	Y=68	K=54		R=46	G=61	B=54

DARK

C=4	M=6	Y=22	K=50		R=142	G=137	B=121
C=11	M=22	Y=73	K=50		R=132	G=113	B=56
C=12	M=68	Y=100	K=51		R=126	G=62	B=11
C=84	M=36	Y=45	K=54		R=0	G=74	B=78
C=75	M=55	Y=68	K=77		R=21	G=36	B=29

LIGHT

C=2	M=2	Y=6	K=0		R=250	G=247	B=237
C=3	M=6	Y=20	K=0		R=245	G=234	B=206
C=4	M=19	Y=27	K=0		R=241	G=207	B=182
C=23	M=10	Y=12	K=2		R=189	G=204	B=208
C=20	M=15	Y=18	K=15		R=176	G=178	B=175

MUTED

C=10	M=11	Y=16	K=0		R=228	G=219	B=207
C=31	M=35	Y=53	K=0		R=182	G=160	B=128
C=40	M=60	Y=71	K=2		R=163	G=115	B=91
C=69	M=51	Y=55	K=9		R=95	G=111	B=110
C=67	M=60	Y=66	K=54		R=57	G=57	B=53

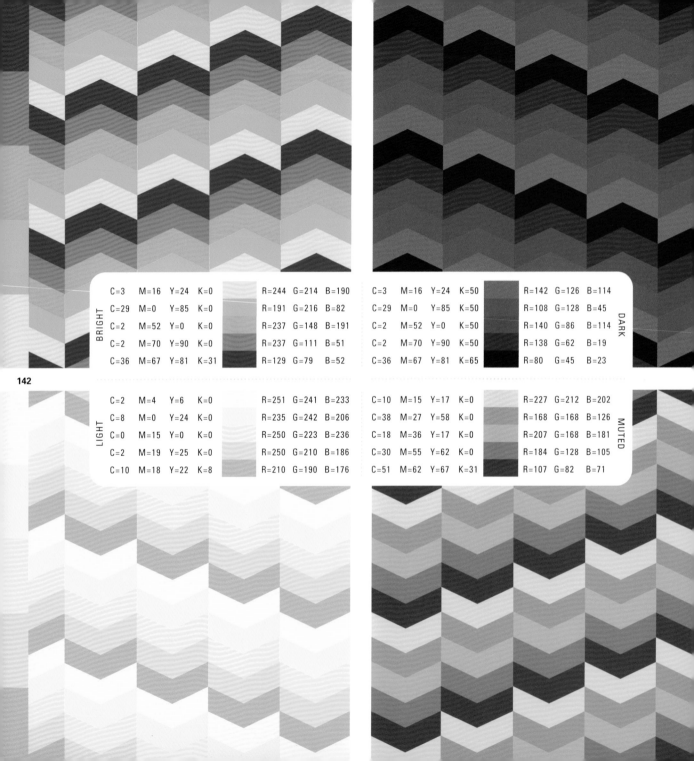

142

BRIGHT

C=3	M=16	Y=24	K=0		R=244	G=214	B=190
C=29	M=0	Y=85	K=0		R=191	G=216	B=82
C=2	M=52	Y=0	K=0		R=237	G=148	B=191
C=2	M=70	Y=90	K=0		R=237	G=111	B=51
C=36	M=67	Y=81	K=31		R=129	G=79	B=52

DARK

C=3	M=16	Y=24	K=50		R=142	G=126	B=114
C=29	M=0	Y=85	K=50		R=108	G=128	B=45
C=2	M=52	Y=0	K=50		R=140	G=86	B=114
C=2	M=70	Y=90	K=50		R=138	G=62	B=19
C=36	M=67	Y=81	K=65		R=80	G=45	B=23

LIGHT

C=2	M=4	Y=6	K=0		R=251	G=241	B=233
C=8	M=0	Y=24	K=0		R=235	G=242	B=206
C=0	M=15	Y=0	K=0		R=250	G=223	B=236
C=2	M=19	Y=25	K=0		R=250	G=210	B=186
C=10	M=18	Y=22	K=8		R=210	G=190	B=176

MUTED

C=10	M=15	Y=17	K=0		R=227	G=212	B=202
C=38	M=27	Y=58	K=0		R=168	G=168	B=126
C=18	M=36	Y=17	K=0		R=207	G=168	B=181
C=30	M=55	Y=62	K=0		R=184	G=128	B=105
C=51	M=62	Y=67	K=31		R=107	G=82	B=71

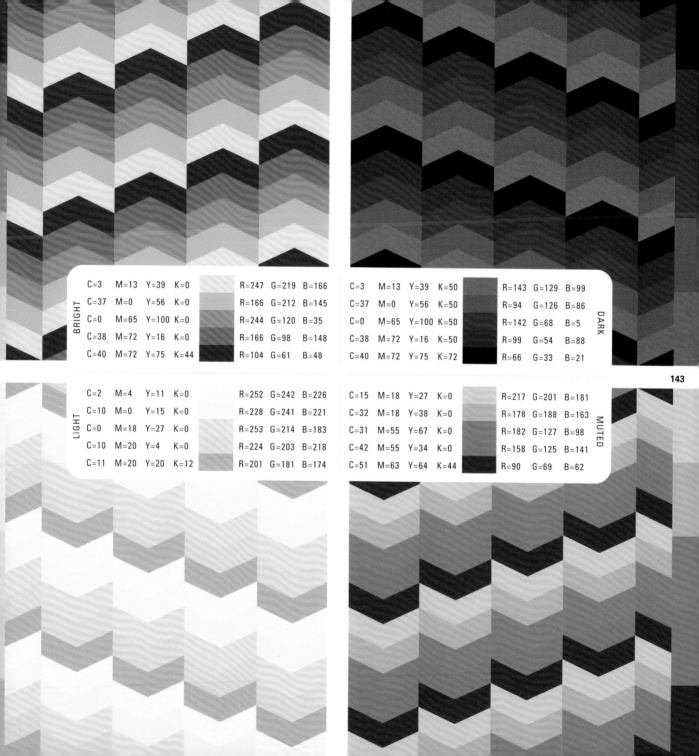

BRIGHT

C=3	M=13	Y=39	K=0		R=247	G=219	B=166
C=37	M=0	Y=56	K=0		R=166	G=212	B=145
C=0	M=65	Y=100	K=0		R=244	G=120	B=35
C=38	M=72	Y=16	K=0		R=166	G=98	B=148
C=40	M=72	Y=75	K=44		R=104	G=61	B=48

DARK

C=3	M=13	Y=39	K=50		R=143	G=129	B=99
C=37	M=0	Y=56	K=50		R=94	G=126	B=86
C=0	M=65	Y=100	K=50		R=142	G=68	B=5
C=38	M=72	Y=16	K=50		R=99	G=54	B=88
C=40	M=72	Y=75	K=72		R=66	G=33	B=21

LIGHT

C=2	M=4	Y=11	K=0		R=252	G=242	B=226
C=10	M=0	Y=15	K=0		R=228	G=241	B=221
C=0	M=18	Y=27	K=0		R=253	G=214	B=183
C=10	M=20	Y=4	K=0		R=224	G=203	B=218
C=11	M=20	Y=20	K=12		R=201	G=181	B=174

MUTED

C=15	M=18	Y=27	K=0		R=217	G=201	B=181
C=32	M=18	Y=38	K=0		R=178	G=188	B=163
C=31	M=55	Y=67	K=0		R=182	G=127	B=98
C=42	M=55	Y=34	K=0		R=158	G=125	B=141
C=51	M=63	Y=64	K=44		R=90	G=69	B=62

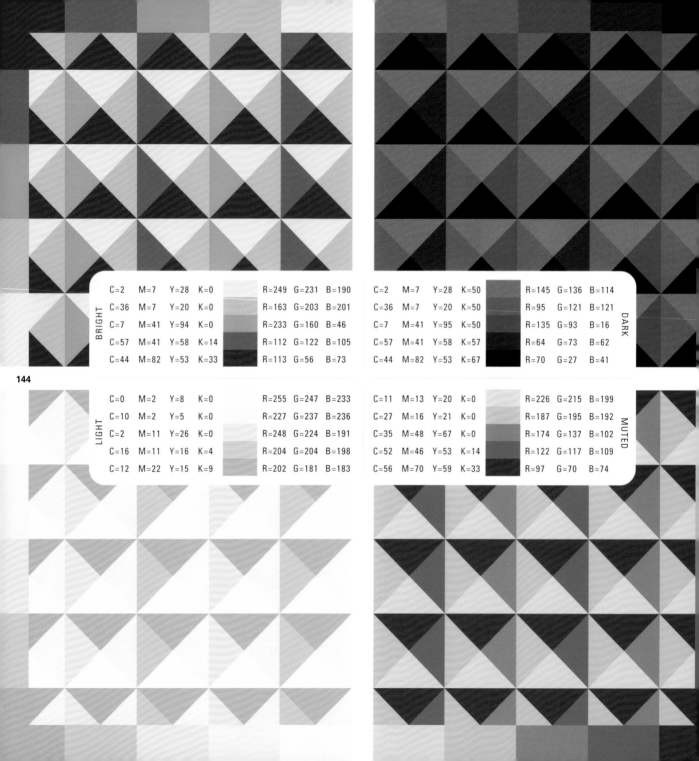

	C	M	Y	K		R	G	B
BRIGHT	C=2	M=7	Y=28	K=0		R=249	G=231	B=190
	C=36	M=7	Y=20	K=0		R=163	G=203	B=201
	C=7	M=41	Y=94	K=0		R=233	G=160	B=46
	C=57	M=41	Y=58	K=14		R=112	G=122	B=105
	C=44	M=82	Y=53	K=33		R=113	G=56	B=73

	C	M	Y	K		R	G	B
DARK	C=2	M=7	Y=28	K=50		R=145	G=136	B=114
	C=36	M=7	Y=20	K=50		R=95	G=121	B=121
	C=7	M=41	Y=95	K=50		R=135	G=93	B=16
	C=57	M=41	Y=58	K=57		R=64	G=73	B=62
	C=44	M=82	Y=53	K=67		R=70	G=27	B=41

	C	M	Y	K		R	G	B
LIGHT	C=0	M=2	Y=8	K=0		R=255	G=247	B=233
	C=10	M=2	Y=5	K=0		R=227	G=237	B=236
	C=2	M=11	Y=26	K=0		R=248	G=224	B=191
	C=16	M=11	Y=16	K=4		R=204	G=204	B=198
	C=12	M=22	Y=15	K=9		R=202	G=181	B=183

	C	M	Y	K		R	G	B
MUTED	C=11	M=13	Y=20	K=0		R=226	G=215	B=199
	C=27	M=16	Y=21	K=0		R=187	G=195	B=192
	C=35	M=48	Y=67	K=0		R=174	G=137	B=102
	C=52	M=46	Y=53	K=14		R=122	G=117	B=109
	C=56	M=70	Y=59	K=33		R=97	G=70	B=74

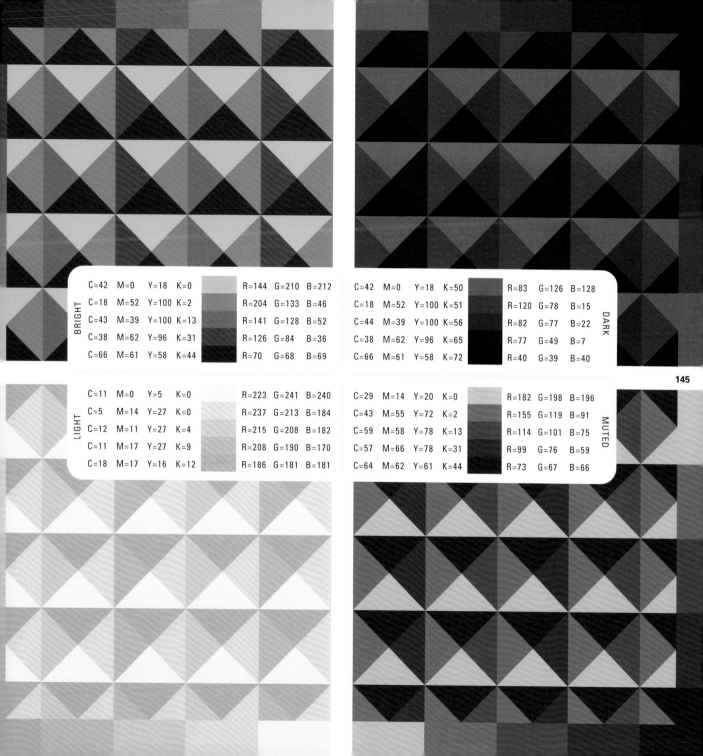

BRIGHT

C=42	M=0	Y=18	K=0		R=144	G=210	B=212
C=18	M=52	Y=100	K=2		R=204	G=133	B=46
C=43	M=39	Y=100	K=13		R=141	G=128	B=52
C=38	M=62	Y=96	K=31		R=126	G=84	B=36
C=66	M=61	Y=58	K=44		R=70	G=68	B=69

DARK

C=42	M=0	Y=18	K=50		R=83	G=126	B=128
C=18	M=52	Y=100	K=51		R=120	G=78	B=15
C=44	M=39	Y=100	K=56		R=82	G=77	B=22
C=38	M=62	Y=96	K=65		R=77	G=49	B=7
C=66	M=61	Y=58	K=72		R=40	G=39	B=40

LIGHT

C=11	M=0	Y=5	K=0		R=223	G=241	B=240
C=5	M=14	Y=27	K=0		R=237	G=213	B=184
C=12	M=11	Y=27	K=4		R=215	G=208	B=182
C=11	M=17	Y=27	K=9		R=208	G=190	B=170
C=18	M=17	Y=16	K=12		R=186	G=181	B=181

MUTED

C=29	M=14	Y=20	K=0		R=182	G=198	B=196
C=43	M=55	Y=72	K=2		R=155	G=119	B=91
C=59	M=58	Y=78	K=13		R=114	G=101	B=75
C=57	M=66	Y=78	K=31		R=99	G=76	B=59
C=64	M=62	Y=61	K=44		R=73	G=67	B=66

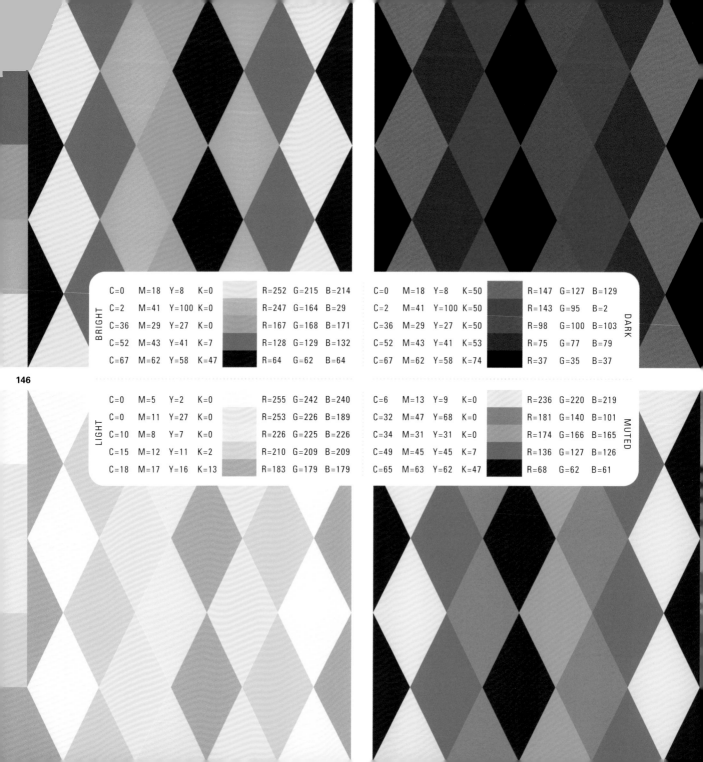

BRIGHT

C=0	M=18	Y=8	K=0		R=252	G=215	B=214
C=2	M=41	Y=100	K=0		R=247	G=164	B=29
C=36	M=29	Y=27	K=0		R=167	G=168	B=171
C=52	M=43	Y=41	K=7		R=128	G=129	B=132
C=67	M=62	Y=58	K=47		R=64	G=62	B=64

DARK

C=0	M=18	Y=8	K=50		R=147	G=127	B=129
C=2	M=41	Y=100	K=50		R=143	G=95	B=2
C=36	M=29	Y=27	K=50		R=98	G=100	B=103
C=52	M=43	Y=41	K=53		R=75	G=77	B=79
C=67	M=62	Y=58	K=74		R=37	G=35	B=37

LIGHT

C=0	M=5	Y=2	K=0		R=255	G=242	B=240
C=0	M=11	Y=27	K=0		R=253	G=226	B=189
C=10	M=8	Y=7	K=0		R=226	G=225	B=226
C=15	M=12	Y=11	K=2		R=210	G=209	B=209
C=18	M=17	Y=16	K=13		R=183	G=179	B=179

MUTED

C=6	M=13	Y=9	K=0		R=236	G=220	B=219
C=32	M=47	Y=68	K=0		R=181	G=140	B=101
C=34	M=31	Y=31	K=0		R=174	G=166	B=165
C=49	M=45	Y=45	K=7		R=136	G=127	B=126
C=65	M=63	Y=62	K=47		R=68	G=62	B=61

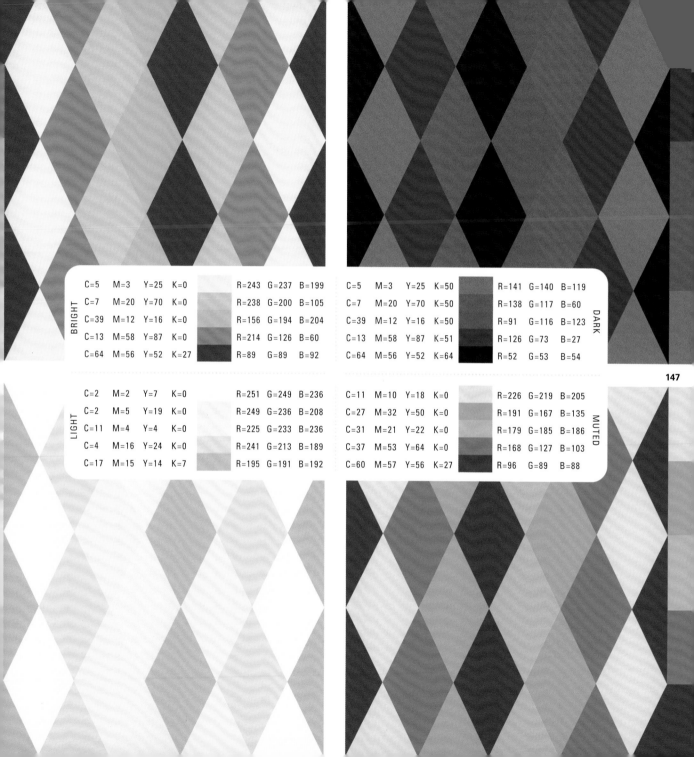

BRIGHT

					R	G	B
C=5	M=3	Y=25	K=0		R=243	G=237	B=199
C=7	M=20	Y=70	K=0		R=238	G=200	B=105
C=39	M=12	Y=16	K=0		R=156	G=194	B=204
C=13	M=58	Y=87	K=0		R=214	G=126	B=60
C=64	M=56	Y=52	K=27		R=89	G=89	B=92

DARK

					R	G	B
C=5	M=3	Y=25	K=50		R=141	G=140	B=119
C=7	M=20	Y=70	K=50		R=138	G=117	B=60
C=39	M=12	Y=16	K=50		R=91	G=116	B=123
C=13	M=58	Y=87	K=51		R=126	G=73	B=27
C=64	M=56	Y=52	K=64		R=52	G=53	B=54

LIGHT

					R	G	B
C=2	M=2	Y=7	K=0		R=251	G=249	B=236
C=2	M=5	Y=19	K=0		R=249	G=236	B=208
C=11	M=4	Y=4	K=0		R=225	G=233	B=236
C=4	M=16	Y=24	K=0		R=241	G=213	B=189
C=17	M=15	Y=14	K=7		R=195	G=191	B=192

MUTED

					R	G	B
C=11	M=10	Y=18	K=0		R=226	G=219	B=205
C=27	M=32	Y=50	K=0		R=191	G=167	B=135
C=31	M=21	Y=22	K=0		R=179	G=185	B=186
C=37	M=53	Y=64	K=0		R=168	G=127	B=103
C=60	M=57	Y=56	K=27		R=96	G=89	B=88

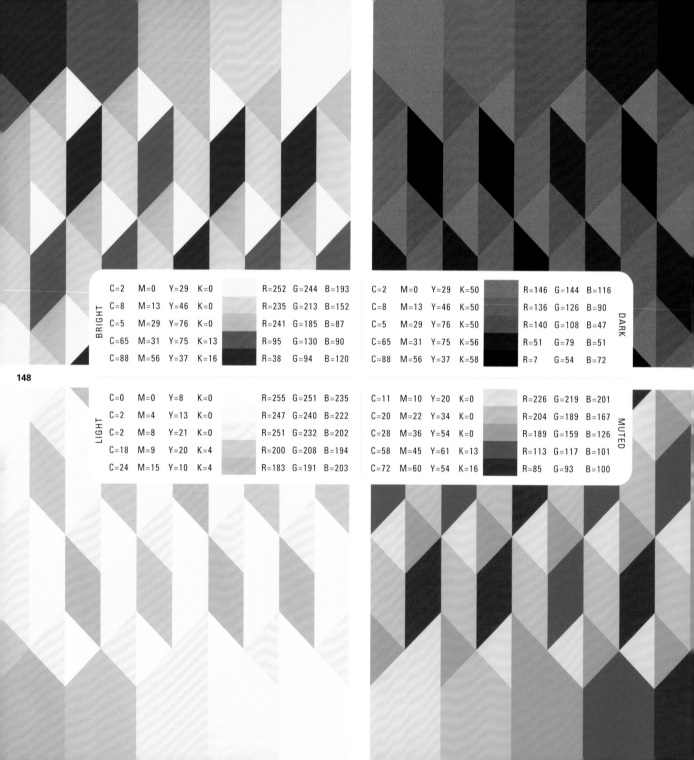

	C	M	Y	K		R	G	B
BRIGHT	C=2	M=0	Y=29	K=0		R=252	G=244	B=193
	C=8	M=13	Y=46	K=0		R=235	G=213	B=152
	C=5	M=29	Y=76	K=0		R=241	G=185	B=87
	C=65	M=31	Y=75	K=13		R=95	G=130	B=90
	C=88	M=56	Y=37	K=16		R=38	G=94	B=120

	C	M	Y	K		R	G	B
DARK	C=2	M=0	Y=29	K=50		R=146	G=144	B=116
	C=8	M=13	Y=46	K=50		R=136	G=126	B=90
	C=5	M=29	Y=76	K=50		R=140	G=108	B=47
	C=65	M=31	Y=75	K=56		R=51	G=79	B=51
	C=88	M=56	Y=37	K=58		R=7	G=54	B=72

	C	M	Y	K		R	G	B
LIGHT	C=0	M=0	Y=8	K=0		R=255	G=251	B=235
	C=2	M=4	Y=13	K=0		R=247	G=240	B=222
	C=2	M=8	Y=21	K=0		R=251	G=232	B=202
	C=18	M=9	Y=20	K=4		R=200	G=208	B=194
	C=24	M=15	Y=10	K=4		R=183	G=191	B=203

	C	M	Y	K		R	G	B
MUTED	C=11	M=10	Y=20	K=0		R=226	G=219	B=201
	C=20	M=22	Y=34	K=0		R=204	G=189	B=167
	C=28	M=36	Y=54	K=0		R=189	G=159	B=126
	C=58	M=45	Y=61	K=13		R=113	G=117	B=101
	C=72	M=60	Y=54	K=16		R=85	G=93	B=100

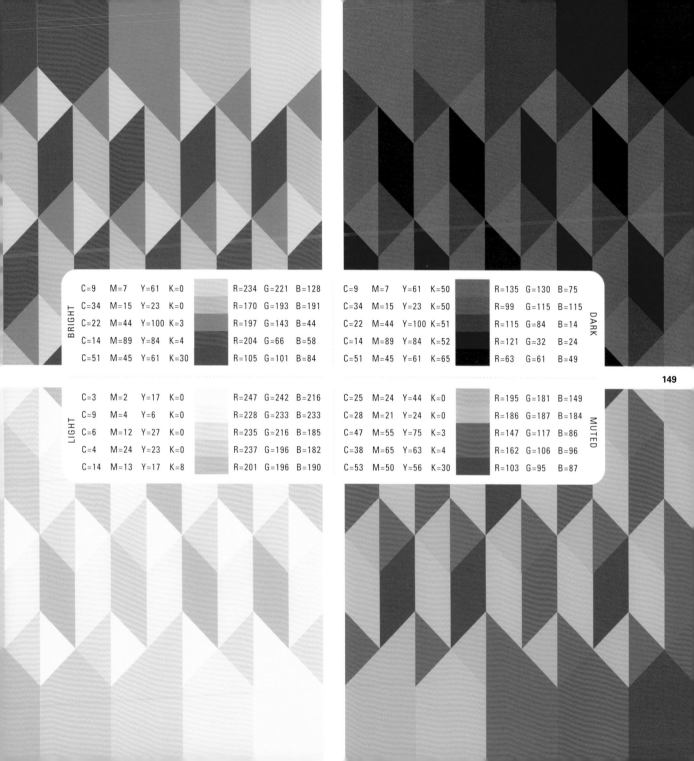

BRIGHT								
C=9	M=7	Y=61	K=0		R=234	G=221	B=128	
C=34	M=15	Y=23	K=0		R=170	G=193	B=191	
C=22	M=44	Y=100	K=3		R=197	G=143	B=44	
C=14	M=89	Y=84	K=4		R=204	G=66	B=58	
C=51	M=45	Y=61	K=30		R=105	G=101	B=84	

DARK								
C=9	M=7	Y=61	K=50		R=135	G=130	B=75	
C=34	M=15	Y=23	K=50		R=99	G=115	B=115	
C=22	M=44	Y=100	K=51		R=115	G=84	B=14	
C=14	M=89	Y=84	K=52		R=121	G=32	B=24	
C=51	M=45	Y=61	K=65		R=63	G=61	B=49	

LIGHT								
C=3	M=2	Y=17	K=0		R=247	G=242	B=216	
C=9	M=4	Y=6	K=0		R=228	G=233	B=233	
C=6	M=12	Y=27	K=0		R=235	G=216	B=185	
C=4	M=24	Y=23	K=0		R=237	G=196	B=182	
C=14	M=13	Y=17	K=8		R=201	G=196	B=190	

MUTED								
C=25	M=24	Y=44	K=0		R=195	G=181	B=149	
C=28	M=21	Y=24	K=0		R=186	G=187	B=184	
C=47	M=55	Y=75	K=3		R=147	G=117	B=86	
C=38	M=65	Y=63	K=4		R=162	G=106	B=96	
C=53	M=50	Y=56	K=30		R=103	G=95	B=87	

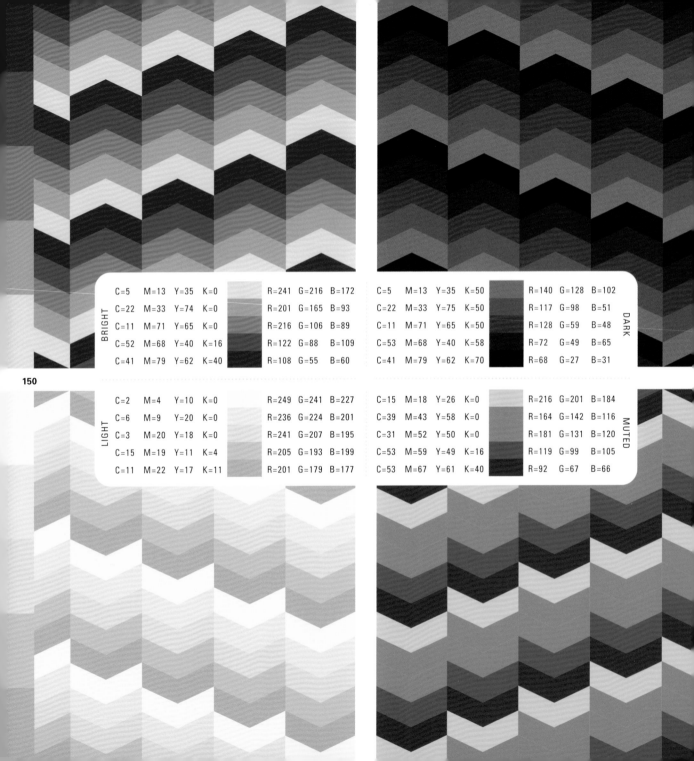

BRIGHT

C=5	M=13	Y=35	K=0	R=241	G=216	B=172	
C=22	M=33	Y=74	K=0	R=201	G=165	B=93	
C=11	M=71	Y=65	K=0	R=216	G=106	B=89	
C=52	M=68	Y=40	K=16	R=122	G=88	B=109	
C=41	M=79	Y=62	K=40	R=108	G=55	B=60	

DARK

C=5	M=13	Y=35	K=50	R=140	G=128	B=102	
C=22	M=33	Y=75	K=50	R=117	G=98	B=51	
C=11	M=71	Y=65	K=50	R=128	G=59	B=48	
C=53	M=68	Y=40	K=58	R=72	G=49	B=65	
C=41	M=79	Y=62	K=70	R=68	G=27	B=31	

LIGHT

C=2	M=4	Y=10	K=0	R=249	G=241	B=227	
C=6	M=9	Y=20	K=0	R=236	G=224	B=201	
C=3	M=20	Y=18	K=0	R=241	G=207	B=195	
C=15	M=19	Y=11	K=4	R=205	G=193	B=199	
C=11	M=22	Y=17	K=11	R=201	G=179	B=177	

MUTED

C=15	M=18	Y=26	K=0	R=216	G=201	B=184	
C=39	M=43	Y=58	K=0	R=164	G=142	B=116	
C=31	M=52	Y=50	K=0	R=181	G=131	B=120	
C=53	M=59	Y=49	K=16	R=119	G=99	B=105	
C=53	M=67	Y=61	K=40	R=92	G=67	B=66	

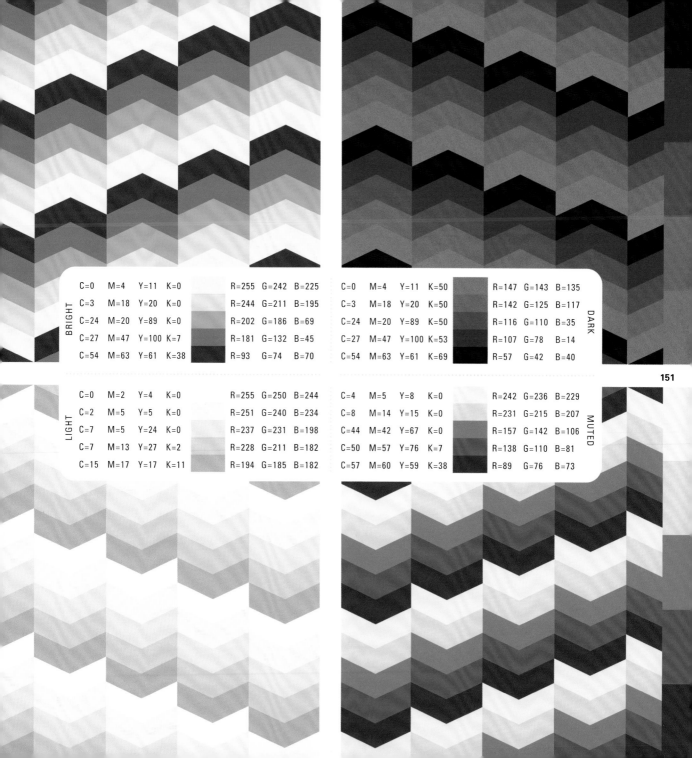

BRIGHT	C=0	M=4	Y=11	K=0	R=255	G=242	B=225
	C=3	M=18	Y=20	K=0	R=244	G=211	B=195
	C=24	M=20	Y=89	K=0	R=202	G=186	B=69
	C=27	M=47	Y=100	K=7	R=181	G=132	B=45
	C=54	M=63	Y=61	K=38	R=93	G=74	B=70

DARK	C=0	M=4	Y=11	K=50	R=147	G=143	B=135
	C=3	M=18	Y=20	K=50	R=142	G=125	B=117
	C=24	M=20	Y=89	K=50	R=116	G=110	B=35
	C=27	M=47	Y=100	K=53	R=107	G=78	B=14
	C=54	M=63	Y=61	K=69	R=57	G=42	B=40

LIGHT	C=0	M=2	Y=4	K=0	R=255	G=250	B=244
	C=2	M=5	Y=5	K=0	R=251	G=240	B=234
	C=7	M=5	Y=24	K=0	R=237	G=231	B=198
	C=7	M=13	Y=27	K=2	R=228	G=211	B=182
	C=15	M=17	Y=17	K=11	R=194	G=185	B=182

MUTED	C=4	M=5	Y=8	K=0	R=242	G=236	B=229
	C=8	M=14	Y=15	K=0	R=231	G=215	B=207
	C=44	M=42	Y=67	K=0	R=157	G=142	B=106
	C=50	M=57	Y=76	K=7	R=138	G=110	B=81
	C=57	M=60	Y=59	K=38	R=89	G=76	B=73

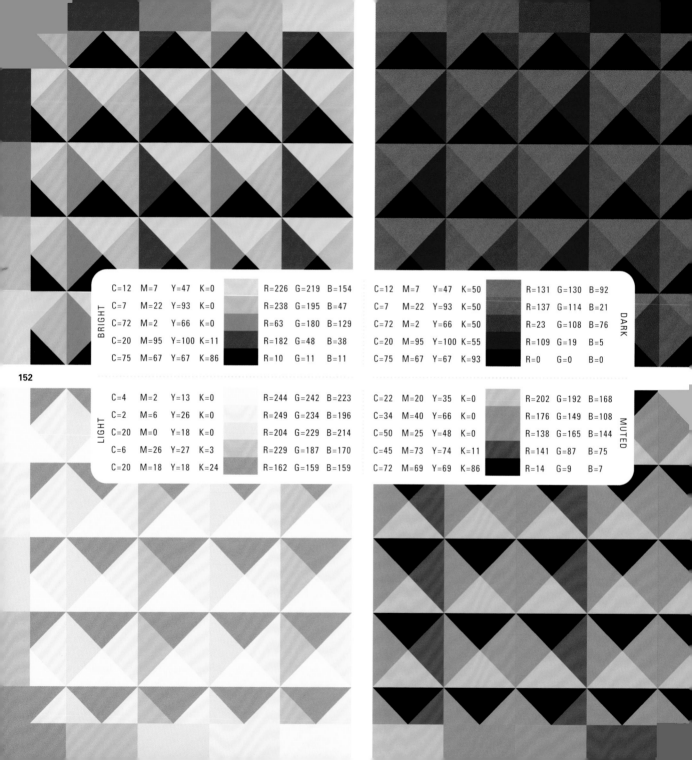

BRIGHT

C=12	M=7	Y=47	K=0		R=226	G=219	B=154
C=7	M=22	Y=93	K=0		R=238	G=195	B=47
C=72	M=2	Y=66	K=0		R=63	G=180	B=129
C=20	M=95	Y=100	K=11		R=182	G=48	B=38
C=75	M=67	Y=67	K=86		R=10	G=11	B=11

DARK

C=12	M=7	Y=47	K=50		R=131	G=130	B=92
C=7	M=22	Y=93	K=50		R=137	G=114	B=21
C=72	M=2	Y=66	K=50		R=23	G=108	B=76
C=20	M=95	Y=100	K=55		R=109	G=19	B=5
C=75	M=67	Y=67	K=93		R=0	G=0	B=0

LIGHT

C=4	M=2	Y=13	K=0		R=244	G=242	B=223
C=2	M=6	Y=26	K=0		R=249	G=234	B=196
C=20	M=0	Y=18	K=0		R=204	G=229	B=214
C=6	M=26	Y=27	K=3		R=229	G=187	B=170
C=20	M=18	Y=18	K=24		R=162	G=159	B=159

MUTED

C=22	M=20	Y=35	K=0		R=202	G=192	B=168
C=34	M=40	Y=66	K=0		R=176	G=149	B=108
C=50	M=25	Y=48	K=0		R=138	G=165	B=144
C=45	M=73	Y=74	K=11		R=141	G=87	B=75
C=72	M=69	Y=69	K=86		R=14	G=9	B=7

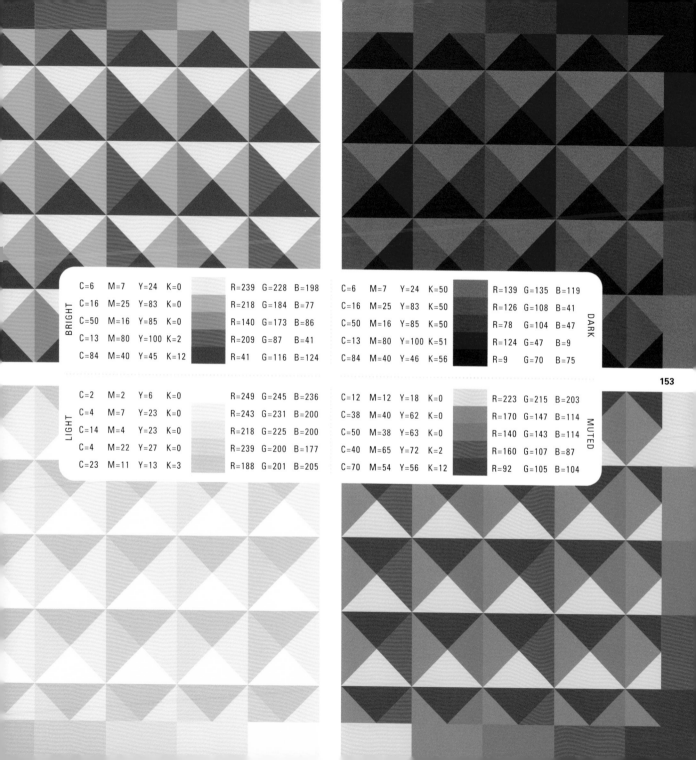

BRIGHT

C=6	M=7	Y=24	K=0		R=239	G=228	B=198
C=16	M=25	Y=83	K=0		R=218	G=184	B=77
C=50	M=16	Y=85	K=0		R=140	G=173	B=86
C=13	M=80	Y=100	K=2		R=209	G=87	B=41
C=84	M=40	Y=45	K=12		R=41	G=116	B=124

DARK

C=6	M=7	Y=24	K=50		R=139	G=135	B=119
C=16	M=25	Y=83	K=50		R=126	G=108	B=41
C=50	M=16	Y=85	K=50		R=78	G=104	B=47
C=13	M=80	Y=100	K=51		R=124	G=47	B=9
C=84	M=40	Y=46	K=56		R=9	G=70	B=75

153

LIGHT

C=2	M=2	Y=6	K=0		R=249	G=245	B=236
C=4	M=7	Y=23	K=0		R=243	G=231	B=200
C=14	M=4	Y=23	K=0		R=218	G=225	B=200
C=4	M=22	Y=27	K=0		R=239	G=200	B=177
C=23	M=11	Y=13	K=3		R=188	G=201	B=205

MUTED

C=12	M=12	Y=18	K=0		R=223	G=215	B=203
C=38	M=40	Y=62	K=0		R=170	G=147	B=114
C=50	M=38	Y=63	K=0		R=140	G=143	B=114
C=40	M=65	Y=72	K=2		R=160	G=107	B=87
C=70	M=54	Y=56	K=12		R=92	G=105	B=104

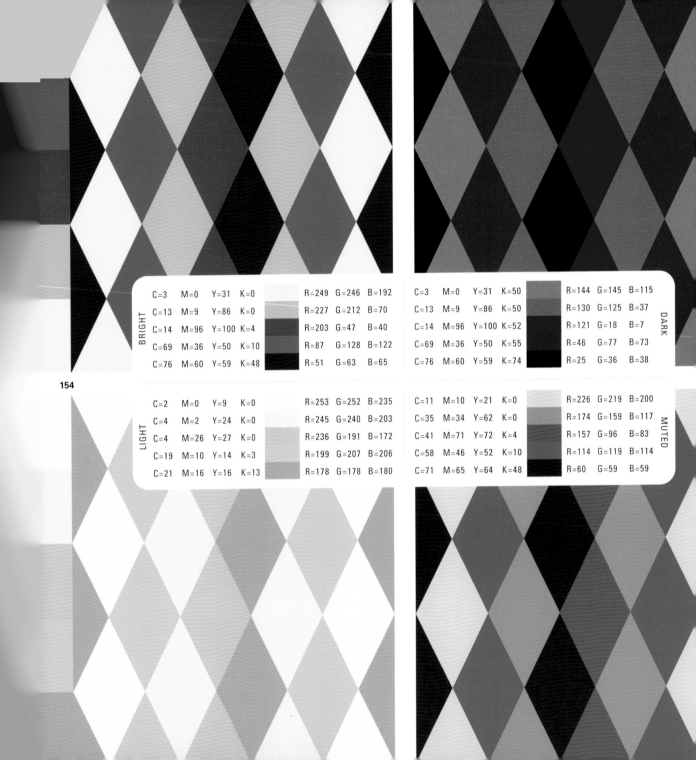

154

BRIGHT

				R	G	B
C=3	M=0	Y=31	K=0	R=249	G=246	B=192
C=13	M=9	Y=86	K=0	R=227	G=212	B=70
C=14	M=96	Y=100	K=4	R=203	G=47	B=40
C=69	M=36	Y=50	K=10	R=87	G=128	B=122
C=76	M=60	Y=59	K=48	R=51	G=63	B=65

DARK

				R	G	B
C=3	M=0	Y=31	K=50	R=144	G=145	B=115
C=13	M=9	Y=86	K=50	R=130	G=125	B=37
C=14	M=96	Y=100	K=52	R=121	G=18	B=7
C=69	M=36	Y=50	K=55	R=46	G=77	B=73
C=76	M=60	Y=59	K=74	R=25	G=36	B=38

LIGHT

				R	G	B
C=2	M=0	Y=9	K=0	R=253	G=252	B=235
C=4	M=2	Y=24	K=0	R=245	G=240	B=203
C=4	M=26	Y=27	K=0	R=236	G=191	B=172
C=19	M=10	Y=14	K=3	R=199	G=207	B=206
C=21	M=16	Y=16	K=13	R=178	G=178	B=180

MUTED

				R	G	B
C=11	M=10	Y=21	K=0	R=226	G=219	B=200
C=35	M=34	Y=62	K=0	R=174	G=159	B=117
C=41	M=71	Y=72	K=4	R=157	G=96	B=83
C=58	M=46	Y=52	K=10	R=114	G=119	B=114
C=71	M=65	Y=64	K=48	R=60	G=59	B=59

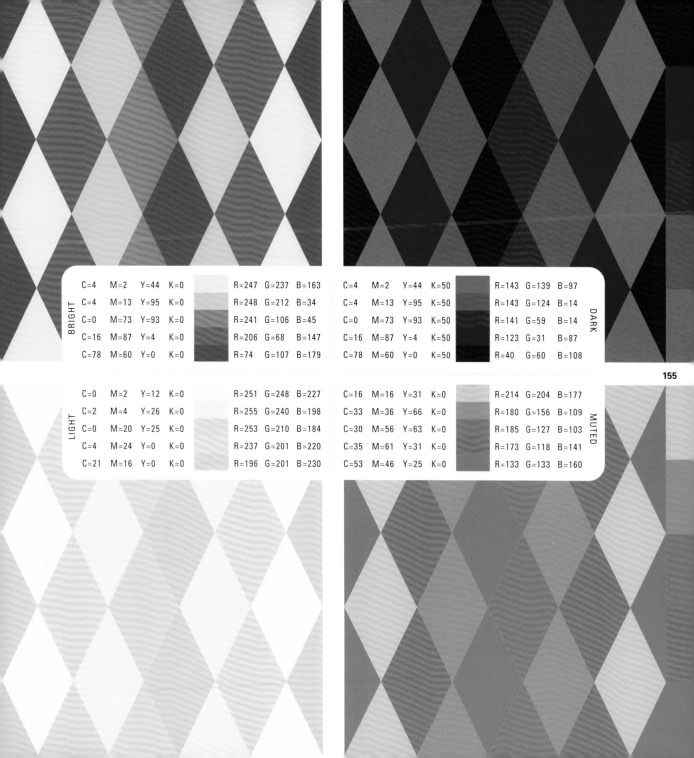

BRIGHT								
C=4	M=2	Y=44	K=0		R=247	G=237	B=163	
C=4	M=13	Y=95	K=0		R=248	G=212	B=34	
C=0	M=73	Y=93	K=0		R=241	G=106	B=45	
C=16	M=87	Y=4	K=0		R=206	G=68	B=147	
C=78	M=60	Y=0	K=0		R=74	G=107	B=179	

DARK								
C=4	M=2	Y=44	K=50		R=143	G=139	B=97	
C=4	M=13	Y=95	K=50		R=143	G=124	B=14	
C=0	M=73	Y=93	K=50		R=141	G=59	B=14	
C=16	M=87	Y=4	K=50		R=123	G=31	B=87	
C=78	M=60	Y=0	K=50		R=40	G=60	B=108	

LIGHT								
C=0	M=2	Y=12	K=0		R=251	G=248	B=227	
C=2	M=4	Y=26	K=0		R=255	G=240	B=198	
C=0	M=20	Y=25	K=0		R=253	G=210	B=184	
C=4	M=24	Y=0	K=0		R=237	G=201	B=220	
C=21	M=16	Y=0	K=0		R=196	G=201	B=230	

MUTED								
C=16	M=16	Y=31	K=0		R=214	G=204	B=177	
C=33	M=36	Y=66	K=0		R=180	G=156	B=109	
C=30	M=56	Y=63	K=0		R=185	G=127	B=103	
C=35	M=61	Y=31	K=0		R=173	G=118	B=141	
C=53	M=46	Y=25	K=0		R=133	G=133	B=160	

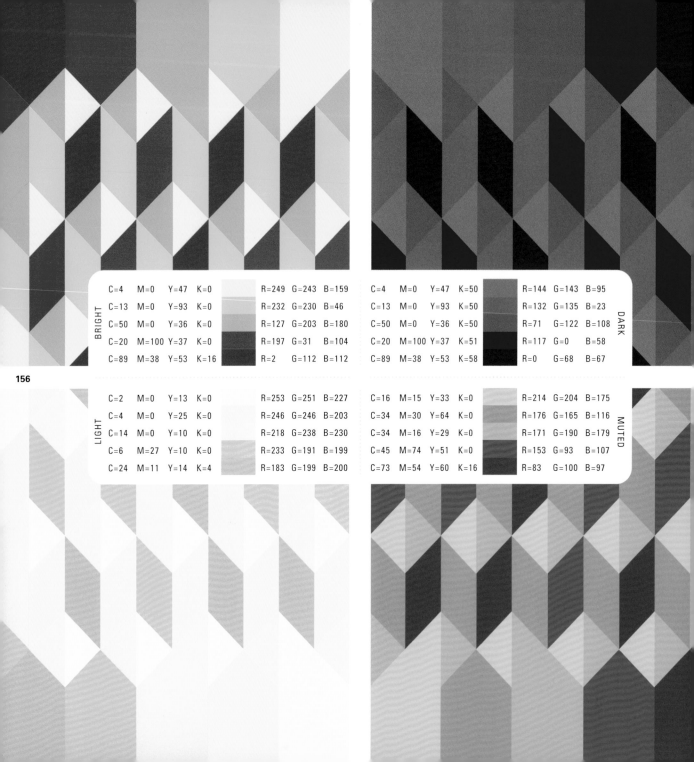

BRIGHT

	C=4	M=0	Y=47	K=0		R=249	G=243	B=159
	C=13	M=0	Y=93	K=0		R=232	G=230	B=46
	C=50	M=0	Y=36	K=0		R=127	G=203	B=180
	C=20	M=100	Y=37	K=0		R=197	G=31	B=104
	C=89	M=38	Y=53	K=16		R=2	G=112	B=112

DARK

C=4	M=0	Y=47	K=50		R=144	G=143	B=95
C=13	M=0	Y=93	K=50		R=132	G=135	B=23
C=50	M=0	Y=36	K=50		R=71	G=122	B=108
C=20	M=100	Y=37	K=51		R=117	G=0	B=58
C=89	M=38	Y=53	K=58		R=0	G=68	B=67

LIGHT

	C=2	M=0	Y=13	K=0		R=253	G=251	B=227
	C=4	M=0	Y=25	K=0		R=246	G=246	B=203
	C=14	M=0	Y=10	K=0		R=218	G=238	B=230
	C=6	M=27	Y=10	K=0		R=233	G=191	B=199
	C=24	M=11	Y=14	K=4		R=183	G=199	B=200

MUTED

C=16	M=15	Y=33	K=0		R=214	G=204	B=175
C=34	M=30	Y=64	K=0		R=176	G=165	B=116
C=34	M=16	Y=29	K=0		R=171	G=190	B=179
C=45	M=74	Y=51	K=0		R=153	G=93	B=107
C=73	M=54	Y=60	K=16		R=83	G=100	B=97

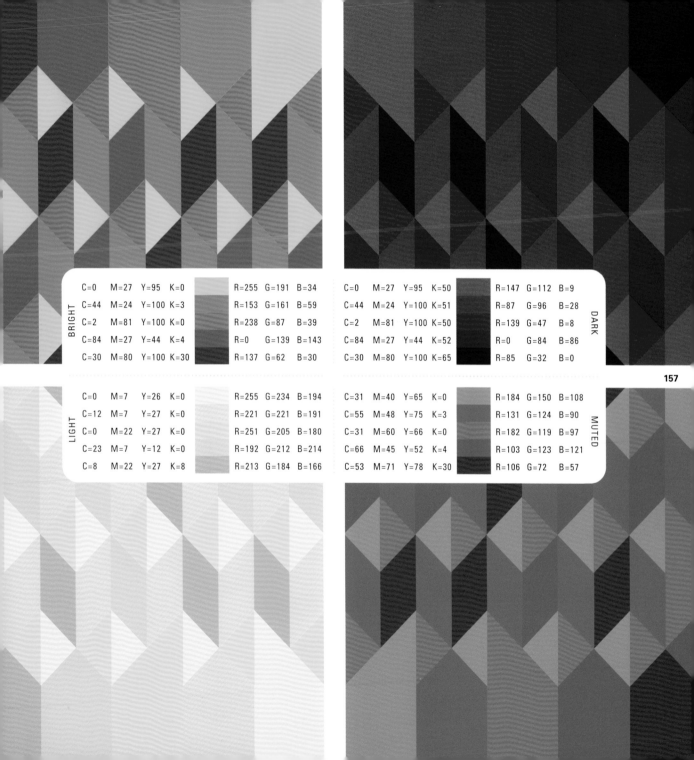

BRIGHT

					R=255	G=191	B=34
C=0	M=27	Y=95	K=0		R=153	G=161	B=59
C=44	M=24	Y=100	K=3		R=238	G=87	B=39
C=2	M=81	Y=100	K=0		R=0	G=139	B=143
C=84	M=27	Y=44	K=4		R=137	G=62	B=30
C=30	M=80	Y=100	K=30				

DARK

C=0	M=27	Y=95	K=50		R=147	G=112	B=9
C=44	M=24	Y=100	K=51		R=87	G=96	B=28
C=2	M=81	Y=100	K=50		R=139	G=47	B=8
C=84	M=27	Y=44	K=52		R=0	G=84	B=86
C=30	M=80	Y=100	K=65		R=85	G=32	B=0

157

LIGHT

C=0	M=7	Y=26	K=0		R=255	G=234	B=194
C=12	M=7	Y=27	K=0		R=221	G=221	B=191
C=0	M=22	Y=27	K=0		R=251	G=205	B=180
C=23	M=7	Y=12	K=0		R=192	G=212	B=214
C=8	M=22	Y=27	K=8		R=213	G=184	B=166

MUTED

C=31	M=40	Y=65	K=0		R=184	G=150	B=108
C=55	M=48	Y=75	K=3		R=131	G=124	B=90
C=31	M=60	Y=66	K=0		R=182	G=119	B=97
C=66	M=45	Y=52	K=4		R=103	G=123	B=121
C=53	M=71	Y=78	K=30		R=106	G=72	B=57

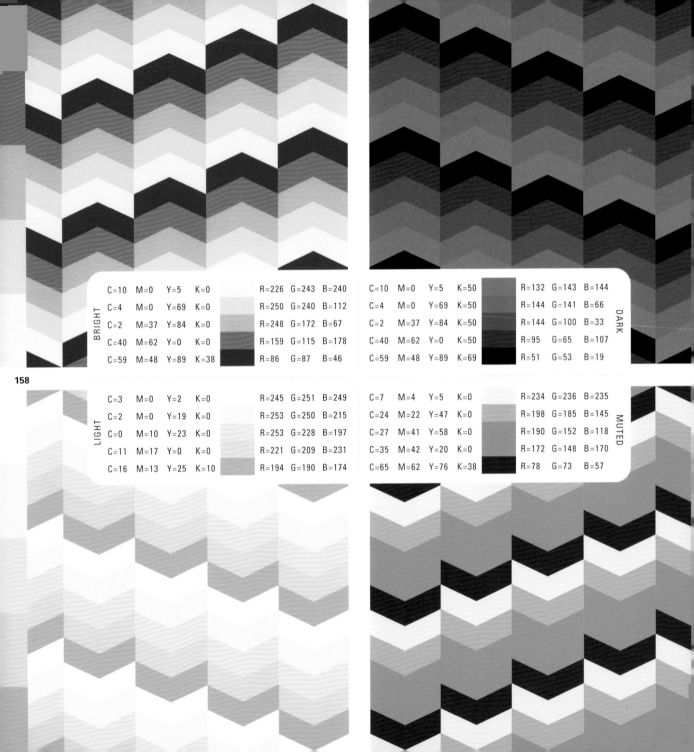

BRIGHT

C=10	M=0	Y=5	K=0
C=4	M=0	Y=69	K=0
C=2	M=37	Y=84	K=0
C=40	M=62	Y=0	K=0
C=59	M=48	Y=89	K=38

R=226	G=243	B=240
R=250	G=240	B=112
R=248	G=172	B=67
R=159	G=115	B=178
R=86	G=87	B=46

DARK

C=10	M=0	Y=5	K=50
C=4	M=0	Y=69	K=50
C=2	M=37	Y=84	K=50
C=40	M=62	Y=0	K=50
C=59	M=48	Y=89	K=69

R=132	G=143	B=144
R=144	G=141	B=66
R=144	G=100	B=33
R=95	G=65	B=107
R=51	G=53	B=19

LIGHT

C=3	M=0	Y=2	K=0
C=2	M=0	Y=19	K=0
C=0	M=10	Y=23	K=0
C=11	M=17	Y=0	K=0
C=16	M=13	Y=25	K=10

R=245	G=251	B=249
R=253	G=250	B=215
R=253	G=228	B=197
R=221	G=209	B=231
R=194	G=190	B=174

MUTED

C=7	M=4	Y=5	K=0
C=24	M=22	Y=47	K=0
C=27	M=41	Y=58	K=0
C=35	M=42	Y=20	K=0
C=65	M=62	Y=76	K=38

R=234	G=236	B=235
R=198	G=185	B=145
R=190	G=152	B=118
R=172	G=148	B=170
R=78	G=73	B=57

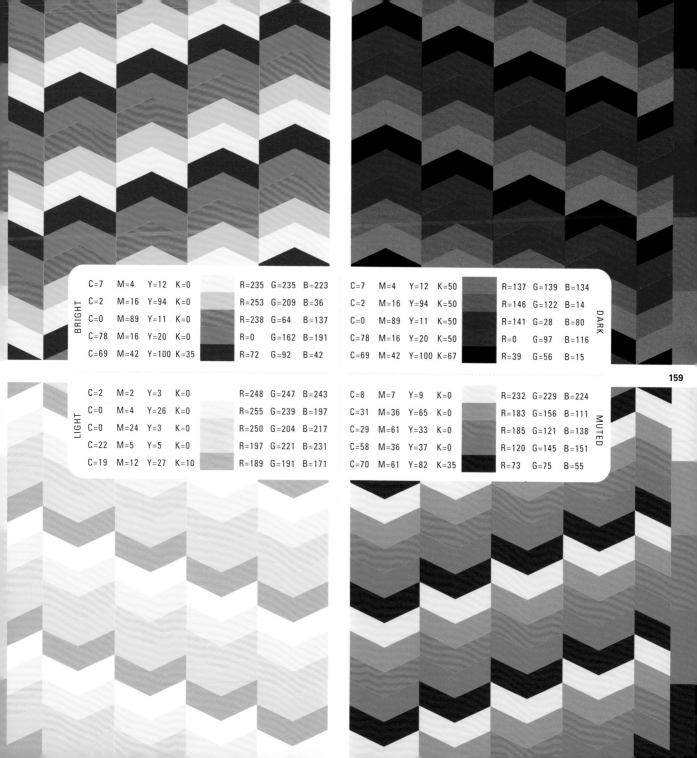

BRIGHT

C=7	M=4	Y=12	K=0		R=235	G=235	B=223
C=2	M=16	Y=94	K=0		R=253	G=209	B=36
C=0	M=89	Y=11	K=0		R=238	G=64	B=137
C=78	M=16	Y=20	K=0		R=0	G=162	B=191
C=69	M=42	Y=100	K=35		R=72	G=92	B=42

DARK

C=7	M=4	Y=12	K=50		R=137	G=139	B=134
C=2	M=16	Y=94	K=50		R=146	G=122	B=14
C=0	M=89	Y=11	K=50		R=141	G=28	B=80
C=78	M=16	Y=20	K=50		R=0	G=97	B=116
C=69	M=42	Y=100	K=67		R=39	G=56	B=15

LIGHT

C=2	M=2	Y=3	K=0		R=248	G=247	B=243
C=0	M=4	Y=26	K=0		R=255	G=239	B=197
C=0	M=24	Y=3	K=0		R=250	G=204	B=217
C=22	M=5	Y=5	K=0		R=197	G=221	B=231
C=19	M=12	Y=27	K=10		R=189	G=191	B=171

MUTED

C=8	M=7	Y=9	K=0		R=232	G=229	B=224
C=31	M=36	Y=65	K=0		R=183	G=156	B=111
C=29	M=61	Y=33	K=0		R=185	G=121	B=138
C=58	M=36	Y=37	K=0		R=120	G=145	B=151
C=70	M=61	Y=82	K=35		R=73	G=75	B=55

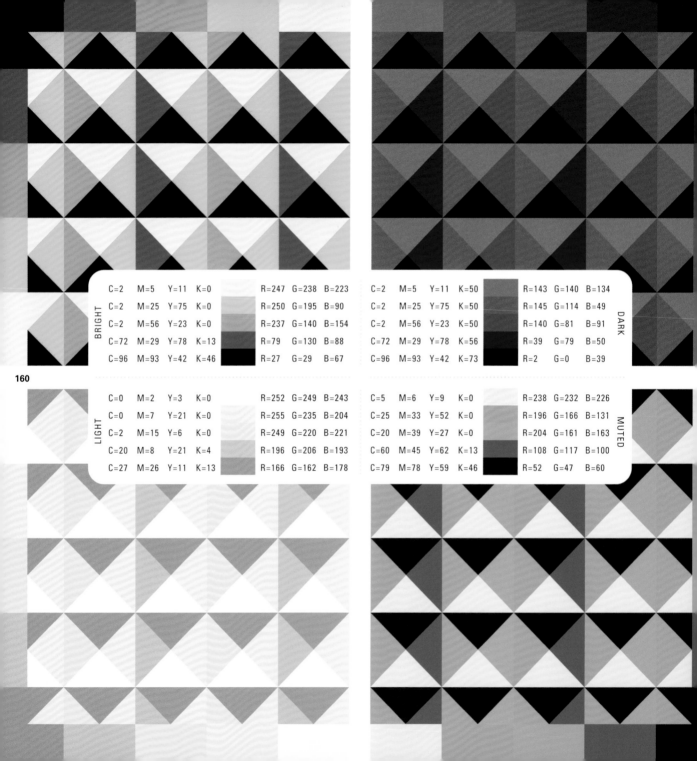

	C=2	M=5	Y=11	K=0		R=247	G=238	B=223
BRIGHT	C=2	M=25	Y=75	K=0		R=250	G=195	B=90
	C=2	M=56	Y=23	K=0		R=237	G=140	B=154
	C=72	M=29	Y=78	K=13		R=79	G=130	B=88
	C=96	M=93	Y=42	K=46		R=27	G=29	B=67

	C=2	M=5	Y=11	K=50		R=143	G=140	B=134
	C=2	M=25	Y=75	K=50		R=145	G=114	B=49
	C=2	M=56	Y=23	K=50		R=140	G=81	B=91
	C=72	M=29	Y=78	K=56		R=39	G=79	B=50
DARK	C=96	M=93	Y=42	K=73		R=2	G=0	B=39

	C=0	M=2	Y=3	K=0		R=252	G=249	B=243
LIGHT	C=0	M=7	Y=21	K=0		R=255	G=235	B=204
	C=2	M=15	Y=6	K=0		R=249	G=220	B=221
	C=20	M=8	Y=21	K=4		R=196	G=206	B=193
	C=27	M=26	Y=11	K=13		R=166	G=162	B=178

	C=5	M=6	Y=9	K=0		R=238	G=232	B=226
	C=25	M=33	Y=52	K=0		R=196	G=166	B=131
	C=20	M=39	Y=27	K=0		R=204	G=161	B=163
	C=60	M=45	Y=62	K=13		R=108	G=117	B=100
MUTED	C=79	M=78	Y=59	K=46		R=52	G=47	B=60

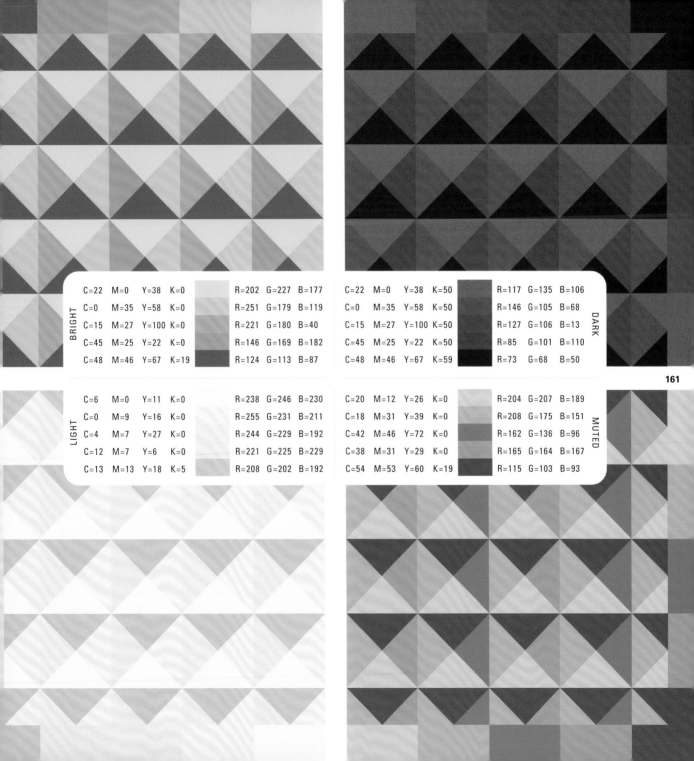

BRIGHT						
C=22	M=0	Y=38	K=0	R=202	G=227	B=177
C=0	M=35	Y=58	K=0	R=251	G=179	B=119
C=15	M=27	Y=100	K=0	R=221	G=180	B=40
C=45	M=25	Y=22	K=0	R=146	G=169	B=182
C=48	M=46	Y=67	K=19	R=124	G=113	B=87

DARK						
C=22	M=0	Y=38	K=50	R=117	G=135	B=106
C=0	M=35	Y=58	K=50	R=146	G=105	B=68
C=15	M=27	Y=100	K=50	R=127	G=106	B=13
C=45	M=25	Y=22	K=50	R=85	G=101	B=110
C=48	M=46	Y=67	K=59	R=73	G=68	B=50

LIGHT						
C=6	M=0	Y=11	K=0	R=238	G=246	B=230
C=0	M=9	Y=16	K=0	R=255	G=231	B=211
C=4	M=7	Y=27	K=0	R=244	G=229	B=192
C=12	M=7	Y=6	K=0	R=221	G=225	B=229
C=13	M=13	Y=18	K=5	R=208	G=202	B=192

MUTED						
C=20	M=12	Y=26	K=0	R=204	G=207	B=189
C=18	M=31	Y=39	K=0	R=208	G=175	B=151
C=42	M=46	Y=72	K=0	R=162	G=136	B=96
C=38	M=31	Y=29	K=0	R=165	G=164	B=167
C=54	M=53	Y=60	K=19	R=115	G=103	B=93

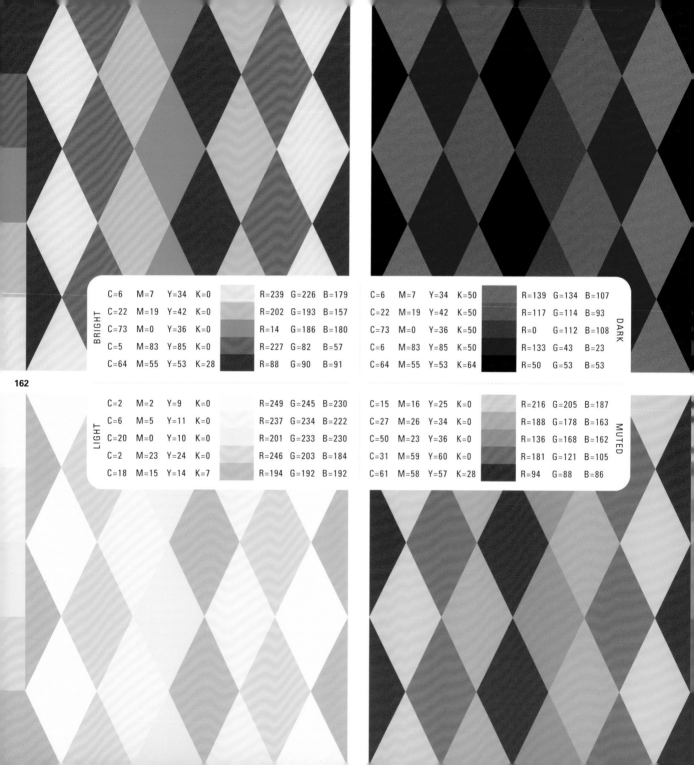

BRIGHT

C=6	M=7	Y=34	K=0	R=239	G=226	B=179
C=22	M=19	Y=42	K=0	R=202	G=193	B=157
C=73	M=0	Y=36	K=0	R=14	G=186	B=180
C=5	M=83	Y=85	K=0	R=227	G=82	B=57
C=64	M=55	Y=53	K=28	R=88	G=90	B=91

DARK

C=6	M=7	Y=34	K=50	R=139	G=134	B=107
C=22	M=19	Y=42	K=50	R=117	G=114	B=93
C=73	M=0	Y=36	K=50	R=0	G=112	B=108
C=6	M=83	Y=85	K=50	R=133	G=43	B=23
C=64	M=55	Y=53	K=64	R=50	G=53	B=53

LIGHT

C=2	M=2	Y=9	K=0	R=249	G=245	B=230
C=6	M=5	Y=11	K=0	R=237	G=234	B=222
C=20	M=0	Y=10	K=0	R=201	G=233	B=230
C=2	M=23	Y=24	K=0	R=246	G=203	B=184
C=18	M=15	Y=14	K=7	R=194	G=192	B=192

MUTED

C=15	M=16	Y=25	K=0	R=216	G=205	B=187
C=27	M=26	Y=34	K=0	R=188	G=178	B=163
C=50	M=23	Y=36	K=0	R=136	G=168	B=162
C=31	M=59	Y=60	K=0	R=181	G=121	B=105
C=61	M=58	Y=57	K=28	R=94	G=88	B=86

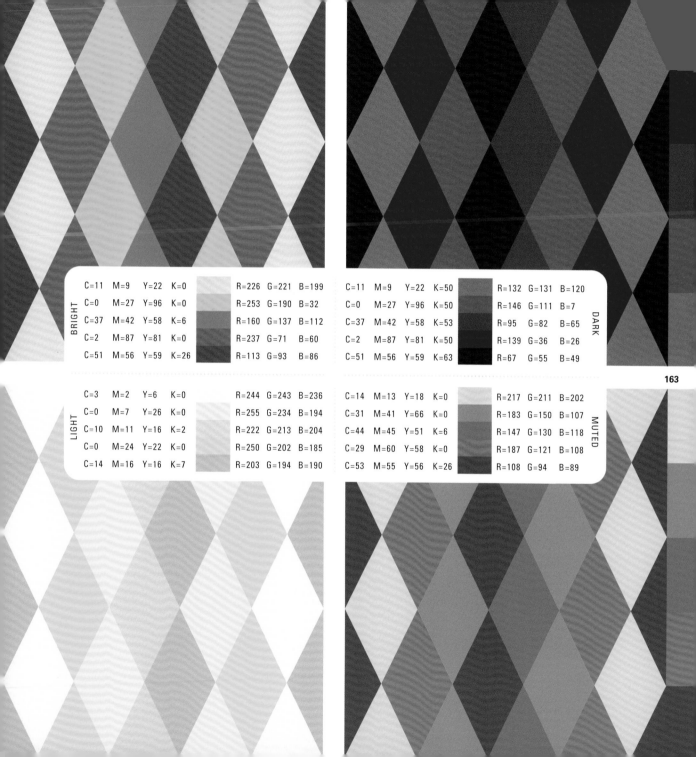

BRIGHT

C=11	M=9	Y=22	K=0		R=226	G=221	B=199
C=0	M=27	Y=96	K=0		R=253	G=190	B=32
C=37	M=42	Y=58	K=6		R=160	G=137	B=112
C=2	M=87	Y=81	K=0		R=237	G=71	B=60
C=51	M=56	Y=59	K=26		R=113	G=93	B=86

DARK

C=11	M=9	Y=22	K=50		R=132	G=131	B=120
C=0	M=27	Y=96	K=50		R=146	G=111	B=7
C=37	M=42	Y=58	K=53		R=95	G=82	B=65
C=2	M=87	Y=81	K=50		R=139	G=36	B=26
C=51	M=56	Y=59	K=63		R=67	G=55	B=49

163

LIGHT

C=3	M=2	Y=6	K=0		R=244	G=243	B=236
C=0	M=7	Y=26	K=0		R=255	G=234	B=194
C=10	M=11	Y=16	K=2		R=222	G=213	B=204
C=0	M=24	Y=22	K=0		R=250	G=202	B=185
C=14	M=16	Y=16	K=7		R=203	G=194	B=190

MUTED

C=14	M=13	Y=18	K=0		R=217	G=211	B=202
C=31	M=41	Y=66	K=0		R=183	G=150	B=107
C=44	M=45	Y=51	K=6		R=147	G=130	B=118
C=29	M=60	Y=58	K=0		R=187	G=121	B=108
C=53	M=55	Y=56	K=26		R=108	G=94	B=89

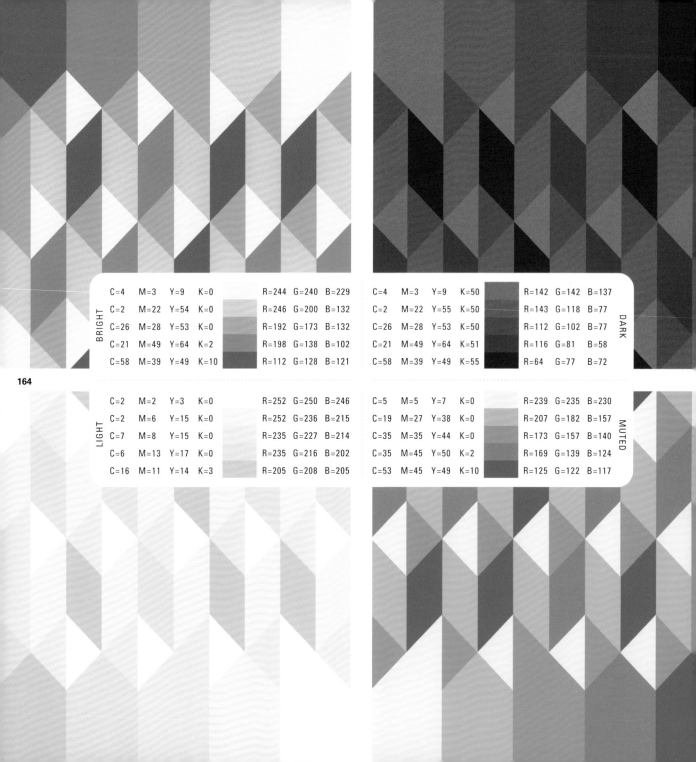

BRIGHT

C=4	M=3	Y=9	K=0		R=244	G=240	B=229
C=2	M=22	Y=54	K=0		R=246	G=200	B=132
C=26	M=28	Y=53	K=0		R=192	G=173	B=132
C=21	M=49	Y=64	K=2		R=198	G=138	B=102
C=58	M=39	Y=49	K=10		R=112	G=128	B=121

DARK

C=4	M=3	Y=9	K=50		R=142	G=142	B=137
C=2	M=22	Y=55	K=50		R=143	G=118	B=77
C=26	M=28	Y=53	K=50		R=112	G=102	B=77
C=21	M=49	Y=64	K=51		R=116	G=81	B=58
C=58	M=39	Y=49	K=55		R=64	G=77	B=72

164

LIGHT

C=2	M=2	Y=3	K=0		R=252	G=250	B=246
C=2	M=6	Y=15	K=0		R=252	G=236	B=215
C=7	M=8	Y=15	K=0		R=235	G=227	B=214
C=6	M=13	Y=17	K=0		R=235	G=216	B=202
C=16	M=11	Y=14	K=3		R=205	G=208	B=205

MUTED

C=5	M=5	Y=7	K=0		R=239	G=235	B=230
C=19	M=27	Y=38	K=0		R=207	G=182	B=157
C=35	M=35	Y=44	K=0		R=173	G=157	B=140
C=35	M=45	Y=50	K=2		R=169	G=139	B=124
C=53	M=45	Y=49	K=10		R=125	G=122	B=117

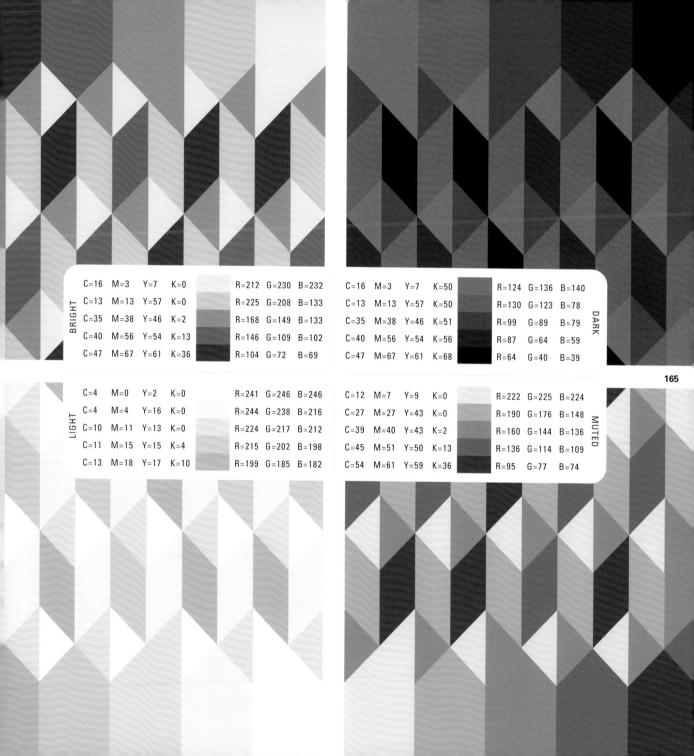

BRIGHT

C=16	M=3	Y=7	K=0		R=212	G=230	B=232
C=13	M=13	Y=57	K=0		R=225	G=208	B=133
C=35	M=38	Y=46	K=2		R=168	G=149	B=133
C=40	M=56	Y=54	K=13		R=146	G=109	B=102
C=47	M=67	Y=61	K=36		R=104	G=72	B=69

DARK

C=16	M=3	Y=7	K=50		R=124	G=136	B=140
C=13	M=13	Y=57	K=50		R=130	G=123	B=78
C=35	M=38	Y=46	K=51		R=99	G=89	B=79
C=40	M=56	Y=54	K=56		R=87	G=64	B=59
C=47	M=67	Y=61	K=68		R=64	G=40	B=39

LIGHT

C=4	M=0	Y=2	K=0		R=241	G=246	B=246
C=4	M=4	Y=16	K=0		R=244	G=238	B=216
C=10	M=11	Y=13	K=0		R=224	G=217	B=212
C=11	M=15	Y=15	K=4		R=215	G=202	B=198
C=13	M=18	Y=17	K=10		R=199	G=185	B=182

MUTED

C=12	M=7	Y=9	K=0		R=222	G=225	B=224
C=27	M=27	Y=43	K=0		R=190	G=176	B=148
C=39	M=40	Y=43	K=2		R=160	G=144	B=136
C=45	M=51	Y=50	K=13		R=136	G=114	B=109
C=54	M=61	Y=59	K=36		R=95	G=77	B=74

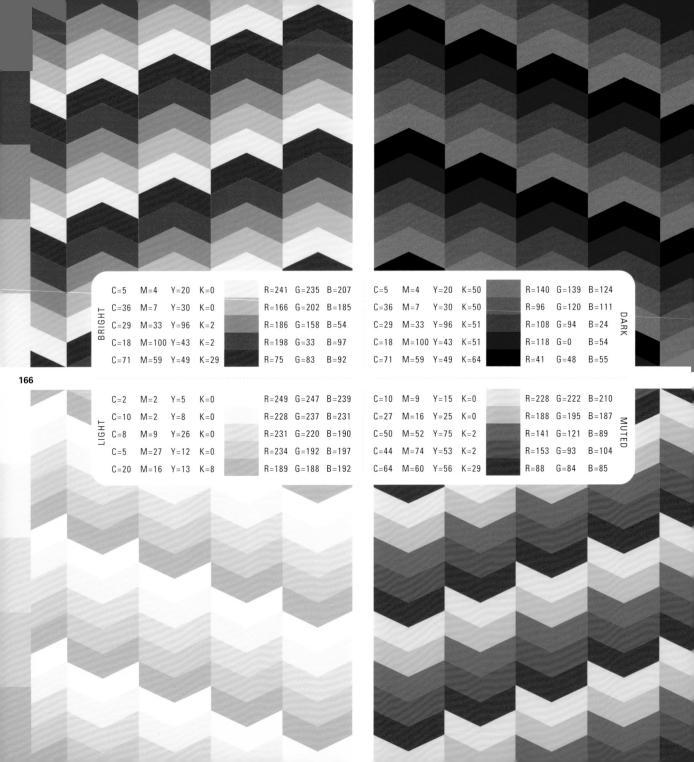

166

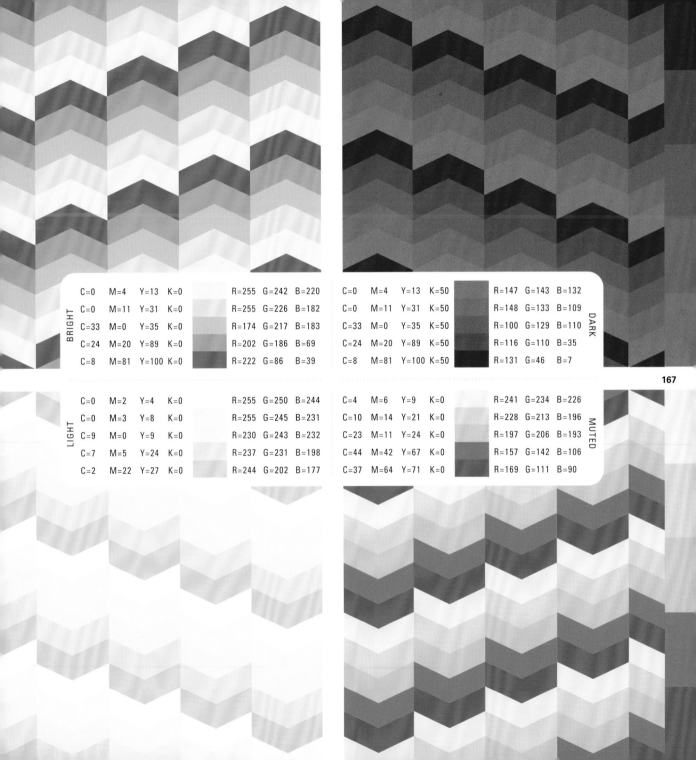

BRIGHT

C=0	M=4	Y=13	K=0		R=255	G=242	B=220
C=0	M=11	Y=31	K=0		R=255	G=226	B=182
C=33	M=0	Y=35	K=0		R=174	G=217	B=183
C=24	M=20	Y=89	K=0		R=202	G=186	B=69
C=8	M=81	Y=100	K=0		R=222	G=86	B=39

DARK

C=0	M=4	Y=13	K=50		R=147	G=143	B=132
C=0	M=11	Y=31	K=50		R=148	G=133	B=109
C=33	M=0	Y=35	K=50		R=100	G=129	B=110
C=24	M=20	Y=89	K=50		R=116	G=110	B=35
C=8	M=81	Y=100	K=50		R=131	G=46	B=7

LIGHT

C=0	M=2	Y=4	K=0		R=255	G=250	B=244
C=0	M=3	Y=8	K=0		R=255	G=245	B=231
C=9	M=0	Y=9	K=0		R=230	G=243	B=232
C=7	M=5	Y=24	K=0		R=237	G=231	B=198
C=2	M=22	Y=27	K=0		R=244	G=202	B=177

MUTED

C=4	M=6	Y=9	K=0		R=241	G=234	B=226
C=10	M=14	Y=21	K=0		R=228	G=213	B=196
C=23	M=11	Y=24	K=0		R=197	G=206	B=193
C=44	M=42	Y=67	K=0		R=157	G=142	B=106
C=37	M=64	Y=71	K=0		R=169	G=111	B=90

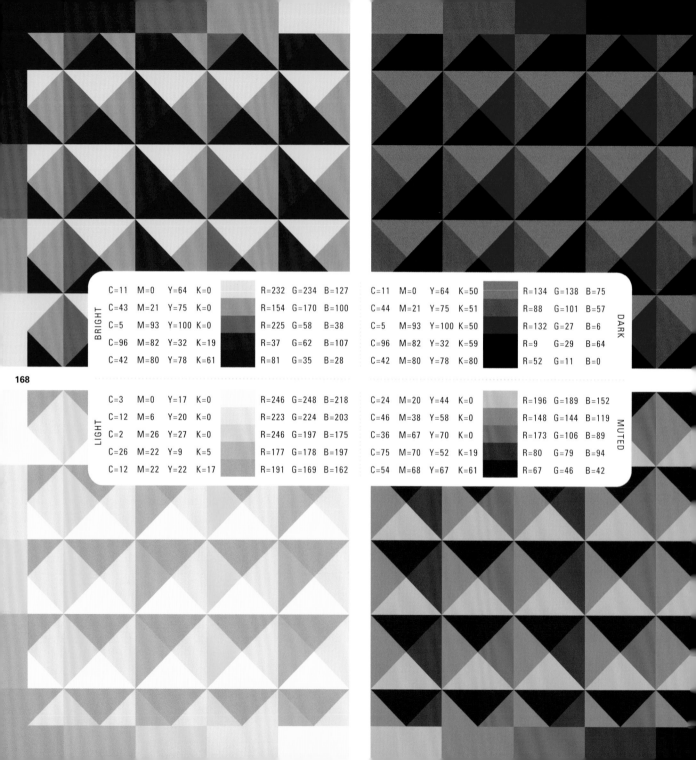

BRIGHT

C=11	M=0	Y=64	K=0		R=232	G=234	B=127
C=43	M=21	Y=75	K=0		R=154	G=170	B=100
C=5	M=93	Y=100	K=0		R=225	G=58	B=38
C=96	M=82	Y=32	K=19		R=37	G=62	B=107
C=42	M=80	Y=78	K=61		R=81	G=35	B=28

DARK

C=11	M=0	Y=64	K=50		R=134	G=138	B=75
C=44	M=21	Y=75	K=51		R=88	G=101	B=57
C=5	M=93	Y=100	K=50		R=132	G=27	B=6
C=96	M=82	Y=32	K=59		R=9	G=29	B=64
C=42	M=80	Y=78	K=80		R=52	G=11	B=0

LIGHT

C=3	M=0	Y=17	K=0		R=246	G=248	B=218
C=12	M=6	Y=20	K=0		R=223	G=224	B=203
C=2	M=26	Y=27	K=0		R=246	G=197	B=175
C=26	M=22	Y=9	K=5		R=177	G=178	B=197
C=12	M=22	Y=22	K=17		R=191	G=169	B=162

MUTED

C=24	M=20	Y=44	K=0		R=196	G=189	B=152
C=46	M=38	Y=58	K=0		R=148	G=144	B=119
C=36	M=67	Y=70	K=0		R=173	G=106	B=89
C=75	M=70	Y=52	K=19		R=80	G=79	B=94
C=54	M=68	Y=67	K=61		R=67	G=46	B=42

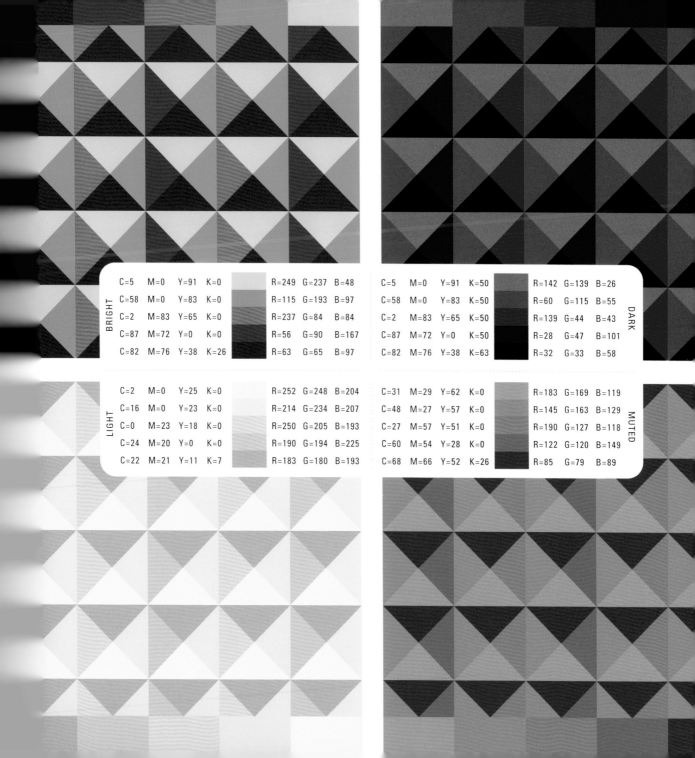

BRIGHT

C	M	Y	K		R	G	B
C=5	M=0	Y=91	K=0		R=249	G=237	B=48
C=58	M=0	Y=83	K=0		R=115	G=193	B=97
C=2	M=83	Y=65	K=0		R=237	G=84	B=84
C=87	M=72	Y=0	K=0		R=56	G=90	B=167
C=82	M=76	Y=38	K=26		R=63	G=65	B=97

DARK

C	M	Y	K		R	G	B
C=5	M=0	Y=91	K=50		R=142	G=139	B=26
C=58	M=0	Y=83	K=50		R=60	G=115	B=55
C=2	M=83	Y=65	K=50		R=139	G=44	B=43
C=87	M=72	Y=0	K=50		R=28	G=47	B=101
C=82	M=76	Y=38	K=63		R=32	G=33	B=58

LIGHT

C	M	Y	K		R	G	B
C=2	M=0	Y=25	K=0		R=252	G=248	B=204
C=16	M=0	Y=23	K=0		R=214	G=234	B=207
C=0	M=23	Y=18	K=0		R=250	G=205	B=193
C=24	M=20	Y=0	K=0		R=190	G=194	B=225
C=22	M=21	Y=11	K=7		R=183	G=180	B=193

MUTED

C	M	Y	K		R	G	B
C=31	M=29	Y=62	K=0		R=183	G=169	B=119
C=48	M=27	Y=57	K=0		R=145	G=163	B=129
C=27	M=57	Y=51	K=0		R=190	G=127	B=118
C=60	M=54	Y=28	K=0		R=122	G=120	B=149
C=68	M=66	Y=52	K=26		R=85	G=79	B=89

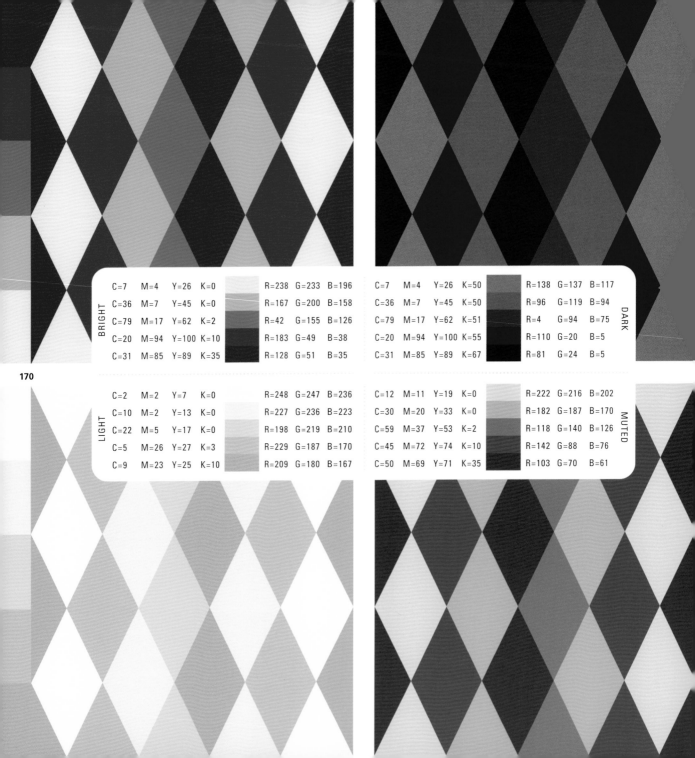

BRIGHT

C=7	M=4	Y=26	K=0		R=238	G=233	B=196
C=36	M=7	Y=45	K=0		R=167	G=200	B=158
C=79	M=17	Y=62	K=2		R=42	G=155	B=126
C=20	M=94	Y=100	K=10		R=183	G=49	B=38
C=31	M=85	Y=89	K=35		R=128	G=51	B=35

DARK

C=7	M=4	Y=26	K=50		R=138	G=137	B=117
C=36	M=7	Y=45	K=50		R=96	G=119	B=94
C=79	M=17	Y=62	K=51		R=4	G=94	B=75
C=20	M=94	Y=100	K=55		R=110	G=20	B=5
C=31	M=85	Y=89	K=67		R=81	G=24	B=5

LIGHT

C=2	M=2	Y=7	K=0		R=248	G=247	B=236
C=10	M=2	Y=13	K=0		R=227	G=236	B=223
C=22	M=5	Y=17	K=0		R=198	G=219	B=210
C=5	M=26	Y=27	K=3		R=229	G=187	B=170
C=9	M=23	Y=25	K=10		R=209	G=180	B=167

MUTED

C=12	M=11	Y=19	K=0		R=222	G=216	B=202
C=30	M=20	Y=33	K=0		R=182	G=187	B=170
C=59	M=37	Y=53	K=2		R=118	G=140	B=126
C=45	M=72	Y=74	K=10		R=142	G=88	B=76
C=50	M=69	Y=71	K=35		R=103	G=70	B=61

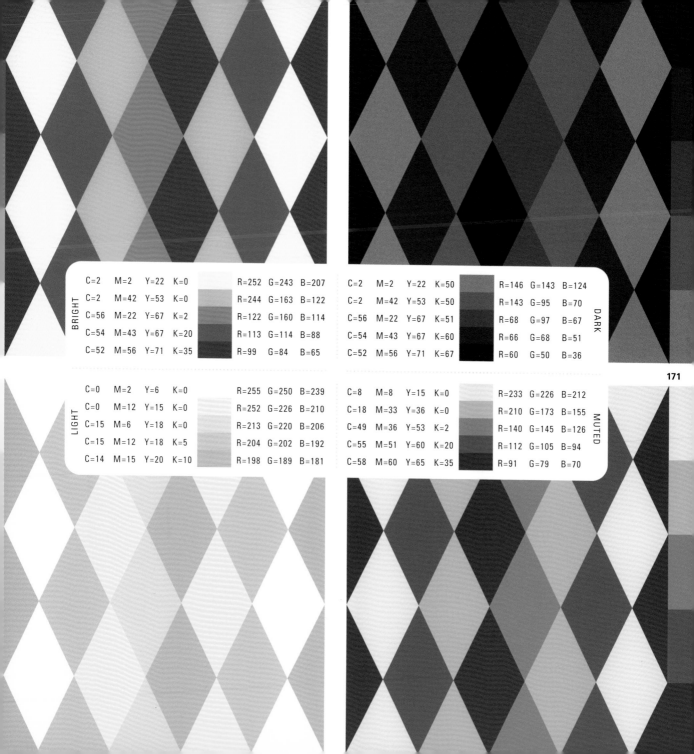

BRIGHT

C=2	M=2	Y=22	K=0
C=2	M=42	Y=53	K=0
C=56	M=22	Y=67	K=2
C=54	M=43	Y=67	K=20
C=52	M=56	Y=71	K=35

R=252	G=243	B=207
R=244	G=163	B=122
R=122	G=160	B=114
R=113	G=114	B=88
R=99	G=84	B=65

DARK

C=2	M=2	Y=22	K=50
C=2	M=42	Y=53	K=50
C=56	M=22	Y=67	K=51
C=54	M=43	Y=67	K=60
C=52	M=56	Y=71	K=67

R=146	G=143	B=124
R=143	G=95	B=70
R=68	G=97	B=67
R=66	G=68	B=51
R=60	G=50	B=36

LIGHT

C=0	M=2	Y=6	K=0
C=0	M=12	Y=15	K=0
C=15	M=6	Y=18	K=0
C=15	M=12	Y=18	K=5
C=14	M=15	Y=20	K=10

R=255	G=250	B=239
R=252	G=226	B=210
R=213	G=220	B=206
R=204	G=202	B=192
R=198	G=189	B=181

MUTED

C=8	M=8	Y=15	K=0
C=18	M=33	Y=36	K=0
C=49	M=36	Y=53	K=2
C=55	M=51	Y=60	K=20
C=58	M=60	Y=65	K=35

R=233	G=226	B=212
R=210	G=173	B=155
R=140	G=145	B=126
R=112	G=105	B=94
R=91	G=79	B=70

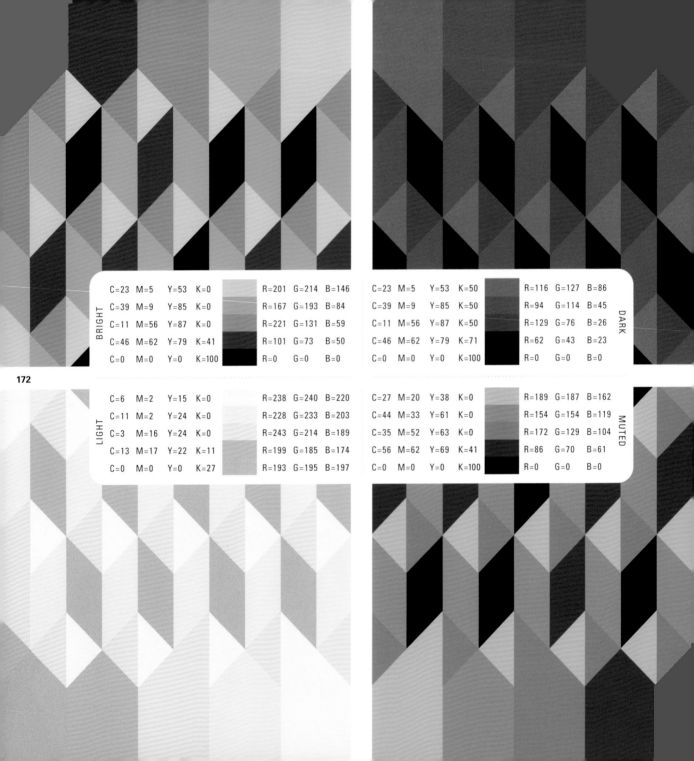

BRIGHT

C=23	M=5	Y=53	K=0
C=39	M=9	Y=85	K=0
C=11	M=56	Y=87	K=0
C=46	M=62	Y=79	K=41
C=0	M=0	Y=0	K=100

R=201	G=214	B=146
R=167	G=193	B=84
R=221	G=131	B=59
R=101	G=73	B=50
R=0	G=0	B=0

DARK

C=23	M=5	Y=53	K=50
C=39	M=9	Y=85	K=50
C=11	M=56	Y=87	K=50
C=46	M=62	Y=79	K=71
C=0	M=0	Y=0	K=100

R=116	G=127	B=86
R=94	G=114	B=45
R=129	G=76	B=26
R=62	G=43	B=23
R=0	G=0	B=0

172

LIGHT

C=6	M=2	Y=15	K=0
C=11	M=2	Y=24	K=0
C=3	M=16	Y=24	K=0
C=13	M=17	Y=22	K=11
C=0	M=0	Y=0	K=27

R=238	G=240	B=220
R=228	G=233	B=203
R=243	G=214	B=189
R=199	G=185	B=174
R=193	G=195	B=197

MUTED

C=27	M=20	Y=38	K=0
C=44	M=33	Y=61	K=0
C=35	M=52	Y=63	K=0
C=56	M=62	Y=69	K=41
C=0	M=0	Y=0	K=100

R=189	G=187	B=162
R=154	G=154	B=119
R=172	G=129	B=104
R=86	G=70	B=61
R=0	G=0	B=0

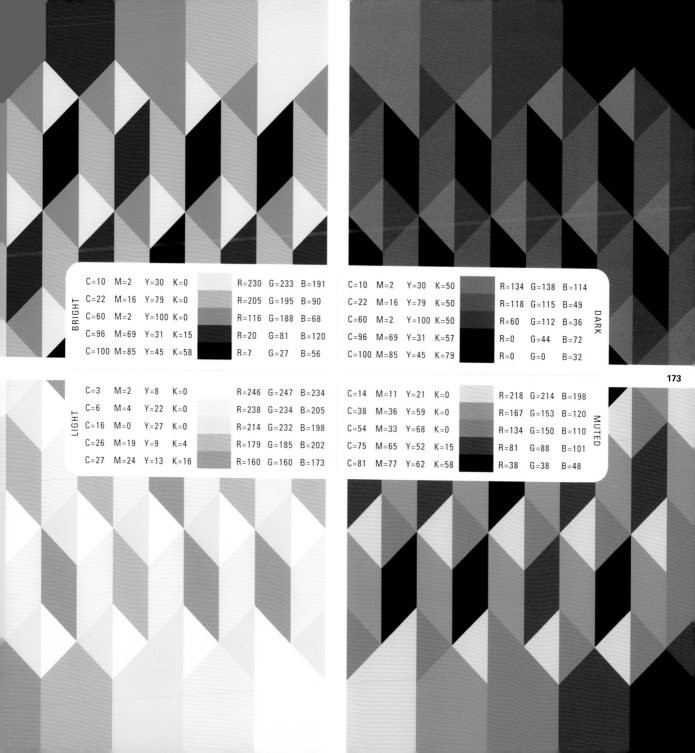

BRIGHT

C=10	M=2	Y=30	K=0		R=230	G=233	B=191
C=22	M=16	Y=79	K=0		R=205	G=195	B=90
C=60	M=2	Y=100	K=0		R=116	G=188	B=68
C=96	M=69	Y=31	K=15		R=20	G=81	B=120
C=100	M=85	Y=45	K=58		R=7	G=27	B=56

DARK

C=10	M=2	Y=30	K=50		R=134	G=138	B=114
C=22	M=16	Y=79	K=50		R=118	G=115	B=49
C=60	M=2	Y=100	K=50		R=60	G=112	B=36
C=96	M=69	Y=31	K=57		R=0	G=44	B=72
C=100	M=85	Y=45	K=79		R=0	G=0	B=32

LIGHT

C=3	M=2	Y=8	K=0		R=246	G=247	B=234
C=6	M=4	Y=22	K=0		R=238	G=234	B=205
C=16	M=0	Y=27	K=0		R=214	G=232	B=198
C=26	M=19	Y=9	K=4		R=179	G=185	B=202
C=27	M=24	Y=13	K=16		R=160	G=160	B=173

MUTED

C=14	M=11	Y=21	K=0		R=218	G=214	B=198
C=38	M=36	Y=59	K=0		R=167	G=153	B=120
C=54	M=33	Y=68	K=0		R=134	G=150	B=110
C=75	M=65	Y=52	K=15		R=81	G=88	B=101
C=81	M=77	Y=62	K=58		R=38	G=38	B=48

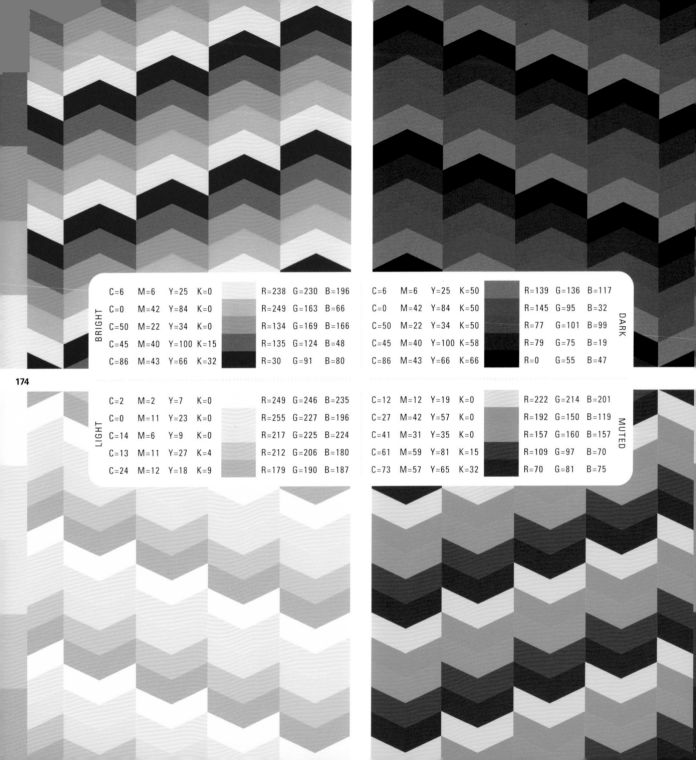

BRIGHT

C=6	M=6	Y=25	K=0		R=238	G=230	B=196
C=0	M=42	Y=84	K=0		R=249	G=163	B=66
C=50	M=22	Y=34	K=0		R=134	G=169	B=166
C=45	M=40	Y=100	K=15		R=135	G=124	B=48
C=86	M=43	Y=66	K=32		R=30	G=91	B=80

DARK

C=6	M=6	Y=25	K=50		R=139	G=136	B=117
C=0	M=42	Y=84	K=50		R=145	G=95	B=32
C=50	M=22	Y=34	K=50		R=77	G=101	B=99
C=45	M=40	Y=100	K=58		R=79	G=75	B=19
C=86	M=43	Y=66	K=66		R=0	G=55	B=47

LIGHT

C=2	M=2	Y=7	K=0		R=249	G=246	B=235
C=0	M=11	Y=23	K=0		R=255	G=227	B=196
C=14	M=6	Y=9	K=0		R=217	G=225	B=224
C=13	M=11	Y=27	K=4		R=212	G=206	B=180
C=24	M=12	Y=18	K=9		R=179	G=190	B=187

MUTED

C=12	M=12	Y=19	K=0		R=222	G=214	B=201
C=27	M=42	Y=57	K=0		R=192	G=150	B=119
C=41	M=31	Y=35	K=0		R=157	G=160	B=157
C=61	M=59	Y=81	K=15		R=109	G=97	B=70
C=73	M=57	Y=65	K=32		R=70	G=81	B=75

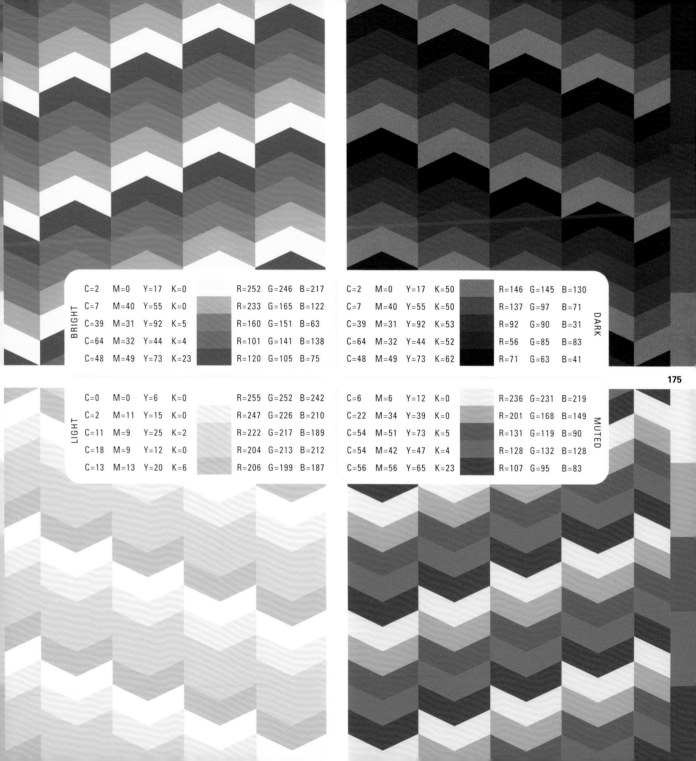

BRIGHT

C=2	M=0	Y=17	K=0		R=252	G=246	B=217
C=7	M=40	Y=55	K=0		R=233	G=165	B=122
C=39	M=31	Y=92	K=5		R=160	G=151	B=63
C=64	M=32	Y=44	K=4		R=101	G=141	B=138
C=48	M=49	Y=73	K=23		R=120	G=105	B=75

DARK

C=2	M=0	Y=17	K=50		R=146	G=145	B=130
C=7	M=40	Y=55	K=50		R=137	G=97	B=71
C=39	M=31	Y=92	K=53		R=92	G=90	B=31
C=64	M=32	Y=44	K=52		R=56	G=85	B=83
C=48	M=49	Y=73	K=62		R=71	G=63	B=41

175

LIGHT

C=0	M=0	Y=6	K=0		R=255	G=252	B=242
C=2	M=11	Y=15	K=0		R=247	G=226	B=210
C=11	M=9	Y=25	K=2		R=222	G=217	B=189
C=18	M=9	Y=12	K=0		R=204	G=213	B=212
C=13	M=13	Y=20	K=6		R=206	G=199	B=187

MUTED

C=6	M=6	Y=12	K=0		R=236	G=231	B=219
C=22	M=34	Y=39	K=0		R=201	G=168	B=149
C=54	M=51	Y=73	K=5		R=131	G=119	B=90
C=54	M=42	Y=47	K=4		R=128	G=132	B=128
C=56	M=56	Y=65	K=23		R=107	G=95	B=83

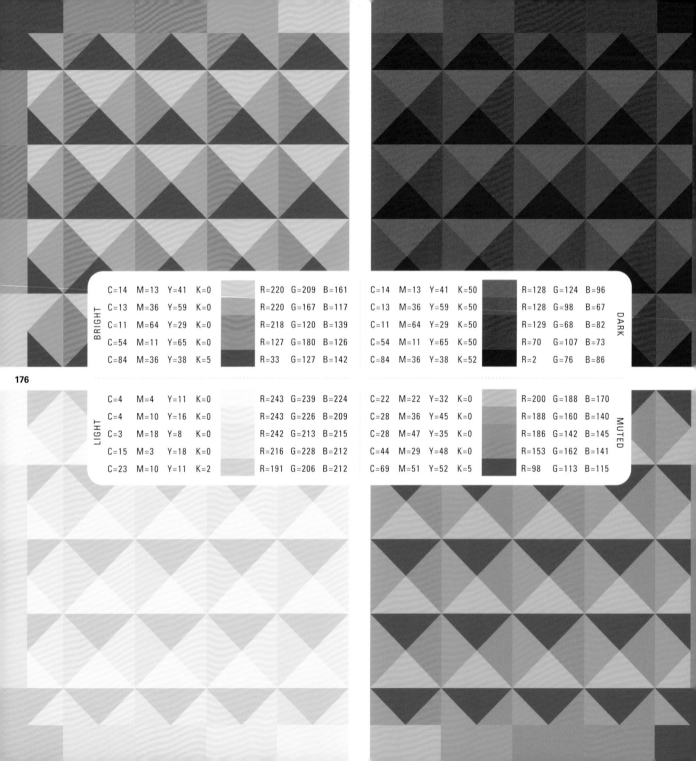

BRIGHT

C=14	M=13	Y=41	K=0	R=220	G=209	B=161
C=13	M=36	Y=59	K=0	R=220	G=167	B=117
C=11	M=64	Y=29	K=0	R=218	G=120	B=139
C=54	M=11	Y=65	K=0	R=127	G=180	B=126
C=84	M=36	Y=38	K=5	R=33	G=127	B=142

DARK

C=14	M=13	Y=41	K=50	R=128	G=124	B=96
C=13	M=36	Y=59	K=50	R=128	G=98	B=67
C=11	M=64	Y=29	K=50	R=129	G=68	B=82
C=54	M=11	Y=65	K=50	R=70	G=107	B=73
C=84	M=36	Y=38	K=52	R=2	G=76	B=86

LIGHT

C=4	M=4	Y=11	K=0	R=243	G=239	B=224
C=4	M=10	Y=16	K=0	R=243	G=226	B=209
C=3	M=18	Y=8	K=0	R=242	G=213	B=215
C=15	M=3	Y=18	K=0	R=216	G=228	B=212
C=23	M=10	Y=11	K=2	R=191	G=206	B=212

MUTED

C=22	M=22	Y=32	K=0	R=200	G=188	B=170
C=28	M=36	Y=45	K=0	R=188	G=160	B=140
C=28	M=47	Y=35	K=0	R=186	G=142	B=145
C=44	M=29	Y=48	K=0	R=153	G=162	B=141
C=69	M=51	Y=52	K=5	R=98	G=113	B=115

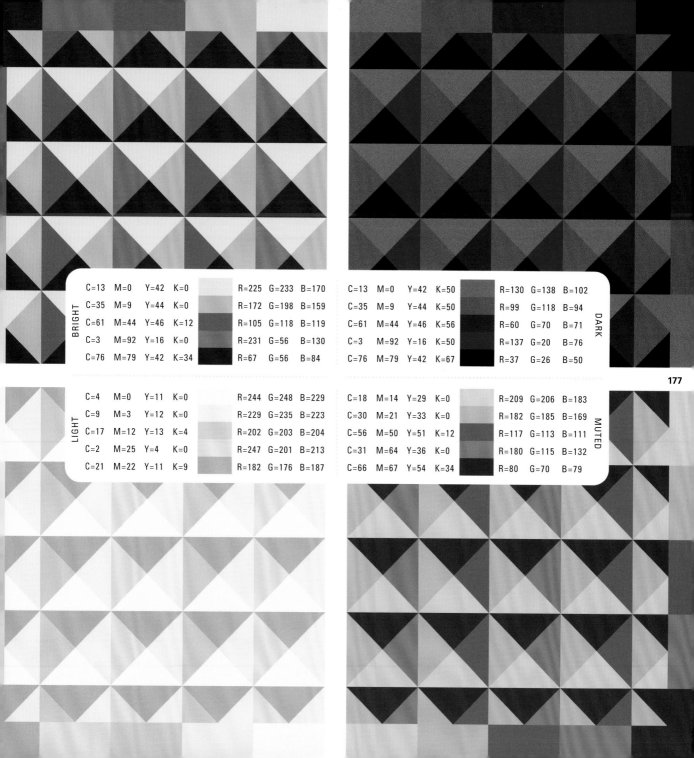

BRIGHT

C=13	M=0	Y=42	K=0		R=225	G=233	B=170
C=35	M=9	Y=44	K=0		R=172	G=198	B=159
C=61	M=44	Y=46	K=12		R=105	G=118	B=119
C=3	M=92	Y=16	K=0		R=231	G=56	B=130
C=76	M=79	Y=42	K=34		R=67	G=56	B=84

DARK

C=13	M=0	Y=42	K=50		R=130	G=138	B=102
C=35	M=9	Y=44	K=50		R=99	G=118	B=94
C=61	M=44	Y=46	K=56		R=60	G=70	B=71
C=3	M=92	Y=16	K=50		R=137	G=20	B=76
C=76	M=79	Y=42	K=67		R=37	G=26	B=50

LIGHT

C=4	M=0	Y=11	K=0		R=244	G=248	B=229
C=9	M=3	Y=12	K=0		R=229	G=235	B=223
C=17	M=12	Y=13	K=4		R=202	G=203	B=204
C=2	M=25	Y=4	K=0		R=247	G=201	B=213
C=21	M=22	Y=11	K=9		R=182	G=176	B=187

MUTED

C=18	M=14	Y=29	K=0		R=209	G=206	B=183
C=30	M=21	Y=33	K=0		R=182	G=185	B=169
C=56	M=50	Y=51	K=12		R=117	G=113	B=111
C=31	M=64	Y=36	K=0		R=180	G=115	B=132
C=66	M=67	Y=54	K=34		R=80	G=70	B=79

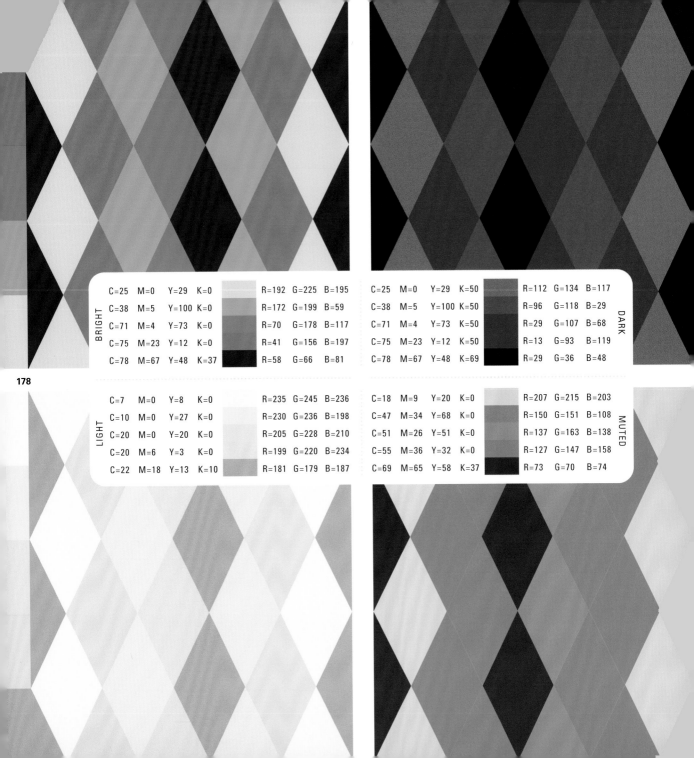

BRIGHT

C=25	M=0	Y=29	K=0		R=192 G=225 B=195	
C=38	M=5	Y=100	K=0		R=172 G=199 B=59	
C=71	M=4	Y=73	K=0		R=70 G=178 B=117	
C=75	M=23	Y=12	K=0		R=41 G=156 B=197	
C=78	M=67	Y=48	K=37		R=58 G=66 B=81	

DARK

C=25	M=0	Y=29	K=50		R=112 G=134 B=117	
C=38	M=5	Y=100	K=50		R=96 G=118 B=29	
C=71	M=4	Y=73	K=50		R=29 G=107 B=68	
C=75	M=23	Y=12	K=50		R=13 G=93 B=119	
C=78	M=67	Y=48	K=69		R=29 G=36 B=48	

178

LIGHT

C=7	M=0	Y=8	K=0		R=235 G=245 B=236	
C=10	M=0	Y=27	K=0		R=230 G=236 B=198	
C=20	M=0	Y=20	K=0		R=205 G=228 B=210	
C=20	M=6	Y=3	K=0		R=199 G=220 B=234	
C=22	M=18	Y=13	K=10		R=181 G=179 B=187	

MUTED

C=18	M=9	Y=20	K=0		R=207 G=215 B=203	
C=47	M=34	Y=68	K=0		R=150 G=151 B=108	
C=51	M=26	Y=51	K=0		R=137 G=163 B=138	
C=55	M=36	Y=32	K=0		R=127 G=147 B=158	
C=69	M=65	Y=58	K=37		R=73 G=70 B=74	

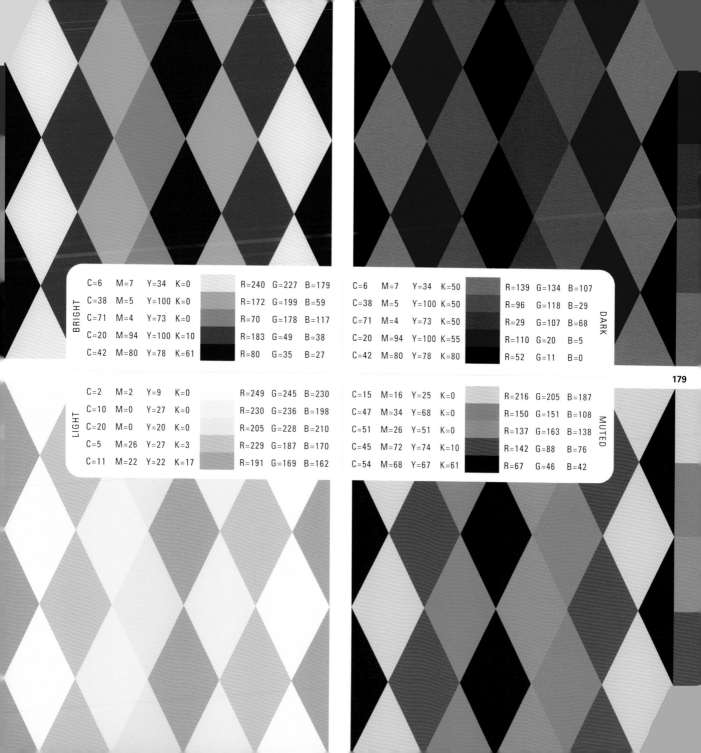

BRIGHT

C=6	M=7	Y=34	K=0		R=240	G=227	B=179
C=38	M=5	Y=100	K=0		R=172	G=199	B=59
C=71	M=4	Y=73	K=0		R=70	G=178	B=117
C=20	M=94	Y=100	K=10		R=183	G=49	B=38
C=42	M=80	Y=78	K=61		R=80	G=35	B=27

DARK

C=6	M=7	Y=34	K=50		R=139	G=134	B=107
C=38	M=5	Y=100	K=50		R=96	G=118	B=29
C=71	M=4	Y=73	K=50		R=29	G=107	B=68
C=20	M=94	Y=100	K=55		R=110	G=20	B=5
C=42	M=80	Y=78	K=80		R=52	G=11	B=0

LIGHT

C=2	M=2	Y=9	K=0		R=249	G=245	B=230
C=10	M=0	Y=27	K=0		R=230	G=236	B=198
C=20	M=0	Y=20	K=0		R=205	G=228	B=210
C=5	M=26	Y=27	K=3		R=229	G=187	B=170
C=11	M=22	Y=22	K=17		R=191	G=169	B=162

MUTED

C=15	M=16	Y=25	K=0		R=216	G=205	B=187
C=47	M=34	Y=68	K=0		R=150	G=151	B=108
C=51	M=26	Y=51	K=0		R=137	G=163	B=138
C=45	M=72	Y=74	K=10		R=142	G=88	B=76
C=54	M=68	Y=67	K=61		R=67	G=46	B=42

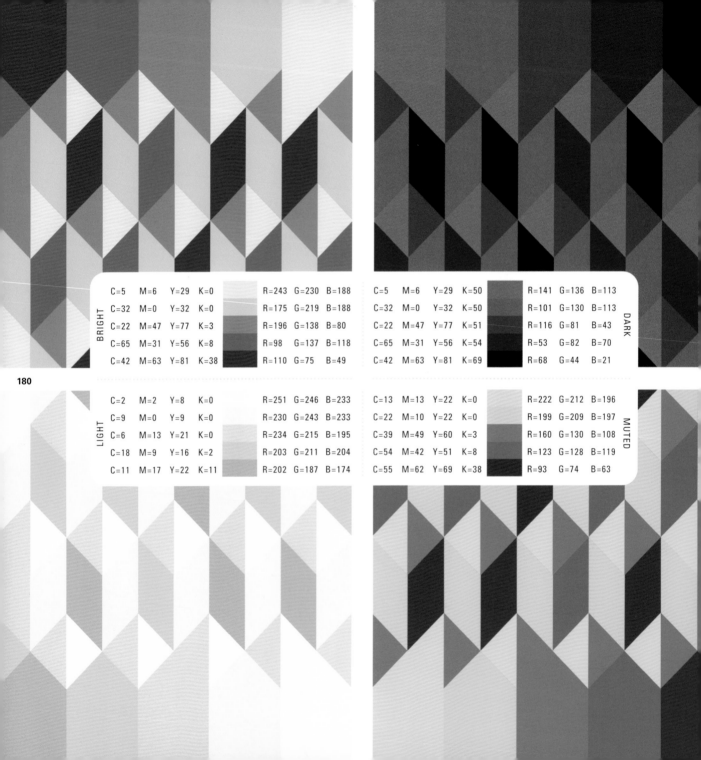

BRIGHT

C=5	M=6	Y=29	K=0		R=243	G=230	B=188
C=32	M=0	Y=32	K=0		R=175	G=219	B=188
C=22	M=47	Y=77	K=3		R=196	G=138	B=80
C=65	M=31	Y=56	K=8		R=98	G=137	B=118
C=42	M=63	Y=81	K=38		R=110	G=75	B=49

DARK

C=5	M=6	Y=29	K=50		R=141	G=136	B=113
C=32	M=0	Y=32	K=50		R=101	G=130	B=113
C=22	M=47	Y=77	K=51		R=116	G=81	B=43
C=65	M=31	Y=56	K=54		R=53	G=82	B=70
C=42	M=63	Y=81	K=69		R=68	G=44	B=21

LIGHT

C=2	M=2	Y=8	K=0		R=251	G=246	B=233
C=9	M=0	Y=9	K=0		R=230	G=243	B=233
C=6	M=13	Y=21	K=0		R=234	G=215	B=195
C=18	M=9	Y=16	K=2		R=203	G=211	B=204
C=11	M=17	Y=22	K=11		R=202	G=187	B=174

MUTED

C=13	M=13	Y=22	K=0		R=222	G=212	B=196
C=22	M=10	Y=22	K=0		R=199	G=209	B=197
C=39	M=49	Y=60	K=3		R=160	G=130	B=108
C=54	M=42	Y=51	K=8		R=123	G=128	B=119
C=55	M=62	Y=69	K=38		R=93	G=74	B=63

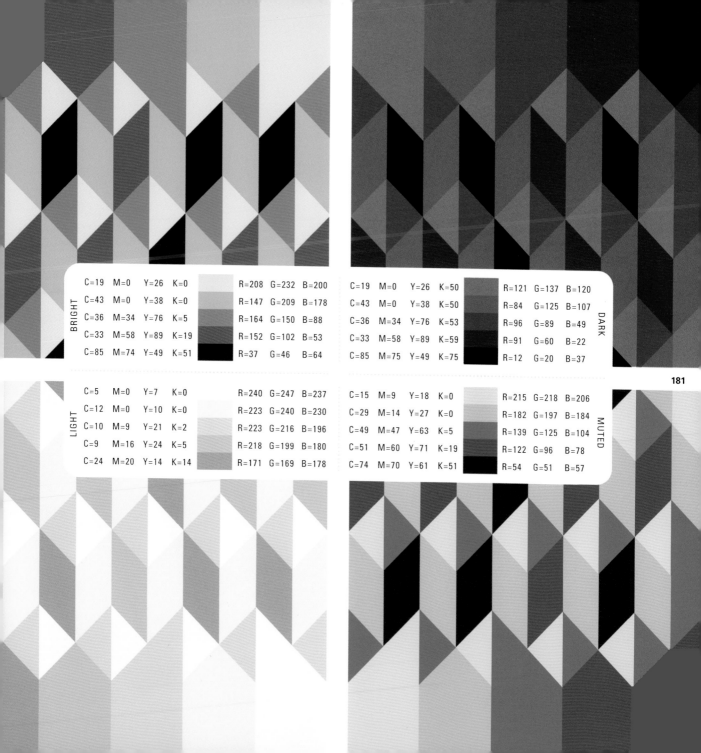

BRIGHT

C=19	M=0	Y=26	K=0		R=208	G=232	B=200
C=43	M=0	Y=38	K=0		R=147	G=209	B=178
C=36	M=34	Y=76	K=5		R=164	G=150	B=88
C=33	M=58	Y=89	K=19		R=152	G=102	B=53
C=85	M=74	Y=49	K=51		R=37	G=46	B=64

DARK

C=19	M=0	Y=26	K=50		R=121	G=137	B=120
C=43	M=0	Y=38	K=50		R=84	G=125	B=107
C=36	M=34	Y=76	K=53		R=96	G=89	B=49
C=33	M=58	Y=89	K=59		R=91	G=60	B=22
C=85	M=75	Y=49	K=75		R=12	G=20	B=37

LIGHT

C=5	M=0	Y=7	K=0		R=240	G=247	B=237
C=12	M=0	Y=10	K=0		R=223	G=240	B=230
C=10	M=9	Y=21	K=2		R=223	G=216	B=196
C=9	M=16	Y=24	K=5		R=218	G=199	B=180
C=24	M=20	Y=14	K=14		R=171	G=169	B=178

MUTED

C=15	M=9	Y=18	K=0		R=215	G=218	B=206
C=29	M=14	Y=27	K=0		R=182	G=197	B=184
C=49	M=47	Y=63	K=5		R=139	G=125	B=104
C=51	M=60	Y=71	K=19		R=122	G=96	B=78
C=74	M=70	Y=61	K=51		R=54	G=51	B=57

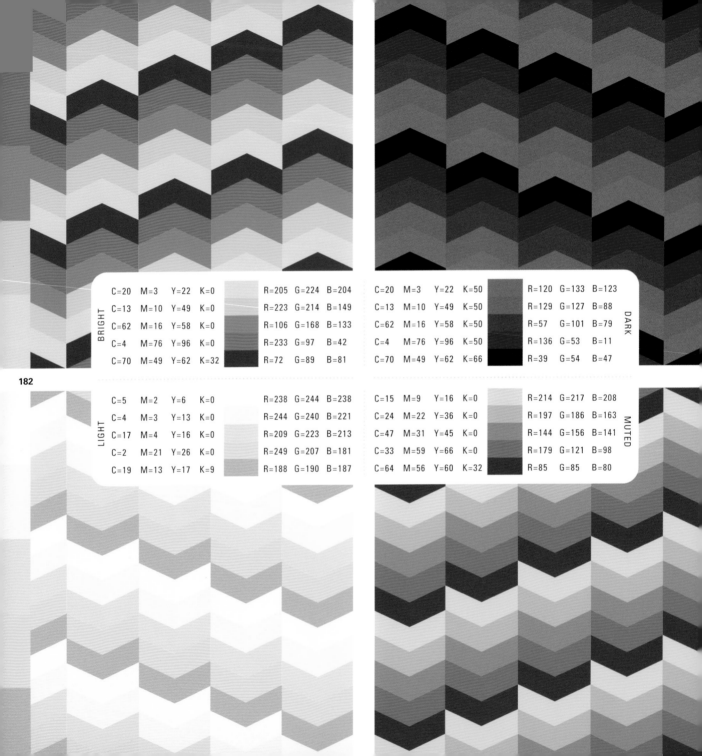

BRIGHT

C=20	M=3	Y=22	K=0		R=205	G=224	B=204
C=13	M=10	Y=49	K=0		R=223	G=214	B=149
C=62	M=16	Y=58	K=0		R=106	G=168	B=133
C=4	M=76	Y=96	K=0		R=233	G=97	B=42
C=70	M=49	Y=62	K=32		R=72	G=89	B=81

DARK

C=20	M=3	Y=22	K=50		R=120	G=133	B=123
C=13	M=10	Y=49	K=50		R=129	G=127	B=88
C=62	M=16	Y=58	K=50		R=57	G=101	B=79
C=4	M=76	Y=96	K=50		R=136	G=53	B=11
C=70	M=49	Y=62	K=66		R=39	G=54	B=47

LIGHT

C=5	M=2	Y=6	K=0		R=238	G=244	B=238
C=4	M=3	Y=13	K=0		R=244	G=240	B=221
C=17	M=4	Y=16	K=0		R=209	G=223	B=213
C=2	M=21	Y=26	K=0		R=249	G=207	B=181
C=19	M=13	Y=17	K=9		R=188	G=190	B=187

MUTED

C=15	M=9	Y=16	K=0		R=214	G=217	B=208
C=24	M=22	Y=36	K=0		R=197	G=186	B=163
C=47	M=31	Y=45	K=0		R=144	G=156	B=141
C=33	M=59	Y=66	K=0		R=179	G=121	B=98
C=64	M=56	Y=60	K=32		R=85	G=85	B=80

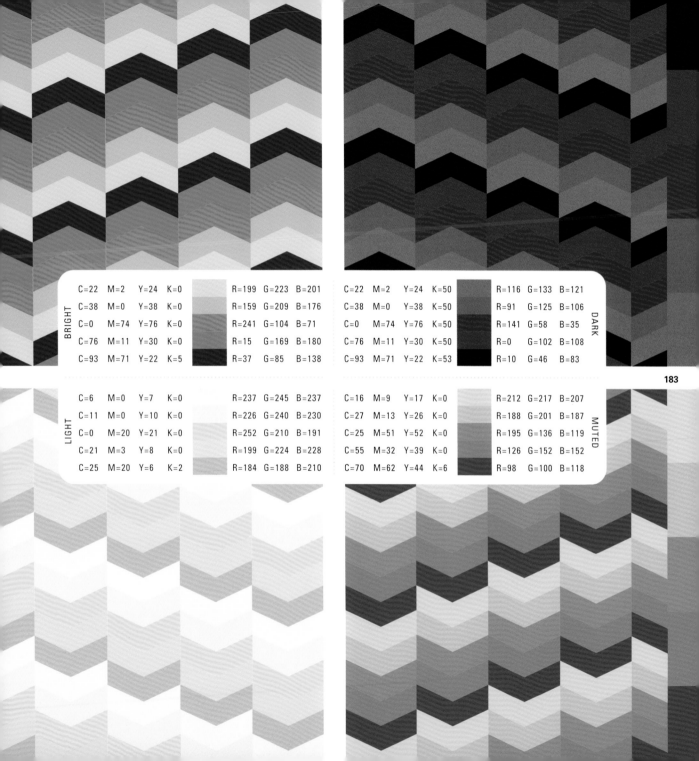

BRIGHT

C=22	M=2	Y=24	K=0		R=199	G=223	B=201
C=38	M=0	Y=38	K=0		R=159	G=209	B=176
C=0	M=74	Y=76	K=0		R=241	G=104	B=71
C=76	M=11	Y=30	K=0		R=15	G=169	B=180
C=93	M=71	Y=22	K=5		R=37	G=85	B=138

DARK

C=22	M=2	Y=24	K=50		R=116	G=133	B=121
C=38	M=0	Y=38	K=50		R=91	G=125	B=106
C=0	M=74	Y=76	K=50		R=141	G=58	B=35
C=76	M=11	Y=30	K=50		R=0	G=102	B=108
C=93	M=71	Y=22	K=53		R=10	G=46	B=83

183

LIGHT

C=6	M=0	Y=7	K=0		R=237	G=245	B=237
C=11	M=0	Y=10	K=0		R=226	G=240	B=230
C=0	M=20	Y=21	K=0		R=252	G=210	B=191
C=21	M=3	Y=8	K=0		R=199	G=224	B=228
C=25	M=20	Y=6	K=2		R=184	G=188	B=210

MUTED

C=16	M=9	Y=17	K=0		R=212	G=217	B=207
C=27	M=13	Y=26	K=0		R=188	G=201	B=187
C=25	M=51	Y=52	K=0		R=195	G=136	B=119
C=55	M=32	Y=39	K=0		R=126	G=152	B=152
C=70	M=62	Y=44	K=6		R=98	G=100	B=118

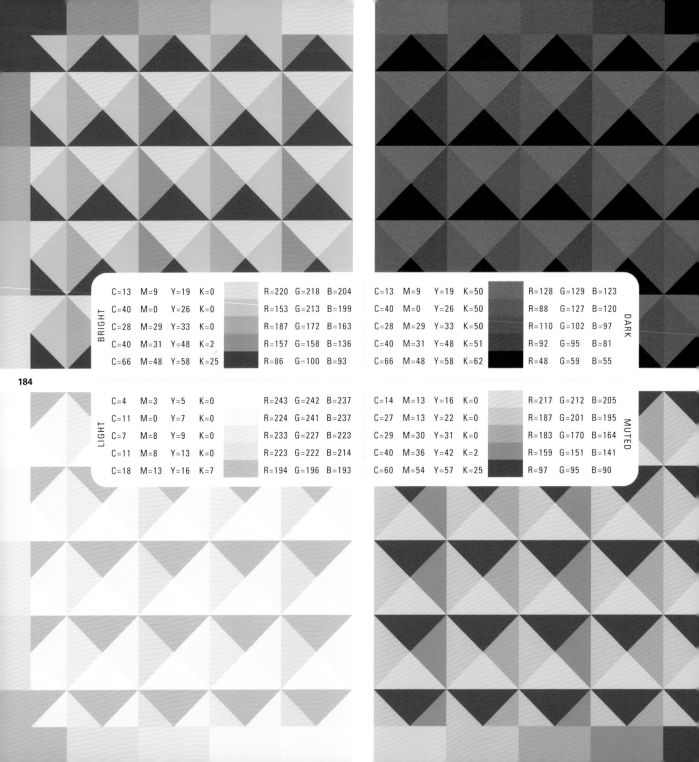

BRIGHT	C=13	M=9	Y=19	K=0		R=220	G=218	B=204
	C=40	M=0	Y=26	K=0		R=153	G=213	B=199
	C=28	M=29	Y=33	K=0		R=187	G=172	B=163
	C=40	M=31	Y=48	K=2		R=157	G=158	B=136
	C=66	M=48	Y=58	K=25		R=86	G=100	B=93

C=13	M=9	Y=19	K=50		R=128	G=129	B=123	**DARK**
C=40	M=0	Y=26	K=50		R=88	G=127	B=120	
C=28	M=29	Y=33	K=50		R=110	G=102	B=97	
C=40	M=31	Y=48	K=51		R=92	G=95	B=81	
C=66	M=48	Y=58	K=62		R=48	G=59	B=55	

LIGHT	C=4	M=3	Y=5	K=0		R=243	G=242	B=237
	C=11	M=0	Y=7	K=0		R=224	G=241	B=237
	C=7	M=8	Y=9	K=0		R=233	G=227	B=223
	C=11	M=8	Y=13	K=0		R=223	G=222	B=214
	C=18	M=13	Y=16	K=7		R=194	G=196	B=193

C=14	M=13	Y=16	K=0		R=217	G=212	B=205	**MUTED**
C=27	M=13	Y=22	K=0		R=187	G=201	B=195	
C=29	M=30	Y=31	K=0		R=183	G=170	B=164	
C=40	M=36	Y=42	K=2		R=159	G=151	B=141	
C=60	M=54	Y=57	K=25		R=97	G=95	B=90	

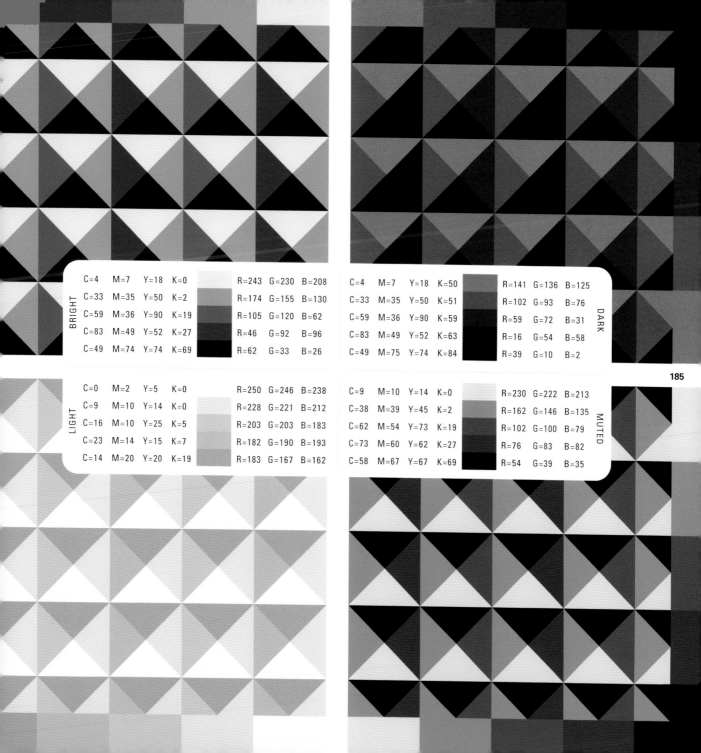

BRIGHT

C=4	M=7	Y=18	K=0		R=243	G=230	B=208
C=33	M=35	Y=50	K=2		R=174	G=155	B=130
C=59	M=36	Y=90	K=19		R=105	G=120	B=62
C=83	M=49	Y=52	K=27		R=46	G=92	B=96
C=49	M=74	Y=74	K=69		R=62	G=33	B=26

DARK

C=4	M=7	Y=18	K=50		R=141	G=136	B=125
C=33	M=35	Y=50	K=51		R=102	G=93	B=76
C=59	M=36	Y=90	K=59		R=59	G=72	B=31
C=83	M=49	Y=52	K=63		R=16	G=54	B=58
C=49	M=75	Y=74	K=84		R=39	G=10	B=2

LIGHT

C=0	M=2	Y=5	K=0		R=250	G=246	B=238
C=9	M=10	Y=14	K=0		R=228	G=221	B=212
C=16	M=10	Y=25	K=5		R=203	G=203	B=183
C=23	M=14	Y=15	K=7		R=182	G=190	B=193
C=14	M=20	Y=20	K=19		R=183	G=167	B=162

MUTED

C=9	M=10	Y=14	K=0		R=230	G=222	B=213
C=38	M=39	Y=45	K=2		R=162	G=146	B=135
C=62	M=54	Y=73	K=19		R=102	G=100	B=79
C=73	M=60	Y=62	K=27		R=76	G=83	B=82
C=58	M=67	Y=67	K=69		R=54	G=39	B=35

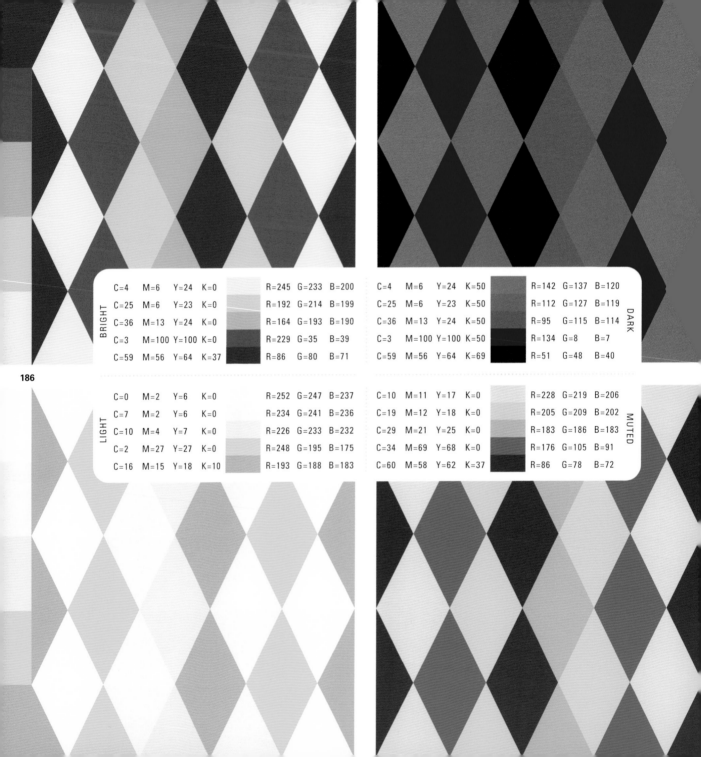

BRIGHT

C=4	M=6	Y=24	K=0		R=245	G=233	B=200
C=25	M=6	Y=23	K=0		R=192	G=214	B=199
C=36	M=13	Y=24	K=0		R=164	G=193	B=190
C=3	M=100	Y=100	K=0		R=229	G=35	B=39
C=59	M=56	Y=64	K=37		R=86	G=80	B=71

DARK

C=4	M=6	Y=24	K=50		R=142	G=137	B=120
C=25	M=6	Y=23	K=50		R=112	G=127	B=119
C=36	M=13	Y=24	K=50		R=95	G=115	B=114
C=3	M=100	Y=100	K=50		R=134	G=8	B=7
C=59	M=56	Y=64	K=69		R=51	G=48	B=40

LIGHT

C=0	M=2	Y=6	K=0		R=252	G=247	B=237
C=7	M=2	Y=6	K=0		R=234	G=241	B=236
C=10	M=4	Y=7	K=0		R=226	G=233	B=232
C=2	M=27	Y=27	K=0		R=248	G=195	B=175
C=16	M=15	Y=18	K=10		R=193	G=188	B=183

MUTED

C=10	M=11	Y=17	K=0		R=228	G=219	B=206
C=19	M=12	Y=18	K=0		R=205	G=209	B=202
C=29	M=21	Y=25	K=0		R=183	G=186	B=183
C=34	M=69	Y=68	K=0		R=176	G=105	B=91
C=60	M=58	Y=62	K=37		R=86	G=78	B=72

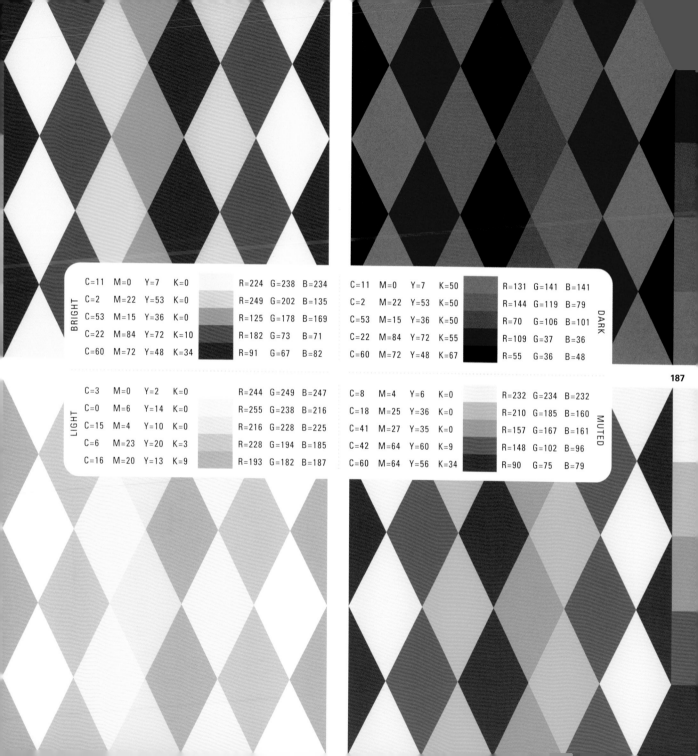

BRIGHT

C=11	M=0	Y=7	K=0		R=224	G=238	B=234
C=2	M=22	Y=53	K=0		R=249	G=202	B=135
C=53	M=15	Y=36	K=0		R=125	G=178	B=169
C=22	M=84	Y=72	K=10		R=182	G=73	B=71
C=60	M=72	Y=48	K=34		R=91	G=67	B=82

DARK

C=11	M=0	Y=7	K=50		R=131	G=141	B=141
C=2	M=22	Y=53	K=50		R=144	G=119	B=79
C=53	M=15	Y=36	K=50		R=70	G=106	B=101
C=22	M=84	Y=72	K=55		R=109	G=37	B=36
C=60	M=72	Y=48	K=67		R=55	G=36	B=48

LIGHT

C=3	M=0	Y=2	K=0		R=244	G=249	B=247
C=0	M=6	Y=14	K=0		R=255	G=238	B=216
C=15	M=4	Y=10	K=0		R=216	G=228	B=225
C=6	M=23	Y=20	K=3		R=228	G=194	B=185
C=16	M=20	Y=13	K=9		R=193	G=182	B=187

MUTED

C=8	M=4	Y=6	K=0		R=232	G=234	B=232
C=18	M=25	Y=36	K=0		R=210	G=185	B=160
C=41	M=27	Y=35	K=0		R=157	G=167	B=161
C=42	M=64	Y=60	K=9		R=148	G=102	B=96
C=60	M=64	Y=56	K=34		R=90	G=75	B=79

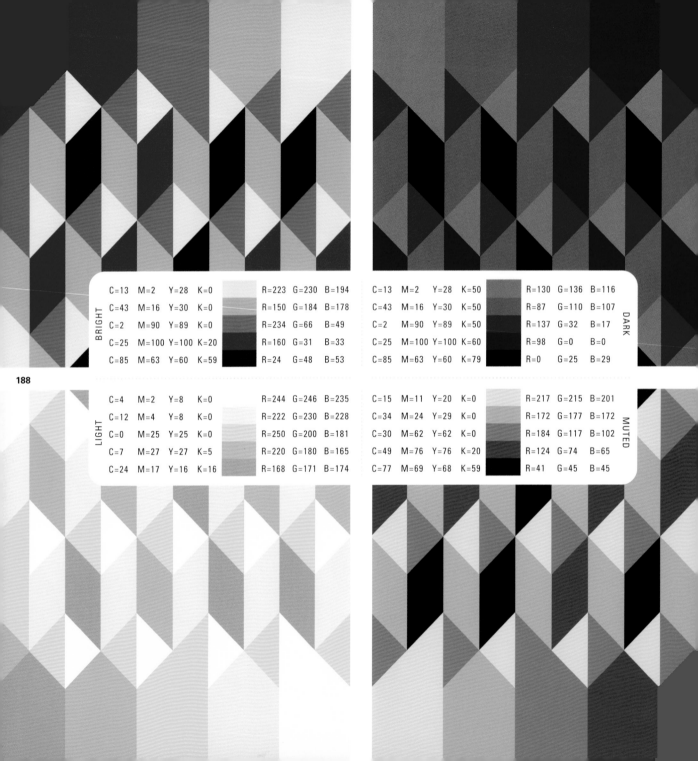

	C	M	Y	K		R	G	B
BRIGHT	C=13	M=2	Y=28	K=0		R=223	G=230	B=194
	C=43	M=16	Y=30	K=0		R=150	G=184	B=178
	C=2	M=90	Y=89	K=0		R=234	G=66	B=49
	C=25	M=100	Y=100	K=20		R=160	G=31	B=33
	C=85	M=63	Y=60	K=59		R=24	G=48	B=53

	C	M	Y	K		R	G	B
DARK	C=13	M=2	Y=28	K=50		R=130	G=136	B=116
	C=43	M=16	Y=30	K=50		R=87	G=110	B=107
	C=2	M=90	Y=89	K=50		R=137	G=32	B=17
	C=25	M=100	Y=100	K=60		R=98	G=0	B=0
	C=85	M=63	Y=60	K=79		R=0	G=25	B=29

	C	M	Y	K		R	G	B
LIGHT	C=4	M=2	Y=8	K=0		R=244	G=246	B=235
	C=12	M=4	Y=8	K=0		R=222	G=230	B=228
	C=0	M=25	Y=25	K=0		R=250	G=200	B=181
	C=7	M=27	Y=27	K=5		R=220	G=180	B=165
	C=24	M=17	Y=16	K=16		R=168	G=171	B=174

	C	M	Y	K		R	G	B
MUTED	C=15	M=11	Y=20	K=0		R=217	G=215	B=201
	C=34	M=24	Y=29	K=0		R=172	G=177	B=172
	C=30	M=62	Y=62	K=0		R=184	G=117	B=102
	C=49	M=76	Y=76	K=20		R=124	G=74	B=65
	C=77	M=69	Y=68	K=59		R=41	G=45	B=45

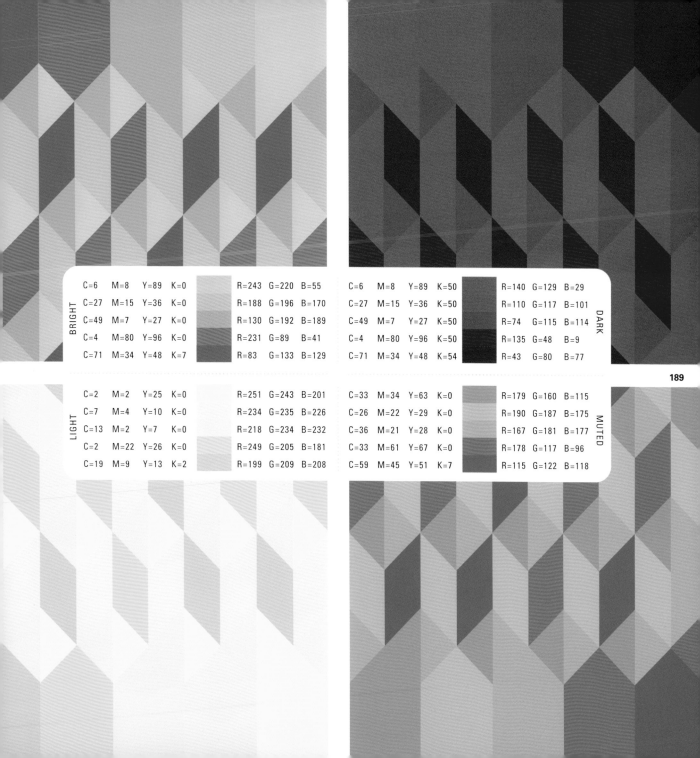

BRIGHT

C=6	M=8	Y=89	K=0		R=243	G=220	B=55
C=27	M=15	Y=36	K=0		R=188	G=196	B=170
C=49	M=7	Y=27	K=0		R=130	G=192	B=189
C=4	M=80	Y=96	K=0		R=231	G=89	B=41
C=71	M=34	Y=48	K=7		R=83	G=133	B=129

DARK

C=6	M=8	Y=89	K=50		R=140	G=129	B=29
C=27	M=15	Y=36	K=50		R=110	G=117	B=101
C=49	M=7	Y=27	K=50		R=74	G=115	B=114
C=4	M=80	Y=96	K=50		R=135	G=48	B=9
C=71	M=34	Y=48	K=54		R=43	G=80	B=77

LIGHT

C=2	M=2	Y=25	K=0		R=251	G=243	B=201
C=7	M=4	Y=10	K=0		R=234	G=235	B=226
C=13	M=2	Y=7	K=0		R=218	G=234	B=232
C=2	M=22	Y=26	K=0		R=249	G=205	B=181
C=19	M=9	Y=13	K=2		R=199	G=209	B=208

MUTED

C=33	M=34	Y=63	K=0		R=179	G=160	B=115
C=26	M=22	Y=29	K=0		R=190	G=187	B=175
C=36	M=21	Y=28	K=0		R=167	G=181	B=177
C=33	M=61	Y=67	K=0		R=178	G=117	B=96
C=59	M=45	Y=51	K=7		R=115	G=122	B=118

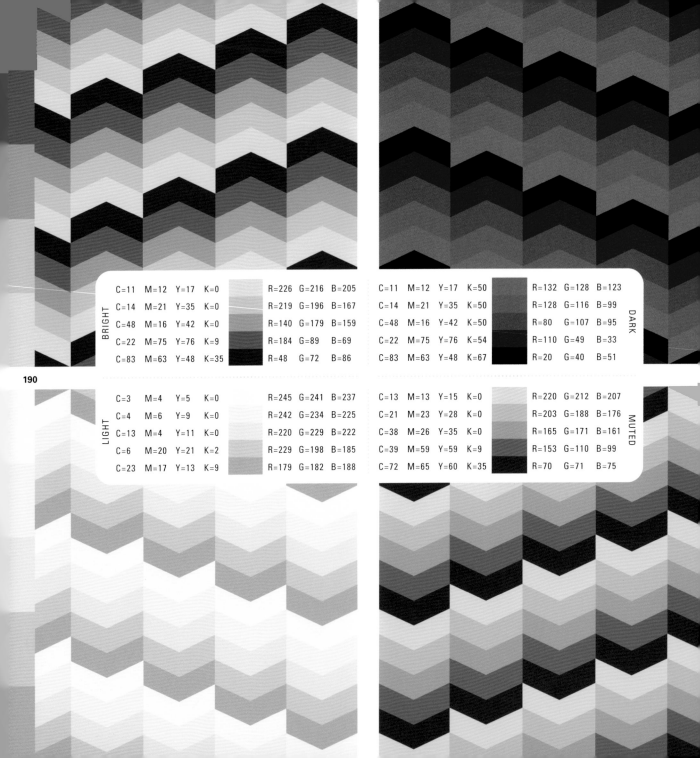

BRIGHT

C=11	M=12	Y=17	K=0		R=226	G=216	B=205
C=14	M=21	Y=35	K=0		R=219	G=196	B=167
C=48	M=16	Y=42	K=0		R=140	G=179	B=159
C=22	M=75	Y=76	K=9		R=184	G=89	B=69
C=83	M=63	Y=48	K=35		R=48	G=72	B=86

DARK

C=11	M=12	Y=17	K=50		R=132	G=128	B=123
C=14	M=21	Y=35	K=50		R=128	G=116	B=99
C=48	M=16	Y=42	K=50		R=80	G=107	B=95
C=22	M=75	Y=76	K=54		R=110	G=49	B=33
C=83	M=63	Y=48	K=67		R=20	G=40	B=51

LIGHT

C=3	M=4	Y=5	K=0		R=245	G=241	B=237
C=4	M=6	Y=9	K=0		R=242	G=234	B=225
C=13	M=4	Y=11	K=0		R=220	G=229	B=222
C=6	M=20	Y=21	K=2		R=229	G=198	B=185
C=23	M=17	Y=13	K=9		R=179	G=182	B=188

MUTED

C=13	M=13	Y=15	K=0		R=220	G=212	B=207
C=21	M=23	Y=28	K=0		R=203	G=188	B=176
C=38	M=26	Y=35	K=0		R=165	G=171	B=161
C=39	M=59	Y=59	K=9		R=153	G=110	B=99
C=72	M=65	Y=60	K=35		R=70	G=71	B=75

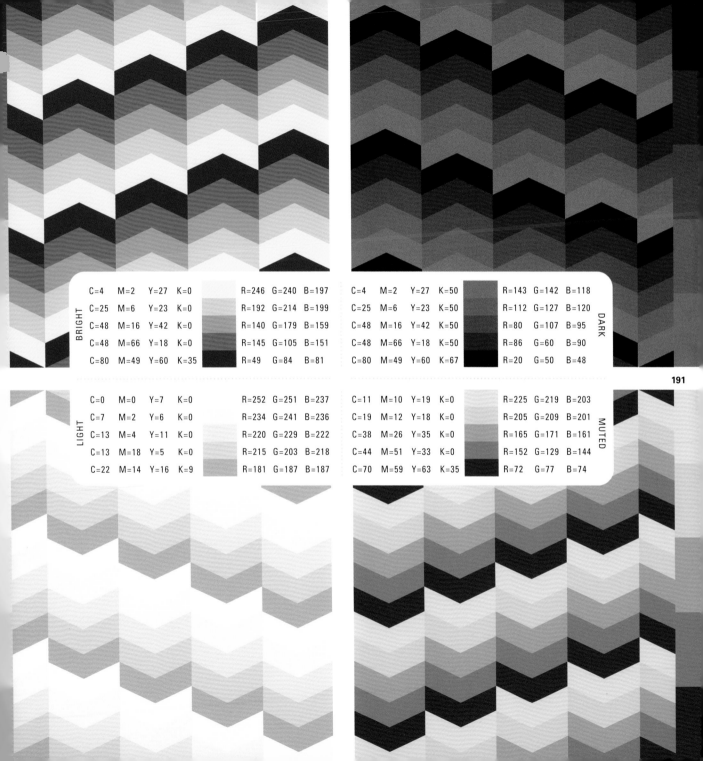

BRIGHT

C=4	M=2	Y=27	K=0		R=246	G=240	B=197
C=25	M=6	Y=23	K=0		R=192	G=214	B=199
C=48	M=16	Y=42	K=0		R=140	G=179	B=159
C=48	M=66	Y=18	K=0		R=145	G=105	B=151
C=80	M=49	Y=60	K=35		R=49	G=84	B=81

DARK

C=4	M=2	Y=27	K=50		R=143	G=142	B=118
C=25	M=6	Y=23	K=50		R=112	G=127	B=120
C=48	M=16	Y=42	K=50		R=80	G=107	B=95
C=48	M=66	Y=18	K=50		R=86	G=60	B=90
C=80	M=49	Y=60	K=67		R=20	G=50	B=48

LIGHT

C=0	M=0	Y=7	K=0		R=252	G=251	B=237
C=7	M=2	Y=6	K=0		R=234	G=241	B=236
C=13	M=4	Y=11	K=0		R=220	G=229	B=222
C=13	M=18	Y=5	K=0		R=215	G=203	B=218
C=22	M=14	Y=16	K=9		R=181	G=187	B=187

MUTED

C=11	M=10	Y=19	K=0		R=225	G=219	B=203
C=19	M=12	Y=18	K=0		R=205	G=209	B=201
C=38	M=26	Y=35	K=0		R=165	G=171	B=161
C=44	M=51	Y=33	K=0		R=152	G=129	B=144
C=70	M=59	Y=63	K=35		R=72	G=77	B=74

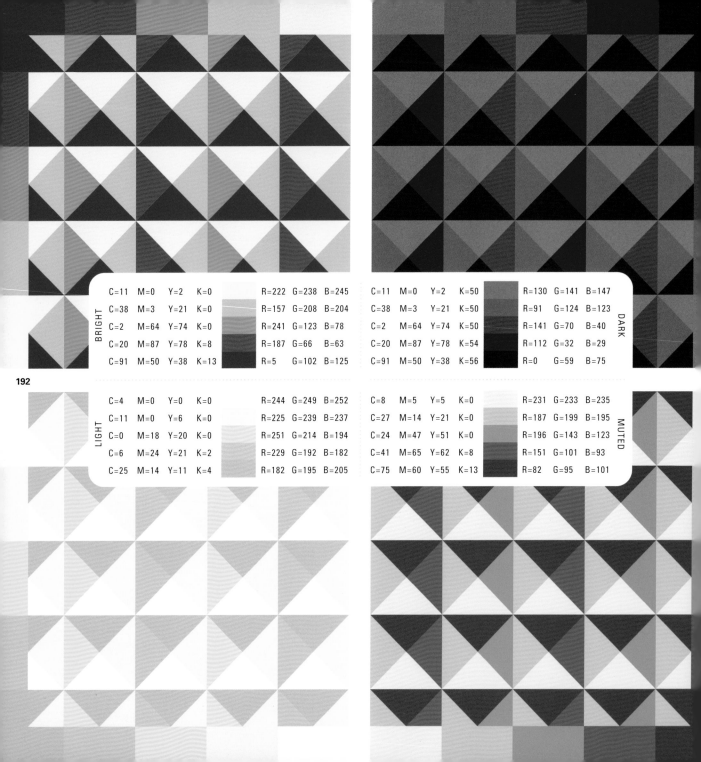

BRIGHT

C=11	M=0	Y=2	K=0		R=222	G=238	B=245
C=38	M=3	Y=21	K=0		R=157	G=208	B=204
C=2	M=64	Y=74	K=0		R=241	G=123	B=78
C=20	M=87	Y=78	K=8		R=187	G=66	B=63
C=91	M=50	Y=38	K=13		R=5	G=102	B=125

DARK

C=11	M=0	Y=2	K=50		R=130	G=141	B=147
C=38	M=3	Y=21	K=50		R=91	G=124	B=123
C=2	M=64	Y=74	K=50		R=141	G=70	B=40
C=20	M=87	Y=78	K=54		R=112	G=32	B=29
C=91	M=50	Y=38	K=56		R=0	G=59	B=75

192

LIGHT

C=4	M=0	Y=0	K=0		R=244	G=249	B=252
C=11	M=0	Y=6	K=0		R=225	G=239	B=237
C=0	M=18	Y=20	K=0		R=251	G=214	B=194
C=6	M=24	Y=21	K=2		R=229	G=192	B=182
C=25	M=14	Y=11	K=4		R=182	G=195	B=205

MUTED

C=8	M=5	Y=5	K=0		R=231	G=233	B=235
C=27	M=14	Y=21	K=0		R=187	G=199	B=195
C=24	M=47	Y=51	K=0		R=196	G=143	B=123
C=41	M=65	Y=62	K=8		R=151	G=101	B=93
C=75	M=60	Y=55	K=13		R=82	G=95	B=101

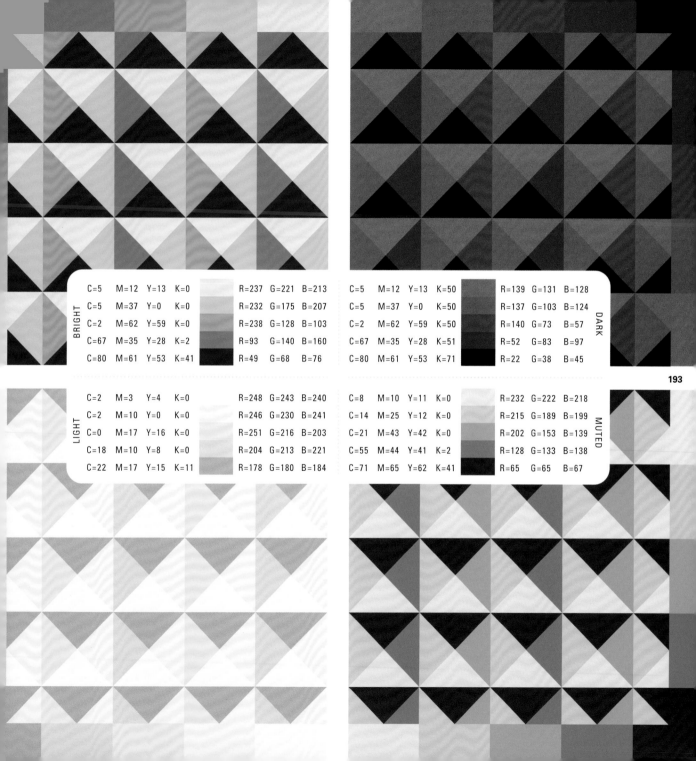

BRIGHT

					R=237	G=221	B=213
C=5	M=12	Y=13	K=0		R=237	G=221	B=213
C=5	M=37	Y=0	K=0		R=232	G=175	B=207
C=2	M=62	Y=59	K=0		R=238	G=128	B=103
C=67	M=35	Y=28	K=2		R=93	G=140	B=160
C=80	M=61	Y=53	K=41		R=49	G=68	B=76

DARK

C=5	M=12	Y=13	K=50		R=139	G=131	B=128
C=5	M=37	Y=0	K=50		R=137	G=103	B=124
C=2	M=62	Y=59	K=50		R=140	G=73	B=57
C=67	M=35	Y=28	K=51		R=52	G=83	B=97
C=80	M=61	Y=53	K=71		R=22	G=38	B=45

LIGHT

C=2	M=3	Y=4	K=0		R=248	G=243	B=240
C=2	M=10	Y=0	K=0		R=246	G=230	B=241
C=0	M=17	Y=16	K=0		R=251	G=216	B=203
C=18	M=10	Y=8	K=0		R=204	G=213	B=221
C=22	M=17	Y=15	K=11		R=178	G=180	B=184

MUTED

C=8	M=10	Y=11	K=0		R=232	G=222	B=218
C=14	M=25	Y=12	K=0		R=215	G=189	B=199
C=21	M=43	Y=42	K=0		R=202	G=153	B=139
C=55	M=44	Y=41	K=2		R=128	G=133	B=138
C=71	M=65	Y=62	K=41		R=65	G=65	B=67

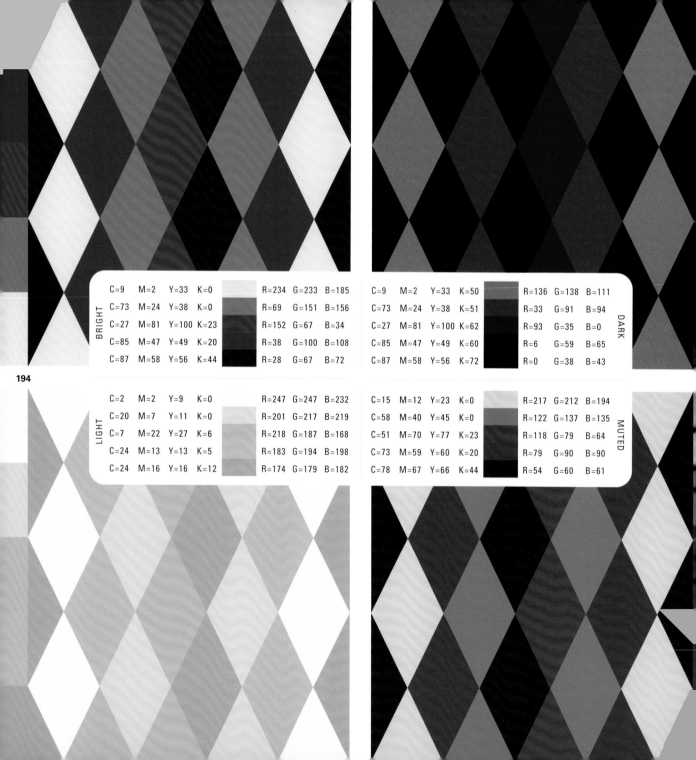

BRIGHT	C=9	M=2	Y=33	K=0	R=234	G=233	B=185
	C=73	M=24	Y=38	K=0	R=69	G=151	B=156
	C=27	M=81	Y=100	K=23	R=152	G=67	B=34
	C=85	M=47	Y=49	K=20	R=38	G=100	B=108
	C=87	M=58	Y=56	K=44	R=28	G=67	B=72

C=9	M=2	Y=33	K=50	R=136	G=138	B=111	**DARK**
C=73	M=24	Y=38	K=51	R=33	G=91	B=94	
C=27	M=81	Y=100	K=62	R=93	G=35	B=0	
C=85	M=47	Y=49	K=60	R=6	G=59	B=65	
C=87	M=58	Y=56	K=72	R=0	G=38	B=43	

LIGHT	C=2	M=2	Y=9	K=0	R=247	G=247	B=232
	C=20	M=7	Y=11	K=0	R=201	G=217	B=219
	C=7	M=22	Y=27	K=6	R=218	G=187	B=168
	C=24	M=13	Y=13	K=5	R=183	G=194	B=198
	C=24	M=16	Y=16	K=12	R=174	G=179	B=182

C=15	M=12	Y=23	K=0	R=217	G=212	B=194	**MUTED**
C=58	M=40	Y=45	K=0	R=122	G=137	B=135	
C=51	M=70	Y=77	K=23	R=118	G=79	B=64	
C=73	M=59	Y=60	K=20	R=79	G=90	B=90	
C=78	M=67	Y=66	K=44	R=54	G=60	B=61	

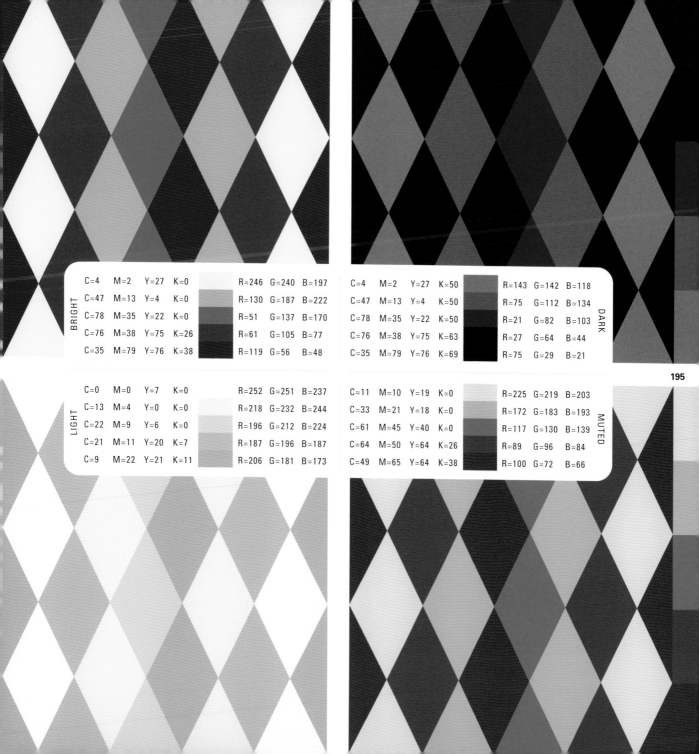

BRIGHT

C=4	M=2	Y=27	K=0		R=246	G=240	B=197
C=47	M=13	Y=4	K=0		R=130	G=187	B=222
C=78	M=35	Y=22	K=0		R=51	G=137	B=170
C=76	M=38	Y=75	K=26		R=61	G=105	B=77
C=35	M=79	Y=76	K=38		R=119	G=56	B=48

DARK

C=4	M=2	Y=27	K=50		R=143	G=142	B=118
C=47	M=13	Y=4	K=50		R=75	G=112	B=134
C=78	M=35	Y=22	K=50		R=21	G=82	B=103
C=76	M=38	Y=75	K=63		R=27	G=64	B=44
C=35	M=79	Y=76	K=69		R=75	G=29	B=21

LIGHT

C=0	M=0	Y=7	K=0		R=252	G=251	B=237
C=13	M=4	Y=0	K=0		R=218	G=232	B=244
C=22	M=9	Y=6	K=0		R=196	G=212	B=224
C=21	M=11	Y=20	K=7		R=187	G=196	B=187
C=9	M=22	Y=21	K=11		R=206	G=181	B=173

MUTED

C=11	M=10	Y=19	K=0		R=225	G=219	B=203
C=33	M=21	Y=18	K=0		R=172	G=183	B=193
C=61	M=45	Y=40	K=0		R=117	G=130	B=139
C=64	M=50	Y=64	K=26		R=89	G=96	B=84
C=49	M=65	Y=64	K=38		R=100	G=72	B=66

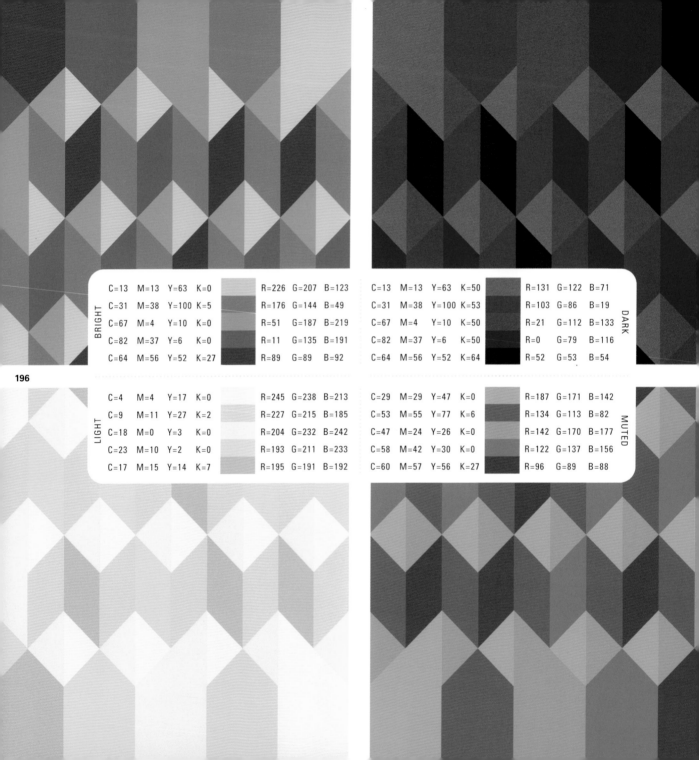

BRIGHT

C=13	M=13	Y=63	K=0		R=226	G=207	B=123
C=31	M=38	Y=100	K=5		R=176	G=144	B=49
C=67	M=4	Y=10	K=0		R=51	G=187	B=219
C=82	M=37	Y=6	K=0		R=11	G=135	B=191
C=64	M=56	Y=52	K=27		R=89	G=89	B=92

DARK

C=13	M=13	Y=63	K=50		R=131	G=122	B=71
C=31	M=38	Y=100	K=53		R=103	G=86	B=19
C=67	M=4	Y=10	K=50		R=21	G=112	B=133
C=82	M=37	Y=6	K=50		R=0	G=79	B=116
C=64	M=56	Y=52	K=64		R=52	G=53	B=54

LIGHT

C=4	M=4	Y=17	K=0		R=245	G=238	B=213
C=9	M=11	Y=27	K=2		R=227	G=215	B=185
C=18	M=0	Y=3	K=0		R=204	G=232	B=242
C=23	M=10	Y=2	K=0		R=193	G=211	B=233
C=17	M=15	Y=14	K=7		R=195	G=191	B=192

MUTED

C=29	M=29	Y=47	K=0		R=187	G=171	B=142
C=53	M=55	Y=77	K=6		R=134	G=113	B=82
C=47	M=24	Y=26	K=0		R=142	G=170	B=177
C=58	M=42	Y=30	K=0		R=122	G=137	B=156
C=60	M=57	Y=56	K=27		R=96	G=89	B=88

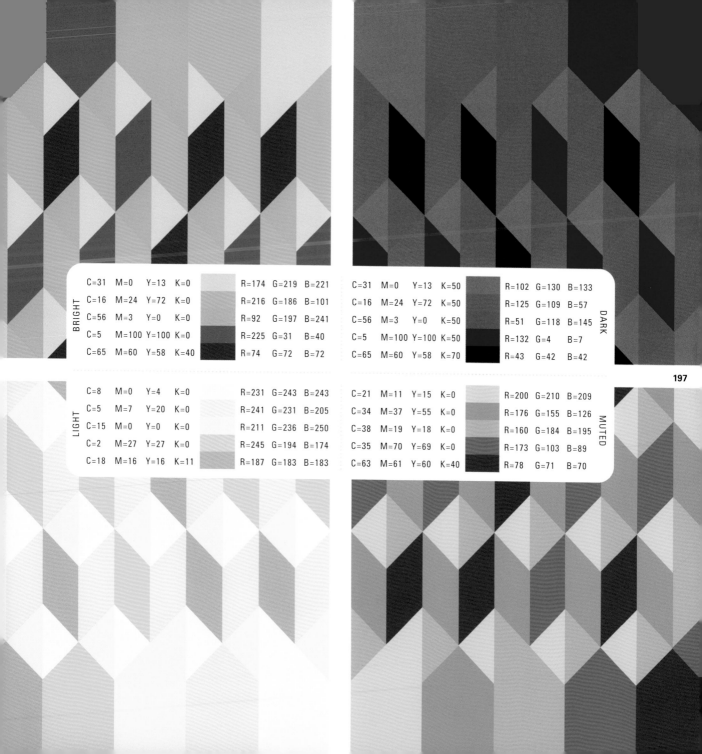

BRIGHT

C=31	M=0	Y=13	K=0		R=174	G=219	B=221
C=16	M=24	Y=72	K=0		R=216	G=186	B=101
C=56	M=3	Y=0	K=0		R=92	G=197	B=241
C=5	M=100	Y=100	K=0		R=225	G=31	B=40
C=65	M=60	Y=58	K=40		R=74	G=72	B=72

DARK

C=31	M=0	Y=13	K=50		R=102	G=130	B=133
C=16	M=24	Y=72	K=50		R=125	G=109	B=57
C=56	M=3	Y=0	K=50		R=51	G=118	B=145
C=5	M=100	Y=100	K=50		R=132	G=4	B=7
C=65	M=60	Y=58	K=70		R=43	G=42	B=42

LIGHT

C=8	M=0	Y=4	K=0		R=231	G=243	B=243
C=5	M=7	Y=20	K=0		R=241	G=231	B=205
C=15	M=0	Y=0	K=0		R=211	G=236	B=250
C=2	M=27	Y=27	K=0		R=245	G=194	B=174
C=18	M=16	Y=16	K=11		R=187	G=183	B=183

MUTED

C=21	M=11	Y=15	K=0		R=200	G=210	B=209
C=34	M=37	Y=55	K=0		R=176	G=155	B=126
C=38	M=19	Y=18	K=0		R=160	G=184	B=195
C=35	M=70	Y=69	K=0		R=173	G=103	B=89
C=63	M=61	Y=60	K=40		R=78	G=71	B=70

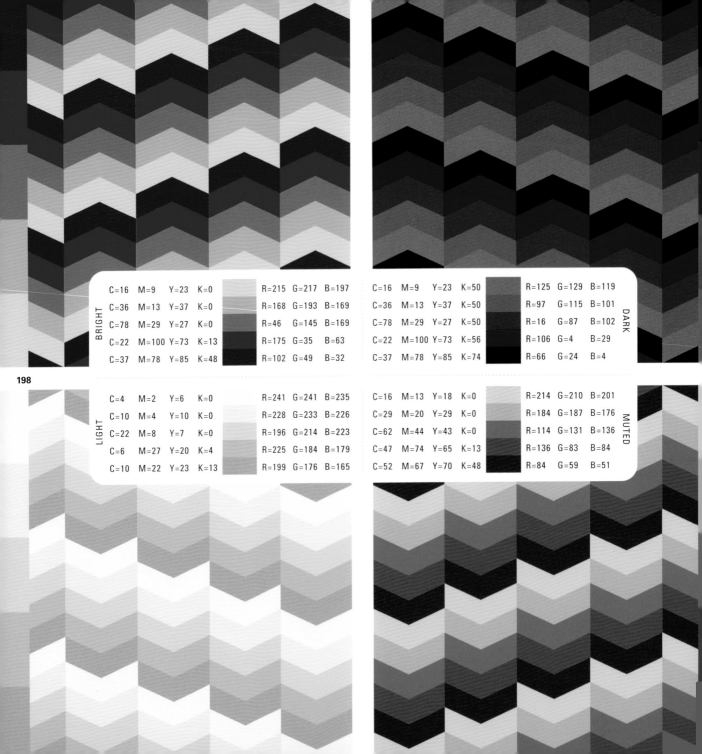

BRIGHT

C=16	M=9	Y=23	K=0		R=215	G=217	B=197
C=36	M=13	Y=37	K=0		R=168	G=193	B=169
C=78	M=29	Y=27	K=0		R=46	G=145	B=169
C=22	M=100	Y=73	K=13		R=175	G=35	B=63
C=37	M=78	Y=85	K=48		R=102	G=49	B=32

DARK

C=16	M=9	Y=23	K=50		R=125	G=129	B=119
C=36	M=13	Y=37	K=50		R=97	G=115	B=101
C=78	M=29	Y=27	K=50		R=16	G=87	B=102
C=22	M=100	Y=73	K=56		R=106	G=4	B=29
C=37	M=78	Y=85	K=74		R=66	G=24	B=4

LIGHT

C=4	M=2	Y=6	K=0		R=241	G=241	B=235
C=10	M=4	Y=10	K=0		R=228	G=233	B=226
C=22	M=8	Y=7	K=0		R=196	G=214	B=223
C=6	M=27	Y=20	K=4		R=225	G=184	B=179
C=10	M=22	Y=23	K=13		R=199	G=176	B=165

MUTED

C=16	M=13	Y=18	K=0		R=214	G=210	B=201
C=29	M=20	Y=29	K=0		R=184	G=187	B=176
C=62	M=44	Y=43	K=0		R=114	G=131	B=136
C=47	M=74	Y=65	K=13		R=136	G=83	B=84
C=52	M=67	Y=70	K=48		R=84	G=59	B=51

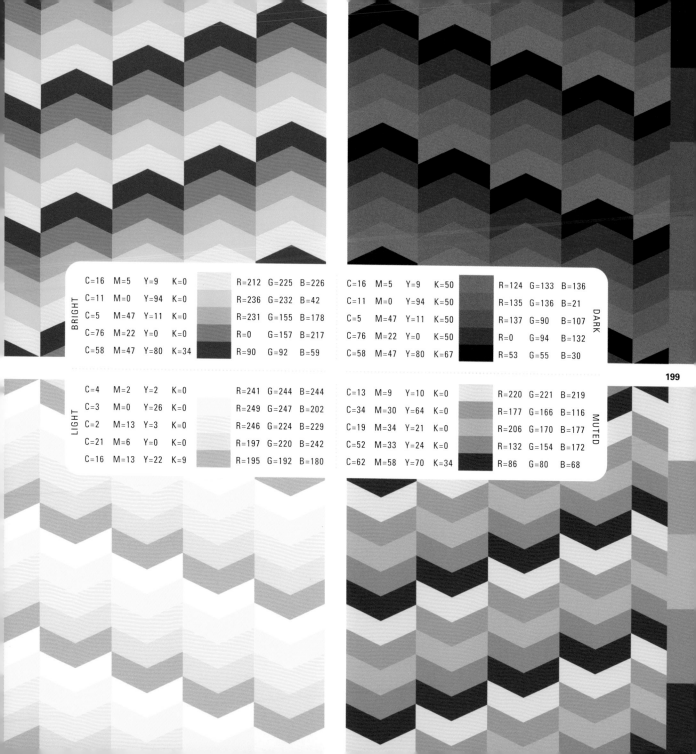

BRIGHT

C=16	M=5	Y=9	K=0
C=11	M=0	Y=94	K=0
C=5	M=47	Y=11	K=0
C=76	M=22	Y=0	K=0
C=58	M=47	Y=80	K=34

R=212	G=225	B=226
R=236	G=232	B=42
R=231	G=155	B=178
R=0	G=157	B=217
R=90	G=92	B=59

C=16	M=5	Y=9	K=50
C=11	M=0	Y=94	K=50
C=5	M=47	Y=11	K=50
C=76	M=22	Y=0	K=50
C=58	M=47	Y=80	K=67

DARK

R=124	G=133	B=136
R=135	G=136	B=21
R=137	G=90	B=107
R=0	G=94	B=132
R=53	G=55	B=30

LIGHT

C=4	M=2	Y=2	K=0
C=3	M=0	Y=26	K=0
C=2	M=13	Y=3	K=0
C=21	M=6	Y=0	K=0
C=16	M=13	Y=22	K=9

R=241	G=244	B=244
R=249	G=247	B=202
R=246	G=224	B=229
R=197	G=220	B=242
R=195	G=192	B=180

C=13	M=9	Y=10	K=0
C=34	M=30	Y=64	K=0
C=19	M=34	Y=21	K=0
C=52	M=33	Y=24	K=0
C=62	M=58	Y=70	K=34

MUTED

R=220	G=221	B=219
R=177	G=166	B=116
R=206	G=170	B=177
R=132	G=154	B=172
R=86	G=80	B=68

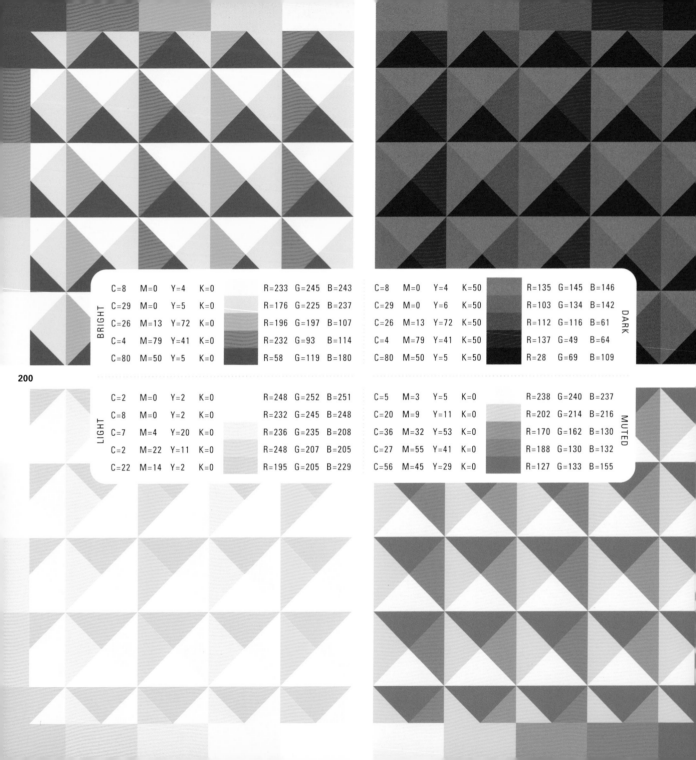

	C=8	M=0	Y=4	K=0		R=233	G=245	B=243
BRIGHT	C=29	M=0	Y=5	K=0		R=176	G=225	B=237
	C=26	M=13	Y=72	K=0		R=196	G=197	B=107
	C=4	M=79	Y=41	K=0		R=232	G=93	B=114
	C=80	M=50	Y=5	K=0		R=58	G=119	B=180

	C=8	M=0	Y=4	K=50		R=135	G=145	B=146	
	C=29	M=0	Y=6	K=50		R=103	G=134	B=142	DARK
	C=26	M=13	Y=72	K=50		R=112	G=116	B=61	
	C=4	M=79	Y=41	K=50		R=137	G=49	B=64	
	C=80	M=50	Y=5	K=50		R=28	G=69	B=109	

	C=2	M=0	Y=2	K=0		R=248	G=252	B=251
LIGHT	C=8	M=0	Y=2	K=0		R=232	G=245	B=248
	C=7	M=4	Y=20	K=0		R=236	G=235	B=208
	C=2	M=22	Y=11	K=0		R=248	G=207	B=205
	C=22	M=14	Y=2	K=0		R=195	G=205	B=229

	C=5	M=3	Y=5	K=0		R=238	G=240	B=237	
	C=20	M=9	Y=11	K=0		R=202	G=214	B=216	MUTED
	C=36	M=32	Y=53	K=0		R=170	G=162	B=130	
	C=27	M=55	Y=41	K=0		R=188	G=130	B=132	
	C=56	M=45	Y=29	K=0		R=127	G=133	B=155	

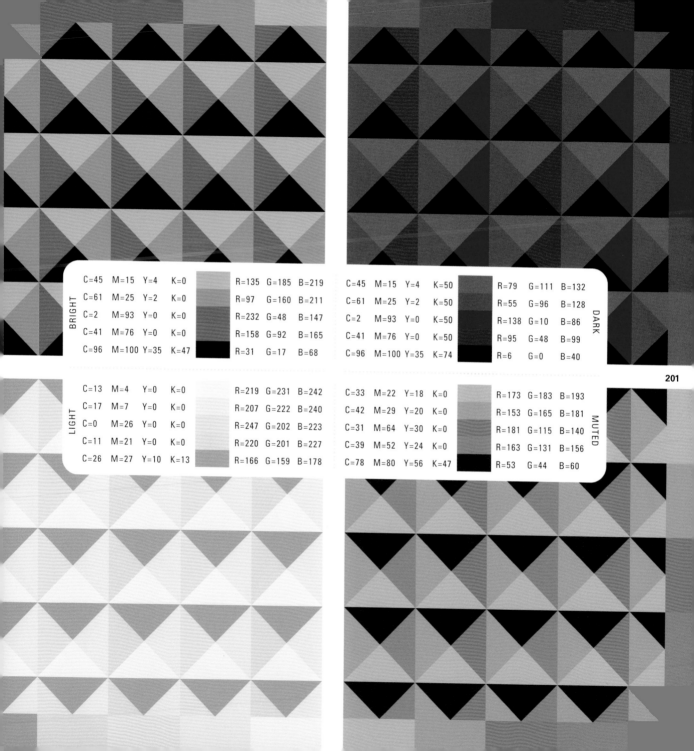

BRIGHT

C=45	M=15	Y=4	K=0
C=61	M=25	Y=2	K=0
C=2	M=93	Y=0	K=0
C=41	M=76	Y=0	K=0
C=96	M=100	Y=35	K=47

R=135	G=185	B=219
R=97	G=160	B=211
R=232	G=48	B=147
R=158	G=92	B=165
R=31	G=17	B=68

C=45	M=15	Y=4	K=50
C=61	M=25	Y=2	K=50
C=2	M=93	Y=0	K=50
C=41	M=76	Y=0	K=50
C=96	M=100	Y=35	K=74

R=79	G=111	B=132
R=55	G=96	B=128
R=138	G=10	B=86
R=95	G=48	B=99
R=6	G=0	B=40

DARK

LIGHT

C=13	M=4	Y=0	K=0
C=17	M=7	Y=0	K=0
C=0	M=26	Y=0	K=0
C=11	M=21	Y=0	K=0
C=26	M=27	Y=10	K=13

R=219	G=231	B=242
R=207	G=222	B=240
R=247	G=202	B=223
R=220	G=201	B=227
R=166	G=159	B=178

C=33	M=22	Y=18	K=0
C=42	M=29	Y=20	K=0
C=31	M=64	Y=30	K=0
C=39	M=52	Y=24	K=0
C=78	M=80	Y=56	K=47

R=173	G=183	B=193
R=153	G=165	B=181
R=181	G=115	B=140
R=163	G=131	B=156
R=53	G=44	B=60

MUTED

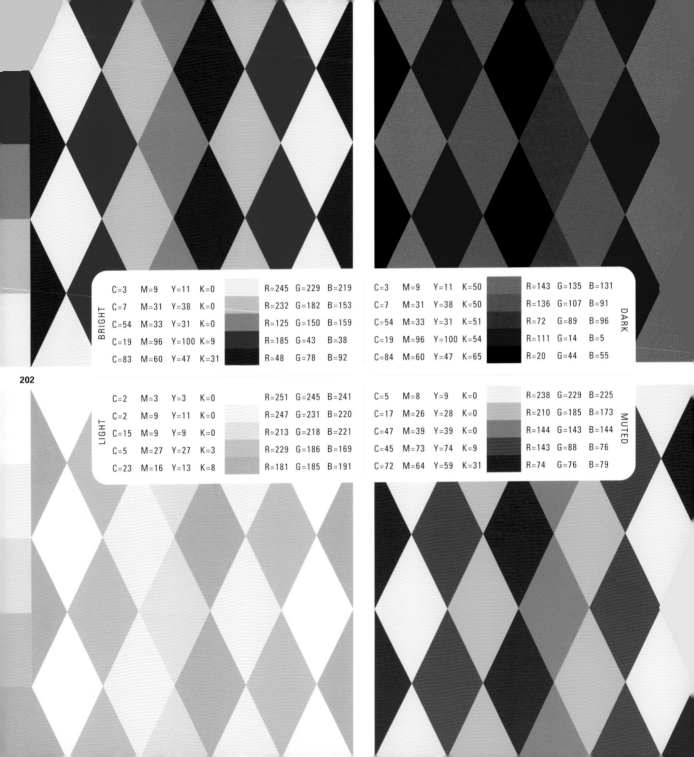

202

BRIGHT

C=3	M=9	Y=11	K=0		R=245	G=229	B=219
C=7	M=31	Y=38	K=0		R=232	G=182	B=153
C=54	M=33	Y=31	K=0		R=125	G=150	B=159
C=19	M=96	Y=100	K=9		R=185	G=43	B=38
C=83	M=60	Y=47	K=31		R=48	G=78	B=92

DARK

C=3	M=9	Y=11	K=50		R=143	G=135	B=131
C=7	M=31	Y=38	K=50		R=136	G=107	B=91
C=54	M=33	Y=31	K=51		R=72	G=89	B=96
C=19	M=96	Y=100	K=54		R=111	G=14	B=5
C=84	M=60	Y=47	K=65		R=20	G=44	B=55

LIGHT

C=2	M=3	Y=3	K=0		R=251	G=245	B=241
C=2	M=9	Y=11	K=0		R=247	G=231	B=220
C=15	M=9	Y=9	K=0		R=213	G=218	B=221
C=5	M=27	Y=27	K=3		R=229	G=186	B=169
C=23	M=16	Y=13	K=8		R=181	G=185	B=191

MUTED

C=5	M=8	Y=9	K=0		R=238	G=229	B=225
C=17	M=26	Y=28	K=0		R=210	G=185	B=173
C=47	M=39	Y=39	K=0		R=144	G=143	B=144
C=45	M=73	Y=74	K=9		R=143	G=88	B=76
C=72	M=64	Y=59	K=31		R=74	G=76	B=79

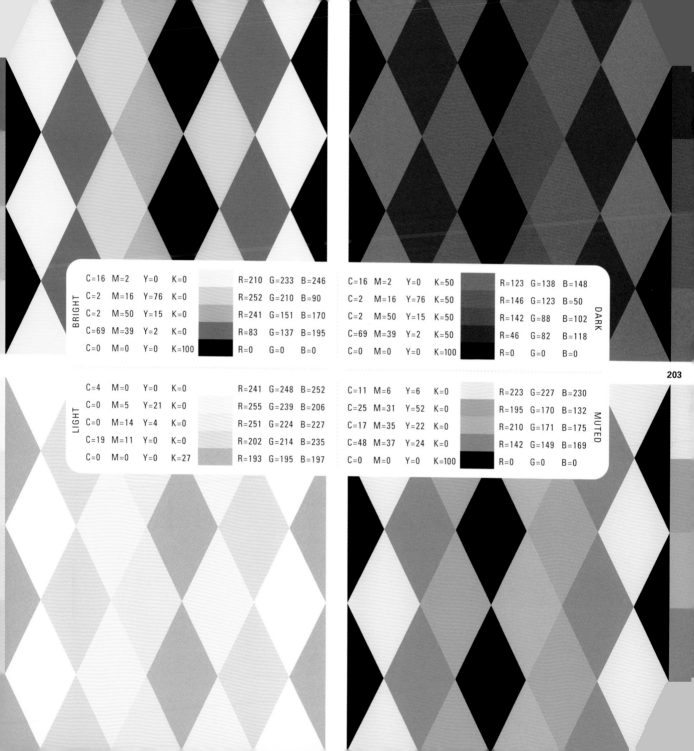

BRIGHT

C=16	M=2	Y=0	K=0		R=210	G=233	B=246
C=2	M=16	Y=76	K=0		R=252	G=210	B=90
C=2	M=50	Y=15	K=0		R=241	G=151	B=170
C=69	M=39	Y=2	K=0		R=83	G=137	B=195
C=0	M=0	Y=0	K=100		R=0	G=0	B=0

DARK

C=16	M=2	Y=0	K=50		R=123	G=138	B=148
C=2	M=16	Y=76	K=50		R=146	G=123	B=50
C=2	M=50	Y=15	K=50		R=142	G=88	B=102
C=69	M=39	Y=2	K=50		R=46	G=82	B=118
C=0	M=0	Y=0	K=100		R=0	G=0	B=0

LIGHT

C=4	M=0	Y=0	K=0		R=241	G=248	B=252
C=0	M=5	Y=21	K=0		R=255	G=239	B=206
C=0	M=14	Y=4	K=0		R=251	G=224	B=227
C=19	M=11	Y=0	K=0		R=202	G=214	B=235
C=0	M=0	Y=0	K=27		R=193	G=195	B=197

MUTED

C=11	M=6	Y=6	K=0		R=223	G=227	B=230
C=25	M=31	Y=52	K=0		R=195	G=170	B=132
C=17	M=35	Y=22	K=0		R=210	G=171	B=175
C=48	M=37	Y=24	K=0		R=142	G=149	B=169
C=0	M=0	Y=0	K=100		R=0	G=0	B=0

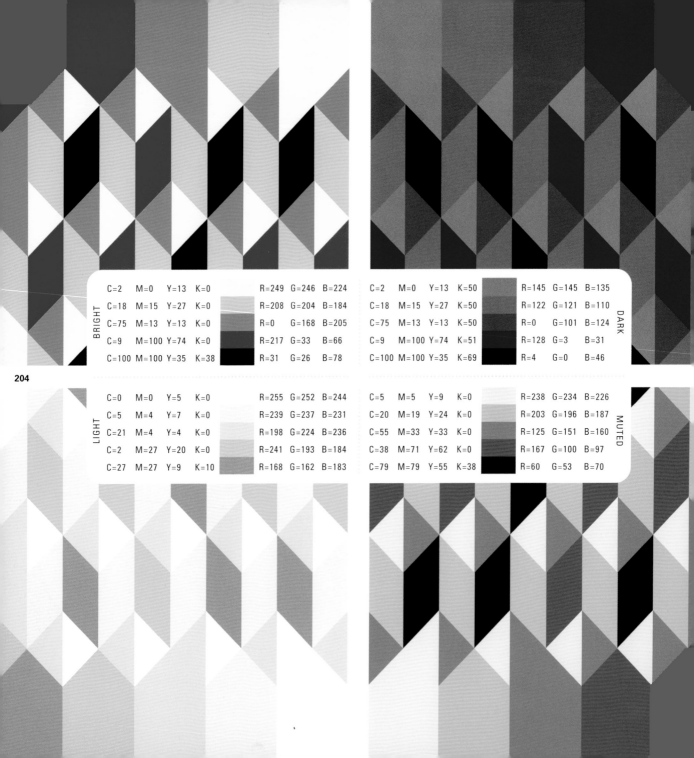

BRIGHT

C=2	M=0	Y=13	K=0		R=249	G=246	B=224
C=18	M=15	Y=27	K=0		R=208	G=204	B=184
C=75	M=13	Y=13	K=0		R=0	G=168	B=205
C=9	M=100	Y=74	K=0		R=217	G=33	B=66
C=100	M=100	Y=35	K=38		R=31	G=26	B=78

DARK

C=2	M=0	Y=13	K=50		R=145	G=145	B=135
C=18	M=15	Y=27	K=50		R=122	G=121	B=110
C=75	M=13	Y=13	K=50		R=0	G=101	B=124
C=9	M=100	Y=74	K=51		R=128	G=3	B=31
C=100	M=100	Y=35	K=69		R=4	G=0	B=46

LIGHT

C=0	M=0	Y=5	K=0		R=255	G=252	B=244
C=5	M=4	Y=7	K=0		R=239	G=237	B=231
C=21	M=4	Y=4	K=0		R=198	G=224	B=236
C=2	M=27	Y=20	K=0		R=241	G=193	B=184
C=27	M=27	Y=9	K=10		R=168	G=162	B=183

MUTED

C=5	M=5	Y=9	K=0		R=238	G=234	B=226
C=20	M=19	Y=24	K=0		R=203	G=196	B=187
C=55	M=33	Y=33	K=0		R=125	G=151	B=160
C=38	M=71	Y=62	K=0		R=167	G=100	B=97
C=79	M=79	Y=55	K=38		R=60	G=53	B=70

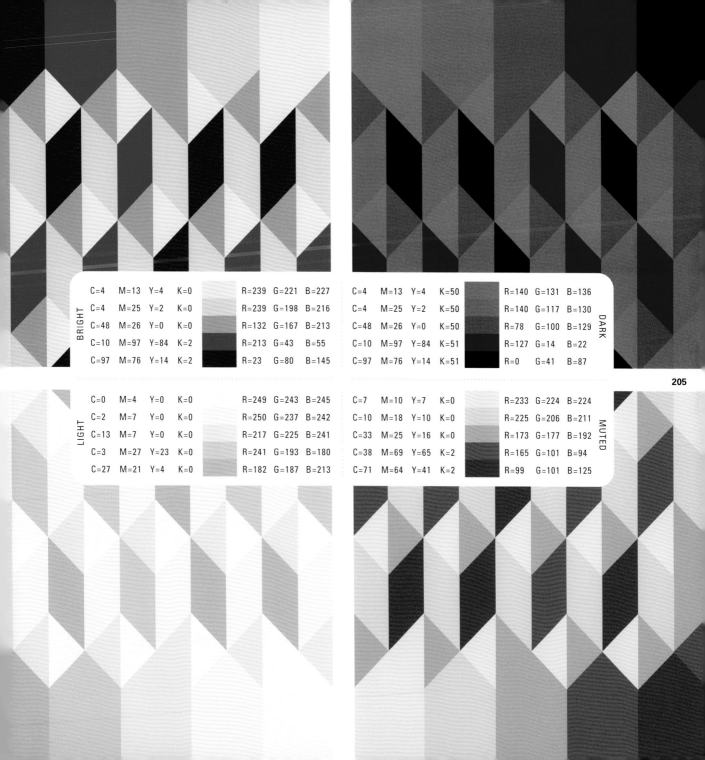

BRIGHT						
C=4	M=13	Y=4	K=0	R=239	G=221	B=227
C=4	M=25	Y=2	K=0	R=239	G=198	B=216
C=48	M=26	Y=0	K=0	R=132	G=167	B=213
C=10	M=97	Y=84	K=2	R=213	G=43	B=55
C=97	M=76	Y=14	K=2	R=23	G=80	B=145

DARK						
C=4	M=13	Y=4	K=50	R=140	G=131	B=136
C=4	M=25	Y=2	K=50	R=140	G=117	B=130
C=48	M=26	Y=0	K=50	R=78	G=100	B=129
C=10	M=97	Y=84	K=51	R=127	G=14	B=22
C=97	M=76	Y=14	K=51	R=0	G=41	B=87

LIGHT						
C=0	M=4	Y=0	K=0	R=249	G=243	B=245
C=2	M=7	Y=0	K=0	R=250	G=237	B=242
C=13	M=7	Y=0	K=0	R=217	G=225	B=241
C=3	M=27	Y=23	K=0	R=241	G=193	B=180
C=27	M=21	Y=4	K=0	R=182	G=187	B=213

MUTED						
C=7	M=10	Y=7	K=0	R=233	G=224	B=224
C=10	M=18	Y=10	K=0	R=225	G=206	B=211
C=33	M=25	Y=16	K=0	R=173	G=177	B=192
C=38	M=69	Y=65	K=2	R=165	G=101	B=94
C=71	M=64	Y=41	K=2	R=99	G=101	B=125

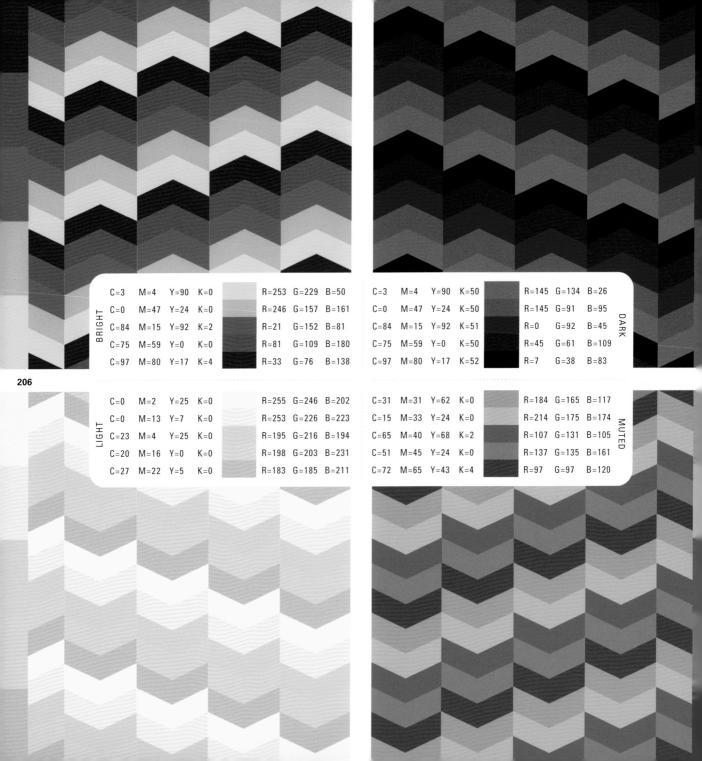

206

BRIGHT

C=3	M=4	Y=90	K=0		R=253	G=229	B=50
C=0	M=47	Y=24	K=0		R=246	G=157	B=161
C=84	M=15	Y=92	K=2		R=21	G=152	B=81
C=75	M=59	Y=0	K=0		R=81	G=109	B=180
C=97	M=80	Y=17	K=4		R=33	G=76	B=138

DARK

C=3	M=4	Y=90	K=50		R=145	G=134	B=26
C=0	M=47	Y=24	K=50		R=145	G=91	B=95
C=84	M=15	Y=92	K=51		R=0	G=92	B=45
C=75	M=59	Y=0	K=50		R=45	G=61	B=109
C=97	M=80	Y=17	K=52		R=7	G=38	B=83

LIGHT

C=0	M=2	Y=25	K=0		R=255	G=246	B=202
C=0	M=13	Y=7	K=0		R=253	G=226	B=223
C=23	M=4	Y=25	K=0		R=195	G=216	B=194
C=20	M=16	Y=0	K=0		R=198	G=203	B=231
C=27	M=22	Y=5	K=0		R=183	G=185	B=211

MUTED

C=31	M=31	Y=62	K=0		R=184	G=165	B=117
C=15	M=33	Y=24	K=0		R=214	G=175	B=174
C=65	M=40	Y=68	K=2		R=107	G=131	B=105
C=51	M=45	Y=24	K=0		R=137	G=135	B=161
C=72	M=65	Y=43	K=4		R=97	G=97	B=120

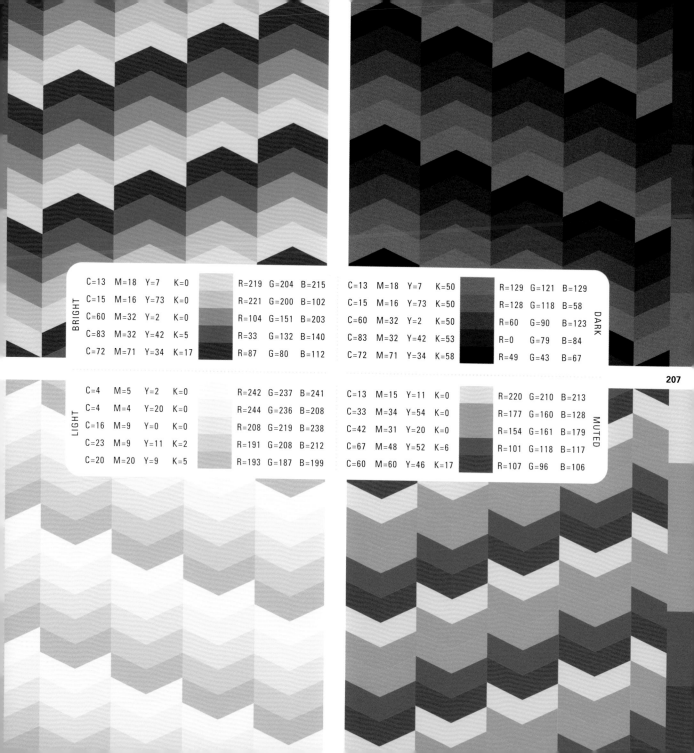

BRIGHT

C=13	M=18	Y=7	K=0		R=219	G=204	B=215
C=15	M=16	Y=73	K=0		R=221	G=200	B=102
C=60	M=32	Y=2	K=0		R=104	G=151	B=203
C=83	M=32	Y=42	K=5		R=33	G=132	B=140
C=72	M=71	Y=34	K=17		R=87	G=80	B=112

DARK

C=13	M=18	Y=7	K=50		R=129	G=121	B=129
C=15	M=16	Y=73	K=50		R=128	G=118	B=58
C=60	M=32	Y=2	K=50		R=60	G=90	B=123
C=83	M=32	Y=42	K=53		R=0	G=79	B=84
C=72	M=71	Y=34	K=58		R=49	G=43	B=67

LIGHT

C=4	M=5	Y=2	K=0		R=242	G=237	B=241
C=4	M=4	Y=20	K=0		R=244	G=236	B=208
C=16	M=9	Y=0	K=0		R=208	G=219	B=238
C=23	M=9	Y=11	K=2		R=191	G=208	B=212
C=20	M=20	Y=9	K=5		R=193	G=187	B=199

MUTED

C=13	M=15	Y=11	K=0		R=220	G=210	B=213
C=33	M=34	Y=54	K=0		R=177	G=160	B=128
C=42	M=31	Y=20	K=0		R=154	G=161	B=179
C=67	M=48	Y=52	K=6		R=101	G=118	B=117
C=60	M=60	Y=46	K=17		R=107	G=96	B=106

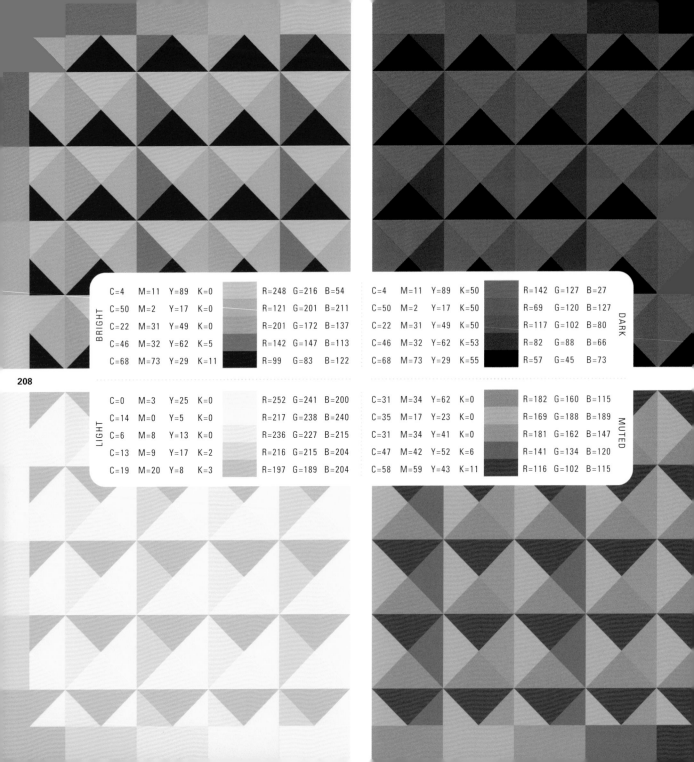

208

BRIGHT	C=4	M=11	Y=89	K=0		R=248	G=216	B=54
	C=50	M=2	Y=17	K=0		R=121	G=201	B=211
	C=22	M=31	Y=49	K=0		R=201	G=172	B=137
	C=46	M=32	Y=62	K=5		R=142	G=147	B=113
	C=68	M=73	Y=29	K=11		R=99	G=83	B=122

C=4	M=11	Y=89	K=50		R=142	G=127	B=27	**DARK**
C=50	M=2	Y=17	K=50		R=69	G=120	B=127	
C=22	M=31	Y=49	K=50		R=117	G=102	B=80	
C=46	M=32	Y=62	K=53		R=82	G=88	B=66	
C=68	M=73	Y=29	K=55		R=57	G=45	B=73	

LIGHT	C=0	M=3	Y=25	K=0		R=252	G=241	B=200
	C=14	M=0	Y=5	K=0		R=217	G=238	B=240
	C=6	M=8	Y=13	K=0		R=236	G=227	B=215
	C=13	M=9	Y=17	K=2		R=216	G=215	B=204
	C=19	M=20	Y=8	K=3		R=197	G=189	B=204

C=31	M=34	Y=62	K=0		R=182	G=160	B=115	**MUTED**
C=35	M=17	Y=23	K=0		R=169	G=188	B=189	
C=31	M=34	Y=41	K=0		R=181	G=162	B=147	
C=47	M=42	Y=52	K=6		R=141	G=134	B=120	
C=58	M=59	Y=43	K=11		R=116	G=102	B=115	

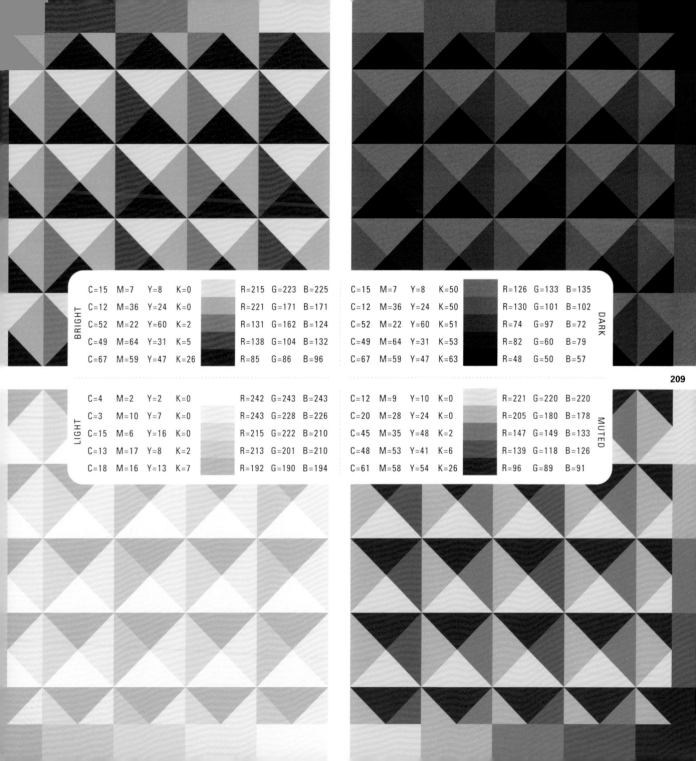

BRIGHT

C=15	M=7	Y=8	K=0		R=215	G=223	B=225
C=12	M=36	Y=24	K=0		R=221	G=171	B=171
C=52	M=22	Y=60	K=2		R=131	G=162	B=124
C=49	M=64	Y=31	K=5		R=138	G=104	B=132
C=67	M=59	Y=47	K=26		R=85	G=86	B=96

DARK

C=15	M=7	Y=8	K=50		R=126	G=133	B=135
C=12	M=36	Y=24	K=50		R=130	G=101	B=102
C=52	M=22	Y=60	K=51		R=74	G=97	B=72
C=49	M=64	Y=31	K=53		R=82	G=60	B=79
C=67	M=59	Y=47	K=63		R=48	G=50	B=57

LIGHT

C=4	M=2	Y=2	K=0		R=242	G=243	B=243
C=3	M=10	Y=7	K=0		R=243	G=228	B=226
C=15	M=6	Y=16	K=0		R=215	G=222	B=210
C=13	M=17	Y=8	K=2		R=213	G=201	B=210
C=18	M=16	Y=13	K=7		R=192	G=190	B=194

MUTED

C=12	M=9	Y=10	K=0		R=221	G=220	B=220
C=20	M=28	Y=24	K=0		R=205	G=180	B=178
C=45	M=35	Y=48	K=2		R=147	G=149	B=133
C=48	M=53	Y=41	K=6		R=139	G=118	B=126
C=61	M=58	Y=54	K=26		R=96	G=89	B=91

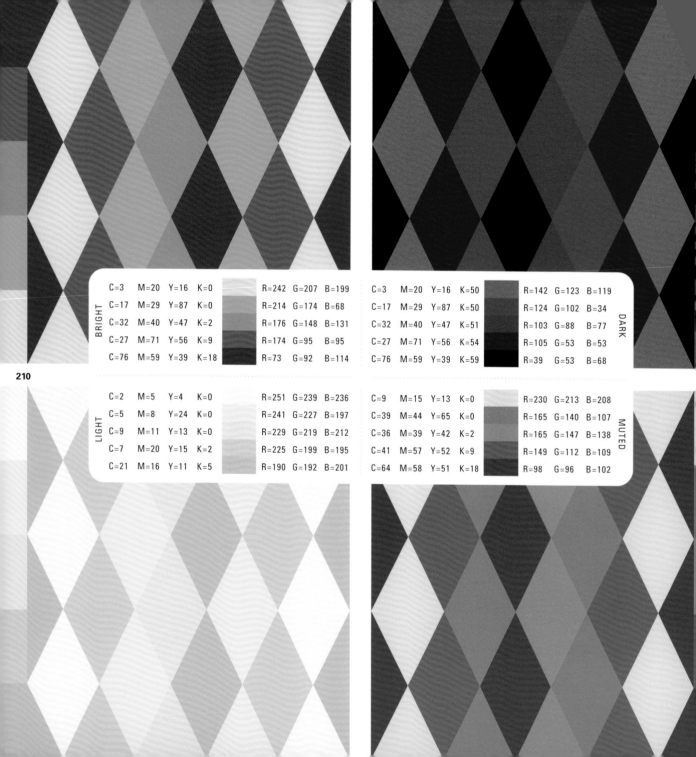

BRIGHT

C=3	M=20	Y=16	K=0		R=242	G=207	B=199
C=17	M=29	Y=87	K=0		R=214	G=174	B=68
C=32	M=40	Y=47	K=2		R=176	G=148	B=131
C=27	M=71	Y=56	K=9		R=174	G=95	B=95
C=76	M=59	Y=39	K=18		R=73	G=92	B=114

DARK

C=3	M=20	Y=16	K=50		R=142	G=123	B=119
C=17	M=29	Y=87	K=50		R=124	G=102	B=34
C=32	M=40	Y=47	K=51		R=103	G=88	B=77
C=27	M=71	Y=56	K=54		R=105	G=53	B=53
C=76	M=59	Y=39	K=59		R=39	G=53	B=68

LIGHT

C=2	M=5	Y=4	K=0		R=251	G=239	B=236
C=5	M=8	Y=24	K=0		R=241	G=227	B=197
C=9	M=11	Y=13	K=0		R=229	G=219	B=212
C=7	M=20	Y=15	K=2		R=225	G=199	B=195
C=21	M=16	Y=11	K=5		R=190	G=192	B=201

MUTED

C=9	M=15	Y=13	K=0		R=230	G=213	B=208
C=39	M=44	Y=65	K=0		R=165	G=140	B=107
C=36	M=39	Y=42	K=2		R=165	G=147	B=138
C=41	M=57	Y=52	K=9		R=149	G=112	B=109
C=64	M=58	Y=51	K=18		R=98	G=96	B=102

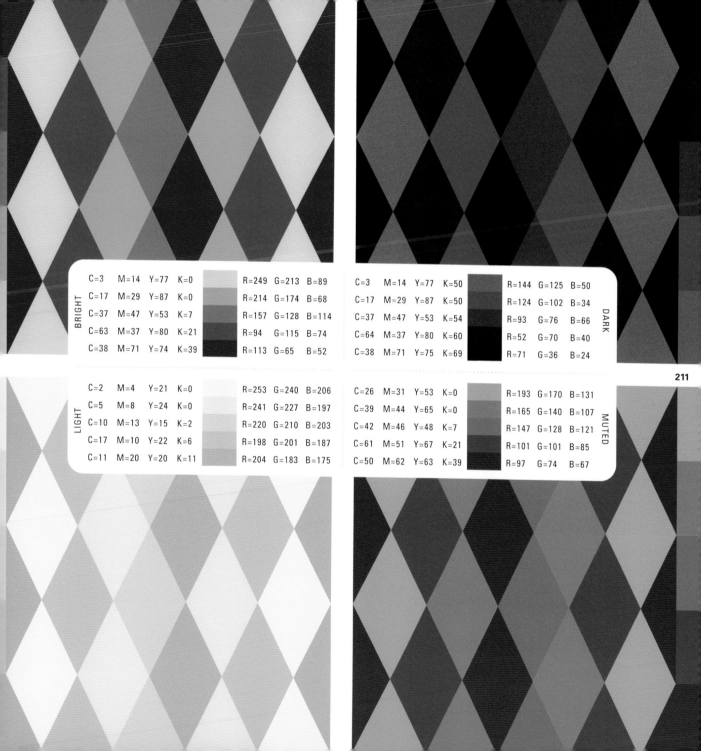

BRIGHT

C	M	Y	K		R	G	B
C=3	M=14	Y=77	K=0		R=249	G=213	B=89
C=17	M=29	Y=87	K=0		R=214	G=174	B=68
C=37	M=47	Y=53	K=7		R=157	G=128	B=114
C=63	M=37	Y=80	K=21		R=94	G=115	B=74
C=38	M=71	Y=74	K=39		R=113	G=65	B=52

DARK

C	M	Y	K		R	G	B
C=3	M=14	Y=77	K=50		R=144	G=125	B=50
C=17	M=29	Y=87	K=50		R=124	G=102	B=34
C=37	M=47	Y=53	K=54		R=93	G=76	B=66
C=64	M=37	Y=80	K=60		R=52	G=70	B=40
C=38	M=71	Y=75	K=69		R=71	G=36	B=24

LIGHT

C	M	Y	K		R	G	B
C=2	M=4	Y=21	K=0		R=253	G=240	B=206
C=5	M=8	Y=24	K=0		R=241	G=227	B=197
C=10	M=13	Y=15	K=2		R=220	G=210	B=203
C=17	M=10	Y=22	K=6		R=198	G=201	B=187
C=11	M=20	Y=20	K=11		R=204	G=183	B=175

MUTED

C	M	Y	K		R	G	B
C=26	M=31	Y=53	K=0		R=193	G=170	B=131
C=39	M=44	Y=65	K=0		R=165	G=140	B=107
C=42	M=46	Y=48	K=7		R=147	G=128	B=121
C=61	M=51	Y=67	K=21		R=101	G=101	B=85
C=50	M=62	Y=63	K=39		R=97	G=74	B=67

CHAPTER 3
COOLER PALETTES

336 color schemes made from hues
that lean toward the cool colors of
green, blue, and violet.

Reminders:

• Each of this book's palettes includes five colors. Feel free to use all five colors for a project, or to go with just one, two, three, or four.

• Any of this book's palettes can be attractively expanded into more colors by including monochromatic relatives of one or more of its hues (see page 10 for more about monochromatic color schemes).

• Substitutions between the colors of each page's quad-set of palettes is permissible. Just be certain of the value differences between the hues you're combining (see page 5–7 for more about values and color substitutions).

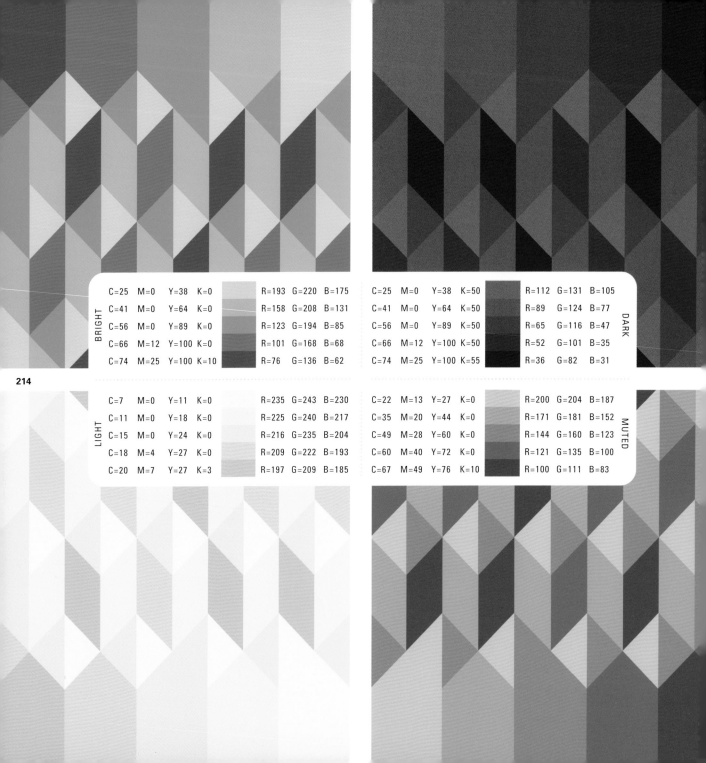

BRIGHT

C=25	M=0	Y=38	K=0		R=193	G=220	B=175
C=41	M=0	Y=64	K=0		R=158	G=208	B=131
C=56	M=0	Y=89	K=0		R=123	G=194	B=85
C=66	M=12	Y=100	K=0		R=101	G=168	B=68
C=74	M=25	Y=100	K=10		R=76	G=136	B=62

DARK

C=25	M=0	Y=38	K=50		R=112	G=131	B=105
C=41	M=0	Y=64	K=50		R=89	G=124	B=77
C=56	M=0	Y=89	K=50		R=65	G=116	B=47
C=66	M=12	Y=100	K=50		R=52	G=101	B=35
C=74	M=25	Y=100	K=55		R=36	G=82	B=31

LIGHT

C=7	M=0	Y=11	K=0		R=235	G=243	B=230
C=11	M=0	Y=18	K=0		R=225	G=240	B=217
C=15	M=0	Y=24	K=0		R=216	G=235	B=204
C=18	M=4	Y=27	K=0		R=209	G=222	B=193
C=20	M=7	Y=27	K=3		R=197	G=209	B=185

MUTED

C=22	M=13	Y=27	K=0		R=200	G=204	B=187
C=35	M=20	Y=44	K=0		R=171	G=181	B=152
C=49	M=28	Y=60	K=0		R=144	G=160	B=123
C=60	M=40	Y=72	K=0		R=121	G=135	B=100
C=67	M=49	Y=76	K=10		R=100	G=111	B=83

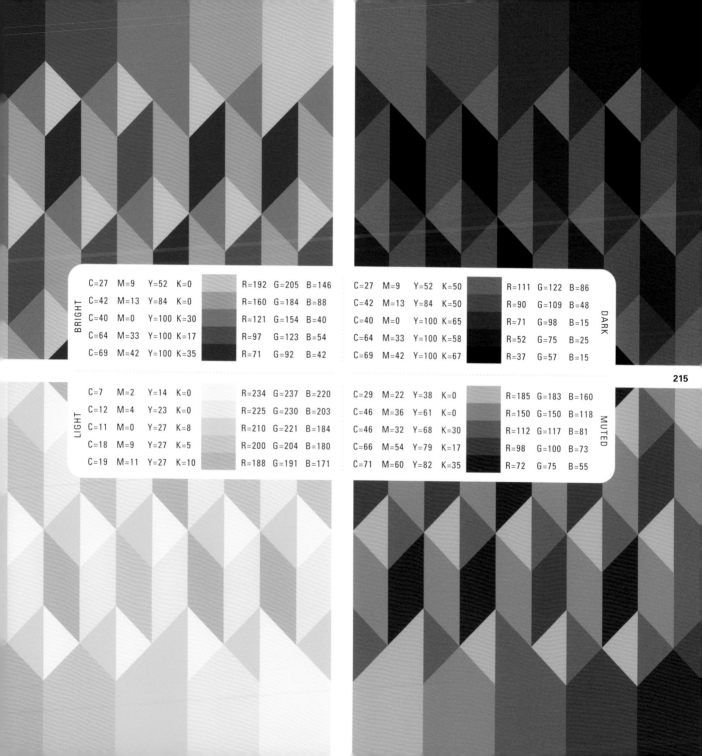

BRIGHT

C=27	M=9	Y=52	K=0
C=42	M=13	Y=84	K=0
C=40	M=0	Y=100	K=30
C=64	M=33	Y=100	K=17
C=69	M=42	Y=100	K=35

R=192	G=205	B=146
R=160	G=184	B=88
R=121	G=154	B=40
R=97	G=123	B=54
R=71	G=92	B=42

DARK

C=27	M=9	Y=52	K=50
C=42	M=13	Y=84	K=50
C=40	M=0	Y=100	K=65
C=64	M=33	Y=100	K=58
C=69	M=42	Y=100	K=67

R=111	G=122	B=86
R=90	G=109	B=48
R=71	G=98	B=15
R=52	G=75	B=25
R=37	G=57	B=15

LIGHT

C=7	M=2	Y=14	K=0
C=12	M=4	Y=23	K=0
C=11	M=0	Y=27	K=8
C=18	M=9	Y=27	K=5
C=19	M=11	Y=27	K=10

R=234	G=237	B=220
R=225	G=230	B=203
R=210	G=221	B=184
R=200	G=204	B=180
R=188	G=191	B=171

MUTED

C=29	M=22	Y=38	K=0
C=46	M=36	Y=61	K=0
C=46	M=32	Y=68	K=30
C=66	M=54	Y=79	K=17
C=71	M=60	Y=82	K=35

R=185	G=183	B=160
R=150	G=150	B=118
R=112	G=117	B=81
R=98	G=100	B=73
R=72	G=75	B=55

BRIGHT

C=4	M=0	Y=34	K=0		R=245	G=244	B=186
C=15	M=0	Y=60	K=0		R=222	G=231	B=135
C=23	M=5	Y=83	K=0		R=205	G=210	B=82
C=34	M=18	Y=100	K=0		R=180	G=181	B=52
C=46	M=33	Y=100	K=9		R=142	G=140	B=52

DARK

C=4	M=0	Y=34	K=50		R=142	G=144	B=111
C=15	M=0	Y=60	K=50		R=128	G=136	B=80
C=23	M=5	Y=84	K=50		R=117	G=124	B=45
C=34	M=18	Y=100	K=50		R=102	G=107	B=23
C=46	M=33	Y=100	K=55		R=81	G=84	B=22

LIGHT

C=2	M=0	Y=9	K=0		R=251	G=251	B=233
C=4	M=0	Y=16	K=0		R=244	G=247	B=220
C=6	M=2	Y=23	K=0		R=239	G=239	B=205
C=9	M=5	Y=27	K=0		R=231	G=229	B=193
C=13	M=9	Y=27	K=3		R=215	G=212	B=184

MUTED

C=13	M=11	Y=23	K=0		R=222	G=216	B=195
C=25	M=19	Y=41	K=0		R=195	G=190	B=157
C=37	M=31	Y=59	K=0		R=169	G=163	B=123
C=50	M=44	Y=74	K=0		R=144	G=134	B=95
C=59	M=55	Y=79	K=9		R=117	G=108	B=78

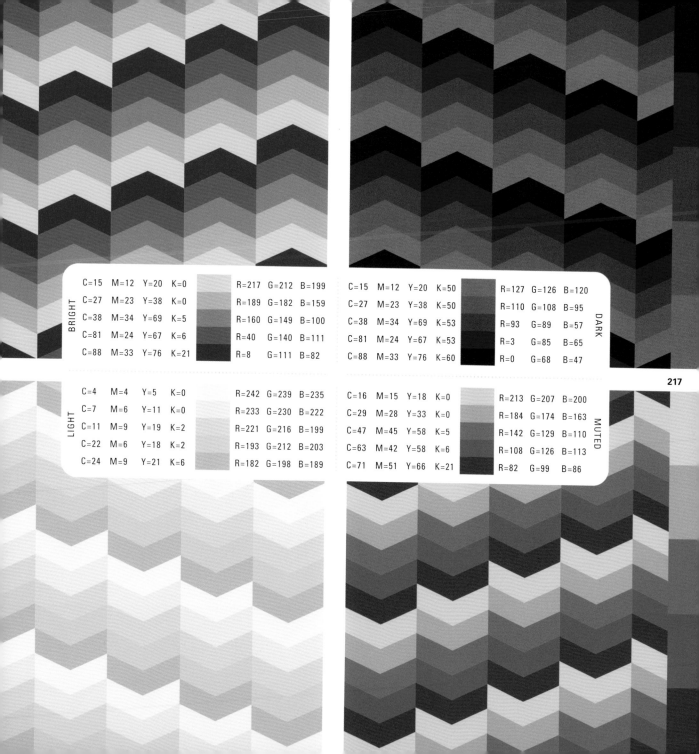

BRIGHT

C=15	M=12	Y=20	K=0		R=217	G=212	B=199
C=27	M=23	Y=38	K=0		R=189	G=182	B=159
C=38	M=34	Y=69	K=5		R=160	G=149	B=100
C=81	M=24	Y=67	K=6		R=40	G=140	B=111
C=88	M=33	Y=76	K=21		R=8	G=111	B=82

C=15	M=12	Y=20	K=50		R=127	G=126	B=120
C=27	M=23	Y=38	K=50		R=110	G=108	B=95
C=38	M=34	Y=69	K=53		R=93	G=89	B=57
C=81	M=24	Y=67	K=53		R=3	G=85	B=65
C=88	M=33	Y=76	K=60		R=0	G=68	B=47

DARK

217

LIGHT

C=4	M=4	Y=5	K=0		R=242	G=239	B=235
C=7	M=6	Y=11	K=0		R=233	G=230	B=222
C=11	M=9	Y=19	K=2		R=221	G=216	B=199
C=22	M=6	Y=18	K=2		R=193	G=212	B=203
C=24	M=9	Y=21	K=6		R=182	G=198	B=189

C=16	M=15	Y=18	K=0		R=213	G=207	B=200
C=29	M=28	Y=33	K=0		R=184	G=174	B=163
C=47	M=45	Y=58	K=5		R=142	G=129	B=110
C=63	M=42	Y=58	K=6		R=108	G=126	B=113
C=71	M=51	Y=66	K=21		R=82	G=99	B=86

MUTED

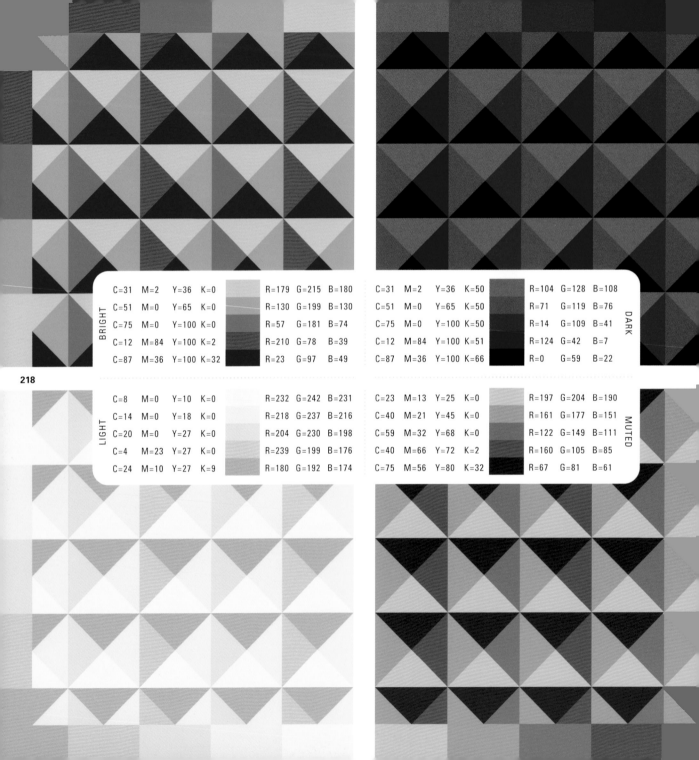

BRIGHT

					R	G	B
C=31	M=2	Y=36	K=0		R=179	G=215	B=180
C=51	M=0	Y=65	K=0		R=130	G=199	B=130
C=75	M=0	Y=100	K=0		R=57	G=181	B=74
C=12	M=84	Y=100	K=2		R=210	G=78	B=39
C=87	M=36	Y=100	K=32		R=23	G=97	B=49

DARK

					R	G	B
C=31	M=2	Y=36	K=50		R=104	G=128	B=108
C=51	M=0	Y=65	K=50		R=71	G=119	B=76
C=75	M=0	Y=100	K=50		R=14	G=109	B=41
C=12	M=84	Y=100	K=51		R=124	G=42	B=7
C=87	M=36	Y=100	K=66		R=0	G=59	B=22

LIGHT

					R	G	B
C=8	M=0	Y=10	K=0		R=232	G=242	B=231
C=14	M=0	Y=18	K=0		R=218	G=237	B=216
C=20	M=0	Y=27	K=0		R=204	G=230	B=198
C=4	M=23	Y=27	K=0		R=239	G=199	B=176
C=24	M=10	Y=27	K=9		R=180	G=192	B=174

MUTED

					R	G	B
C=23	M=13	Y=25	K=0		R=197	G=204	B=190
C=40	M=21	Y=45	K=0		R=161	G=177	B=151
C=59	M=32	Y=68	K=0		R=122	G=149	B=111
C=40	M=66	Y=72	K=2		R=160	G=105	B=85
C=75	M=56	Y=80	K=32		R=67	G=81	B=61

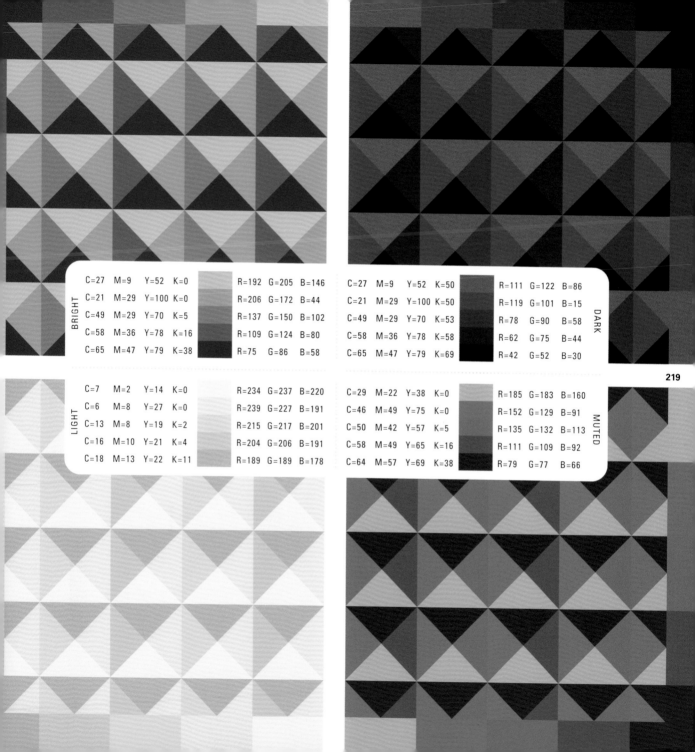

BRIGHT

C=27	M=9	Y=52	K=0		R=192	G=205	B=146
C=21	M=29	Y=100	K=0		R=206	G=172	B=44
C=49	M=29	Y=70	K=5		R=137	G=150	B=102
C=58	M=36	Y=78	K=16		R=109	G=124	B=80
C=65	M=47	Y=79	K=38		R=75	G=86	B=58

DARK

C=27	M=9	Y=52	K=50		R=111	G=122	B=86
C=21	M=29	Y=100	K=50		R=119	G=101	B=15
C=49	M=29	Y=70	K=53		R=78	G=90	B=58
C=58	M=36	Y=78	K=58		R=62	G=75	B=44
C=65	M=47	Y=79	K=69		R=42	G=52	B=30

LIGHT

C=7	M=2	Y=14	K=0		R=234	G=237	B=220
C=6	M=8	Y=27	K=0		R=239	G=227	B=191
C=13	M=8	Y=19	K=2		R=215	G=217	B=201
C=16	M=10	Y=21	K=4		R=204	G=206	B=191
C=18	M=13	Y=22	K=11		R=189	G=189	B=178

MUTED

C=29	M=22	Y=38	K=0		R=185	G=183	B=160
C=46	M=49	Y=75	K=0		R=152	G=129	B=91
C=50	M=42	Y=57	K=5		R=135	G=132	B=113
C=58	M=49	Y=65	K=16		R=111	G=109	B=92
C=64	M=57	Y=69	K=38		R=79	G=77	B=66

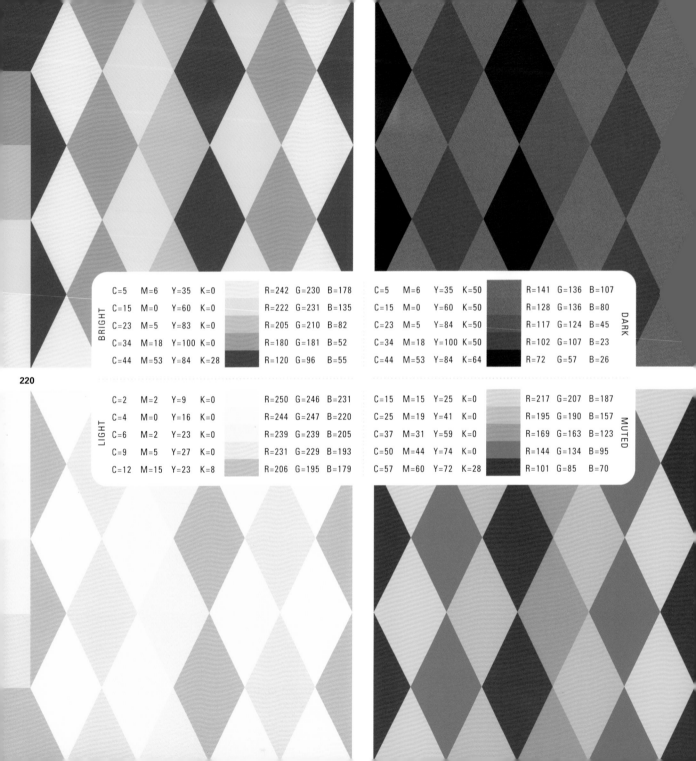

220

BRIGHT

C=5	M=6	Y=35	K=0		R=242	G=230	B=178
C=15	M=0	Y=60	K=0		R=222	G=231	B=135
C=23	M=5	Y=83	K=0		R=205	G=210	B=82
C=34	M=18	Y=100	K=0		R=180	G=181	B=52
C=44	M=53	Y=84	K=28		R=120	G=96	B=55

DARK

C=5	M=6	Y=35	K=50		R=141	G=136	B=107
C=15	M=0	Y=60	K=50		R=128	G=136	B=80
C=23	M=5	Y=84	K=50		R=117	G=124	B=45
C=34	M=18	Y=100	K=50		R=102	G=107	B=23
C=44	M=53	Y=84	K=64		R=72	G=57	B=26

LIGHT

C=2	M=2	Y=9	K=0		R=250	G=246	B=231
C=4	M=0	Y=16	K=0		R=244	G=247	B=220
C=6	M=2	Y=23	K=0		R=239	G=239	B=205
C=9	M=5	Y=27	K=0		R=231	G=229	B=193
C=12	M=15	Y=23	K=8		R=206	G=195	B=179

MUTED

C=15	M=15	Y=25	K=0		R=217	G=207	B=187
C=25	M=19	Y=41	K=0		R=195	G=190	B=157
C=37	M=31	Y=59	K=0		R=169	G=163	B=123
C=50	M=44	Y=74	K=0		R=144	G=134	B=95
C=57	M=60	Y=72	K=28		R=101	G=85	B=70

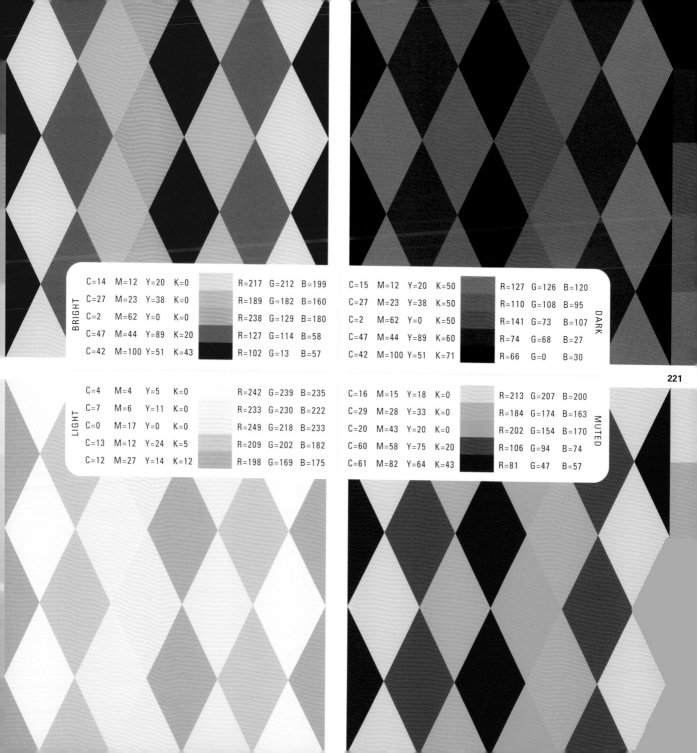

BRIGHT

C=14	M=12	Y=20	K=0		R=217	G=212	B=199
C=27	M=23	Y=38	K=0		R=189	G=182	B=160
C=2	M=62	Y=0	K=0		R=238	G=129	B=180
C=47	M=44	Y=89	K=20		R=127	G=114	B=58
C=42	M=100	Y=51	K=43		R=102	G=13	B=57

DARK

C=15	M=12	Y=20	K=50		R=127	G=126	B=120
C=27	M=23	Y=38	K=50		R=110	G=108	B=95
C=2	M=62	Y=0	K=50		R=141	G=73	B=107
C=47	M=44	Y=89	K=60		R=74	G=68	B=27
C=42	M=100	Y=51	K=71		R=66	G=0	B=30

LIGHT

C=4	M=4	Y=5	K=0		R=242	G=239	B=235
C=7	M=6	Y=11	K=0		R=233	G=230	B=222
C=0	M=17	Y=0	K=0		R=249	G=218	B=233
C=13	M=12	Y=24	K=5		R=209	G=202	B=182
C=12	M=27	Y=14	K=12		R=198	G=169	B=175

MUTED

C=16	M=15	Y=18	K=0		R=213	G=207	B=200
C=29	M=28	Y=33	K=0		R=184	G=174	B=163
C=20	M=43	Y=20	K=0		R=202	G=154	B=170
C=60	M=58	Y=75	K=20		R=106	G=94	B=74
C=61	M=82	Y=64	K=43		R=81	G=47	B=57

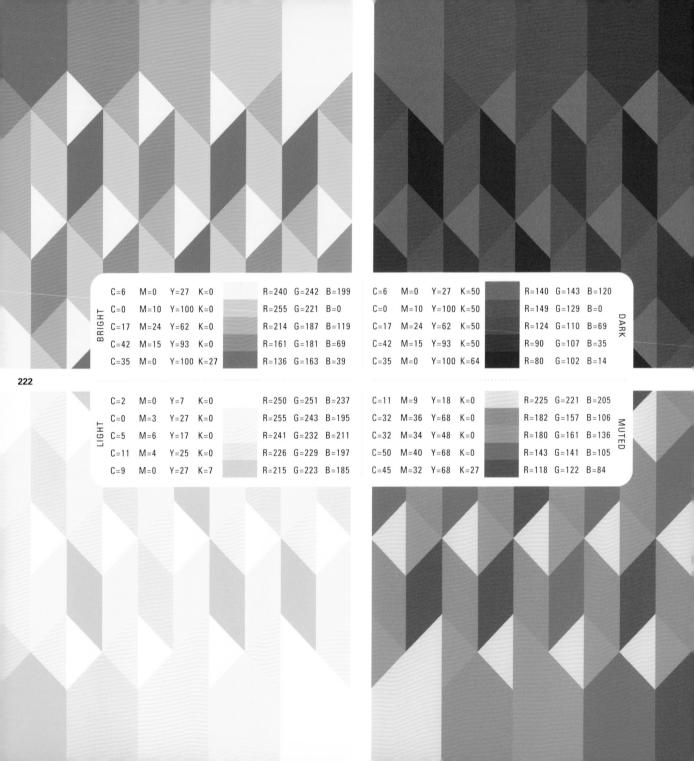

BRIGHT

					R=240	G=242	B=199
C=6	M=0	Y=27	K=0		R=240	G=242	B=199
C=0	M=10	Y=100	K=0		R=255	G=221	B=0
C=17	M=24	Y=62	K=0		R=214	G=187	B=119
C=42	M=15	Y=93	K=0		R=161	G=181	B=69
C=35	M=0	Y=100	K=27		R=136	G=163	B=39

DARK

C=6	M=0	Y=27	K=50		R=140	G=143	B=120
C=0	M=10	Y=100	K=50		R=149	G=129	B=0
C=17	M=24	Y=62	K=50		R=124	G=110	B=69
C=42	M=15	Y=93	K=50		R=90	G=107	B=35
C=35	M=0	Y=100	K=64		R=80	G=102	B=14

LIGHT

C=2	M=0	Y=7	K=0		R=250	G=251	B=237
C=0	M=3	Y=27	K=0		R=255	G=243	B=195
C=5	M=6	Y=17	K=0		R=241	G=232	B=211
C=11	M=4	Y=25	K=0		R=226	G=229	B=197
C=9	M=0	Y=27	K=7		R=215	G=223	B=185

MUTED

C=11	M=9	Y=18	K=0		R=225	G=221	B=205
C=32	M=36	Y=68	K=0		R=182	G=157	B=106
C=32	M=34	Y=48	K=0		R=180	G=161	B=136
C=50	M=40	Y=68	K=0		R=143	G=141	B=105
C=45	M=32	Y=68	K=27		R=118	G=122	B=84

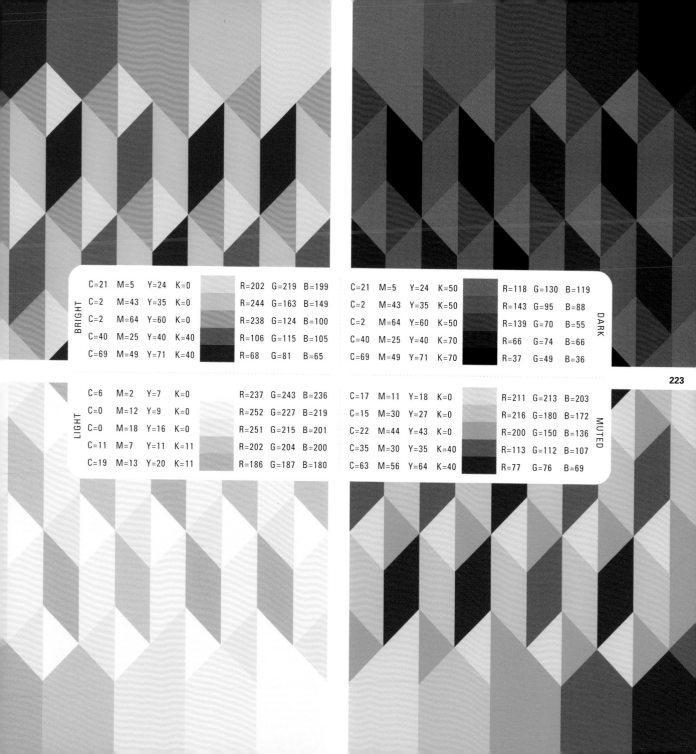

BRIGHT							
C=21	M=5	Y=24	K=0		R=202	G=219	B=199
C=2	M=43	Y=35	K=0		R=244	G=163	B=149
C=2	M=64	Y=60	K=0		R=238	G=124	B=100
C=40	M=25	Y=40	K=40		R=106	G=115	B=105
C=69	M=49	Y=71	K=40		R=68	G=81	B=65

DARK							
C=21	M=5	Y=24	K=50		R=118	G=130	B=119
C=2	M=43	Y=35	K=50		R=143	G=95	B=88
C=2	M=64	Y=60	K=50		R=139	G=70	B=55
C=40	M=25	Y=40	K=70		R=66	G=74	B=66
C=69	M=49	Y=71	K=70		R=37	G=49	B=36

223

LIGHT							
C=6	M=2	Y=7	K=0		R=237	G=243	B=236
C=0	M=12	Y=9	K=0		R=252	G=227	B=219
C=0	M=18	Y=16	K=0		R=251	G=215	B=201
C=11	M=7	Y=11	K=11		R=202	G=204	B=200
C=19	M=13	Y=20	K=11		R=186	G=187	B=180

MUTED							
C=17	M=11	Y=18	K=0		R=211	G=213	B=203
C=15	M=30	Y=27	K=0		R=216	G=180	B=172
C=22	M=44	Y=43	K=0		R=200	G=150	B=136
C=35	M=30	Y=35	K=40		R=113	G=112	B=107
C=63	M=56	Y=64	K=40		R=77	G=76	B=69

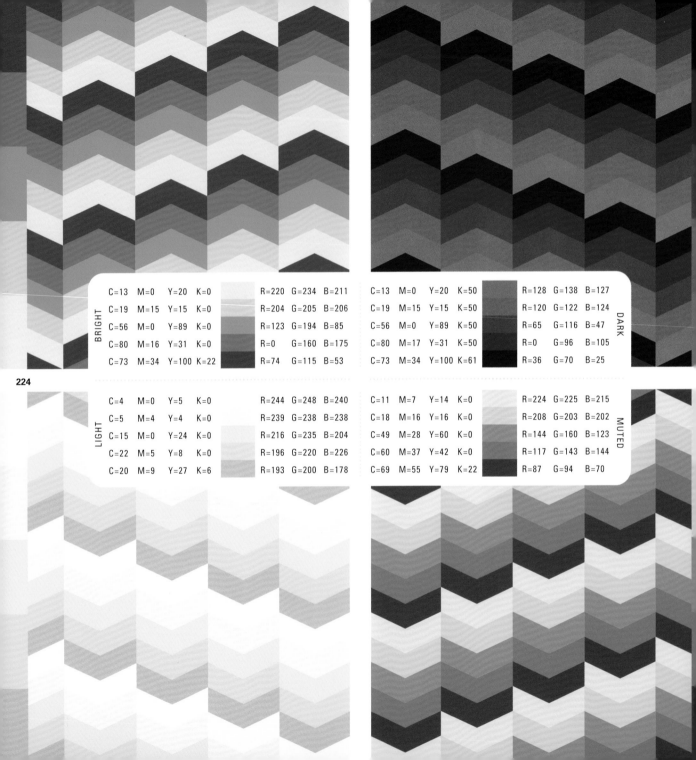

BRIGHT

C=13	M=0	Y=20	K=0
C=19	M=15	Y=15	K=0
C=56	M=0	Y=89	K=0
C=80	M=16	Y=31	K=0
C=73	M=34	Y=100	K=22

R=220	G=234	B=211
R=204	G=205	B=206
R=123	G=194	B=85
R=0	G=160	B=175
R=74	G=115	B=53

DARK

C=13	M=0	Y=20	K=50
C=19	M=15	Y=15	K=50
C=56	M=0	Y=89	K=50
C=80	M=17	Y=31	K=50
C=73	M=34	Y=100	K=61

R=128	G=138	B=127
R=120	G=122	B=124
R=65	G=116	B=47
R=0	G=96	B=105
R=36	G=70	B=25

LIGHT

C=4	M=0	Y=5	K=0
C=5	M=4	Y=4	K=0
C=15	M=0	Y=24	K=0
C=22	M=5	Y=8	K=0
C=20	M=9	Y=27	K=6

R=244	G=248	B=240
R=239	G=238	B=238
R=216	G=235	B=204
R=196	G=220	B=226
R=193	G=200	B=178

MUTED

C=11	M=7	Y=14	K=0
C=18	M=16	Y=16	K=0
C=49	M=28	Y=60	K=0
C=60	M=37	Y=42	K=0
C=69	M=55	Y=79	K=22

R=224	G=225	B=215
R=208	G=203	B=202
R=144	G=160	B=123
R=117	G=143	B=144
R=87	G=94	B=70

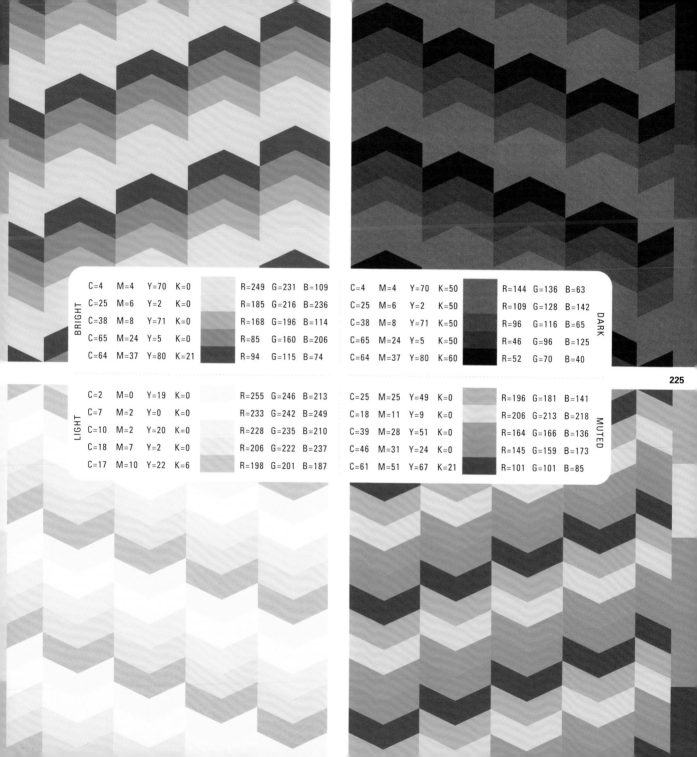

BRIGHT

C=4	M=4	Y=70	K=0		R=249	G=231	B=109
C=25	M=6	Y=2	K=0		R=185	G=216	B=236
C=38	M=8	Y=71	K=0		R=168	G=196	B=114
C=65	M=24	Y=5	K=0		R=85	G=160	B=206
C=64	M=37	Y=80	K=21		R=94	G=115	B=74

DARK

C=4	M=4	Y=70	K=50		R=144	G=136	B=63
C=25	M=6	Y=2	K=50		R=109	G=128	B=142
C=38	M=8	Y=71	K=50		R=96	G=116	B=65
C=65	M=24	Y=5	K=50		R=46	G=96	B=125
C=64	M=37	Y=80	K=60		R=52	G=70	B=40

LIGHT

C=2	M=0	Y=19	K=0		R=255	G=246	B=213
C=7	M=2	Y=0	K=0		R=233	G=242	B=249
C=10	M=2	Y=20	K=0		R=228	G=235	B=210
C=18	M=7	Y=2	K=0		R=206	G=222	B=237
C=17	M=10	Y=22	K=6		R=198	G=201	B=187

MUTED

C=25	M=25	Y=49	K=0		R=196	G=181	B=141
C=18	M=11	Y=9	K=0		R=206	G=213	B=218
C=39	M=28	Y=51	K=0		R=164	G=166	B=136
C=46	M=31	Y=24	K=0		R=145	G=159	B=173
C=61	M=51	Y=67	K=21		R=101	G=101	B=85

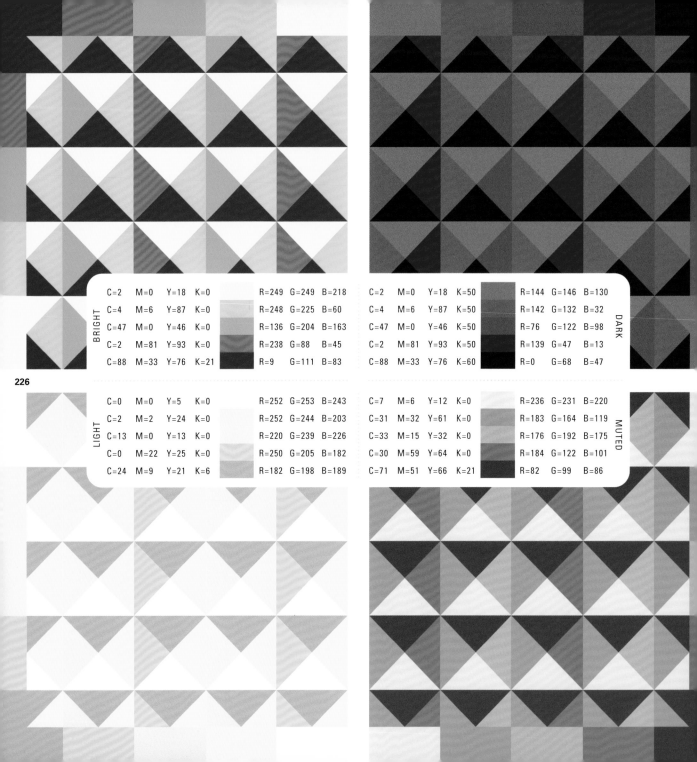

BRIGHT

C=2	M=0	Y=18	K=0		R=249	G=249	B=218
C=4	M=6	Y=87	K=0		R=248	G=225	B=60
C=47	M=0	Y=46	K=0		R=136	G=204	B=163
C=2	M=81	Y=93	K=0		R=238	G=88	B=45
C=88	M=33	Y=76	K=21		R=9	G=111	B=83

DARK

C=2	M=0	Y=18	K=50		R=144	G=146	B=130
C=4	M=6	Y=87	K=50		R=142	G=132	B=32
C=47	M=0	Y=46	K=50		R=76	G=122	B=98
C=2	M=81	Y=93	K=50		R=139	G=47	B=13
C=88	M=33	Y=76	K=60		R=0	G=68	B=47

LIGHT

C=0	M=0	Y=5	K=0		R=252	G=253	B=243
C=2	M=2	Y=24	K=0		R=252	G=244	B=203
C=13	M=0	Y=13	K=0		R=220	G=239	B=226
C=0	M=22	Y=25	K=0		R=250	G=205	B=182
C=24	M=9	Y=21	K=6		R=182	G=198	B=189

MUTED

C=7	M=6	Y=12	K=0		R=236	G=231	B=220
C=31	M=32	Y=61	K=0		R=183	G=164	B=119
C=33	M=15	Y=32	K=0		R=176	G=192	B=175
C=30	M=59	Y=64	K=0		R=184	G=122	B=101
C=71	M=51	Y=66	K=21		R=82	G=99	B=86

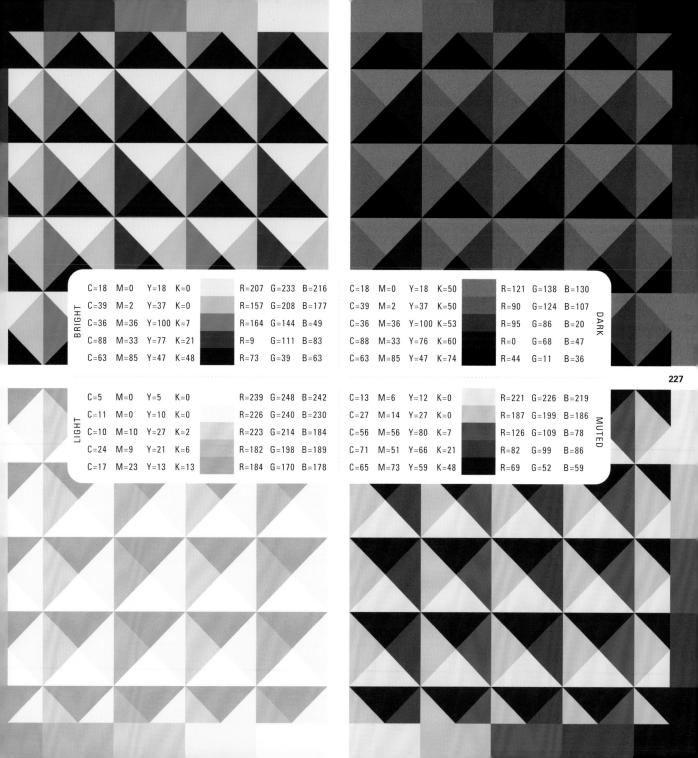

227

	C=18	M=0	Y=18	K=0		R=207	G=233	B=216
BRIGHT	C=39	M=2	Y=37	K=0		R=157	G=208	B=177
	C=36	M=36	Y=100	K=7		R=164	G=144	B=49
	C=88	M=33	Y=77	K=21		R=9	G=111	B=83
	C=63	M=85	Y=47	K=48		R=73	G=39	B=63

C=18	M=0	Y=18	K=50		R=121	G=138	B=130
C=39	M=2	Y=37	K=50		R=90	G=124	B=107
C=36	M=36	Y=100	K=53		R=95	G=86	B=20
C=88	M=33	Y=76	K=60		R=0	G=68	B=47
C=63	M=85	Y=47	K=74		R=44	G=11	B=36

DARK

227

LIGHT

C=5	M=0	Y=5	K=0		R=239	G=248	B=242
C=11	M=0	Y=10	K=0		R=226	G=240	B=230
C=10	M=10	Y=27	K=2		R=223	G=214	B=184
C=24	M=9	Y=21	K=6		R=182	G=198	B=189
C=17	M=23	Y=13	K=13		R=184	G=170	B=178

C=13	M=6	Y=12	K=0		R=221	G=226	B=219
C=27	M=14	Y=27	K=0		R=187	G=199	B=186
C=56	M=56	Y=80	K=7		R=126	G=109	B=78
C=71	M=51	Y=66	K=21		R=82	G=99	B=86
C=65	M=73	Y=59	K=48		R=69	G=52	B=59

MUTED

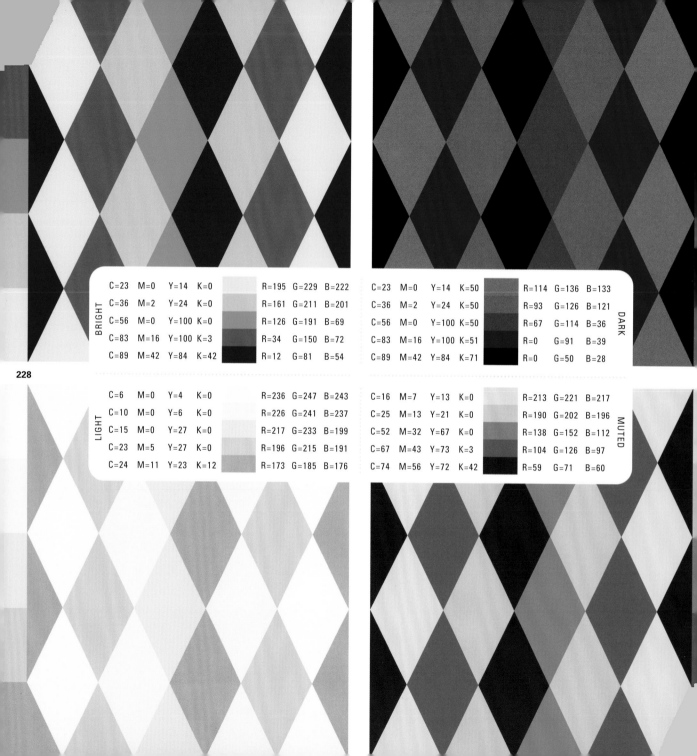

BRIGHT

C=23	M=0	Y=14	K=0		R=195	G=229	B=222
C=36	M=2	Y=24	K=0		R=161	G=211	B=201
C=56	M=0	Y=100	K=0		R=126	G=191	B=69
C=83	M=16	Y=100	K=3		R=34	G=150	B=72
C=89	M=42	Y=84	K=42		R=12	G=81	B=54

DARK

C=23	M=0	Y=14	K=50		R=114	G=136	B=133
C=36	M=2	Y=24	K=50		R=93	G=126	B=121
C=56	M=0	Y=100	K=50		R=67	G=114	B=36
C=83	M=16	Y=100	K=51		R=0	G=91	B=39
C=89	M=42	Y=84	K=71		R=0	G=50	B=28

LIGHT

C=6	M=0	Y=4	K=0		R=236	G=247	B=243
C=10	M=0	Y=6	K=0		R=226	G=241	B=237
C=15	M=0	Y=27	K=0		R=217	G=233	B=199
C=23	M=5	Y=27	K=0		R=196	G=215	B=191
C=24	M=11	Y=23	K=12		R=173	G=185	B=176

MUTED

C=16	M=7	Y=13	K=0		R=213	G=221	B=217
C=25	M=13	Y=21	K=0		R=190	G=202	B=196
C=52	M=32	Y=67	K=0		R=138	G=152	B=112
C=67	M=43	Y=73	K=3		R=104	G=126	B=97
C=74	M=56	Y=72	K=42		R=59	G=71	B=60

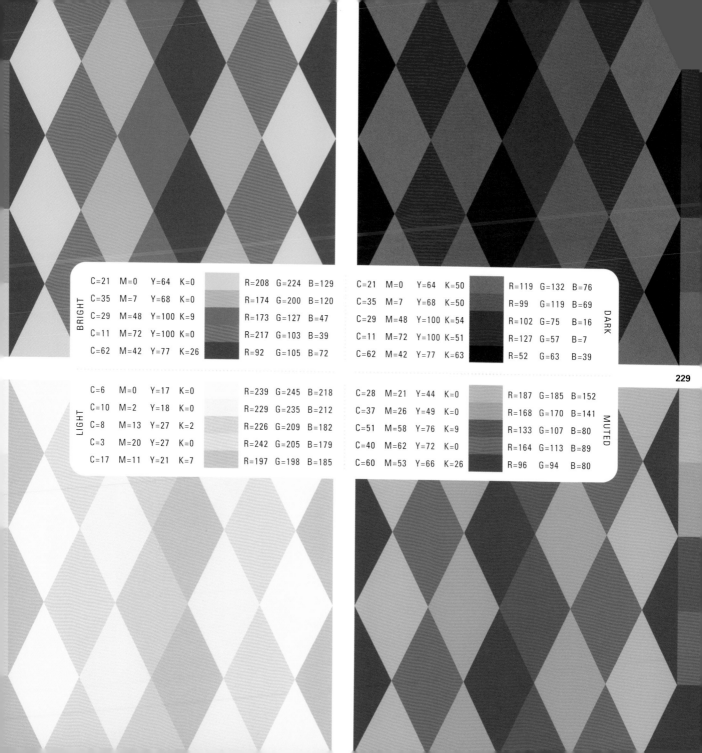

BRIGHT

C=21	M=0	Y=64	K=0		R=208	G=224	B=129
C=35	M=7	Y=68	K=0		R=174	G=200	B=120
C=29	M=48	Y=100	K=9		R=173	G=127	B=47
C=11	M=72	Y=100	K=0		R=217	G=103	B=39
C=62	M=42	Y=77	K=26		R=92	G=105	B=72

DARK

C=21	M=0	Y=64	K=50		R=119	G=132	B=76
C=35	M=7	Y=68	K=50		R=99	G=119	B=69
C=29	M=48	Y=100	K=54		R=102	G=75	B=16
C=11	M=72	Y=100	K=51		R=127	G=57	B=7
C=62	M=42	Y=77	K=63		R=52	G=63	B=39

LIGHT

C=6	M=0	Y=17	K=0		R=239	G=245	B=218
C=10	M=2	Y=18	K=0		R=229	G=235	B=212
C=8	M=13	Y=27	K=2		R=226	G=209	B=182
C=3	M=20	Y=27	K=0		R=242	G=205	B=179
C=17	M=11	Y=21	K=7		R=197	G=198	B=185

MUTED

C=28	M=21	Y=44	K=0		R=187	G=185	B=152
C=37	M=26	Y=49	K=0		R=168	G=170	B=141
C=51	M=58	Y=76	K=9		R=133	G=107	B=80
C=40	M=62	Y=72	K=0		R=164	G=113	B=89
C=60	M=53	Y=66	K=26		R=96	G=94	B=80

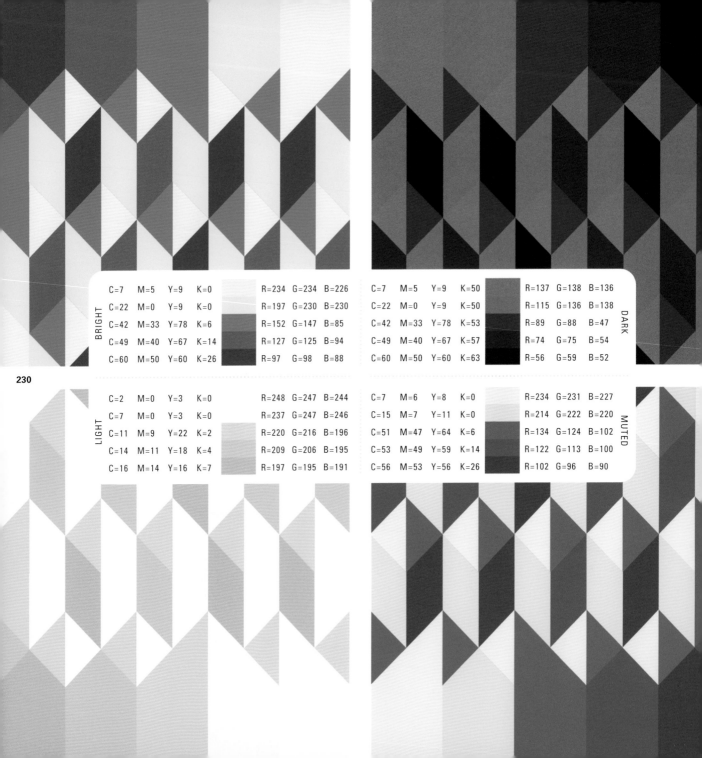

BRIGHT	C=7	M=5	Y=9	K=0	R=234	G=234	B=226
	C=22	M=0	Y=9	K=0	R=197	G=230	B=230
	C=42	M=33	Y=78	K=6	R=152	G=147	B=85
	C=49	M=40	Y=67	K=14	R=127	G=125	B=94
	C=60	M=50	Y=60	K=26	R=97	G=98	B=88

C=7	M=5	Y=9	K=50	R=137	G=138	B=136	**DARK**
C=22	M=0	Y=9	K=50	R=115	G=136	B=138	
C=42	M=33	Y=78	K=53	R=89	G=88	B=47	
C=49	M=40	Y=67	K=57	R=74	G=75	B=54	
C=60	M=50	Y=60	K=63	R=56	G=59	B=52	

230

LIGHT	C=2	M=0	Y=3	K=0	R=248	G=247	B=244
	C=7	M=0	Y=3	K=0	R=237	G=247	B=246
	C=11	M=9	Y=22	K=2	R=220	G=216	B=196
	C=14	M=11	Y=18	K=4	R=209	G=206	B=195
	C=16	M=14	Y=16	K=7	R=197	G=195	B=191

C=7	M=6	Y=8	K=0	R=234	G=231	B=227	**MUTED**
C=15	M=7	Y=11	K=0	R=214	G=222	B=220	
C=51	M=47	Y=64	K=6	R=134	G=124	B=102	
C=53	M=49	Y=59	K=14	R=122	G=113	B=100	
C=56	M=53	Y=56	K=26	R=102	G=96	B=90	

BRIGHT

C=15	M=0	Y=22	K=0		R=217	G=233	B=208
C=26	M=3	Y=41	K=0		R=193	G=216	B=168
C=42	M=34	Y=35	K=0		R=154	G=154	B=155
C=58	M=34	Y=71	K=12		R=113	G=132	B=94
C=0	M=0	Y=0	K=100		R=0	G=0	B=0

DARK

C=15	M=0	Y=22	K=50		R=126	G=138	B=125
C=26	M=3	Y=41	K=50		R=111	G=128	B=101
C=42	M=34	Y=35	K=50		R=90	G=92	B=92
C=58	M=34	Y=71	K=56		R=64	G=79	B=54
C=0	M=0	Y=0	K=100		R=0	G=0	B=0

LIGHT

C=4	M=0	Y=6	K=0		R=243	G=247	B=239
C=7	M=0	Y=11	K=0		R=235	G=242	B=227
C=11	M=9	Y=9	K=0		R=221	G=220	B=219
C=16	M=9	Y=20	K=4		R=206	G=208	B=195
C=0	M=0	Y=0	K=27		R=193	G=195	B=197

MUTED

C=13	M=7	Y=15	K=0		R=221	G=223	B=213
C=24	M=15	Y=29	K=0		R=197	G=199	B=181
C=40	M=37	Y=37	K=0		R=160	G=151	B=149
C=55	M=45	Y=59	K=12		R=120	G=119	B=103
C=0	M=0	Y=0	K=100		R=0	G=0	B=0

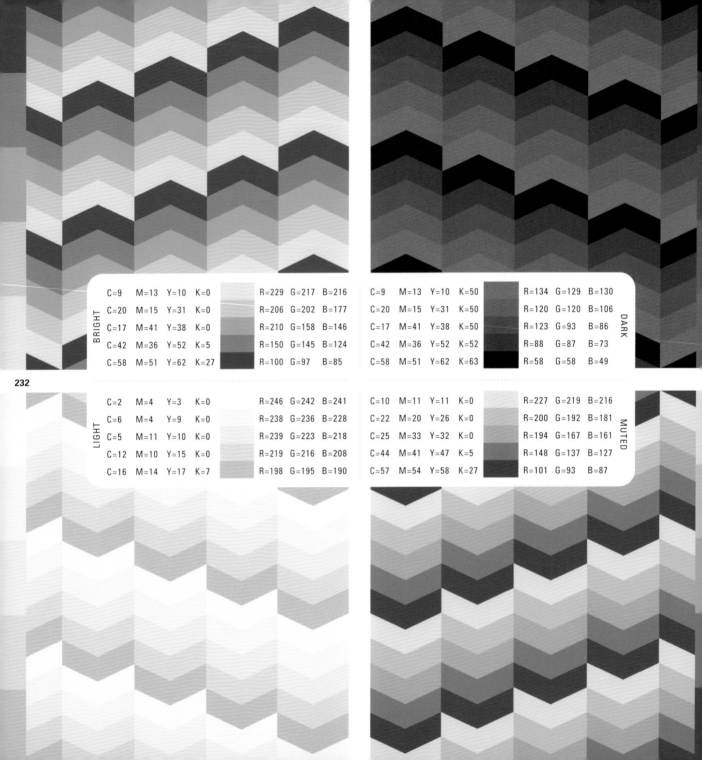

BRIGHT

C=9	M=13	Y=10	K=0	R=229	G=217	B=216
C=20	M=15	Y=31	K=0	R=206	G=202	B=177
C=17	M=41	Y=38	K=0	R=210	G=158	B=146
C=42	M=36	Y=52	K=5	R=150	G=145	B=124
C=58	M=51	Y=62	K=27	R=100	G=97	B=85

DARK

C=9	M=13	Y=10	K=50	R=134	G=129	B=130
C=20	M=15	Y=31	K=50	R=120	G=120	B=106
C=17	M=41	Y=38	K=50	R=123	G=93	B=86
C=42	M=36	Y=52	K=52	R=88	G=87	B=73
C=58	M=51	Y=62	K=63	R=58	G=58	B=49

LIGHT

C=2	M=4	Y=3	K=0	R=246	G=242	B=241
C=6	M=4	Y=9	K=0	R=238	G=236	B=228
C=5	M=11	Y=10	K=0	R=239	G=223	B=218
C=12	M=10	Y=15	K=0	R=219	G=216	B=208
C=16	M=14	Y=17	K=7	R=198	G=195	B=190

MUTED

C=10	M=11	Y=11	K=0	R=227	G=219	B=216
C=22	M=20	Y=26	K=0	R=200	G=192	B=181
C=25	M=33	Y=32	K=0	R=194	G=167	B=161
C=44	M=41	Y=47	K=5	R=148	G=137	B=127
C=57	M=54	Y=58	K=27	R=101	G=93	B=87

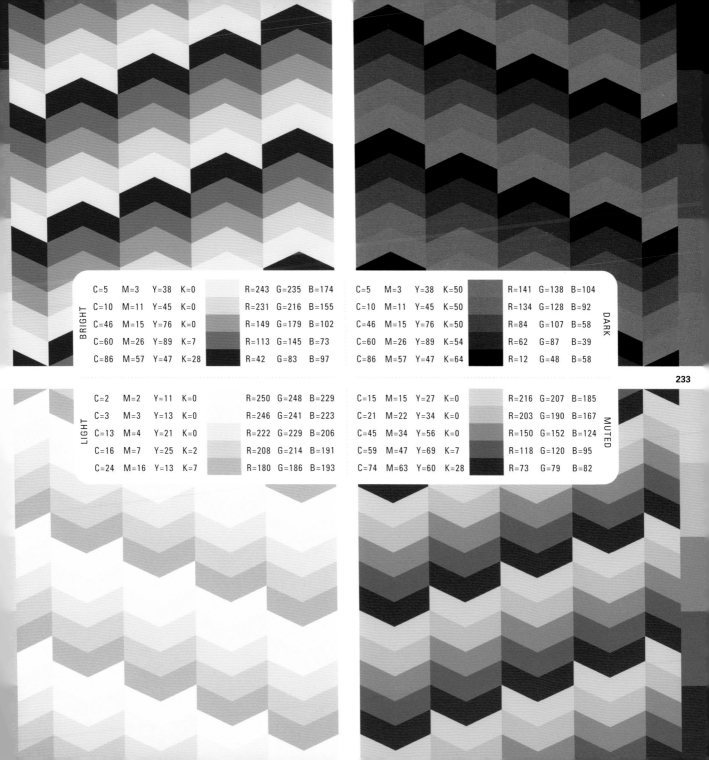

BRIGHT

C=5	M=3	Y=38	K=0		R=243	G=235	B=174
C=10	M=11	Y=45	K=0		R=231	G=216	B=155
C=46	M=15	Y=76	K=0		R=149	G=179	B=102
C=60	M=26	Y=89	K=7		R=113	G=145	B=73
C=86	M=57	Y=47	K=28		R=42	G=83	B=97

DARK

C=5	M=3	Y=38	K=50		R=141	G=138	B=104
C=10	M=11	Y=45	K=50		R=134	G=128	B=92
C=46	M=15	Y=76	K=50		R=84	G=107	B=58
C=60	M=26	Y=89	K=54		R=62	G=87	B=39
C=86	M=57	Y=47	K=64		R=12	G=48	B=58

LIGHT

C=2	M=2	Y=11	K=0		R=250	G=248	B=229
C=3	M=3	Y=13	K=0		R=246	G=241	B=223
C=13	M=4	Y=21	K=0		R=222	G=229	B=206
C=16	M=7	Y=25	K=2		R=208	G=214	B=191
C=24	M=16	Y=13	K=7		R=180	G=186	B=193

MUTED

C=15	M=15	Y=27	K=0		R=216	G=207	B=185
C=21	M=22	Y=34	K=0		R=203	G=190	B=167
C=45	M=34	Y=56	K=0		R=150	G=152	B=124
C=59	M=47	Y=69	K=7		R=118	G=120	B=95
C=74	M=63	Y=60	K=28		R=73	G=79	B=82

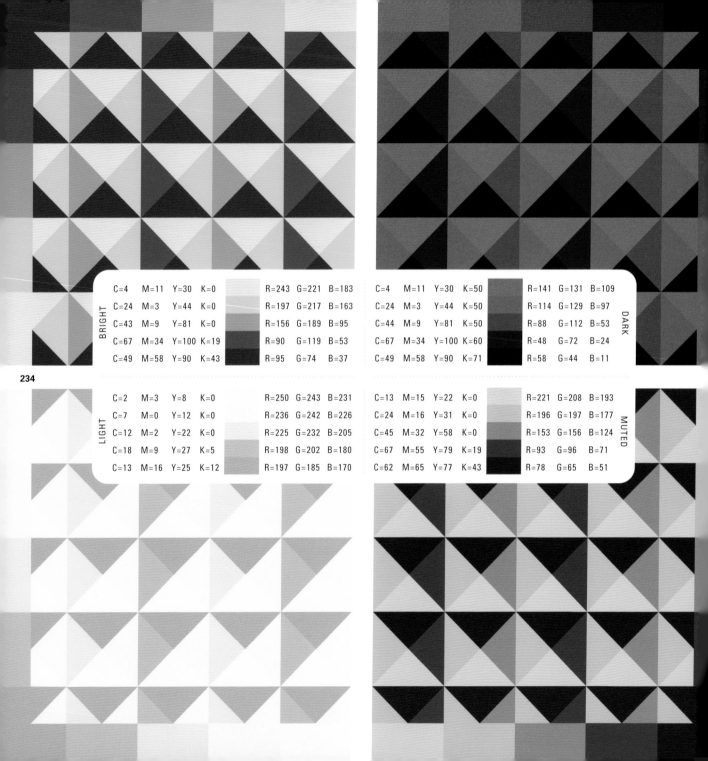

BRIGHT	C=4	M=11	Y=30	K=0	R=243	G=221	B=183
	C=24	M=3	Y=44	K=0	R=197	G=217	B=163
	C=43	M=9	Y=81	K=0	R=156	G=189	B=95
	C=67	M=34	Y=100	K=19	R=90	G=119	B=53
	C=49	M=58	Y=90	K=43	R=95	G=74	B=37

C=4	M=11	Y=30	K=50	R=141	G=131	B=109	DARK
C=24	M=3	Y=44	K=50	R=114	G=129	B=97	
C=44	M=9	Y=81	K=50	R=88	G=112	B=53	
C=67	M=34	Y=100	K=60	R=48	G=72	B=24	
C=49	M=58	Y=90	K=71	R=58	G=44	B=11	

234

LIGHT	C=2	M=3	Y=8	K=0	R=250	G=243	B=231
	C=7	M=0	Y=12	K=0	R=236	G=242	B=226
	C=12	M=2	Y=22	K=0	R=225	G=232	B=205
	C=18	M=9	Y=27	K=5	R=198	G=202	B=180
	C=13	M=16	Y=25	K=12	R=197	G=185	B=170

C=13	M=15	Y=22	K=0	R=221	G=208	B=193	MUTED
C=24	M=16	Y=31	K=0	R=196	G=197	B=177	
C=45	M=32	Y=58	K=0	R=153	G=156	B=124	
C=67	M=55	Y=79	K=19	R=93	G=96	B=71	
C=62	M=65	Y=77	K=43	R=78	G=65	B=51	

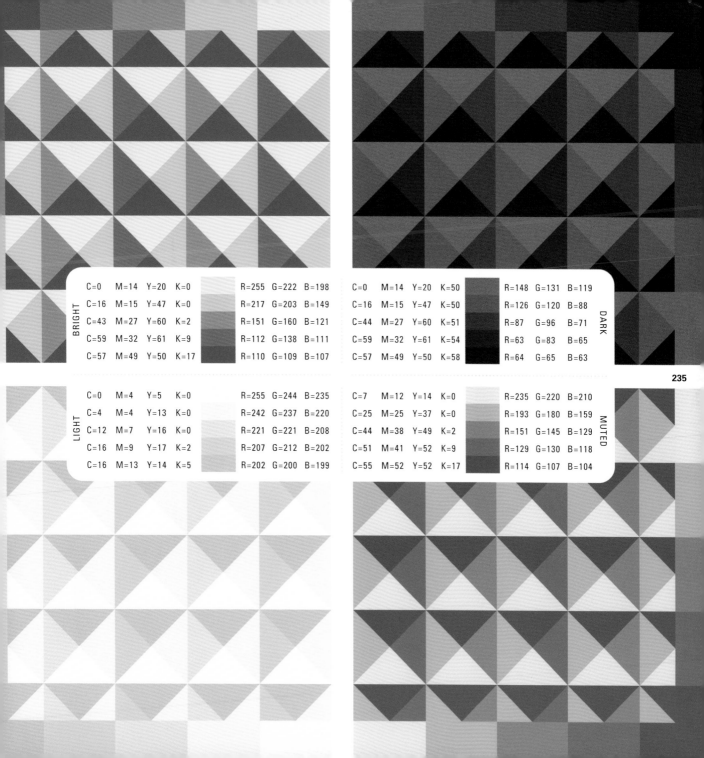

C=0	M=14	Y=20	K=0	R=255	G=222	B=198
C=16	M=15	Y=47	K=0	R=217	G=203	B=149
C=43	M=27	Y=60	K=2	R=151	G=160	B=121
C=59	M=32	Y=61	K=9	R=112	G=138	B=111
C=57	M=49	Y=50	K=17	R=110	G=109	B=107

DARK

C=0	M=14	Y=20	K=50	R=148	G=131	B=119
C=16	M=15	Y=47	K=50	R=126	G=120	B=88
C=44	M=27	Y=60	K=51	R=87	G=96	B=71
C=59	M=32	Y=61	K=54	R=63	G=83	B=65
C=57	M=49	Y=50	K=58	R=64	G=65	B=63

235

LIGHT

C=0	M=4	Y=5	K=0	R=255	G=244	B=235
C=4	M=4	Y=13	K=0	R=242	G=237	B=220
C=12	M=7	Y=16	K=0	R=221	G=221	B=208
C=16	M=9	Y=17	K=2	R=207	G=212	B=202
C=16	M=13	Y=14	K=5	R=202	G=200	B=199

MUTED

C=7	M=12	Y=14	K=0	R=235	G=220	B=210
C=25	M=25	Y=37	K=0	R=193	G=180	B=159
C=44	M=38	Y=49	K=2	R=151	G=145	B=129
C=51	M=41	Y=52	K=9	R=129	G=130	B=118
C=55	M=52	Y=52	K=17	R=114	G=107	B=104

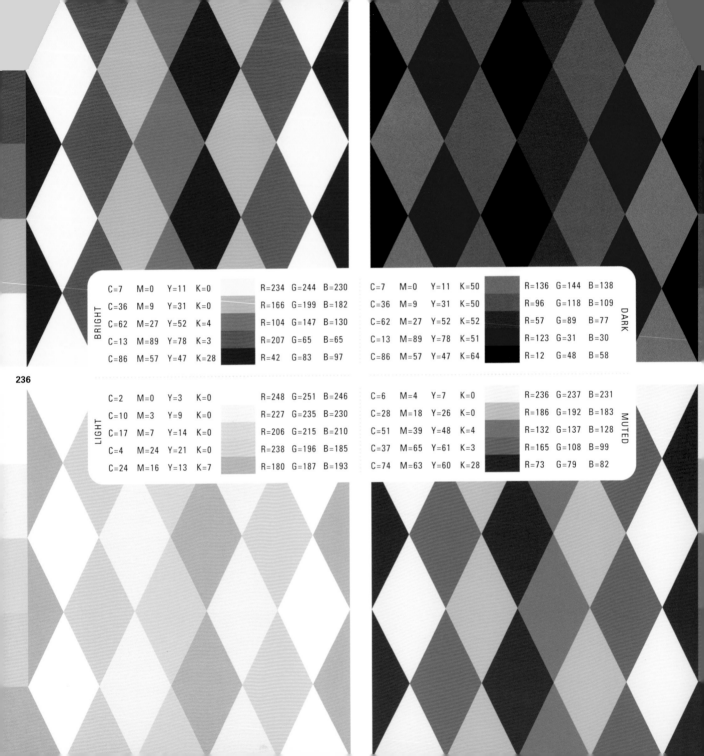

BRIGHT

C=7	M=0	Y=11	K=0
C=36	M=9	Y=31	K=0
C=62	M=27	Y=52	K=4
C=13	M=89	Y=78	K=3
C=86	M=57	Y=47	K=28

R=234	G=244	B=230
R=166	G=199	B=182
R=104	G=147	B=130
R=207	G=65	B=65
R=42	G=83	B=97

DARK

C=7	M=0	Y=11	K=50
C=36	M=9	Y=31	K=50
C=62	M=27	Y=52	K=52
C=13	M=89	Y=78	K=51
C=86	M=57	Y=47	K=64

R=136	G=144	B=138
R=96	G=118	B=109
R=57	G=89	B=77
R=123	G=31	B=30
R=12	G=48	B=58

LIGHT

C=2	M=0	Y=3	K=0
C=10	M=3	Y=9	K=0
C=17	M=7	Y=14	K=0
C=4	M=24	Y=21	K=0
C=24	M=16	Y=13	K=7

R=248	G=251	B=246
R=227	G=235	B=230
R=206	G=215	B=210
R=238	G=196	B=185
R=180	G=187	B=193

MUTED

C=6	M=4	Y=7	K=0
C=28	M=18	Y=26	K=0
C=51	M=39	Y=48	K=4
C=37	M=65	Y=61	K=3
C=74	M=63	Y=60	K=28

R=236	G=237	B=231
R=186	G=192	B=183
R=132	G=137	B=128
R=165	G=108	B=99
R=73	G=79	B=82

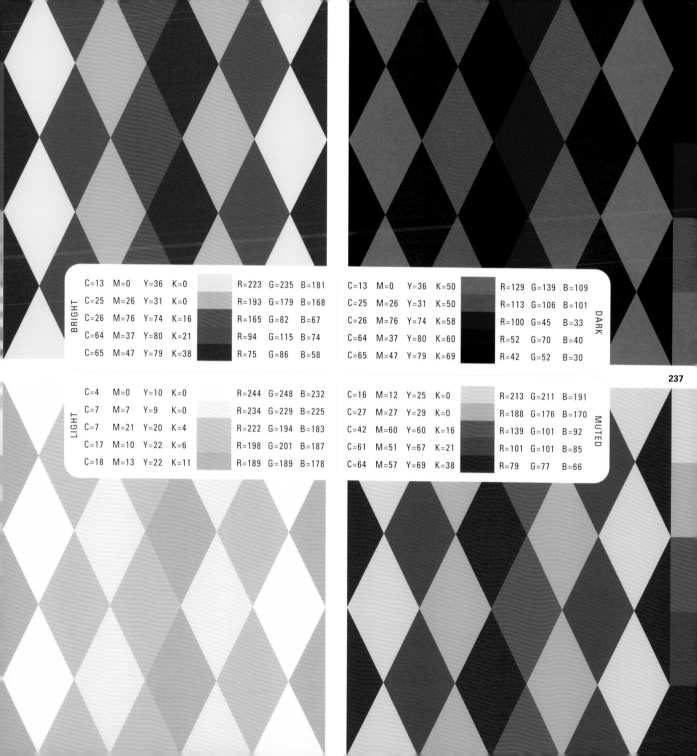

BRIGHT

C=13	M=0	Y=36	K=0		R=223	G=235	B=181
C=25	M=26	Y=31	K=0		R=193	G=179	B=168
C=26	M=76	Y=74	K=16		R=165	G=82	B=67
C=64	M=37	Y=80	K=21		R=94	G=115	B=74
C=65	M=47	Y=79	K=38		R=75	G=86	B=58

DARK

C=13	M=0	Y=36	K=50		R=129	G=139	B=109
C=25	M=26	Y=31	K=50		R=113	G=106	B=101
C=26	M=76	Y=74	K=58		R=100	G=45	B=33
C=64	M=37	Y=80	K=60		R=52	G=70	B=40
C=65	M=47	Y=79	K=69		R=42	G=52	B=30

LIGHT

C=4	M=0	Y=10	K=0		R=244	G=248	B=232
C=7	M=7	Y=9	K=0		R=234	G=229	B=225
C=7	M=21	Y=20	K=4		R=222	G=194	B=183
C=17	M=10	Y=22	K=6		R=198	G=201	B=187
C=18	M=13	Y=22	K=11		R=189	G=189	B=178

MUTED

C=16	M=12	Y=25	K=0		R=213	G=211	B=191
C=27	M=27	Y=29	K=0		R=188	G=176	B=170
C=42	M=60	Y=60	K=16		R=139	G=101	B=92
C=61	M=51	Y=67	K=21		R=101	G=101	B=85
C=64	M=57	Y=69	K=38		R=79	G=77	B=66

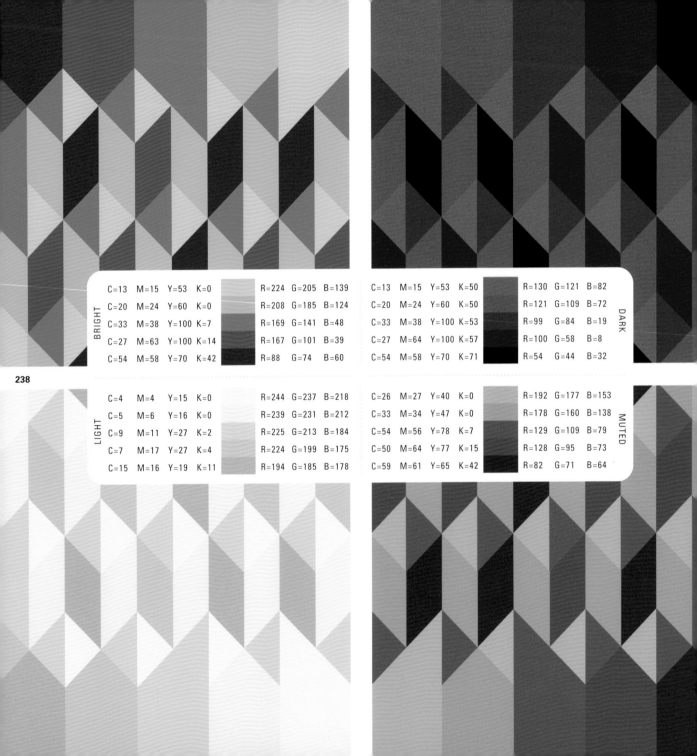

BRIGHT

C=13	M=15	Y=53	K=0		R=224	G=205	B=139
C=20	M=24	Y=60	K=0		R=208	G=185	B=124
C=33	M=38	Y=100	K=7		R=169	G=141	B=48
C=27	M=63	Y=100	K=14		R=167	G=101	B=39
C=54	M=58	Y=70	K=42		R=88	G=74	B=60

DARK

C=13	M=15	Y=53	K=50		R=130	G=121	B=82
C=20	M=24	Y=60	K=50		R=121	G=109	B=72
C=33	M=38	Y=100	K=53		R=99	G=84	B=19
C=27	M=64	Y=100	K=57		R=100	G=58	B=8
C=54	M=58	Y=70	K=71		R=54	G=44	B=32

LIGHT

C=4	M=4	Y=15	K=0		R=244	G=237	B=218
C=5	M=6	Y=16	K=0		R=239	G=231	B=212
C=9	M=11	Y=27	K=2		R=225	G=213	B=184
C=7	M=17	Y=27	K=4		R=224	G=199	B=175
C=15	M=16	Y=19	K=11		R=194	G=185	B=178

MUTED

C=26	M=27	Y=40	K=0		R=192	G=177	B=153
C=33	M=34	Y=47	K=0		R=178	G=160	B=138
C=54	M=56	Y=78	K=7		R=129	G=109	B=79
C=50	M=64	Y=77	K=15		R=128	G=95	B=73
C=59	M=61	Y=65	K=42		R=82	G=71	B=64

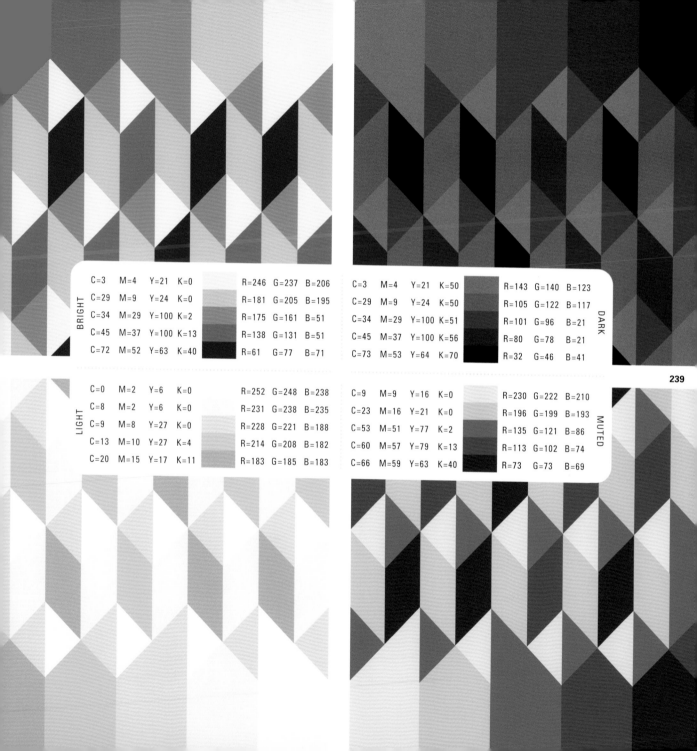

BRIGHT

C=3	M=4	Y=21	K=0	R=246	G=237	B=206
C=29	M=9	Y=24	K=0	R=181	G=205	B=195
C=34	M=29	Y=100	K=2	R=175	G=161	B=51
C=45	M=37	Y=100	K=13	R=138	G=131	B=51
C=72	M=52	Y=63	K=40	R=61	G=77	B=71

DARK

C=3	M=4	Y=21	K=50	R=143	G=140	B=123
C=29	M=9	Y=24	K=50	R=105	G=122	B=117
C=34	M=29	Y=100	K=51	R=101	G=96	B=21
C=45	M=37	Y=100	K=56	R=80	G=78	B=21
C=73	M=53	Y=64	K=70	R=32	G=46	B=41

LIGHT

C=0	M=2	Y=6	K=0	R=252	G=248	B=238
C=8	M=2	Y=6	K=0	R=231	G=238	B=235
C=9	M=8	Y=27	K=0	R=228	G=221	B=188
C=13	M=10	Y=27	K=4	R=214	G=208	B=182
C=20	M=15	Y=17	K=11	R=183	G=185	B=183

MUTED

C=9	M=9	Y=16	K=0	R=230	G=222	B=210
C=23	M=16	Y=21	K=0	R=196	G=199	B=193
C=53	M=51	Y=77	K=2	R=135	G=121	B=86
C=60	M=57	Y=79	K=13	R=113	G=102	B=74
C=66	M=59	Y=63	K=40	R=73	G=73	B=69

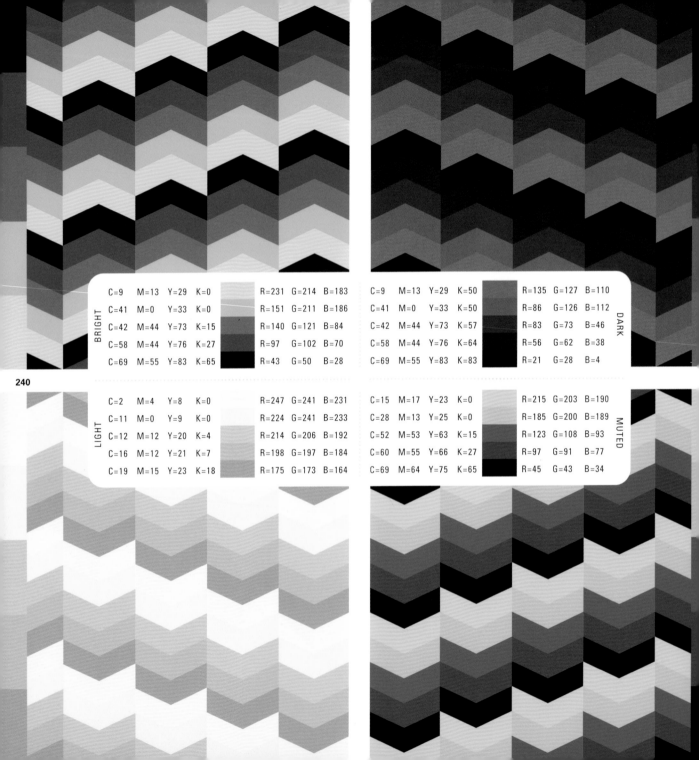

240

<table>
<tr><td rowspan="5">BRIGHT</td><td>C=9</td><td>M=13</td><td>Y=29</td><td>K=0</td><td></td><td>R=231</td><td>G=214</td><td>B=183</td></tr>
<tr><td>C=41</td><td>M=0</td><td>Y=33</td><td>K=0</td><td></td><td>R=151</td><td>G=211</td><td>B=186</td></tr>
<tr><td>C=42</td><td>M=44</td><td>Y=73</td><td>K=15</td><td></td><td>R=140</td><td>G=121</td><td>B=84</td></tr>
<tr><td>C=58</td><td>M=44</td><td>Y=76</td><td>K=27</td><td></td><td>R=97</td><td>G=102</td><td>B=70</td></tr>
<tr><td>C=69</td><td>M=55</td><td>Y=83</td><td>K=65</td><td></td><td>R=43</td><td>G=50</td><td>B=28</td></tr>
</table>

<table>
<tr><td>C=9</td><td>M=13</td><td>Y=29</td><td>K=50</td><td></td><td>R=135</td><td>G=127</td><td>B=110</td><td rowspan="5">DARK</td></tr>
<tr><td>C=41</td><td>M=0</td><td>Y=33</td><td>K=50</td><td></td><td>R=86</td><td>G=126</td><td>B=112</td></tr>
<tr><td>C=42</td><td>M=44</td><td>Y=73</td><td>K=57</td><td></td><td>R=83</td><td>G=73</td><td>B=46</td></tr>
<tr><td>C=58</td><td>M=44</td><td>Y=76</td><td>K=64</td><td></td><td>R=56</td><td>G=62</td><td>B=38</td></tr>
<tr><td>C=69</td><td>M=55</td><td>Y=83</td><td>K=83</td><td></td><td>R=21</td><td>G=28</td><td>B=4</td></tr>
</table>

<table>
<tr><td rowspan="5">LIGHT</td><td>C=2</td><td>M=4</td><td>Y=8</td><td>K=0</td><td></td><td>R=247</td><td>G=241</td><td>B=231</td></tr>
<tr><td>C=11</td><td>M=0</td><td>Y=9</td><td>K=0</td><td></td><td>R=224</td><td>G=241</td><td>B=233</td></tr>
<tr><td>C=12</td><td>M=12</td><td>Y=20</td><td>K=4</td><td></td><td>R=214</td><td>G=206</td><td>B=192</td></tr>
<tr><td>C=16</td><td>M=12</td><td>Y=21</td><td>K=7</td><td></td><td>R=198</td><td>G=197</td><td>B=184</td></tr>
<tr><td>C=19</td><td>M=15</td><td>Y=23</td><td>K=18</td><td></td><td>R=175</td><td>G=173</td><td>B=164</td></tr>
</table>

<table>
<tr><td>C=15</td><td>M=17</td><td>Y=23</td><td>K=0</td><td></td><td>R=215</td><td>G=203</td><td>B=190</td><td rowspan="5">MUTED</td></tr>
<tr><td>C=28</td><td>M=13</td><td>Y=25</td><td>K=0</td><td></td><td>R=185</td><td>G=200</td><td>B=189</td></tr>
<tr><td>C=52</td><td>M=53</td><td>Y=63</td><td>K=15</td><td></td><td>R=123</td><td>G=108</td><td>B=93</td></tr>
<tr><td>C=60</td><td>M=55</td><td>Y=66</td><td>K=27</td><td></td><td>R=97</td><td>G=91</td><td>B=77</td></tr>
<tr><td>C=69</td><td>M=64</td><td>Y=75</td><td>K=65</td><td></td><td>R=45</td><td>G=43</td><td>B=34</td></tr>
</table>

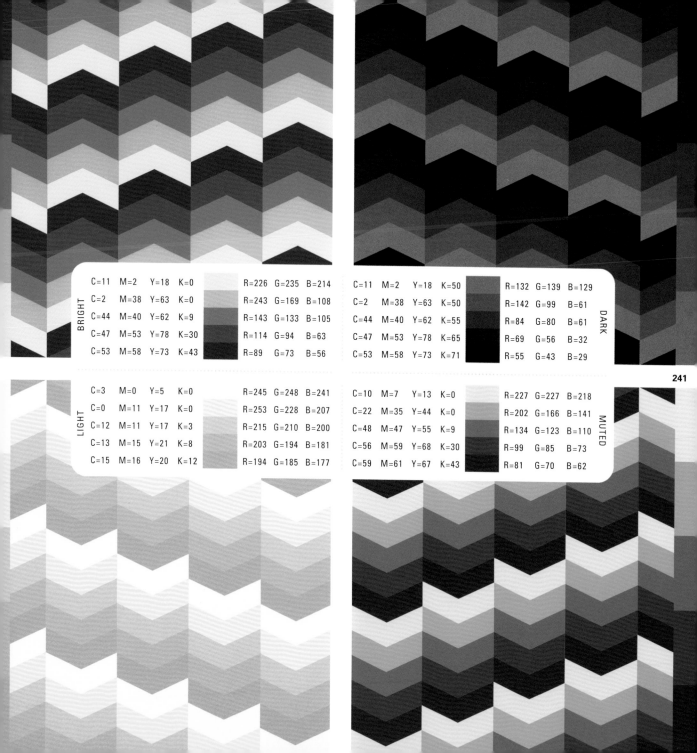

BRIGHT

C=11	M=2	Y=18	K=0		R=226	G=235	B=214
C=2	M=38	Y=63	K=0		R=243	G=169	B=108
C=44	M=40	Y=62	K=9		R=143	G=133	B=105
C=47	M=53	Y=78	K=30		R=114	G=94	B=63
C=53	M=58	Y=73	K=43		R=89	G=73	B=56

DARK

C=11	M=2	Y=18	K=50		R=132	G=139	B=129
C=2	M=38	Y=63	K=50		R=142	G=99	B=61
C=44	M=40	Y=62	K=55		R=84	G=80	B=61
C=47	M=53	Y=78	K=65		R=69	G=56	B=32
C=53	M=58	Y=73	K=71		R=55	G=43	B=29

LIGHT

C=3	M=0	Y=5	K=0		R=245	G=248	B=241
C=0	M=11	Y=17	K=0		R=253	G=228	B=207
C=12	M=11	Y=17	K=3		R=215	G=210	B=200
C=13	M=15	Y=21	K=8		R=203	G=194	B=181
C=15	M=16	Y=20	K=12		R=194	G=185	B=177

MUTED

C=10	M=7	Y=13	K=0		R=227	G=227	B=218
C=22	M=35	Y=44	K=0		R=202	G=166	B=141
C=48	M=47	Y=55	K=9		R=134	G=123	B=110
C=56	M=59	Y=68	K=30		R=99	G=85	B=73
C=59	M=61	Y=67	K=43		R=81	G=70	B=62

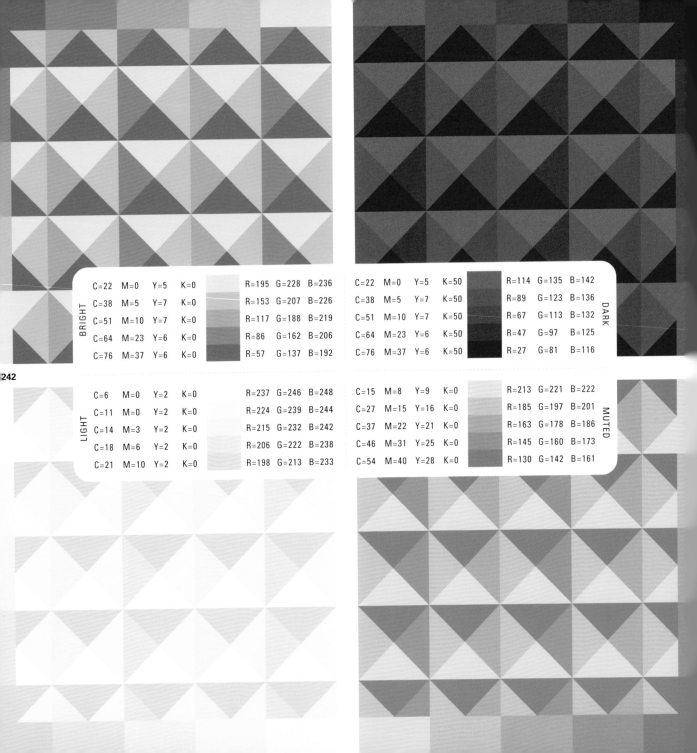

BRIGHT					R=195 G=228 B=236
C=22	M=0	Y=5	K=0		R=195 G=228 B=236
C=38	M=5	Y=7	K=0		R=153 G=207 B=226
C=51	M=10	Y=7	K=0		R=117 G=188 B=219
C=64	M=23	Y=6	K=0		R=86 G=162 B=206
C=76	M=37	Y=6	K=0		R=57 G=137 B=192

DARK					
C=22	M=0	Y=5	K=50		R=114 G=135 B=142
C=38	M=5	Y=7	K=50		R=89 G=123 B=136
C=51	M=10	Y=7	K=50		R=67 G=113 B=132
C=64	M=23	Y=6	K=50		R=47 G=97 B=125
C=76	M=37	Y=6	K=50		R=27 G=81 B=116

LIGHT					
C=6	M=0	Y=2	K=0		R=237 G=246 B=248
C=11	M=0	Y=2	K=0		R=224 G=239 B=244
C=14	M=3	Y=2	K=0		R=215 G=232 B=242
C=18	M=6	Y=2	K=0		R=206 G=222 B=238
C=21	M=10	Y=2	K=0		R=198 G=213 B=233

MUTED					
C=15	M=8	Y=9	K=0		R=213 G=221 B=222
C=27	M=15	Y=16	K=0		R=185 G=197 B=201
C=37	M=22	Y=21	K=0		R=163 G=178 B=186
C=46	M=31	Y=25	K=0		R=145 G=160 B=173
C=54	M=40	Y=28	K=0		R=130 G=142 B=161

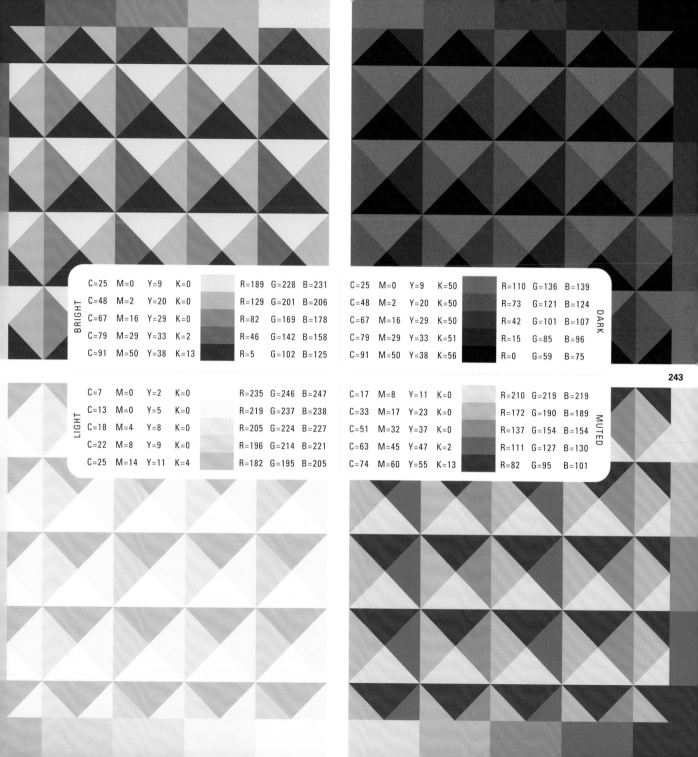

BRIGHT	C=25	M=0	Y=9	K=0		R=189	G=228	B=231
	C=48	M=2	Y=20	K=0		R=129	G=201	B=206
	C=67	M=16	Y=29	K=0		R=82	G=169	B=178
	C=79	M=29	Y=33	K=2		R=46	G=142	B=158
	C=91	M=50	Y=38	K=13		R=5	G=102	B=125

C=25	M=0	Y=9	K=50		R=110	G=136	B=139	DARK
C=48	M=2	Y=20	K=50		R=73	G=121	B=124	
C=67	M=16	Y=29	K=50		R=42	G=101	B=107	
C=79	M=29	Y=33	K=51		R=15	G=85	B=96	
C=91	M=50	Y=38	K=56		R=0	G=59	B=75	

LIGHT	C=7	M=0	Y=2	K=0		R=235	G=246	B=247
	C=13	M=0	Y=5	K=0		R=219	G=237	B=238
	C=18	M=4	Y=8	K=0		R=205	G=224	B=227
	C=22	M=8	Y=9	K=0		R=196	G=214	B=221
	C=25	M=14	Y=11	K=4		R=182	G=195	B=205

C=17	M=8	Y=11	K=0		R=210	G=219	B=219	MUTED
C=33	M=17	Y=23	K=0		R=172	G=190	B=189	
C=51	M=32	Y=37	K=0		R=137	G=154	B=154	
C=63	M=45	Y=47	K=2		R=111	G=127	B=130	
C=74	M=60	Y=55	K=13		R=82	G=95	B=101	

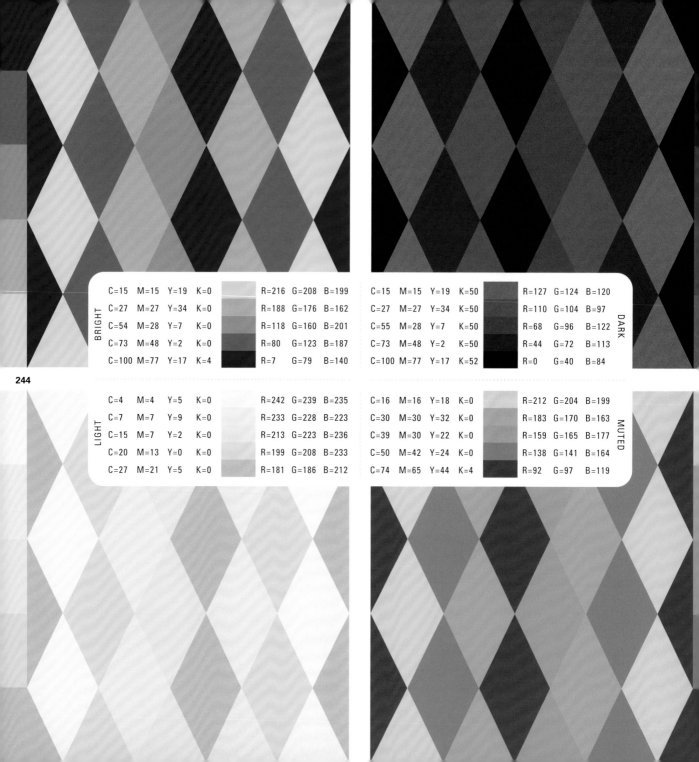

244

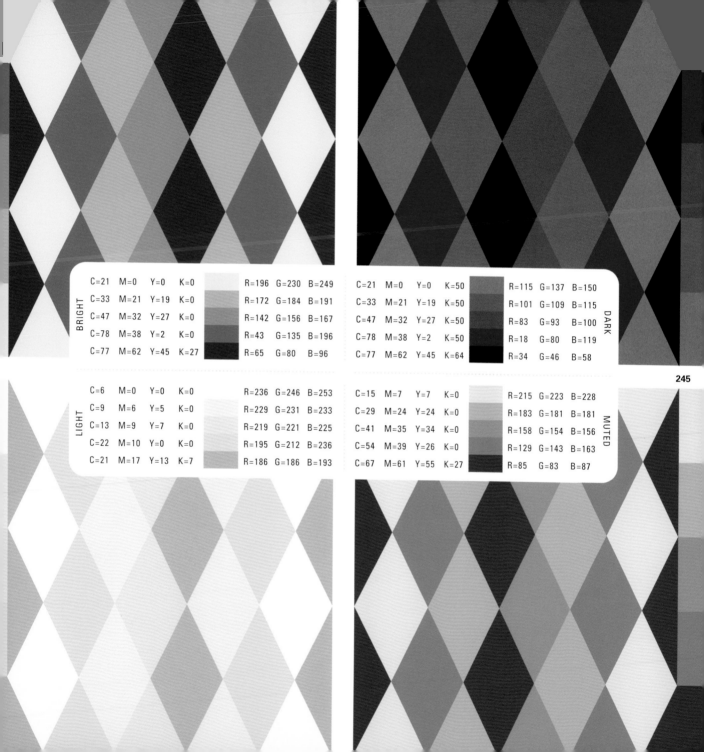

BRIGHT

C=21	M=0	Y=0	K=0		R=196	G=230	B=249
C=33	M=21	Y=19	K=0		R=172	G=184	B=191
C=47	M=32	Y=27	K=0		R=142	G=156	B=167
C=78	M=38	Y=2	K=0		R=43	G=135	B=196
C=77	M=62	Y=45	K=27		R=65	G=80	B=96

DARK

C=21	M=0	Y=0	K=50		R=115	G=137	B=150
C=33	M=21	Y=19	K=50		R=101	G=109	B=115
C=47	M=32	Y=27	K=50		R=83	G=93	B=100
C=78	M=38	Y=2	K=50		R=18	G=80	B=119
C=77	M=62	Y=45	K=64		R=34	G=46	B=58

LIGHT

C=6	M=0	Y=0	K=0		R=236	G=246	B=253
C=9	M=6	Y=5	K=0		R=229	G=231	B=233
C=13	M=9	Y=7	K=0		R=219	G=221	B=225
C=22	M=10	Y=0	K=0		R=195	G=212	B=236
C=21	M=17	Y=13	K=7		R=186	G=186	B=193

MUTED

C=15	M=7	Y=7	K=0		R=215	G=223	B=228
C=29	M=24	Y=24	K=0		R=183	G=181	B=181
C=41	M=35	Y=34	K=0		R=158	G=154	B=156
C=54	M=39	Y=26	K=0		R=129	G=143	B=163
C=67	M=61	Y=55	K=27		R=85	G=83	B=87

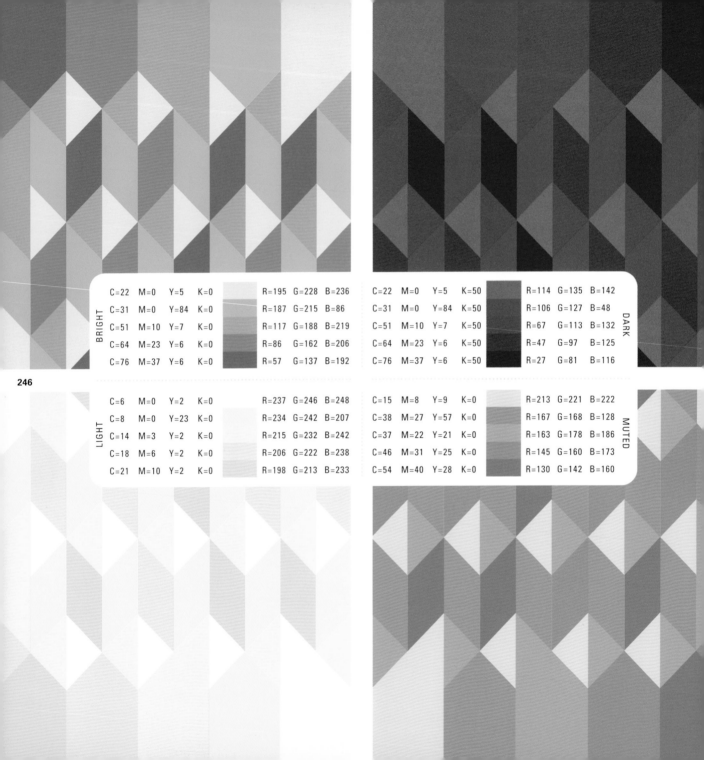

BRIGHT

C=22	M=0	Y=5	K=0		R=195	G=228	B=236
C=31	M=0	Y=84	K=0		R=187	G=215	B=86
C=51	M=10	Y=7	K=0		R=117	G=188	B=219
C=64	M=23	Y=6	K=0		R=86	G=162	B=206
C=76	M=37	Y=6	K=0		R=57	G=137	B=192

DARK

C=22	M=0	Y=5	K=50		R=114	G=135	B=142
C=31	M=0	Y=84	K=50		R=106	G=127	B=48
C=51	M=10	Y=7	K=50		R=67	G=113	B=132
C=64	M=23	Y=6	K=50		R=47	G=97	B=125
C=76	M=37	Y=6	K=50		R=27	G=81	B=116

LIGHT

C=6	M=0	Y=2	K=0		R=237	G=246	B=248
C=8	M=0	Y=23	K=0		R=234	G=242	B=207
C=14	M=3	Y=2	K=0		R=215	G=232	B=242
C=18	M=6	Y=2	K=0		R=206	G=222	B=238
C=21	M=10	Y=2	K=0		R=198	G=213	B=233

MUTED

C=15	M=8	Y=9	K=0		R=213	G=221	B=222
C=38	M=27	Y=57	K=0		R=167	G=168	B=128
C=37	M=22	Y=21	K=0		R=163	G=178	B=186
C=46	M=31	Y=25	K=0		R=145	G=160	B=173
C=54	M=40	Y=28	K=0		R=130	G=142	B=160

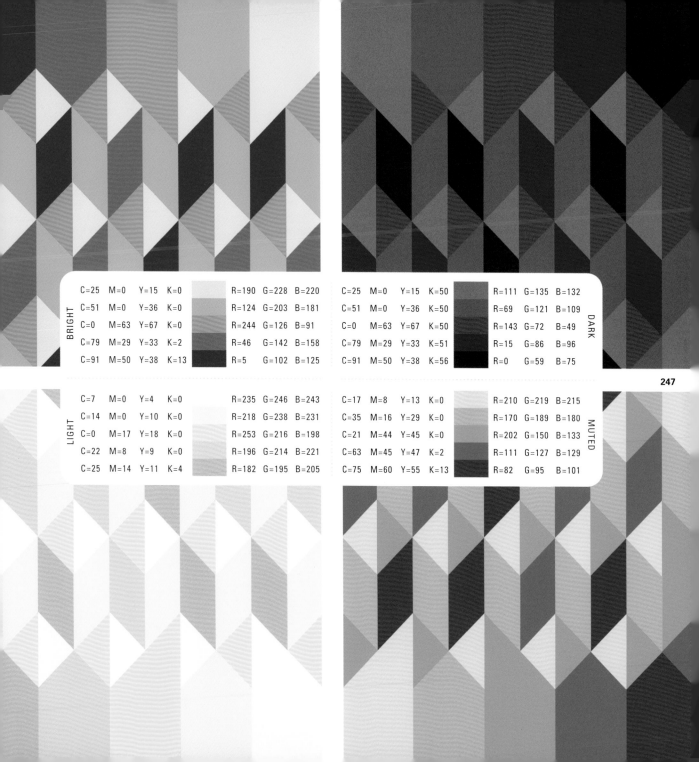

BRIGHT

C=25	M=0	Y=15	K=0		R=190	G=228	B=220
C=51	M=0	Y=36	K=0		R=124	G=203	B=181
C=0	M=63	Y=67	K=0		R=244	G=126	B=91
C=79	M=29	Y=33	K=2		R=46	G=142	B=158
C=91	M=50	Y=38	K=13		R=5	G=102	B=125

DARK

C=25	M=0	Y=15	K=50		R=111	G=135	B=132
C=51	M=0	Y=36	K=50		R=69	G=121	B=109
C=0	M=63	Y=67	K=50		R=143	G=72	B=49
C=79	M=29	Y=33	K=51		R=15	G=86	B=96
C=91	M=50	Y=38	K=56		R=0	G=59	B=75

LIGHT

C=7	M=0	Y=4	K=0		R=235	G=246	B=243
C=14	M=0	Y=10	K=0		R=218	G=238	B=231
C=0	M=17	Y=18	K=0		R=253	G=216	B=198
C=22	M=8	Y=9	K=0		R=196	G=214	B=221
C=25	M=14	Y=11	K=4		R=182	G=195	B=205

MUTED

C=17	M=8	Y=13	K=0		R=210	G=219	B=215
C=35	M=16	Y=29	K=0		R=170	G=189	B=180
C=21	M=44	Y=45	K=0		R=202	G=150	B=133
C=63	M=45	Y=47	K=2		R=111	G=127	B=129
C=75	M=60	Y=55	K=13		R=82	G=95	B=101

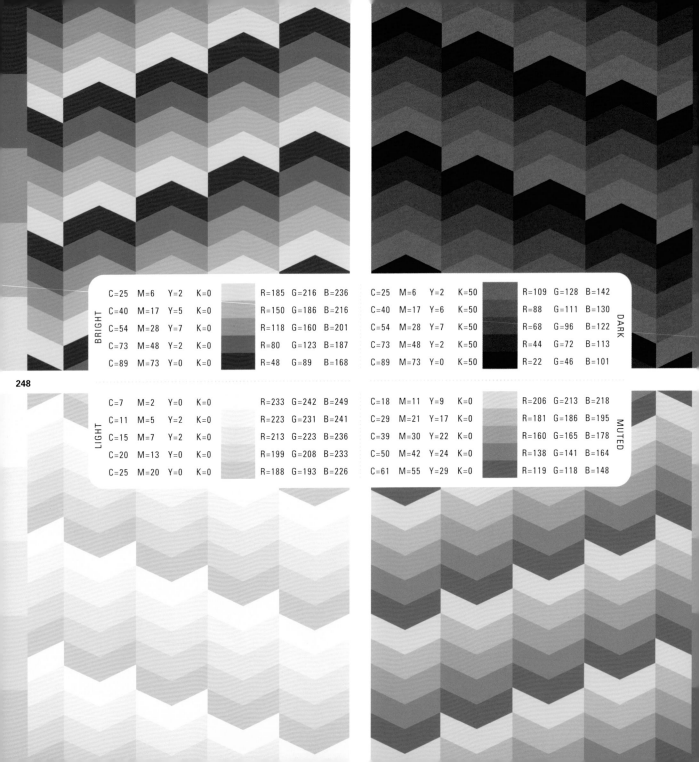

248

BRIGHT

C=25	M=6	Y=2	K=0		R=185	G=216	B=236
C=40	M=17	Y=5	K=0		R=150	G=186	B=216
C=54	M=28	Y=7	K=0		R=118	G=160	B=201
C=73	M=48	Y=2	K=0		R=80	G=123	B=187
C=89	M=73	Y=0	K=0		R=48	G=89	B=168

DARK

C=25	M=6	Y=2	K=50		R=109	G=128	B=142
C=40	M=17	Y=6	K=50		R=88	G=111	B=130
C=54	M=28	Y=7	K=50		R=68	G=96	B=122
C=73	M=48	Y=2	K=50		R=44	G=72	B=113
C=89	M=73	Y=0	K=50		R=22	G=46	B=101

LIGHT

C=7	M=2	Y=0	K=0		R=233	G=242	B=249
C=11	M=5	Y=2	K=0		R=223	G=231	B=241
C=15	M=7	Y=2	K=0		R=213	G=223	B=236
C=20	M=13	Y=0	K=0		R=199	G=208	B=233
C=25	M=20	Y=0	K=0		R=188	G=193	B=226

MUTED

C=18	M=11	Y=9	K=0		R=206	G=213	B=218
C=29	M=21	Y=17	K=0		R=181	G=186	B=195
C=39	M=30	Y=22	K=0		R=160	G=165	B=178
C=50	M=42	Y=24	K=0		R=138	G=141	B=164
C=61	M=55	Y=29	K=0		R=119	G=118	B=148

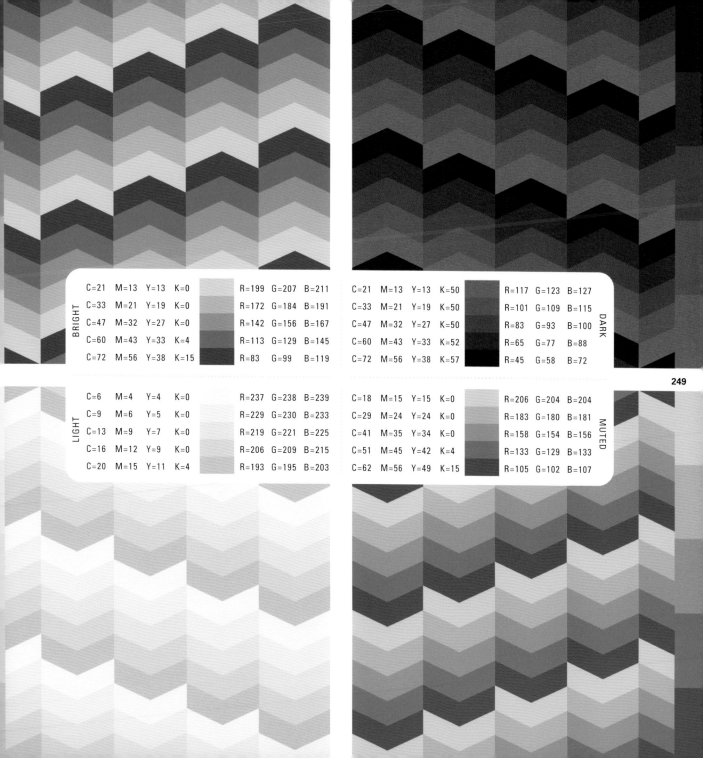

BRIGHT

C=21	M=13	Y=13	K=0		R=199	G=207	B=211
C=33	M=21	Y=19	K=0		R=172	G=184	B=191
C=47	M=32	Y=27	K=0		R=142	G=156	B=167
C=60	M=43	Y=33	K=4		R=113	G=129	B=145
C=72	M=56	Y=38	K=15		R=83	G=99	B=119

DARK

C=21	M=13	Y=13	K=50		R=117	G=123	B=127
C=33	M=21	Y=19	K=50		R=101	G=109	B=115
C=47	M=32	Y=27	K=50		R=83	G=93	B=100
C=60	M=43	Y=33	K=52		R=65	G=77	B=88
C=72	M=56	Y=38	K=57		R=45	G=58	B=72

LIGHT

C=6	M=4	Y=4	K=0		R=237	G=238	B=239
C=9	M=6	Y=5	K=0		R=229	G=230	B=233
C=13	M=9	Y=7	K=0		R=219	G=221	B=225
C=16	M=12	Y=9	K=0		R=206	G=209	B=215
C=20	M=15	Y=11	K=4		R=193	G=195	B=203

MUTED

C=18	M=15	Y=15	K=0		R=206	G=204	B=204
C=29	M=24	Y=24	K=0		R=183	G=180	B=181
C=41	M=35	Y=34	K=0		R=158	G=154	B=156
C=51	M=45	Y=42	K=4		R=133	G=129	B=133
C=62	M=56	Y=49	K=15		R=105	G=102	B=107

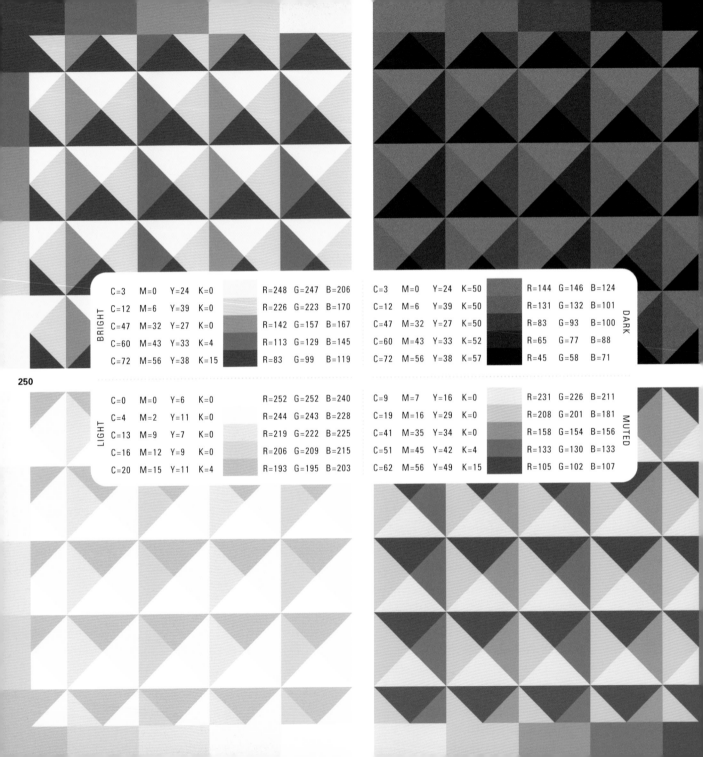

BRIGHT

C=3	M=0	Y=24	K=0		R=248	G=247	B=206
C=12	M=6	Y=39	K=0		R=226	G=223	B=170
C=47	M=32	Y=27	K=0		R=142	G=157	B=167
C=60	M=43	Y=33	K=4		R=113	G=129	B=145
C=72	M=56	Y=38	K=15		R=83	G=99	B=119

DARK

C=3	M=0	Y=24	K=50		R=144	G=146	B=124
C=12	M=6	Y=39	K=50		R=131	G=132	B=101
C=47	M=32	Y=27	K=50		R=83	G=93	B=100
C=60	M=43	Y=33	K=52		R=65	G=77	B=88
C=72	M=56	Y=38	K=57		R=45	G=58	B=71

LIGHT

C=0	M=0	Y=6	K=0		R=252	G=252	B=240
C=4	M=2	Y=11	K=0		R=244	G=243	B=228
C=13	M=9	Y=7	K=0		R=219	G=222	B=225
C=16	M=12	Y=9	K=0		R=206	G=209	B=215
C=20	M=15	Y=11	K=4		R=193	G=195	B=203

MUTED

C=9	M=7	Y=16	K=0		R=231	G=226	B=211
C=19	M=16	Y=29	K=0		R=208	G=201	B=181
C=41	M=35	Y=34	K=0		R=158	G=154	B=156
C=51	M=45	Y=42	K=4		R=133	G=130	B=133
C=62	M=56	Y=49	K=15		R=105	G=102	B=107

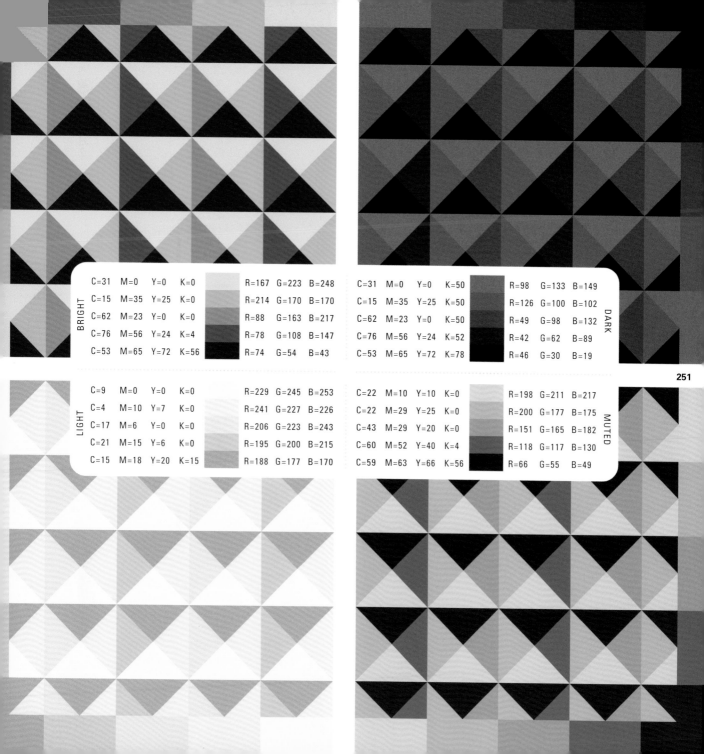

BRIGHT

C=31	M=0	Y=0	K=0		R=167	G=223	B=248
C=15	M=35	Y=25	K=0		R=214	G=170	B=170
C=62	M=23	Y=0	K=0		R=88	G=163	B=217
C=76	M=56	Y=24	K=4		R=78	G=108	B=147
C=53	M=65	Y=72	K=56		R=74	G=54	B=43

DARK

C=31	M=0	Y=0	K=50		R=98	G=133	B=149
C=15	M=35	Y=25	K=50		R=126	G=100	B=102
C=62	M=23	Y=0	K=50		R=49	G=98	B=132
C=76	M=56	Y=24	K=52		R=42	G=62	B=89
C=53	M=65	Y=72	K=78		R=46	G=30	B=19

LIGHT

C=9	M=0	Y=0	K=0		R=229	G=245	B=253
C=4	M=10	Y=7	K=0		R=241	G=227	B=226
C=17	M=6	Y=0	K=0		R=206	G=223	B=243
C=21	M=15	Y=6	K=0		R=195	G=200	B=215
C=15	M=18	Y=20	K=15		R=188	G=177	B=170

MUTED

C=22	M=10	Y=10	K=0		R=198	G=211	B=217
C=22	M=29	Y=25	K=0		R=200	G=177	B=175
C=43	M=29	Y=20	K=0		R=151	G=165	B=182
C=60	M=52	Y=40	K=4		R=118	G=117	B=130
C=59	M=63	Y=66	K=56		R=66	G=55	B=49

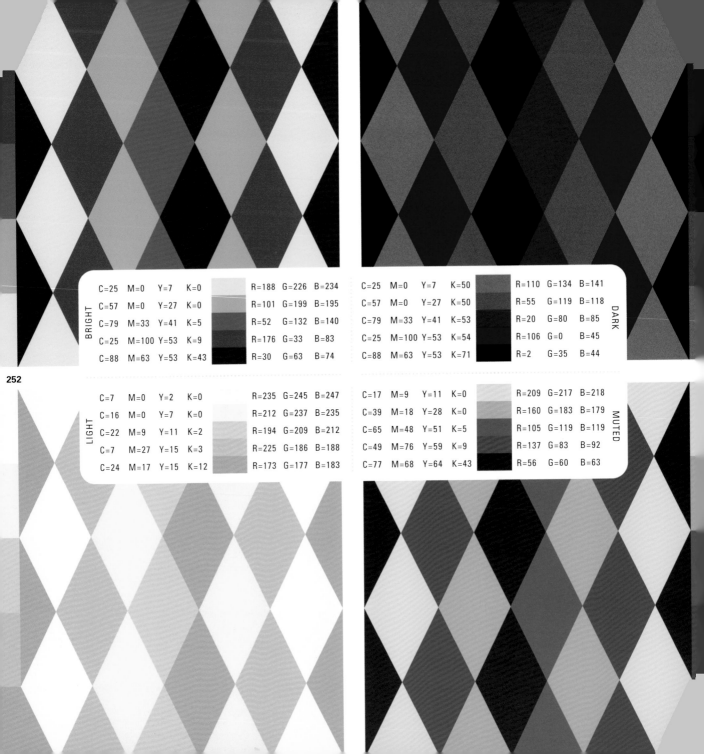

BRIGHT

C=25	M=0	Y=7	K=0		R=188	G=226	B=234
C=57	M=0	Y=27	K=0		R=101	G=199	B=195
C=79	M=33	Y=41	K=5		R=52	G=132	B=140
C=25	M=100	Y=53	K=9		R=176	G=33	B=83
C=88	M=63	Y=53	K=43		R=30	G=63	B=74

DARK

C=25	M=0	Y=7	K=50		R=110	G=134	B=141
C=57	M=0	Y=27	K=50		R=55	G=119	B=118
C=79	M=33	Y=41	K=53		R=20	G=80	B=85
C=25	M=100	Y=53	K=54		R=106	G=0	B=45
C=88	M=63	Y=53	K=71		R=2	G=35	B=44

LIGHT

C=7	M=0	Y=2	K=0		R=235	G=245	B=247
C=16	M=0	Y=7	K=0		R=212	G=237	B=235
C=22	M=9	Y=11	K=2		R=194	G=209	B=212
C=7	M=27	Y=15	K=3		R=225	G=186	B=188
C=24	M=17	Y=15	K=12		R=173	G=177	B=183

MUTED

C=17	M=9	Y=11	K=0		R=209	G=217	B=218
C=39	M=18	Y=28	K=0		R=160	G=183	B=179
C=65	M=48	Y=51	K=5		R=105	G=119	B=119
C=49	M=76	Y=59	K=9		R=137	G=83	B=92
C=77	M=68	Y=64	K=43		R=56	G=60	B=63

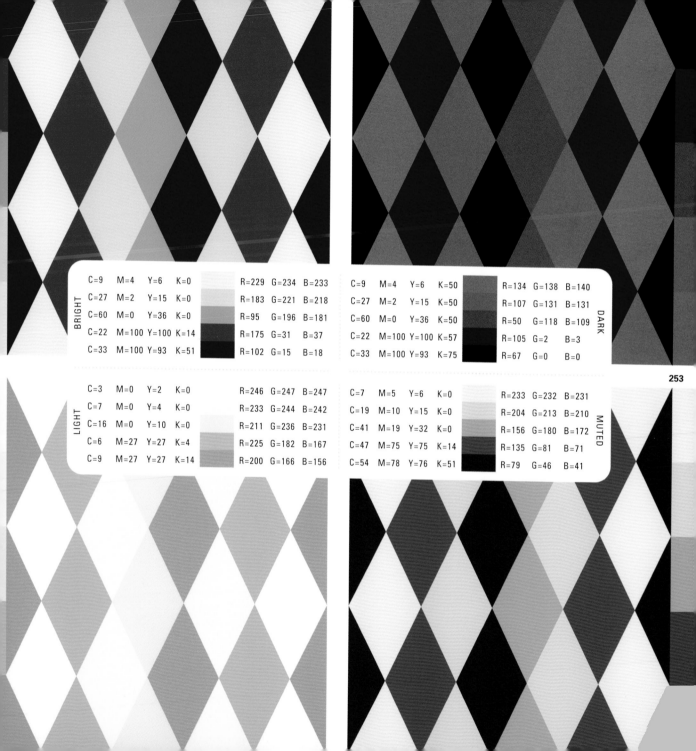

BRIGHT

C=9	M=4	Y=6	K=0		R=229	G=234	B=233
C=27	M=2	Y=15	K=0		R=183	G=221	B=218
C=60	M=0	Y=36	K=0		R=95	G=196	B=181
C=22	M=100	Y=100	K=14		R=175	G=31	B=37
C=33	M=100	Y=93	K=51		R=102	G=15	B=18

DARK

C=9	M=4	Y=6	K=50		R=134	G=138	B=140
C=27	M=2	Y=15	K=50		R=107	G=131	B=131
C=60	M=0	Y=36	K=50		R=50	G=118	B=109
C=22	M=100	Y=100	K=57		R=105	G=2	B=3
C=33	M=100	Y=93	K=75		R=67	G=0	B=0

LIGHT

C=3	M=0	Y=2	K=0		R=246	G=247	B=247
C=7	M=0	Y=4	K=0		R=233	G=244	B=242
C=16	M=0	Y=10	K=0		R=211	G=236	B=231
C=6	M=27	Y=27	K=4		R=225	G=182	B=167
C=9	M=27	Y=27	K=14		R=200	G=166	B=156

MUTED

C=7	M=5	Y=6	K=0		R=233	G=232	B=231
C=19	M=10	Y=15	K=0		R=204	G=213	B=210
C=41	M=19	Y=32	K=0		R=156	G=180	B=172
C=47	M=75	Y=75	K=14		R=135	G=81	B=71
C=54	M=78	Y=76	K=51		R=79	G=46	B=41

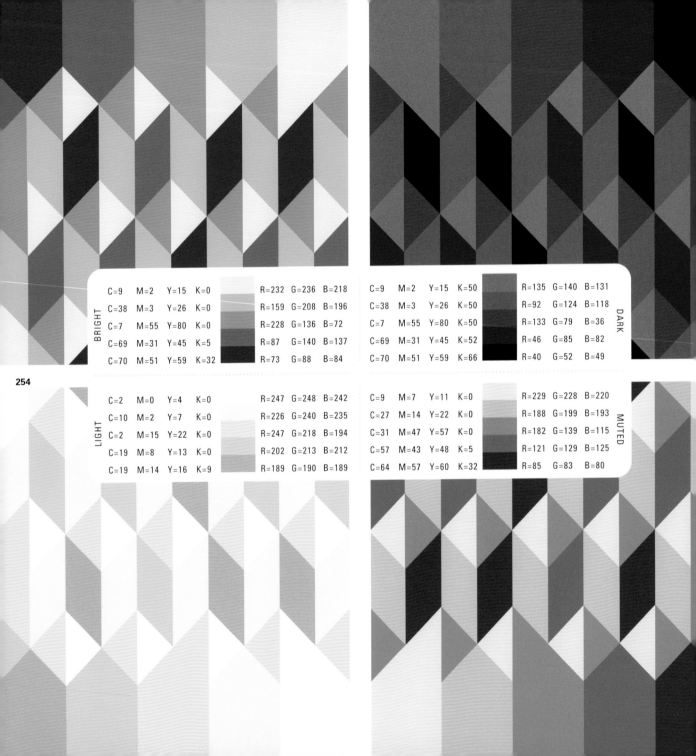

BRIGHT

				R=232	G=236	B=218
C=9	M=2	Y=15	K=0	R=232	G=236	B=218
C=38	M=3	Y=26	K=0	R=159	G=208	B=196
C=7	M=55	Y=80	K=0	R=228	G=136	B=72
C=69	M=31	Y=45	K=5	R=87	G=140	B=137
C=70	M=51	Y=59	K=32	R=73	G=88	B=84

DARK

C=9	M=2	Y=15	K=50	R=135	G=140	B=131
C=38	M=3	Y=26	K=50	R=92	G=124	B=118
C=7	M=55	Y=80	K=50	R=133	G=79	B=36
C=69	M=31	Y=45	K=52	R=46	G=85	B=82
C=70	M=51	Y=59	K=66	R=40	G=52	B=49

LIGHT

C=2	M=0	Y=4	K=0	R=247	G=248	B=242
C=10	M=2	Y=7	K=0	R=226	G=240	B=235
C=2	M=15	Y=22	K=0	R=247	G=218	B=194
C=19	M=8	Y=13	K=0	R=202	G=213	B=212
C=19	M=14	Y=16	K=9	R=189	G=190	B=189

MUTED

C=9	M=7	Y=11	K=0	R=229	G=228	B=220
C=27	M=14	Y=22	K=0	R=188	G=199	B=193
C=31	M=47	Y=57	K=0	R=182	G=139	B=115
C=57	M=43	Y=48	K=5	R=121	G=129	B=125
C=64	M=57	Y=60	K=32	R=85	G=83	B=80

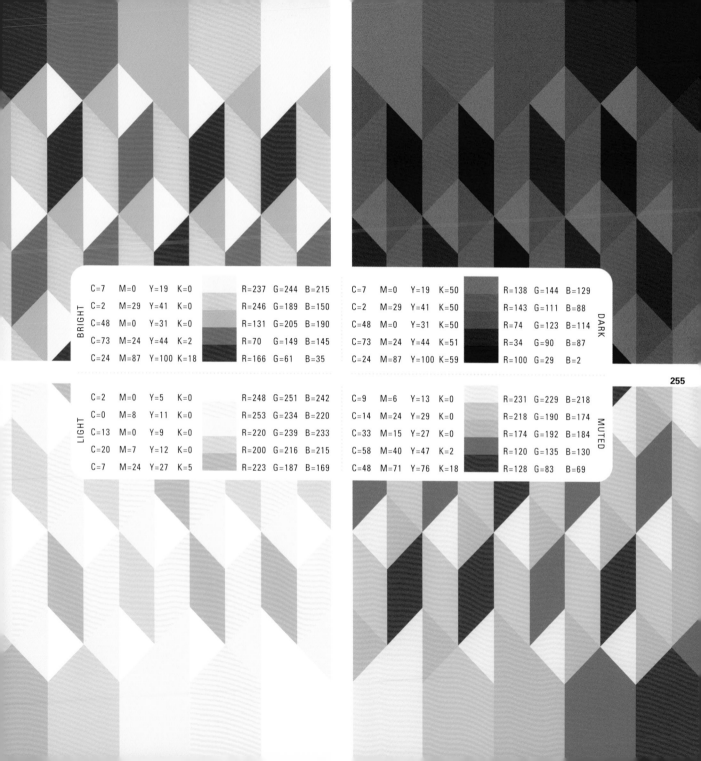

BRIGHT

C=7	M=0	Y=19	K=0		R=237	G=244	B=215
C=2	M=29	Y=41	K=0		R=246	G=189	B=150
C=48	M=0	Y=31	K=0		R=131	G=205	B=190
C=73	M=24	Y=44	K=2		R=70	G=149	B=145
C=24	M=87	Y=100	K=18		R=166	G=61	B=35

DARK

C=7	M=0	Y=19	K=50		R=138	G=144	B=129
C=2	M=29	Y=41	K=50		R=143	G=111	B=88
C=48	M=0	Y=31	K=50		R=74	G=123	B=114
C=73	M=24	Y=44	K=51		R=34	G=90	B=87
C=24	M=87	Y=100	K=59		R=100	G=29	B=2

LIGHT

C=2	M=0	Y=5	K=0		R=248	G=251	B=242
C=0	M=8	Y=11	K=0		R=253	G=234	B=220
C=13	M=0	Y=9	K=0		R=220	G=239	B=233
C=20	M=7	Y=12	K=0		R=200	G=216	B=215
C=7	M=24	Y=27	K=5		R=223	G=187	B=169

MUTED

C=9	M=6	Y=13	K=0		R=231	G=229	B=218
C=14	M=24	Y=29	K=0		R=218	G=190	B=174
C=33	M=15	Y=27	K=0		R=174	G=192	B=184
C=58	M=40	Y=47	K=2		R=120	G=135	B=130
C=48	M=71	Y=76	K=18		R=128	G=83	B=69

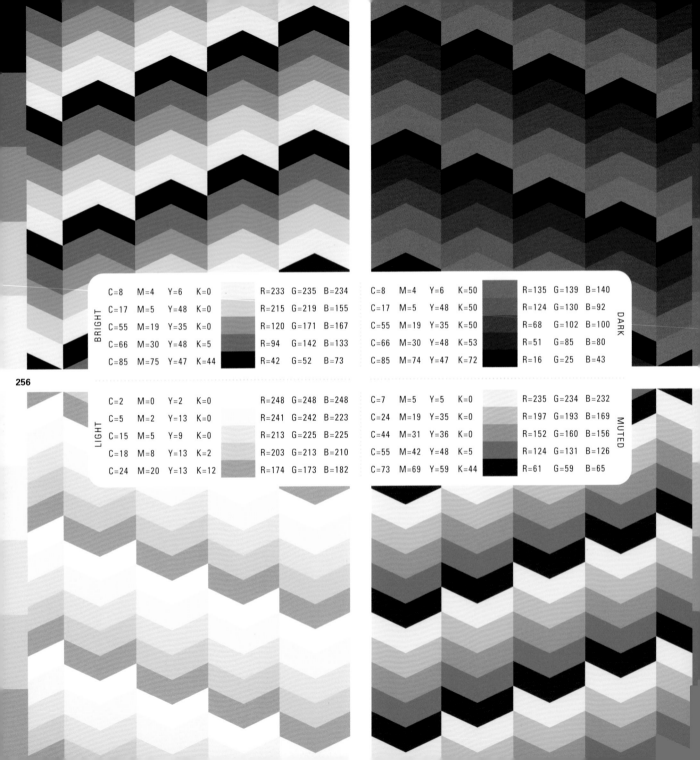

256

BRIGHT

C=8	M=4	Y=6	K=0		R=233	G=235	B=234
C=17	M=5	Y=48	K=0		R=215	G=219	B=155
C=55	M=19	Y=35	K=0		R=120	G=171	B=167
C=66	M=30	Y=48	K=5		R=94	G=142	B=133
C=85	M=75	Y=47	K=44		R=42	G=52	B=73

DARK

C=8	M=4	Y=6	K=50		R=135	G=139	B=140
C=17	M=5	Y=48	K=50		R=124	G=130	B=92
C=55	M=19	Y=35	K=50		R=68	G=102	B=100
C=66	M=30	Y=48	K=53		R=51	G=85	B=80
C=85	M=74	Y=47	K=72		R=16	G=25	B=43

LIGHT

C=2	M=0	Y=2	K=0		R=248	G=248	B=248
C=5	M=2	Y=13	K=0		R=241	G=242	B=223
C=15	M=5	Y=9	K=0		R=213	G=225	B=225
C=18	M=8	Y=13	K=2		R=203	G=213	B=210
C=24	M=20	Y=13	K=12		R=174	G=173	B=182

MUTED

C=7	M=5	Y=5	K=0		R=235	G=234	B=232
C=24	M=19	Y=35	K=0		R=197	G=193	B=169
C=44	M=31	Y=36	K=0		R=152	G=160	B=156
C=55	M=42	Y=48	K=5		R=124	G=131	B=126
C=73	M=69	Y=59	K=44		R=61	G=59	B=65

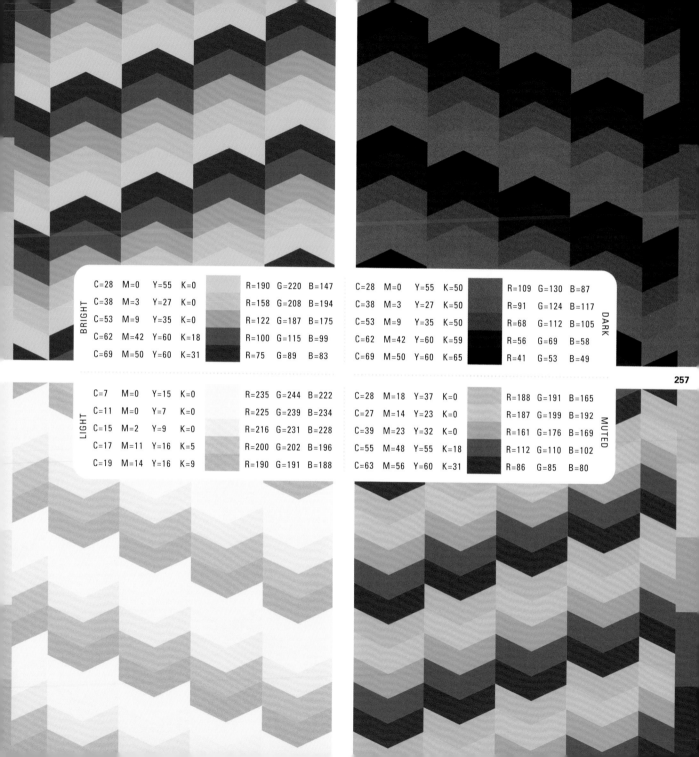

BRIGHT

C=28	M=0	Y=55	K=0		R=190	G=220	B=147
C=38	M=3	Y=27	K=0		R=158	G=208	B=194
C=53	M=9	Y=35	K=0		R=122	G=187	B=175
C=62	M=42	Y=60	K=18		R=100	G=115	B=99
C=69	M=50	Y=60	K=31		R=75	G=89	B=83

DARK

C=28	M=0	Y=55	K=50		R=109	G=130	B=87
C=38	M=3	Y=27	K=50		R=91	G=124	B=117
C=53	M=9	Y=35	K=50		R=68	G=112	B=105
C=62	M=42	Y=60	K=59		R=56	G=69	B=58
C=69	M=50	Y=60	K=65		R=41	G=53	B=49

LIGHT

C=7	M=0	Y=15	K=0		R=235	G=244	B=222
C=11	M=0	Y=7	K=0		R=225	G=239	B=234
C=15	M=2	Y=9	K=0		R=216	G=231	B=228
C=17	M=11	Y=16	K=5		R=200	G=202	B=196
C=19	M=14	Y=16	K=9		R=190	G=191	B=188

MUTED

C=28	M=18	Y=37	K=0		R=188	G=191	B=165
C=27	M=14	Y=23	K=0		R=187	G=199	B=192
C=39	M=23	Y=32	K=0		R=161	G=176	B=169
C=55	M=48	Y=55	K=18		R=112	G=110	B=102
C=63	M=56	Y=60	K=31		R=86	G=85	B=80

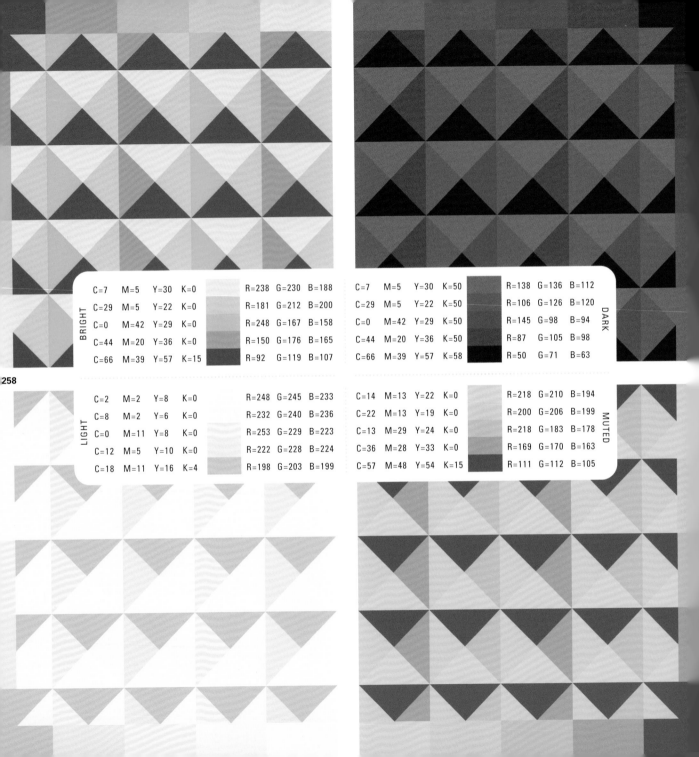

	C	M	Y	K		R	G	B
BRIGHT	C=7	M=5	Y=30	K=0		R=238	G=230	B=188
	C=29	M=5	Y=22	K=0		R=181	G=212	B=200
	C=0	M=42	Y=29	K=0		R=248	G=167	B=158
	C=44	M=20	Y=36	K=0		R=150	G=176	B=165
	C=66	M=39	Y=57	K=15		R=92	G=119	B=107

	C	M	Y	K		R	G	B	
	C=7	M=5	Y=30	K=50		R=138	G=136	B=112	**DARK**
	C=29	M=5	Y=22	K=50		R=106	G=126	B=120	
	C=0	M=42	Y=29	K=50		R=145	G=98	B=94	
	C=44	M=20	Y=36	K=50		R=87	G=105	B=98	
	C=66	M=39	Y=57	K=58		R=50	G=71	B=63	

	C	M	Y	K		R	G	B
LIGHT	C=2	M=2	Y=8	K=0		R=248	G=245	B=233
	C=8	M=2	Y=6	K=0		R=232	G=240	B=236
	C=0	M=11	Y=8	K=0		R=253	G=229	B=223
	C=12	M=5	Y=10	K=0		R=222	G=228	B=224
	C=18	M=11	Y=16	K=4		R=198	G=203	B=199

	C	M	Y	K		R	G	B	
	C=14	M=13	Y=22	K=0		R=218	G=210	B=194	**MUTED**
	C=22	M=13	Y=19	K=0		R=200	G=206	B=199	
	C=13	M=29	Y=24	K=0		R=218	G=183	B=178	
	C=36	M=28	Y=33	K=0		R=169	G=170	B=163	
	C=57	M=48	Y=54	K=15		R=111	G=112	B=105	

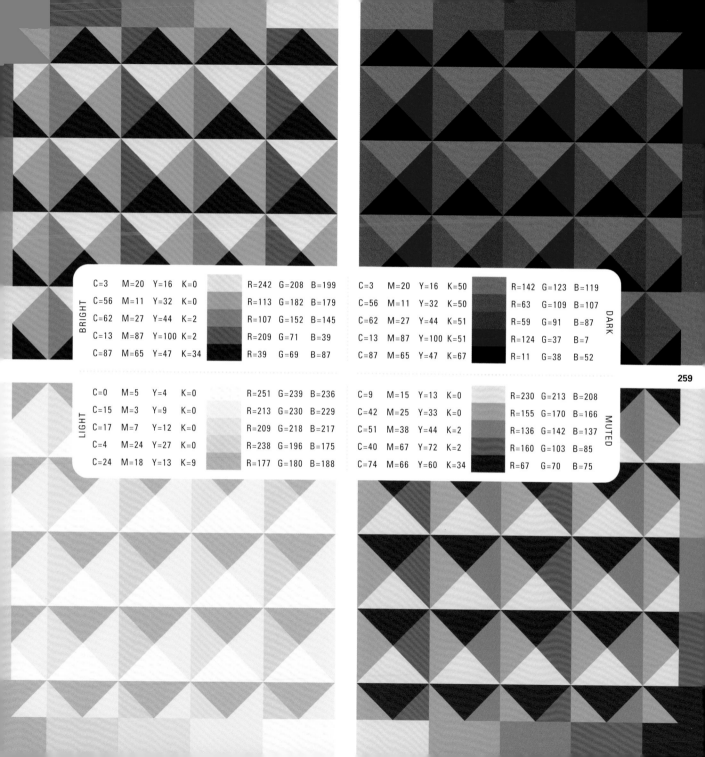

BRIGHT

C=3	M=20	Y=16	K=0		R=242	G=208	B=199
C=56	M=11	Y=32	K=0		R=113	G=182	B=179
C=62	M=27	Y=44	K=2		R=107	G=152	B=145
C=13	M=87	Y=100	K=2		R=209	G=71	B=39
C=87	M=65	Y=47	K=34		R=39	G=69	B=87

DARK

C=3	M=20	Y=16	K=50		R=142	G=123	B=119
C=56	M=11	Y=32	K=50		R=63	G=109	B=107
C=62	M=27	Y=44	K=51		R=59	G=91	B=87
C=13	M=87	Y=100	K=51		R=124	G=37	B=7
C=87	M=65	Y=47	K=67		R=11	G=38	B=52

LIGHT

C=0	M=5	Y=4	K=0		R=251	G=239	B=236
C=15	M=3	Y=9	K=0		R=213	G=230	B=229
C=17	M=7	Y=12	K=0		R=209	G=218	B=217
C=4	M=24	Y=27	K=0		R=238	G=196	B=175
C=24	M=18	Y=13	K=9		R=177	G=180	B=188

MUTED

C=9	M=15	Y=13	K=0		R=230	G=213	B=208
C=42	M=25	Y=33	K=0		R=155	G=170	B=166
C=51	M=38	Y=44	K=2		R=136	G=142	B=137
C=40	M=67	Y=72	K=2		R=160	G=103	B=85
C=74	M=66	Y=60	K=34		R=67	G=70	B=75

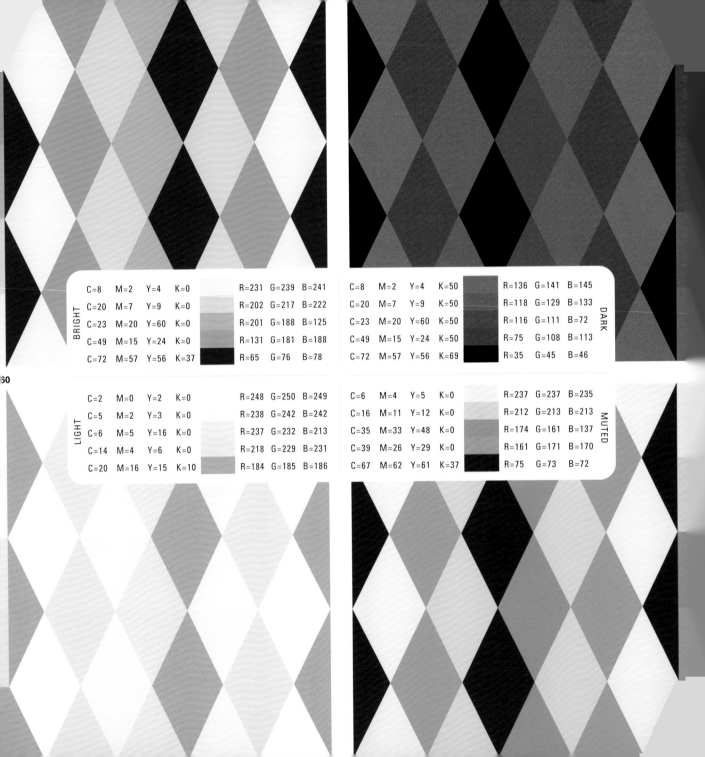

BRIGHT

C=8	M=2	Y=4	K=0
C=20	M=7	Y=9	K=0
C=23	M=20	Y=60	K=0
C=49	M=15	Y=24	K=0
C=72	M=57	Y=56	K=37

R=231	G=239	B=241
R=202	G=217	B=222
R=201	G=188	B=125
R=131	G=181	B=188
R=65	G=76	B=78

DARK

C=8	M=2	Y=4	K=50
C=20	M=7	Y=9	K=50
C=23	M=20	Y=60	K=50
C=49	M=15	Y=24	K=50
C=72	M=57	Y=56	K=69

R=136	G=141	B=145
R=118	G=129	B=133
R=116	G=111	B=72
R=75	G=108	B=113
R=35	G=45	B=46

LIGHT

C=2	M=0	Y=2	K=0
C=5	M=2	Y=3	K=0
C=6	M=5	Y=16	K=0
C=14	M=4	Y=6	K=0
C=20	M=16	Y=15	K=10

R=248	G=250	B=249
R=238	G=242	B=242
R=237	G=232	B=213
R=218	G=229	B=231
R=184	G=185	B=186

MUTED

C=6	M=4	Y=5	K=0
C=16	M=11	Y=12	K=0
C=35	M=33	Y=48	K=0
C=39	M=26	Y=29	K=0
C=67	M=62	Y=61	K=37

R=237	G=237	B=235
R=212	G=213	B=213
R=174	G=161	B=137
R=161	G=171	B=170
R=75	G=73	B=72

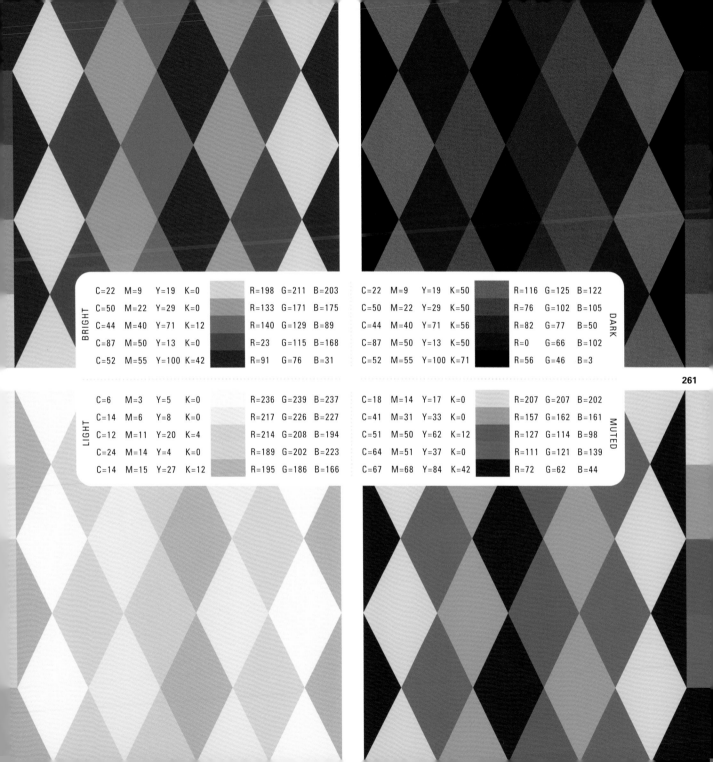

BRIGHT

C=22	M=9	Y=19	K=0
C=50	M=22	Y=29	K=0
C=44	M=40	Y=71	K=12
C=87	M=50	Y=13	K=0
C=52	M=55	Y=100	K=42

R=198	G=211	B=203
R=133	G=171	B=175
R=140	G=129	B=89
R=23	G=115	B=168
R=91	G=76	B=31

DARK

C=22	M=9	Y=19	K=50
C=50	M=22	Y=29	K=50
C=44	M=40	Y=71	K=56
C=87	M=50	Y=13	K=50
C=52	M=55	Y=100	K=71

R=116	G=125	B=122
R=76	G=102	B=105
R=82	G=77	B=50
R=0	G=66	B=102
R=56	G=46	B=3

LIGHT

C=6	M=3	Y=5	K=0
C=14	M=6	Y=8	K=0
C=12	M=11	Y=20	K=4
C=24	M=14	Y=4	K=0
C=14	M=15	Y=27	K=12

R=236	G=239	B=237
R=217	G=226	B=227
R=214	G=208	B=194
R=189	G=202	B=223
R=195	G=186	B=166

MUTED

C=18	M=14	Y=17	K=0
C=41	M=31	Y=33	K=0
C=51	M=50	Y=62	K=12
C=64	M=51	Y=37	K=0
C=67	M=68	Y=84	K=42

R=207	G=207	B=202
R=157	G=162	B=161
R=127	G=114	B=98
R=111	G=121	B=139
R=72	G=62	B=44

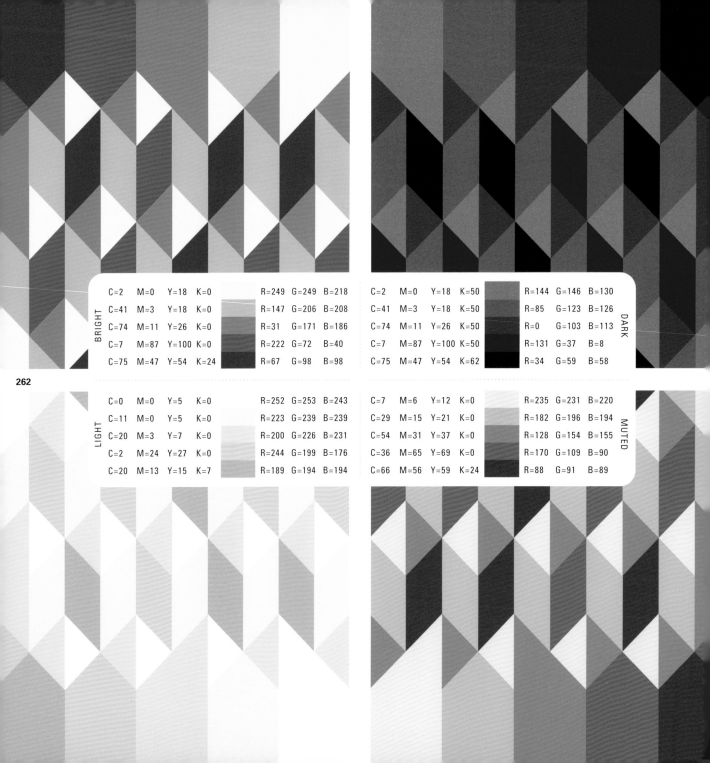

BRIGHT

C=2	M=0	Y=18	K=0		R=249	G=249	B=218
C=41	M=3	Y=18	K=0		R=147	G=206	B=208
C=74	M=11	Y=26	K=0		R=31	G=171	B=186
C=7	M=87	Y=100	K=0		R=222	G=72	B=40
C=75	M=47	Y=54	K=24		R=67	G=98	B=98

DARK

C=2	M=0	Y=18	K=50		R=144	G=146	B=130
C=41	M=3	Y=18	K=50		R=85	G=123	B=126
C=74	M=11	Y=26	K=50		R=0	G=103	B=113
C=7	M=87	Y=100	K=50		R=131	G=37	B=8
C=75	M=47	Y=54	K=62		R=34	G=59	B=58

LIGHT

C=0	M=0	Y=5	K=0		R=252	G=253	B=243
C=11	M=0	Y=5	K=0		R=223	G=239	B=239
C=20	M=3	Y=7	K=0		R=200	G=226	B=231
C=2	M=24	Y=27	K=0		R=244	G=199	B=176
C=20	M=13	Y=15	K=7		R=189	G=194	B=194

MUTED

C=7	M=6	Y=12	K=0		R=235	G=231	B=220
C=29	M=15	Y=21	K=0		R=182	G=196	B=194
C=54	M=31	Y=37	K=0		R=128	G=154	B=155
C=36	M=65	Y=69	K=0		R=170	G=109	B=90
C=66	M=56	Y=59	K=24		R=88	G=91	B=89

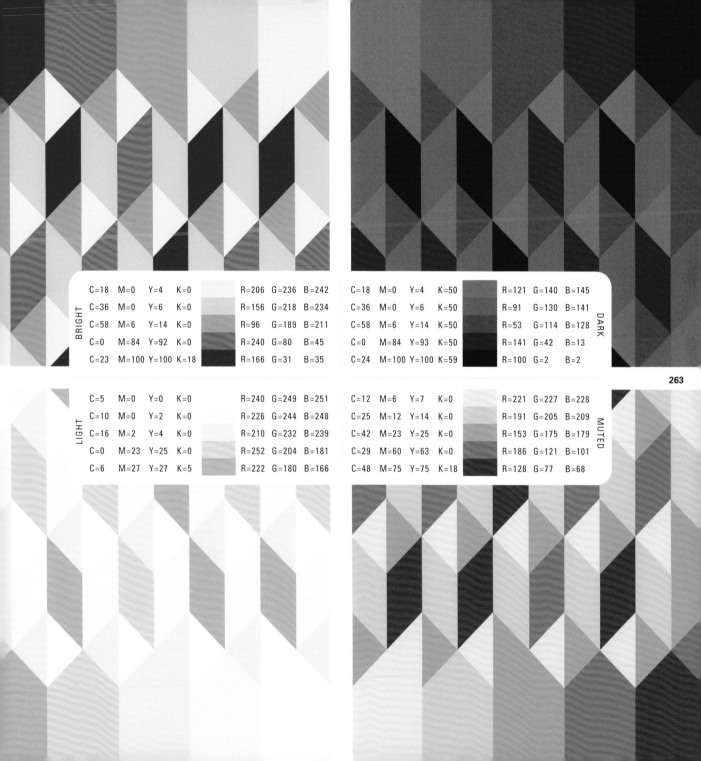

BRIGHT

C=18	M=0	Y=4	K=0		R=206	G=236	B=242
C=36	M=0	Y=6	K=0		R=156	G=218	B=234
C=58	M=6	Y=14	K=0		R=96	G=189	B=211
C=0	M=84	Y=92	K=0		R=240	G=80	B=45
C=23	M=100	Y=100	K=18		R=166	G=31	B=35

DARK

C=18	M=0	Y=4	K=50		R=121	G=140	B=145
C=36	M=0	Y=6	K=50		R=91	G=130	B=141
C=58	M=6	Y=14	K=50		R=53	G=114	B=128
C=0	M=84	Y=93	K=50		R=141	G=42	B=13
C=24	M=100	Y=100	K=59		R=100	G=2	B=2

LIGHT

C=5	M=0	Y=0	K=0		R=240	G=249	B=251
C=10	M=0	Y=2	K=0		R=226	G=244	B=248
C=16	M=2	Y=4	K=0		R=210	G=232	B=239
C=0	M=23	Y=25	K=0		R=252	G=204	B=181
C=6	M=27	Y=27	K=5		R=222	G=180	B=166

MUTED

C=12	M=6	Y=7	K=0		R=221	G=227	B=228
C=25	M=12	Y=14	K=0		R=191	G=205	B=209
C=42	M=23	Y=25	K=0		R=153	G=175	B=179
C=29	M=60	Y=63	K=0		R=186	G=121	B=101
C=48	M=75	Y=75	K=18		R=128	G=77	B=68

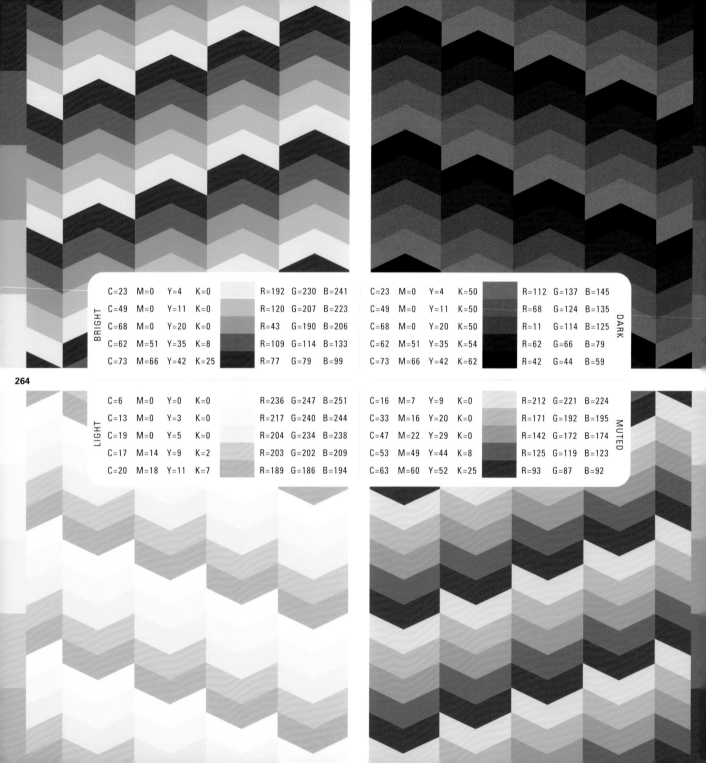

BRIGHT

C=23	M=0	Y=4	K=0		R=192	G=230	B=241
C=49	M=0	Y=11	K=0		R=120	G=207	B=223
C=68	M=0	Y=20	K=0		R=43	G=190	B=206
C=62	M=51	Y=35	K=8		R=109	G=114	B=133
C=73	M=66	Y=42	K=25		R=77	G=79	B=99

DARK

C=23	M=0	Y=4	K=50		R=112	G=137	B=145
C=49	M=0	Y=11	K=50		R=68	G=124	B=135
C=68	M=0	Y=20	K=50		R=11	G=114	B=125
C=62	M=51	Y=35	K=54		R=62	G=66	B=79
C=73	M=66	Y=42	K=62		R=42	G=44	B=59

LIGHT

C=6	M=0	Y=0	K=0		R=236	G=247	B=251
C=13	M=0	Y=3	K=0		R=217	G=240	B=244
C=19	M=0	Y=5	K=0		R=204	G=234	B=238
C=17	M=14	Y=9	K=2		R=203	G=202	B=209
C=20	M=18	Y=11	K=7		R=189	G=186	B=194

MUTED

C=16	M=7	Y=9	K=0		R=212	G=221	B=224
C=33	M=16	Y=20	K=0		R=171	G=192	B=195
C=47	M=22	Y=29	K=0		R=142	G=172	B=174
C=53	M=49	Y=44	K=8		R=125	G=119	B=123
C=63	M=60	Y=52	K=25		R=93	G=87	B=92

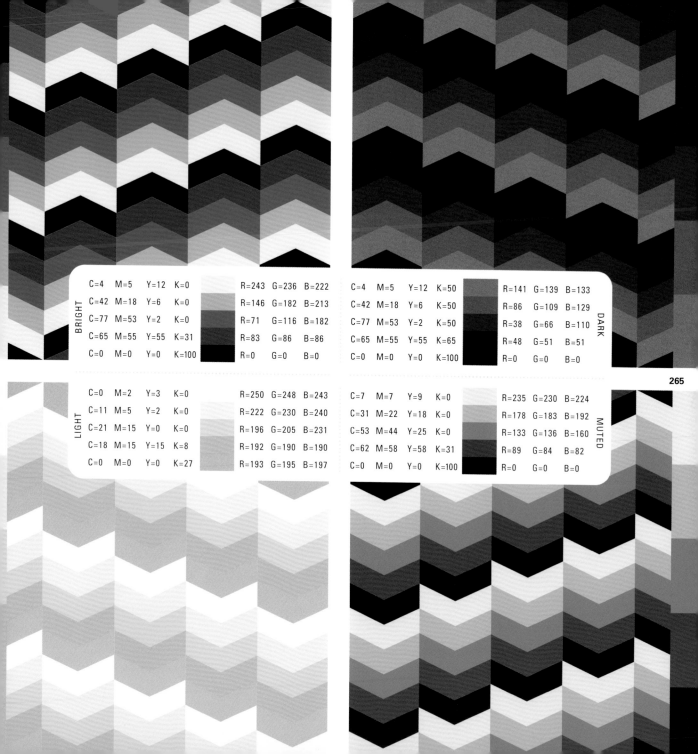

BRIGHT

C=4	M=5	Y=12	K=0		R=243	G=236	B=222
C=42	M=18	Y=6	K=0		R=146	G=182	B=213
C=77	M=53	Y=2	K=0		R=71	G=116	B=182
C=65	M=55	Y=55	K=31		R=83	G=86	B=86
C=0	M=0	Y=0	K=100		R=0	G=0	B=0

DARK

C=4	M=5	Y=12	K=50		R=141	G=139	B=133
C=42	M=18	Y=6	K=50		R=86	G=109	B=129
C=77	M=53	Y=2	K=50		R=38	G=66	B=110
C=65	M=55	Y=55	K=65		R=48	G=51	B=51
C=0	M=0	Y=0	K=100		R=0	G=0	B=0

LIGHT

C=0	M=2	Y=3	K=0		R=250	G=248	B=243
C=11	M=5	Y=2	K=0		R=222	G=230	B=240
C=21	M=15	Y=0	K=0		R=196	G=205	B=231
C=18	M=15	Y=15	K=8		R=192	G=190	B=190
C=0	M=0	Y=0	K=27		R=193	G=195	B=197

MUTED

C=7	M=7	Y=9	K=0		R=235	G=230	B=224
C=31	M=22	Y=18	K=0		R=178	G=183	B=192
C=53	M=44	Y=25	K=0		R=133	G=136	B=160
C=62	M=58	Y=58	K=31		R=89	G=84	B=82
C=0	M=0	Y=0	K=100		R=0	G=0	B=0

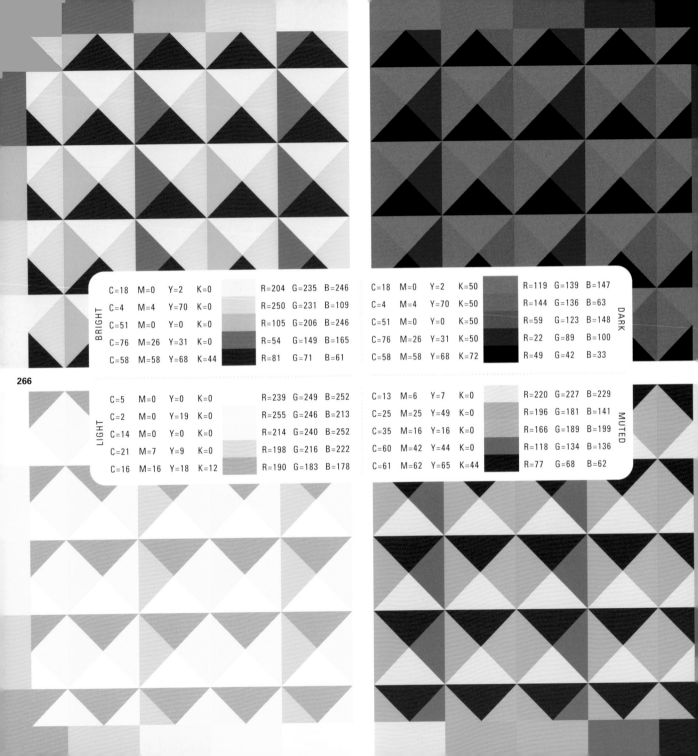

BRIGHT

C=18	M=0	Y=2	K=0		R=204	G=235	B=246
C=4	M=4	Y=70	K=0		R=250	G=231	B=109
C=51	M=0	Y=0	K=0		R=105	G=206	B=246
C=76	M=26	Y=31	K=0		R=54	G=149	B=165
C=58	M=58	Y=68	K=44		R=81	G=71	B=61

DARK

C=18	M=0	Y=2	K=50		R=119	G=139	B=147
C=4	M=4	Y=70	K=50		R=144	G=136	B=63
C=51	M=0	Y=0	K=50		R=59	G=123	B=148
C=76	M=26	Y=31	K=50		R=22	G=89	B=100
C=58	M=58	Y=68	K=72		R=49	G=42	B=33

LIGHT

C=5	M=0	Y=0	K=0		R=239	G=249	B=252
C=2	M=0	Y=19	K=0		R=255	G=246	B=213
C=14	M=0	Y=0	K=0		R=214	G=240	B=252
C=21	M=7	Y=9	K=0		R=198	G=216	B=222
C=16	M=16	Y=18	K=12		R=190	G=183	B=178

MUTED

C=13	M=6	Y=7	K=0		R=220	G=227	B=229
C=25	M=25	Y=49	K=0		R=196	G=181	B=141
C=35	M=16	Y=16	K=0		R=166	G=189	B=199
C=60	M=42	Y=44	K=0		R=118	G=134	B=136
C=61	M=62	Y=65	K=44		R=77	G=68	B=62

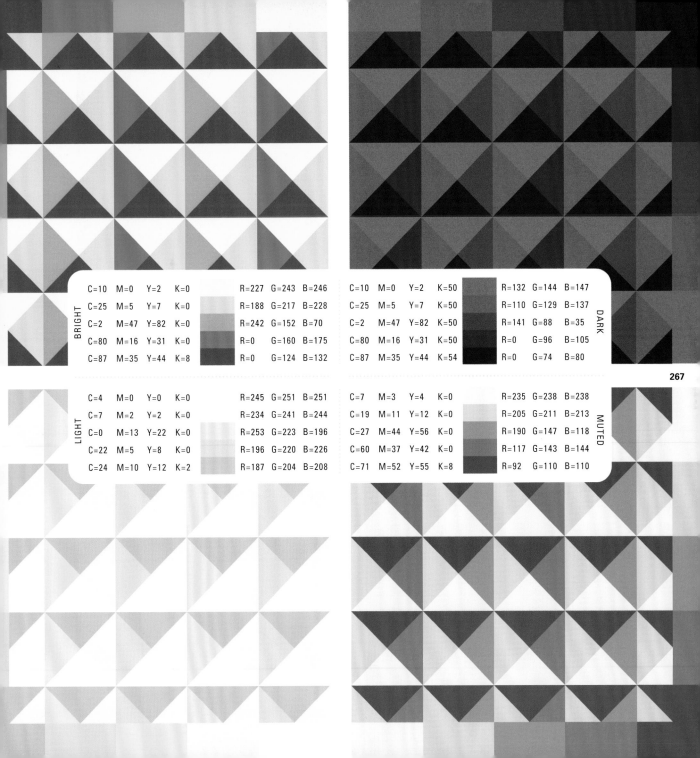

	C=10	M=0	Y=2	K=0		R=227	G=243	B=246
BRIGHT	C=25	M=5	Y=7	K=0		R=188	G=217	B=228
	C=2	M=47	Y=82	K=0		R=242	G=152	B=70
	C=80	M=16	Y=31	K=0		R=0	G=160	B=175
	C=87	M=35	Y=44	K=8		R=0	G=124	B=132

	C=10	M=0	Y=2	K=50		R=132	G=144	B=147
	C=25	M=5	Y=7	K=50		R=110	G=129	B=137
	C=2	M=47	Y=82	K=50		R=141	G=88	B=35
	C=80	M=16	Y=31	K=50		R=0	G=96	B=105
DARK	C=87	M=35	Y=44	K=54		R=0	G=74	B=80

	C=4	M=0	Y=0	K=0		R=245	G=251	B=251
LIGHT	C=7	M=2	Y=2	K=0		R=234	G=241	B=244
	C=0	M=13	Y=22	K=0		R=253	G=223	B=196
	C=22	M=5	Y=8	K=0		R=196	G=220	B=226
	C=24	M=10	Y=12	K=2		R=187	G=204	B=208

	C=7	M=3	Y=4	K=0		R=235	G=238	B=238
	C=19	M=11	Y=12	K=0		R=205	G=211	B=213
	C=27	M=44	Y=56	K=0		R=190	G=147	B=118
	C=60	M=37	Y=42	K=0		R=117	G=143	B=144
MUTED	C=71	M=52	Y=55	K=8		R=92	G=110	B=110

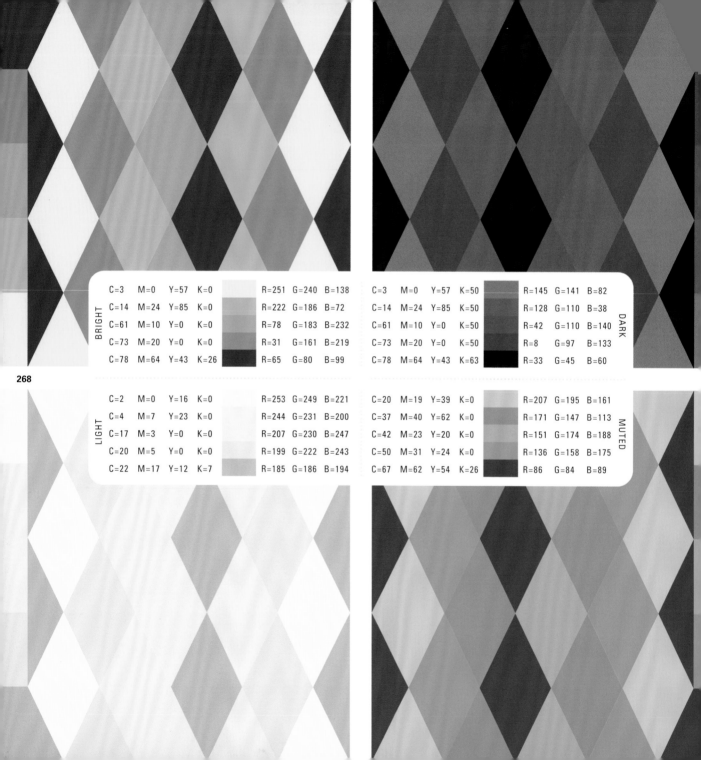

BRIGHT

C=3	M=0	Y=57	K=0		R=251	G=240	B=138
C=14	M=24	Y=85	K=0		R=222	G=186	B=72
C=61	M=10	Y=0	K=0		R=78	G=183	B=232
C=73	M=20	Y=0	K=0		R=31	G=161	B=219
C=78	M=64	Y=43	K=26		R=65	G=80	B=99

DARK

C=3	M=0	Y=57	K=50		R=145	G=141	B=82
C=14	M=24	Y=85	K=50		R=128	G=110	B=38
C=61	M=10	Y=0	K=50		R=42	G=110	B=140
C=73	M=20	Y=0	K=50		R=8	G=97	B=133
C=78	M=64	Y=43	K=63		R=33	G=45	B=60

LIGHT

C=2	M=0	Y=16	K=0		R=253	G=249	B=221
C=4	M=7	Y=23	K=0		R=244	G=231	B=200
C=17	M=3	Y=0	K=0		R=207	G=230	B=247
C=20	M=5	Y=0	K=0		R=199	G=222	B=243
C=22	M=17	Y=12	K=7		R=185	G=186	B=194

MUTED

C=20	M=19	Y=39	K=0		R=207	G=195	B=161
C=37	M=40	Y=62	K=0		R=171	G=147	B=113
C=42	M=23	Y=20	K=0		R=151	G=174	B=188
C=50	M=31	Y=24	K=0		R=136	G=158	B=175
C=67	M=62	Y=54	K=26		R=86	G=84	B=89

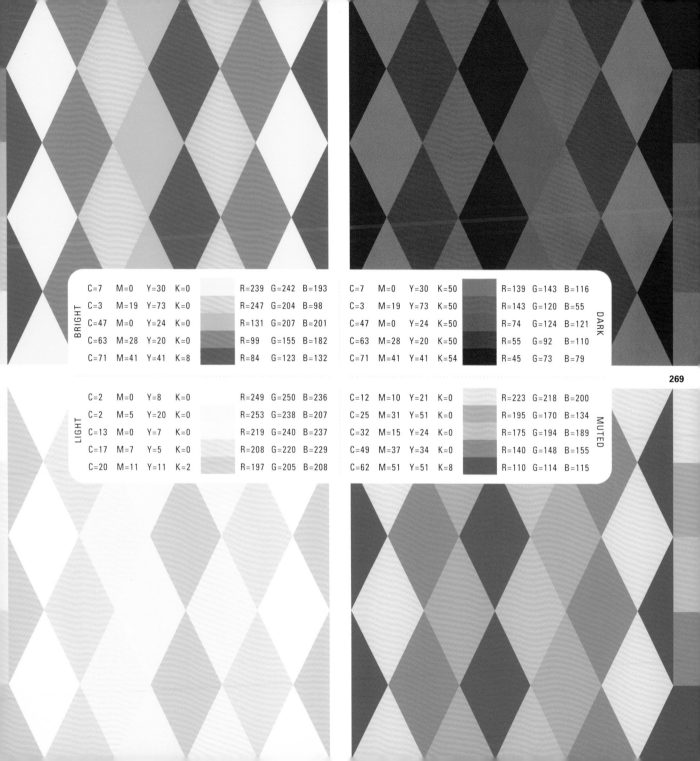

BRIGHT

C=7	M=0	Y=30	K=0		R=239	G=242	B=193
C=3	M=19	Y=73	K=0		R=247	G=204	B=98
C=47	M=0	Y=24	K=0		R=131	G=207	B=201
C=63	M=28	Y=20	K=0		R=99	G=155	B=182
C=71	M=41	Y=41	K=8		R=84	G=123	B=132

DARK

C=7	M=0	Y=30	K=50		R=139	G=143	B=116
C=3	M=19	Y=73	K=50		R=143	G=120	B=55
C=47	M=0	Y=24	K=50		R=74	G=124	B=121
C=63	M=28	Y=20	K=50		R=55	G=92	B=110
C=71	M=41	Y=41	K=54		R=45	G=73	B=79

LIGHT

C=2	M=0	Y=8	K=0		R=249	G=250	B=236
C=2	M=5	Y=20	K=0		R=253	G=238	B=207
C=13	M=0	Y=7	K=0		R=219	G=240	B=237
C=17	M=7	Y=5	K=0		R=208	G=220	B=229
C=20	M=11	Y=11	K=2		R=197	G=205	B=208

MUTED

C=12	M=10	Y=21	K=0		R=223	G=218	B=200
C=25	M=31	Y=51	K=0		R=195	G=170	B=134
C=32	M=15	Y=24	K=0		R=175	G=194	B=189
C=49	M=37	Y=34	K=0		R=140	G=148	B=155
C=62	M=51	Y=51	K=8		R=110	G=114	B=115

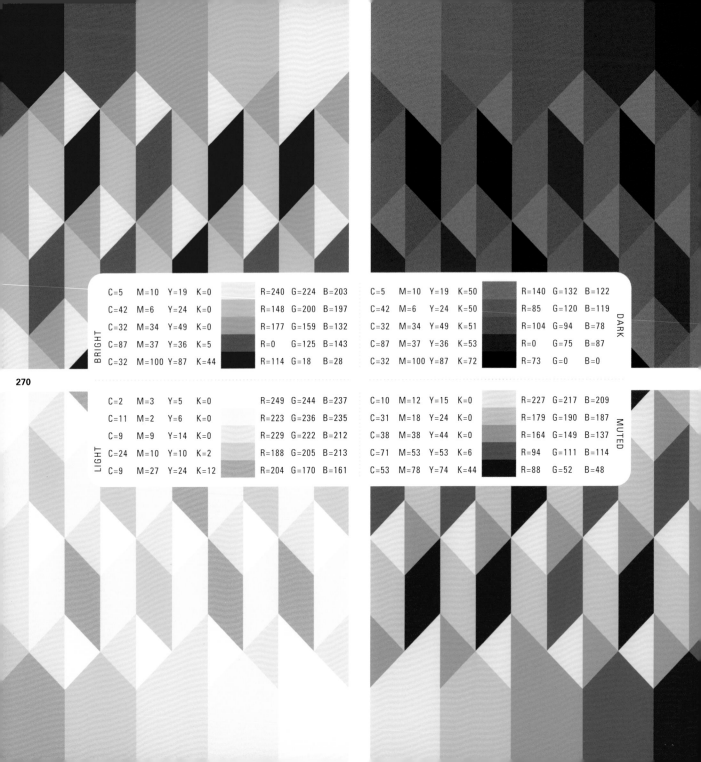

BRIGHT

C=5	M=10	Y=19	K=0		R=240	G=224	B=203
C=42	M=6	Y=24	K=0		R=148	G=200	B=197
C=32	M=34	Y=49	K=0		R=177	G=159	B=132
C=87	M=37	Y=36	K=5		R=0	G=125	B=143
C=32	M=100	Y=87	K=44		R=114	G=18	B=28

DARK

C=5	M=10	Y=19	K=50		R=140	G=132	B=122
C=42	M=6	Y=24	K=50		R=85	G=120	B=119
C=32	M=34	Y=49	K=51		R=104	G=94	B=78
C=87	M=37	Y=36	K=53		R=0	G=75	B=87
C=32	M=100	Y=87	K=72		R=73	G=0	B=0

LIGHT

C=2	M=3	Y=5	K=0		R=249	G=244	B=237
C=11	M=2	Y=6	K=0		R=223	G=236	B=235
C=9	M=9	Y=14	K=0		R=229	G=222	B=212
C=24	M=10	Y=10	K=2		R=188	G=205	B=213
C=9	M=27	Y=24	K=12		R=204	G=170	B=161

MUTED

C=10	M=12	Y=15	K=0		R=227	G=217	B=209
C=31	M=18	Y=24	K=0		R=179	G=190	B=187
C=38	M=38	Y=44	K=0		R=164	G=149	B=137
C=71	M=53	Y=53	K=6		R=94	G=111	B=114
C=53	M=78	Y=74	K=44		R=88	G=52	B=48

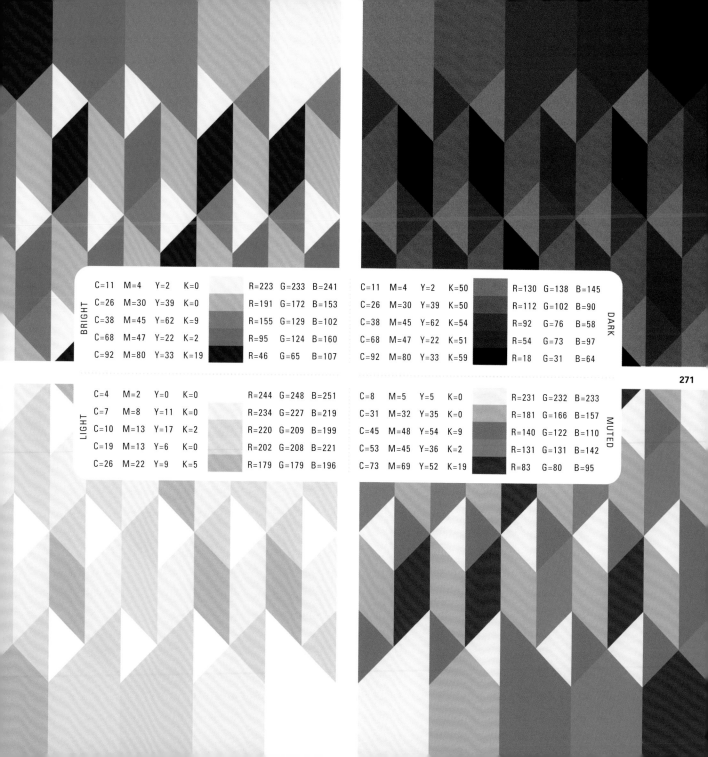

BRIGHT

C=11	M=4	Y=2	K=0		R=223	G=233	B=241
C=26	M=30	Y=39	K=0		R=191	G=172	B=153
C=38	M=45	Y=62	K=9		R=155	G=129	B=102
C=68	M=47	Y=22	K=2		R=95	G=124	B=160
C=92	M=80	Y=33	K=19		R=46	G=65	B=107

DARK

C=11	M=4	Y=2	K=50		R=130	G=138	B=145
C=26	M=30	Y=39	K=50		R=112	G=102	B=90
C=38	M=45	Y=62	K=54		R=92	G=76	B=58
C=68	M=47	Y=22	K=51		R=54	G=73	B=97
C=92	M=80	Y=33	K=59		R=18	G=31	B=64

LIGHT

C=4	M=2	Y=0	K=0		R=244	G=248	B=251
C=7	M=8	Y=11	K=0		R=234	G=227	B=219
C=10	M=13	Y=17	K=2		R=220	G=209	B=199
C=19	M=13	Y=6	K=0		R=202	G=208	B=221
C=26	M=22	Y=9	K=5		R=179	G=179	B=196

MUTED

C=8	M=5	Y=5	K=0		R=231	G=232	B=233
C=31	M=32	Y=35	K=0		R=181	G=166	B=157
C=45	M=48	Y=54	K=9		R=140	G=122	B=110
C=53	M=45	Y=36	K=2		R=131	G=131	B=142
C=73	M=69	Y=52	K=19		R=83	G=80	B=95

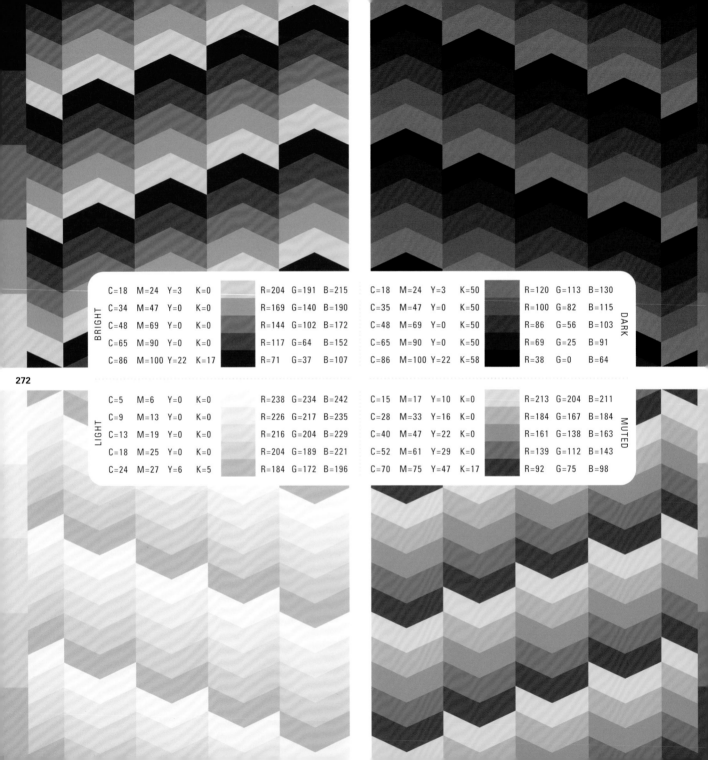

BRIGHT

C=18	M=24	Y=3	K=0		R=204	G=191	B=215
C=34	M=47	Y=0	K=0		R=169	G=140	B=190
C=48	M=69	Y=0	K=0		R=144	G=102	B=172
C=65	M=90	Y=0	K=0		R=117	G=64	B=152
C=86	M=100	Y=22	K=17		R=71	G=37	B=107

DARK

C=18	M=24	Y=3	K=50		R=120	G=113	B=130
C=35	M=47	Y=0	K=50		R=100	G=82	B=115
C=48	M=69	Y=0	K=50		R=86	G=56	B=103
C=65	M=90	Y=0	K=50		R=69	G=25	B=91
C=86	M=100	Y=22	K=58		R=38	G=0	B=64

LIGHT

C=5	M=6	Y=0	K=0		R=238	G=234	B=242
C=9	M=13	Y=0	K=0		R=226	G=217	B=235
C=13	M=19	Y=0	K=0		R=216	G=204	B=229
C=18	M=25	Y=0	K=0		R=204	G=189	B=221
C=24	M=27	Y=6	K=5		R=184	G=172	B=196

MUTED

C=15	M=17	Y=10	K=0		R=213	G=204	B=211
C=28	M=33	Y=16	K=0		R=184	G=167	B=184
C=40	M=47	Y=22	K=0		R=161	G=138	B=163
C=52	M=61	Y=29	K=0		R=139	G=112	B=143
C=70	M=75	Y=47	K=17		R=92	G=75	B=98

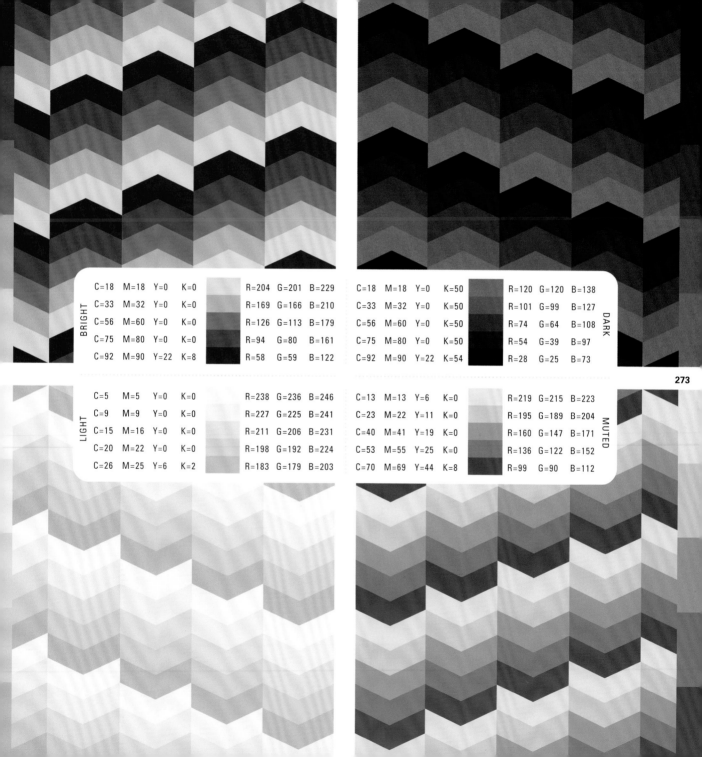

	C=18	M=18	Y=0	K=0		R=204	G=201	B=229	
BRIGHT	C=33	M=32	Y=0	K=0		R=169	G=166	B=210	
	C=56	M=60	Y=0	K=0		R=126	G=113	B=179	
	C=75	M=80	Y=0	K=0		R=94	G=80	B=161	
	C=92	M=90	Y=22	K=8		R=58	G=59	B=122	

	C=18	M=18	Y=0	K=50		R=120	G=120	B=138	
	C=33	M=32	Y=0	K=50		R=101	G=99	B=127	
	C=56	M=60	Y=0	K=50		R=74	G=64	B=108	**DARK**
	C=75	M=80	Y=0	K=50		R=54	G=39	B=97	
	C=92	M=90	Y=22	K=54		R=28	G=25	B=73	

	C=5	M=5	Y=0	K=0		R=238	G=236	B=246	
LIGHT	C=9	M=9	Y=0	K=0		R=227	G=225	B=241	
	C=15	M=16	Y=0	K=0		R=211	G=206	B=231	
	C=20	M=22	Y=0	K=0		R=198	G=192	B=224	
	C=26	M=25	Y=6	K=2		R=183	G=179	B=203	

	C=13	M=13	Y=6	K=0		R=219	G=215	B=223	
	C=23	M=22	Y=11	K=0		R=195	G=189	B=204	
	C=40	M=41	Y=19	K=0		R=160	G=147	B=171	**MUTED**
	C=53	M=55	Y=25	K=0		R=136	G=122	B=152	
	C=70	M=69	Y=44	K=8		R=99	G=90	B=112	

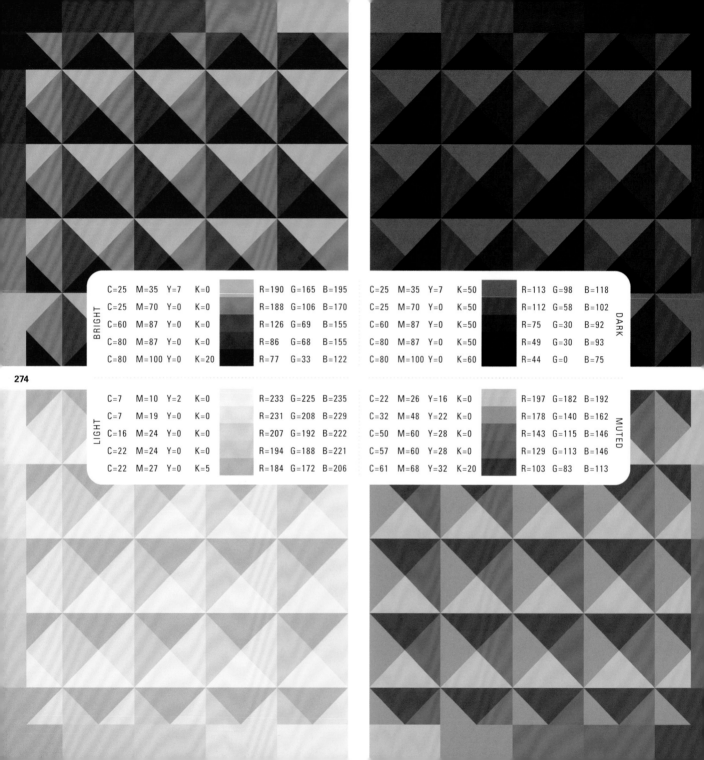

BRIGHT								
C=25	M=35	Y=7	K=0		R=190	G=165	B=195	
C=25	M=70	Y=0	K=0		R=188	G=106	B=170	
C=60	M=87	Y=0	K=0		R=126	G=69	B=155	
C=80	M=87	Y=0	K=0		R=86	G=68	B=155	
C=80	M=100	Y=0	K=20		R=77	G=33	B=122	

DARK								
C=25	M=35	Y=7	K=50		R=113	G=98	B=118	
C=25	M=70	Y=0	K=50		R=112	G=58	B=102	
C=60	M=87	Y=0	K=50		R=75	G=30	B=92	
C=80	M=87	Y=0	K=50		R=49	G=30	B=93	
C=80	M=100	Y=0	K=60		R=44	G=0	B=75	

LIGHT								
C=7	M=10	Y=2	K=0		R=233	G=225	B=235	
C=7	M=19	Y=0	K=0		R=231	G=208	B=229	
C=16	M=24	Y=0	K=0		R=207	G=192	B=222	
C=22	M=24	Y=0	K=0		R=194	G=188	B=221	
C=22	M=27	Y=0	K=5		R=184	G=172	B=206	

MUTED								
C=22	M=26	Y=16	K=0		R=197	G=182	B=192	
C=32	M=48	Y=22	K=0		R=178	G=140	B=162	
C=50	M=60	Y=28	K=0		R=143	G=115	B=146	
C=57	M=60	Y=28	K=0		R=129	G=113	B=146	
C=61	M=68	Y=32	K=20		R=103	G=83	B=113	

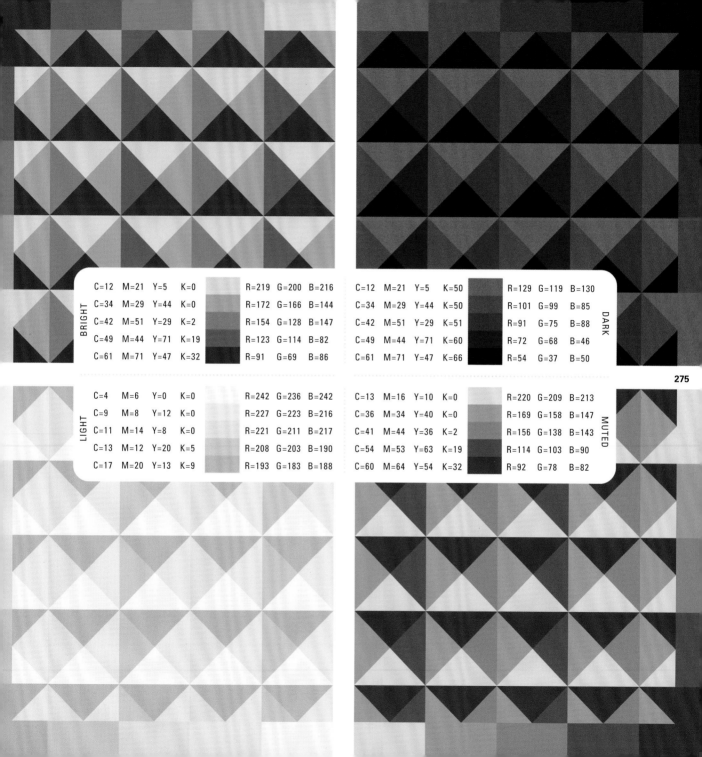

BRIGHT	C=12	M=21	Y=5	K=0		R=219	G=200	B=216
	C=34	M=29	Y=44	K=0		R=172	G=166	B=144
	C=42	M=51	Y=29	K=2		R=154	G=128	B=147
	C=49	M=44	Y=71	K=19		R=123	G=114	B=82
	C=61	M=71	Y=47	K=32		R=91	G=69	B=86

C=12	M=21	Y=5	K=50		R=129	G=119	B=130	DARK
C=34	M=29	Y=44	K=50		R=101	G=99	B=85	
C=42	M=51	Y=29	K=51		R=91	G=75	B=88	
C=49	M=44	Y=71	K=60		R=72	G=68	B=46	
C=61	M=71	Y=47	K=66		R=54	G=37	B=50	

LIGHT	C=4	M=6	Y=0	K=0		R=242	G=236	B=242
	C=9	M=8	Y=12	K=0		R=227	G=223	B=216
	C=11	M=14	Y=8	K=0		R=221	G=211	B=217
	C=13	M=12	Y=20	K=5		R=208	G=203	B=190
	C=17	M=20	Y=13	K=9		R=193	G=183	B=188

C=13	M=16	Y=10	K=0		R=220	G=209	B=213	MUTED
C=36	M=34	Y=40	K=0		R=169	G=158	B=147	
C=41	M=44	Y=36	K=2		R=156	G=138	B=143	
C=54	M=53	Y=63	K=19		R=114	G=103	B=90	
C=60	M=64	Y=54	K=32		R=92	G=78	B=82	

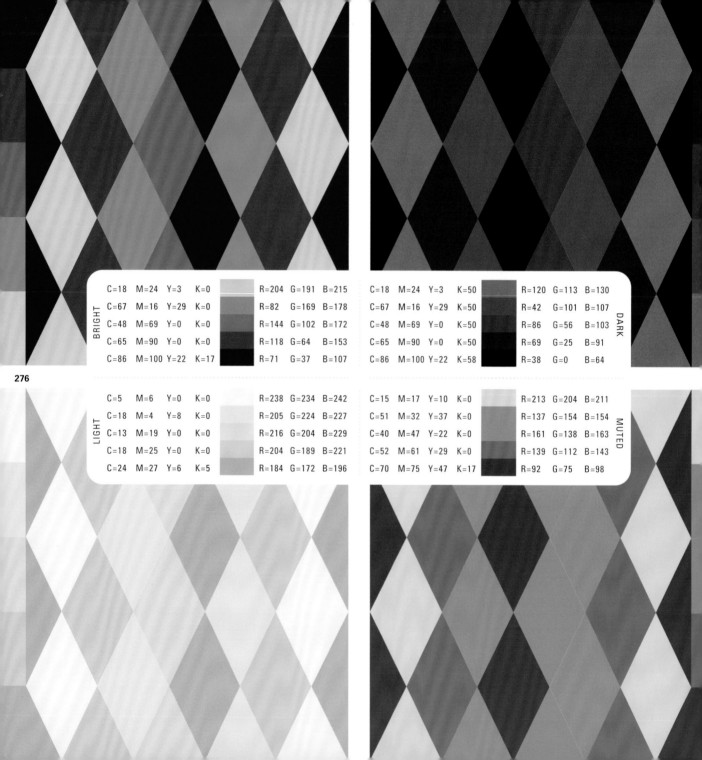

BRIGHT

C=18	M=24	Y=3	K=0		R=204	G=191	B=215
C=67	M=16	Y=29	K=0		R=82	G=169	B=178
C=48	M=69	Y=0	K=0		R=144	G=102	B=172
C=65	M=90	Y=0	K=0		R=118	G=64	B=153
C=86	M=100	Y=22	K=17		R=71	G=37	B=107

DARK

C=18	M=24	Y=3	K=50		R=120	G=113	B=130
C=67	M=16	Y=29	K=50		R=42	G=101	B=107
C=48	M=69	Y=0	K=50		R=86	G=56	B=103
C=65	M=90	Y=0	K=50		R=69	G=25	B=91
C=86	M=100	Y=22	K=58		R=38	G=0	B=64

LIGHT

C=5	M=6	Y=0	K=0		R=238	G=234	B=242
C=18	M=4	Y=8	K=0		R=205	G=224	B=227
C=13	M=19	Y=0	K=0		R=216	G=204	B=229
C=18	M=25	Y=0	K=0		R=204	G=189	B=221
C=24	M=27	Y=6	K=5		R=184	G=172	B=196

MUTED

C=15	M=17	Y=10	K=0		R=213	G=204	B=211
C=51	M=32	Y=37	K=0		R=137	G=154	B=154
C=40	M=47	Y=22	K=0		R=161	G=138	B=163
C=52	M=61	Y=29	K=0		R=139	G=112	B=143
C=70	M=75	Y=47	K=17		R=92	G=75	B=98

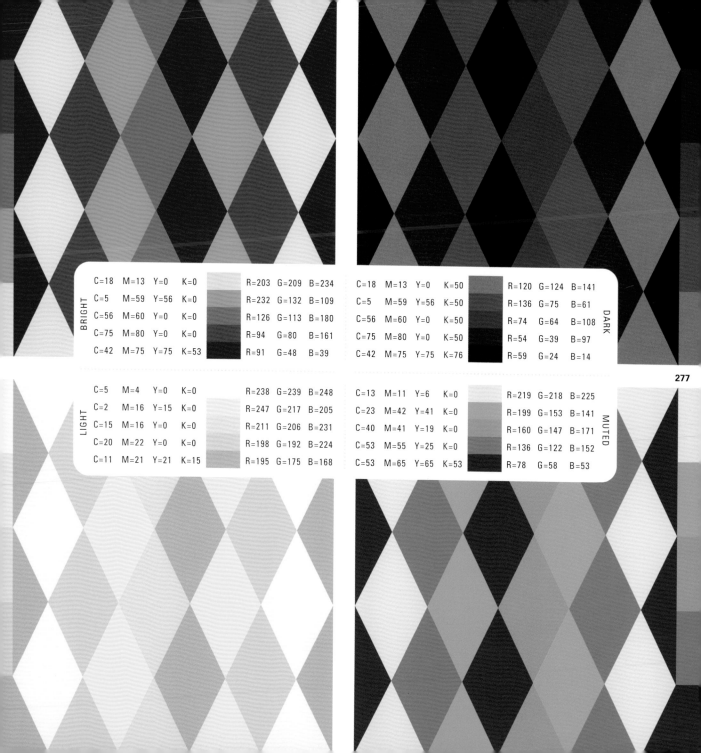

BRIGHT

C=18	M=13	Y=0	K=0		R=203	G=209	B=234
C=5	M=59	Y=56	K=0		R=232	G=132	B=109
C=56	M=60	Y=0	K=0		R=126	G=113	B=180
C=75	M=80	Y=0	K=0		R=94	G=80	B=161
C=42	M=75	Y=75	K=53		R=91	G=48	B=39

DARK

C=18	M=13	Y=0	K=50		R=120	G=124	B=141
C=5	M=59	Y=56	K=50		R=136	G=75	B=61
C=56	M=60	Y=0	K=50		R=74	G=64	B=108
C=75	M=80	Y=0	K=50		R=54	G=39	B=97
C=42	M=75	Y=75	K=76		R=59	G=24	B=14

LIGHT

C=5	M=4	Y=0	K=0		R=238	G=239	B=248
C=2	M=16	Y=15	K=0		R=247	G=217	B=205
C=15	M=16	Y=0	K=0		R=211	G=206	B=231
C=20	M=22	Y=0	K=0		R=198	G=192	B=224
C=11	M=21	Y=21	K=15		R=195	G=175	B=168

MUTED

C=13	M=11	Y=6	K=0		R=219	G=218	B=225
C=23	M=42	Y=41	K=0		R=199	G=153	B=141
C=40	M=41	Y=19	K=0		R=160	G=147	B=171
C=53	M=55	Y=25	K=0		R=136	G=122	B=152
C=53	M=65	Y=65	K=53		R=78	G=58	B=53

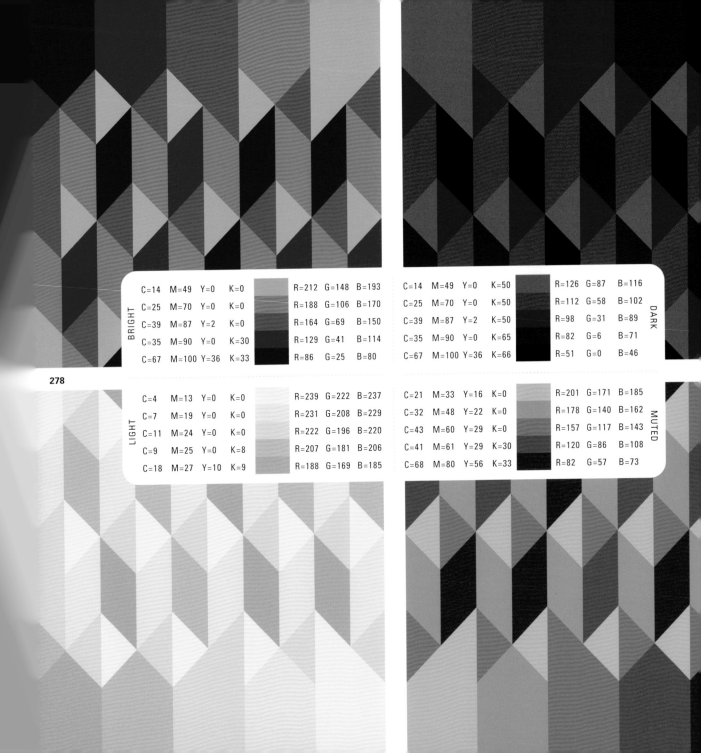

BRIGHT

C=14	M=49	Y=0	K=0		R=212	G=148	B=193
C=25	M=70	Y=0	K=0		R=188	G=106	B=170
C=39	M=87	Y=2	K=0		R=164	G=69	B=150
C=35	M=90	Y=0	K=30		R=129	G=41	B=114
C=67	M=100	Y=36	K=33		R=86	G=25	B=80

DARK

C=14	M=49	Y=0	K=50		R=126	G=87	B=116
C=25	M=70	Y=0	K=50		R=112	G=58	B=102
C=39	M=87	Y=2	K=50		R=98	G=31	B=89
C=35	M=90	Y=0	K=65		R=82	G=6	B=71
C=67	M=100	Y=36	K=66		R=51	G=0	B=46

LIGHT

C=4	M=13	Y=0	K=0		R=239	G=222	B=237
C=7	M=19	Y=0	K=0		R=231	G=208	B=229
C=11	M=24	Y=0	K=0		R=222	G=196	B=220
C=9	M=25	Y=0	K=8		R=207	G=181	B=206
C=18	M=27	Y=10	K=9		R=188	G=169	B=185

MUTED

C=21	M=33	Y=16	K=0		R=201	G=171	B=185
C=32	M=48	Y=22	K=0		R=178	G=140	B=162
C=43	M=60	Y=29	K=0		R=157	G=117	B=143
C=41	M=61	Y=29	K=30		R=120	G=86	B=108
C=68	M=80	Y=56	K=33		R=82	G=57	B=73

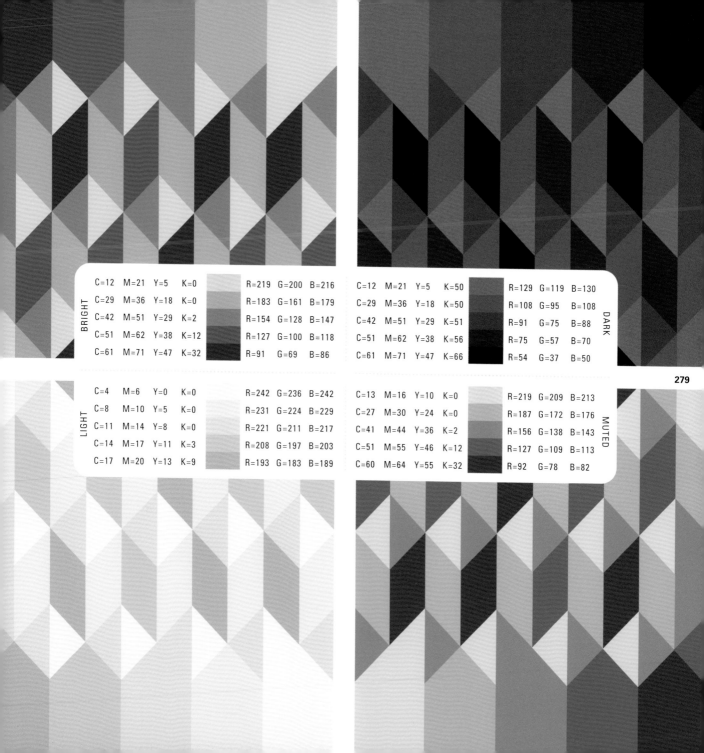

BRIGHT	C=12 M=21 Y=5 K=0		R=219 G=200 B=216
	C=29 M=36 Y=18 K=0		R=183 G=161 B=179
	C=42 M=51 Y=29 K=2		R=154 G=128 B=147
	C=51 M=62 Y=38 K=12		R=127 G=100 B=118
	C=61 M=71 Y=47 K=32		R=91 G=69 B=86

C=12 M=21 Y=5 K=50		R=129 G=119 B=130	**DARK**
C=29 M=36 Y=18 K=50		R=108 G=95 B=108	
C=42 M=51 Y=29 K=51		R=91 G=75 B=88	
C=51 M=62 Y=38 K=56		R=75 G=57 B=70	
C=61 M=71 Y=47 K=66		R=54 G=37 B=50	

279

LIGHT	C=4 M=6 Y=0 K=0		R=242 G=236 B=242
	C=8 M=10 Y=5 K=0		R=231 G=224 B=229
	C=11 M=14 Y=8 K=0		R=221 G=211 B=217
	C=14 M=17 Y=11 K=3		R=208 G=197 B=203
	C=17 M=20 Y=13 K=9		R=193 G=183 B=189

C=13 M=16 Y=10 K=0		R=219 G=209 B=213	**MUTED**
C=27 M=30 Y=24 K=0		R=187 G=172 B=176	
C=41 M=44 Y=36 K=2		R=156 G=138 B=143	
C=51 M=55 Y=46 K=12		R=127 G=109 B=113	
C=60 M=64 Y=55 K=32		R=92 G=78 B=82	

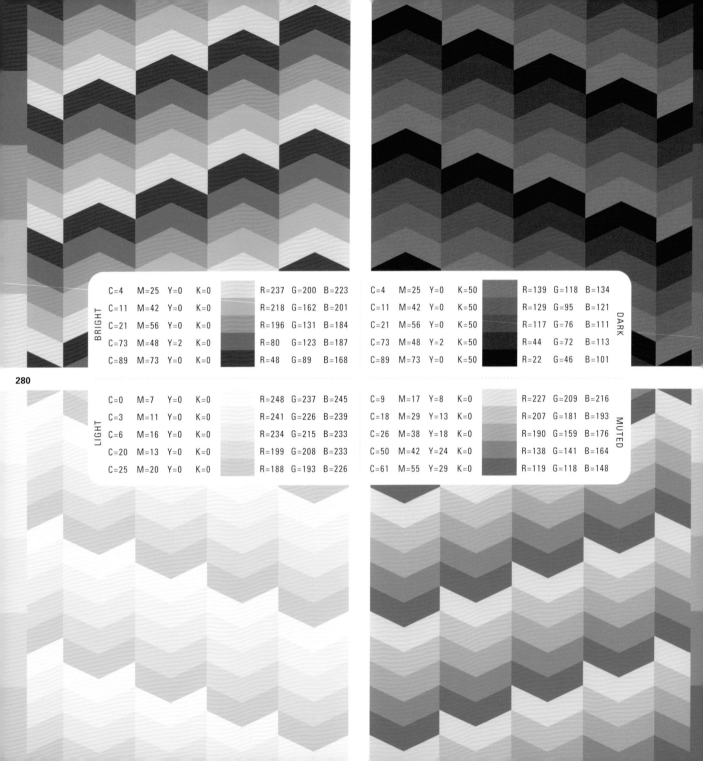

	C=4	M=25	Y=0	K=0		R=237	G=200	B=223
BRIGHT	C=11	M=42	Y=0	K=0		R=218	G=162	B=201
	C=21	M=56	Y=0	K=0		R=196	G=131	B=184
	C=73	M=48	Y=2	K=0		R=80	G=123	B=187
	C=89	M=73	Y=0	K=0		R=48	G=89	B=168

	C=4	M=25	Y=0	K=50		R=139	G=118	B=134
	C=11	M=42	Y=0	K=50		R=129	G=95	B=121
	C=21	M=56	Y=0	K=50		R=117	G=76	B=111
	C=73	M=48	Y=2	K=50		R=44	G=72	B=113
DARK	C=89	M=73	Y=0	K=50		R=22	G=46	B=101

	C=0	M=7	Y=0	K=0		R=248	G=237	B=245
LIGHT	C=3	M=11	Y=0	K=0		R=241	G=226	B=239
	C=6	M=16	Y=0	K=0		R=234	G=215	B=233
	C=20	M=13	Y=0	K=0		R=199	G=208	B=233
	C=25	M=20	Y=0	K=0		R=188	G=193	B=226

	C=9	M=17	Y=8	K=0		R=227	G=209	B=216
	C=18	M=29	Y=13	K=0		R=207	G=181	B=193
	C=26	M=38	Y=18	K=0		R=190	G=159	B=176
	C=50	M=42	Y=24	K=0		R=138	G=141	B=164
MUTED	C=61	M=55	Y=29	K=0		R=119	G=118	B=148

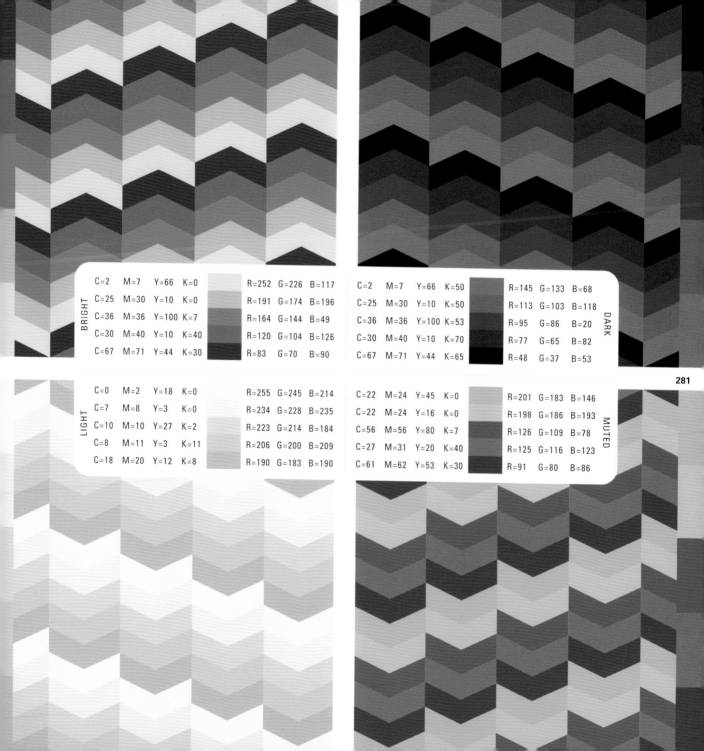

BRIGHT

C=2	M=7	Y=66	K=0	R=252	G=226	B=117
C=25	M=30	Y=10	K=0	R=191	G=174	B=196
C=36	M=36	Y=100	K=7	R=164	G=144	B=49
C=30	M=40	Y=10	K=40	R=120	G=104	B=126
C=67	M=71	Y=44	K=30	R=83	G=70	B=90

DARK

C=2	M=7	Y=66	K=50	R=145	G=133	B=68
C=25	M=30	Y=10	K=50	R=113	G=103	B=118
C=36	M=36	Y=100	K=53	R=95	G=86	B=20
C=30	M=40	Y=10	K=70	R=77	G=65	B=82
C=67	M=71	Y=44	K=65	R=48	G=37	B=53

LIGHT

C=0	M=2	Y=18	K=0	R=255	G=245	B=214
C=7	M=8	Y=3	K=0	R=234	G=228	B=235
C=10	M=10	Y=27	K=2	R=223	G=214	B=184
C=8	M=11	Y=3	K=11	R=206	G=200	B=209
C=18	M=20	Y=12	K=8	R=190	G=183	B=190

MUTED

C=22	M=24	Y=45	K=0	R=201	G=183	B=146
C=22	M=24	Y=16	K=0	R=198	G=186	B=193
C=56	M=56	Y=80	K=7	R=126	G=109	B=78
C=27	M=31	Y=20	K=40	R=125	G=116	B=123
C=61	M=62	Y=53	K=30	R=91	G=80	B=86

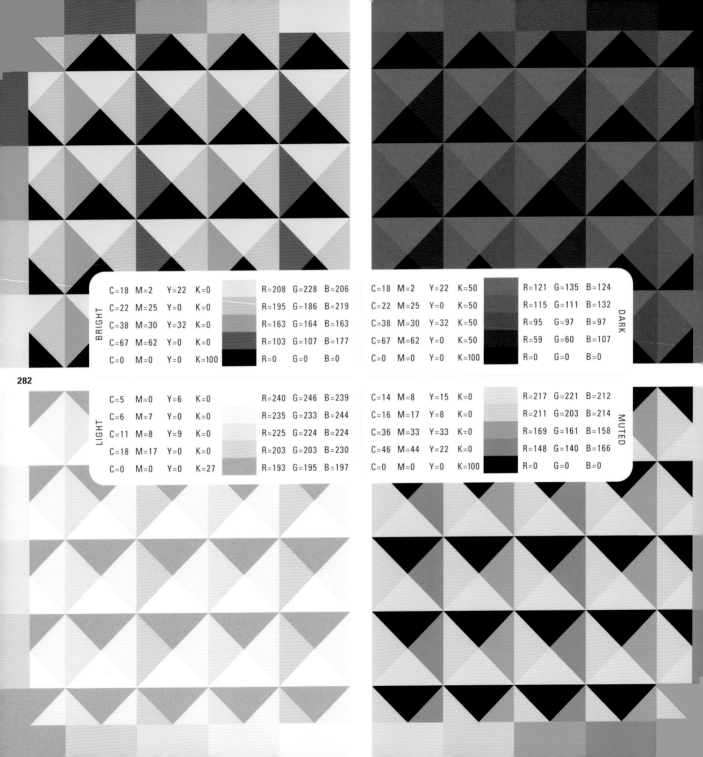

BRIGHT

C=18	M=2	Y=22	K=0		R=208	G=228	B=206
C=22	M=25	Y=0	K=0		R=195	G=186	B=219
C=38	M=30	Y=32	K=0		R=163	G=164	B=163
C=67	M=62	Y=0	K=0		R=103	G=107	B=177
C=0	M=0	Y=0	K=100		R=0	G=0	B=0

DARK

C=18	M=2	Y=22	K=50		R=121	G=135	B=124
C=22	M=25	Y=0	K=50		R=115	G=111	B=132
C=38	M=30	Y=32	K=50		R=95	G=97	B=97
C=67	M=62	Y=0	K=50		R=59	G=60	B=107
C=0	M=0	Y=0	K=100		R=0	G=0	B=0

LIGHT

C=5	M=0	Y=6	K=0		R=240	G=246	B=239
C=6	M=7	Y=0	K=0		R=235	G=233	B=244
C=11	M=8	Y=9	K=0		R=225	G=224	B=224
C=18	M=17	Y=0	K=0		R=203	G=203	B=230
C=0	M=0	Y=0	K=27		R=193	G=195	B=197

MUTED

C=14	M=8	Y=15	K=0		R=217	G=221	B=212
C=16	M=17	Y=8	K=0		R=211	G=203	B=214
C=36	M=33	Y=33	K=0		R=169	G=161	B=158
C=46	M=44	Y=22	K=0		R=148	G=140	B=166
C=0	M=0	Y=0	K=100		R=0	G=0	B=0

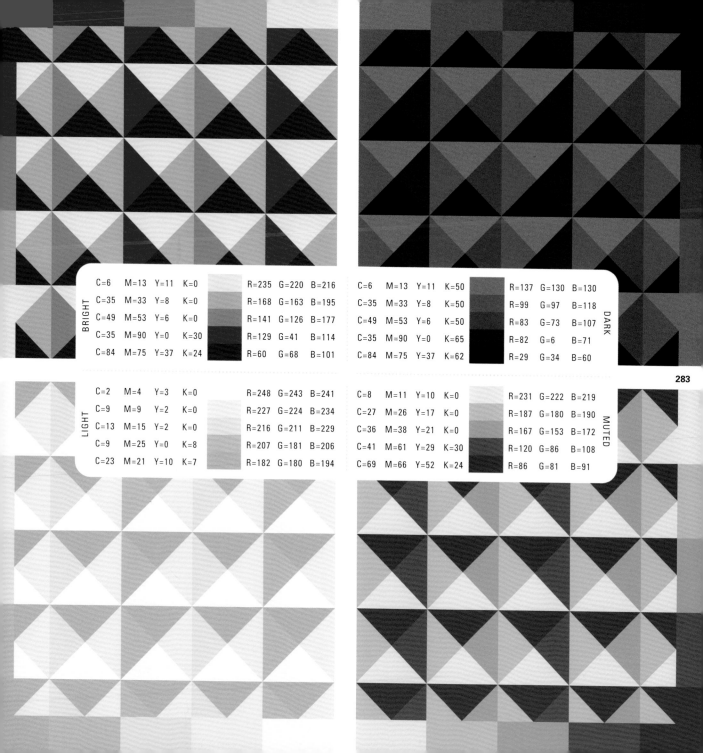

BRIGHT	C=6	M=13	Y=11	K=0		R=235	G=220	B=216
	C=35	M=33	Y=8	K=0		R=168	G=163	B=195
	C=49	M=53	Y=6	K=0		R=141	G=126	B=177
	C=35	M=90	Y=0	K=30		R=129	G=41	B=114
	C=84	M=75	Y=37	K=24		R=60	G=68	B=101

C=6	M=13	Y=11	K=50		R=137	G=130	B=130	**DARK**
C=35	M=33	Y=8	K=50		R=99	G=97	B=118	
C=49	M=53	Y=6	K=50		R=83	G=73	B=107	
C=35	M=90	Y=0	K=65		R=82	G=6	B=71	
C=84	M=75	Y=37	K=62		R=29	G=34	B=60	

LIGHT	C=2	M=4	Y=3	K=0		R=248	G=243	B=241
	C=9	M=9	Y=2	K=0		R=227	G=224	B=234
	C=13	M=15	Y=2	K=0		R=216	G=211	B=229
	C=9	M=25	Y=0	K=8		R=207	G=181	B=206
	C=23	M=21	Y=10	K=7		R=182	G=180	B=194

C=8	M=11	Y=10	K=0		R=231	G=222	B=219	**MUTED**
C=27	M=26	Y=17	K=0		R=187	G=180	B=190	
C=36	M=38	Y=21	K=0		R=167	G=153	B=172	
C=41	M=61	Y=29	K=30		R=120	G=86	B=108	
C=69	M=66	Y=52	K=24		R=86	G=81	B=91	

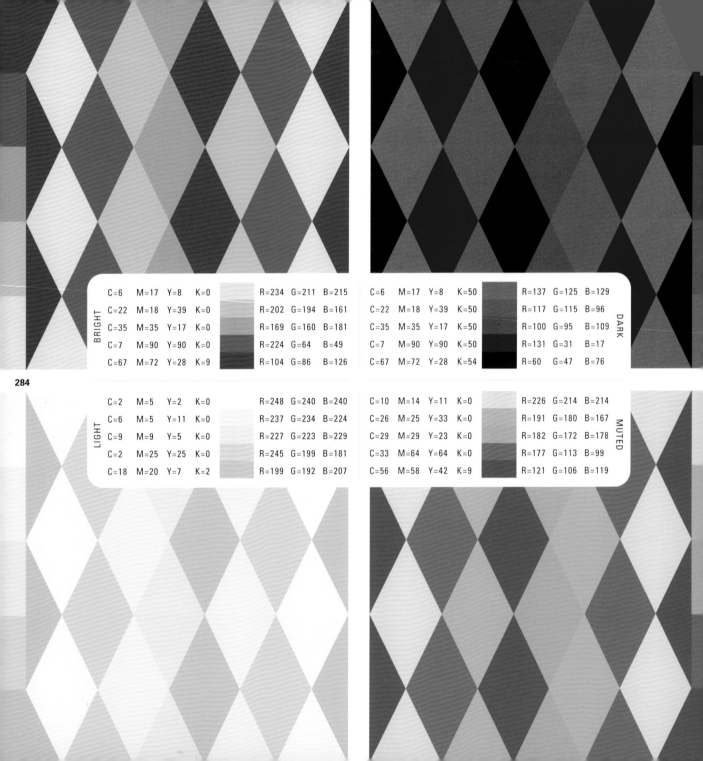

284

BRIGHT

C=6	M=17	Y=8	K=0		R=234	G=211	B=215
C=22	M=18	Y=39	K=0		R=202	G=194	B=161
C=35	M=35	Y=17	K=0		R=169	G=160	B=181
C=7	M=90	Y=90	K=0		R=224	G=64	B=49
C=67	M=72	Y=28	K=9		R=104	G=86	B=126

DARK

C=6	M=17	Y=8	K=50		R=137	G=125	B=129
C=22	M=18	Y=39	K=50		R=117	G=115	B=96
C=35	M=35	Y=17	K=50		R=100	G=95	B=109
C=7	M=90	Y=90	K=50		R=131	G=31	B=17
C=67	M=72	Y=28	K=54		R=60	G=47	B=76

LIGHT

C=2	M=5	Y=2	K=0		R=248	G=240	B=240
C=6	M=5	Y=11	K=0		R=237	G=234	B=224
C=9	M=9	Y=5	K=0		R=227	G=223	B=229
C=2	M=25	Y=25	K=0		R=245	G=199	B=181
C=18	M=20	Y=7	K=2		R=199	G=192	B=207

MUTED

C=10	M=14	Y=11	K=0		R=226	G=214	B=214
C=26	M=25	Y=33	K=0		R=191	G=180	B=167
C=29	M=29	Y=23	K=0		R=182	G=172	B=178
C=33	M=64	Y=64	K=0		R=177	G=113	B=99
C=56	M=58	Y=42	K=9		R=121	G=106	B=119

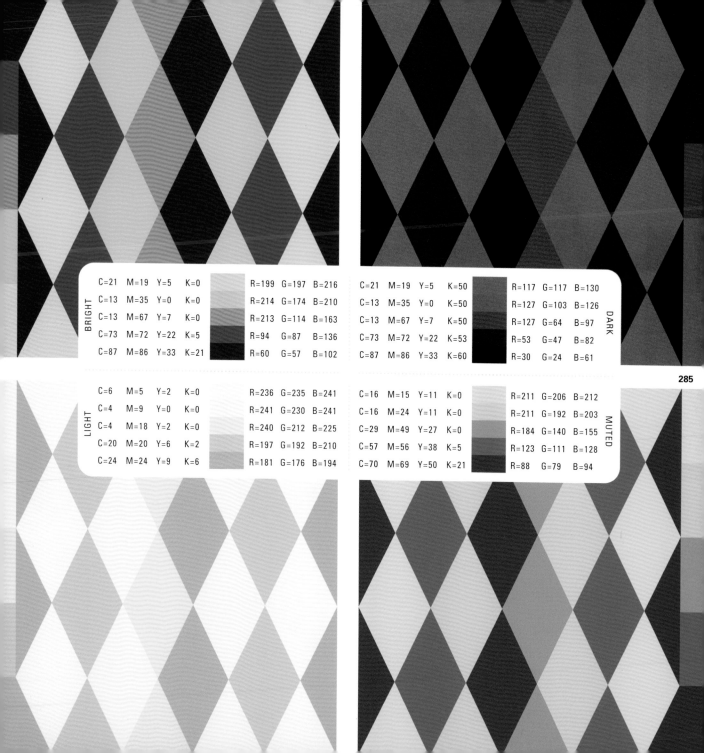

BRIGHT

C=21	M=19	Y=5	K=0		R=199	G=197	B=216
C=13	M=35	Y=0	K=0		R=214	G=174	B=210
C=13	M=67	Y=7	K=0		R=213	G=114	B=163
C=73	M=72	Y=22	K=5		R=94	G=87	B=136
C=87	M=86	Y=33	K=21		R=60	G=57	B=102

DARK

C=21	M=19	Y=5	K=50		R=117	G=117	B=130
C=13	M=35	Y=0	K=50		R=127	G=103	B=126
C=13	M=67	Y=7	K=50		R=127	G=64	B=97
C=73	M=72	Y=22	K=53		R=53	G=47	B=82
C=87	M=86	Y=33	K=60		R=30	G=24	B=61

LIGHT

C=6	M=5	Y=2	K=0		R=236	G=235	B=241
C=4	M=9	Y=0	K=0		R=241	G=230	B=241
C=4	M=18	Y=2	K=0		R=240	G=212	B=225
C=20	M=20	Y=6	K=2		R=197	G=192	B=210
C=24	M=24	Y=9	K=6		R=181	G=176	B=194

MUTED

C=16	M=15	Y=11	K=0		R=211	G=206	B=212
C=16	M=24	Y=11	K=0		R=211	G=192	B=203
C=29	M=49	Y=27	K=0		R=184	G=140	B=155
C=57	M=56	Y=38	K=5		R=123	G=111	B=128
C=70	M=69	Y=50	K=21		R=88	G=79	B=94

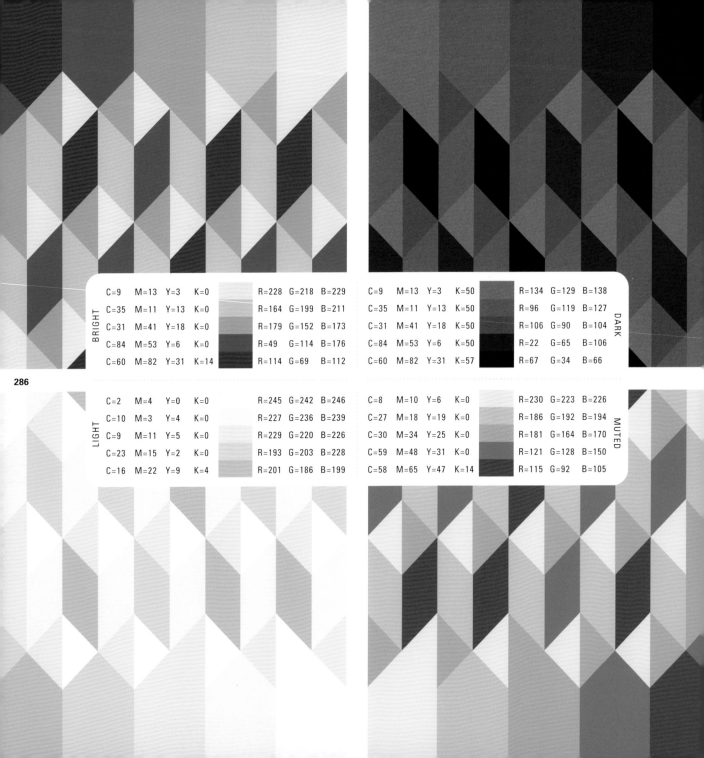

BRIGHT

C=9	M=13	Y=3	K=0		R=228	G=218	B=229
C=35	M=11	Y=13	K=0		R=164	G=199	B=211
C=31	M=41	Y=18	K=0		R=179	G=152	B=173
C=84	M=53	Y=6	K=0		R=49	G=114	B=176
C=60	M=82	Y=31	K=14		R=114	G=69	B=112

DARK

C=9	M=13	Y=3	K=50		R=134	G=129	B=138
C=35	M=11	Y=13	K=50		R=96	G=119	B=127
C=31	M=41	Y=18	K=50		R=106	G=90	B=104
C=84	M=53	Y=6	K=50		R=22	G=65	B=106
C=60	M=82	Y=31	K=57		R=67	G=34	B=66

LIGHT

C=2	M=4	Y=0	K=0		R=245	G=242	B=246
C=10	M=3	Y=4	K=0		R=227	G=236	B=239
C=9	M=11	Y=5	K=0		R=229	G=220	B=226
C=23	M=15	Y=2	K=0		R=193	G=203	B=228
C=16	M=22	Y=9	K=4		R=201	G=186	B=199

MUTED

C=8	M=10	Y=6	K=0		R=230	G=223	B=226
C=27	M=18	Y=19	K=0		R=186	G=192	B=194
C=30	M=34	Y=25	K=0		R=181	G=164	B=170
C=59	M=48	Y=31	K=0		R=121	G=128	B=150
C=58	M=65	Y=47	K=14		R=115	G=92	B=105

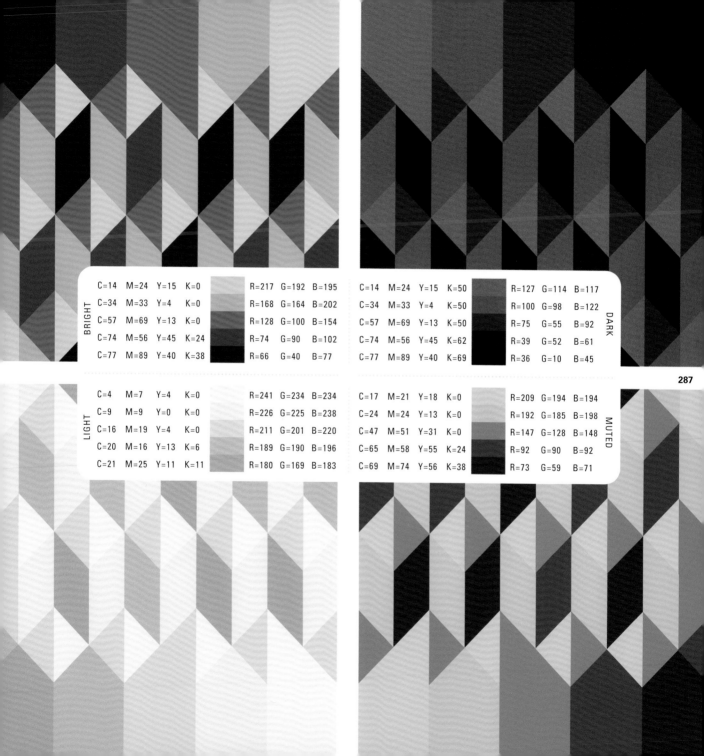

BRIGHT

C=14	M=24	Y=15	K=0		R=217	G=192	B=195
C=34	M=33	Y=4	K=0		R=168	G=164	B=202
C=57	M=69	Y=13	K=0		R=128	G=100	B=154
C=74	M=56	Y=45	K=24		R=74	G=90	B=102
C=77	M=89	Y=40	K=38		R=66	G=40	B=77

DARK

C=14	M=24	Y=15	K=50		R=127	G=114	B=117
C=34	M=33	Y=4	K=50		R=100	G=98	B=122
C=57	M=69	Y=13	K=50		R=75	G=55	B=92
C=74	M=56	Y=45	K=62		R=39	G=52	B=61
C=77	M=89	Y=40	K=69		R=36	G=10	B=45

LIGHT

C=4	M=7	Y=4	K=0		R=241	G=234	B=234
C=9	M=9	Y=0	K=0		R=226	G=225	B=238
C=16	M=19	Y=4	K=0		R=211	G=201	B=220
C=20	M=16	Y=13	K=6		R=189	G=190	B=196
C=21	M=25	Y=11	K=11		R=180	G=169	B=183

MUTED

C=17	M=21	Y=18	K=0		R=209	G=194	B=194
C=24	M=24	Y=13	K=0		R=192	G=185	B=198
C=47	M=51	Y=31	K=0		R=147	G=128	B=148
C=65	M=58	Y=55	K=24		R=92	G=90	B=92
C=69	M=74	Y=56	K=38		R=73	G=59	B=71

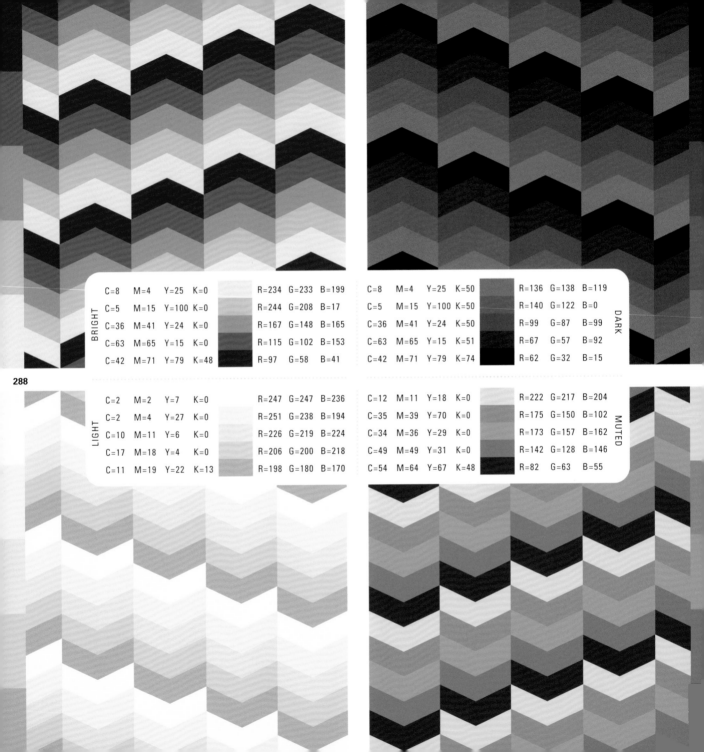

BRIGHT

C=8	M=4	Y=25	K=0		R=234	G=233	B=199
C=5	M=15	Y=100	K=0		R=244	G=208	B=17
C=36	M=41	Y=24	K=0		R=167	G=148	B=165
C=63	M=65	Y=15	K=0		R=115	G=102	B=153
C=42	M=71	Y=79	K=48		R=97	G=58	B=41

DARK

C=8	M=4	Y=25	K=50		R=136	G=138	B=119
C=5	M=15	Y=100	K=50		R=140	G=122	B=0
C=36	M=41	Y=24	K=50		R=99	G=87	B=99
C=63	M=65	Y=15	K=51		R=67	G=57	B=92
C=42	M=71	Y=79	K=74		R=62	G=32	B=15

LIGHT

C=2	M=2	Y=7	K=0		R=247	G=247	B=236
C=2	M=4	Y=27	K=0		R=251	G=238	B=194
C=10	M=11	Y=6	K=0		R=226	G=219	B=224
C=17	M=18	Y=4	K=0		R=206	G=200	B=218
C=11	M=19	Y=22	K=13		R=198	G=180	B=170

MUTED

C=12	M=11	Y=18	K=0		R=222	G=217	B=204
C=35	M=39	Y=70	K=0		R=175	G=150	B=102
C=34	M=36	Y=29	K=0		R=173	G=157	B=162
C=49	M=49	Y=31	K=0		R=142	G=128	B=146
C=54	M=64	Y=67	K=48		R=82	G=63	B=55

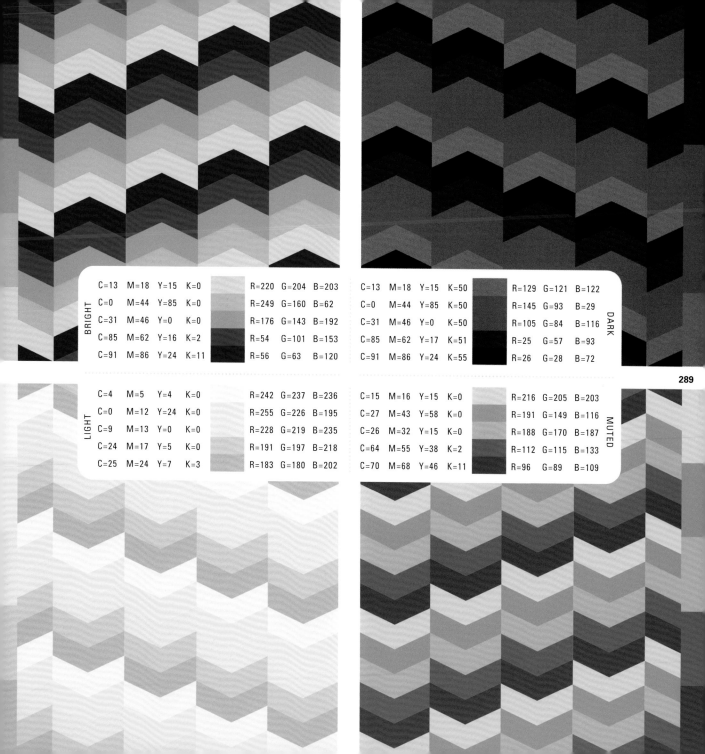

289

BRIGHT

C=13	M=18	Y=15	K=0	R=220	G=204	B=203
C=0	M=44	Y=85	K=0	R=249	G=160	B=62
C=31	M=46	Y=0	K=0	R=176	G=143	B=192
C=85	M=62	Y=16	K=2	R=54	G=101	B=153
C=91	M=86	Y=24	K=11	R=56	G=63	B=120

DARK

C=13	M=18	Y=15	K=50	R=129	G=121	B=122
C=0	M=44	Y=85	K=50	R=145	G=93	B=29
C=31	M=46	Y=0	K=50	R=105	G=84	B=116
C=85	M=62	Y=17	K=51	R=25	G=57	B=93
C=91	M=86	Y=24	K=55	R=26	G=28	B=72

LIGHT

C=4	M=5	Y=4	K=0	R=242	G=237	B=236
C=0	M=12	Y=24	K=0	R=255	G=226	B=195
C=9	M=13	Y=0	K=0	R=228	G=219	B=235
C=24	M=17	Y=5	K=0	R=191	G=197	B=218
C=25	M=24	Y=7	K=3	R=183	G=180	B=202

MUTED

C=15	M=16	Y=15	K=0	R=216	G=205	B=203
C=27	M=43	Y=58	K=0	R=191	G=149	B=116
C=26	M=32	Y=15	K=0	R=188	G=170	B=187
C=64	M=55	Y=38	K=2	R=112	G=115	B=133
C=70	M=68	Y=46	K=11	R=96	G=89	B=109

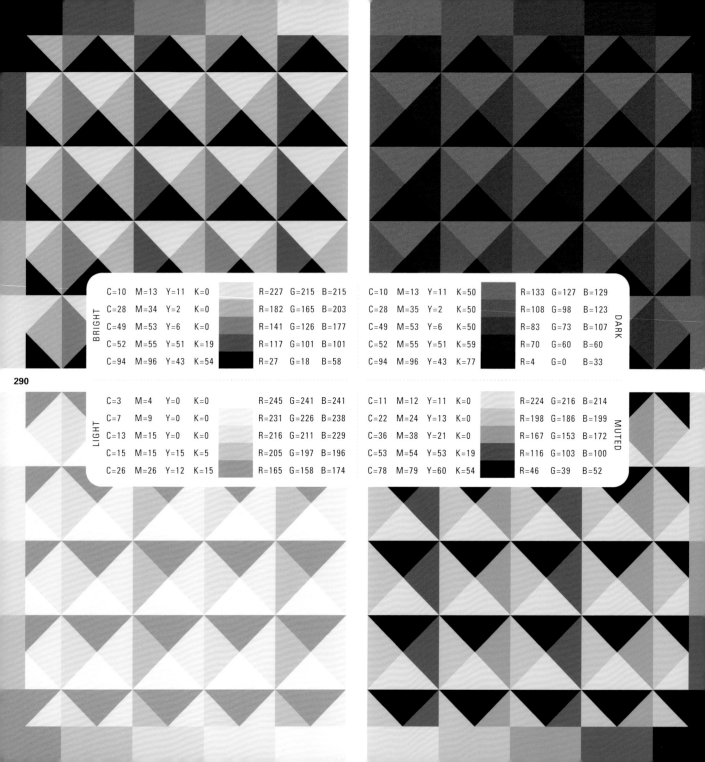

		BRIGHT							
C=10	M=13	Y=11	K=0		R=227	G=215	B=215		
C=28	M=34	Y=2	K=0		R=182	G=165	B=203		
C=49	M=53	Y=6	K=0		R=141	G=126	B=177		
C=52	M=55	Y=51	K=19		R=117	G=101	B=101		
C=94	M=96	Y=43	K=54		R=27	G=18	B=58		

DARK

C=10	M=13	Y=11	K=50		R=133	G=127	B=129
C=28	M=35	Y=2	K=50		R=108	G=98	B=123
C=49	M=53	Y=6	K=50		R=83	G=73	B=107
C=52	M=55	Y=51	K=59		R=70	G=60	B=60
C=94	M=96	Y=43	K=77		R=4	G=0	B=33

LIGHT

C=3	M=4	Y=0	K=0		R=245	G=241	B=241
C=7	M=9	Y=0	K=0		R=231	G=226	B=238
C=13	M=15	Y=0	K=0		R=216	G=211	B=229
C=15	M=15	Y=15	K=5		R=205	G=197	B=196
C=26	M=26	Y=12	K=15		R=165	G=158	B=174

MUTED

C=11	M=12	Y=11	K=0		R=224	G=216	B=214
C=22	M=24	Y=13	K=0		R=198	G=186	B=199
C=36	M=38	Y=21	K=0		R=167	G=153	B=172
C=53	M=54	Y=53	K=19		R=116	G=103	B=100
C=78	M=79	Y=60	K=54		R=46	G=39	B=52

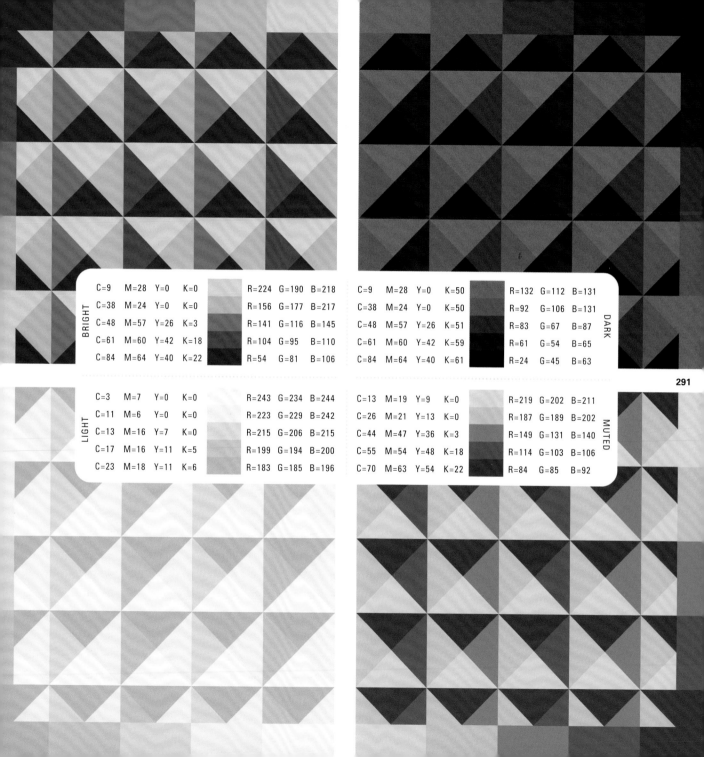

BRIGHT	C=9	M=28	Y=0	K=0	R=224	G=190	B=218
	C=38	M=24	Y=0	K=0	R=156	G=177	B=217
	C=48	M=57	Y=26	K=3	R=141	G=116	B=145
	C=61	M=60	Y=42	K=18	R=104	G=95	B=110
	C=84	M=64	Y=40	K=22	R=54	G=81	B=106

C=9	M=28	Y=0	K=50	R=132	G=112	B=131	**DARK**
C=38	M=24	Y=0	K=50	R=92	G=106	B=131	
C=48	M=57	Y=26	K=51	R=83	G=67	B=87	
C=61	M=60	Y=42	K=59	R=61	G=54	B=65	
C=84	M=64	Y=40	K=61	R=24	G=45	B=63	

LIGHT	C=3	M=7	Y=0	K=0	R=243	G=234	B=244
	C=11	M=6	Y=0	K=0	R=223	G=229	B=242
	C=13	M=16	Y=7	K=0	R=215	G=206	B=215
	C=17	M=16	Y=11	K=5	R=199	G=194	B=200
	C=23	M=18	Y=11	K=6	R=183	G=185	B=196

C=13	M=19	Y=9	K=0	R=219	G=202	B=211	**MUTED**
C=26	M=21	Y=13	K=0	R=187	G=189	B=202	
C=44	M=47	Y=36	K=3	R=149	G=131	B=140	
C=55	M=54	Y=48	K=18	R=114	G=103	B=106	
C=70	M=63	Y=54	K=22	R=84	G=85	B=92	

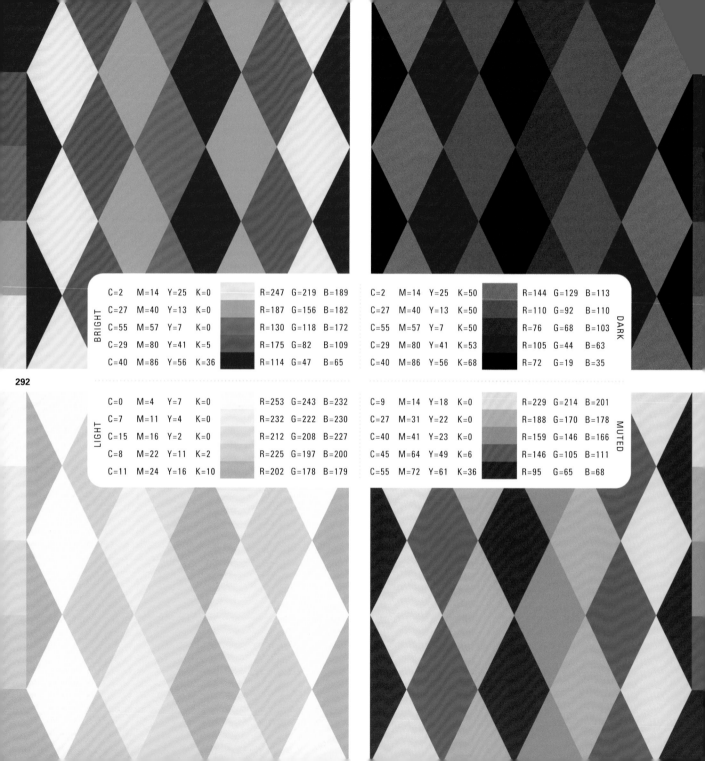

BRIGHT

C=2	M=14	Y=25	K=0		R=247	G=219	B=189
C=27	M=40	Y=13	K=0		R=187	G=156	B=182
C=55	M=57	Y=7	K=0		R=130	G=118	B=172
C=29	M=80	Y=41	K=5		R=175	G=82	B=109
C=40	M=86	Y=56	K=36		R=114	G=47	B=65

DARK

C=2	M=14	Y=25	K=50		R=144	G=129	B=113
C=27	M=40	Y=13	K=50		R=110	G=92	B=110
C=55	M=57	Y=7	K=50		R=76	G=68	B=103
C=29	M=80	Y=41	K=53		R=105	G=44	B=63
C=40	M=86	Y=56	K=68		R=72	G=19	B=35

LIGHT

C=0	M=4	Y=7	K=0		R=253	G=243	B=232
C=7	M=11	Y=4	K=0		R=232	G=222	B=230
C=15	M=16	Y=2	K=0		R=212	G=208	B=227
C=8	M=22	Y=11	K=2		R=225	G=197	B=200
C=11	M=24	Y=16	K=10		R=202	G=178	B=179

MUTED

C=9	M=14	Y=18	K=0		R=229	G=214	B=201
C=27	M=31	Y=22	K=0		R=188	G=170	B=178
C=40	M=41	Y=23	K=0		R=159	G=146	B=166
C=45	M=64	Y=49	K=6		R=146	G=105	B=111
C=55	M=72	Y=61	K=36		R=95	G=65	B=68

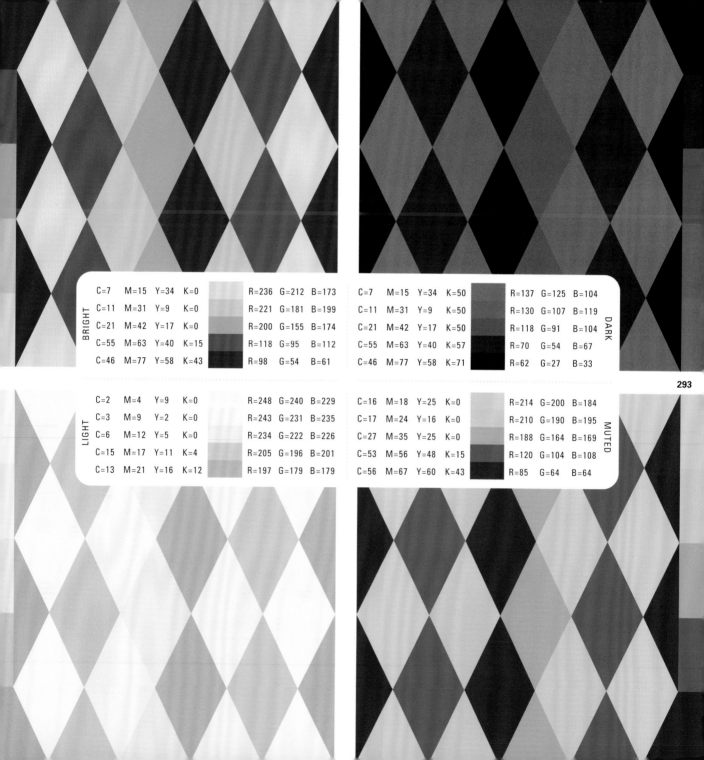

BRIGHT

C=7	M=15	Y=34	K=0		R=236	G=212	B=173
C=11	M=31	Y=9	K=0		R=221	G=181	B=199
C=21	M=42	Y=17	K=0		R=200	G=155	B=174
C=55	M=63	Y=40	K=15		R=118	G=95	B=112
C=46	M=77	Y=58	K=43		R=98	G=54	B=61

DARK

C=7	M=15	Y=34	K=50		R=137	G=125	B=104
C=11	M=31	Y=9	K=50		R=130	G=107	B=119
C=21	M=42	Y=17	K=50		R=118	G=91	B=104
C=55	M=63	Y=40	K=57		R=70	G=54	B=67
C=46	M=77	Y=58	K=71		R=62	G=27	B=33

293

LIGHT

C=2	M=4	Y=9	K=0		R=248	G=240	B=229
C=3	M=9	Y=2	K=0		R=243	G=231	B=235
C=6	M=12	Y=5	K=0		R=234	G=222	B=226
C=15	M=17	Y=11	K=4		R=205	G=196	B=201
C=13	M=21	Y=16	K=12		R=197	G=179	B=179

MUTED

C=16	M=18	Y=25	K=0		R=214	G=200	B=184
C=17	M=24	Y=16	K=0		R=210	G=190	B=195
C=27	M=35	Y=25	K=0		R=188	G=164	B=169
C=53	M=56	Y=48	K=15		R=120	G=104	B=108
C=56	M=67	Y=60	K=43		R=85	G=64	B=64

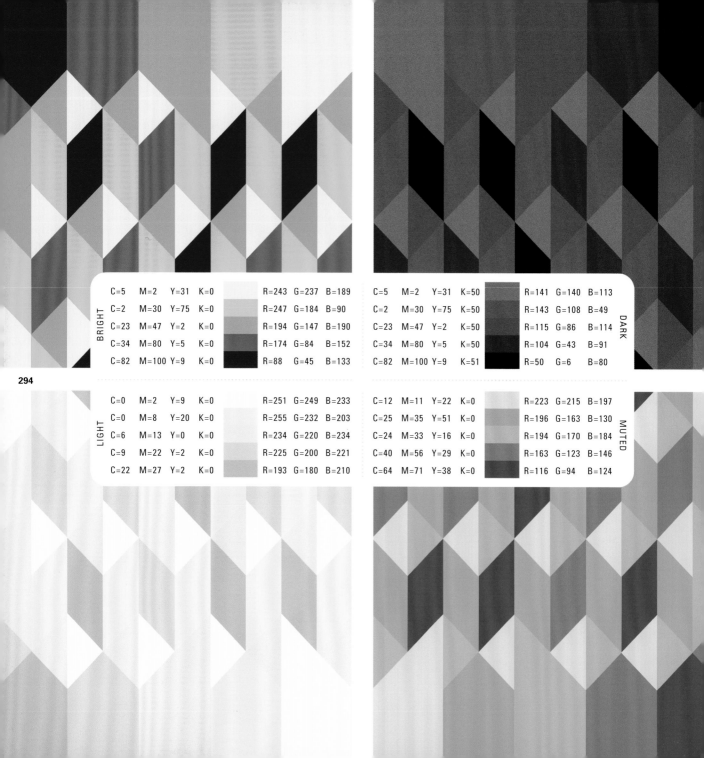

BRIGHT

C	M	Y	K		R	G	B
C=5	M=2	Y=31	K=0		R=243	G=237	B=189
C=2	M=30	Y=75	K=0		R=247	G=184	B=90
C=23	M=47	Y=2	K=0		R=194	G=147	B=190
C=34	M=80	Y=5	K=0		R=174	G=84	B=152
C=82	M=100	Y=9	K=0		R=88	G=45	B=133

DARK

C	M	Y	K		R	G	B
C=5	M=2	Y=31	K=50		R=141	G=140	B=113
C=2	M=30	Y=75	K=50		R=143	G=108	B=49
C=23	M=47	Y=2	K=50		R=115	G=86	B=114
C=34	M=80	Y=5	K=50		R=104	G=43	B=91
C=82	M=100	Y=9	K=51		R=50	G=6	B=80

LIGHT

C	M	Y	K		R	G	B
C=0	M=2	Y=9	K=0		R=251	G=249	B=233
C=0	M=8	Y=20	K=0		R=255	G=232	B=203
C=6	M=13	Y=0	K=0		R=234	G=220	B=234
C=9	M=22	Y=2	K=0		R=225	G=200	B=221
C=22	M=27	Y=2	K=0		R=193	G=180	B=210

MUTED

C	M	Y	K		R	G	B
C=12	M=11	Y=22	K=0		R=223	G=215	B=197
C=25	M=35	Y=51	K=0		R=196	G=163	B=130
C=24	M=33	Y=16	K=0		R=194	G=170	B=184
C=40	M=56	Y=29	K=0		R=163	G=123	B=146
C=64	M=71	Y=38	K=0		R=116	G=94	B=124

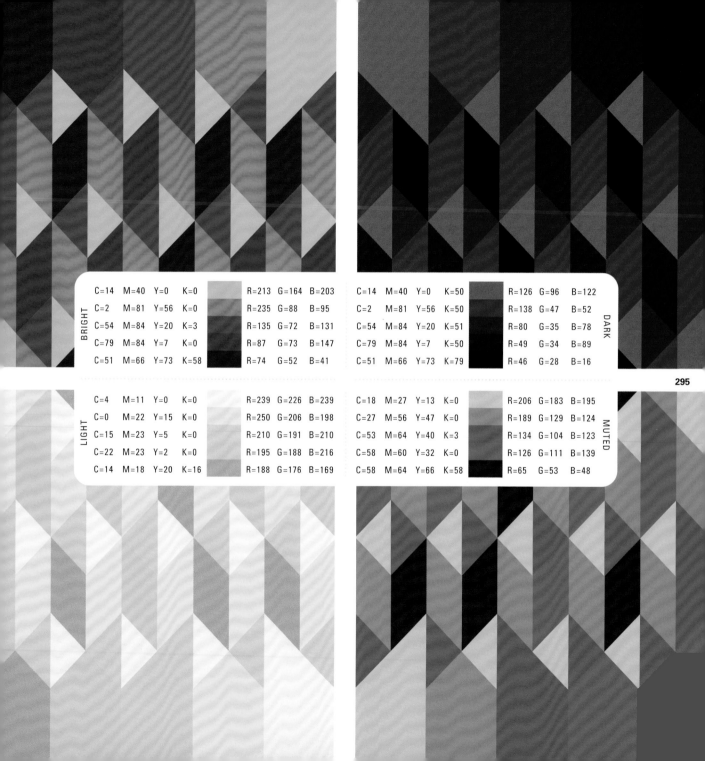

BRIGHT

C=14	M=40	Y=0	K=0		R=213	G=164	B=203
C=2	M=81	Y=56	K=0		R=235	G=88	B=95
C=54	M=84	Y=20	K=3		R=135	G=72	B=131
C=79	M=84	Y=7	K=0		R=87	G=73	B=147
C=51	M=66	Y=73	K=58		R=74	G=52	B=41

DARK

C=14	M=40	Y=0	K=50		R=126	G=96	B=122
C=2	M=81	Y=56	K=50		R=138	G=47	B=52
C=54	M=84	Y=20	K=51		R=80	G=35	B=78
C=79	M=84	Y=7	K=50		R=49	G=34	B=89
C=51	M=66	Y=73	K=79		R=46	G=28	B=16

LIGHT

C=4	M=11	Y=0	K=0		R=239	G=226	B=239
C=0	M=22	Y=15	K=0		R=250	G=206	B=198
C=15	M=23	Y=5	K=0		R=210	G=191	B=210
C=22	M=23	Y=2	K=0		R=195	G=188	B=216
C=14	M=18	Y=20	K=16		R=188	G=176	B=169

MUTED

C=18	M=27	Y=13	K=0		R=206	G=183	B=195
C=27	M=56	Y=47	K=0		R=189	G=129	B=124
C=53	M=64	Y=40	K=3		R=134	G=104	B=123
C=58	M=60	Y=32	K=0		R=126	G=111	B=139
C=58	M=64	Y=66	K=58		R=65	G=53	B=48

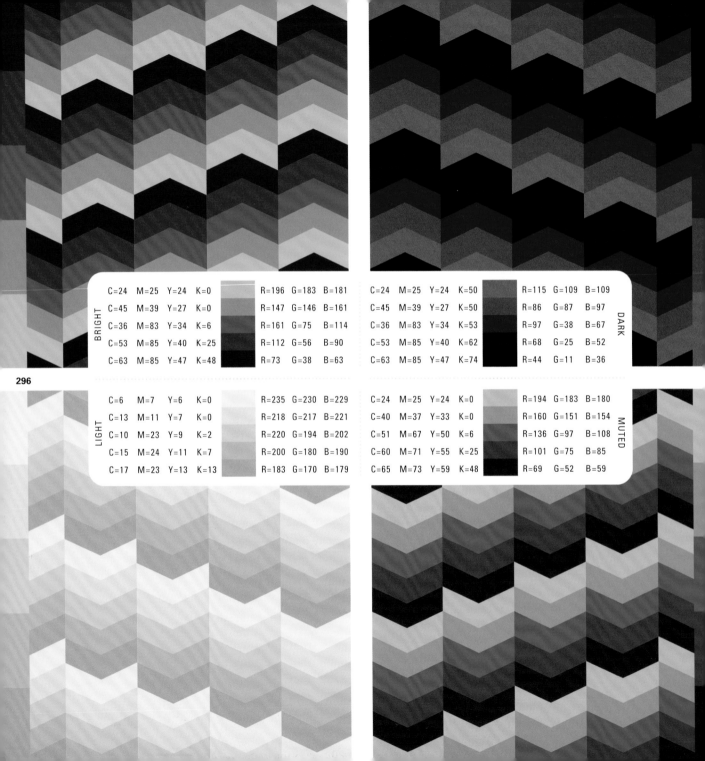

BRIGHT

C=24	M=25	Y=24	K=0		R=196	G=183	B=181
C=45	M=39	Y=27	K=0		R=147	G=146	B=161
C=36	M=83	Y=34	K=6		R=161	G=75	B=114
C=53	M=85	Y=40	K=25		R=112	G=56	B=90
C=63	M=85	Y=47	K=48		R=73	G=38	B=63

DARK

C=24	M=25	Y=24	K=50		R=115	G=109	B=109
C=45	M=39	Y=27	K=50		R=86	G=87	B=97
C=36	M=83	Y=34	K=53		R=97	G=38	B=67
C=53	M=85	Y=40	K=62		R=68	G=25	B=52
C=63	M=85	Y=47	K=74		R=44	G=11	B=36

LIGHT

C=6	M=7	Y=6	K=0		R=235	G=230	B=229
C=13	M=11	Y=7	K=0		R=218	G=217	B=221
C=10	M=23	Y=9	K=2		R=220	G=194	B=202
C=15	M=24	Y=11	K=7		R=200	G=180	B=190
C=17	M=23	Y=13	K=13		R=183	G=170	B=179

MUTED

C=24	M=25	Y=24	K=0		R=194	G=183	B=180
C=40	M=37	Y=33	K=0		R=160	G=151	B=154
C=51	M=67	Y=50	K=6		R=136	G=97	B=108
C=60	M=71	Y=55	K=25		R=101	G=75	B=85
C=65	M=73	Y=59	K=48		R=69	G=52	B=59

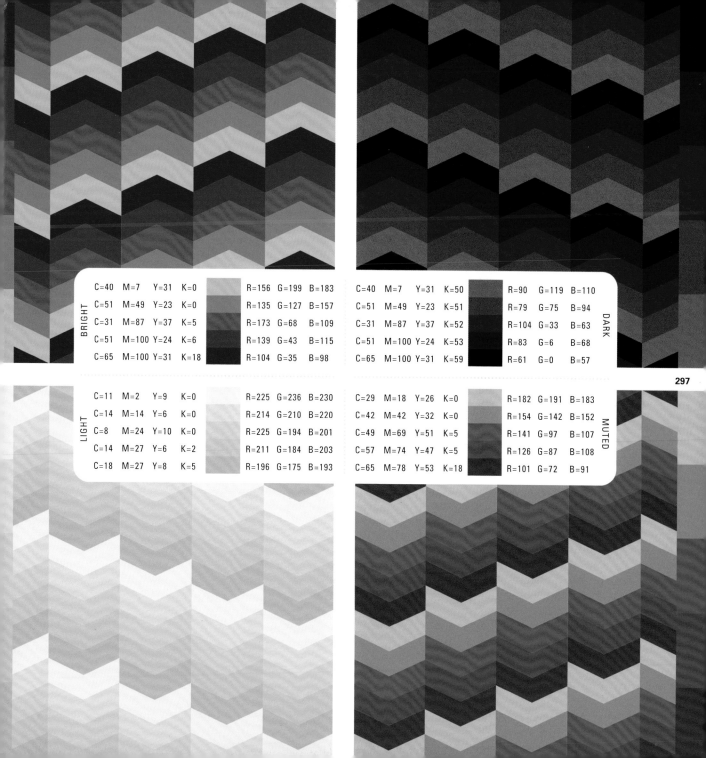

BRIGHT

C=40	M=7	Y=31	K=0		R=156	G=199	B=183
C=51	M=49	Y=23	K=0		R=135	G=127	B=157
C=31	M=87	Y=37	K=5		R=173	G=68	B=109
C=51	M=100	Y=24	K=6		R=139	G=43	B=115
C=65	M=100	Y=31	K=18		R=104	G=35	B=98

DARK

C=40	M=7	Y=31	K=50		R=90	G=119	B=110
C=51	M=49	Y=23	K=51		R=79	G=75	B=94
C=31	M=87	Y=37	K=52		R=104	G=33	B=63
C=51	M=100	Y=24	K=53		R=83	G=6	B=68
C=65	M=100	Y=31	K=59		R=61	G=0	B=57

LIGHT

C=11	M=2	Y=9	K=0		R=225	G=236	B=230
C=14	M=14	Y=6	K=0		R=214	G=210	B=220
C=8	M=24	Y=10	K=0		R=225	G=194	B=201
C=14	M=27	Y=6	K=2		R=211	G=184	B=203
C=18	M=27	Y=8	K=5		R=196	G=175	B=193

MUTED

C=29	M=18	Y=26	K=0		R=182	G=191	B=183
C=42	M=42	Y=32	K=0		R=154	G=142	B=152
C=49	M=69	Y=51	K=5		R=141	G=97	B=107
C=57	M=74	Y=47	K=5		R=126	G=87	B=108
C=65	M=78	Y=53	K=18		R=101	G=72	B=91

Published in the United States by Watson-Guptill Publications, an imprint of the
Crown Publishing Group, a division of Penguin Random House LLC, New York.
www.crownpublishing.com
www.watsonguptill.com

WATSON-GUPTILL and the WG and Horse designs are registered trademarks of
Penguin Random House LLC.

Library of Congress Cataloging-in-Publication Data
Names: Krause, Jim, 1962- author.
Title: Color index XL : more than 1100 new palettes with CMYK and RGB formulas
 for designers and artists / Jim Krause.
Description: First edition. | California : Watson-Guptill, 2017.
Identifiers: LCCN 2017001752 (print) | LCCN 2017005990 (ebook)
Subjects: LCSH: Graphic arts—Handbooks, manuals, etc. | Color in art. | National
 characteristics in art. | Color computer graphics. | BISAC: ART / Color Theory. |
 ART / Reference. | DESIGN / Reference.
Classification: LCC NC997 .K7322 2017 (print) | LCC NC997 (ebook) | DDC 740—dc23
LC record available at https://lccn.loc.gov/2017001752

Trade Paperback ISBN: 978-0-399-57978-3
eBook ISBN: 978-0-399-57979-0

Printed in China

Design by Jim Krause

10 9 8 7 6 5 4 3 2 1

First Edition